SCOTTISH ART 1460–1990

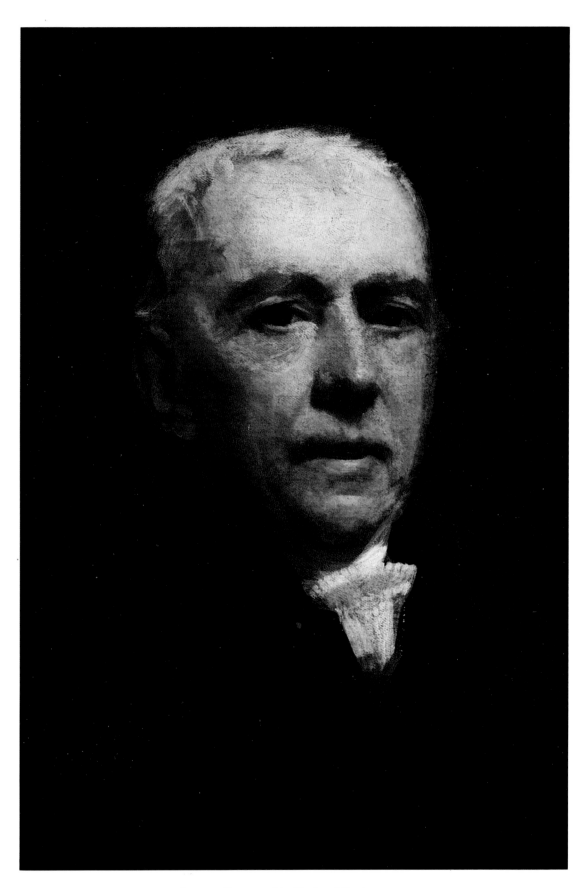

RAEBURN, DETAIL OF *John Pitcairn of Pitcairn*, c. 1823

SCOTTISH ART 1460 1990

DUNCAN MACMILLAN

MAINSTREAM PUBLISHING

For my Wife
and
In Memory of my Father

First published in Great Britain 1990 by
MAINSTREAM PUBLISHING COMPANY (EDINBURGH) LTD
7 Albany Street
Edinburgh EH1 3UG

British Library Cataloguing in Publication Data

Macmillan, Duncan
Scottish Art, 1460–1990
1. Scottish visual arts, history
I. Title
709.411

ISBN 1-85158-251-7

The publisher gratefully acknowledges financial
assistance from the Scottish Arts Council in the
publication of this volume.

Book design by James Hutcheson and Paul Keir, Wide Art, Edinburgh
Typeset in 12/13pt Perpetua by Blackpool Typesetting Services Ltd, Blackpool
Monochrome and colour separation by Hislop & Day, Edinburgh
Printed in Great Britain by Butler and Tanner, Frome, Somerset

CONTENTS

INTRODUCTION

. . . mi venne in concetto potersene fare una chiara dimonstrazione, mediante un albero, nel quale si vedesse apertamente da' primi fino a' viventi.

(The idea came to me that by means of a tree it would be possible to make a clear demonstration in which [this development] could be plainly seen from the earliest [artists] down to those living today.)

Fillipo Baldinucci, 'L'Autore a chi legge', *Notizie de'Professori del Disegno da Cimabue in Qua*, 1681

Vasari will always remain unchallenged as the first great writer of art history, but it was Baldinucci, writing at the end of the seventeenth century, who was the first modern art-historian. Vasari's *Lives of the Artists* constitutes a brilliant, dramatic tale in which his recording of objective fact serves his sense of the way art evolved, leading up to its high point and the dramatic conclusion of his book, the supreme achievement of Michelangelo. Baldinucci, however, did not seek to put the history that he wrote into the service of a dramatic idea. He was an empiricist, a historian dedicated to describing what he found, not to enlisting it in the service of a preconception. He saw that the history of art in Europe, properly approached, revealed its own structures. Thus, in the quotation given above, he likens the history of art to a tree, a complex organism extending and ramifying slowly through time.

In choosing such a metaphor to describe his perception, Baldinucci was also consciously distancing himself from his great rival, G. P. Bellori, the champion of the idealist and academic theory of art who set much of the agenda for art theory in the eighteenth century and beyond. His *Le Vite de Pittori, Scultori et Architetti Moderni*, published nine years before publication of Baldinucci's many volumed work began, was a selective account of modern art, from the late sixteenth century through to his own time.[1] He does not open it with a modest metaphor of continuity and organic growth like Baldinucci, but with a dramatic picture of art in Italy in the late sixteenth century in a state of darkness and terminal decline. Art, he says, was coming to its end when 'the stars shone more kindly on Italy and it pleased God that in Bologna' Annibale Carracci emerged to redeem art in a new Renaissance.[2]

Bellori had few followers among the Scots, but Baldinucci seems to have had a direct influence on one of the first major Scottish texts on art, Allan Ramsay's *A Dialogue on Taste* (1755). In choosing the form of a dialogue, Ramsay was inspired by a similar dialogue called *La Veglia* that Baldinucci had written to justify his adoption of an objective, non-partisan approach to the writing of art history in his *Notizie de'Professori del Disegno*.[3] Ramsay also shared with him a belief that clarity and intelligibility were virtues in all branches of human understanding. He made this luminously apparent in his art, but in *A Dialogue on Taste* he also extended it to make connections between values in art and values in society at large. The idea of such connections was first formulated in English at the beginning of the eighteenth century by the Earl of Shaftesbury, but it constantly surfaces in the work of the artists discussed here.

Baldinucci would have been particularly attractive to Ramsay because of his empiricism. Ramsay too was an empiricist whose own theory of art, set out in *A Dialogue on Taste*, effectively disposes of Bellori's idealism on empirical grounds. Ramsay was also a close friend of David Hume, the greatest of the empirical philosophers whose writings are central to Scottish thought. It is ironic therefore that

without a proper perspective Scottish art will always be seen in terms of Bellori's metaphor, not Baldinucci's, as born in a dark age without art or even hostile to it. This idea went back at least to Pliny in classical antiquity however. It had been borrowed by Ghiberti in the fifteenth century to contrast what he saw as the darkness of the Middle Ages with the new light of his own age and was then developed by Vasari into the fully fledged idea of the Renaissance before Bellori adapted it to his own purposes. In its application to Scotland though, it has been given a peculiar twist. Here, we are told, the darkness is not succeeded by the contrasting brilliance of new light. Instead it is a permanent state, a long shadow stretching over Scottish history from the iconoclasm of the Reformation. Thus the history of the nation's art appears to start with a great negative and against this its subsequent achievements, the art of Ramsay, for example, of Raeburn, of Mackintosh or the Colourists, can only appear as a series of meteors, blazing inexplicably against a sky forever darkened by the shadow of that bitter legacy.

Though wholly misleading, this is a simple vision that has proved remarkably durable. It suggests that there is a fundamental incompatibility between Protestantism and painting which puts visual art in Scotland at a permanent disadvantage. Even in 1990 I have seen the headline 'Scots visual art and Calvinist neglect'.[4] It is a sad irony, in addition, that the prominence that this view gives to iconoclasm prevents the Scots from seeing that their contribution to the humanising of western culture – the philosophy of Hume, the portraits of Ramsay, the poetry of Burns, the novels of Scott, the paintings of Wilkie or the town planning of Patrick Geddes, to name just a few examples – has not been achieved in spite of the Reformation, but is in fact an integral extension of their profound involvement in that event which was where this humanising process began.

It became clear to me therefore that until the Reformation was included in the story of Scottish art, iconoclasm would continue to cast this shadow. Even so, however, when I set out on this project, perhaps unconsciously I still shared something of this traditional vision. I

was not convinced for instance that the late Middle Ages were not as impoverished as they seemed and that the Reformation would not in the end prove to have constituted a complete break even with their tentative beginnings. Perhaps, at the other end of the story, it would turn out too that twentieth century art was only preserved from finally sliding into provincialism by the work of a few isolated individuals, flourishing in spite of the poverty of their cultural environment and without continuity.

In the end though, Scottish art proves itself to have a continuous and distinct identity as part of the European tradition – as a branch of Baldinucci's tree. There is however another problem to be overcome in trying to find an acceptable frame of reference within which to define that identity. Bellori's slanted view of art history is relevant here too and will no doubt manifest itself in some of the responses to this book. His academic idealism depends on the notion that certain artists have brought art to a level of achievement that provides a norm. All other art must therefore be judged by the extent to which it approaches to, or reflects that norm. It is an easy step to see this norm as the art of certain centres and of certain times and it follows that all transmission of ideas must be outwards and downwards from these centres. It is a view that conveniently simplifies art history and so has shaped some of its basic assumptions. It follows from it that a country like Scotland, seen as on the periphery, must always be at a disadvantage, a receiver, not a generator of ideas.

In fact of course the real flow of exchanges by which art in Europe has evolved has been much more complex. It has not been a matter of large central units with smaller units forever dependent on them, but of an overall pattern in which the major schools form the great branches of the tree perhaps, but the smaller branches and even the twigs form with them an interlace of great complexity. Scottish artists have always been consciously European and they have both taken and given inspiration in this exchange. Our picture of European art will not be complete therefore till Scotland's contribution is made part of it.

This book is written as a narrative. Its subject is the history of painting and it is

limited almost entirely to art in two dimensions: to painting and the related graphic arts. The exceptions are at the beginning where, because of the loss of so much of the painting, it has been necessary to invoke parallel examples from sculpture or the applied arts, and at the end where the traditional distinctions between art in two and three dimensions no longer hold. Sculpture otherwise has a distinct story for most of the period, a story to which it would be impossible to do justice in the space available.

The story of painting as it is told here begins in the reign of James III, not because there is no earlier art, but because at this point we begin to see it in relation to particular people, in a way that is recognisably modern. It is part of their awareness of themselves and, through the king, of Scotland as a nation. It was just this kind of self-awareness and European sophistication that opened Scotland to the Reformation. It was perhaps a hard winter for art that followed that event, between the late sixteenth and the late seventeenth centuries, but the branch did not die in the frost, nor was it torn from the parent stem by the harsh winds of civil strife. Judged by the conventional view, the surprising thing is indeed the extent to which painting and painted decoration remained part of Scottish life in the Reformation and post-Reformation years.

The disruption of the art markets that had traditionally supplied Scottish needs was a European, not merely a Scottish phenomenon and the evolution of new markets and new suppliers was a slow business. Nevertheless, far from being monochrome, life in Scotland was rather colourful in the post-Reformation period with plenty of employment for the painters. Their art may not always have been very sophisticated, but George Jamesone, the first recognisably modern Scottish artist, was one of them and they helped lay the foundation of the art that developed in the eighteenth century. Nor was taste in the visual arts a forgotten virtue in the seventeenth century. The remarkable correspondence between John Clerk of Penicuik and the Earl of Lothian reveals that even one of the leaders of the party of the Covenant was building up his collection of paintings at the height of the Civil War.

It was this continuity, and the emergence in the later seventeenth century of a professional class which included the artists, that made it possible for them to participate fully when, in the eighteenth century, the radical, mental habits of the Reformation were put to new uses and a secular generation built on the social concern that from the start had been part of Protestant thought. The analysis of human nature conducted by Hume and Thomas Reid was at the centre of this development. Perception, and especially the sense of sight, were in turn central to their analysis. The links between painting and empirical philosophy, between Ramsay and Hume, or Raeburn and Reid, must therefore be at the heart of our understanding of the painting of the age of the Enlightenment. It was however one of the first premises of this analysis that the moral and the physical universe are indivisible.

Questions of moral and actual perception were closely allied therefore and the idea that imagination and intuition played a central role in perception of both kinds had profound consequences for the arts. It suggested, not just that art could impinge on moral behaviour, but that moral and aesthetic ideas actually shared a common field of experience, a theory first put forward by Francis Hutcheson and whose consequences for the history of art have still not fully run their course.[5] Behind this lay a belief in the original potential of human nature. The search for an art that might reflect this primitive state – which was therefore originally a moral objective however it developed in the subsequent history of modern art – began with the reassessment of Homer and evolved through the appreciation of folk-music and the ballad as well as the enthusiasm for Ossian. These things provided the inspiration, not just for the poetry of Fergusson and Burns, but also for the painting of Hamilton, Runciman and Wilkie. Their precociousness is a real feature of the place of Scottish art in Europe, for they were among the first painters to explore ideas which have continued to reverberate down to the present day. Prophetically they stood for the maintenance of human values in the face of the

increasingly radical effect on society of the pursuit of purely material ones.

Such was the energy of the achievement in which artists, poets and philosophers came together in the Enlightenment that Scottish painting maintained its vigour throughout the nineteenth century. Towards the end of the century, for example, William McTaggart must now be recognised as a great European painter. However, neither he nor his younger contemporaries, the Glasgow Boys, were just another case of the shooting star against a dark sky. They were all building on a European achievement to which their own native tradition had already contributed. Patrick Geddes championed this view of Scotland as part of the European tradition, but he also restated once again the importance of the social role of art. These things are reflected in the etchings and the first world war drawings of Muirhead Bone and in the paintings of J. D. Fergusson.

In the twenties the tradition established by Geddes ensured that the Scottish 'Renascence' in literature had a close analogy in painting, either through direct exchange as between Hugh MacDiarmid and William Johnstone, or in parallel as with James Cowie and Lewis Grassic Gibbon. Its legacy, especially in Glasgow where J. D. Fergusson went in 1939 with the conscious intention of passing on the torch to a new generation, has given distinction to the work of artists from Scotland still working today. The best among them have kept alive the tradition of the essential seriousness of art. They have not lost sight of the pleasure it can give but they have remained loyal to the relationship between art and conscience, whose origins lie in the eighteenth century or, even earlier, in the Reformation itself.

The last question that must be addressed underlies this whole enterprise. How is Scottish art to be defined? In the end there can be no simple definition and the edges are bound to be blurred as they are of any national art, but the central definition is clear. It is art produced by Scottish artists, by artists in Scotland who have settled and become part of the culture of the place, or, in the earlier period, art produced for Scottish patrons, though through a nexus of expatriates and Scottish overseas connections. It is also a matter of cultural climate, of shared ideas and shared values. It is not simply a matter of blood and birth, but of something slightly more elusive therefore, but which I hope I have captured. There have of course always been outside influences, but it has rarely been simply a matter of putting on second-hand clothes, and Scottish artists, when they have gone to work elsewhere, have usually kept their identities. Ramsay for example made his base in London, but outside Scotland his education as an artist included Italy as well as England and he learnt from the French too. Wherever he was, however, in learning, his premises were always his own, established in his background in Scotland. Wilkie likewise worked in England, but his art is incomprehensible without the background, not just of Scottish painting represented by Raeburn and Nasmyth, but of the whole literary and philosophic tradition in Scotland. The same can be said of Orchardson, Muirhead Bone, Johnstone, or even Paolozzi.

The fact that this book is a narrative means, too, that I have had to concentrate on the more important artists. There was little point in putting together a string of names with the kind of minimal information that could be provided by a simple dictionary. Instead of a cast of thousands with little more than walk-on parts, there seemed more point in giving scope to the analysis of the art of the principal characters and for the development of the themes that it suggests. Even so, writing on this scale is a bit like painting a landscape of distant mountains. There is some hope that you may get the overall configuration right, but you know that the view is bound to seem different if you move closer, or even if the light changes or the clouds lift. All history is provisional, but I hope that as the landscape of Scottish art is mapped in more detail the outlines that I have drawn will hold good. In drawing this outline I have of course not been alone. A book of this kind draws on the work of many people, and I gratefully acknowledge my indebtedness to my predecessors as well as to the many contemporaries and friends whose names appear in the footnotes and bibliography.

The historiography of Scottish art begins more than two centuries ago. The earliest consecutive account was written by the portrait

painter Sir George Chalmers in the mid-eighteenth century. It occupied three pages of *The Weekly Magazine* in 1772.[6] Another short account was given in 1799 in John Pinkerton's *Scottish Gallery; or Portraits of Eminent Persons*, but the first extended account was given by Alexander Campbell in 1810 in *A Journey from Edinburgh through Parts of North Britain*.[7] Allan Cunningham, in his *Lives of the Most Eminent British Painters etc.* (1829–33), also recorded the careers of several Scottish artists, though with less accuracy than he did that of Wilkie in his remarkable biography (1843) of the most influential of all Scottish artists.

The first scholarly account of Scottish art was put together by the antiquary David Laing whose research was more extensive than his publications, but it was left, in the form of his notes and the documents he collected, in the library of Edinburgh University where subsequent generations have been able to draw on it. Laing died in 1878. In 1888 Sir Walter Armstrong wrote a short account of Scottish painting, *Scottish Painters: A Critical Study*, but the real groundwork for all modern accounts was laid by Robert Brydall whose *Art in Scotland* (1889), is still an indispensable book. W. D. McKay's *The Scottish School of Painting* was published in 1906 and the later nineteenth and early twentieth centuries also saw the publication of a number of important monographs and biographies of individual artists, including James Caw's life of William McTaggart and, in collaboration with Walter Armstrong, his life and catalogue *raisonné* of Raeburn. Caw's principal achievement though was his *Scottish Painting* (1908), a deservedly popular book which has inspired and informed Scottish readers for more than eighty years.

More recently invaluable work has been done on the medieval and Reformation period under the aegis of the late Monsignor David McRoberts and the journal he founded in 1950, *The Innes Review*. The Scottish National Portrait Gallery, particularly through the work of its keeper, Duncan Thomson, has laid the foundation for our understanding of the post-Reformation period and the seventeenth century. Carrying on the scholarly tradition of the Portrait Gallery which began with its first keeper, John Gray and which continued with

Basil Skinner, Dr Thomson's work has recently been extended into the eighteenth century by James Holloway. Caw's account of the later period remained unchallenged, however, and also largely unmodified by any subsequent books, including John Tonge's *The Arts in Scotland* (1938) which coincided with the great Scottish art exhibition at the Royal Academy organised by Caw, Ian Finlay's *Art in Scotland* (1948) and Stanley Cursiter's *Scottish Art to the Close of the Nineteenth Century* (1949), until Alistair Smart published the first modern, scholarly monograph on a Scottish artist, *The Life and Art of Allan Ramsay* (1952) and Ellis Waterhouse gave some account of Scottish painting as a separate entity in his classic *Painting in Britain 1530–1790* (1953). David and Francina Irwin greatly extended any previous account, however, in their monumental *Scottish Painters at Home and Abroad 1700–1900*, published in 1975. It was limited in period, but was brought up to date by William Hardie's *Scottish Painting 1837–1939* (1976), Edward Gage's *The Eye in the Wind, Contemporary Scottish Painting since 1945* (1977), Jack Firth's *Scottish Watercolour Painting* (1979), and recently by Julian Halsby's *Scottish Watercolours 1740–1940* (1986) and the catalogue by Keith Hartley of the exhibition *Scottish Art since 1900* (1989). My own *Painting in Scotland; the Golden Age 1707–1843* (1986), while giving an account of the art of the period, was also intended to open discussion towards the other areas of Scottish cultural history, an approach I have endeavoured to follow here too.

The last fifteen years has seen a great increase in the publication of work on Scottish art and artists. Especially important has been the work of Lindsay Errington on the nineteenth century and of Roger Billcliffe on the Glasgow Boys and the Colourists. Martin Forrest, Cordelia Oliver and Elizabeth Cumming have also made valuable contributions in the study of the late nineteenth and twentieth centuries. Much else that is valuable has frequently been published in the form of exhibition catalogues, here cited by author's name rather than simply by the place of exhibition.

I also gratefully acknowledge my indebtedness to the many people who have helped me with this project. The Carnegie Trust for the

Universities has assisted with research funding, and practical help has been important in collecting the illustrations, especially from Glasgow Art Galleries and Museums, City of Edinburgh Art Centre, Dundee Art Galleries and Museums, Kirkcaldy Museum and Art Gallery, Glasgow School of Art and Paisley Museum and Art Gallery. Special thanks go to staff of the National Galleries of Scotland and in particular Deborah Hunter and Susanna Kerr. Private galleries have also contributed however, particularly Andrew McIntosh Patrick and Roger Billcliffe of the Fine Art Society and Patrick Bourne of Bourne Fine Art, also Forrest-McKay, Marlborough Fine Art, Edinburgh Printmakers Workshop, the Scottish Gallery, the Portland Gallery, the Picadilly Gallery, the Frances Graham-Dixon Gallery, Runkel-Hew-Williams and Tom Fidelo, so too have Christies and Phillips. Several corporate owners have also been most helpful, particularly Robert Fleming Holdings Plc, the Royal College of Physicians and the Merchant Company of Edinburgh. Many private owners have granted permission to use their pictures without charge, often also allowing access to their collections for the purpose of photography. Joe Rock has travelled around Scotland with me and has as usual produced quality photographs often under very difficult conditions. Thanks are also due to Hislop & Day for their cooperation and willingness to achieve excellence in both monochrome and colour reproduction of the plates. Many artists have also helped with illustrations, notably Ian Fleming, William Gear, John McLean, Ken Dingwall and Elizabeth Ogilvie. I am especially grateful to Will Maclean, however, for the etching that appears with the limited edition and to Peacock Printmakers for printing it.

Foremost among those who have provided indispensable moral support are my wife and family who have been very patient with my distraction and preoccupation over a very long period of time. The staff of the Talbot Rice Gallery and in particular Bill Hare have also helped carry the burden. Many people, both friends and strangers, have encouraged me with their interest in the project to believe that it was worthwhile persevering as what began as a modest undertaking grew and grew. Amongst those who I must thank particularly though, for their courage in undertaking and seeing through such a large and complex production, are Bill Campbell and Peter MacKenzie and their staff at Mainstream, especially Judy, Janene and Penny.

Duncan Macmillan,
1 March 1990

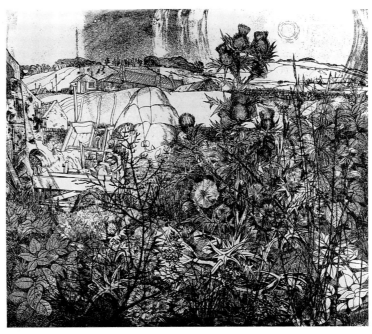

Plate 1. IAN FLEMING. *Thistles in the Sun*, 1974

Part One

The Later Middle Ages
and
The Reformation

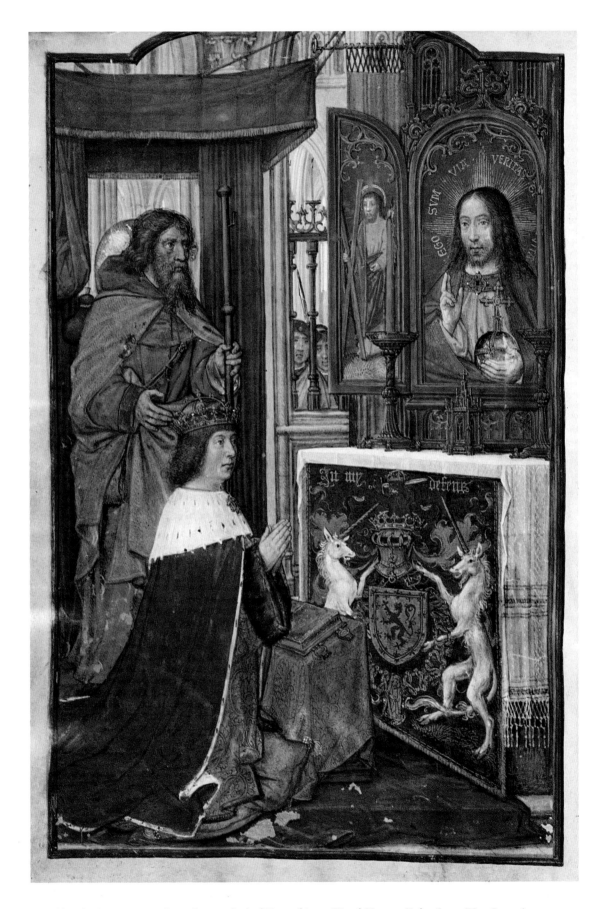

Plate 2. ATTRIBUTED TO SIMON BENING, *Book of Hours of James IV and Margaret Tudor*, 'JAMES IV AT PRAYER', 1503

THE EMERGENCE OF A MODERN NATION
James III, IV & V

Schir, ye have mony servitouris
and officiaris of dyvers curis;
kirkmen, courtmen, and craftsmen fyne;
doctouris in jure, and medicyne;
divinouris, rethoris, and philosophouris,
astrologis, artistis, and oratouris;
men of armes, and vailyeand knychtis,
and mony other gudlie wychtis;
musicianis, menstralis, and mirrie singaris;
chevalouris, cawandaris, and flingaris;
cunyouris, carvouris, and carpentaris,
beildaris of barkis and ballingaris;
masounis lyand upon the land,
and schipwrichtis hewand upon the strand;
glasing wrichtis, goldsmythis, and lapidaris,
pryntouris, payntouris, and potingaris;
and all of thair craft cunning,
and all at anis lawboring.
William Dunbar, 'Remonstrance to the King'

In these lines Dunbar describes the court of James IV at the opening of the sixteenth century. Perhaps he takes a little poetic licence, but it is a wonderful crowd that he evokes; artists and craftsmen, musicians and acrobats, printers, painters and apothecaries, doctors, lawyers, philosophers and many others besides, all working at once. James's father, James III, had come to the throne of Scotland in 1460 and from that date the Scottish court came increasingly to have this character, a character typical of the European Renaissance in the way that art in its many forms played a central role in the personal life of the king and through him in the political life of the nation. Indeed so much was this the case that in 1482 just such a group of people as Dunbar describes may actually have been at the centre of a political crisis. In that year, at Lauder Bridge, the king was ambushed by a group of nobles who proceeded to hang several of his household 'familiars' from the bridge before taking the king himself captive to Edinburgh Castle. According to tradition, principal among those who suffered was James's favourite, Thomas (or

Robert) Cochrane who is said to have been an architect[1] and the others were of similar professions.

This bloody incident was described by Stanley Cursiter as 'an early example of Scottish art criticism . . . lacking nothing in definiteness or finality.'[2] Its real explanation is obscure. That any of those killed at Lauder Bridge were actually connected with the arts, except possibly an unfortunate English musician, has been shown to have no earlier authority than the sixteenth-century chroniclers, but the original story should not be completely discounted. The traditional account of the motives for the massacre is that the nobles were prompted by jealousy and disapproval of their king who was perceived as consorting with inferior persons. But these nobles were not children vying for attention. Though their methods were primitive their political analysis need not have been. As a modern nation-state emerged with its focus of identity in the crown, such a new aristocracy of talent as was represented by Cochrane and his associates was a powerful ally of the king against the self-interest of the traditional aristocracy. Self-awareness and the projection of the image of the crown were an important part of this process. There is enough surviving evidence, even though it is fragmentary, to make it clear that James understood this very well, and that in this he was a man of his time, a renaissance prince.

Looking at James's own patronage in the light of the grim events at Lauder Bridge there are one or two examples that can be seen to have political overtones. One of these may have involved the unhappy Cochrane, if indeed he was the king's architect. At Restalrig near Edinburgh the bottom part survives of the shrine of

St Triduana, completed in 1487 and begun some ten years earlier. Known as St Triduana's Well, it originally housed a well from which the water was believed to have special qualities for the cure of disorders of the eyes. The building was two-storeyed and centrally planned, a rather exotic, Middle-Eastern form that may reflect James's interest in the wider world. In 1470–71 Sir Anselm Adornes had travelled to the Holy Land as a kind of proxy for the king and addressed to him an account of his journey.[3]

Dedicating such an elaborate and conspicuous building to an apparently obscure saint was not an act of eccentricity. In the late fifteenth century interest in native Scottish saints was being cultivated as an important aspect of the articulation of a distinct national identity. This had existed in the popular mind at least since the Wars of Independence nearly two centuries earlier, but it was now being developed at a much higher level of political consciousness. The move culminated in the creation of a proper Scottish liturgy with a calendar of seventy Scottish saints in the *Aberdeen Breviary* of Bishop Elphinstone in 1509–10. It was a move that was paralleled in the shift from Latin to the vernacular in legal and state documents and also in the contemporary historical writings of John Major and Hector Boece which formulated a credible history for the Scottish nation. Significantly it was Elphinstone who brought Boece back from Paris to be principal of King's College Aberdeen in 1500.

The special importance of St Triduana's Well is attested by the report of a pilgrimage to the church by the king accompanied by the papal legate, James Passarella, Bishop of Imola in 1485.[4] Similar evidence of the personal interest of the king in artistic innovation and his awareness of its political significance is seen in James's handling of his coinage. A fine groat of the 1470s may have been the work of one Thomas Tod,[5] but the most famous coin that James issued was the groat which appeared towards the end of his reign as part of a wholesale attempt to reform the coinage. The coinage was a matter of grave concern and its debasement, with which Cochrane's name was associated by later chroniclers, was among the motives for the massacre at Lauder Bridge.[6]

Though we do not know who designed this coin, it is exceptional in the coinage of late medieval Britain. It has a three-quarter view portrait of the king which is strongly individualised. This and the realism of the perspective view of the head appear to draw inspiration from contemporary Italian medals, while the similarity of this portrait to the portrait of the king on the contemporary *Trinity College Altarpiece* is clear.[7] In the few battered coins that have come down to us, the design cannot be compared in beauty to the great medals of the Italian Renaissance, but its vigour and effectiveness cannot be denied. Whoever designed it was an artist of talent, but there is also a clear extension of thought beyond the limits of the merely aesthetic. The king's portrait, rendered so tangibly, authenticates the coin. What was at stake was confidence. The quality of the portrait adds the psychological weight of the king's presence to the more concrete considerations of the weight and quality of the metal. It reveals a sophisticated understanding of the subtlety and fragility of economic confidence and the role that imagery can play.

The king was not alone in understanding the political potential of art. One of the most beautiful objects to survive from this period is the mace given to his foundation, St Salvator's College, St Andrews, by Bishop James Kennedy. (*Plate 3*) It is one of three fifteenth-century maces belonging to St Andrews University. Glasgow University also has one and they are all remarkable survivors of the Reformation.

When James III succeeded to the throne in 1460, Kennedy was abroad visiting the Low Countries and France. It was in Paris in 1460–1 that he commissioned the mace. There is evidence in its iconography of very precise instructions from the patron and so of his close oversight of the work and to find a craftsman Kennedy drew on the nexus of political, economic and social contacts that bound the Scots into Europe. The man he chose, Jean Mayelle, was one of the leading goldsmiths in Paris, but he signed his work; 'John Maiel Gouldsmithe and Verlette of Chamer til the Lord Dalfyne hes made this Masse in the toun of Paris the yher of our Lorde mcccclxi.' He uses the Scots language, something he would

hardly have done if it had not been his own native tongue. The Lord Dalfyne was the Dauphin of France and his first wife, Princess Margaret, had been the sister of James II of Scotland and also a cousin to Kennedy himself. Mayelle must have come to Paris in her entourage. On her death he would naturally have remained her husband's man, his Verlette of Chamer, or *Valet de Chambre*.

The mace is executed with marvellous delicacy. Its head is a hexagonal shrine with at its centre the figure of the Saviour, St Salvator. On the six faces are three shields and three figures, a king, a bishop and a burgess – the three estates. On the stem of the mace are three knops (ornamental knobs) each with three pulpits with angels, and men reading or preaching. The iconography of this beautiful work has been interpreted by Monsignor David McRoberts as a soliloquy, or even a sermon, on the Holy Name, St Salvator, taking its text from the *Epistle of Paul to the Collossians* and it certainly represents careful thought on the part of patron and artist.[8]

Such beauty, skill and thought as is preserved to us in this one object must have characterised much else that was made for Scotland's churches. McRoberts concludes his account of St Andrews Cathedral to which he has added this account of the mace, as follows: 'Bishop Kennedy's mace is assuredly an item of furnishing which has richness of meaning as well as excellence of craftsmanship. There are indications that these characteristics were not exceptional among the furnishings provided for Scottish medieval churches, and accordingly we can assume that in the great church of St Andrews much of the furnishing in metalwork, wood-carving, stained glass and manuscript illumination, in embroidery, painting and kindred crafts would be of much more than passing interest.'[9] Kennedy's own tomb, originally intended for the cathedral but eventually housed in St Salvator's College Chapel, confirms this view. It was even criticised by Kennedy's own near contemporary, John Major, for its sumptuousness and, though the tomb is now a ruin, its intricacy and elaboration are still apparent.[10]

Illuminated manuscripts which survive in some numbers, and from both Highland and

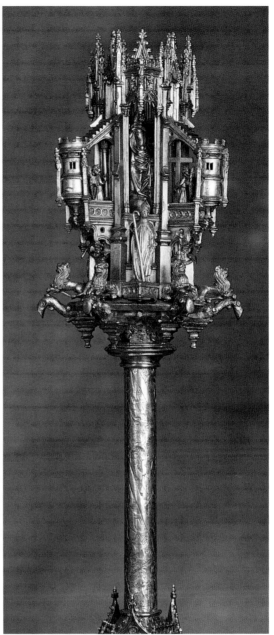

Plate 3. JEAN MAYELLE, *Mace of St Salvator's College*, 1461

Lowland Scotland, are however the best evidence for the nature and quality of the visual arts from this period. The survivors tend to be private, devotional books. The *Talbot Hours* (NLS), for example, was a book owned by an unknown Scottish royal patron. It was made in France, probably during the reign of James III – presumably to commission as it contains the Scottish royal arms – and it is a book of very high quality. Patronage of this kind, too, was not only confined to religious art. From much the same date among the treasures of Edinburgh University Library is a very beautiful

Virgil. (It was given to the library in 1654, a date which testifies to the continuing care for beautiful things even in the age of iconoclasm.) Written in Paris by the scribe, Florus Informatus, it is decorated with a series of beautiful landscapes which present parts of the narrative of the poems in a setting that is created with a marvellous eye for the incidental detail of the countryside, including the grape harvest, to illustrate *The Georgics* (Plate 4), an exotic event to Scottish eyes.

This book, like the *Talbot Hours*, was made at much the same time as Kennedy's mace, for a member of the Scottish royal family, though the individual, identified by the initials 'PL', is unknown. It is a book of great beauty, but it was not merely ornamental and was clearly intended to be read. So, as well as the evidence that the book provides for the sophistication and liveliness of secular taste, it also provides evidence for secular literacy. In 1496 James IV decreed that lairds' sons should be taught to read.[11] The spread of literacy, enormously accelerated by printing later introduced to Scotland by the same king, was the principal motor of the great changes of the sixteenth century, but the charm of the *Virgil* reveals how taste could be an integral part of the original spread of secular learning. Whatever its consequences may have been, it was not in its origins a grim and monkish business.

The *Virgil*, the *Talbot Hours* and Kennedy's mace were all works commissioned in Paris. Scotland had even closer links with the Netherlands than with France however. The Netherlands were her principal trading partner and there was a major Scottish establishment there. One of the most important large-scale paintings to survive in all of Britain from the pre-Reformation period is the *Trinity College Altarpiece* which was a product of this Scoto-Flemish connection. The Trinity College Church was founded by James III's mother, Mary of Gelders, in 1460 when she was regent. The building, though it survived the Reformation, was effectively destroyed by a combination of the greed of the railway companies and the neglect of the city in 1840 when it was moved to make way for the new railway into Waverley. The altarpiece was part of its rich furnishings which also included an organ.

The painting of the altarpiece is not documented, but it is universally accepted as the work of Hugo van der Goes, dating from the late 1470s. From the original altarpiece two wings survive and they are painted on both sides. What went between them is a matter of conjecture, but it seems most likely, following the model of other fifteenth-century Flemish altarpieces, that the Madonna would have been seated enthroned in the nave of a church whose architecture is continued in the wings. The king and a royal prince are on what would have been the left, and the queen is on the right wing of the triptych. When the wings were open, they would be seen kneeling in adoration of the central image. (*Plates 5* and *6*) This might have been carved, but is most likely to have been a painting by the same hand as the wings. The suggestion that has been made in the past that the panels might have been the shutters of an organ is absurd. The king and queen would not kneel to a musical instrument.[12]

King James and his son are presented by St Andrew to the missing central figure, and the queen, Margaret of Denmark, by a figure identified as St Canute. The saints, superbly painted, are in marked contrast to the royal portraits. Clearly the royal partrons could not go overseas to the artist to have their portraits painted. He left spaces and the likenesses were incorporated when the picture was brought to Scotland. The king's painter, who provided the missing portraits, was a competent though not outstanding artist, so while the king could expect a workmanlike result from his court artist, like James Kennedy before him, when he wanted real quality he had to go abroad. Like Kennedy too he went to the best available artist and approached him through the same well-established set of international contacts.

The most striking image on the *Trinity College* panels is the portrait of Sir Edward Bonkil (or Boncle). He is an individual painted with force and clarity in an astonishing piece of portraiture. (*Plate 8*) He comes down to us as a person as vividly as Dunbar in his poetry and was clearly painted from the life. Presumably he travelled to Flanders where he must have commissioned the painting. This is not unlikely, for an Alexander Bonkil had settled in Bruges a few years earlier. It has been suggested

that he was a brother of Edward. Though there is nothing to support this, he must certainly have been a family connection of some kind.[13] The Scottish merchant class was not large. Alexander Bonkil acquired Flemish citizenship and in 1469 returned to Scotland on a diplomatic mission. Links between Scotland and the Netherlands mattered to both parties. In the altarpiece therefore we see the king co-operating in a major piece of patronage, not with one of his magnates or with one of the princes of the church, but with a member of the Edinburgh merchant class, and it is notable that one of the complaints against James was just such an alliance with the bourgeoisie.

In Bruges in 1469 Hugo van der Goes sponsored one Alexander Bening for membership of the painters' guild and a year earlier in 1468 a painter called Sanders Escochois, that is Sanders, or Alexander, the Scotsman, is also mentioned in Bruges.[14] Alexander Bening subsequently married one Catherine van der Goes who it seems may have been a sister of the artist. Such marriages, between two families linked by common membership of a trade, were certainly the norm in Scotland at a later date.[15] Bening's name is Scottish and there was in Edinburgh in the sixteenth century a family of painters of that name. His origins are unknown, but his daughter, Cornelia, married Alexander Halyburton, Conservator of the Scottish Privileges in the Netherlands, a key figure in the economic and diplomatic relations of Scotland and the Low Countries. The marriage confirms that Bening's links with the Scottish community were close.[16]

These various relationships help us to see the one surviving really important commission of the period being carried out against a background of easy and constant interaction between the Scots at home and their overseas contacts. This in turn helps to explain how a work that in its time was very modern was the product of such patronage. It was commissioned from der Goes at much the same time as the altarpiece, now in the Uffizi, that bears the name of the family who commissioned it, the Portinari, and which then as now was one of the most celebrated works in Florence.

We cannot judge in full der Goes's original intention from the surviving parts of the *Trinity*

altarpiece, but we can say that the magnificent saints, especially St Andrew, have such power and presence that he was clearly putting his mind into the picture. The missing central part is the more to be regretted therefore. The outside is complete, however, and it is very remarkable. Bonkil is kneeling beside an organ, no doubt representing that which he had himself presented to the church in 1466/7. The organ is executed anachronistically with gold-leaf and silver for the pipes, not in paint as had by then become customary in Flemish painting. This is a device which sets it apart as belonging, not to the real world, but to the transcendental world of the angels who escort him, one of whom is playing the organ, but is also touching him on the shoulder. Bonkil is kneeling and when the wings of the altar were closed he would be seen in adoration of the Trinity – the Father, Son | and | Holy Ghost – on | the | left-hand, outside panel. (*Plate 7*) His magnificent, fur-trimmed robe indicates his position in the

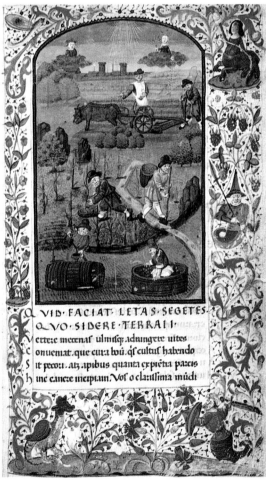

Plate 4. FRENCH ILLUMINATION, *The Georgics of Virgil*

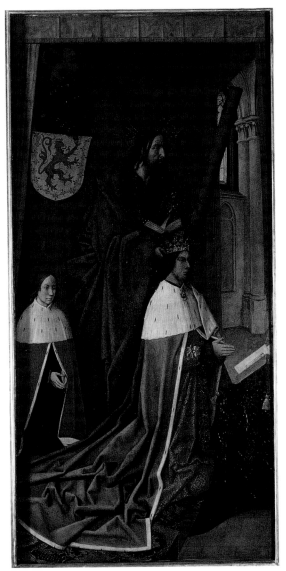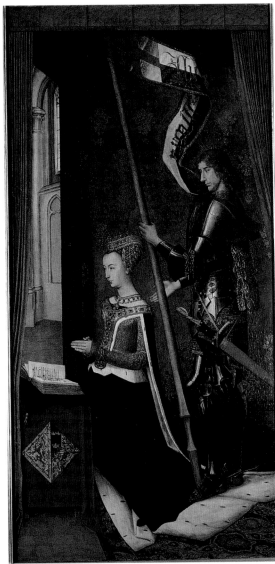

Plates 5 and 6. HUGO VAN DER GOES, *Trinity College Altarpiece*, INNER PANELS, LATE 1470s

world. He belongs with us most tangibly, but as we move into the picture the order of reality changes. The angels who support him are beautiful, ethereal creatures. The music they make is a link to the celestial. It is through angels, according to St Thomas Aquinas, 'that "divine enlightenment and revelations" proceed from God to men'.[17] So we are prepared for the left-hand panel and in it we shift entirely into the realm of the spiritual.

The three figures of the Trinity are the Father, seated on a golden throne (like the organ, belonging to the world of visions, it is gold-leaf not paint), the Son, his body in the broken attitude of the deposition and supported on the out-stretched arms of his Father, and the Holy Ghost, the Dove, that hovers

above the heads of both. A crystal orb, representing the world, sits at Christ's feet. The whole group is surrounded in a blazing glory. The vision floats detached from the spatial considerations that prevail elsewhere in the painting. It is of a different order of reality. The throne is in gold, but in addition its perspective is drawn in such a way that it could not exist in actual space. The wings follow a concave curve at the base, but a convex one at the upper edge. The dais is at an impossibly steep angle, yet the crystal orb of the world holds its position. Christ's feet hang almost at the front edge of this dais. His body appears to be in a vertical plane, yet the Father, seated well back on the throne, supports him comfortably.

Der Goes of course knew what he was

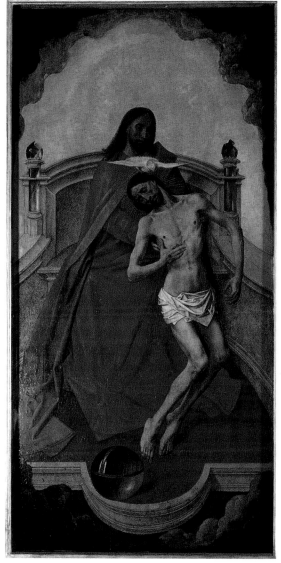

Plates 7 and 8. HUGO VAN DER GOES, *Trinity College Altarpiece*, OUTER PANELS, LATE 1470s

doing and no doubt Bonkil understood it equally clearly. The painter was abandoning the convention of Flemish painting whereby divine events are shown subject to the principles of order that govern the real world, a convention that a conservative patron might have insisted was observed. Instead der Goes makes a visible distinction between this world with its rational order and the spiritual world, subject to no such constraints. It is a brilliant illustration of the difference between the mundane and the transcendental. What is more, he presents these two orders of reality in direct confrontation without the mediation of a saint or even a priest. This is Bonkil's own vision, a meeting of the finite and individual self with the divine. In its stress on personal experience this image

startlingly anticipates the ideas of the Reformers half a century later. One of the classic images of early Reformation painting, for example, is a picture by Cranach of the crucified Christ with Longinus, the centurion who was converted at the Crucifixion. He is shown alone with Christ. His conversion was the result of his own direct experience, without any mediator.

There can be no doubt that the survival of the *Trinity College* panels is due to the presence on them of royal portraits. Even at the height of the Reformation the king's image was not to be treated lightly. In a grim incident in 1601 an unfortunate town officer was hung for the crime of failing to display due respect to the royal image. 'Archibald Cornell, towne officer,

Plate 9. NORTH GERMAN, *Helsingør Altarpiece*, c. 1500

[was] hangit at the crosse, and hung on the gallows twenty four hours; and the caus quhairof he was hangit: He being an unmerciful, greidie creatur, he poyndit ane honist manis house, and amongst the rest he poyndit the king and queins picturis; and quhen he came to the cross to compryse the same, he hung thame upon twa naillis on the same gallows, to be comprysit; and thei being sene, word gead to the king and queine, quhairupone he was apprehendit and hangit.'[18] Similar respect for the image of the individual is reflected in the survival in Aberdeen University of the portrait of the founder, Bishop Elphinstone. It is a contemporary likeness, cut from a larger composition, though it is now too damaged to provide much basis for judging the quality of the original painting.

While such survivals as the *Trinity College* panels and the Elphinstone portrait, together with the story of the unfortunate Cornell, prove that iconoclasm was not wholly indiscriminate, they do also indicate the exceptional circumstances of any such survival. It does not follow however that because survival is exceptional, that the original paintings were equally so. The *Trinity College Altarpiece* is outstanding in Euro-

pean terms for its quality, but not in Scottish terms for its existence. There is ample evidence that Scottish churches were as richly furnished as churches of comparable size anywhere else in Europe and that painted and carved altarpieces were a normal part of that furnishing. For example in 1505 Bishop George Brown imported two Flemish altarpieces, one for St Mary's Dundee with an *Adoration of the Kings*, and the other for Dunkeld. There was already extensive painted decoration at Dunkeld as the miracles of St Columba had been painted there for an earlier bishop in the reign of James III and Bishop Brown employed a painter there from *c.* 1505 for a number of years. Two 'tabernacles' or altarpieces were similarly imported for Pluscarden Abbey in 1508.[19]

There is other evidence too of the existence of such things. There are important fragments of the kind of sculptured altarpiece that was fashionable in northern Europe in the late fifteenth century preserved in the Royal Museum of Scotland. Similar tabernacles are represented on some of the seals of the period like that of Holyrood for example, but the only Scottish altarpiece that survives wholly intact is not, nor ever has been, in Scotland. This is an

Plate 10. NORTH GERMAN, *Helsingør Altarpiece*, DETAIL *St Ninian Giving Alms*

elaborate work, both painted and carved that was made for the Scottish community in Helsingor, Denmark. It was made for the Scottish chapel in the Olavskirk there and is now in Copenhagen. Similar altars existed in Copenhagen, at Roscoff in Brittany, at Bruges, at Bergen-op-Zoom, possibly in Cologne and elsewhere no doubt where there was a permanent Scottish community.[20]

The *Helsingør Altarpiece* (National Museum of Denmark), (*Plate 9*) seems to have been made in North Germany late in the fifteenth century. In 1511 the chapel where it stood was described as founded by the parents of Alexander Lyall and Ellen Davidson 'with others who were born in Scotland'. It was dedicated to St Ninian who, with St Columba, seems to have been even more popular than St Andrew where dedications implied a declaration of national identity. The central part of the altarpiece consists of three figures, St Ninian himself flanked by St Andrew and St James the Less. On either side of this central group are double wings – four painted surfaces with two sets of hinges – with Sts Martin, Erasmus, Barbara and John the Evangelist and eight scenes from the life of St Ninian. (*Plate 10*) The whole ensemble is a rich, handsome and complex creation, typical of the late fifteenth century in northern Europe and surely representative of what the Scots abroad might have expected to find in their churches at home, churches from which such overseas

endowments were not remote. The burgh records of Edinburgh for example record that a levy was taken from ships going out from Leith to support the 'chaplaine of St Niniane's altar' at Bruges.[21]

The *Helsingør Altarpiece* is further evidence for the richness of Scottish overseas connections in the later fifteenth century. Their importance in artistic matters, the basis of the Trinity College commission under James III, is maintained or indeed developed in the reign of James IV. He was even more than his father a renaissance prince. It was in his reign that the poets flourished, not Dunbar alone, but Henryson, Gavin Douglas and some at least of those poets whose work is unknown to us, but whose names are recorded by Dunbar in his poem 'Quhen He Wes Sek' (also called 'Lament for the Makars'). It was James IV who founded the Royal College of Surgeons, Aberdeen University and St Leonard's College at St Andrews, who built the *Great Michael*, the greatest warship of its day, who introduced printing to Scotland and indeed who patronised such a renaissance eccentric as John Damian de Falcusis, the Abbot of Tongland, who in 1503 attempted to fly from the battlements of Stirling Castle. (Dunbar commented unkindly on his failure. Bishop Lesley attributed it to the fact that 'thair was sum hen fedders in the wingis, quhilk . . . covet the mydding and not the skyis'.)[22] James was a great builder too, though it is difficult now to separate his work at Edinburgh, Stirling, Linlithgow, Dunfermline and Falkland from that of his son. It was certainly he who set up the Chapel Royal at Stirling which became the centre for his patronage of both music and painting. In the light of so much activity Dunbar's account, quoted at the beginning of this chapter, of the assemblage of skills at his patron's court does not seem exaggerated.

As for all the rest of the pre-Reformation period, the art of the reign of James IV has to be reconstructed from fragments, but there is again one outstanding work to give us a sense of the kind of standards that prevailed. This is the *Book of Hours of James IV and Margaret Tudor* (Osterreiches Staatsbibliothek). (*Plate 2*) It was a wedding present from James to his wife. The couple were married in 1503. Celebrated in Dunbar's poem 'The Thrissil and the Rose', it

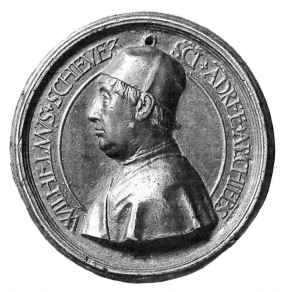

Plate 11. ATTRIBUTED TO QUENTIN MATSYS, *Portrait Medal of Archbishop Schevez*, 1491

Plate 12. ATTRIBUTED TO SIMON BENING, *Book of Hours of James IV and Margaret Tudor*, 'REQUIEM MASS FOR THE KING OF SCOTS', 1503

was a momentous marriage for it was from this union of individuals that the Union of the Crowns of Scotland and England eventually resulted. The book has nineteen full-page miniatures and is richly decorated throughout its 250 pages.[23] Its status as a wedding gift is identified by the repeated initials, 'I' and 'M', bound together in a love knot. Some of the narrative scenes are painted with great liveliness and invention, the page devoted to King David for example, or St Christopher in a landscape of wild, hairy men. The secondary borders are likewise rich and inventive, including architecture, jewels, butterflies and flowers in pots and vases. Everywhere there are thistles for James, and daisies, the marguerite, Margaret's flower, for his queen. In fact the book has to the highest degree all the decorative richness and the charm of detailed observation of the very finest manuscripts of its period. All sorts of details point to the close oversight of the commission. In the calendar for example the signs of the zodiac are set over landscapes of rocks, mountains, lakes and castles, surely intended for the land of 'the mountain and the flood'. Virgo is adorned with the royal arms of Scotland, presumably referring to Margaret. St

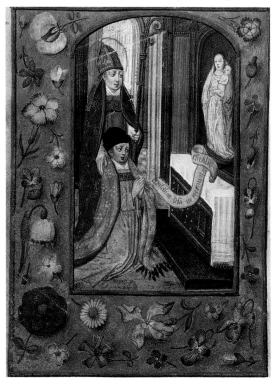

Plate 13. STUDIO OF ALEXANDER BENING, *Book of Hours of Dean James Brown*, 'DEAN BROWN PRESENTED TO THE VIRGIN', 1498

Jerome who must have been of special importance to James has the royal motto, *In my defens*, and the cross of St Andrew in the border of the page devoted to him. St Margaret is given a page of special richness, but is curiously identified as Margaret Magdalena, somehow combining two saints whose feasts are within a day of each other, but who were both presumably special to Margaret herself.

As well as these details, from a Scottish point of view it is the principal royal miniatures that are of most interest. These are first of all the royal coat of arms in a magnificent full page, placed after the calendar and at the opening of the *Book of Hours* proper. The next full-page miniature is of James himself, being presented by St James to Christ. Christ is on an altar adorned with the royal arms and motto, *In my defens*. He has St Andrew at his side. The companion to this is the full page of Margaret which has apparently become displaced and is now at the back of the book. It shows Margaret, likewise kneeling before an altar. On it is a vision of the Virgin. The frontal is again the royal arms, but the motto now reads *In our defens*. The two figures as they kneel, though now separated, face each other as do James's parents on the *Trinity College Altarpiece*. His figure and that of St James are in fact closely modelled on der Goes's painting of James III and St Andrew.

The most striking of the royal miniatures, however, and the most unexpected, is the mass for the dead. (*Plate 12*) One of the most beautiful images in the book, it shows the interior of a church with a coffin laid out among candles. Its notes of black and white make a stark contrast to the richness of the rest of the book. Hanging above the coffin are the unicorn banner, and a gold tabard with lion rampant and cross of St Andrew which identify the deceased as king of the Scots. This miniature lends a note to the book that is very personal to the king. His father was murdered when James was sixteen and, as he was involved in the rebellion that led to his father's death, he appears to have held himself responsible for the rest of his life. He is reputed to have worn a chain round his waist in penance and he built a magnificent tomb at Cambuskenneth for his father who was slain nearby after the battle of

Sauchieburn by an anonymous murderer. It was one of the great works of the reign, constructed between 1501 and 1508, begun therefore just at the moment that the *Book of Hours* was commissioned. The presence in it of this beautiful miniature is clearly a reference to the same sense of guilt and the need for expiation.

The artists of the *Hours of James IV and Margaret* have been identified on grounds of style as Simon Bening and Gerard Horenbout.[24] Simon, who would have been about nineteen in 1502, was son of Alexander Bening and went on to become one of the most celebrated painters of the last great age of illumination. Horenbout was a member of Alexander Bening's studio. Simon, through his sister was a brother-in-law to Andrew Halyburton. In placing a commission of such importance the king would naturally have gone to Halyburton who was his agent in the Low Countries. In 1505 for example Halyburton was being reimbursed for money laid out in sending a French artist called Piers to Scotland,[25] into the service of the king. It was natural for Halyburton to take the opportunity to give his talented brother-in-law the opportunity of such a commission. Thus the major surviving work from James IV's reign has its origins in the same Scoto-Flemish circle as the major surviving work of his father's. The reference to the *Trinity College Altarpiece* in the miniature of James presented by St Andrew is therefore an appropriate act of homage to their predecessors by both patron and artist.

The *Hours of James IV and Margaret* are outstanding in their richness among works of Scottish patronage from the Low Countries that survive from this time, but as with the *Trinity College Altarpiece* this does not mean to say that they were unique. There is evidence of similar patronage by church magnates and even by lesser men. William Schevez, Archbishop of St Andrews, for example, designed himself a magnificent tomb to stand in the nave of St Andrews Cathedral and in 1495 is recorded ordering it in Bruges.[26] Schevez was an educated man, a graduate of St Andrews and Louvain. He had been the king's doctor and perhaps his astrologer and he had built up a substantial library. He was in fact typical of a new breed of secular churchmen, a man of the Renaissance and a

powerful personality. Like Sir Edward Bonkil we know him from his portrait for in 1491 when he was in the Netherlands he had a portrait medal struck (NMS). (*Plate 11*) It is attributed to Quentin Matsys[27] and is a striking image of a man of the Renaissance. In 1486 he went on an embassy to Rome in company with Bishop Blackadder of Glasgow who was similarly a literate, cosmopolitan church magnate. Blackadder did much for Glasgow Cathedral and University. He has also left an important item of personal patronage, a prayer-book (NLS) commissioned in northern France or the Netherlands probably at the time of this embassy to Rome. That the book was intended for Scottish use is identified by the presence of St Margaret of Scotland and St Ninian among

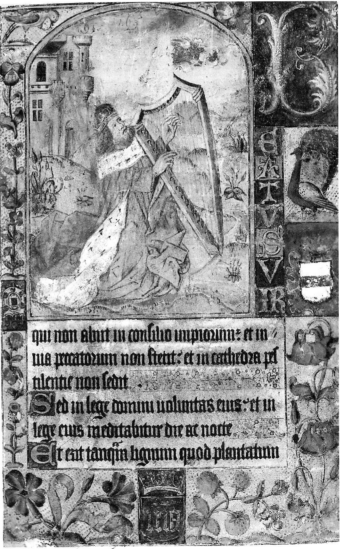

Plate 14. SCOTTISH ILLUMINATION, *The Kinloss, or Boswell Psalter*, 'DAVID PLAYING THE HARP', *c.* 1500

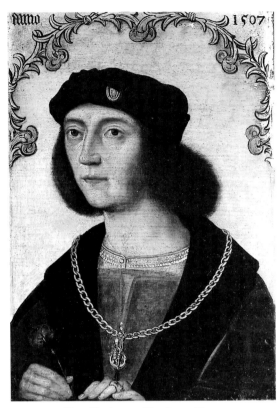

Plate 15. ANON., *King James IV,* 1507

the illuminations and Blackadder himself is present in a beautiful donor portrait, kneeling before a crucifix.

There are a considerable number of illuminated books that can be identified as made for Scottish use and enough of these can be associated with places distributed throughout the whole of Scotland to make it clear that there was no differentiation between Highlands and Lowlands in the matter of material culture. Indeed the quality and distinctive style of highland metalwork seen in brooches like those of Lochbuy or Glendrochit, or in cups such as that of Cadboll, and also in the stone carving of the grave slabs of the west, indicate that the Highlands kept their own traditions and high standards in these fields even if, like the rest of Scotland, they looked to the Continent for the best in painting and illumination.

The number of illuminated books that exists, compared to other forms of painting, is presumably an accident of survival. Illuminated books are small, portable and inconspicuous. They could easily be hidden from the iconoclasts or carried overseas out of harm's way. Although the vellum on which they were painted could be re-used and they were often cut up to make bindings, they did not have an intrinsic material value which would attract the eye of the covetous as precious metal did. The great majority of the books that do survive date from the century before the Reformation, principally from the decades either side of 1500, and are of a character that suggests personal rather than public use. The survival of such books which were private property obviously reflects the much more efficient destruction of liturgical books held publicly in churches, but the evidence for their existence in so much greater numbers than at any previous period parallels other signs of the increasing stress on the personal nature of religion and of the prosperity which made this possible. The outer panels of the *Trinity College Altarpiece* focus this very clearly in their iconography. The fashion for such collegiate churches as Trinity covers just the same period of the late fifteenth and early sixteenth centuries and reflects this same interest in personal worship. They were a kind of establishment in which the patron's own interest and control could be maintained far more easily than if he or she should be donors to one of the larger ecclesiastical bodies.

Some of the books that survive, like the *Playfair Hours* (V & A) and a similar *Book of Hours* in Edinburgh University Library, are works of great quality and sometimes, like *Bishop Blackadder's Hours* (NLS), they can be identified with an important individual, but they were not all made for men of such exalted status. One of the most charming books of this kind is the *Book of Hours of Dean James Brown* (NLS). It contains a delightful portrait of him kneeling in gorgeous vestments before an altar with the Virgin and Child set on it in a niche. (*Plate 13*) A saint, perhaps St Ninian, in bishop's robes of green and scarlet and a bright blue mitre, is presenting him. The miniature is set in a field of flowers. In 1497 on the death of Archbishop Schevez, Dean Brown was sent to Rome as emissary to secure the vacant archbishopric for King James's brother. He was successful and in 1498 on his return to Scotland he stopped in Flanders where his presence is recorded in the accounts of Andrew Halyburton. It seems likely therefore that his book was begun in the studio of Alexander Bening, but it appears to

have been finished by a different hand. The last miniature, of Lazarus, is painted with less skill and so perhaps Brown had to take it home unfinished to be completed in Aberdeen.[28]

As the last miniature in Dean Brown's book suggests, there were artists in Scotland capable of producing professional work, even if not to the standard of the best Flemish and French ateliers. There are quite a number of books, cartularies and other documents such as *Abbot Bothwell's Psalter* (Boulogne, Bibliotheque Municipale), *Andrew Lundy's Primer* (NLS), or the *Pittenweem Cartulary* (St Andrews University) which can be associated with people and places in Scotland and a good few others which can be identified as Scottish though their origins are unknown. In the case of one group of books, the *Arbuthnot Missal, Psalter* and *Book of Hours* (Paisley Museum and Art Gallery), we know them to have been written, not in a monastic scriptorium, but by an individual parish priest, James Sibbald, vicar of St Ternan's church, Arbuthnot. This is an important piece of information for it means that, in effect, in modern terms these books are amateur productions and that is exactly what they look like.

Sibbald was evidently an enthusiast and as with any amateur work his standards are set by his own untutored abilities, not by the broader standards that prevailed in his time. It is important therefore, in looking at this kind of Scottish production in the context of European art, to be sure that like is being compared with like. The Netherlandish ateliers were highly professional and specialised. There was nothing in Scotland that could compete with them except the court which was the only place that could provide the level of patronage needed for a similar level of specialisation. However, as we have seen, when the king needed anything really special, like a wedding present for his future wife, he sent to the Netherlands. Any religious house worthy of the name would expect to decorate important documents, however, 'in-house' as it were, and there are documents of that kind from Pittenweem, Aberdeen and other places, but they too are in a sense amateur. Monastic houses like Culross Abbey, Kinloss Abbey and others may have produced more ambitious books (*Plate 14*) – *Abbot Bothwell's Psalter* may be a product of Culross for example[29] – but the church, like

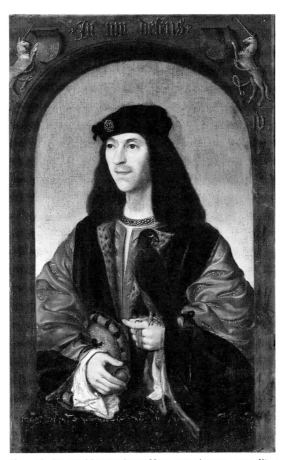

Plate 16. DANIEL MYTENS, AFTER UNKNOWN ARTIST, *c.* 1500, *King James IV*

the crown, could and did go for the best available, which meant going to the specialised ateliers in the Netherlands or in France.

For this reason when these manuscripts of Scottish provenance are discussed there is a tendency to argue that if the painting is crude or obviously imitative, it is Scottish. If it is of quality, then it is imported. There is a certain logic in this. Where first-class work was readily available from overseas if it could be afforded, then there was little point in importing work of lesser quality at relatively greater expense than local work of similar standard, but it is a dangerous rule of thumb. James III's coinage which had to be home produced is a clear example of the possibility of locally commissioned work in another medium being imaginative, effective and of undoubted quality. James IV would have been unlikely to have been backward in such matters and as evidence of the quality of court painting in his reign there are two good portraits of James himself. One, dated 1507, is at Abbotsford and is a small

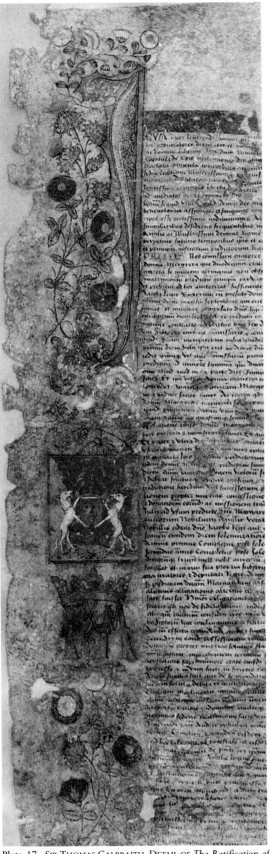

Plate 17. SIR THOMAS GALBRAITH, DETAIL OF *The Ratification of the Marriage Contract of James IV and Margaret Tudor*, 1502

and accomplished picture rather in the French than the Flemish manner (Mrs Maxwell-Scott of Abbotsford). (*Plate 15*) The other only survives in a copy made for Charles I by Mytens (*c.* 1500, Private Scottish Collection). (*Plate 16*) It shows the king with a hawk on his wrist and is an elegant and informal portrait of a courtly prince. Mytens copied at the same time an equally fine portrait of Queen Margaret, the original of which may have been by the same hand. There is no way of knowing who painted these portraits though we do know that James employed a number of artists, some brought in from abroad and some apparently native.

Until his death in 1503, David Prat seems to have been the king's principal painter. He first appears in the accounts in 1496. It seems to have been Prat who designed James III's tomb at Cambuskenneth, for which work he received payment in 1502 and '03, though a sculptor, described in the records as 'the Almayn', the German, but more likely a Fleming, was also employed there to 'mak the kingis lair in Cambuskinneth in marbill'.[30] Prat was also paid for an altar painting at Stirling in 1497. In 1505 the altarpiece of the Chapel Royal, which may have been the one painted by Prat, was recorded in an inventory. It was a triptych of *Our Lady with her Son in her arms and two angels with musical instruments.*[31] An English painter called Mynours and identified as John de Mayne or Maynard, came to Scotland in 1502, at the time of the marriage of James and Margaret Tudor. Payment is recorded to 'ye inglise payntour whilk brocht ye figuris of ye King, Queen and Princes of England and of our Queen'.[32] Such portraits, and the presence of a painter, were a natural part of the diplomatic exchange surrounding the wedding. A year later he was given money for his journey home. There was also the Frenchman, Piers, who came to Scotland to the service of the king in 1505, perhaps to succeed Prat as king's painter. He appears as receiving a regular wage in the records until 1508 when money was paid for him to 'pas in Flandres'. The only work by him of which there is any description however is heraldic.[33]

Two other painters appear in the records of the reign of James IV, Alexander Chalmers and Sir Thomas Galbraith. Chalmers in fact is

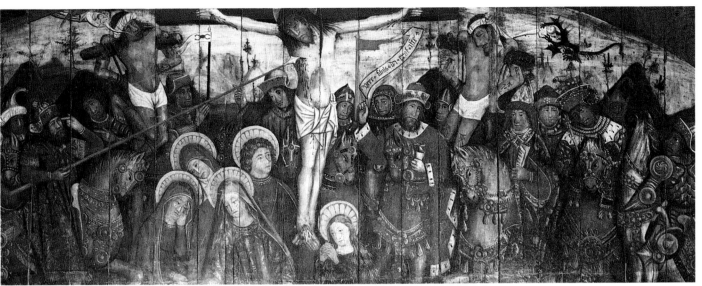

Plate 18. ANON., *The Crucifixion*, FOULIS EASTER CHURCH, LATE 15TH CENTURY

recorded over the period 1506–32. Heraldic and decorative work by him included not only coats of arms for tournaments, but, in 1506, canvas beasts and in 1511–13 the painting of the king's ships including 'the kingis gret schip', the *Great Michael*. From the accounts it must have been a gorgeous sight with its 'standaris, pinsalis and banaris in gold colouris, olye and vernesing', and 'the kingis ymagery, pinsalis and flaggis'.[34] It was Chalmers who decorated the Chapel Royal for the funeral of James in 1515, and he last appears working at Holyrood in 1532 painting the iron gates and windows vermilion.

Sir Thomas Galbraith appears in the records from 1491–1512. He too did heraldic and decorative work, including a cover for the great gun, *Mons Meg*, itself a surviving symbol of the king's ambition to have the biggest and the best, but Galbraith is more recognisable as an artist than Chalmers and there is one work by him that survives. He was clerk of the Chapel Royal as well as a painter, and *The Ratification of the Marriage Contract of James IV and Margaret Tudor*, (PRO), (*Plate 17*), dated 17 December 1502, and the related peace treaty were written by him. The left-hand border of the marriage contract is an elegant ornament, composed, like Dunbar's poem celebrating the marriage, on the theme of the thistle and the rose, though with the marguerite as well. Within this interlace of naturalistic painting is set the royal arms. So, fittingly, art assisted at one of the key moments of Scottish history. It

is a tantalising glimpse of the work of an artist of standing who was Dunbar's contemporary. He enjoyed important patronage from the king, for his greatest work was illuminating two books for the Chapel Royal, the *Gospels* in 1507–8 and a 'porteous' or breviary in 1511–12, described as 'the kingis gret parchment portews' and 'the grete portuus of the kingis chapel'.[35] If the king's standards can be judged by the *Book of Hours* that he commissioned for his queen, he would not have accepted indifferent work in a book of such importance. Sadly, all we know of it now is that it once existed.

The most remarkable survival from the reign of James IV which was not imported and must have been painted on the spot, is the set of painted panels in the church of Foulis Easter, near Dundee. James visited the church in 1497 and at St Andrews, shortly after, he was presented with a picture, 'ane painted table', by Dean James Gray[36]. There may be some connection between these two events as this would be an appropriate date for the paintings. They are a remarkable set of pictures, though as with the der Goes panels it is certainly their survival that is exceptional, not their existence in the first place. The majority of the paintings originally formed part of the rood-screen and loft of the church. Their survival is explained by the conversion of the choir into the burial place of the Graham family whose arms appear on the vestments of St Ninian among the saints. The rood-screen, now dismantled, made a

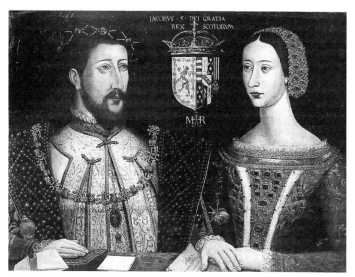

Plate 19. ANON., *James V and Mary of Guise*, *c.* 1538

convenient partition between the nave and this burial aisle. The paintings were described *in situ* in 1825: 'The east end is separated from the pews by a boarded partition wall of wainscot whereon is painted the crucifixion, with the figures in the foreground as large as life. Under this on a belt of wood which extends across the church from wall to wall, the heads of the twelve apostles as they are called, are delineated. All these figures have suffered much from time, but apparently nothing from the rough hands of the Reformation.'[37]

What survives of this part of the decoration is *The Crucifixion* (*Plate 18*) which formed the screen and eleven figures of Christ, saints and apostles which seem to have been the front of the rood-loft. There is a separate painting which has been identified as *The Trinity*,[38] but which seems to be *Christ in Majesty*. Christ is flanked by St Catherine of Alexandria, St John the Baptist and to his extreme right, the Madonna suckling the child. Beneath are six saints ranged either side of a *Pietà*. The arrangement of the figures in this panel suggests a retable or altarpiece. The painting of all the pictures seems to be by the same hand. It is Flemish in manner, though not in execution, which has a kind of earthy vigour. The effect is crude but striking. A fool leers over the heads of the soldiers at the Crucifixion looking directly at the spectator. It is a sardonic touch of startling directness that is quite unexpected in the iconography of the Crucifixion. Through it we make contact with the individualism of the forgotten artist.

Not far away at Guthrie in Angus, there are the remains of a similar painting, albeit more damaged. It was a *Last Judgement* with Christ seated on a rainbow. Beneath him are interceding saints and the souls of the blessed and the damned. At Dunkeld too in the tower of the cathedral there is still clearly legible the remains of a painting of the *Judgement of Solomon*, together with some other traces of painting. In this case we may know the painter's name for one William Wallange or Valance was employed there by Bishop George Brown from *c.* 1505–15.[39] Other significant traces of painting also survive at Dunfermline Abbey.

James IV died at the battle of Flodden, a calamitous defeat, according to popular tradition brought about by his own misplaced sense of chivalry. If his son, James V, did not inherit the generosity that was at the root of such a quixotic act of self-destruction, he did inherit his father's taste and belief in the importance of the arts. If the identification of the sitters has any foundation in fact, there dates even from the period of his minority a very striking painting of his mother, *Margaret Tudor with Regent Albany* (Marquess of Bute). It is by an unknown painter, but is similar in character to the work of Matsys. No other portrait of this quality survives from the period. The grounds for the identification are not clear, though if it is indeed what it appears to be, then it would be evidence of an artist of considerable sophistication working in Scotland.

There are several portraits of James V himself. The most striking is a small panel in the royal collection at Windsor. There are also two versions of a double portrait of *James V and Mary of Guise* (NT, Hardwick Hall and Duke of Atholl, Blair Castle). The original is likely to have been a marriage portrait. Both show the king and queen seated side by side in half-length. Otherwise quite different, they both suggest the splendour and dignity of the king and his bride. In the better of the two, the Blair Castle picture, he holds her hand. (*Plate 19*) He has a book in his other hand and looks up towards the joined arms of Scotland and of Guise, while she looks at him. They are seated behind a table or desk. This intimate proximity and the expression of their relationship in the details of hand and glance reveal a degree of invention on the part

of the painter which is at variance with the rather wooden execution of the painting.

Whatever their previous history the royal palaces at Stirling, Holyrood, Falkland, Dunfermline and perhaps Edinburgh Castle all took the character that they retain today, in the reign of James V. He also did extensive work at Linlithgow. At Falkland there is some of the earliest renaissance architectural detail in Britain. These palaces, excepting Holyrood and Edinburgh Castle, all subsequently more or less ruined, give to what survives from James's reign, even more than from those of his father and grandfather, the likeness of a once gorgeous, renaissance frame, now crumbling and ruined, but with its former glory still legible and a few scraps of canvas still clinging to it as a witness of the picture it once contained.

Because of the beauty and richness of these buildings, the loss of secular art from this period is acutely apparent. This cannot be laid

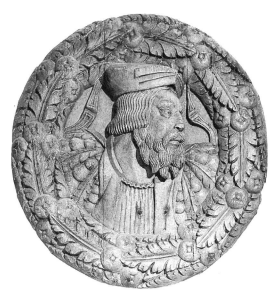

Plate 20. ANON., *Head of a King*, ROOF BOSS FROM STIRLING CASTLE, *c.* 1540

to the blame of the reformers, but to that potent mixture of neglect, civil strife and political change with which their work is compounded and often confused. Falkland was half destroyed in the seventeenth century, Linlithgow was burned, Stirling gutted and turned into a barracks in the eighteenth, an indignity that it would never have suffered if Scotland had retained its crown and independence, though like the great hall of Edinburgh Castle it might have been almost equally damaged by well-intentioned restoration.

Nevertheless, even as they survive the stylishness of these buildings remains as testimony to the taste and patronage of the king, though what they once contained we can only guess. The quality of the decoration within was certainly as fine as that which is preserved outside. The *Stirling Heads*, roundels of carved oak each containing a strongly characterised head, which once decorated the royal presence chamber at Stirling are works of great strength and vigour by an artist of real talent, working in a strikingly uninhibited way. (*Plate 20*) They were thrown out as rubbish in 1777 and those that survive were rescued, from the skip as it were, by interested amateurs. Two stone roundels on either side of what may have been the royal bedroom at Falkland contain sculptured busts, possibly portraits of the king and queen. They are closely comparable to the *Stirling Heads* some of which have always been

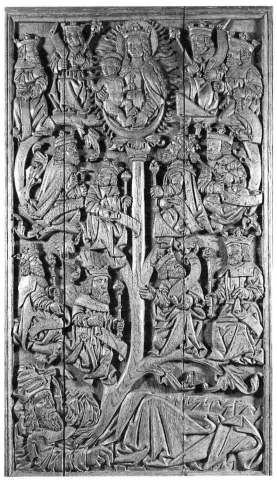

Plate 21. ANON., *The Tree of Jesse* FROM THE BEATON PANELS, *c.* 1530

Plate 22. DAVID DOUGLAS, OPENING PAGE OF *The Cronikill of Scotland* BY HECTOR BOECE, 1531

believed to be portraits, including one of the king himself.

There are other examples of oak carving of quality from this period. It seems to have been quite a feature of Scottish decoration and does have a distinctive style close to Flemish work of similar kind, but characterised by a sort of blunt simplicity not unlike the paintings at Foulis Easter. The finest examples are the *Beaton Panels* (Private Collection). They include the royal arms and the arms and initials of Cardinal Beaton and are thought to have been made by him for Arbroath Abbey. *The Tree of Jesse* from this series is a masterpiece of strong, clear design, realised in low relief. (*Plate 21*)

The *Stirling Heads* and the *Beaton Panels* have a kind of ruggedness which is not merely

provincial. In so far as one can compare two things which are so unalike, their style is similar to the way that Stirling Castle itself is an inspired adaptation of the refined forms of early renaissance and late gothic to a wild and rugged site. They fit into the kind of landscape epitomised in the calendar paintings of the *Hours of James IV and Margaret.*

Scottish castle architecture developed in the sixteenth century into the fantastic and highly individual forms of buildings like Craigevar and Crathes. These are certainly sophisticated and self-conscious and as they turn upside down conventions of symmetry and proportion they could be an architectural metaphor representative of a wild and untamed country. The culture that produced Dunbar and Sir David Lindsay, companion to King James V from the king's childhood, was highly articulate and self-conscious. David Lindsay's *Thrie Estaits* is the most famous literary product of this court and it evinces a self-consciousness which could well have extended to the artists. They might have felt that the kind of bluntness and ruggedness that is seen in the *Stirling Heads*, the *Beaton Panels* and the Foulis Easter paintings was an appropriate form of expression for a peculiarly Scottish art.

This kind of self-consciousness is seen most closely linked with the painter's art in the remarkable survival of a book from the king's library, the *Cronikill of Scotland* by Hector Boece, translated into Scots by John Ballantyne, or Bellenden, and written and decorated by David Douglas in 1531 (Pierpont Morgan Library). (*Plate 22*) James was a lively minded and intelligent king consciously promoting his own and his people's status and indeed achieving a recognised place for Scotland on the European stage. The opening inscription reads: 'Here begyne the Chronikille of Scotland . . . translatit into our common language be Maister John Ballantyne . . . at the desyre of . . . James king of Scottis.' There follows a remarkable preface which declares what is in effect the political significance of such a book made available to the 'pepill' by such a translation.[40]

David Douglas's illuminations of Bellenden's book consist of a fine heraldic frontispiece and three other fully decorated pages. There are in addition ornamented initials

throughout. The decoration is vigorous and confident, almost cursive in character. It is not highly polished, but is informal with touches of humour in some of the grotesque initials. The objective here was avowedly to record for the king the nation's history in the national tongue. If there was such a thing as a national style it is the place that one would most expect to see it. A similar free and informal way of painting is seen in the earliest of the Scottish armorials compiled under the direction of Sir David Lindsay and bearing the date 1542, though this has been added later. Armorials are heraldic reference books and the *Lindsay Armorial* (NLS) is the first in a series that continues into the seventeenth century (see below, p48).

Sculpture and painting can be more legitimately compared with each other than either with architecture, because the two were frequently seen in conjunction and sculpture seems usually to have been painted. The wooden ceiling at Falkland Palace for example, though less ambitious than the one at Stirling, showed signs in the nineteenth century of having once been painted. From the records of payments to painters indeed there was not much decoration inside or out that was not painted. In 1535, for example, John Ross was paid for painting the beautiful early fifteenth-century sculpture over the doorways at Linlithgow[41] and coats of arms on the facades of buildings like those at Holyrood and Falkland were always painted. Even guns were painted, but of actual paintings we have even less evidence from the court of James V than we do from that of his father and we are hardly able to say more than that they once existed. Even the written records are less revealing. We know the names of several painters who worked for the king – Andrew Watson appears from 1539, Robert Galbraith, presumably related to Thomas, appears at the same time, but both are only paid for heraldic and decorative work. Patrick Pow worked at Falkland in 1537. The king's second wife, Mary of Guise, brought with her from France the painter, Pierre Quesnel, and his son, the painter Francois Quesnel, was born in Edinburgh, but none of these painters can be associated with any recorded work other than of a decorative or heraldic nature.

Art continued to be imported and in 1535 the king paid for 'certane fyne picturis of Flanders coff fra John Brown to the Kingis grace'.[42] There is also evidence of artistic activity outside the court. Robert Reid, Abbot of Kinloss and Bishop of Orkney, employed the painter, Andrew Bairhum at Kinloss and possibly also at the neighbouring abbey of Pluscarden. Reid was a scholar, a great churchman and a leader of reform from within the church. He was a man of culture and European experience who would have understood quality and looked for it in any artist that he employed. Bairhum was employed for three years from *c*. 1538 at Kinloss during which time he painted three altarpieces for the chapels of the abbey. He is described in the history of Kinloss by Ferrerius, who must have known him personally, as:

> outstanding in his craft, but a man who was difficult to handle and cantankerous, struggling with a violent temper no less than with a weak body, and lame in both feet . . . He decorated with three separate panels, painted in a simple but beautiful manner, three chapels in the church, viz those of Mary Magdalene, John the Evangelist, and St Thomas of Canterbury. He also painted in the lighter style of painting which is now customary throughout Scotland, the Abbot's cell and oratory, and at the same time a large chamber in front of the stair which leads to the Abbot's cell.[43]

With this remarkable account of artist and patron we seem to move into modern times. Bairhum's was clearly a true artistic

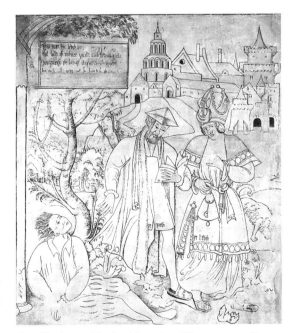

Plate 23. ANON., *The Good Samaritan*, WALL-PAINTING, KINNEIL HOUSE, *c.* 1553

temperament and his patron must equally have been endowed with the forebearance needed by a true lover of art. Some indication of Reid's taste and his sophistication is given by the work that he undertook as Bishop of Orkney in his cathedral of Kirkwall, for there he completed work begun in an earlier time in a style that harmonises with it. A man of Reid's culture would not have put up with Bairhum's cantankerousness if the art that he produced was indifferent, but we have no other evidence than this account by which to judge what it was like, though the remains of a wall painting of St John the Evangelist, still visible at Pluscarden, might have been his work, given the relationship between Kinloss and Pluscarden and the scale of the painting campaign on which he was employed.

One of the most interesting aspects of the record of Bairhum is the very specific reference that it makes to the 'lighter style of painting now customary throughout Scotland'. This suggests that the fashion for painted interiors, that we know from surviving painted ceilings prevailed in Scotland in the later sixteenth and seventeenth centuries, was already established in the reign of James V and Ferrerius's account of Bairhum's work is actually closely contemporary with the earliest surviving example of just such painting. This is the series of wall-paintings in two rooms at Kinneil House, executed for the Regent Arran c. 1553. Arran was regent between 1542 and 1554. There was also other painting in the building. The two surviving rooms are both decorated in the same technique of dark line drawn on white which gives them a strong resemblance to contemporary engravings from which no doubt their iconography derives. They may not always have been so stark though, as there are some traces of colour.

The first scheme is taken up principally with six scenes of *The Good Samaritan*, (*Plate 23*), with three additional panels representing, St Jerome, the Magdalene and possibly Lucretia. The second series in a vaulted room is more decorative. Four roundels representing *Samson and Delilah*, *David and Bathsheba*, the *Sacrifice of Isaac* and the *Temptation of St Anthony* are supported by ribbons and wreaths of foliage with birds and beasts. The arms of Arran and his wife are at the centre of the vault. The painting in this room really does answer the description of a 'lighter style' of painting and both series are painted with vigour. They show the artist to be quite at home working on a considerable scale and in the second room the scheme is worked out with some care. On the eve of the Reformation therefore, though the main decoration for walls was probably tapestry, secular painting was already established as a normal part of life.

That this should be so is not surprising. Scotland in the late fifteenth and sixteenth centuries was not a backward place. For instance in 1508 Alexander Stewart, illegitimate son of James IV, was sent to Italy where he studied for a while with Erasmus. In seeking such an education for his son, James was acting in the true Renaissance spirit as it was set out by Baldassare Castiglione in his classic guide for the civilised Renaissance statesman, *Il Cortigiano*, or *The Courtier*, though it was not published till twenty years later. Men like Hector Boece and John Major moved easily among European intellectuals and so, in the next generation, did John Knox and George Buchanan. William Dunbar, Robert Henryson, Gavin Douglas and Sir David Lindsay were poets who could also draw on the whole European tradition. We have tantalising glimpses in figures like David Prat, Thomas Galbraith and Andrew Bairhum of those who might have been their equivalent in the field of painting and we know from commissions like the *Trinity College Altarpiece* or the *Book of Hours of James IV and Margaret Tudor* that the standards of their patrons were high. Because of the iconoclasm of the Reformation that followed we cannot get close to them as individuals. Nevertheless it is clear that Scotland was no more backward in the visual arts than in other fields as, led by a succession of three competent and cultivated kings, the country took its place among the modern nation-states. If the reign of James IV constituted an 'aureate age' the term can surely be extended to cover the reign of his father and of his son too.[44] The Reformation was not a reaction against this, but developed naturally from it and the impact of the Reformation on the visual arts therefore must be seen in this light. Iconoclasm was a specific doctrinal issue. It did not entail a blanket rejection of art and throughout the Reformation period, artists continued to serve the community.

THE REFORMATION

The death of James V, from shame or a broken heart after the disastrous battle of Solway Moss in 1542, saw the end of what had been since the reign of his grandfather a golden age for Scotland. For all the occasional upheavals, relative peace had prevailed and the kings had successfully brought about the expression of the state in themselves, an essential stage in the emergence of the modern nation. In this the arts played an important role that the kings clearly understood, but after James's death, first of all his daughter presided reluctantly over the destruction of the medieval church, then his grandson willingly participated in the removal from Scotland of king and court and in little more than sixty years the country lost its only two fully evolved institutions of nationhood. Even without the iconoclasm of the Reformers it would have been a difficult time for the arts, for church and crown were their principal patrons. What is surprising though is the extent to which artistic activity was maintained throughout this period in spite of these events.

Though the Reformation in Scotland was not accomplished till 1560, the political battle had been fought out over the two previous decades, and in the 1540s successive English invasions caused considerable damage and dislocation even before the iconoclasm of the Reformers. These were the years of Mary's minority and to compound the losses there was no longer a stable court around an energetic and imaginative prince where the arts could flourish. The successive regents did however continue to employ painters. The paintings done for Regent Arran at Kinneil House and a very fine later portrait of him (1578, SNPG)

show that he was not indifferent to the visual arts. Mary of Guise, regent from 1554–60, likewise seems to have continued what might be regarded as the normal private uses of painting. There is a beautiful small portrait of her in the manner of the French painter Corneille de Lyon (SNPG). It may have been painted in France, but in her palace in Edinburgh, painting of considerable elaboration was preserved till the early nineteenth century. Three sections of a painted ceiling in the National Museums of Scotland together with a very fine carved oak door and a carved *Madonna and Child* are all believed to have come from this palace.

There are also signs of church art continuing as normal in the time of Mary's minority. There are for example a number of decorated manuscripts like the *Inventory of the Treasures of Aberdeen Cathedral* (1549, Aberdeen University Library) that date from this time, but the first recorded incident of iconoclasm was as early as 1533, and it was in the reign of James V that the seeds of the Reformation were first sown. As early as 1525 a prohibition had been issued against the import of Lutheran books and in 1527 Reform had its first martyr in Patrick Hamilton, burned at the stake in St Andrews. In 1533 one Maister Walter Stewart was called before the Archbishop of Glasgow to answer a charge of malicious damage to a statue of Our Lady, at Ayr. Another incident is recorded in Perth in 1537, and in 1541 James V was moved to pass an act against iconoclasm. In 1543 a major iconoclastic riot took place in Dundee that is recorded in some detail in the indictment against its perpetrators:

> For art and part in the oppression committed on the Friars, Preachers and Minorites of Dundee, by coming to their places within the said burgh with convocations of the Queen's lieges

in great number, armed in warlike manner, there breaking up the doors and gates of the Places and breaking and destroying the ornaments, vestments, images and candlesticks, carrying off the silvering of the altars, and stealing the bedclothes, cowls etc., victuals, meal, malt, flesh, fish, coals, napery, pewter plates, tin stoups, etc,. which were in keeping in the said Places in company with Mr Henry Durham and his accomplices – rebels of Our Lady the Queen, and at the horn [outlawed] – on the last day of August 1543.[1]

There were other incidents in the 1540s. George Wishart preached in Ayrshire in 1545 against images and caused great damage, though he was frustrated on one occasion when at Mauchline, the sheriff, Sir Hugh Campbell, blocked his access to the kirk there 'for preservation of a tabernacle that was theire, beautiful to the eye'.[2] This is an interesting example of the priority of aesthetics over piety and creates a welcome counterpoint to the tale of opportunistic greed and casual vandalism as unholy partners to pious zeal that is told in the account of events in Dundee. There could not be much justification in iconoclast theology for stealing the monks' food, their bedclothes and even their cowls. But these events also had a political dimension for it was in 1543 that Regent Arran was flirting with the Protestant and English cause. His move away from that sympathy in 1544 led to the brutal English invasion of the following year, followed by further invasions in 1545 and 1547. These added a military dimension to the early history of iconoclasm and Holyrood and a number of other major churches in south-eastern Scotland were sacked by the English.

The early Reformation in Scotland was the product of the country's direct access to European ideas, not by any backwardness. Men like Wishart, Hamilton and later Knox were inspired by the wave of intellectual energy whose other face is seen in the cultured courts of James IV and V. They were fully participating members of the European avant-garde. Just like John Major and Hector Boece before him, George Buchanan, for example, had taught at several European universities before returning to Scotland as one of the leaders of reform.

It was Luther initially who gave this intellectual energy its spiritual focus. The imperative of iconoclasm was simple and inescapable. The first generation to have access to the bible through printing and translation, searching it for rules of conduct, found the Ten Command-

ments that had the primitive authority of the word of God to set them far above any rules laid down by the discredited priestly hierarchy. The Second Commandment is quite unambiguous: 'Thou shalt not make unto thee any graven image, or any likeness of any thing that is in heaven above, or that is in the earth beneath, or that is in the water under the earth.' This imperative was invoked periodically throughout much of the succeeding century and the prolongation of the crisis was an important factor in the completeness of the destruction.

In the first excitment of the new ideas the Second Commandment played an important psychological role. Arguing for the rejection of the old order, the preacher could actually point to the visible evidence of its corruption and to the neglect of the law of God in the church around him. He could incite his audience to reject it by practical action, action which also cemented the identification of individuals with the wider cause by securing their complicity in acts which, as they were illegal and put the command of God above the laws of men, also put their perpetrators outside the law. This is exactly how Knox used his audience in Perth as he himself describes events there in 1559. In the political circumstances in which he found himself, rallying opposition to the Regent Mary of Guise, it was imperative that he gave his congregations an excited sense of group identity. The first wave of iconoclasm that followed his preaching, not only in Perth, but from there east to St Andrews and Dundee, west to Stirling and south to Edinburgh, was an essential part of the political strategy of the Reformers.

The history of iconoclasm was not however a purely disinterested application of divine law, nor even of the expediencies of politics. A contemporary remarks that the iconoclasts were 'pretending religione for quhat euir vice or crime tha did and al thair wicketnes religioune tha callit'.[3] The whole thing was in fact a mixture of piety, greed, and vandalism with the manoeuvring of politicians, secular and ecclesiastical, local, national and international. Knox himself recognised the impurity of motive in much that happened as a direct result of his own preaching and denounced the rascal multitude, but by the end of 1559 the work of destruction had spread through to Glasgow and

north to Aberdeen. By the summer of 1560 and the death of Mary of Guise, the Reformers were in full control. When her daughter returned to Scotland to claim her throne, the Reformation was already established.

Already early in 1559 the authors of *The First Book of Discipline*, which set out the basis of the reformation of the church in Scotland, had proposed as a matter of principle the comprehensive destruction of the physical witness of the old order.

> As we require Christ Jesus to be truly preached and his holy Sacraments to be rightly ministered; so can we not cease to require idolatry, with all monuments and places of the same, as abbeys, monasteries, friaries, nunneries, chapels, chantries, cathedral kirks, canonries, colleges, other than are presently parish Kirks or Schools, to be utterly suppressed in all bounds and places of this Realm (except only the palaces, mansions and dwelling places adjacent thereto, with orchards and yards of the same): as also that idolatry may be removed from the presence of all persons, of what estate or condition that ever may be, within this Realm.[4]

This was the text for systematic destruction of all church furnishings and of any ecclesiastical building that was not serviceable as a parish church. The account given in *A Diurnal of Remarkable Occurents* of events in 1559 surely holds good for much of what happened in the years following the final establishment of the Reformed Kirk: 'In all this tyme, all kirkmennis goodis and geir wer spoulyeit and reft frae thame, in everie place quhair the samyne culd be apprehendit; for everie man for the maist part that culd get any thing pertenyng to any Kirkmen thocht the same as wele won geir.'[5]

According to McRoberts the most intensive period of destruction was between 1559 and 1580, but even then it does not seem to have been comprehensive. There was a second wave in the aftermath of the signing of the Covenant in 1638 and during the Civil War that followed. It was then that St Machar's Cathedral, Aberdeen, was finally stripped of its remaining images. The General Assembly 'ordained that our blessed Lord Jesus Christ His arms to be hewene out of the front of the pulpit, and to tak doon the portrait of our blessed Mary and her dear Son baby Jesus in her arms, that had stood since the up-putting thereof, in curious work.'[6] At the same time the crucifix on the old town cross was 'dung doon' and the crucifix in St Nicholas Kirk was 'dung doon, whilk was never troubled before'.[7] A note of prudence

Plate 24. WILLIAM KEY, *Mark Ker*, 1551

and perhaps the anticipation of better times is sounded as 'the crucifix on the new town cross [was] closed up, being loath to break the stone'.[8] It seems not to have been till 1649 that the high altar of St Machar's was finally 'hewed to pieces by order and with the aid of the parish minister'.[9]

Personal property of a religious kind was equally involved in all this destruction. 'Any former papist reconciled to the Kirk was required to throw out all religious objects, rosaries, crucifixes, images of saints,'[10] but private habits were tenacious and the latest reference to a specific act of iconoclasm dates from 1688 when 'Popish trinkets in my Lord Traquhair's house' were burnt at the cross in Peebles.[11]

The wreck of Scotland's medieval past was comprehensive and it makes a sad record. Loaded as our judgement must be by regret at our loss, it is difficult for us to form any balanced view of it. Indeed in the subsequent history of Scotland nothing has told so effectively against the reputation of the Reformers as their promotion of iconoclasm. Under the general label of 'Calvinism', because of their attack on what later centuries have come to regard as the very fabric of civilisation, the

whole cause of Reform has been discredited and its central place in creating what is distinctive in the history of the modern West has been largely lost from view. The self-confidence that allowed the Reformers to reject the past is very different from our modern attitude to 'heritage'. Creditable though that may be, its corollary is surely a neurosis about the present and the future which our reforming ancestors would not have understood. The whole basis of radical thought, the motor of the intellectual originality on which western civilisation has been built is, after all, the idea that it is possible, or even necessary, to start afresh, to jettison any preconceptions and preconditions and to begin again from first principles.

In spite of the Second Commandment, however, Reform and the visual arts were not utterly inimical to each other. Dürer and Cranach belonged to the circle of Luther, and Calvin's own attitude towards painting appears to have been tolerant. In a deeper way too clearly the Reformation shaped the future course of European art. At the centre of Protestant thought in all its variations stood the idea of individual responsibility and the separateness of each person's experience. Protestants did not invent portraiture, but the origins of the Reformation and the modern portrait do seem to be very closely bound up with each other. In Scotland the number of portraits increases as the Reformation movement gathers pace, though from both sides of the struggle. George Wishart, for example, is commemorated in a fine contemporary portrait (1543, SNPG). Two of the finest portraits of the period of the Regency are of *Mark Ker*, Abbot of Newbattle, (*Plate 24*), and his wife *Lady Helen Leslie*, painted in 1551 by William Key, one of the leading portrait painters in Antwerp (both SNPG). There is no indication that Key travelled to Scotland

Plate 25. ANON., *Earl of Bothwell*, 1566

to paint these portraits, so the sitters must have come to him, but we do know that in 1561 Hans Eworth visited Scotland and painted *James Stewart, Earl of Moray* and half-brother of the Queen and his wife *Agnes Keith* (both Earl of Moray, Darnaway Castle). His characterisation of the sly, lop-sided earl and his hard and pretty wife is unforgettable and in the best traditions of Holbein. Eworth had already painted Henry Darnley in 1554 (Lord Bolton, Bolton Hall) and he painted him again in 1563, copying a full-length portrait painted the previous year by an unknown artist of Darnley with his brother (HM the Queen). All three pictures were probably painted in England however and the full-length of Darnley that Eworth copied was painted in the unusual medium of watercolour on fabric. It has been suggested that this was to make it light and portable so that Mary could be sent a likeness of her prospective husband.[12]

There is a miniature on copper of the man who replaced Darnley, the *Earl of Bothwell* (SNPG) which is of great quality. (*Plate 25*) It is dated 1566 and is one of a pair with a similar painting of his first wife, *Lady Jean Gordon* (also SNPG), which bears the same date. These paintings are by an unknown hand, but the portrait of Bothwell in particular is a strong and sensitive characterisation. Bothwell was in Scotland in 1566 where the picture must have been painted therefore. One of the finest full-size portraits of a member of Mary's court is the painting by an unknown artist of *George, 5th Lord Seton*, master of her household (SNPG). (*Plate 26*) Seton holds the baton of his office. His armour is set out behind him and he is wearing a marvellous red and gold costume. Although he is presented in the full splendour of his office in this way, the picture appears to have been painted after Mary's abdication in 1568 as it bears a date 157? (the last digit is illegible). It is the richest and most splendid court portrait of the period to survive, but it relates to an even finer, but less formal portrait of the same sitter (NGS). This shows him with his wife and four sons and was painted by Frans Pourbus in 1572. A touching and beautiful family group, it was presumably painted in France where Seton was in exile.

There is further evidence too for Seton's

Plate 26. ANON., *George, 5th Lord Seton*, 1570s

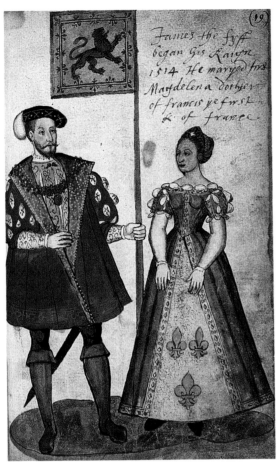

Plate 27. ANON., *James V* FROM THE *Seton Armorial, c.* 1580

interest in painting. The *Seton Armorial* (Sir David Ogilvy), (*Plate 27*), from the point of view of painting the best of the Scottish armorials (books of heraldry), bears his arms on its cover, though it may have been undertaken for his son, Robert, sixth Lord Seton.[13] Its authorship is unknown, but in 1582 Seton had an artist in his household for there is a record in the treasurer's accounts of payment to 'my Lord Seytonis painter for certane picturis of his majesties visage drawin by him and gevin to the sinkar [coiner] to be graven in the new cunze [coinage]'.[14] This reference has been tentatively interpreted by Thomson as suggesting that the painter in question was actually Adrian Vanson, a Netherlandish artist who became court painter to James VI some time before 1584 and who remained in that position till 1602. It is also very likely that he was father to the painter Adam de Colone who flourished briefly in the 1620s.

George Seton was it seems a man of taste and a patron of painters. If indeed it was he who brought Adrian Vanson to Scotland then

there is a clear continuity from Mary's reign through that of her son, in spite of the upheavals of the Reformation. Mary herself, of course, had been portrayed several times by artists at the French court. The most beautiful of these portraits is the superb drawing in the Bibliothèque Nationale by Francis Clouet of her, aged about sixteen, to which a miniature in the Royal Collection is also closely related. Less intimate, but an image of great courtly sophistication, is a small bronze bust of her by Ponce Jacquio (SNPG). This was also made in France, but she had already been recorded by a Scottish artist there for in 1553 John Acheson, master coiner, had travelled to France in order to take her portrait for the coinage,[15] evidence like that from the coins of James III of the importance of the coinage bearing a true likeness of the sovereign.

Mary by her upbringing was therefore accustomed to art of a very high quality. Such jewellery, needlework and other personal relics associated with her that survive suggest that she endeavoured to maintain these standards in her immediate surroundings in Scotland. There is still painted decoration in her bedchamber at Holyrood though it may be of a later date. It is a monochrome frieze of foliage running round the upper part of the wall which, then as now, had tapestries hung beneath it. Not in itself a very exciting piece of painting; taken in context the frieze gives us some idea of a decorative environment. There is also a double portrait of *Mary Queen of Scots and Henry Darnley* at Hardwick Hall (NT), (*Plate 29*), which must originally have been a picture of some splendour. The figures are three-quarter length, very richly dressed and set against a gold-patterned ground.

The couple also appear together on a silver commemorative medal (SNPG) and there can be no doubt that Mary understood the power of imagery. In 1575 she wrote from her captivity asking James Beaton, Archbishop of Glasgow, to send her, in secret and in all haste, four miniatures of herself, set in gold, for her friends in England. Just such a miniature of Mary towards the end of her life, beautifully set in gold and enamel with her crowned monogram on the back, is preserved at Blair College.[16] After her death Mary's image continued to be

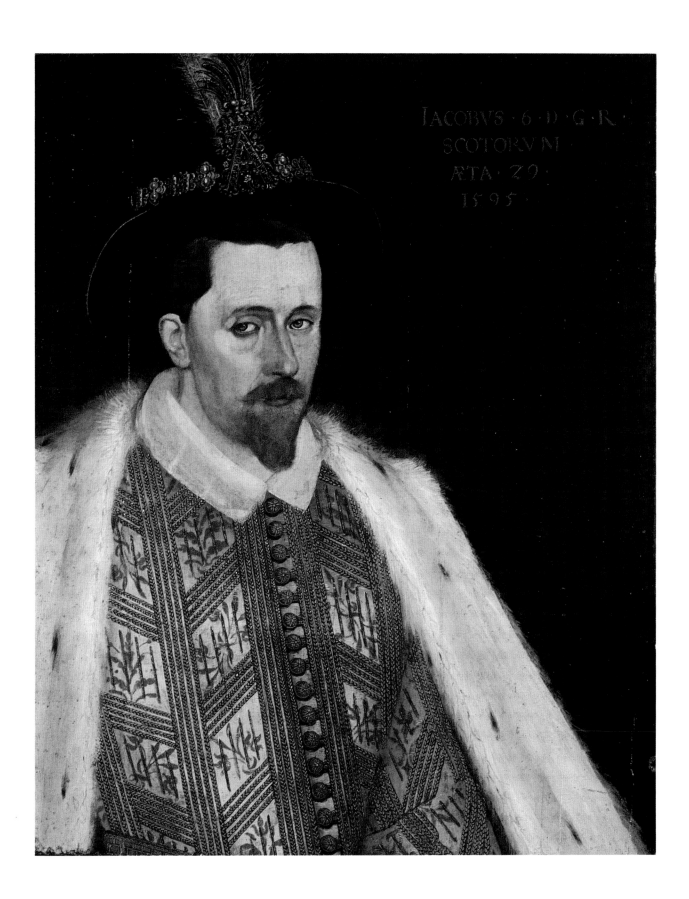

IACOBVS · 6 · D · G · R ·
SCOTORVM
ÆTA · 29 ·
1595

in demand, for there exist a number of versions of posthumous portraits of her. The most elaborate is the full-length Blair College portrait, probably painted in the Netherlands, which has on it inscriptions describing the tragedy of her career and the cruelty and inhumanity of her death. In addition to the main portrait there are two subsidiary scenes, one showing her execution and the other her two faithful attendants, Joanna Keith and Elizabeth Curle.

The abdication of Mary in 1568 was the final step in Scotland's commitment to the Reformation and correspondingly the final break with France; nevertheless the earliest painting of James VI which is a true portrait (SNPG) seems to relate to a payment in the treasury records, of £10 to 'the Frenche panter' in September, 1573. It is a painting of a solemn, pale and peaky child, aged six or seven. He has a hawk on his wrist. This detail as well as the angle of the head and the position of his right hand recall the most memorable, known family portrait, that of his great-grandfather, James IV, who is carrying a hawk and who had likewise come to the throne on the murder of his father. It is interesting if James VI was identified with James IV in this way, for though it could not be said that as he came to manhood he shared his taste or that of James V, in the more confined circumstances of Reformation Scotland he did carry on the Stuart tradition of the renaissance prince with an active interest in culture. He was an educated man, a patron of

poets and musicians and, as an author in his own right, he took part in the literary culture of his court.

As a patron of painters too James left his mark, for it is with his reign that it is possible for the first time to identify named artists with at least a hypothetical oeuvre, though it is also true that the earliest account of his own personal involvement with a painter is a reference in 1579 to the problem that a Flemish painter was having in persuading him to sit to be painted.[17] The first named court artist to work for James was Arnold Bronckhorst (*fl.* 1565/6–1583), described in a record of 1583 as a 'Dutche painter'. A number of important pictures have been attributed to him, but what we actually know of his career in Scotland is brief and shadowy. The first record is in April 1580. On 9 September of the same year he was paid for several portraits, two of the king himself and one of George Buchanan. According to a contemporary account Bronckhorst had come to Scotland from England, where he was associated with Nicholas Hilliard, in order to prospect for gold. For some reason he was detained in Scotland. In September 1581 he became king's painter 'for all the days of his lyvetime', but he last appears in the records in 1583 as resident in London.[18]

The only certain work by Bronckhorst is a signed portrait painted in England in 1578 of Baron St John of Bletso. It is a powerful, blunt image consistent with Bronckhorst's identification as a Dutchman. The painting could be compared to the work of the Dutch painter, Pieter Pieterszon, for example, and shows the same rough immediacy which a generation later was to flower in the painting of Frans Hals. Of the pictures that have been associated with Bronckhorst, the most convincing display these qualities. One of the finest is the portrait of *Regent Morton* (SNPG). (*Plate 30*) His regency lasted from 1572 to 1578. In December 1580 he was arrested and in 1581 executed for complicity in Darnley's murder. It is a three-quarter length. In a tall, black hat and black suit with a high, white ruff, Morton stands in a confident posture with one hand on his sword, the other on his hip. He is partly behind a table on which his gloves are laid and behind his shoulder an open parapet gives a view of Tantallon Castle.

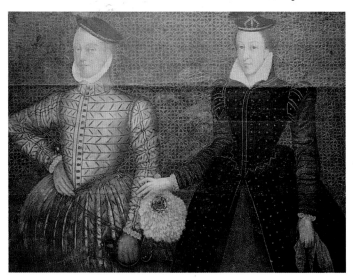

Plate 29. ANON., *Mary Queen of Scots and Henry Darnley*, c. 1565

The picture is undoubtedly one of a man of authority. It achieves this impression, not by any emblematic account of office or status, nor by the use of rich materials, but by the way in which the artist has conveyed the presence of a powerful personality. The dates are such, however, that although the picture could be by Bronckhorst, it must have been painted after the end of Morton's regency and shortly before his arrest.

The achievement of the Reformation was a heroic one. It was a revolution brought about by individuals, mostly without status, but relying instead on force of personality and intellect. For such a movement the portrait was the most appropriate commemorative form. In 1580, acting on this perception, Theodore Beza published in Geneva *Icones, id est Verae Imagines, Virorum Doctrina simul et Pietate Illustrium*, his iconography of the Reformation, consisting of a collection of woodcut portraits of leading figures, accompanied by brief biographies. The book is dedicated to James VI and has for its frontispiece a portrait of the young king. In June 1581 Adrian Vanson was paid for two portraits sent to Beza. Thomson argues that the original of this woodcut portrait of James was one of these.[19] In it the king is armed and crowned, a sword in his right hand and an olive branch in his left. This is so close to the royal portrait on the £20 piece of 1575, though, even to the detail of the Scottish crown, the placing of the motto and in the motto the same substitution of an 'n' for an 'm' in the word '*utrum*', that the coin must have been the model for Beza's portrait. It was designed by the master of the mint, John Acheson, the same coiner who travelled to Paris to draw James's mother for her coinage twenty years earlier.

In a letter to Beza written in 1579, the king's tutor, Peter Young,[20] refers to portraits of Knox and Buchanan and it is surely for these that Vanson was being paid two years later. The portrait of *John Knox* appears in the *Icones*. (*Plate 31*) It is the only authentic portrait of him. With long beard and flat hat he has all the dignity and presence that one might seek in the father of the Kirk. Buchanan does not appear in the *Icones* however. Presumably Beza decided not to include him, but there are several contemporary portraits of him. One rather crude one is dated 1581 (SNPG) and so cannot be

identified with the picture mentioned two years earlier. The most memorable is a small circular portrait (also SNPG), (*Plate 32*) and perhaps it is not just the circular shape which this powerfully characterised image has in common with the miniature of Bothwell painted in 1566.

Also connected in some way with Beza's *Icones* is the remainder of a once extensive gallery of Reformers in Edinburgh University. The university was founded in 1583 by James, on the model of Leyden University, as a Protestant institution. The portraits are not recorded until they appear in the first catalogue of the library a century later under the heading *Icones Virorum Illustrium etc*. By that time the original Reformers had been joined in the collection by other famous men, including the Stuart kings, the twelve emperors and a variety of others, all set out programmatically. Inspired by Beza, some at least of these portraits may have been part of the original furnishings of the

Plate 30. ARNOLD BRONCKHORST, *Regent Morton*, c. 1580

university. Most of those that survive are of a character which is compatible with a late sixteenth-century date. There is a similar collection at the University of Geneva and they would have provided a very fitting *exemplum virtutis* in a Protestant college.

Vanson became king's painter after the departure of Bronckhorst. As with Bronckhorst, although it is quite clear that Vanson produced paintings in the king's service, it is not easy to say with confidence which of those that survive might be by him as the only certain identification is the woodcut portrait of Knox. Vanson however worked for the king for twenty years. Duncan Thomson worked out the basis of an oeuvre for him in the catalogue of the pioneering exhibition, *Painting in Scotland 1570–1650* which is by far the most substantial study of this difficult period that has been undertaken. Central to this view of Vanson is a half-length portrait of *James VI* (SNPG), (*Plate 28*) that is dated 1595. The previous year the king had given Vanson a medal and called him 'our painter' so the grounds for supposing that this is by him are very strong. (There is also a circular miniature version of the picture with a companion of Anne of Denmark [SNPG].)

The picture lacks something in skill in the

Plate 32. ANON., *George Buchanan*, *c.* 1580

handling of space and the placing of the figure. The effect of these deficiencies is exacerbated by the way in which the panel appears to have been cut, most severely on the left side, but this does not conceal the qualities of what is an unusually psychological and intimate painting for a portrait of a sovereign. The odd way that the figure is set, so that, as Thomson observes, we are partly looking down on the king, makes him seem very close to us. The eyes fix us warily and the whole effect is a startlingly close encounter with a complex character. There is another portrait of the king, dated 1586, which may also be by Vanson and amongst a number of other pictures possibly by him the most impressive is a full-length portrait of *Sir Thomas Kennedy of Culzean* (NTS), but in none of these do we get the feeling that the artist is responding to his sitter as in the royal portrait of 1595.

Although at the court of James VI portraiture was the central activity of the court painters, and the story of the unfortunate town officer, Cornell, is a reminder of how seriously it was treated (see above, p21–22), portrait painting did not constitute the whole artistic activity of the time. The Blair College portrait of *Mary* is just one of a number of pictures which, though ostensibly portraits, have a more polemic character than is usually associated with the genre. Their existence testifies to the perceived power of painting as public propaganda. Even more elaborate than the portrait of Mary, for example, is a painting, *The*

Plate 31. AFTER ADRIAN VANSON, *John Knox*, FROM THEODORE BEZA'S *Icones*, 1580

Memorial of Henry Stewart, Lord Darnley, King of Scots, commissioned by Darnley's parents, the Earl and Countess of Lennox, from Lieven de Vogeleer in London in 1567/8 (HM the Queen). It was to commemorate Darnley's death and to bear witness to his parents' accusation of his murderers, in particular Bothwell, but also by implication Mary herself. Together with lengthy inscriptions, the picture has a complex iconography. It is set in the interior of a chapel hung with the banners of those present. These include the Earl and Countess, their son Charles and their grandson, the infant James VI. They are kneeling, praying to the figure of the risen Christ on an altar. Darnley himself is present in an effigy laid out on an elaborate tomb. Inset in the foreground of the picture is a landscape of the field at Carberry where Mary surrendered without a fight to her enemies while Bothwell fled.

At Carberry Mary's opponents carried a banner which is shown in this painting and is also recorded in a contemporary drawing (PRO). It shows the murdered body of Darnley, half-naked as it was found at Kirk o'Fields after the explosion that killed him. The infant James kneels beside his father's body, praying. The words of his prayer 'God judge and revenge my cause' are written above him. A similar drawing (also PRO), half map and half narrative, records the scene at Kirk o'Fields when Darnley's body was found.

An equally blood-thirsty image was used against James himself in 1591 after the death of the Earl of Moray. Moray, suspected of treasonable contacts with the exiled Bothwell, was murdered by the Earl of Huntly with the king's connivance. The house of Donibristle, where Moray was staying, was set on fire. Fleeing to escape the flames he was discovered in the dark 'by some sparks of fire in his knapskall and so was killed and cruelly demained'.[21] Like Agrippina returning to Rome with the ashes of Germanicus to accuse his murderer, the Emperor Tiberius, the Earl's mother brought his body to Leith in mute accusation of the king. Prevented from carrying out the funeral as planned, she had painted *The Memorial of James Stewart, Earl of Moray* (1591, Private Collection), (*Plate 33*) and presented the picture to the king. It is a stark and graphic image. The 'bonnie earl's' naked body, laid out as though for burial, clearly bears the marks of his death by gun and sword.

A third example of a similar revenge picture in which the intention to shock is quite explicit is recorded from 1595. The Earl of Mar, after the murder of one of his servants, 'cawsit mak the picture of the defunct on a fayre cammes, payntit with the number of the shots and wounds, to appeare the mair horrible and rewthfull to the behalders'.[22]

John Workman (*fl.* 1589–1604), one of three painters known to be working at the court at this time, was paid for the 'ceremonies and furnitour' for the funeral of the Earl of Moray, but it seems that he was not the author of this grisly painting of the Earl as it was specifically excluded from his contract under the condition that he 'be nocht subject to furneis nor deliver the said noble lordis pictour'.[23] It sounds very much as though he wanted to distance himself from such a pointed political statement.

Plate 33. ANON., *The Memorial of James Stewart, Earl of Moray,* 1591

Workman was licensed as a herald-painter in the same year, but another member of the family, James Workman the elder (*fl.* 1587–1633), was actually a full herald. He became Marchmont Herald in 1597, one of the five Scottish heralds under the Lord Lyon, King of Arms. The office of herald had generally been reserved for individuals of rank, but Workman was the first of many painters to be elevated in what was a logical combination of roles, as heraldry involved painting not just arms and escutcheons, but more directly pictorial works as well. James Workman for instance is recorded in 1633 as the painter of a processional roll, part of the 'ceremonies and furnitour' for the funeral of a member of the Keir family. A processional, or funeral, roll was painted – a visual guide to a funeral procession – relying on heraldry to establish and identify the order. One such roll survives in the National Museums of Scotland. (*Plates 34 and 35*) Though the artist and the occasion for which it was prepared are actually unknown, it is traditionally linked with the obsequies of George, first Marquess of Huntly, who died in 1636.[24] As herald, the painter was responsible for the order of procession, a very important duty as in effect he was in charge of protocol. Heraldry was a major social responsibility therefore and an extremely important part of the painter's job, requiring accuracy, tact, and a considerable amount of historical and genealogical knowledge. The basic work of reference for a herald was the armorial, a codification of coats of arms, and James Workman was himself the author of an important armorial, the *Workman Armorial* (NLS). It is the first Scottish armorial in which we can be sure that the herald who was its author was also the artist who painted it.

Herald painting is not obviously part of the mainstream of modern art, but painters continued to hold heraldic offices of this kind until the later eighteenth century. Through herald painting they were directly involved at a high level in the organisation of very important functions in the social life of the nation. This included the provision of such topical pictures as the grisly placard of the *Earl of Moray* and the *Darnley Banner*, just as much as heraldic devices, escutcheons and processional rolls. Painting of this kind was a feature of both crises and celebrations in late sixteenth- and seventeenth-century Scotland. The Reformation did not put an end to pageantry, and painters like the Workmans, or their contemporaries such as Walter Binning (*fl.* 1540–1594) were fulfilling exactly the same role as their predecessors David Prat, Alexander Chalmers and Thomas Galbraith.

The notion of art as a commodity was hardly developed and this kind of painting was by its nature ephemeral, but it is quite clear that the public occasions when painted imagery and decoration played an important role were frequent. In 1594, for example, the decoration of the Chapel Royal at Stirling for the baptism of Prince Henry was a major issue, but the most elaborate of such occasions were the royal entries which were a very important part of the ceremonial linking crown and people. When Mary arrived at Leith in 1561 she came sooner than expected and the city was taken by surprise. Nevertheless, within a few days, an elaborate pageant of formal welcome had been organised. Her son entered Edinburgh for the first time as ruler in his own right to a triumphal welcome in 1579. 'The haill streets were spread with flowers, and the forehouses of the streets by the whilk the king passit were all hung with magnific tapestry, with painted histories and with the effigies of noble men and women.'[25] There was also an arch erected 'quharupon was erectit the genealogie of the kings of Scotland'.[26] Thomson suggests that a set of portraits of the first five Jameses now in the Scottish National

Plate 34. ANON., DETAIL FROM *Processional Roll for an Armorial Funeral, c.* 1636

Portrait Gallery may in fact be survivors from this genealogy. They are certainly of this period. The *James V* in the series is copied directly from the double portrait of *James and Mary of Guise* at Blair Castle so the portraits are secondary, not part of any royal collection. Such an identification is plausible, therefore, though the Edinburgh University series suggests that such sets of portraits were also made for permanent sites in the sixteenth century just as they were a hundred years later at Holyrood.

There was a similar welcome for the royal couple when James brought his bride Anne of Denmark home to Edinburgh in 1590, and in 1603 James made sure that the city of London also observed this custom. A magnificent series of triumphal arches were made for his reception there whose appearance was recorded in engravings by Stephen Harrison in 1604 (BM). At the top of one of these arches were figures of Peace and Plenty and amongst a variety of other allegorical figures the Nine Muses and Seven Liberal Arts are prominent in reference to the king's personal culture and patronage of the arts. (*Plate 55*) James returned to a similar allegorical scheme, on a permanent site, in the paintings commissioned from Rubens for the Banqueting Hall. Rubens himself designed a triumphal entry for Archduke Ferdinand into Antwerp.

In 1617 when James returned to Scotland for the first time, he took a personal interest in the decoration of Holyrood in preparation for his arrival. He sent Nicholas Stone and his assistant, sculptors, and Matthew Goodrick, painter, from England to prepare Holyrood and Stirling for his visit in 1617, but ran into some trouble over the potentially idolatrous nature of what was proposed for Holyrood Chapel. There was an exchange of letters between James and his Scottish subjects which ended in James abandoning his intention to redecorate

the chapel, but comforting himself against any apparent loss of face he remarked: 'Do not deceive yourselves with a vain imagination of anything done therein for ease of your hearts or ratifying your error of your judgement of that graven work; which is not of an idolatrous kind like to images and painted pictures adored and worshipped by Papists, but merely intended for ornament and decoration of the place wherein we shall sit, and might have been wrought as well with figures of lions, dragons, and devils as with those of patriarchs and apostles.'[27]

The reason why James sent Stone to Scotland and so presumably also the painter, Goodrick, was nominally because 'this work could not be gottin so perfytlie and well done within this countrey as is requisite'.[28] It is an account of things that has been heard often since, but which surely, then as now, reflects the depressing effect of external patronage on local opportunity. This is certainly the case with Matthew Goodrick who is otherwise unknown in Scotland, but Nicholas Stone was rather different as he was certainly the best sculptor of the time. Nothing by him survives in Scotland, but there is contemporary sculpture in his style, and probably imported from the south, in Dunbar church on the monument of George Home, who died in 1611, and in Culross Abbey on the monument of Sir George Bruce, who died in 1625. These suggest that there was a fashion for his kind of work and that the king's high opinion of him was shared in Scotland.

The exchange between James and his Scottish subjects over the decoration of Holyrood highlights the specific nature of the ban on religious imagery. We do not know what public display was made for the king's entry into Edinburgh in 1617, but when his son came to the city in 1633 for his coronation the tradition of pageantry and the decoration of the city with

Plate 35. ANON., DETAIL FROM *Processional Roll for an Armorial Funeral, c.* 1636

painted constructions was again observed. Although this really belongs with the discussion of the work of George Jamesone in the next chapter, it is most appropriate to discuss it in this context as Charles I's entry was no doubt typical of the form that had been established at least sixty years earlier and it is the entry for which we have the clearest evidence of the elaborate iconography that was involved.[29]

George Jamesone (1589/90–1644), by that time the leading painter in Scotland, was in charge of the decorations and himself painted the ancestors of the king which were displayed on a triumphal arch. It was the same genealogical display as had greeted James in 1579. There were 109 kings. Twenty-six of the pictures painted for this arch, remarkably, survive and several of them are signed by Jamesone himself. In the 1640s the Earl of Lothian was actively engaged in building up a gallery of famous men. Presumably he acquired the portraits and these twenty-six survivors remained in his house of Newbattle until they were dispersed in 1971. The Reformation has not had a monopoly of iconoclasm in Scottish history. These portraits are lively and colourful. While they were obviously painted rapidly, they nevertheless reveal a degree of care and imagination in the way that the artist has differentiated the physiognomies of such imaginary figures as the Roman general Metellanus from the mythic origins of the nation (*Plate 36*), as well as more recent monarchs for whom he may well have had an actual likeness as model. Jamesone's invention was sufficiently lively for his series to have provided the models for the series of Scottish kings painted later in the century by Jacob de Wet for the Long Gallery at Holyrood where they still hang.

The entry of Charles in 1633 was stage-managed by Jamesone together with the poet, William Drummond of Hawthornden. There were three separate tableaux. At the West Port the king was presented with the keys of the city by the nymph Edina before a landscape depicting the town. At the first triumphal arch Caledonia made an address to the king. Jamesone's arch with the 109 monarchs was the second. At this arch Mercury led forth Fergus, legendary first king of Scotland to deliver another address. Because the painting for these

Plate 36. GEORGE JAMESONE, *Metellanus*, 1633

events was ephemeral, the involvement of Rubens and also before him of Dürer in similar occasions has sometimes been seen as puzzling, but in fact it testifies to the importance of these events. They were not just conceits and entertainment, but public statements in which imagery had a central role. In execution they were akin to decorative or stage painting, but they were meant to be taken seriously. The origin of these entries was in Germany and the Low Countries whence they were imported into Scotland. In the Netherlands they were of special importance because they involved the confirmation of the town's privileges. The same was no doubt true in Scotland. They were presented by the town to the monarch and were therefore clear evidence of civic as distinct from court patronage, even at the beginning of the reign of James. Jamesone may have been invited to Edinburgh from Aberdeen especially to undertake this work. The city was looking for the best available and knew where to find it. It is an important stage in the coming of age of the Scottish towns and the emergence of secular patronage concurrently with the Reformation.

A COUNTRY WITHOUT
A COURT

In just two generations art in Scotland lost first the patronage of the church and then of the crown. After the departure of the king in 1603, the palaces of Holyrood, Stirling and Falkland were refurbished in 1617 for his first return to Scotland. More work was undertaken in the royal palaces, including Linlithgow, in 1627–29 in preparation for the coronation of Charles I which finally took place in 1633. Holyrood was refurbished and largely rebuilt again after the Restoration when for a while it became the residence of James, Duke of York, later James VII, but from 1603 onwards these occasional visits of the kings, punctuated by all the upheaval of the Civil War, were a sad contrast to the active involvement of the monarch in patronage that had been so much a feature of Scottish life from James III to James VI. The Scottish burghs, although plainly self-conscious, were still too small to fill this cultural vacuum in the remarkable way that their neighbours did in the Netherlands.

In the pre-Reformation era, lay or civic patronage had been concentrated on the churches. This could reflect the interest of individuals or of families in particular institutions, especially the collegiate churches, or of the citizens and guilds in their town churches. The craft and trade guilds in the larger towns maintained chapels to their patron saints in the town church. The expression of pride in these things was not entirely extinguished by the Reformation either. In 1579 it was the intervention of the craftsmen that saved Glasgow Cathedral from the wrecking mob. In Perth, Monsignor McRoberts has identified a surviving painting of St Bartholomew as having once been part of the altarpiece of the Skinners Chapel in St John's Kirk, now heavily disguised by over-paint to conceal its idolatrous nature.[1] Proprietorial pride in this case was stronger than the risk of the accusation of idolatry. Presumably similar motives were involved in the preservation of a remarkable and very beautiful brass chandelier with the *Madonna and Child* as its crowning feature in the same church in Perth, the very site of Knox's famous sermon. The reluctance of the people of Aberdeen to destroy their new cross has already been remarked, and St Machar's has kept to this day its beautiful heraldic ceiling, set up between 1520–24,[2] which sets Scotland's own hierarchy, secular as well as ecclesiastical, in a European context and still includes the arms of the Pope.

Such expression of pride was not confined to rare acts of preservation. The spectacular church towers of East Fife, especially at Anstruther and Pittenweem, echo the national castle style of the later sixteenth century and so appear to have been built at the height of the Reformation with pride in innovation. There are several silver cups of the period possibly made as communion cups, such as the *Tulloch Mazer* made by James Gray in the late 1550s in Edinburgh, which have a chaste simplicity appropriate to the new rite, but lack nothing in refined elegance as a consequence. It is to this period too that the remarkable painted ceilings of Scotland belong. At least a hundred of these survive or are recorded. Such popularity must be seen in the context provided by the popularity of heraldic painting and of such events as the triumphal entries. They all provide evidence that painting was part of daily life.

The earliest surviving example of this kind of painting is the decoration at Kinneil House (*c.* 1553) but, though much is difficult to date, the majority seems to belong to the post-

Reformation period, that is to the later years of James's reign which ended in 1625 and the reign of his son, Charles I. This type of decorative painting stopped abruptly with the Civil War, whose first episode in Scotland was 'the Bishops' War of 1639 which followed the signing of the National Covenant in the previous year, 1638. In 1642 the first battle of the civil war in England was fought at Edgehill and in 1644 the Scots Presbyterians joined the war in the southern kingdom. Five years later Charles I was executed. The Scots however recognised his son, Charles II, who was crowned at Scone in 1651, but the consequence of their loyalty was the invasion and occupation of Scotland by Cromwell.

The quantity of decorative painting in the period from the Reformation to the crisis of the Civil War and Commonwealth surely reflects the same spread of wealth and literacy which was the trigger of the Reformation itself. The altercation between James and his Scottish subjects over the decoration of Holyrood Chapel in 1617 might seem to confirm the conventional view of Scotland as a joyless and colourless

Plate 37. ANON., CEILING DECORATION, NORTHFIELD HOUSE, c. 1600

place, a view which James himself helps to confirm by attributing the argument to the ignorance of his critics, but he was patently trying to score points to save face. The evidence for both public and private uses of painting is such that it is quite clear that Scotland, far from being kept in joyless (and unpainted) gloom by a dominant caste of black-browed Presbyterians, was actually rather a jazzy place. Not only the number of painted ceilings that survive, but also the range of dwellings in which these, or traces of them are found, is such that we have to conclude that painted decoration of considerable elaboration was the norm even in relatively modest houses.

In Burntisland, for example, Mary Somerville's House was originally the dwelling of a merchant captain. It has painted decoration similar to that in Rossend Castle, also in Burntisland, or to Earshall in Fife. The painter, James Workman, (*fl.* 1587–1633) owned property in Burntisland so may be associated with these paintings. In Edinburgh, John Knox's House and Gladstone's Land (dated 1620) are two merchant's houses decorated in this way from the period, *c.* 1600–1620, and at least eleven others survive in part, or are recorded in the city. Gladstone's Land shows signs of having been painted on all the principal floors. Restoration of a section of the ceiling of John Knox's House using the original pigments shows that the colours, now so faded, must once have been brilliant in all these decorations. Much of the exterior of these houses would have been painted and gilded too, the beautiful sculpture on John Knox's House for example, and the whole effect must have been colourful indeed.

This type of decoration was executed directly on the wooden beams or boards of the ceilings, in tempera, a kind of glue-size distemper, usually over a chalk-white priming. The majority of the ceilings are of the open beam type. The exposed rafters support the planks of the floor above. Thus there are in effect three distinct sets of surfaces, the underside of the plank floor framed between the beams, the vertical sides of the beams, and their undersides or soffits. This arrangement dictated long, narrow, running patterns. The painters used abstract, floral, heraldic, grotesque and animal motifs to build these up and they are often very

Plate 38. ANON., *The Muses and Virtues*, PAINTED CEILING, CRATHES, *c.* 1599

complex. At Prestongrange, dated 1581 and one of the earliest dated schemes of this type, the decoration shows direct knowledge of the kind of Italian grotesques, or at least their French derivatives, which were the models for this sort of decoration. At Northfield House, also near Edinburgh, a similar scheme in very good preservation reveals the vivid charm that the best decorative painters could achieve. (*Plate 37*) They were real craftsmen. Their painting always shows a strong decorative sense, though they do not always use strong colour – at Earlshall in Fife for example there is a very fine ceiling in monochrome – great deftness of hand and immaculate judgement in the use of complicated spacing, apparently without any very elaborate preparation. Three of the most complex schemes of this type survive intact at Crathes. They were painted for Alexander Burnett and one is dated 1599. It has an intricate design of grotesques and emblems supporting the Muses and the Virtues, all in brilliant colours. (*Plates 38 and 39*) Such designs show the painter making a virtue of the constraints placed upon him by the divisions of the ceiling.

There is very little documentary evidence relating to this kind of painting, but at Stirling the work done by Valentine Jenkin in 1627–29,

part of which survives, is recorded in some detail. Jenkin (*fl.* 1617–34) was one of the few English painters known to have worked in Scotland. He may have been part of the team sent north with Nicholas Stone by the king in 1617, but he stayed in Scotland. He also worked in Glasgow and at Hamilton Palace for Anne, Duchess of Hamilton, and is last heard of helping to prepare Holyrood for the visit of Charles I in 1633. The proposed painting by him of the beams of one of the ceilings at Stirling is described as follows. They are to be 'weill paintit, the field thairof blew with flouris going all along thame and antikis'.[3] It is a fair description of much, though by no means all, of this kind of decoration. The surviving part of the decoration includes the royal coat of arms and quite elaborate strap-work, all carried out in a rather more spacious and controlled manner than is seen in the work of his Scottish contemporaries, though in consequence it lacks something in vigour.

Jenkin's work at Stirling is on the upper part of the walls, not the ceiling, and wall-painting of this kind was not uncommon. At Gladstone's Land for example there is at one level an arcade with flowers set in arches along the wallhead. At Northfield and Crathes the decoration likewise

Plate 39. DETAIL FROM *The Muses and Virtues*, CRATHES

runs on to the wall, but in both cases the main wall surface is bare. The custom was for the walls themselves to be covered in hangings and several references are made to painting 'above the hangings'. Scope for more ambitious painting was provided when the structure of the ceiling provided larger flat surfaces. Where a room was immediately beneath a pitched roof or a vault, the surface of the vault itself, or planks laid over roof beams, gave a continuous flat surface. This could either be a barrel vault, an elliptical vault, or a coved ceiling.

Given such a surface, painters frequently opted for designs which included straightforward pictorial elements. At Culross Palace, built for Sir George Bruce, a merchant, there were originally eight painted rooms, apparently dating from 1597 and 1611. The most elaborate is a barrel-vaulted, panelled room with large, separate scenes illustrating moral and emblematic texts. Another similar scheme, with the twelve months of the year, existed in the original Ravelston House in Edinburgh, built *c.* 1622 by George Foulis, master of the king's mint and a baillie (burgess) of Edinburgh.[4] Also in

Edinburgh another civic dignitary, William Nisbet of Dean, several times provost of the city, built Dean House (*c.* 1614) which contained an equally ambitious ceiling in a long gallery that survived until the early nineteenth century. Panels from it are preserved in the Royal Museum of Scotland. They include a crude but powerful *St Luke* (*Plate 40*) and equally forceful renderings of the *Sacrifice of Isaac, Judith and Holofernes*, and *King David the Psalmist*. In addition to these there are personifications of *Sight, Hearing* and *Taste. Sight* has in the background a landscape recognisable as Edinburgh.

Pinkie House in Musselburgh was built at very much the same date, *c.* 1613, for Alexander Seton, Chancellor of Scotland and first Earl of Dunfermline, a man of national rather than local, political status. As well as other painted decoration, on the top floor he decorated the Long Gallery, a room twenty-three metres in length, with a ceiling of truly ambitious scale. The painting is on the boards of the ceiling which is an elliptical vault. Its principal detail is similar to that at Culross, a series of emblems and grotesques, but these are enlivened by *trompe l'oeil* features. Painted panels bearing inscriptions are hung on painted nails, and fictive architecture in the centre of the long, low vault creates an octagon open to the sky with cupids looking down.

The grandest of all these decorations however is that at Cullen House. (*Plates 41 and 42*) There, the flat of a coved ceiling is decorated with an elaborate pattern of clouds with the deities Mercury, Neptune, Flora, and Luna, together with a number of winged cherubs. The cove contains various scenes from the stories of Aeneas, Atalanta, Meleager, and Diana and Actaeon. They seem to be miscellaneous, but may conceal some kind of programme. The best of the paintings is the *Siege of Troy*, but though restored, they are all painted with great verve and are on a grand scale. Cullen was not unique, however, for an equally ambitious classical scheme existed at Monymusk where the lone survivor of a set of paintings is an unusual subject, the *Conference of Achilles and Hector*. The heroes are sitting in a tent created by the window embrasure. The subject is described in an inscription which reads: 'Quhen durying a trewes of foiur monethes maist worthy and

noble Hector walked into the Grekes host and of the talking betwyxe him and ferce Achilles.'[5]

Looking at schemes of painting like Pinkie, Cullen, or Monymusk as it might have been, we are faced with a problem. This is still craftsman's painting. We cannot look in it for the complexities of personal statement which by the early seventeenth century were becoming the norm in European art, yet there can be no mistaking the ambition of either the artist or his patron. In an inscription in the garden at Pinkie House, Alexander Seton recorded his ambition in an account which clearly includes his painted ceilings. He writes in the true spirit of Horace: 'For himself, for his descendants, for all civilized men, Alexander Seton, lover of mankind and of civilisation, founded, built and adorned his house and gardens and these out-of-town [in the latin "suburbana"] buildings. Here is nothing warlike, even for defence; no ditch, no rampart. But for the kind welcome and hospitable entertainment of guests a fountain of pure water, lawns, ponds and aviaries.'[6] Pinkie was one of the first major Scottish houses to show no trace of defensive intention so Seton's remarks were not just conventional hyperbole.

Over the front door Seton placed a simpler inscription: 'Alexander Seton built this house not to the measure of his desire, but of his fortunes and estate.'[7] The modesty of this disclaimer is surely formal. Pinkie House is still very grand and in the context of Edinburgh in the early seventeenth century it was a palace. Seton was proud of it.

The principal source for the iconography of these painted ceilings is to be found in contemporary emblem-books. The popularity of these books was itself a reflection of the widespread interest in symbols and the processes of interpretation as providing a key to the metaphysical world. John MacQueen speaks of Seton's contemporary, William Drummond of Hawthornden, accepting the revolutionary ideas of Kepler because they 'confirmed his intuition that the total world revealed to him by the senses was only a shadow of the ideal world of reality'.[8] At a humbler level such an attitude would encourage the spectator to look through the superficial appearance of an image to the set of references that it contained. To adapt a modern phrase, the message was more important than the medium. This is exactly how emblems were treated. They rarely had aesthetic merit in themselves.

The importance of heraldry in this period is a manifestation of the same thing and the elaborate staging and iconography of the royal entries is an example of it in action. The role of such walking abstractions as Caledonia or the nymph Edina shows an easy transition between real and ideal. The garden of Edzell Castle is another example of this, miraculously surviving to the present day. There, emblems, heraldry, the flowers and the plants in the garden, all combine to locate the abstract in the concrete. Even if this was done without any very closely wrought programme, it achieves great decorative effect. Another modern writer says of William Drummond of Hawthornden that 'his longer poems, sacred or secular, read as a loose set of decorative impulses, moving indeed, but not altogether to one end'.[9] This would be a fair description of one of the more ambitious large-scale ceilings of the time. In the patterns of the Crathes ceilings, for example,

Plate 40. ANON., *St Luke*, PANEL FROM DEAN HOUSE, EDINBURGH, *c.* 1614

Plate 41. ANON., PAINTED CEILING, CULLEN HOUSE, *c.* 1610

complexity becomes an end in itself. The potential meaning of such images as the Muses, the Nobles and the Virtues, backed up by assorted lesser emblems, is suggestive of wider meaning and of the ideal world, but it is not asked to be precise. It adds a dimension of learned association to visual complexity, and is redeemed from pedantry by the decorative skill and energy of the painter.

The decorative painting of the reign of James VI and the early years of the reign of his son would, by its quantity alone, be a striking feature of Scottish culture, but it also seems to be quite specific to Scotland. Its origins

Plate 42. *The Siege of Troy*, DETAIL OF CEILING, CULLEN HOUSE

probably lie in France in the decorative traditions established by the School of Fontainebleau in the mid-sixteenth century. Its closest parallels however are in Scandinavia. The links between Scotland and Scandinavia were of course close, as the *Helsingør Altarpiece* bears witness. The only evidence for what would nowadays be called artistic exchange however is an account of Scottish masons working in Bergen about 1563.[10] Most of the painting in Norway, Denmark, or Sweden that is at all similar in type to this Scottish decoration is later than its equivalent in Scotland however, so perhaps this is something that was exported. There is certainly evidence later in the century of Scottish artists working in northern Europe (see below, p78). It is just hypothesis, but it is important to challenge the assumption that Scotland was always a net importer of such things. At the very least these analogies are a reminder of the way in which the country continued to lay an integral part in the northern European community.

The sheer quantity of this kind of painting and the social range of those for whom it was executed clearly reflect the establishment of a new standard of civil life, even in the absence

of the court, before the second great crisis of the Reformation turned everything upside down once again, for virtually none of this kind of painting can be dated after the beginning of this second crisis in 1638. The appearance of religious imagery among the paintings is an indication too of the relative freedom that prevailed up till then. The ceiling in Mary Somerville's House includes the head of Christ, the Virgin Mary and the Apostles, for example. In the church at Grandtully which was restored c. 1636 there is a vigorously executed, elaborate scheme of grotesque and heraldic painting which incorporates the evangelists and a *Last Judgement* apparently modelled directly on pre-Reformation types like the painting at Guthrie. (*Plates 43 and 44*) The decoration of a vaulted ceiling in Provost Skene's House in the centre of Aberdeen some time between 1622 and 1641 with a full-blown religious scheme including scenes from the Passion and Nativity is nevertheless surprising.

It is also surprising that with so much decorative painting we can identify so few individual painters. This is certainly a reflection of their continuing as craftsmen and there is little sign in this field of artistic personalities as complex as those of the poets and other figures of cultural life, though this may still reflect our ignorance. Occasionally we do know the names of painters and they certainly travelled around in a way that suggests a degree of specialisation beyond that offered by the local jobbing painter. John Anderson (*fl.* 1599–1649), for example, came from Aberdeen, but is recorded working at Edinburgh Castle and at Falkland. He had his share of artistic temperament too for, being dilatory, he was ordered to Falkland in preparation for James VI's visit in 1617 'under the pane of rebellioun', and his similar non-appearance at Edinburgh was justified by 'ane idill and frivolous excuse quhairon his majesteis workis in the said castell . . . are lyke to be disapointit and hinderit to his Majesteis offence.'[11]

Anderson's painting at Edinburgh Castle is a repainting of the decoration of the room in which James VI was born and gives us little ground on which to judge him, but he did do more elaborate decorative schemes and at least one of his patrons, Sir John Grant of Freuchie, in 1634 thought so highly of him that he would have no other painter paint the ceiling of his gallery at Ballachastell.[12] In another letter from the same writer there is mention of some portraits which Anderson has for framing. It does not say that they are by him, but this is a possibility, and on the grounds that he was the leading artistic personality of the years before 1620 Thomson has suggested that the portrait of *John, Lord Napier of Merchiston* (1616, EU), the inventor of logarithms and pioneer of computing, may be by him. (*Plate 46*) The portrait was gifted by Napier's daughter in 1676 to Edinburgh University. It is a strong image and achieves its effect by its direct simplicity in a way that is certainly consistent with the habits of the decorative painters. In spite of its shortcomings it has a sense of balance and dignity that suggests that the artist was looking beyond immediately available continental models to the broader Renaissance tradition. The result is the type of image of the scholar in his study that was to become in the eighteenth century one of the most familiar kinds of Scottish portrait.

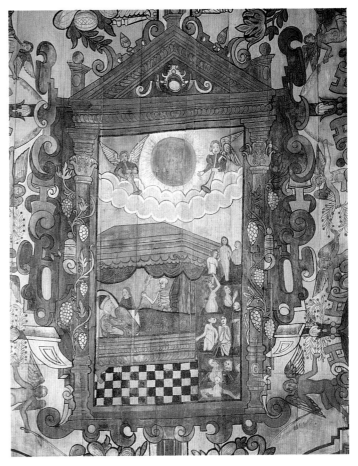

Plate 43. ANON., *Last Judgement*, ST MARY'S, GRANDTULLY, c. 1636

One decorative scheme is actually signed. This is the *Skelmorlie Aisle*, the memorial chapel of the Montgomery family in Largs which survived the destruction of its mother church. It is painted with a rich variety of images, including landscapes of the four seasons and emblems of *The Land* and *The Sea*, all set in a very elegant framework of grotesques. (*Plate 47*) *The Land* is signed and dated 1638 by J(ames) Stalker (*fl.* 1632–8). Whereas the other decorative paintings of the period seem to belong to a tradition which is really purely local, Stalker's landscapes, one of which actually includes an image of the building itself, show an awareness of contemporary Dutch painting and it is surprising, given the links with Holland, that this is not more common. Stalker had been trained in Edinburgh where he had completed his apprenticeship with John Sawers (*fl.* 1617–1651) four years before he

painted these pictures. That he travelled across the country to Ayr shows that he too, like Anderson, enjoyed a reputation.

Such individuals as Anderson and Stalker provide a precedent for the emergence from among the craftsmen-painters of the first distinct and fully rounded artistic personality in Scottish painting, Anderson's apprentice, George Jamesone (1589 or 1590–1644). Though Jamesone later became, beyond challenge, the dominant personality in Scottish art, during the first years of his career, in the mid-1620s, he did have a rival in Adam de Colone (*fl.* 1622–8). There is a certain amount of documentary evidence in which Colone can be identified, most importantly in an application for a protection to travel, a passport, in 1625 and, as Adam the painter, in payments made by George Seton, Earl of Winton, in 1628.[13] One of these is probably for a portrait

Plate 44. PAINTED CEILING, ST MARY'S, GRANDTULLY, *c.* 1636

Plate 45. ADAM DE COLONE, *George Seton, 3rd Earl of Winton, and his Two Sons*, 1625

Plate 46. ANON., *John, Lord Napier,* 1616

of the Earl at Traquair, but really for an idea of his work we are dependent on Thomson's recognition of a distinct artistic personality as the author of a number of distinguished portraits of Scottish sitters dated between 1625 and 1628, and his identification of this as Adam de Colone.

Colone seems to have been the son of Adrian Vanson, though as he was born in the mid-1590s (before 1595) he was too young to have been trained by his father who died before 1610. He is likely to have trained abroad, as he had certainly been in the Netherlands before he was recorded in London in 1622, copying a portrait by Geerhaerts of Alexander Seton, builder of Pinkie.[14] In 1628 he painted Seton's wife, Margaret Hay, by then six years a widow and his connections with the Seton family seem to have been close. His father's position as king's painter was not forgotten however, for in 1623 he painted two full-length portraits of the king, one of which is now at Newbattle. Thomson suggests that these link him very closely to Paul van Somer who painted the king several times around 1620. If he enjoyed the

favour of King James, Colone seems to have been less confident of that of his son, for his return to Scotland coincides with Charles's accession in 1625.

Colone was in Scotland in 1625 when he applied for a passport to travel abroad. It was in the same year, for they are dated, that he painted the most remarkable of the pictures securely attributed to him, the portraits of *George Seton, 3rd Earl of Winton, and his Two Sons (Plate 45)* and of Seton's wife, *Anne Hay, with their Two Daughters* (both 1625, Trustees of Kintore Estate). In the portrait of George Seton, he stands with one hand placed protectively on the shoulder of each of his sons. Though there is some insecurity about the levels on which the three figures are standing, it is not disturbing for the composition is elegantly balanced.

These pictures have a tender humanity, especially in the treatment of the children who are beautifully described as whole people. This quality depends on sensitively precise observation and a clear delineation of form under positive and consistent lighting. Painting like this links Colone directly to the contemporary art of the Netherlands and because of his sensitivity he succeeds in presenting a view of family life that is felt, not formal. This painting of *George Seton, 3rd Earl of Winton,* bears a strong resemblance to the painting of one of his ancestors, George, 5th Lord Seton, with his family, painted by Pourbus more than fifty years before. It is a comparison which was no doubt intended, but which underlines how much life in Scotland had softened in the intervening years. It expresses through an image of real people the ideal of civilisation expressed by Alexander Seton. It is this same gentler, more humane world of the new Reformation society to which George Jamesone gives us access.

Jamesone had a great reputation in his own time and immediately after his death. He was not a great inventor of pictures, nor an artist of bold experiment. His art is low-key, almost tentative, but the extent to which it was appreciated by his contemporaries suggests a society softened by ideas of mutual tolerance and respect for the individual, much as was the contemporary Netherlands. If this was so, then this apparent tranquility was shattered all the

Plate 47. JOHN STALKER, *Winter*, DETAIL, SKELMORLIE AISLE, 1638

more rudely by the events of the mid-century. Whether, if circumstances had been different, Jamesone would have been able to provide the kind of images that politics demanded, we have no way of knowing, but even when he is painting aristocratic patrons, he is very much the artist of the new bourgeoisie. The most important witness of this is in his own self-portraits of which there are no less than four, a number that by itself testifies to the artist's sense of his own station.

That Jamesone's art, unlike that of Van Dyck in England, does not reflect contemporary politics, is a reminder that Scotland was a nation without a court, whose politics took place elsewhere. It is significant that Adam de Colone, who painted the king, began his career in London and that James VI sent Nicholas Stone and a team of sculptors and painters from the south in preparation for his visit in 1617.

Our understanding of Jamesone's life and work once again depends on Duncan Thomson. Jamesone trained with John Anderson in Edinburgh, though both men were Aberdonians and he kept close links with Aberdeen. Anderson and Jamesone may well have been related as Jamesone's mother was Marjory Anderson. Entrance to an apprenticeship was usually by right of a parent or some such relation, and as a result families remained in the same craft over several generations, while marriages between craft families seem to have been the norm. The

records of the painters constantly reveal such links. Apprentices usually began in their teens, but Jamesone did not join Anderson till he was twenty-two years old. He may therefore have been away in the intervening time, but there is no evidence of this other than the relative sophistication of his earliest works. The first one that can be attributed to him is a portrait in Marischal College, Aberdeen, of *Sir Paul Menzies of Kinmundy* dated 1620. In 1624 he painted a portrait of *James Sandilands*, Rector of King's College, Aberdeen (both University of Aberdeen), and by analogy with this Thomson has dated a portrait of an *Unknown Man* to the same period (NTS, Craigevar). The sitters in these two portraits are very alike and may be relatives. Thomson suggests father and son but, whoever he is, Jamesone at the very beginning of his career painted one of his most memorable paintings in this portrait of an unknown young man.

His face is open and our access to him is immediate. It is not shaped by formality, nor made awkward by clumsiness of execution. A picture of such sensitivity must belong in some way to the same context that was at just that moment shaping the early work of Rembrandt and Hals, but Jamesone, like Cornelius Johnson in England to whose work his own is closely comparable, is quite untouched by that element of the drama of the baroque which gave life and energy to the new Dutch painting. Bravura was never part of his style and it is perhaps his curiously reticent way of painting which suggests most strongly that his knowledge of such art was at one remove. It is most likely therefore that if he did have artistic links outside Scotland, they were with painters in England like Johnson, or others in the circle of Mytens.

Two years after he painted these pictures, Jamesone painted *Mary Erskine, Countess Marischal* (1626, NGS). (*Plate 48*) Because of the costume this is a more elaborate picture than the portrait of the unknown man, but it is marked by the same pensive delicacy. It calls to mind William Drummond's preoccupation with life's fragility:

. . . nought lighter is than airy praise;
I know frail beauty like the purple flower,
To which one morn oft birth and death affords.

William Drummond of Hawthornden,
'I know that all beneath the Moon decays'

In the same year, 1626, Jamesone painted Mary Erskine's sister, *Anne Erskine, Countess of Rothes, and her Two Daughters* (SNPG). (*Plate 49*) It is a full-length and in conventional terms it is more ambitious than the portrait of Mary Erskine. The costume, for example, is marvellously rich and elaborate. Even in the absence of the court, the aristocracy did not entirely neglect fashion it seems. In fact in one important feature this is a courtly portrait. By reducing the head and exaggerating the height of his principal sitter, he gives her additional elegance in the accepted courtly manner. The figures are set in an interior and it too is elegant and elaborate. In a deep room behind them there is a variety of furniture, a leaded window with a stained-glass panel, and an interesting array of pictures on the wall. Impressive and in a documentary way fascinating as this picture is, comparison with the portrait of the sitter's sister suggests that Jamesone was more at home in the more intimate mode. George, son of the Countess Marischal, was godfather to one of Jamesone's children in 1633. Thomson's research shows that this kind of close connection with his patrons was a common pattern for Jamesone. It suggests a private and domestic role for his art concerned with the interaction of personalities in a world of domestic dimensions, rather than in the wider world of politics.

Such an observation is also a reflection of the status of the artist. We know various things about Jamesone's personal standing. We know, for instance, that from his marriage with Isobel Tosche in Aberdeen at some time between 1625–27 he built up his property in the city until he became quite a substantial citizen. We know too that he enjoyed a very considerable reputation in his lifetime (a reputation so inflated after his death that it eventually grew out of all proportion until Thomson's biography set the record straight). One measure of this was the commission to undertake responsibilty for the decorations in Edinburgh for the entry of Charles II in 1633. He may have been invited from Aberdeen especially for this work and the Edinburgh Town Council records show payment to him of £764 for 'his extraordinar paynes taken . . . in the Townes affaires at his Majesteis entrie within this burgh'.[15] Jamesone

may have been producer, as it were, to the whole event. His personal contribution was described as follows: 'At the western end of the Tolbooth, in the High Street, stood the second triumphal arch, whereon were painted the Portraits of the Hundred and Nine Kings of Scotland; within the arch Mercury was represented conducting Fergus, first King of Scotland, who, in a grave speech, gave many paternal and wholesome advices to Charles, his Royal successor.'[16]

Jamesone's series of kings has a parallel in his work for Sir Colin Campbell of Glenorchy. Campbell was spending considerable sums of money on the furnishing and decorating of his house in the 1630s. In 1633 he employed a German painter 'quhom he entertainit in his house aucht moneth' to produce as many as forty-one portraits of kings, queens and ancestors.[17] He then employed Jamesone apparently to carry on the series and there are references to this in letters from Campbell's agent and from Jamesone himself in 1634, 1635 and 1636.[18] In one of these letters the agent, Archibald Campbell, foreshadowing future events remarks of the situation in Edinburgh: 'The churchmen rewlis all for the present.'[19]

The whole series of Campbell portraits, including various Scottish kings, must have constituted quite a gallery and a number of pictures have been identified by Thomson as having belonged to it. The works done by Jamesone for Campbell may also have included a portrait of Campbell himself contributed to the *Black Book of Taymouth*, a genealogical compilation similar in character to some of the armorials of the period, though with more stress on portraiture. Even more unusual was a large panel of the *Genealogy of the House of Glenorchy* (1635, SNPG). (*Plate 50*) It is modelled directly on a medieval Tree of Jesse. At the foot, Duncan Campbell of Lochow reclines in the position of Jesse, a series of portraits on the trunk includes seven successive Lairds of Glenorchy with Jamesone's patron at the top, though there is a half-defaced or incomplete portrait of an heir above him. The rest of the details of the family tree are inscribed on medallions hanging from the tree which is a cherry, bearing leaves and fruit.

Plate 48. GEORGE JAMESONE, *Mary Erskine, Countess Marischal,* 1626

In 1643 the Earl of Lothian, through the agency of John Clerk of Penicuik in Paris, was trying to form a similar collection. Partly by commissioning pictures and partly by collecting he was building up a gallery of famous men. In Paris he had commissioned thirty paintings from 'Ferdinand the painter'. He had either bought, or was asking Clerk to look out for, portraits of the king and many others of various royal houses by 'Michael Janson of Delft, or by Honthorst' of noblemen and authors of France.[20] Such a project might have been inspired by Cardinal Mazarin's celebrated gallery of famous men in Paris, but the existence of Campbell of Glenorchy's project as well as the Edinburgh University portraits of *Reformers* makes it clear that this kind of thing was an important adjunct of the well-appointed house and stood somewhere between collecting and decorative painting. In fact the analogy with the painting for the royal entries suggests that the gap between this kind of painting, with its stress on genealogy and the formal art of

Plate 49. GEORGE JAMESONE, *Anne Erskine, Countess of Rothes and her Two Daughters*, 1626

herald painting, is not great. Lothian after all actually acquired twenty-six of Jamesone's kings for his collection. It seems that inclusion of a representation of an individual was more important either than likeness or what we would call artistic quality.

Jamesone's work for the royal entry enlarged his practice from its local Aberdeen base to a national scale and the self-confidence that he developed as a result is nowhere more clearly seen than in his self-portraits. One of these shows him as a family man. The picture has been much repainted, but is still a touching family group with Isabel Tosche at its centre and the artist looking proudly on, brush and palette in hand. The most important of the self-portraits, however, shows him alone and in his professional role (c. 1637–40, SNPG). (*Plate 51*) He is wearing respectable black, bourgeois costume and hat. His palette and brushes are in his left hand. There is a still-life to the right of the picture which includes a suit of armour, an hour glass and a skull, all *vanitas* or *memento mori* symbols. He addresses the spectator as, with his right hand, he indicates on the wall behind him an array of paintings.

Jamesone's is not the first identifiable self-portrait of a Scottish artist. That honour goes to a woman, Esther Inglis or Kello (1571–1624), a calligrapher and miniature painter. Her father was a French Huguenot who arrived in Scotland in 1578. His daughter may have been born in France and moved with her husband, Bartholomew Kello, to England in 1607. One of the manuscripts that she wrote, *Cinquante Octonaires sur la Vanité et Inconstance du Monde*, contains amongst its decorations, her self-portrait (1607, SRO). Iconographically though, Jamesone's *Self-Portrait* is only matched in ambition and complexity amongst the work of his contemporaries in Britain by the full-length self-portrait of Sir Nathaniel Bacon.

Bacon was an amateur who could perhaps indulge himself. Jamesone's *Self-Portrait* presents us with a successful professional, a man of status. It is tempting to read its principal message as just that, the man and his works. He is like a shop-keeper presenting his wares, but though the seven small paintings on the wall, like those in the background of the portrait of *Anne Erskine, Countess of Rothes and her Two*

Daughters, bear a generic resemblance to Jamesone's own paintings, there are also a landscape and, partly visible, a seascape. There is no record of his producing such things though they would otherwise be perfectly compatible with our understanding of his artistic position. The pictures are all dominated, however, by a large historical composition. Its subject is the *Chastisement of Cupid*. This, if it existed, would be an ambitious painting and the possibility that it represents a real painting that he produced himself has to be accepted as logical. A generation later Medina produced just such pictures without any market for them, but it does seem unlikely, in the absence of any other evidence, that Jamesone was in the habit of producing such ambitious subject pictures. If it was not an actual painting by him then it has to be seen as an invention for the purpose of his composition, or else a painting by someone else that was an object of particular pride. If the painting was by someone else then it would have to be someone that Jamesone held in very

Plate 50. GEORGE JAMESONE, *Genealogy of the House of Glenorchy*, 1635

Plate 51. GEORGE JAMESONE, *Self-Portrait*, *c.* 1637–40

high regard and whose status would be enough to enhance his own. One possibility therefore is that it represents the work of an unidentified, but distinguished teacher.

The most likely explanation though is that this is a compositional invention to suit the subject. It should be seen therefore in conjunction with the *memento mori* symbols in the still-life. If these two parts of the picture are seen together, they provide an antidote to pride, otherwise so much the picture's subject. A painter must invest above all in the senses, but as he contemplates mortality, sense, like the sensual Cupid, must be chastened.

> Your soules immortall are, then place them hence,
> And doe not drown them in the Must of Sense.
> William Drummond of Hawthornden
> *Poems: The Second Part*[21]

It is fitting to introduce into a discussion of Jamesone, quotations from Drummond of Hawthornden. The two men certainly knew each other as they had in effect collaborated in 1633. Drummond's achievement is no doubt broader than Jamesone's, but they do seem to stand for something very similar. Jamesone's pictures reflect the ideal of a humane and ordered society in which rank, if not secondary to individuality, certainly does not eliminate it. He should be seen therefore as belonging to that group of Scots who, because they kept alive the central ideal of the Reformation – the importance of the individual – have been identified by John MacQueen as the bridge between the Reformation and the Enlightenment.[22]

This *Self-Portrait* by Jamesone is his most ambitious surviving work. In most of the rest

of his pictures, with occasional exceptions, he seems to have been content with a bust-length, three-quarter view composition which is repetitive though it never becomes a mere formula. In each picture, in spite of the similarity of composition, he seems to approach his subject afresh, as for example in one of his finest male portraits, *James Graham, Marquis of Montrose* (1629, Earl of Southesk, Kinnaird Castle, Angus). In addition to such half-lengths there are also occasional full-lengths such as *William Ramsay of Ochtertyre* (c. 1635, unknown). There is also one conversation piece, a group of the *Earl of Haddington and his family* (c. 1637, the Earl of Haddington). The countess was a member of the Erskine family. It has rather a grand setting which includes a column and cupids in the sky. They are bearing a crown and a martyr's palm which seem to reflect, slightly awkwardly, the fact that it is a posthumous portrait of the countess. In spite of these grandiose details however, the picture looks a bit like a summary of seven half-length portraits in his more familiar style.

It is difficult to form a clear picture of the kind of framework of taste in which Jamesone's reputation should be seen. At one level he still had links with decorative and heraldic painting of a kind that make it clear that we should not assume the same sharp division between such craftsman's painting and high art that we ourselves perceive. Charles I was of course one of the greatest collectors of his age, but it is not clear how many of his Scottish courtiers shared his passion or his connoisseurship. The greater magnates, like the Hamiltons, were in a position to commission their portraits at the court. Like other families of similar importance their family portraits include works by Mytens and Van Dyck. Family portraits usually carry with them their own identities, but the former ownership of other works of art is less easy to trace. There are very few houses in Scotland whose contents are recorded from this early date. The example of the Campbells of Glenorchy makes it clear, however, that there were families for whom painting had an important role. In their case it was a quite specific one

Plate 52. ALEXANDER KIERINCX, *Seton House*, 1636–37

which could not be described as connoisseurship, but there was at least one Scottish magnate whose passion for art was formed with wider horizons. This was William Kerr, Earl of Lothian.

Lothian was a remarkable man. He was a leading figure in the cause of the Kirk against Charles's attempt to impose episcopacy and his name appears high amongst the signatories of the National Covenant in 1638. In his youth he had travelled widely in Europe, going as far as Rome. He was a man of learning and undoubted taste. In 1643 he was in Paris on a mission from Scotland and took the opportunity to buy pictures, books and other *objets d'art*, on a considerable scale. In Paris he established a relationship with John Clerk of Penicuik who continued to work as his agent and dealer in such matters for a number of years. A large part of their correspondence survives, together with Clerk's own inventories.[23] These documents give us a revealing insight into the way a collection might be built up, even by a leader of the Protestant cause, and also into some of the problems faced by both collector and dealer in difficult times.

Clerk, it seems, was in Paris independently in 1643 in his capacity as dealer and merchant. With his contacts and his knowledge of the market he made himself invaluable to Lothian. Through him we find the Earl seeking to purchase 'Abraham going to sacrifice Isaac and the picture is extraordinarie', and 'a picture of some prissoners tyed with chaines to a wall and a keeper standing by them with a key in his hand'. These are anonymous, but then he adds: 'If you have gotten or can gett a woman's picture by Tintorett . . . there is likeways the picture of a Venetian, Victor Capello.' Clerk replies a little later that he had bought the Tintorettos and intends 'to cause wash them a little and varnis them and dicht the frames a little'.

The correspondence starts while the Earl is still in Paris. He then set out on his return journey to Scotland, but in England, under suspicion, which was perhaps not unfounded given his record of opposition, he was arrested. Released, he continued to Scotland and was soon engaged in the opening campaigns of the Civil War. In spite of all this, however, the correspondence and Lothian's concern with his collection continues. In 1649 he bought a number of pictures from Clerk's stock. These include only one picture by a named artist, Alexander Kierincx, though most of the other pictures he names can be identified in Clerk's inventories.[24]

Clerk was very much a general merchant. His detailed inventories of goods bought in France, the Netherlands and England date from the years 1647–50. They include every possible kind of merchandise from toothpicks and mousetraps through clothes and furnishings to pictures. Over a hundred of these are separately listed under the heading, 'Divers rare pictures, all originalls of excellent Maisters . . . walued and esteimed by thrie of the most special painters in Paris'. The pictures were bought in Paris, Middleburg and elsewhere. The list is dominated by painters who were already Old Masters, including such names as Durer, Brougl (Breughel), Corege (Corregio), and Martin de Vos. Among the moderns those that are immediately recognisable are Vouet, Brouwer, and Rembrand(t). The one painting by the latter is simply identified as a portrait.

Clerk was a canny businessman and this list of paintings represents a considerable outlay. He must have had more customers in mind than just Lothian, so his inventory, by implication at least, suggests that Lothian was not unique and that Clerk was serving other collectors in Scotland. It is not at all clear what the status of any of his pictures might have been however. Clerk's own collection survives and it does include some rather hopeful attributions as well as one or two pictures of undoubted quality. It is perhaps significant that Lothian himself only mentions one artist by name, Kierens or Kierincx, a painter who had in fact worked in Scotland in 1636–37 and with whose work Lothian was likely to have been familiar at first hand. Kierincx had travelled in Scotland on a commission from Charles I in the 1630s to paint a series of landscape paintings, two of which, *Seton House* (*Plate 52*) and *Falkland Palace* are now in the Scottish National Portrait Gallery and are the earliest landscapes of quality painted in Scotland. Amongst Clerk's purchases were portraits of *Alexander Henderson* which were very topical as Henderson had been one of the heroes of the Covenant Parliament in 1638–39. Clerk with an eye for the market had two or possibly even three portraits

Mr Alexr Henderson.

Plate 53. ANON., *Alexander Henderson*, c. 1639

Plate 54. JAN LIEVENS, *Robert Kerr, 1st Earl of Ancram*, 1654

of Henderson. One of them 'curiously wrott – done on wood by Geldrops' (George Geldorp). This may be the same as 'A pictur of Alexander Henderson litle on board', but is certainly different from 'the pictur of Mr. Alexander Henderson to the knee, large on cloth'.

These items are of interest not only because they show the continuing demand for portraits of what would, in modern times, be called celebrities, a demand evidently well understood by Clerk, but also because they may have some bearing on the contemporary portrait of *Alexander Henderson* to the knee, now in the Portrait Gallery and formerly at Yester. (*Plate 53*) It has been attributed to Van Dyck, though this reflects its quality rather than any very close affinity to Van Dyck's actual style, for it has a kind of severity that is not usually associated with his work. Whoever it is by, it is one of the outstanding portraits of the period of a Scottish sitter. Its existence, like the evidence for Lothian's collecting, underlines the danger of accepting the simplification of history that assumes that art and the Protestant cause are incompatible.

In the relationship between Clerk and Lothian which continued throughout the troubled years of the 1640s and fifties – Clerk for example fitted Lothian out for Charles II's hurried coronation on 1 January 1651 – payment became increasingly a problem. As early as 1644 when Lothian was in the field against Montrose, he wrote to Clerk in response to a request for money, more or less from the battlefield, 'When I received your letter yesterday in the field before the Rebells I was more troubled with it than with anything I sawe.'[25] Up until 1658 Clerk was still trying to secure payment of the considerable sums that he had laid out on Lothian's behalf. His difficulties in securing payment from one of the leading figures on the Scottish political stage and a man of undoubted probity is symptomatic of the disruption of Scottish life in the twenty years following the signing of the Covenant. Jamesone's last years illustrate this equally vividly. His native town of Aberdeen managed to get the worst of both worlds. It suffered in 1639–40 for its support of the king and Jamesone himself was taken to Edinburgh and briefly imprisoned; then in 1643–44, again on the wrong side, Aberdeen suffered for its support of the Covenant. It was sacked in September 1644 and Jamesone himself was dead by December.

Portrait and sitter provide a commentary on the uncertainty of the times in the contrast between two paintings of Lothian's father, the Earl of Ancram. In effective exile and in poverty in the Netherlands in 1653, having just said goodbye to his two grandsons, sent by their father to the Continent for their education and perhaps to get them away from the troubles of Scotland, the Earl of Ancram had himself painted by Hercules Sanders. He sent the portrait home to his son with a wistful letter saying: 'I send home to Scotland a picture of mine for you, done by a good hand. I would have it hung up in Ancram on the wall of the hall, just foregainst the door as you come in ... I think that will be the true place, for it may be a monument of my so long being there – and not to show which of the bairns is likest their grandfather.'[26] He was already seventy-five, but the portrait shows a strong and upright man. A year later he was painted by Jan Lievens in the striking portrait now in the Scottish National Portrait Gallery.

(*Plate 54*) It is recognisably the same man, but Lievens has captured most poignantly the wear on his handsome features of age and anxiety.

Ancram himself makes this comment on the contrast between the two pictures in a letter of 30 May 1654: 'I grow very old which showeth more in one year now than in three before as you will see by the difference of my pictures, whereof I have sent you one, and hath another much older done since, by a good master to bestow upon you if I have my tongue to my end, otherwise you may call for it at this town.'[27] The earl was dead within a few months of writing this sad letter. An exile for the Stuart king, he was just one victim of the convulsions that shook Scotland for fifty years from the signing of the Covenant to the revolution of 1688 and whose after-shocks continued until the final end of the Stuart cause at Culloden on 16 April 1746.

Plate 55. STEPHEN HARRISON, *Triumphal Arch for the Entry of James VI & I into London*, ENGRAVING 1603

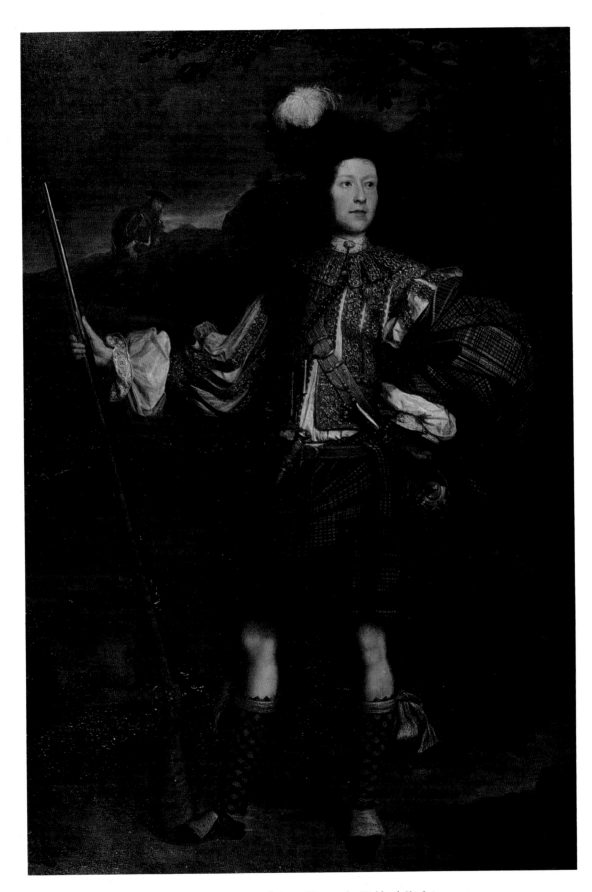

Plate 56. MICHAEL WRIGHT, *Lord Mungo Murray, the Highland Chieftain*, *c.* 1680

AN AGE OF TRANSITION

The times of the Civil War and Commonwealth were not propitious for the arts, yet the Earl of Lothian went on collecting throughout the troubles. His father, even in poverty and exile, communicated through portraits and his son carried on the family collection so that by 1720 there were over two hundred items in an inventory of the pictures at Newbattle.[1]

John Clerk of Penicuik, in spite of his difficulties over payment by the Earl, managed to leave a fortune. He too established an interest in the arts that his son maintained and the Clerk family played a central part in the subsequent history of art in Scotland. Although the return of the Stuarts, with the Restoration of Charles II in 1660, did not lead to immediate pacification, and in fact more people were put to death in the name of God in the first thirty years after the Restoration than in the whole previous course of the Reformation in Scotland, the culture of the Clerks and the Lothians is a sign that the threads of continuity in Scottish culture were not broken. As they were taken up again, it became for the first time possible to exploit the enormous intellectual energy that the Reformation had released and which became the motor of the flowering of Scottish life over the next century and a half.

The last four decades of the seventeenth century were the age of Sir Robert Sibbald and the foundation of the Royal College of Physicians, 1681, and of the Physic Garden in Edinburgh, ancestor of the Royal Botanic Gardens, 1671. Sir George Mackenzie of Rosehaugh founded the Advocates Library in 1682; Sir James Dalrymple, Lord Stair, published in 1681 the *Institutions of the Laws of Scotland*, systematising Scots law for the first time. Scotland was mapped and surveyed botanically. John Slezer produced his *Theatrum Scotiae* in 1693 which was an attempt to chart systematically the topography at least of the principal Scottish towns and is the first substantial body of landscape images. The Church of Scotland was established finally as a result of the Revolution of 1688. William Carstares, chaplain to William of Orange, played a leading part in this and went on to take the initiative in establishing at Edinburgh the modern organisation of the university. In 1695 the Bank of Scotland was founded. Most of the institutions that shaped Scotland in the eighteenth century were in fact the creations of the late seventeenth century. In addition, the foundations of future intellectual revolutions were laid by the Newtonian empiricism of men like James Gregory, inventor of the reflecting telescope who was also, incidentally, married to George Jamesone's daughter, and Archibald Pitcairne, one of the leading figures in the establishment of Scottish medicine on empirical principles.

These men were representatives of a new, modern intelligentsia in Scotland.[2] This was an age of transition for painting because it was during these years, the two generations or more following the Restoration, that the painters joined this group to emerge eventually as artists in the modern sense. The initial development of demand is reflected in the number of foreign artists working in Scotland in the later seventeenth century, though Scottish artists also continued to go elsewhere to work. In the later stages too there were painters, like James Norie for example, who were working in a craft tradition that in its essentials had changed little since the early seventeenth century, but who at the same time

also took part in the formulation of higher ambitions for their art. There was continuity therefore as new aspirations grew out of older traditions. It was a long process however and for this reason this chapter overlaps chronologically with the next as it traces the continuing vitality of the craft tradition in the eighteenth century.

The impact of new ideas is clearly apparent in various aspects of Scottish life. In architecture, for example, after 1660, though tardily following the example of Pinkie and a few other earlier houses, Scottish houses began to open doors and windows to the world at ground level. The architect Sir William Bruce developed a new relationship, not only between the house and its grounds, but also with the wider landscape beyond – with Loch Leven at Kinross House, the Bass Rock at Balcaskie in Fife and the River Forth at Hopetoun. This implies a very different view of nature to that represented in the garden at Edzell Castle. Simpler, more rational and more concrete, it is a vision of the order of human life as an integral part of the wider order of the natural world that was to find many different forms of expression over the succeeding century, in poetry, philosophy and in painting. The same is true of the internal arrangement of these houses. Whether or not they followed the classical models of proportion and symmetry favoured by Bruce or by James Smith, Bruce's pupil, internal arrangements became much more orderly, practical and comfortable. They included provision for decorative painting, as in the work of Jacob de Wet, but now, even when it was on the ceiling, it was contained and rationally ordered. Externally too this rationalism was apparent, for example in the classicism of Smith's work at Newhailes, Musselburgh (1686), and in his design for Dalkeith Palace (1702–11). Buildings of this kind were the principal link between the neo-classicism of Dutch architecture in the mid-seventeenth century and the Palladian revival in Britain in the eighteenth.

Dutch influence was generally very strong, particularly in the towns. The Canongate Kirk, Edinburgh, begun in 1689, is in a pure Dutch style, as are surviving town houses like Crockett's Land, Edinburgh. Though a little later in date it is a classic, tall, narrow Dutch merchant's house, but built in stone not brick. In Prestonfield House, Edinburgh, completed in 1689 for Lord Provost James Dick, this Dutch taste is used on a grander scale for a suburban villa. Its informal opulence even includes a full-scale, baroque, plaster ceiling in a room scarcely more than eight feet high. The original furnishings of Prestonfield included Dutch or Flemish pictures bought specially 'in bright colours'. At Hopetoun House a series of thirty-seven allegorical paintings was commissioned by the Hopes from the Dutch painter, Philip Tideman. They were paid for in 1703 and their number, suggesting something of a bulk purchase, is reminiscent of the Earl of Lothian's commission to 'Ferdinand the painter' sixty years earlier (see above, p63). Five years later a pupil of Tideman came over to complete the decorations at Hopetoun by painting the dome of the principal staircase, a work that was recently rediscovered *in situ* by Basil Skinner.

This work at Hopetoun, like that at Prestonfield, was decorative in character, but there is also evidence of the collection of painting more clearly guided by ideas of connoisseurship at Hopetoun itself, at Newbattle and at Penicuik, as we have seen, and elsewhere too. Lord Stair at Newhailes, for example, the Dukes of Queensberry at Drumlanrig, the Dukes of Hamilton at Hamilton Palace and others in Scotland's great houses were all building up art collections at this time.

The reason for the relatively slow emergence of native painters able to match this new mood is probably structural. It is not easy to produce painters on demand. It takes a generation to train them to meet new levels of expectation. There was continuity however. The example of foreign painters working in Scotland in the later seventeenth century was important in the emergence of artists from this background of decorative painting who are recognisably modern, but Jamesone too did leave a legacy here. His one outstanding pupil was John Michael Wright (1617–1694) who joined him as an apprentice in 1636. Wright's origins are obscure. Research shows that his father was a Scottish tailor living in London. Whether Wright himself was born there or in Scotland is uncertain, but he must certainly have had Scottish connections to have chosen Jamesone

as a master. It is not clear how long Wright stayed with Jamesone, but at some date in the early 1640s he painted his earliest certain work, a portrait of the seventeen-year-old *Earl of Elgin* which, according to a contemporary inscription, was painted by Wright in Rome (Marquess of Ailesbury). It has the same quality as Jamesone's own painting, of reticent sensitivity.

By 1648, Wright, who was a Catholic, was well enough established in Rome to be a member of the Academy of St Luke there, the painters' academy. As well as a being a painter, he was an antiquary and dealer in paintings, an activity that apparently took him back to England to buy at the sale of the collection of Charles I.[3] Works collected by Wright also found their way into the royal collection following a lottery that he held some time after 1662. He returned permanently to England in 1656 and in spite of his religion found equal favour with both political sides, painting, for example, a remarkable, posthumous portrait of Cromwell's daughter, *Elizabeth, Mrs John Claypole* (1658, NPG), and the superb portrait of *Colonel, the Hon. John Russell* (1659, NT, Ham House), a member of the Sealed Knot, a conspiracy for the return of the king. Wright came into his own at the Restoration however, though equally 1688 and the departure of the Stuarts saw the end of his career. Whatever his origins, Wright really became part of the history of art in England. Rather like his younger contemporary, the Scots architect James Gibbs, he brought a self-confident cosmopolitanism from Italy into the still provincial English art world. Wright did continue to paint Scottish sitters however, from the Lord Chancellor of Scotland, *William Cunningham, Earl of Glencairn* (1661, SNPG) to the dashingly informal painting of the young and handsome, *Sir William Bruce* (1664, SNPG) which is so easy and relaxed that it must reflect friendship between the two like-minded men, a feeling of community endorsed by the *porte-crayon* that Bruce is holding to indicate his architectural interest. The painting known as *The Highland Chieftain* (c. 1680, SNPG), (*Plate 56*), has recently been identified as a portrait of Lord Mungo Murray.[4] In it Wright created one of the icons of Scottish art, the definitive image of highland costume at its most flamboyant.

Plate 57. DAVID SCOUGALL, *Jean Campbell, Marchioness of Lothian*, 1654

Amongst native-born painters in Scotland or in England Wright was outstanding. He was without rival in the directness and sympathetic humanity of his painting. This is especially true of his portraits of women, where he anticipates Ramsay in his ability to compliment beauty and feminine charm without either condescension or archness. This is very much in contrast to his contemporary, Lely, and *Mary Scrope, the Hon. Mrs Arundell* (undated, Private Collection), *Susanna Hamilton, Countess of Cassilis* (1662, SNPG), or any one of several such portraits of women must all rate amongst the finest paintings by any British-born artist of the seventeenth century. By then he had left Jamesone far behind, but it is not too far-fetched to see some continuity between Wright's humanity and Jamesone's decorous, but civilised art. Portraits that Wright painted for Scottish patrons and which found their way to Scotland undoubtedly made an impact there too. There may be a link between Wright and David Scougall, or Scougal (*fl.* 1654–1677) for example,[5] who was the most important painter to emerge in Scotland in the generation after Jamesone and who, though he is a shadowy figure, appears to have remained in Scotland.

Plate 58. DAVID SCOUGALL, *Archibald Campbell, 1st Marquis of Argyll*, c. 1660

There are a great many portraits in older Scottish houses which carry an attribution to Scougall. Some may indeed be by David Scougall, others by John Scougall (*c.* 1645–1737) who may have been his nephew. Still others though may be by anonymous painters whose names are lost and to which the generic name of 'Scougall' is applied as a general indication of period. David Scougall's name appears for the first time on a small, signed and dated picture of 1654 of *Jean Campbell* (SNPG), (*Plate 57*), daughter of the Marquess of Argyll, and wife of the Earl of Lothian's son, Robert, who became the first Marquess of Lothian. The picture is cabinet-sized, reminiscent of the pictures in the background of Jamesone's *Self-Portrait.* (*Plate 51*) It is richly painted in a way that is quite untypical of Jamesone, however, and it has a kind of sensual awareness which, equally foreign to Jamesone, would make sense of a connection with Michael Wright if it were not that we know that Wright himself was far away in Rome in the 1640s and fifties. Later pictures, once attributed to Wright, are now recognised as by Scougall. A portrait of *Robert Macgill*, second Viscount Oxfuird, for example,

once identified as by Wright, must certainly be identical with a picture that Scougall was paid for in 1666 (Private Collection).[6] Similarly Scougall's portrait of *Lord David Hay*, datable to 1668 (formerly Tweeddale Collection), bears a close relationship to Wright's portrait of the *Earl of Glencairn*.[7] It seems certain to have been David Scougall who as 'Mr Scougall' was paid in 1674 by Sir John Clerk for portraits of himself and his wife – strong, simple and severe paintings, still akin to Wright, but harsher in feeling (Sir John Clerk of Penicuik).

This same quality is the distinctive feature of Scougall's best known portrait which is very different from anything painted by Wright, his painting of the *1st Marquis of Argyll* (*c.* 1660 SNPG), (*Plate 58*). Argyll was one of the principal leaders of Scotland throughout the whole period from the signing of the Covenant to the Restoration. It was he who took the lead in recalling Charles II after the execution of his father and it was he who crowned the young king at Scone. In an act of peculiar vindictiveness he was nevertheless executed in 1661 on suspicion of his complicity in the execution of Charles I.

His picture formerly belonged to the Marquess of Lothian and came to the Scottish National Portrait Gallery from Newbattle where it is first recorded in 1720. It is boldly and firmly painted. The painter meets head-on the problem of his sitter's pronounced squint and the way he does so may have ideological implications that reflect Argyll's position and reputation. The portrait must have been very topical and its frankness exactly parallels Samuel Cooper's famous account of Cromwell's warts in his miniature portrait of the Lord Protector, but this detail of the eyes also directly invokes a whole debate about the classical ideal. Pliny's best known direct recommendation, and one of the few on which any theory of classical art could be based, was his praise of Apelles who, he said, presented the model of decorum in his painting of King Antigonus. It showed the king, although he was one-eyed, in such a way that this was not apparent. Piero della Francesca copied him in his portrait of the Duke of Montefeltro who, like Antigonus, had lost an eye in battle. There seems little doubt that in the mid-seventeenth century the classical

idealism that was the basis of baroque painting had a political connotation that identified it with the Catholic side in the division of Europe. Correspondingly therefore an artist who wanted to be identifiably Protestant would be pointedly anti-classical. Rembrandt had this clear intention when he made Claudius Civilis conspicuously one-eyed in *The Oath of the Batavians* of 1660. The picture commemorated the rebellion of the Batavians, the proto-Dutch, against the Romans, in analogy with the rebellion of the modern Dutch against Spain. Perhaps, as it is softened in later engraved versions of the picture, the way Scougall stresses Argyll's squint originally had a similar political connotation.

In England this same frankness characterised painting from Cornelius Johnson to Samuel Cooper, but it was overlaid, first by the more courtly and baroque style of Lely, and then by the rather solemn pomp of Kneller. It survived, except for Hogarth for whom frankness was an article of faith, as an alternative mode, called upon when needed by Kneller himself, by Richardson and others down to Reynolds, but in Scotland it seems to have been much more of an exclusive condition of portraiture. It was maintained, though at a lesser level of achievement, in the work of John Scougall who lived on till 1737, and it passed on to Aikman and Smibert, and so eventually to Ramsay and Raeburn in the eighteenth century.

John Scougall is probably the author of a group of rather severe paintings to be found at a house near Hamilton, called The Ross, and elsewhere. He is certainly the author of a number of paintings in Glasgow University, some of them copies of other works, whose commission is recorded. His work is a trifle crude but it is direct. Its presence at The Ross in particular underlines the importance of Scougall in this continuity, for the house belonged to William Aikman's family.

The name of David Paton, a miniature painter (*fl.* 1660–98), is connected with that of John Scougall when they appear within three months of each other in 1697 in the Wemyss Castle papers,[8] both having provided portraits of *Lord Elcho*, but there is nothing else to connect them. Paton enjoyed the patronage of the Duke of Lauderdale and was in his sophistication more comparable to Michael Wright than

to either of the Scougalls. His portrait of the *Duke of Lauderdale*, dated 1669 (NT, Ham House), like most of his surviving work in monochrome plumbago or graphite, is a powerful image. That of the Duchess, *Elizabeth, Countess of Dysart*, is gentler and is close in feeling to some of Wright's female portraits (undated, NT, Ham House). The same balance of elegance and accuracy that is typical of Wright is seen as Paton's own in his portraits of *Archibald Campbell, 1st Duke of Argyll* (undated, NT, Ham House) and of *John Graham of Claverhouse, Bonnie Dundee* (undated, SNPG). (*Plate 59*)

Ham House, Lauderdale's English home in Richmond, was redesigned by William Bruce from 1671 and became the greatest Scottish house in England. As well as David Paton, another Scottish painter, William Gouw Ferguson (1632/33 – after 1695), is represented there by two classical landscapes apparently done to commission about 1673. There are other examples of this kind of work by him and it was sufficiently distinguished to earn the praise of George Vertue, painter and chronicler of English art in the early eighteenth century.[9] Ferguson is best known, however, as a painter of still-lifes. In that genre he specialised in painting dead game-birds, for example *Still-Life with Dead Game Birds*, (*Plate 60*), signed and

Plate 59. DAVID PATON, *John Graham of Claverhouse, Bonnie Dundee.*

Plate 60. WILLIAM GOUW FERGUSON, *Still-Life with Dead Game Birds*, 1677

dated 1677 (NGS). It is a subject that perhaps lacks charm to modern eyes, but at his best his treatment is equal in quality to that of such Dutch contemporaries as Weenix to whom he is very close.

Ferguson, like so many Scots during the period of the Civil War and Commonwealth, settled in Holland. He is recorded in Utrecht between 1648 and 1651. Between 1660 and 1668 he was at the Hague and he was living in Amsterdam in 1681.[10] He died after 1695 and he may have returned to Scotland towards the end of his life. An auction in Edinburgh in 1693 included eight of his works, so even if he did not return to Scotland it seems his work was well known there.

There is also some evidence of still-life painting by other Scots painters in the period. There are one or two minor examples still *in situ* as decorative overdoors and one important painting by Thomas Warrender, dated 1708 (NGS). (*Plate 61*) Warrender (*fl.* 1673–1713) is only known otherwise as a decorative painter. This picture is similar to *trompe l'oeil* paintings

by the Dutch painter Edward Collier and others working in England. It represents a board with a variety of objects attached to it. These include documents that illustrate Warrender's own position as native of Haddington and burgess and guild-brother of that town as well as of Edinburgh. These and other details make the painting very personal to the painter. It is almost an emblematic self-portrait. The objects include a political pamphlet which gives not only a date, but seems also to imply some political point connected with the Union of 1707. A very similar painting is recorded by James Norie (1684–1757) who, it has been suggested,[11] may have been a pupil of Warrender. Though it is later, *Still-Life with Cauliflowers and a Leg of Lamb* by Richard Waitt of 1724 belongs in this tradition. (*Plate 69*) A fly settled on the lamb indicates the artist's *trompe l'oeil* intention which is rather different from the more sophisticated decorative use of still-life by Ferguson. The solid and positive way in which Waitt's picture is painted is nevertheless distinctly Dutch. It could be compared to the one surviving still-life by Jacob de Wet which is discussed below.

Ferguson has been accepted in Holland as a Dutch artist, but he was not the only Scottish painter to make a successful career abroad. His contemporary, James Hamilton (*c.* 1640– *c.* 1720), likewise a still-life painter, moved on from the Netherlands to Germany where he and his sons became part of the history of German art. In Warsaw a Scot, Jan Collison (*fl.* 1664–65), was appointed court painter to Jan Casimir of Poland in 1664, and another Scot, John Cruden (*fl.* 1667–91), was established as a painter in Silesia. Not much more is known about these two, but there was a large Scots community in the eastern Baltic in the seventeenth century and it was presumably through similar connections that one of Ferguson's paintings is to be found in the Hermitage. The careers of such men are a reminder of how, in spite of the political and ecclesiastical upheavals of the Reformation and its aftermath, Scotland was part of the North Sea and Baltic community in the seventeenth century just as it had been in the fifteenth.

In 1672 the Duke of Lauderdale took up residence at Holyrood as Commissioner for

Plate 61. THOMAS WARRENDER, *Still-Life*, 1708

Parliament. The restoration of Holyrood had been planned since 1663 and by 1671 William Bruce was engaged there, remaining in charge till 1678. The appearance of Holyrood in the 1680s is recorded in an anonymous painting, one of several views in Scotland which may all have been the product of the same commission (Private Collection). Between Lauderdale and Bruce, Holyrood became the principal monument in Scotland of Charles II's vision of restored monarchy. In the south this was expressed through the extensive use of baroque painting and decoration in the royal palaces. Sequences of rooms became progressively richer as they approached the royal presence. One of the first examples of this kind of painted decoration was a ceiling painting by Michael Wright for the royal bedchamber, Whitehall, which may date from as early as 1663 and which survives at Somerset House. It is an allegory of the Restoration. At Holyrood the intention was to create a similar effect of decorative richness and much of it is still visible, though the logic of the original layout has been lost. The political significance of such work became even more pointed after 1679 when James, Duke of York, and later James VII and II, took up residence in the palace, recreating for just four years a royal court in Edinburgh.

For the decorative work at Holyrood, Bruce turned to Holland. In 1673 Jacob de Wet, or de Witt (1640–1697), was 'called from his owne country by Sir William Bruce then Master of His Majesty's work in this kingdome for painting of His Majesty's pallace of Holyroodhouse'.[12] At Holyrood, de Wet carried out a number of ceiling and overmantel

paintings in a style which is really only baroque in the context created by the richness of the other decoration. He carried out similar paintings for Bruce at Balkaskie and at Kellie Castle, both in Fife. Between 1683 and 1686 he painted a sequence of kings for the Long Gallery at Holyrood which were expressly based on Jamesone's originals. At Glamis Castle there is an important series of large-scale portraits of members of the Strathmore family by him. These include a life-size family group, *The Earl of Strathmore and his Family* (c. 1688). At Blair Castle there is also an extremely flamboyant full-length of the Marquess of Atholl (c. 1688) and these portraits are quite unlike anything seen in Scotland before. At Glamis in 1688, besides portraits and some other decorative work, de Wet signed a contract to decorate the chapel with 'a full and distinct story of our blessed Saviour conforme to the cutts in a bible here in the house or the service book'.[13]

The result is a curious example of painted history. The ceiling is laid out in separate panels in a way that the artist of nearby Foulis Easter would have understood. Nevertheless the existence of the paintings is of considerable interest, demonstrating, like Provost Skene's House forty years earlier, that the demand for religious painting could surface even in the prevailing climate of Protestant Scotland as soon as there was opportunity.

De Wet's most interesting legacy however is also his most Dutch. There is one superb *Still-Life* signed by him (Private Scottish Collection). (*Plate 63*) It is a *memento mori* with a skull and a candle. In the background there is a convex mirror in whose distorted depth perhaps we glimpse the artist himself. There is also one genre picture, *The Highland Wedding* (Sir John Clerk of Penicuik), (*Plate 62*) which is recorded as by him in an inventory of 1724. The quality of his decorative painting in the baroque manner is efficient, but wooden. These two pictures give us a glimpse of a much more interesting artist. *The Highland Wedding* especially is a rumbustious picture which introduces a new element into Scottish painting, the depiction of the vigorous and earthy pleasures of ordinary people. The picture is in the well-established tradition of Dutch genre, but it seems quite at home on Scottish soil.

Plate 62. JACOB DE WET, *The Highland Wedding*

The poet Allan Ramsay composed several stanzas to complete the poem *Christ's Kirk on the Green* of which the original part is attributed to James I. Ramsay seems to have drawn inspiration for what he wrote – the poem describes a rather wild wedding – from the picture of *The Highland Wedding* which was in the collection of his close friend, Sir John Clerk of Penicuik. It may even have been painted for Clerk's father. Ramsay was in turn a major source of inspiration, not only to the poets, Burns and Fergusson, but also to the painters, David Allan and David Wilkie, who both painted just such a wedding scene in their respective versions of *The Penny Wedding*. De Wet's painting thus has a central place in the iconography of Scottish art.

De Wet was brought to Scotland to serve a political purpose. He found enough employment beyond that, however, to keep him here for a number of years. He may have left the country briefly in 1686, but not finally until some time before 1691. Perhaps he left in 1688, motivated by political prudence. There were other expatriate artists working in the country around this time however. David des Granges (1611–1671/2) accompanied Charles II to Scotland. He was primarily a miniature painter and in 1651 painted a number of pictures for the king, perhaps in the context of his coronation. He appears to have remained in Scotland, for in 1671 in a 'poor and necessitous condition', he petitioned the king.[14] Another foreign painter, Isaac Visitella (*fl.* 1649–1657), is mentioned in the Earl of Lothian's correspondence with John Clerk and died in Edinburgh in 1658. A German painter called Schuneman (*fl.* 1660–1674) was likewise employed by Lothian about 1660 and remained in the country for a number of years. A French Huguenot painter, Nicholas Heude, or Hood (*fl.* 1672–1703), was brought to Scotland, *c.* 1688, by the Duke of Queensberry and was employed on his new house of Drumlanrig. Two circular ceiling paintings, one of *Aurora* and the other of *Diana and Endymion* at Caroline Park in Granton, are attributed to him. The house, then known as Royston House, was reconstructed after 1685 by Viscount Tarbat and so is contemporary with Prestonfield House. The similar work by a follower

Plate 63. JACOB DE WET, *Still-Life*

of Tideman at Hopetoun has already been mentioned.

Thomas Murray (1666–1724) was a Scot who studied with Riley in London and who stayed to work in the South. He worked for the Dukes of Atholl on a number of occasions and his sensitive, half-length portrait of the Duke painted in 1711 (Blair Castle) suggests that he was a talented painter.

Kenneth Smith (*fl.* 1700–*c.* 1707), probably an Englishman, was, like Heude, in the service of the Duke of Queensberry. He also worked as an assistant to Medina but seems to have operated as a picture dealer as well. He is recorded in 1700 petitioning the town council of Edinburgh for permission to sell some pictures in the following terms: 'he being commissionat by some noblemen and others to bring home some pictures and frames for staircases, chambers and closets, and there being severall of them left . . . indisposed of, which he designed to make sale of by public auction.'[15] Clearly there was sufficient market for the wholesale import of paintings for decorative purposes. There is no indication of their origin, but it is likely to have been the Netherlands, the place most geared to such wholesale production and certainly the source of such overdoor paintings as survive in houses of the period such as Wemyss Castle and Newhailes.

Plate 64. SIR JOHN DE MEDINA, *Sir John Clerk of Penicuik*,
BEFORE 1701

The rising demand for portraits, however, was sufficiently strong by the 1690s to support for the first time a painter in Scotland of some standing and in considerable affluence as a portrait painter exclusively. This was John de Medina (1659–1710). He was born in Brussels in 1659, son of a Spanish sea-captain. He trained there with the painter Duchatel. In 1686 he travelled to London where he set up practice as a portrait painter, though the top end of the market was already monopolised by Kneller. In 1694 he travelled to Scotland. He had been persuaded to make the journey rather against his better judgement by the Earl of Melville and his son, the Earl of Leven, both of whom he had painted in London. They were ably seconded by three ladies, the Countesses of Melville and Leven and Margaret, Countess of Rothes, cousin to the Countess of Melville, whom he had also painted in London. In persuading him, the Melville-Leven family was supported by other members of the Scottish aristocracy resident in London. Rosalind Marshall suggests

convincingly that it was not a coincidence that the women took a leading role in persuading Medina to go north.[16] Although for the men in political circles the arduous journey between Scotland and London was a necessary feature of their lives, the women did not undertake it so often. They needed a painter at home who could match the standards that their menfolk could find in the south. Conversely after the Union of 1707 the position was reversed. As the political classes took up more permanent residence in the south their families went with them and the demand for portraiture in Scotland suffered accordingly.

The understanding with Medina was that he would be guaranteed a certain number of commissions, (twenty full-lengths or forty half-lengths) and he would go prepared, even including a number of canvasses with the draperies already painted, 'so that ther will be little to doe except to add a head and neck'.[17] This was all so that he would have 'only to stay so long as to doe all the faces of his pictors'.[18] Thus he would only have to stay in Scotland the shortest possible time. In the event he realised that Scotland represented a golden opportunity, a market crying out for a painter of talent who could satisfy the demand for a more sophisticated kind of painting than any native painter was able to provide. When Medina died in 1710 he had become a naturalised Scot. He had been knighted and he left a considerable sum in cash and property to his widow. There were in his studio at the time of his death, amongst a large number of pictures of various kinds, almost twenty portraits awaiting completion or collection, which suggests a busy practice.

In the 1690s, in spite of the livening influence of Michael Wright, it was the formulae of Lely and then Kneller that dominated British portraiture. With Kneller himself and even more in the work of some of his followers, this becomes at times a rather joyless kind of painting, but Medina remained loyal to his Flemish background and this sets him a little apart from the painters that he left in England. Like any busy portrait painter his work is uneven, and he certainly used assistants of whom the principal was his own son, John, but his best work is marked by sharpness of observation combined with a rich and lively execution. His

female portraits, like that of the *Countess of Rothes* (1694, Earl of Haddington), or, in the same collection, *Lady Helen Hope, Countess of Haddington* (1694), are almost startlingly frank. His forthright, but sympathetic characterisation of the faces, which makes no concession to conventions of beautification, is oddly at variance with the conventional elegance of quasi-classical costume and pose.

He does not seem to have regarded inventiveness in his poses as a merit to be cultivated, as his willingness to fit heads and necks on to ready-painted canvasses makes clear. In the male portraits the resultant sameness is emphasised by the fashion for flowing wigs, but the actual painting of the heads is often remarkably incisive. This is particularly marked in his less formal paintings like his portrait of *Sir John Clerk of Penicuik*, the first baronet, for example (before 1701, Sir John Clerk of Penicuik). (*Plate 64*) For the Royal College of Surgeons he painted an extensive series of oval, bust-length portraits of the Fellows, probably begun in 1697. This includes a number of very lively paintings, handled with real bravura.

The informality and freedom seen in the best of this series is even more marked in a small number of actually informal portraits. The butler of Wemyss Castle, David Ayton, must have proved himself a congenial companion to Medina at some time when he was working there and so Medina painted him in a half-length portrait (1702, Private Collection). (*Plate 65*) He is seen coming forward with a hospitable smile and a welcome decanter of wine. With more art than de Wet in his *Highland Wedding*, Medina gives us a glimpse into the ordinary exchanges of life behind the conventions of representation. This is perhaps even more striking in two portraits of his children. One of these is a fairly conventional portrait of his son John (NGS), but the other is more unusual (Earl of Wemyss & March, SNPG). It is of a boy and a girl in half-length. The boy is holding a book and is apparently reading to his younger sister. The painting is outstanding in British art of the time. It is really necessary to look to Hogarth or even to Gainsborough to find such a combination of precision and freedom, of the integration of eye and hand with a delicacy of touch which

Plate 65. SIR JOHN DE MEDINA, *David Ayton, Butler of Wemyss Castle*, 1702

is the vehicle for the expression of genuine feeling.

As well as portraits, at his death Medina left a number of subject pictures in his studio. They appear to have been painted for his own amusement rather than to be the remains of unrecorded commissions, but they clearly reveal his sense of himself as an artist. Sir John Clerk bought several from his widow including a very fine *Cain and Abel* (Sir John Clerk of Penicuik). This is almost a demonstration piece of the use of glazes and high colour in the rendering of flesh tones in the Rubens manner. It is described in the inventory of his effects as 'a coppie picture of Cain and Abel not finished'.[19] It may have been related to another item in the same inventory, a 'paris plaister figure of Cain and Abel, being broken'[20] which might in turn explain its generic likeness to the sculptural treatment of this theme by Adrian de Vries, perhaps the model for this cast. Most revealing of the artist's image of himself, however, is an ambitious composition of *Apelles painting Campaspe* in which presumably there is some self-identification in the figure of Apelles, though it is not obviously a self-portrait (Earl of Wemyss & March).

The College of Surgeons series terminated in 1708 with the painter's own self-portrait,

Plate 66. RODERICK CHALMERS, *The Edinburgh Trades*, 1720

provided, according to the inscription on it, at the request of the surgeons. Like Medina's knighthood this was a striking recognition, not just of the man, but of the status of his art, recovering the position reached by Jamesone sixty years before. Medina therefore occupies a very important place in the history of Scottish painting and it is not surprising to find William Aikman (1682–1731), one of the first Scottish painters to come up clearly outside the decorative tradition, learning from him. Aikman was one of three artists who at much the same time, though from very different backgrounds, demonstrated ambitions to be professional painters – they clearly perceived themselves differently from any of their predecessors, at

least since Jamesone, for all three travelled to study painting in Italy. The other two were John Smibert (1688–1751) and John Alexander (1686–c. 1766). It is not necessary to attribute their ambitions solely to the example of Medina, but his success is a clear indication of the public recognition of painting.

At a more humble level too, the growing importance of painting had an effect and the painter-decorators began to see themselves as more a profession than a craft. Socially this was a shift upwards, but it was one which also reflected a genuine enlargement of ambition among the painters. There is one intriguing piece of evidence for this. In 1703 the painters had joined the Edinburgh trade guild, the Incorporation of St Mary's Chapel. It is not quite clear what the significance was of this step, for they had played a full part in the guild life of the city up to this time, but once in the guild they began to make their presence felt. In 1709 for instance two young members, James Norie (1684–1757) and Roderick Chalmers (*fl.* 1709–30), proposed that the painters be granted the privilege of donating the masterpiece, by which the individual qualified for membership of the guild, to adorn the guild's meeting house instead of paying the usual fee. Chalmers's royal coat of arms was accepted in this way.[21]

A few years later, pursuing the same line of

Plate 67. RODERICK CHALMERS, *Self-Portrait*, DETAIL OF PLATE 66

thought, James Norie caused a fierce row within the Incorporation. On his own suggestion he was commissioned to repaint the chimney-piece of the Meeting House which represented all the trades outside Holyrood Palace, but in repainting it, which he did in 1718, Norie changed the order of precedence. This deeply offended the masons and the trades associated with them, so much so that one of their number crept into the Meeting House at night and changed the picture. The dispute was only resolved by cutting the picture in half and giving half each to the two contending parties, the masons and the wrights. Two years later Norie's friend Chalmers painted another chimney-piece that restored the original order and which survives (1720, Joint Incorporation of Wrights and Masons of Edinburgh).[22] (Plate 66) In Chalmers's picture the ten trades are arranged in front of Holyrood. The mason is standing prominently at the centre with the trades allied to the masons on his right, and the wrights on his left. Each tradesman is engaged in his respective occupation and is wearing working clothes, but the painter, who is presumably Chalmers himself, is sitting on a high-backed chair wearing a velvet coat and a full-bottomed wig, (Plate 67). Although the stock-in-trade of the painters was house-painting, he is seated in front of an easel, painting a picture. If Norie's crime had been to improve the status of the painters, Chalmers has done it just as effectively with this image of himself.

Chalmers was a herald-painter and, as Ross Herald, was like James Workman before him one of the five Scottish heralds. He was not without distinction in his field therefore. Norie, however, is more clearly identifiable as an artist in the modern sense, though at the same time he was also still very much a traditional painter-decorator. He was in fact truly a transitional figure, representing the old tradition while not only harbouring wider ambitions himself, but also encouraging them in younger artists. Allan Ramsay's father was a close friend of James Norie and the young painter must have benefited from his encouragement, for example, and even later in the eighteenth century, Alexander Runciman was an apprentice in the Norie firm while James Norie was still alive.

It is indicative of Norie's sense of his own status that a portrait in the Scottish National Portrait Gallery has traditionally been identified as his Self-Portrait. There is also the still-life similar to that by Thomas Warrender which has been mentioned above, but he specialised in landscape decorations which survive in some number attributable either to him, or to the family firm that he founded and which flourished well into the second half of the

Plate 68. JAMES NORIE, *Landscape Capriccio*, 1736

century. His eldest son, James, was also a painter, but he died in 1736 and the business was carried on after the elder Norie's death by his son, Robert, who died in 1766. Another son, George, appears in the accounts, though he may have worked principally in the retail side of the business, selling colours and painting materials. After Robert's death, the business was carried on by Runciman for a short while and then by a Mrs Norie who was handling the accounts while James senior was still alive and who was still trading in 1775–6. She is described by James on one occasion as his daughter-in-law and was presumably Robert's widow.

Fragments of mid-seventeenth-century wall-decorations of painted foliage in George Heriot's Hospital, Edinburgh, are perhaps a link between the Nories' kind of decoration and earlier styles in Scotland, but James Norie's decorative landscape painting really derives

from a widespread, late seventeenth-century fashion for overdoors and overmantels, associated originally with Dutch painters. It is seen, for example, in England in decorations at Hampton Court Palace, but it remained popular in England, as in Scotland, well into the eighteenth century.

Two paintings in the National Gallery of Scotland signed and dated James Norie, 1736, are probably by James Norie senior, rather than by his son of the same name. They are freely and vigorously painted capricci – invented landscapes with classical figures and details. (*Plate 68*) They reveal a distant acquaintance with seventeenth-century models like Gaspar Poussin, and a kind of simple, rather classical construction is a quality of James Norie's work whose influence is still apparent in Scottish landscape painting two generations later. This kind of capriccio is typical of the Nories, though virtually all the surviving panels *in situ*

Plate 69. RICHARD WAITT, *Still-Life with Cauliflowers and a Leg of Lamb*, 1724

are in grisaille (monochrome), not like these two in full colour. Where such schemes survive intact this is extremely effective. The landscapes and the architectural details that often accompany them – fictive cornices and frames for example – which are painted directly on to the plaster or the panelling of the room, appear as a natural extension of the rest of the decoration.

One of the most elaborate schemes to survive is a series of rooms in Caroline Park, painted as part of the refurbishing of the house which Nicholas Heude had decorated fifty years earlier. This was after it had changed hands in 1739 and the Nories work is therefore dateable to *c.* 1740. The scheme consists of vigorously painted, grisaille landscapes, all completely imaginary, but mixing classical elements with such distinctively Scottish ones as waterfalls and mountain scenery. There are similar paintings in an even more elaborate arrangement at Kellie Castle in Fife in a room where the ceiling is by de Wet. At Prestonfield House in Edinburgh there is a similar scheme which consists of multiple landscape paintings covering most of the wall surface of the room. A very fine room decoration of this kind is also preserved, dismantled, from a house in Riddle's Court in the Lawnmarket, Edinburgh, demonstrating that this kind of decoration, like the painted ceilings of the previous century to which it is closely akin, was not confined to stately homes. Numerous other schemes by the Nories survive in part, or whole, and the firm appears in the accounts of most of the major east coast houses at one time or another.

Some of the paintings in these decorative schemes are of recognisable places. At Biel House, East Lothian, for example, there is a view of the house in grisaille, executed in the rough and ready technique that is typical of this kind of decoration, and which indeed is its principal charm. Landscape painting whose purpose was not simply decorative was also part of the Nories production however. There is, for example, a view of *Taymouth Castle* in the Scottish National Portrait Gallery which James Norie painted in 1733, where the description of the precise layout of the grounds was sufficiently important for the painting also to have been changed when the grounds were altered

Plate 70. RICHARD WAITT, *Nic Ciarain, Hen-Wife of Castle Grant*, 1726

six years later. Similar local views by James Norie once existed at Blair Castle and a view by him of the avenue of trees at Hopetoun House was recorded in an inventory there in 1808. The firm worked frequently at Hopetoun from its first appearance in the accounts there in 1718. The work they did covers everything from so many yards of plain painting to specifically commissioned pictures of this kind.

There were other decorative painters working in Scotland during the first part of the eighteenth century. Some can be named but few can be identified with surviving works. One of the most ambitious paintings of this kind is by a Dutch artist, John van Sypen (Private Collection).[23] It is a panoramic view of Wemyss from the sea. In the foreground the Scottish and Dutch navies are engaged in a skirmish which took place on 30 April 1667 in the Dutch war. This suggests a date, but the picture was painted many years later. Behind this remarkable scene the coast of Wemyss is set out in great detail, including Wemyss Castle, the

coal mines with a procession of horses bringing coal down to the sea and, in the foreground, the harbour and salt-works.

Richard Waitt (*fl.* 1707–*d.* 1732) was, like James Norie, very much a transitional figure. In style and practice he belongs with the decorative painters, but he specialised in portraits, though one of his most outstanding paintings is *Still-Life with Cauliflowers and a Leg of Lamb* (NGS) which is signed and dated 1724. (*Plate 69*) It is strong, clear and simple, but if it was not signed it is unlikely that it would be attributed to him as most of the rest of his known work is very different in character. He may have been trained by John Scougall, but if so, such traces of conventional sophistication as Scougall preserved were lost in the transmission. Waitt's hard, bright painting is almost naïve.[24]

His origins are unknown, but Waitt first appears in Edinburgh in 1707 when he was married and his first recorded work dates from 1708 when he was paid for a coat of arms of the Earl of Hopetoun at Abercorn. The nature of the work, identical to Roderick Chalmers's masterpiece for the Incorporation of Trades the following year, suggests that Waitt was a decorative painter whose ambitions, like those of James Norie, took him beyond the narrower limits of his trade. His curious *Self-Portrait* (SNPG) painted in 1728, in which he shows himself before an easel displaying a picture of the *Muse of Painting*, is closer to Chalmers's self-portrait (in the chimney-piece for the Incorporation of St Mary's Chapel) painted eight years before in 1720, than it is to Jamesone's *Self-Portrait* at an easel, though Waitt's association with the North East through his work for Clan Grant (see below) may have led him to identify with Jamesone.

Waitt painted a number of small, cabinet-sized portraits like *Sir Archibald Grant of Monymusk*, signed and dated 1715 (Royal Company of Archers), which have an almost miniature-like delicacy in their observation of detail and their density of colour, but his most notable achievement was a series of portraits of members of Clan Grant and their retainers, begun in 1713 or 1714 on a commission from Alexander Grant of Grant and forming a unique clan gallery at Castle Grant. The most impressive of the paintings that he provided are two full-lengths of *William Cummine*, piper to the Laird of Grant (RMS) and of *Alastair Grant Mor*, the Laird's champion (Hon Viscount Reidhaven). Like Waitt's small portraits these two strange, flat paintings are more notable for the detailed observation of costume and accoutrements than for their grace and elegance. Equally impressive in a very different way though is his half-length portrait of *Nic Ciarain, Hen-Wife of Castle Grant* (Private Scottish Collection) for which in 1726 he was paid the sum of £1. 5s. (*Plate 70*) It is the one picture in which the bold simplicity of the *Still-Life* is apparent. Dressed in the costume of a highland woman, with a white head-dress and shawl fastened with a circular brooch, she is holding a snuff horn from which she is taking a pinch with a snuff spoon.

Waitt's touching portrait of the hen-wife of Castle Grant is very rare as a portrait of an ordinary member of the Scottish peasantry. It is even rarer as a picture of a true Gael. Fifty years later James Cumming in Edinburgh painted a portrait of a highland porter, *William McGregor* (ECAC), (*Plate 107*), and there are, of course, as the eighteenth century progressed, increasingly frequent portraits of the cosmopolitan aristocracy of the highlands, but Waitt's position as clan painter to the Grants seems to have been unique. In spirit it is akin to the collecting and commissioning of portraits by the Campbells of Glenorchy in the previous century, but its comprehensiveness as a representation of a chief and his people, rather than of his lineage and exalted connections, is, it seems, a wholly highland phenomenon. The Grants, on the edge of the Highlands, were Hanoverians. It is sad that no clan chief in the remoter parts of the Highlands seems to have thought of employing a clan painter.

PART TWO

THE ENLIGHTENMENT

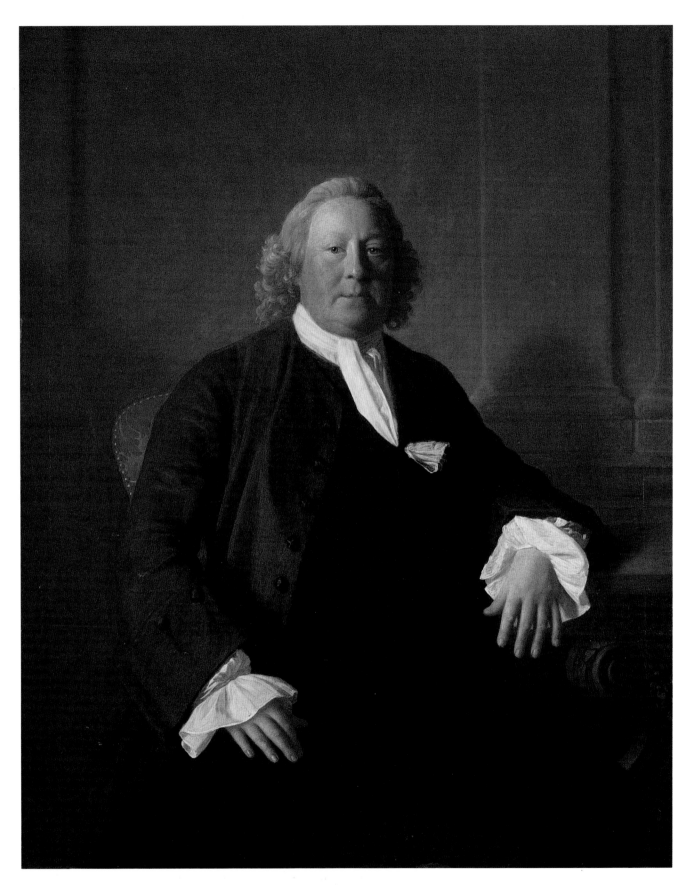

Plate 71. ALLAN RAMSAY, *Lord Drummore*, 1754

A NEW ART
Portraiture Comes of Age

Painters like Richard Waitt, or James Norie, working in the first half of the eighteenth century, belonged in a long tradition of craftsmen that stretched back to the early seventeenth century and beyond. Jamesone too had belonged to it, so the self-consciousness that is detectable in the dealings of these painters with the Incorporation of Trades in Edinburgh was not the dawning of something entirely new. It did, however, mark the beginning of a change in the status of the native painters in Scotland from a craft to a profession as they moved into the new intelligentsia. There were painters like William Aikman, a country gentleman, who came into painting as a profession from outside the craft tradition, but it was not simply that a new class of professional replaced the old craftsman-painter. The activities of Norie and Chalmers make clear that the craftsmen-painters themselves had new aspirations. As a consequence the apprentice system continued to make a valuable contribution to painting throughout the eighteenth century. Alexander Runciman, Jacob More, Alexander Nasmyth and even Raeburn all began as apprentices, though Raeburn was apprenticed to a goldsmith not a painter.

It was principally in the field of portraiture at the beginning of the eighteenth century that a qualitative change is first apparent as the painters moved to participate more directly, through their art, in the intellectual and imaginative life of the country. This change was stimulated partly by the growing market, indicated by the success of Medina, and by the increasing popularity of the Grand Tour – Sir John Clerk, for example, went on the Grand Tour as far as Italy in 1697 – but also by a

combination of the impact of the Act of Union in 1707 with the intellectual developments that marked the later seventeenth century. Whether they welcomed or opposed the Union – and Scotland was very divided – the feeling that they had to take an initiative in the face of its clearly perceived, negative effects, was a preoccupation of many thinking Scots.

The real effect on Scotland of the Union of Parliaments in 1707 is still a matter of debate. It may have checked, but it certainly did not stop the developments in Scottish intellectual and cultural life that are apparent in the generation following the Restoration of the monarchy in 1660. As the urgency had gone out of the great theological questions, the intellectual and moral tools forged in the heat of the Reformation could be turned to more constructive uses. The crisis of the Union may have served to focus this more clearly in Scotland.

Central to all Protestant thought, however much it was overlaid by the intolerance of sectarianism, was the belief in the primacy of individual experience as a basis for judgement. This was the cornerstone of empiricism. Developed by Bacon, Newton and Locke in England, it was the special contribution of the Scots, like David Hume, Adam Ferguson and Adam Smith, to turn this to the study of human nature, the nature of human society and its place in the wider world. There can be no doubt that the questions about the nature of their own society in Scotland, or the potential new society of the United Kingdom, posed by the Union gave a special urgency to such reflections in Scotland. It was because they were part of this that painters like William Aikman, John Smibert and later Allan Ramsay were able to open up

new horizons for their art, even though painting suffered especially severely from the direct economic and social consequences of the Union. The evidence that it did so is clear. In 1694 Medina had been persuaded to come and to stay in Scotland by the volume of work available; less than thirty years later William Aikman regretfully left his native land because there was so little. Just as Medina visited Scotland intending to stay for a short time, so Aikman visited London for a short stay in 1720, intending to return to Edinburgh and remain there 'unless I find that there is no more to be done in my way at Edinburgh which I fear much will be the case'.[1] It was the case and two years later he moved to London permanently.

The Union, by shifting definitively Scotland's political base to London, took away from Edinburgh the last vestiges of political life and patronage. The poet Allan Ramsay was one of those who were acutely aware of this. He was a central figure in Edinburgh's cultural life during the first half of the eighteenth century and a close friend of James Norie as well as of Aikman. Another painter friend of the poet, John Smibert, left Scotland first, like Aikman, for London, but he settled eventually in America. Allan Ramsay's son was the portrait painter of the same name and so the father's interest in the position of painting in Scotland was more than casual. He was acutely aware of the departure of his friends as a symptom of decline. Being an energetic and enterprising individual, he took a number of initiatives to try to counter this. The best known were his own poetry and his publication in *The Evergreen* and *The Tea Table Miscellany* of collections of older Scots poetry. In 1729, however, he appears, together with James Norie, Roderick Chalmers and a number of others, participating in a project specifically aimed at improving the position of painting as he was one of the signatories of a document which in that year established Scotland's first art institution, the Academy of St Luke in Edinburgh.

The charter of the Academy is preserved in the Royal Scottish Academy, its eventual heir.[2] It describes the intentions of its members as the 'encouragement of these excellent arts of Painting, Sculpture and Architecture &c and the Improvement of the Students'. The signatories also agreed 'to erect a public Academy, whereinto everyone that inclines, on application to our Director and Council, shall be admitted on paying a small sum for defraying charges of Figure, Lights &c, For further encouragement some of our members who have a fine collection of Models in Plaister from the best Antique Statues are to lend the use of them to the Academy.' Though it was named after the Academy in Rome, the model for the Academy of St Luke was Kneller's Academy in London, currently under the direction of Thornhill and later under that of Hogarth. Who it was who owned the casts 'from the best Antique Statues' is not clear, but Richard Cooper, the engraver who had settled in Scotland on his return from Italy and who himself subsequently ran a small academy, did have a collection of drawings and of drawings after the old masters. John Alexander, whose name also appears on the list of signatories, had spent ten years in Italy and had also brought back copies of old masters, so probably had Andrew Hay who in 1725 had already sold a collection made in Italy.[3] He was one of the first of a number of Scottish artists to move from painting into dealing and the related activity of 'bear leader'. Other signatories included William Adam, the architect. His son Robert and the younger Allan Ramsay, though both were still scarcely more than boys, also added their names, as did the portrait painter William Denune who was probably much the same age.

It is indicative of the situation that prevailed in the first years after the Union that the two most gifted Scottish artists of the time, Aikman and Smibert, had already left Scotland by 1729, Aikman to return once briefly the year before his early death in 1731, but Smibert never to return. Settled in Boston he became instead the father of painting in North America. Nevertheless the collective experience of the professional members made the Academy more than a gesture of pious aspiration and the fact that at least two of its younger members, Adam and Ramsay, went on to become the leaders of their professions suggests that it cannot have been an ineffective institution, or at least that it represented the aspirations of an extremely effective group of individuals, but it does seem to have been short-lived.

In 1731 the Academy was granted rooms in the College (Edinburgh University). A few years later Richard Cooper was teaching independently. He had the engraver Robert Strange among his pupils. Strange, who also went on to become the leader of his profession, left an autobiographical sketch which gives an account of his time with Cooper. As he makes no mention of the Academy it may already have been defunct, but if it was short-lived, it was not insignificant. The idea of a permanent art academy had first been mooted in the context of the improvement of design in the linen industry by John Clerk in 1728, and thirty-two years later, in 1760, the Trustees Academy was founded with this end in view. The linen industry was, along with fishing, the principal concern of the Board of Trustees for Manufactures, a body set up to administer a fund voted by the new United Kingdom parliament, for investment in Scottish industry in recognition of the loss of state revenues in Scotland following the Union. The Trustees Academy, after a long and distinguished existence, was eventually taken over by the Department of Science and Art and merged with the Royal Scottish Academy school. That in turn was merged with the new Edinburgh College of Art at the beginning of the twentieth century.

Aikman (1682–1731), Smibert (1688–1751) and John Alexander (1686–c. 1766) had all studied in Italy and this brought a quite new level of sophistication into Scottish painting. It is most obvious in Alexander's major work, the ceiling with the legend of *Pluto and Proserpine* that he painted for the Duke of Gordon in Gordon Castle in 1720. Sadly, this has long since disappeared, though Alexander's small sketch for it survives (NGS). (*Plate 72*) He was a great-grandson of George Jamesone, a Jacobite and a Catholic, like the Duke his patron. He was also incidentally a close friend of the architect, James Gibbs. Alexander was in Italy between 1710 and 1720. He studied there with Giuseppe Bartolomeo Chiari and in Rome produced a set of engravings after Raphael's frescos in the Vatican Loggia. He also enjoyed the patronage of the Medici in Florence and of the Jacobite court in Rome.

The commission for the ceiling may have been given to him in Italy. The result was the

Plate 72. JOHN ALEXANDER, *Pluto and Proserpine*, SKETCH, 1720

only large-scale, fully baroque painting done in Scotland, for it was directly inspired by Italian baroque painting and was quite different to anything produced by de Wet for example. The sketch is square. A fictive architectural border with the four seasons in the corners opens in an oculus at the centre to show Pluto clutching the protesting Proserpine as his chariot plunges over the edge of a fiery abyss. The main part of the composition is in conventional perspective. Only in a curiously drawn temple façade to the right does the painter attempt to acknowledge the actual viewpoint of the spectator which is from below.

Most of Alexander's later work consisted of portraits of a rather stiff kind, though an ambition to paint the life of Mary Queen of Scots, first voiced when he was in Italy, does seem to have been realised towards the end of his life. The most ambitious of his portraits is of the artist himself in attendance on the Duke of Hamilton, painted in 1724 (Duke of Hamilton), but his later portrait of *William Drummond, Lord Provost of Edinburgh* (1752, ECAC) is of great importance because of Drummond's place in the history of the city. Alexander's son, Cosmo (1724–1772), named after Cosimo de Medici, was also a painter, though like his father, more competent than distinguished. He worked in America in the last years of his life, from 1765–71, and thus played a part in the

Plate 73. JOHN SMIBERT, *Allan Ramsay*, c. 1719

early career of Gilbert Stuart who became his assistant and travelled back with him to Scotland in the latter year. Alexander's daughter married George Chalmers (c. 1720–1791), son of Roderick Chalmers and heir to an impoverished baronetcy. He was another competent painter who travelled to Italy and then practised in Edinburgh. His most original picture is his portrait of *William St Clair of Roslin* playing golf, as captain of the Honourable Company of Golfers of Edinburgh (1771, RCA).

John Smibert's role in the early history of painting in America has given him a special place in the history books. He began his career in Edinburgh as apprentice to a painter called Marshall who may have been identical with the George Marshall who was president of the Academy of St Luke and who according to Brydall had studied with Kneller.[4] Smibert then studied in London from 1709. He returned to Scotland and worked in Edinburgh between 1716 and '19. It was at this date that he painted two portraits of his friend Allan Ramsay. (*Plate 73*) He then travelled to Italy, returning to settle in London in 1722. Finally, according to his friend Vertue, 'having a particular turn of mind towards honest, fair and righteous dealing he could not well relish the selfish, gripping, over-reaching ways too

commonly practised in London',[5] and he joined Bishop Berkeley in an expedition to set up a Christian College in the Bermudas.

It is interesting that Berkeley should have thought it appropriate to take a teacher of art for his enterprise at all, but, though they crossed the Atlantic, the college never got started and so it was that Smibert settled in Boston. His painting of Bishop Berkeley and his companions, the *Bermuda Group* as it is called, stands at the beginning of the history of painting in North America. For a Scottish patron, Sir Francis Grant, Lord Cullen, he had painted an equally ambitious group portrait of Sir Francis with eleven members of his family, and in addition the portraits on the wall of his two dead wives (Sir Archibald Grant of Monymusk Bt). An awkward though ambitious picture, it was possibly painted before Smibert went to Italy and the rather grim, long faces that he gives his sitters are distinctly reminiscent of the paintings of John Scougall. Far more accomplished is his double portrait of another member of the Grant family, *Sir Archibald Grant of Monymusk and his Wife*, painted in 1727 and so showing the effect of his Italian experience (Sir Archibald Grant of Monymusk Bt). (*Plate 74*)

This elegant and gentle portrait shows Sir Archibald seated with a book on his knee. He is holding his wife's hand. She has just come in from the garden and is standing with a basket of flowers on her arm and and a rose in her other hand. They are both wearing informal clothes. The beautiful, soft colouring and the delicacy with which the relationship of husband and wife is treated are such that the picture brings to mind Allan Ramsay's portrait of his wife, *Margaret Lindsay*, arranging flowers. Smibert's portrait of *Col. Douglas*, (NGS) also of 1727, which is simpler, shows his direct approach to painting under natural light, something that he has in common with Aikman and which is also already a distinctive feature of Ramsay's early work. Although Ramsay was too young to have known either Smibert or Aikman well, any assessment of his achievement must take account of the distinction of the work of both these friends of his father.

Aikman, born in 1682, was older than either Smibert or Alexander. Whereas Smibert, because of his place in American art has been

given a fair bit of attention, Aikman who, according to Vertue, his friend and contemporary, was 'esteemed the best painter this country has produced of late years',[6] is still the most underrated. He was the son of a country gentleman. It is significant that he should even have thought of painting as a profession, but we know a little about the debate over his choice of career from his correspondence with his uncle, Sir John Clerk of Penicuik. He was in a dilemma, but the status of painting as an appropriate choice does not seem to have been part of it. He was wondering whether he should not rather go into law or business, in both of which he had good connections. He had graduated from Edinburgh University and in 1701 he was seriously debating whether he should set up as a merchant, but by 1703 he was already

painting, for in that year his uncle paid him for some pictures. Vertue says that he studied with Medina. This must have been between 1701 and 1704 for in the latter year he was painting in London.[7]

Aikman's most securely dateable early works are his portraits of *Sir John Clerk* and his wife, of 1706 (Sir John Clerk of Penicuik). Medina's portrait of Sir John is also at Penicuik. Both painters show the same rather florid handling and a strong sense of likeness. Aikman's pictures were presumably painted in London for he stayed in the south from 1704 till 1707, when, after selling his family property of Cairnie near Arbroath, he set out for Italy. There he appears to have studied with Carlo Maratta.[8] In 1709–10 he travelled on as far as Constantinople and Smyrna and his *Self-Portrait*

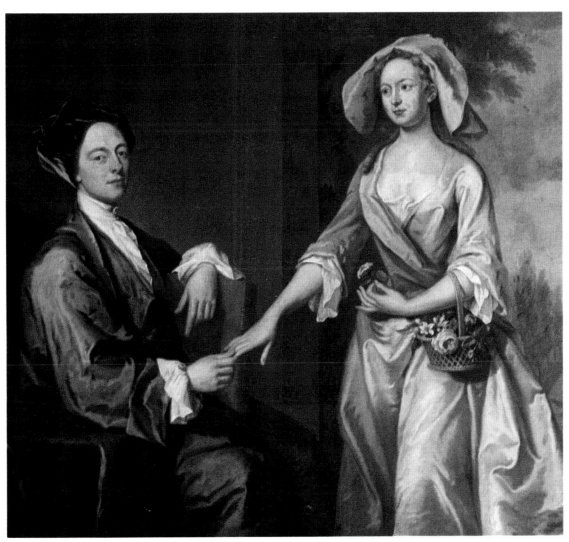

Plate 74. JOHN SMIBERT, *Sir Archibald Grant of Monymusk and his Wife*, 1727

in Eastern Costume (SNPG) is a memento of this trip. He returned to Scotland via Italy to arrive in Edinburgh in March 1711. It was well timed, for Medina had died only a short time earlier in October 1710 and Aikman had no serious rival in his bid to succeed him. He became increasingly conscious of the limitations of the Edinburgh market though and in 1720 he went south, at first for six months, but in 1722 he moved finally to London. He visited Edinburgh once more in 1730, but died in London the following year.

Aikman moved quickly away from the influence of Medina and by the time he returned to Edinburgh his art had clarified, with no trace of Medina's baroque and little too of his own experience of contemporary Italian painting. He retains Medina's essential honesty, but becomes much more analytical, even severe. His own *Self-Portrait* (SNPG) must date from the time of his return. Like his portrait of *Patrick Campbell of Monzie* which is dated 1714 (location unknown), it shows this tendency very clearly and by the time he

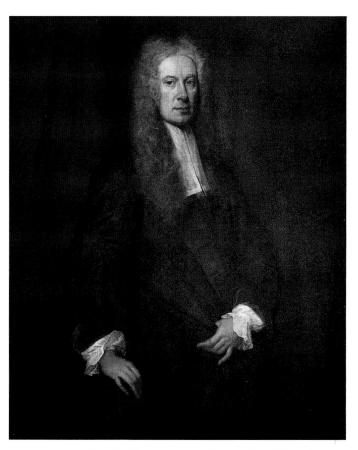

Plate 75. WILLIAM AIKMAN, *Sir John Clerk of Penicuik*, *c.* 1720

painted *George Watson* in 1718 (Merchant Company of Edinburgh) this has become a distinctive characteristic. It may reflect the influence of Kneller, but there were few British painters who showed such scrupulous self-discipline in their attention to the visual information offered by their subjects.

In one of the last pictures Aikman painted before he finally moved south, the portrait of *Sir Hew Dalrymple, Lord North Berwick* which is dated 1722, this analytical approach has the quality of intellectual rigour (Faculty of Advocates). (*Plate 76*) This portrait, a three-quarter length of the *Earl of Marchmont* (1720, formerly Earl of Haddington) and a three-quarter length of *Sir John Clerk of Penicuik* (Sir John Clerk of Penicuik), (*Plate 75*) of similar date, all show that this approach is linked to a powerful sense of design. There is in all three pictures a careful balance of shape and colour under subdued, natural lighting which suggests an idea of elegance that is the very opposite of showy.

We get a sudden glimpse here of what Italy must have meant to Aikman. It is the High Renaissance that lies behind this clarity, dignity and order. His understanding of the power of balance and restraint is classical. In the Dalrymple portrait for example the arrangement of head, body and hands has an overall logic of design which is natural, but achieves clarity in a way that is Raphaelesque. The hands especially are carefully placed. Their positions, though perfectly relaxed, overlap to form a spiral that defines the volume of the body. It is something seen in Raphael's *Bridgewater Madonna*, or more closely in his *Portrait of a Young Man* which has the same arrangement of the hands, though with their positions reversed. As with Rembrandt, however, though this inspiration provides an armature for the more effective presentation of the concrete facts of existence, Aikman pays no ransom to the ideal. His pictures lose nothing of their sharpness of observation.

These qualities in Aikman's work suggest that it may be possible to see an analogy between Aikman's painting and the mix of classicism and naturalism that is seen in the work of several of his Scottish contemporaries and friends, the architect Colen Campbell and

the poets, Allan Ramsay and James Thomson (see below). It was Colen Campbell, for example, who launched the eighteenth-century fashion for Palladio, and the appeal of Palladio, before his work was reduced to a set of rules for building country houses in eighteenth-century England, was just such a combination of dignity and order with simplicity and a kind of fitness that might be called natural, as is seen in these works by Aikman. It is something that is also anticipated in the work of William Bruce and James Smith. Aikman too, like Campbell, enjoyed the patronage of Lord Burlington, leader of Palladian taste, after he moved south. He had also become friendly with William Kent, another of Burlington's protégés, when he was in Italy. He himself had enough interest in architecture to propose at one time a translation of Vitruvius. In Edinburgh he shared this interest with his cousin, John Clerk, whose long poem, *The Country Seat*, had as its subject the ideal country house and is in effect a Palladian poem.

As well as that of Palladio, Clerk's long poem is imbued with the spirit of Horace. An enthusiasm for Horace, and for Horace's particular blend of naturalism and classic form, was something that Clerk shared with his close friend, Allan Ramsay, though the length and didactic intention of his poem are closer to the work of the Scottish poet, James Thomson. Thomson, whose advice in fact Clerk sought, was also a friend of Aikman's. Ramsay himself eventually built his own Horatian villa and 'country seat' on Castle Hill, Edinburgh, where it still stands, buried among the houses of Patrick Geddes's *Ramsay Gardens*. Aikman painted Allan Ramsay's portrait in 1722 and Smibert had also painted him twice.

Ramsay and Aikman were close friends and were members of a circle that included, as well as John Clerk, Duncan Forbes of Culloden who became Lord Chancellor of Scotland and Lord Advocate. Forbes was to be a very important friend to Aikman in the south. James Thomson, though young, was on the edge of this circle. He moved to London just two years after the painter and there published his poem *The Seasons* (1726–30) which was to become amongst the most celebrated poems of the whole eighteenth century. Though it is not

what could be called naturalistic, it gave in classical form an account of nature which is precise, even empirical. [9] It was written in English, but drew on a long tradition of Scottish humanism and nature poetry.

Thomson's language and the large scale of his work have tended to separate our perception of him from our perception of Allan Ramsay who, writing in Scots on a much more domestic scale, is seen as representing the main Scottish tradition. Both were of equal importance to Fergusson and Burns and to the later eighteenth-century Scottish poets however. (Indeed before Burns Night was possible, it was Thomson whose birthday was celebrated as the national bard, in the Cape Club in Edinburgh in the 1770s and eighties.) Although in *The Seasons* Thomson roves across the world, the core of his nature poetry is the description of the Scottish landscape that he knew. His art is based upon the concrete and upon his own experience. This united him with Ramsay and at least the latter part of what Ramsay says, in the most important aesthetic statement that he

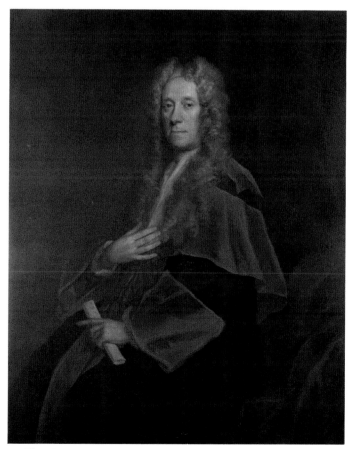

Plate 76. WILLIAM AIKMAN, *Sir Hew Dalrymple*, 1722

made, could apply to both poets and perhaps therefore also to the painters who were their friends. Ramsay gave this account of his principles in the preface that he wrote in 1724 to *The Evergreen*, a collection of Scots poems from before 1600:

> I have often observed that Readers of the best and most exquisite Discernment frequently complain of our modern writings, as filled with Delicacies and studied Refinements, which they would gladly exchange for that natural Strength of Thought and Simplicity of Style our Forefathers practised.
>
> When these good old Bards wrote, we had not yet made Use of imported Trimmings upon our Cloaths, nor of Foreign Embroidery in our Writings. Their Poetry is the Product of their own Country, not pilfered and spoiled in the Transportation from abroad: Their Images are native, and their Landskips domestick: copied from the Fields and Meadows we every Day behold.

Ramsay here presents two ideas. 'Copied from the Fields and Meadows we everyday behold' is the essence of naturalism or empiricism, while the 'natural Strength of Thought and Simplicity of Style our Forefathers practised' summarises the ideal of a kind of natural, primitive classicism. Ramsay's poetry and his letters both record his relationship to Aikman and Smibert. He used an engraving of one of Smibert's portraits of himself as the frontispiece to a collection of his poems in 1721 (the present whereabouts of this painting is unknown) and he must also have liked the other, even more direct and uncompromising portrait that Smibert painted of him (Private Collection). His son took it as a model in a superb early drawing of his father (NGS) and it stayed in the Ramsay family until the early nineteenth century. Its frank familiarity is certainly 'domestick' and even if it is not a 'landskip' it seems that it is copied faithfully from its original.

Both Aikman and Smibert can at this time be seen to share the same direct naturalism – it could perhaps already be called empiricism – as marks Ramsay's poetry and underlies Thomson's therefore. An early portrait of *William Carstares* (EU), traditionally attributed to Aikman, is as blunt as Smibert's surviving Ramsay portrait, but paintings like his portraits of *Sir Hew Dalrymple*, or of *Sir John Clerk of Penicuik*, also recall Ramsay's notion of 'the natural Strength . . . and Simplicity of Style' of the 'good old Bards'. They are strong and simple, almost to sternness. Henryson, Dunbar and Gavin Douglas, the poets of the late fifteenth and sixteenth centuries, were Ramsay's 'good old Bards'. Aikman's inspiration too seems to look back to that time, to Raphael and Titian, and to be quite untouched by 'the studied refinements' of the baroque.

In the south, through his Scottish connections, Aikman enjoyed very important patronage. Not only did he paint the Prime Minister, Sir Robert Walpole, for Duncan Forbes, but at the end of his life he had royal sitters and painted a group portrait of *The Royal Family* possibly for Lord Burlington (1731, Chatsworth). This kind of patron meant that he had to supply a grander kind of painting and faced with this need he turned back to Kneller for inspiration as in his full-length of *John, 2nd Duke of Argyll* (HM the Queen), but some of these grander pictures are very impressive. His portrait of the young *Marquis of Bute* (Private Collection) in highland costume for example, painted in 1727, leads on directly to such pictures as Allan Ramsay's *McLeod of McLeod* (1747–48, Dunvegan). As in the Dalrymple portrait Aikman is rediscovering the logic of High Renaissance design. The same thing can be seen in his portraits of *Major General Charles Hay* (formerly Yester House), or *John Hamilton, Lord Belhaven* (Charles G. Spence Esq.), and elsewhere in his work. Such pictures represent an important stage in the development of a distinctive style of eighteenth-century portraiture in Britain.

In spite of his success Aikman was beset by money problems. His health deteriorated. He drank too much and his wife nagged him mercilessly. Inevitably his art was uneven, yet enjoying such patronage as he did, and as a friend of Alexander Pope, of Thomson, Kent and the other leading figures in London's intellectual milieu, he had a central place in British painting. Ramsay was his heir and the continuity between them is important evidence for the strength of the Scottish cultural base from which they both sprang.

Allan Ramsay who was born in 1713 went on to become the greatest portrait painter of his time. He was however not the only Scottish painter to follow in the footsteps of Aikman and Smibert. When as a boy of sixteen he signed the charter of the Academy of St Luke,

Alexander Clerk (*fl.* 1730–*c.* 1750) and William Denune (*c.* 1712–1750) were also among those who signed. They were much the same age and both went on to become portrait painters, though neither of very great distinction. William Denune's style derives from Aikman in a way that parallels Ramsay's own development, though it was no doubt also influenced by Ramsay himself. A detail of Denune's career that is of interest is the way that he seems to have had a base in Edinburgh and a second base in Dumfries. There was evidently enough demand now for a painter to develop a provincial practice. Alexander – always known as Sandy – Clerk, was a younger son of Sir John Clerk of Penicuik and a cousin therefore of Aikman. He was in Rome studying with Francesco Imperiali between 1732 and 1738. Allan Ramsay was there at that time too, as was another Scottish painter, William Mosman (*c.* 1700–1771). The leading Roman portrait painter of the mid-century, Pompeo Batoni was also a pupil of Imperiali at this time. An important group of paintings by Imperiali are still preserved at Penicuik, the result of purchases by James Clerk, Sandy Clerk's nephew, the future third baronet, who was in Rome on the Grand Tour at much the same time. Later paintings by Clerk, even on a small scale like the portrait of *Hon. George Maitland* at Thirlestane Castle, clearly reveal the influence of Imperiali's delicate late-baroque style.

Mosman was also linked directly to Aikman for on the recommendation of John Clerk of Penicuik he spent a short time in 1727 as his assistant in London, apparently not much to the satisfaction of either of them. He spent some time back in Scotland again before he too went to Rome to study with Imperiali between 1732 and 1735, returning to Scotland in 1736.[10] He worked both in Edinburgh and in the North East. He was not an outstanding talent and his ordinary portraits are fairly mundane, but he could be ambitious and his best paintings clearly reflect the extent to which he became part of the Roman art milieu while he was there. He played a part in commissions and purchases by Scottish patrons from painters like Imperiali and Batoni, and himself provided for Captain John Urquhart a large copy of a composition by Imperiali, *Erminia*

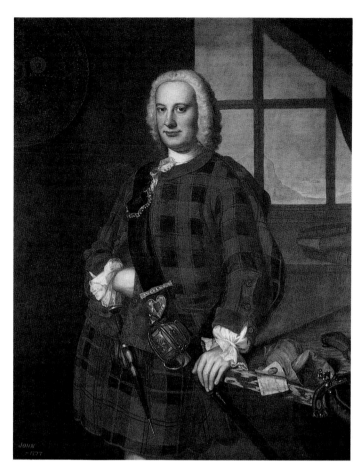

Plate 77. WILLIAM MOSMAN, *John Campbell of the Bank*, 1749

carving Tancred's name on a Tree (James Holloway). The pair of portraits that he painted in 1741 for William Duff, Lord Braco with his son, and of his wife, Jean Grant, with their daughter, are extremely elegant (both Private Collection). His full-length of *Thomas Kennedy of Culzean*, painted in 1746 (NTS, Culzean Castle) has an elegant arrangement and gorgeous light-toned colour to rival Batoni and even though it was painted ten years after Mosman's return from Italy it must be the most Italianate portrait by any British painter of the time. His portrait of *John Campbell of the Bank*, though, is uncompromisingly Scottish (1746, Royal Bank of Scotland). (*Plate 77*)

One other painter who deserves consideration at this point, though he was of an older generation, is Jeremiah Davison (*c.* 1695–1745). He was of Scottish origin, but was born in London and spent his early career there, coming to Scotland in 1736 for a number of years before his death in London in 1745. In London, like Aikman, he evidently enjoyed the

patronage of the Scottish community and he painted a fine portrait of Aikman's friend and patron, Duncan Forbes of Culloden (Duke of Atholl, Blair Castle). Working in Scotland, with portraits like the family group of *James 13th Earl of Morton* of 1740 (SNPG), he provided his sitters with pictures as glamorous as anything that they could have procured in London before the advent of Ramsay.

When Ramsay launched his career therefore, the art market in Scotland was continuing to evolve in spite of the effect of the Union. The professions and the middle classes began to find their feet as patrons to supplement diminishing aristocratic patronage and they were often very enlightened. Scottish history would not have been the same without such families as Dalrymple, Clerk and Forbes, or individuals like Robert Alexander, a banker who financed David Martin, the Runciman brothers and probably Richard Cooper the younger on study tours to Italy. The immediate successor to the Academy of St Luke was the Foulis Academy in Glasgow set up in 1755 by the Foulis brothers, printers and publishers. They even set up a travelling scholarship, the earliest of its kind in Britain. The ambitions of the artists continued to grow in parallel. The careers of Aikman and Smibert were already proof of this and it is confirmed by those of Ramsay's own contemporaries. With him art comes of age and takes its proper place at the highest level of intellectual and imaginative achievement.

Ramsay's ambitions were formed by his father, by his knowledge of Aikman's career and by the circle in Edinburgh of the Academy of St Luke. Robert Adam, equally ambitious and equally important in the history of British art, was a product of the same circle. Ramsay went first in 1732–33 to study in London with Hans Hysing, a Swedish painter who had been established there for many years. After two years back in Edinburgh he travelled to Italy in 1735 in company with his father's friend, Dr Alexander Cunyngham (who became Sir Alexander Dick of Prestonfield when he succeeded to a baronetcy in 1746.) Ramsay studied in Rome with Imperiali and also at the French Academy there to which he had an introduction from the leading French antiquarian, Mariette, whom he

had met in Paris on the recommendation of Sir John Clerk. Clerk was himself a distinguished antiquary and Ramsay, from this beginning, throughout his life moved comfortably in the circle of Europe's leading intellectuals. From Rome he went on to Naples to study with the aged painter, Francesco Solimena, and in 1738 he returned to Britain and set up his practice in London with immediate success. London remained his base, but he visited Scotland regularly and remained in close touch with what was going on there, particularly of course while his father was still alive.

Ramsay's work from before his Italian visit, for example his portrait of *Mary Campbell of Lochlane* (Private Collection), shows that he continued in the manner of Aikman and Smibert. (Smibert, now in America, continued to have reports of the young painter's progress from his father.) What especially distinguishes him from his other contemporaries is his use of natural light, a feature of the work of both Smibert and Aikman. His portrait of the lovely young *Margaret Calderwood* of 1735 (Private Collection, on loan to NTS), however, is an essay in the style of Hysing. The only portrait that he painted in Italy, *Dr Samuel Torriano* (1738, Earl of Haddington, Mellerstain) is distinctly Italian though. His charming picture of a little girl, *Agnes Murray Kynnynmond* (Newhailes), picking a rose, painted immediately after his return is also Italian in colour, with beautiful pink and blue, and a fluttering drapery in the baroque manner. She herself though is real in a way that contrasts with such dainty conceits and, like Aikman, what Ramsay learnt in Italy was something much more subtle than a style. It was a kind of sophistication and eventually, again like Aikman after a period of years, an understanding of how to strike a balance between grace and nature without being untrue to either.

By the time he painted his own *Self-Portrait* (c. 1740, NPG) and the first of two beautiful portraits of his first wife, *Anne Bayne* (c. 1740, SNPG), (*Plate 78*), the basis of Ramsay's mature style was established. These are more gentle than Aikman's portraits, but they are no less direct. He describes his wife without flattery, but with a simple truthfulness that is more affectionate than any elaboration. The vehicle

for this is light, used not as the servant of any preconceived pictorial drama, but as the essential vehicle of living perception. Light is so subtly described, reflected on to Anne Bayne's cheek from the edge of her white bonnet for example, that the sitter exists in a real atmosphere, not in some abstract realm of portraiture. It is necessary to go back to Dutch painting to see such precise observation so gently qualified by a sense of living humanity.

During the 1740s Ramsay's works were not all as delicate and carefully thought out as these early paintings done for himself. Faced with success and consequent demand he used the drapery painter, Van Aken, as did others among his contemporaries and this blurs the difference between his art and theirs. The only painter to whom he was really close aesthetically though was Hogarth. Hogarth had dedicated one of his earliest works, his engravings of Samuel Butler's *Hudibras*, to the senior Ramsay and the two had a great deal in common, though they can never have met. They had both risen through the apprentice system, Hogarth as an engraver and Ramsay as a wig-maker. They shared a sense of commitment and believed their art should be topical. For both of them its root was in experience and so humour was part of art, as it was of life. They both believed too that they were closer to the great originals than many of those who professed more loudly their claim to follow them. The relationship between the younger Ramsay and Hogarth seems not always to have been smooth, but there is no doubt that they supported each other and with Ramsay's father at a distance, Hogarth's passionate convictions must have reinforced those that his young friend had inherited. Hogarth took to portrait painting at much the same time as Ramsay set up his practice in London and almost immediately he embarked on a picture, his full-length portrait of *Thomas Coram* for the Foundling Hospital, which was intended to challenge, not only his contemporaries, but the whole tradition of grand portraiture since Van Dyck. 'The portrait of Captain Coram in the Foundlings was given as a specimen, which still stands in competition with the efforts that have been made since by every painter that has emulated it,' Hogarth remarks in an autobiographical

note.[11] A little earlier he had recorded Ramsay's scepticism of the likelihood of his successfully challenging Van Dyck, but Ramsay himself was one of those who emulated Hogarth's picture, first of all in a portrait of *Dr Mead*, 1747, which he presented to the Foundling Hospital in explicit rivalry with Hogarth, and then two years later in a portrait of *Archibald Campbell, 3rd Duke of Argyll*, which is one of the grandest achievements of his early career (1749, GAGM). (*Plate 79*) Ramsay had painted the Duke's brother, the second Duke, as early as 1740 and, as it had been for Aikman, this connection proved to be of great importance to him.

In his first portrait of the third Duke, whom he painted again nearly ten years later (1758, Duke of Northumberland), Ramsay exerted himself to produce one of his finest paintings to date. It is a state portrait of one of the most powerful men in Scotland, but Ramsay uses no machinery extraneous to the observable facts to convey that impression. The Duke is seated

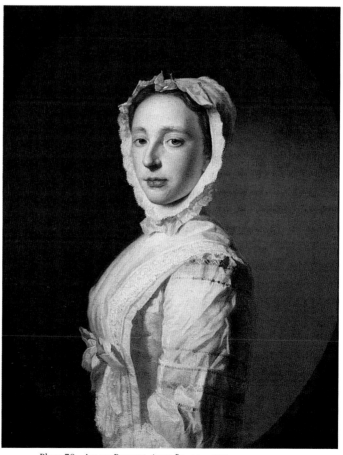

Plate 78. ALLAN RAMSAY, *Anne Bayne*, c. 1740

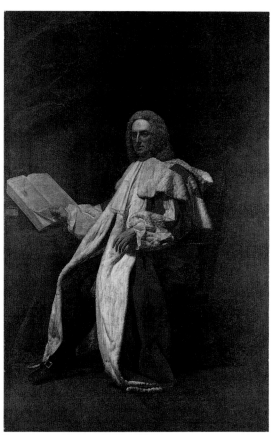

Plate 79. ALLAN RAMSAY, *Archibald Campbell, 3rd Duke of Argyll*, 1749

the most important of a number of incidental essays that he wrote on a variety of topics because its subject has a direct bearing on his own art. The dialogue is between Colonel Freeman, who speaks for Ramsay, and Lord Modish who, as his name implies, speaks for the world of unreflecting fashion. From it we learn that Ramsay believed that art must reflect experience directly and should therefore require as little sophistication to be understood. It should be as simply apprehended as our perception of the actual world about us. There is no place in art or in reality for abstract ideas: 'No analysis can be made of abstract beauty, nor of any abstraction whatever,' he remarks.[12] This anti-idealism even led him to condemn the notion of the classical canon of human beauty. It was an uneasy compromise, he said, because any such generalisation is incompatible with the fact that the human race consists of individuals, none of whom are identical.[13]

In one remark made, not in *A Dialogue on Taste*, but in his essay *On Ridicule* written two years earlier, he asserts consistently with this view, the priority of the observed over what is notionally pleasing. 'The agreeable cannot be separated from the exact; and a posture in painting must be a just resemblance of what is graceful in nature, before it can hope to be esteemed graceful.'[14] Nature cannot be improved by art therefore. This does not mean though that Ramsay rejected the art of the past any more than Hogarth did. When, in Italy, he went to study with Francesco Solimena, he chose the last representative of the tradition of the Carracci, a tradition founded on the belief that the basis of classical form was the study of nature approached through the discipline of drawing. Reinforced by his experience of the French Academy in Rome, drawing remained Ramsay's instrument of analysis. His choice of Solimena though may have had something to do with Aikman, for Aikman's best work reveals the same search for balance and order in the observed world. The implication of Ramsay's remark about the agreeable and the exact is that classical models, whether from Antiquity or the Renaissance, were the result of a process of discovery, not invention. The process by which these discoveries were made

in robes of state, of scarlet and ermine. He has his right hand on a book and is turning a page, but he is looking directly at us. The ultimate model of such a portrait is Titian's painting of Charles V, seated, but Ramsay has set his sitter much further back in the space than most painters when following that model. He has not taken advantage of the extra distance to introduce a step and thus increase his height and dignity however, as they would have done. The Duke stays on our level. The most remarkable thing about the picture though is the light. Raeburn has been compared to Velasquez with some justice ever since Wilkie first made the comparison on seeing Velasquez's work in Spain, but even Raeburn does not come so close to Velasquez as Ramsay does here. He captures the sense that light, though fragile, is also tangible. It qualifies what we see even as it informs us and this is what Velasquez does in *Las Meninas*.

Ramsay's natural portraiture was based on a clearly articulated intellectual position. In 1755 he published *A Dialogue on Taste*. It was

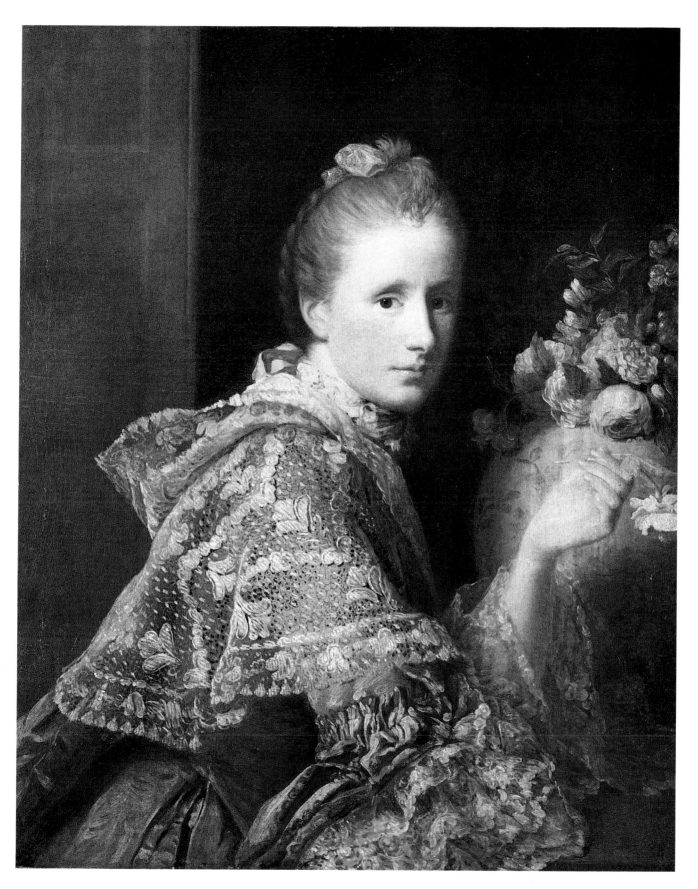

Plate 80. ALLAN RAMSAY, *Margaret Lindsay*, c. 1757

Plate 81. ALLAN RAMSAY, *Margaret Lindsay's hand*, STUDY FOR *Margaret Lindsay*

should be emulated, not their results slavishly copied. Grace and beauty were something to be discovered in the actual, not a set of abstract rules that could be applied at will. It is little wonder that Reynolds and Ramsay did not see eye to eye and that Reynolds is reputed to have said that Ramsay was 'a man of remarkable good sense, but not a painter'.[15]

These aspects of Ramsay's thought are a direct link to his father whose opinions they echo very closely, but they also belong to the traditions of the Reformation as these evolved into empiricism. They connect Ramsay's ideas with those of his friend Hume therefore. The painter and the philosopher, of exactly the same age and both sons of Edinburgh, may have known each other before, but in 1754, both again in Edinburgh, the two men established a close friendship. The basis of Hume's study of human nature was that we cannot understand the world around us other than through what we actually perceive, but what we perceive is particular, 'Everything in nature is individual,' he writes.[16] We cannot perceive generalisations any more than we can formulate ideas that are not based on experience. It is only the imagination that allows us to reach out beyond the limitations of the immediate, and in dealing with other people it is sympathy that is the imagination's vehicle. This is surely precisely what we see in such pictures as Ramsay's two portraits of his first wife, or in his portrait of

Janet Dick of 1748 (Prestonfield House), the wife of his companion in Italy, Sir Alexander Dick, and this approach radiates triumphantly from the finest painting of his sojourn in Edinburgh in 1754, the portrait of *Sir Hew Dalrymple, Lord Drummore* (SNPG). (*Plate 71*)

Ramsay painted Hume twice. The first time in 1754 (Private Collection) and again ten years later (SNPG), but it is the portrait of *Lord Drummore* that seems to epitomise the relationship between Ramsay's art and Hume's philosophy. It is a three-quarter length, beautifully observed and lit by the natural light of day. Drummore sits directly facing us and so we make immediate contact with him. There is no barrier of convention. The social distance is just right. The sitter is present to us in his full humanity and intelligence. It is the special quality of Hume's thought that in ruthlessly dismantling by analysis the intellectual structures that we create for ourselves, he leaves intact both our sense of his humanity and of our own. In just the same way Ramsay paints. He analyses what he sees with the same clarity as Hume, but his image is more than the sum of these observations because it is held together by sympathy and imagination.

Plate 82. ALLAN RAMSAY, *Margaret Lindsay*

These are the outstanding qualities of one of the most enduringly popular of all Scottish pictures, Ramsay's portrait of his second wife, *Margaret Lindsay* (*c.* 1757, NGS). (*Plate 80*) Faced with opposition from her parents (they were Scottish gentry who objected to her marrying anyone so lowly as a painter, even though he was the most successful in the country) he eloped with her in 1752. Anne Bayne had died nine years earlier in 1743. He took his new wife to Italy in 1754 where they stayed till 1757. While they were there he painted her twice. Both are beautiful pictures, but it is the second, later, portrait which has captured the imagination of several generations of Scots. It shows her in a beautiful pink dress with a lace fichu and sleeves, and a blue ribbon in her hair. She is arranging flowers and she has a rose in her hand, a detail for which there is a beautiful red chalk study (NGS). (*Plate 81*), Her action is suspended as she turns at the entry of the artist. We know that it is he who has entered by the expression on her face which is open and unguarded. Although it is so elegant, the painting recalls Rembrandt's *Woman in Bed* where the sitter likewise looks out at a spectator who can only be the artist. It is a measure of Ramsay's strength as a portrait painter that he can stay within the polite conventions of eighteenth-century portraiture yet convey such a complex account of the relationship between two people.

In this portrait it is not only Margaret Lindsay's clothes that reflect the latest French fashions. Ramsay, like Hogarth, was very interested in the latest French painting, especially that of La Tour. The softness of execution and the delicacy of colour are evidence of this. It is a taste that is already apparent in such paintings as *Lady Walpole Wemyss* (Earl of Wemyss and March) and *Thomas Lamb of Rye* (Private Collection) both painted in 1753, but which was reinforced by his return to the French Academy in Rome where the painter Natoire was now in charge. French painters were leaving behind the rather artificial poses and studied elegance of early eighteenth-century portraiture in favour of a more natural and informal style. The manners governing painting were more relaxed. Ramsay followed this example, but he did not sacrifice exactness

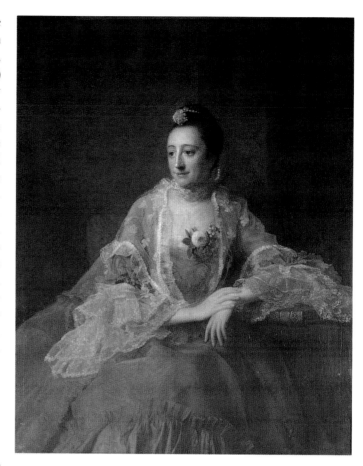

Plate 83. ALLAN RAMSAY, *Mrs Elizabeth Montague*, 1762

in order to be informal or sociable. On the contrary he used the new informality to create painting of even greater subtlety of observation. A marvellous red chalk study of his wife, looking down as though reading, is drawn apparently without her being aware of him (NGS). (*Plate 82*) In it he ignores ordinary conventions of description to go beyond any of his contemporaries in the informality of his vision.

Ramsay delighted too in the depiction of costume and used it to make wonderfully complex and delicate colour compositions, not as an end in themselves, but as a foil to the face. His portrait of *Elizabeth Montague* for example, a close friend and one of the first bluestockings (1762, Private Collection), (*Plate 83*), is a study in the elegance of intellect. She is seated in a relaxed attitude, one elbow on a pile of books with Hume's name prominent on the spine. The beauty of her costume only enhances the lively intelligence of her face.

Martha, Countess of Elgin (1762, Earl of Elgin), (*Plate 84*) is another of the superb

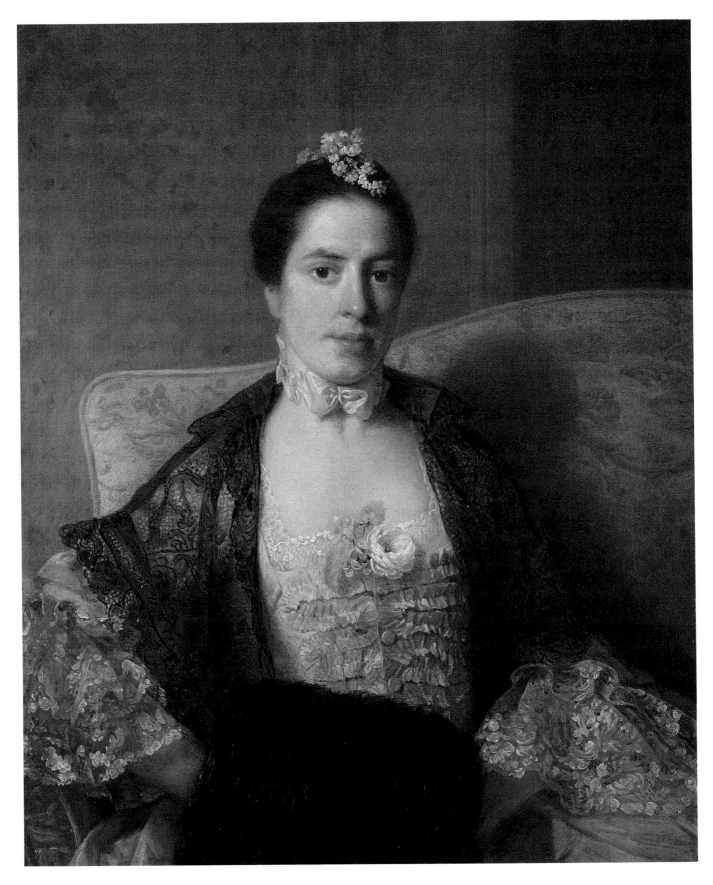

Plate 84. ALLAN RAMSAY, *Martha, Countess of Elgin*, 1762

female portraits painted in the decade after Ramsay's return from his second sojourn in Italy. It is illuminating to compare it with *Elizabeth Montague* for the two paintings are as distinct as the individuals that they represent. Mrs Montague looks reflectively into the distance, the arrangement of her hands and body confidently expressing her composure and implying her intellectual strength. The Countess of Elgin on the other hand sits close to the picture plane and is looking straight at us. The way she is sitting, her head slightly tilted one way, her body the other, is quite unself-conscious and unarranged. It brings her close to us in a way that is natural and intimate and was clearly part of her personality. A sheet of drawings shows Ramsay trying out variations on this pose and of the costume (NGS). In the end he has settled for a beautiful pink dress with black lace that enhances her dark colouring. Though these female portraits are outstanding in European painting, similar quality is seen in such male portraits as the second portrait of the *Duke of Argyll* or his portrait of *Dr William Hunter* (c. 1760, Hunterian Museum, Glasgow) even if they are less simply beautiful.

The sheer quality of painting that Ramsay commands to create such images is breathtaking. Examination of the details of costume reveals a marvellously fluent precision, but as in his earlier work this is still governed by close observation in conditions of natural light. The full-length that he painted in 1762 of *Lady Mary Coke* (Private Collection), (*Plate 85*), standing holding a long-stemmed string instrument, is a beautiful study of light. The tone of the picture is set by her white silk dress and the pearls round her neck and bordering her head-dress. The rest is in subdued tones of brown except the carpet which has a gentle red and blue pattern, and a long, pink ribbon hanging in shadow from the neck of the instrument she is holding. The whole picture has the same pearly light that we have grown accustomed to in the painting of Vermeer, but amongst Ramsay's contemporaries it is really only Chardin who can match his command of paint as a means of describing the perceived world of light, colour and texture.

Mary Coke's pose though is based on a statue of Minerva, at that time in the Gustiniani

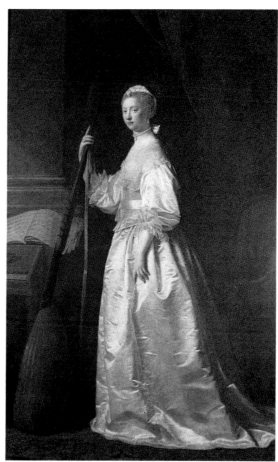

Plate 85. ALLAN RAMSAY, *Lady Mary Coke*, 1762

collection, now in the Vatican. In an equally beautiful full-length of the fourteen-year-old, *Lord Mount Stuart* (Private Collection), dressed as an archer, painted in 1758/9, Ramsay uses another classical female figure, the Cesi Juno from the Capitoline Museum, as his model for the pose. In each case though he has softened the classical formality of his model. Lord Mount Stuart's head and body are in counterbalance with each other in natural sympathy with the way that the weight of his arm is taken on his bow. Ramsay had clearly been looking at the antique when he was in Italy, but he remains wholly loyal to his own maxim that the agreeable must be subservient to the exact in recreating a classical pose from nature.

Ramsay's tact and integrity in dealing with the demands of the grand portrait was what won him favour with the king, a relationship which began in late 1757 with a commission from the Earl of Bute to paint a full-length of him (Private Collection). He was then still Prince of Wales. This was followed by a

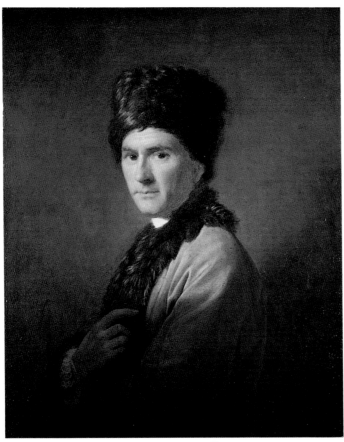

Plate 86. ALLAN RAMSAY, *Jean Jacques Rousseau*, 1766

commission, also from Lord Bute, to paint a full-length of the Prince's mother, Augusta, Dowager Princess of Wales (Private Collection), (a picture that Reynolds remembered when years later he came to paint Lord Bute's own widow, *Mary, Countess of Bute*). Ramsay also painted a full-length of Bute himself (1758, NTS, Bute House) as well as that of his son, Lord Mount Stuart. Mary Coke was also a cousin of the Earl of Bute and his patronage, probably following the lead of his uncles the Dukes of Argyll, produced some of Ramsay's finest late paintings. After George's accession as George III in 1760, Ramsay became the king's painter, though this position was not recognised officially until the end of 1761.

In his approach to the problem of the state portrait Ramsay certainly learnt from his contemporary in Rome, Pompeo Batoni, but he still refused to allow the individual that he was portraying to be overwhelmed by the dramatic machinery of presentation. The artist who painted the full-length of the king as Prince of Wales is recognisably still the artist who had

painted the Duke of Argyll so memorably nine years earlier. State portraiture had become generally an abstract, formal affair in which the representation of office and status were the principal objectives of the painter, but Ramsay succeeds in painting a real person in the office of king. This is even more striking in the portrait that he painted of *Queen Charlotte and her children* (HM the Queen). It is modelled on the grandest Renaissance types of the Madonna and child, like Titian's *Pesaro Madonna*, yet manages to retain a sense of domestic intimacy. Within the grandeur she appears as a sympathetic, slightly uncertain young woman, yet Ramsay achieves this with no loss of the dignity essential to such a picture.

Ramsay's practice diminished in the 1760s. The royal portraits took up his time. They also left him very comfortably off. In the last years of his life an injury to his arm appears, too, to have prevented him painting altogether. While he was still able to paint though, the quality of his painting did not diminish even if the volume did and in these last years he produced some remarkable paintings. They have a fragile delicacy which is almost insubstantial. His second portrait of *Hume* (1766, SNPG) and its companion, the portrait of *Rousseau* (1766, NGS), (*Plate 86*), that was also painted for Hume, are good examples. In these the painter meets as an equal the two most influential thinkers of his time and provides the most penetrating commentary on them. In both pictures the sitter is caught in a fleeting shaft of light. Hume is sitting facing us. The light from above leaves his face partly in shadow, but his eyes meet us with a level gaze. Rousseau turns away from us as though about to vanish in the shadow.

In both these pictures Ramsay pays homage to Rembrandt, but Ramsay does not share Rembrandt's conviction of the tangibility of matter. Here, or in the contemporary, though undated, magical portrait of *Mrs Bruce of Arnot* (c. 1767, NGS), (*Plate 87*), the painter's touch is so light and the paint so transparent that it is hardly present. In her portrait it is only the pinks and greys of her costume that give substance to the flesh tints that they echo. For Hume only the imagination could hold together the fragmentary and incomplete account we have of the

world through our perception of it. This is of course most acutely true in our dealings with other people and is the paradox of portraiture. Leonardo first focused it in the *Mona Lisa*, but Ramsay comes close to it again in these late portraits. With him, British art moves to the centre of the European stage to confront the cardinal mystery of the relationship between seeing and knowing, the central preoccupation too of Scottish empirical philosophy from Hume to Reid.

Ramsay's influence in England is not the business of this study but is worth a moment's attention for it does focus the divergence of English and Scottish painting. His position as an artist was based on the idea that he was, just as Hume was, a servant of truth. What he painted could not be the product of some arbitrary requirement of style, but had to be a reflection of what he saw. Reynolds, who eventually supplanted him as the leading portrait painter in London, and who set the agenda for English painting for a century, had a very different view of how painting worked. For him truth of this kind was only one of a number of variables whose usefulness was to be assessed in approaching each new pictorial challenge. In consequence, as history has accepted Reynolds's own view of English painting, Ramsay's importance has been overlooked just as Hogarth's has, but Reynolds himself was frequently indebted to Ramsay, and his rival, Gainsborough, seems to have taken the inspiration for his poetic later style directly from Ramsay's own late work.

The clarity and humanity of Ramsay's best portraits epitomises the Enlightenment in Scotland. Inevitably therefore it dominates discussion of painting in the period, but he was not alone and there were an increasing number of portrait painters who, even though they are minor beside him, are nevertheless of interest. Principal among these was his assistant, David Martin (1737–1797). Alexander Nasmyth (1758–1840) and Philip Reinagle (1749–1833) were also Ramsay's assistants, but Nasmyth became a landscape painter and Reinagle, though he came from Edinburgh, did not return to work in Scotland as did the other two. Close to Ramsay, also, was William Millar (*fl.* 1751– 1784) who first appears copying a

portrait by him in 1751. He also copied Ramsay's first portrait of Hume shortly after it was painted (1757, EU). Portraits by Millar like that of *Thomas Trotter* (1767, NGS), the cabinet-maker, are akin to Ramsay in the same way as David Martin's work is, but under the influence of Gavin Hamilton whose portrait of *William Hamilton of Bangour* (c. 1746, SNPG) he copied for the Earl of Stair at Oxenford, Millar also painted some unusual, neo-classical portraits.

Although no genius, David Martin was the most successful Scottish portrait painter between Ramsay and Raeburn. He seems to have been recruited by Ramsay when he was in Edinburgh in 1754 and the following year joined Ramsay in Rome. Martin then worked for Ramsay, possibly until the early 1770s though he was evidently also working independently for he painted a portrait of *Benjamin Franklin* in 1767 (The White House, Washington). The year before he had produced a mezzotint of Ramsay's *Rousseau*. He then established himself in Edinburgh where he remained the leading portrait painter until

Plate 87. ALLAN RAMSAY, *Mrs Bruce of Arnot*, c. 1767

he was superseded by Raeburn. In informal half-lengths like that of *Franklin* or that of *Joseph Black* (EU) which is probably of the 1770s he is recognisably a pupil of Ramsay, but he developed the informal qualities of Ramsay's style in a very inventive way in such pictures as his three-quarter length, painted in 1787, of *Joseph Black* conducting an experiment, and its partner, painted in 1776, of *William Cullen*, also engaged in a scientific demonstration (both Royal Medical Society, on loan to SNPG). Though Martin learned from Reynolds too and in such ambitious full-lengths as *William, 1st Earl of Mansfield* (after 1776, Earl of Mansfield), *Sir James Pringle of Stitchell* (1791, RCA), or *Robert Trotter* (1782, EU), Ramsay's grand full-lengths are still his model and so he is an important bridge between Ramsay and Raeburn. In his later career Martin himself was influenced by Raeburn and one of his finest paintings, the half-length of *Provost Murdoch of Glasgow* (c.1790, GAGM), (*Plate 88*) shows this exchange.

Plate 88. DAVID MARTIN. *Provost Murdoch of Glasgow, c. 1790*

Alexander Nasmyth was also recruited in Edinburgh. He was serving an apprenticeship with James Cumming (1732–1793). Cumming was a decorative and herald painter. He was also an antiquary. He trained with Robert Norie alongside Alexander Runciman with whom Nasmyth had also spent some time at the Trustees Academy. Nasmyth worked for Ramsay from 1774 till 1778, though Ramsay himself was away in Italy for part of that time. In the latter year Nasmyth returned to Edinburgh where he worked for a while as a portrait painter. His main achievement though was as a landscape painter and so he is discussed below in Chapter VIII.

Historically one of the most interesting of Ramsay's Scottish contemporaries was Catherine Read (1723–1778). She is the first Scottish woman artist who had a full professional training. This seems to have been first in Paris with La Tour, before 1751, as she described him in a letter in that year as 'my old master'.[17] She then went to Rome in 1751 and on to Naples in 1753. She was a close friend of the engraver, Robert Strange, and in Rome she was assisted by the Jacobite, Abbé Grant, who was Strange's brother-in-law, in securing a number of important commissions from leading members of Roman society. Much, though not all of her work is in pastel which has linked her name with that of the Venetian woman pastellist, Rosalba Carriera, though there does not appear to have been any direct connection between them. Returning to England in 1753, Read worked in London. Ramsay's influence is apparent in her portrait in oil of *Helen Murray of Ochtertyre* (Private Collection), (*Plate 89*), which appears to date from the late 1750s. It is a delightful portrait of a little girl in a tartan dress holding a rose, which successfully avoids the trap of sweetness. Intellectual sympathy with Ramsay and with Gavin Hamilton is suggested by a portrait of the historian, *Mrs Macaulay* (whereabouts unknown), represented as a Roman matron weeping over the the lost liberties of Rome. A link with Hamilton is also suggested by a gouache portrait in Middle-Eastern costume of *Elizabeth Wood*, the twelve-year-old daughter of Hamilton's patron Robert Wood (whereabouts unknown). Read also painted a very

beautiful portait of *Elizabeth Gunning, Duchess of Hamilton and Argyll*, who had previously sat for Hamilton (before 1773, Duke of Argyll).

Catherine Read was evidently something of a character. Fanny Burney in 1775 comments on her, 'that she is naturally melancholy. She is absent, full of care . . . added to which she dresses in a style the most strange and queer that can be conceived.'[18] Such eccentricity does not seem to have stood in her way as she enjoyed considerable success. She was patronised by the Butes and by the royal family. In 1763 she did a portrait of *Queen Charlotte and the Prince of Wales* followed by a second commission for a portrait of the Prince and his brother. She also worked for the Hamiltons, the Lothians and for a number of other Scottish families. At the end of her life she travelled to India where there was a considerable market for portraits, both among the British and among the Indian nobility. She died setting out on the return journey.[19]

Catherine Read's success was no doubt a factor in persuading her younger contemporary Anne Forbes (1745–1834) to take to painting as a profession. She was a grand-daughter of Aikman and inherited his paint-box, a substantial piece of furniture which still survives. It was the enlightened support of the Forbes and Clerk families, perhaps more than her relationship to Aikman, that made it possible for her to take up a career as a painter however. They gathered together a subscription which enabled her to travel to Rome, chaperoned by her mother, where she studied principally under the supervision of Gavin Hamilton. On her return she endeavoured to establish a practice in London. A portrait from this time of *Lady Anne Stewart* (NGS) clearly shows the influence of Ramsay as does a series of family portraits at the Aikman home of The Ross. Her portrait of *Baron Ord* (c. 1775, Royal College of Physicians), (*Plate 90*) was a major commission, but perhaps the Clerk network which had so helped Aikman and Ramsay had declined in effectiveness. Like David Allan a few years later, she failed to find a market in London and she returned to Edinburgh where she seems to have maintained a successful practice for a while, but eventually abandoned painting.

Two other Scots who, like Catherine Read,

worked in the Indian market were George Willison (1741–1797) and John Thomas Seton (or Seaton) (c. 1735–c. 1786). Seton was in India from 1776 to 1785. He had trained in London with Francis Hayman and followed Hayman in specialising in conversation portraits, but only worked briefly in Scotland. One of his finest portraits is *John, 4th Earl of Hyndford* (1773, Private Collection). Willison who was in India from 1774 to 1781 was one of several Scots who studied in Rome with Mengs, though the only one who subsequently had a substantial career as a painter. Colin Morison (1732–1810) and James Nevay (*fl.* 1755–1796) for example, who were both with Mengs at the same time, opted for the job of antiquary and guide, though Morison did so because he was forced to give up painting after an injury to his eyes. Before this happened he had painted at least one very fine surviving picture, a pioneering piece of neo-classicism, *Andromache's Sacrifice* (NGS).

In Rome in 1765 Willison painted *James Boswell* (SNPG). There is an owl sitting on a branch behind Boswell, in reference to his

Plate 89. Catherine Read, *Helen Murray of Ochtertyre*, Late 1750s

nocturnal habits, and such lively and inventive touches mark much of his portraiture. He had a taste for fancy dress and exotic costume as in *Nancy Parsons in Turkish dress* (*c.* 1771, Yale Centre for British Art) and this was an asset in India where he proved fully able to do justice to the fabulous costumes of the Indian princes. He worked among others for Warren Hastings and painted some of the leading figures, both Indian and British. His portrait of the *Nawab of the Carnatic* was sent back by Hastings to George III (HM the Queen).[20]

Plate 90. ANNE FORBES, *Baron Ord, c.* 1775

THE GOOD OLD BARDS
Artists, Poets and the Primitive Ideal

In the 1760s painters began to move beyond portraiture and decorative painting to explore radically new approaches to their art. They did so under the direct inspiration of poetry, and they shared with the poets the excitement of a new idea. It was the belief that the primitive and the unspoiled possessed a special quality, that they were the product of imagination not yet staled by custom and that they offered therefore a way towards a new, imaginative purity of vision. It was an idea that went on to play a central role in the later development of modern art and so the relationship between poetry and painting in the work of Gavin Hamilton, Alexander Runciman and David Allan discussed in this chapter, like the relationship between painting and philosophy in the work of Allan Ramsay discussed in the preceding one, has a significance beyond Scotland.

It was in the preface to *The Evergreen* that Allan Ramsay first proposed that the art of the past, the art of the 'good old Bards', could provide a model of 'natural Strength of Thought and Simplicity of Style' that was in contrast to effete modern taste (see above, p98). This was a view also held by his friend, Sir John Clerk of Penicuik, who upheld the ancient Caledonians as the representatives of just such virtues.[1] Clerk himself was a Unionist, but he shared with Ramsay anxiety about the effect of the Union on the identity of Scotland. In looking to the past the Caledonian resistance to Rome seemed to Clerk to provide a clear example of the advantage of primitive simplicity over decadent civilisation. It was a model that went through many variations as the century progressed. The younger Ramsay presents it as the superiority of the Goths over the Romans, claiming that it was they who established the traditions of democracy that underlay the revolution of 1688.

The most influential early application of this idea though was by Thomas Blackwell, professor at Aberdeen, who transferred it to the study of classical antiquity. His *Inquiry into the Life, Times and Writings of Homer* appeared in 1735. In it he took one of the key figures of ancient civilisation and set him outside the polite culture of the ancient world, locating him instead in the state of incipient civilisation of the earliest history of man. Homer belonged to a pre-literate society, he argued, and the power of his poetry depends on the spontaneity and imaginative freedom peculiar to that moment in human history, before art and life were bound by rules. He also argued that Homer, like Ramsay's bards, described the real world that he knew. It was not a world of Hobbesian moral chaos though. On the contrary, explicitly anticipating Rousseau, he argued that this was a world without deceit whose greater simplicity and directness made it morally superior: 'so unaffected and simple were the manners of those times that the folds and windings of the human breast lay open to the eye.'[2] Imaginative freedom and moral integrity seemed therefore to be closely linked and this anticipates the role of sensibility in morality as argued by Hume. It also reflects the view of Frances Hutcheson, teaching at Glasgow, that much influenced Hume as well as the younger Ramsay, that moral and aesthetic sensibility were closely allied.

Hutcheson himself was influenced by the Earl of Shaftesbury who also had a profound influence on the course of the history of art. He argued that the justification of art lay in its

social utility, promoting the moral welfare of the well-ordered state. Shaftesbury was also a key influence on Blackwell's pupil at Aberdeen, George Turnbull, whose *Treatise on Ancient Painting*, published in 1740, followed his argument to give an account of the place of painting in the civilisation of ancient Greece, Shaftesbury's own model of the democracy that he believed had been established in Britain in 1688. (Ramsay substituted his Goths for Shaftesbury's Greeks.) Turnbull, who Ramsay knew in Rome in 1738, gave a lucid and widely influential account of the history of painting in ancient times. Loyal to Blackwell, he took Homer as the starting point and argued that the superiority of Greek painting to a large extent depended on his being the great model for Greek painters.

Blackwell and Turnbull were both formative influences on the painter Gavin Hamilton (1721–1798) and the first clear manifestation in painting of the new primitivism of Ramsay and Blackwell appears in a series of pictures inspired by Homer's *Iliad*, that Hamilton began in Rome in 1759.[3] Hamilton was, like Aikman, the son of a country gentleman. He went to Glasgow University where Hutcheson was teaching philosophy and from there went on to study painting in Rome, *c.* 1746, in the studio of Agostino Masucci. He was friendly in Rome with James Stuart and Nicholas Revett who went from Italy to Greece to do the groundwork for their monumental *The Antiquities of Athens*, one of the principal source books for the Greek revival in architecture. It was a journey on which Hamilton may have been tempted to join them. He was under pressure though to make his way as a painter and he returned instead to Britain in 1751 where for a period he worked in a rather desultory way as a portrait painter, though he produced one very distinguished and celebrated portrait, that of *Elizabeth Gunning* (Duke of Hamilton, Holyroodhouse). In 1756 he was back in Rome where he remained for the rest of his life. Gathered in Rome at that moment was a remarkable company that included Allan Ramsay, Robert Adam and Robert Wood, explorer of classical Greece and the Near East and author of another important book on Homer, *An Essay on the Original Genius,*

Writings of Homer etc., first printed in 1767 but circulated some time earlier.

Hamilton painted Wood's portrait in an enormous painting that showed him at the ruins of Palmyra in the company of James Dawkins (Glasgow University). The picture was commissioned in 1757 by Wood as a memorial to Dawkins who had recently died and as a record of their joint expedition to the Middle East in search of antiquities. In Rome, Wood was planning his book on Homer. In it he took Blackwell's argument that Homer was essentially a naturalistic poet (one of Ramsay's 'good old Bards') and proved its validity by putting it to the test of comparing Homer's descriptions of landscapes and places with the actual landscapes of Greece which he had already twice visited. The painter Allan Ramsay undertook a very similar project which increasingly preoccupied him in later life, to discover the site of Horace's Sabine Villa and thus prove that Horace too was a poet, like his father, who described the world that he knew, 'the fields and meadows that he everyday beheld', as the elder Ramsay had put it in his preface to *The Evergreen*.

This view of Homer as a historical figure describing the remotest period of human history in a real, not an imaginary epic, was the starting point for Hamilton's pictures from the *Iliad*. Turnbull had argued for the epic in painting and also for its vital links with the inspiration that Greek painters found in Homer. 'Painting plainly admits the same variety as Poetry. . . . There is plainly the Epick, the Lyrick, the Tragick, the Comick, the Pastoral, the Elegiack, in the one art as well as the other,' he wrote.[4] Hamilton's pictures are deliberately epic in scale and grand in design. Though this ambition may well owe something to the French academic tradition of large-scale history painting founded by Le Brun, Hamilton ignores baroque painting and returns to Poussin, the High Renaissance, and their common model in Roman relief sculpture. He also takes such hints as he can about models in ancient Greek painting both from Turnbull and from Shaftesbury, particularly in the matters of figure scale and the absolute scale of the pictures, which are enormous.

Although it was not his first Homeric

Plate 91. GAVIN HAMILTON, *Andromache Mourning the Death of Hector*, SKETCH, c. 1759

subject, the first picture that Hamilton painted that eventually formed part of his series was *Andromache Mourning the Death of Hector* (1759, Earl Spencer, Althorp). It may not have been his plan at this stage to make a series. That idea seems to have sprung from the thought that he could make a set of engravings on the model of Hogarth's *Rake's Progress*, in which the pictures could be treated as a single, unified creation with a dramatic plot. Over the next fifteen years or more, five further compositions followed, all commissioned by different patrons. In order of the narrative they are *Achilles parting with Briseis* (1769, formerly Viscount Palmerston), *Hector's Farewell to Andromache* (c. 1775, Glasgow University), *Achilles Mourning Patroclus* (1763, NGS), *Achilles Revenge on the Body of Hector* (1766, lost), *Priam pleading with Achilles for the Body of Hector* (c. 1775, small version, Tate Gallery) and *Andromache Mourning the Death of Hector*. (*Plate 91*) Together these six scenes extract and condense from the *Iliad* the story of the wrath of Achilles. They match it, however, with a pathetic counter-plot of the story of Hector and Andromache which provides a gloss of

Hamilton's own on Homer's narrative. The subject is therefore passion; passion on an epic scale, but, as in the contemporary assessment of Shakespeare, passion that is entirely human. There is no divine intervention. All the action is explained by human emotion. In this sense the pictures are naturalistic, though not in the manner of representation.

This kind of naturalism, if that is not a misleading term, is another link with Hogarth with whose *Rake's Progress* Hamilton's series has a number of points in common, apart from their being engraved. Hogarth's concern in both the *Rake's* and the *Harlot's Progress* was with natural morality. Neither the Rake nor the Harlot is a villain. They are both victims of an unnatural society. Though Hamilton's *Iliad* series is not explicitly moral in this way, there is an implicit contrast between the present world and the natural society, the world of Homer that he portrays.

Blackwell too makes this contrast: 'The marvellous and wonderful are the nerve of the epic strain; but what marvellous things happen in a well-ordered state,' he writes, and he goes on to enlarge on the condition of the moderns.

They 'can think nothing great or beautiful but what is the product of wealth. They exclude themselves from the pleasantest and most natural images that adorn the old poetry, wealth and luxury disguise nature.'[5] Hamilton's approach puts an absolute value on intensity of feeling as the corollary of imaginative freedom. It was imaginative freedom itself, as the necessary precondition of moral sensibility, that was the primary goal for the artist and it was this to which Homer and, following the logic of Blackwell's argument, ultimately any primitive artist, could provide the key.

Hamilton's epic pictures interpret such ideas for the first time in painting and so have an important place in the early history of modern art. Indeed the Abbé Grant wrote from Rome in 1760 of his *Achilles Mourning Patroclus* that it was 'the best piece of modern painting I have ever seen', and he was not alone in recognising Hamilton's importance for he had a European reputation and influence. John Aikman of The Ross, writing in 1767 to arrange Anne Forbes's tuition in Rome, said of Hamilton that he was 'most renowned of all the History Painters of this age'.[6] His influence in France in particular may also have had a political connotation too, for in two of his pictures, *The Oath of Brutus* (1766, Yale Centre for British Art), (*Plate 92*), and *Agrippina with the Ashes of Germanicus* (1772, Tate Gallery), he seems to make a political point. Both have opposition to tyranny as their subject. In the first Brutus swears revenge against Tarquin for the rape and suicide of Lucretia and, in the second, Agrippina, wife of Germanicus and granddaughter of Augustus, by her return to Rome, mutely accuses the Emperor Tiberius of the murder of her husband. J.-L. David was much influenced by Hamilton and turned to this kind of Homeric subject on his arrival in Rome in 1776. He painted his own version of *Andromache Mourning Hector* for example and his painting of the *Blind Belisarius* is an enlarge-

Plate 92. DOMENICO CUNEGO, AFTER GAVIN HAMILTON, *The Oath of Brutus*, ENGRAVING, 1766

ment of a detail in the background of Hamilton's *Hector's Farewell to Andromache*. Hamilton's *The Oath of Brutus* also provided the starting point for David's expressly political *Oath of the Horatii*, a link which surely reflects David's understanding of Hamilton's subject as much as admiration for his composition.

Rome, as the century went by, became the centre of progressive painting in Europe. Hamilton, who was an amiable and approachable person, became the doyen of painters there and the focus for a considerable group of young Scots, though it was not only the Scots who followed him. As well as the Frenchman David, the Swede Tobias Serghells, the Swiss Henry Fuseli, and the Irishman James Barry were all more or less indebted to his example. He was not the only Scot active in Rome though. Assisted by the presence of the Jacobite court, the Scots occupied an important place there. There were antiquaries like James Byers who had trained as

an architect. The painter Colin Morison (1732–1810) had been a pupil of Blackwell and was a friend of Winckelmann. Andrew Lumsden and Abbé Grant were both well-placed Jacobites who moved into less political areas of activity as the Jacobite cause waned. Apart from Hamilton, the landscape painter Jacob More became a permanent resident in Rome in 1771 and occupied a leading position there. The place of More and Hamilton together was recognised when they were given the major commissions in the renovation of the Villa Borghese in the 1780s. More laid out the gardens and decorated the *Apollo and Daphne* room, while Hamilton realised a long-standing ambition to paint the story of *Paris and Helen* in a monumental series which survives, though it is partly dispersed. The painters David Allan and John Brown both spent fully ten years in the city and others, like Alexander Runciman, were there for long periods.

Plate 93. JOHN RUNCIMAN, *King Lear in the Storm*, 1767

Plate 94. JOHN RUNCIMAN. *The Adoration of the Shepherds, c. 1766*

Scottish artists were therefore at the centre of change in European art and it is not surprising to find that some of them were extremely precocious in developing new ideas and forms of painting. Most precocious of all those in Hamilton's circle were the Runciman brothers, John and Alexander (1744–1768/9 and 1736–1785), but their precocity did not begin in Rome.[7] Alexander was an apprentice in the Norie firm in Edinburgh. By 1767 he had become senior partner and so was one of the leading decorative painters in Scotland. His claim to complete domination of the market though was contested by William Delacour (*fl.* 1740–1767), a French artist who had come to Edinburgh to be first master of the Trustees Academy, founded in 1760, where he taught pattern design to apprentices in the linen trade as well as the art of drawing to students of more genteel origins, or higher ambition. Delacour

was an important figure. He worked with the Adam family at Hawkhill House, Milton House and Yester House and so seems to have supplanted the Nories as leading decorator. His most ambitious decorations are those in the saloon at Yester. They are large and colourful, classical capricci which must have been akin in execution to work that he did for the theatre where it would have been widely seen. In the theatre though, Alexander Runciman may have supplanted him in turn. Runciman certainly worked there and it may have been an important point of contact between them. Delacour, from his surviving decorations and also from such paintings as *A View of Edinburgh* (CEAC), was a considerable colourist. The Nories on the other hand specialised in monochrome decorations. The Runcimans were both technically inventive and Alexander's use of colour is very striking. It may be that Delacour played a part in their background.[8]

There is, however, nothing in Delacour's own art or that of the Nories to explain the ambitions of both brothers that are apparent in the work that they produced in Edinburgh before they left in 1767 to go to Rome. John's works are the most remarkable at this date, but Alexander was working closely alongside. The first dateable work by either brother is an etching of the *Taking down of the Netherbow* in 1764 by John Runciman. It was a record of a disappearing historical monument, the sixteenth-century eastern gate of Edinburgh. This antiquarian purpose is combined with a lively and dramatic vision of city life. The rapid and rather summary execution using bold hatching suggests that John learned his technique from etchings by Salvator Rosa. The Runciman brothers were friendly with the younger Richard Cooper, son of the engraver of the same name who had been one of the founders of the St Luke's Academy. The younger Cooper (*c.* 1740–*c.* 1814) followed Robert Strange to study engraving in Paris and subsequently worked in Spain and Italy as an engraver, and also as a landscape artist in a style very close to that of Alexander Runciman (examples in BM), before settling in England. It may have been from his father that the Runcimans learned to etch, an art in which they were both very accomplished.

John Runciman's early etching is similar in execution to a drawing by Alexander of *King Lear on the Heath* (*c.* 1767, NGS) which though it is crude in execution is a vivid interpretation of the play. In 1767 John treated the same theme in *King Lear in the Storm* (NGS). (*Plate 93*) It is one of about a dozen small oil paintings by him that can be dated to these years, between 1764 and 1767. All the others that survive have biblical subjects, for example his *Flight into Egypt* (NGS) and *The Adoration of the Shepherds* (*c.* 1766, Private Collection), (*Plate 94*), and they suggest that he was looking at Rembrandt, Teniers and ultimately Dürer for inspiration. John Runciman's *King Lear* though is more like a Rubens sketch. It is a remarkable picture. Instead of taking the stage directions, he has taken the poetry itself as the basis for his imagery. The scene is by the sea and the storm thus becomes a figurative interpretation of the play. He presents Lear himself as a calm and stable figure at the centre of the storm. He has not lost his wits, but recovered his humanity in union with nature through the identity of the violence of his own feelings with the violence of the elements. It is a profoundly romantic interpretation of the play and the execution of the picture reinforces that impression. It is painted rapidly and spontaneously and is subjective rather than analytical.

In 1767 the two Runciman brothers were engaged by Sir James Clerk of Penicuik to decorate his new house. He was to pay them in advance and they were to use the money to travel to Rome. Robert Alexander, an Edinburgh banker, gave them additional assistance. He also assisted the younger Richard Cooper. It was the opportunity the brothers had been waiting for. Alexander abandoned his business and arrived in Rome in May 1767. John arrived six months later, but within little more than a year he died of consumption. From his time in Rome there survive only a self-portrait, an etching and a few drawings. In the *Self-Portrait* (SNPG) he shows himself contemplating Michelangelo's figure of *Day* from the Medici Chapel. In its stress on inwardness, on what is going on in the artist's mind, it is already a very romantic picture, and one that may well have helped inspire Fuseli's famous drawing of himself, leaning on a book, deep in thought (NPG).

Plate 95. ALEXANDER RUNCIMAN, *Achilles & Pallas, c.* 1769

Fuseli almost certainly knew John Runciman's picture which must have remained in his brother's possession in Rome. The other works confirm that John was moving towards a dramatic and heroic style based on his admiration of Michelangelo, fulfilling the expressive intention of his early work, but with a new sense of grandeur.

A certain mystery surrounds John's death. He died in Naples, and certainly from consumption, but his departure from Rome was preceded by some kind of spite campaign apparently led by James Nevay (*fl.* 1755–1796). When Alexander first arrived in Rome he concentrated on landscape and produced some dramatic ink-drawings of Roman monuments, reminiscent of Norie decorations at Caroline Park and elsewhere (NGS). It was, he said, in defiance of his brother's enemies that he embarked on a massive painting with a Homeric subject, *Ulysses and Nausicaa* (lost), in direct emulation of Hamilton.[9] He was also friendly with James Barry and later with Henry Fuseli and there can be no doubt that he

already had his own ambitions to succeed as a history painter in the modern manner.

Around 1770 Hamilton was planning the scheme that he eventually carried out in the Villa Borghese.[10] This differed from his earlier Homeric paintings as it was a proposal for a set of narrative paintings designed for a single room. They were to be separate pictures in the Renaissance manner however and had none of the dramatic use of space of baroque decoration. The return to Renaissance sobriety was a fashion that had begun with Mengs's *Parnassus* on the ceiling of the Villa Albani in Rome, painted in 1761. In spite of this common ground, Hamilton's ideas about narrative and the description of heroic action and passion were radically different from the approach that Mengs represented. Mengs was a close ally of Winckelmann who saw Antique art as enshrining a canon of ideal beauty characterised by 'noble simplicity and sedate grandeur'. It is important to see how different this approach is from that adopted by Hamilton and his followers. Treating them as though they were in fact the same has led to a lot of confusion about the real nature of the movement in painting of which Hamilton was the focus in the 1760s and seventies, and for which the label 'neo-classical' is very misleading. To confuse the issue further though, as it was finally executed in the 1780s, Hamilton's *Paris and Helen* cycle was in fact closer to this new 'neo-classical' taste.

Hamilton's idea of a revival of Renaissance and Antique traditions of heroic, narrative painting was taken up by several of his younger associates. James Barry nursed the ambition to do something on these lines until he finally realised it in the paintings that he did in the Society of Arts in London between 1777 and 1783, *The Progress of Human Culture guided by the Arts*. Fuseli painted *The Milton Gallery* and the idea of linking history and poetry in engraved series gave rise to Flaxman's line engravings after Homer, Dante and Hesiod and also to Blake's illustrations culminating in his *Book of Job*. Various projects of the later century, like Boydell's *Shakespeare Gallery*, in whose inception Fuseli was involved, and Bowyer's *History Gallery*, all ultimately derive from the same inspiration.

The first and the most full-bloodedly romantic and primitive of all these projects, however, was the decoration that Alexander Runciman eventually painted to fulfil his contract with Sir James Clerk at Penicuik. Early drawings for the saloon at Penicuik show that what was originally intended, though it included a large subject picture in the centre of a coved ceiling, was fairly tame and recognisably in the Norie tradition. In Rome Runciman soon began to think of more ambitious ideas. His first proposal was a picture of *Bacchus and Ariadne* (location unknown) inspired by Annibale Carracci's ceiling in the Farnese Palace, but then he moved on to a full-scale narrative series of the story of Achilles. It was frankly modelled on Hamilton's *Paris and Helen* project though it was also not a little indebted to his *Iliad* paintings. Runciman did a considerable number of drawings for this scheme. The most interesting of them are a very elaborate study for a central picture with the *Marriage of Peleus and Thetis* (1771, NGS), Achilles' parents, and a study of *Achilles & Pallas* (c. 1769, NGS), (*Plate 95*) from the first scene of the *Iliad* where Pallas intervenes to stop Achilles drawing his sword in his quarrel with Agamemnon. The latter is closely comparable to James Barry's painting of *Adam and Eve*, a picture that he was working on at the time in Rome. Both artists have taken as their model the same detail of the sarcophagus, *Achilles among the Daughters of Lycomedes*, in the Capitoline Museum where we know that they were working together in 1769.[11] What is unusual about these drawings by Runciman though is that they are executed more or less in pure outline.

The younger painters moved on from Hamilton's position to see that emulating art from the time of Homer posed a problem of style. What would such art actually have looked like? It clearly would not have resembled the kind of Roman and Renaissance imagery that were Hamilton's model. One argument was that it would have been extremely simple, reduced to the bare essentials. Confirmation of this view was found in the Greek, Etruscan and Italian vases which seemed to date from the time of Homer himself and whose collection and study was pioneered by Sir William

Plate 96. ALEXANDER RUNCIMAN, *The Origin of Painting*, 1773

Hamilton, British envoy in Naples. Both Runciman and Fuseli imitated these directly in drawings in which the figure, as it is in red-figure vases, is a reserved, light area in a dark field. The inspiration of these vases also lies behind the technique that Runciman adopted in his drawings of *Peleus and Thetis* and *Achilles & Pallas*. They reflect the view that outline was the essential minimum and therefore the first vehicle of expression for the primitive artist.

There was further support of this view of primitive art to be found in Pliny's account of the early history of classical art and Runciman gave this a pictorial interpretation in his picture, *The Origin of Painting* (1773, Sir John Clerk of Penicuik), (*Plate 96*) which, though it was not executed till after his return to Scotland, was planned in a drawing done in Rome (Private Collection). It is a subject taken from Pliny's story of how the daughter of a Corinthian potter, Debutades, made the first drawing when she recorded the outline of her lover's shadow on the wall. In Runciman's picture her hand is guided by Cupid as she traces the shadow with a fine brush.

Runciman, however, moved away from this interpretation of the primitive towards something that was untouched by such classical traditions and so was even more modern. This

was implicit in the subject that he eventually chose at Penicuik, the poems of Ossian, and the room that he painted in the summer of 1772 became known as *The Hall of Ossian*. In an adjacent staircase he also painted four scenes from the life of St Margaret of Scotland. Tragically the paintings were destroyed with the house in a fire in 1899 and so are now only known to us in a series of old photographs, and a nineteenth-century watercolour painting of the saloon which includes a precise account of the ceiling (Sir John Clerk of Penicuik). (*Plate 98*) There are, however, a number of Runciman's own drawings for the paintings, and etchings after several of them. There are also two written descriptions. One is by a friend of Runciman, Walter Ross, done when the pictures were newly completed and the other was written at the end of the nineteenth century by John Gray.

The poems of Ossian were published in stages between 1760 and 1763 by James Macpherson. They purported to be translations of genuine ancient Gaelic poetry. In fact their authenticity ranges from free translation of actual Gaelic verse to pure invention. Because of this their subsequent history and reputation have been clouded by controversy, but they were in their time enormously influential. They

were the object of great excitement throughout Europe and were of course especially so in Scotland. Here it seemed was the authentic voice of the ancient Caledonians. Hugh Blair, who became professor at Edinburgh in 1760, took up Macpherson and championed Ossian's poetry. He wrote an introduction to the collected poems which carries on directly from Blackwell's account of Homer, though now the topic had the immensely greater attraction of immediacy. The poetry of Ossian seemed to be a living survival from the age of heroes.

Hugh Blair's account of the character of such primitive poetry and the qualities from which it drew its power was based on the same model of the evolution of human society as Blackwell's. 'The manners of Ossian's age,' he wrote '. . . were abundantly favourable to a poetical genius. . . . Irregular and unpolished we may expect the productions of uncultivated ages to be; but abounding at the same time with that vehemence and fire which are the soul of poetry. For many circumstances of those times which we call barbarous are favourable to the poetical spirit. That state in which human nature shoots wild and free, though unfit for other improvements, certainly encourages the high exertions of fancy and passion.'[12] As Blair presented it, the poetry of Ossian provided a new and different model of the primitive. It was marked by spontaneity and vivid immediacy, by

lack of restraint and freedom from conventions of form and finish. While he was still in Rome Runciman did a drawing of *Ossian Singing* with just this character (*c.* 1770, Private Collection). (*Plate 97*) It is in pen, handled with great rapidity. Ossian is seated under a tree, playing his harp, the wind blowing his hair and cloak. He is at one with nature.

When Runciman returned to Edinburgh in 1771 his ambition to paint an epic in a true primitive manner was probably already formed, but he would certainly have been encouraged in it by his Edinburgh friends, men like James Cumming, painter and antiquarian, or David Herd, collector of ballads. They were all members of the Cape Club, an Edinburgh drinking club, not of leisured gentlemen, but of actors, musicians, writers' clerks, poets and artists. They drank porter, not claret and met in a variety of taverns wherever they could tolerate the beer or were themselves tolerated.[13] They were a bohemian group, but they represented the same stratum of Edinburgh society as the senior Allan Ramsay and like him they were conscious champions of Scottish culture. One of their number, Walter Ruddiman, founder of the newspaper, *The Caledonian Mercury*, echoes Ramsay's remarks in *The Evergreen* in an editorial where he says: 'We hope to render our publication not a flimsy retail shop of imported foreign articles, but a genuine Caledonian magazine.'[14] The poet, Robert Fergusson, was also a member of the club and it was this same group, again following Ramsay, that provided the support for the revival of poetry in Scots in which he played such an important role.

Runciman eventually painted *The Hall of Ossian* between July and September 1772 and during the next two months he also completed four paintings with the story of St Margaret, in one of the adjacent staircases. It was an astonishing season of work whose rapidity alone testifies to his intention to emulate the 'vehemence and fire' of Ossian. *The Hall of Ossian* was a room thirty-six feet by twenty-four feet with a coved ceiling. The central part of the ceiling was an oval in which Ossian was seen singing to an audience on the sea-shore. (*Plate 100*) The four corners of the rectangle of the ceiling left by the oval were filled with four river gods, the rivers of Scotland; the Tay, the Spey, the

Plate 97. ALEXANDER RUNCIMAN, *Ossian Singing, c. 1770*

Plate 98. G. CARELLI, AFTER ALEXANDER RUNCIMAN, DETAIL OF *The Hall of Ossian*, 1772

Tweed and the Clyde, gigantic Michaelangeles-que figures, but each set in a landscape of appropriate character. (*Plate 99*) In the cove, that is the curved surface between the flat of the wall and the flat of the ceiling, there were twelve compositions, mostly, but not all, illustrating the poetry of Ossian. The exceptions were scenes from 'the era of Ossian' as James Macpherson described it in an introductory essay to his publication of the poems.

It is possible to deduce from the surviving records much of what the impact of Runciman's painting must have been, but perhaps the most convincing evidence for its quality lies in the etchings which represent his own account of his finished work. It may have been his intention to record the whole series in prints, but in the end he seems to have recorded only four of his compositions, two from *The Hall of Ossian* and two from the story of St Margaret. He also did various easel paintings which, as they had the same subjects as some of the decorations, presumably repeated their compositions. Runciman repeated one of the etchings, *Fingal and Conban-cârgla*, in three different versions, but the middle-sized version of the three seems to capture most fully the wild freedom of the paintings. (*Plate 101*) The scene is by moonlight. Conban-cârgla, a captured maiden, is a white figure under the rock to the right. Fingal towers above the landscape. His figure is cut by the shadow of his shield in the moonlight so that its pattern is like that of the mighty, twisted pine that stands between them. All the conventions of figure drawing are ignored, but the

dramatic immediacy of the moment is vividly conveyed. The figures too are at one with the landscape which is held together by an overall pattern of light and shade and which is also clearly characterised as Scotland. The river gods served this same purpose. Ossian, like Homer according to Blackwell and Wood, or like Ramsay's 'good old Bards', was presented as describing a real, known world, 'the Fields and Meadows we every Day behold'.

The painting of *The Hall of Ossian* was done in oil directly on to white-primed plaster and the colour was brilliant. We can see something of the effect in the paintings that survive from a scheme that Runciman carried out the following year in the new Episcopal Chapel in the Cowgate, Edinburgh, where he painted a half-dome with the *Ascension* (which was subsequently painted out when the church changed hands at the beginning of the nineteenth century) and four wall-panels. The church has since changed hands again and is now St Patrick's Catholic Church. These latter panels have remained visible. Two are ovals with the prophets, Elijah and Moses, and two are scenes from the New Testament, the *Return of the Prodigal* and *Christ and the Woman of Samaria*, both subjects which refer to the position of the Episcopal Church in Scotland. Even in the condition that they are in it is possible to see that the painting was very free and rapid, and the colour brilliant. The technical virtuosity of the painting and its lack of inhibition is a reminder that by training Runciman belonged in the tradition of the decorative

painters. At one level therefore the painting at Penicuik revives the skills of the painters who painted the ceilings of Scottish houses in the previous century. At another level though it was a work that was dramatically modern. He abandoned conventions of finish and of drawing to court spontaneity and expression in a way that was quite at variance with neo-classical taste, but was prophetic of the way that modern art eventually developed.

For a long time Runciman was regarded as a follower of Fuseli on the rather simplistic assumption that because Fuseli was subsequently more famous he was always the more important. Fuseli's own opinion of Runciman though was that he was the 'best painter among us here in Rome'[15] and later after Runciman's death he wrote of his special skill in the techniques of painting.[16] It was a good assessment for Runciman's achievement as an artist depends on such painterly skills as his use of colour, his feeling for light and shade and the overall unity of a picture. These were the gifts of a landscape painter, an area in which he was celebrated in his lifetime though only a few of his landscapes now survive. These include a few small oil paintings and a number of landscape drawings. A series of unknown date in pen and watercolour of East Lothian and the eastern outskirts of Edinburgh are of great beauty (NGS). There is also one major subject landscape, however, *The Allegro*, painted in 1773 (Private Collection). (*Plate 102*) The subject is Milton's poem of the same name, but it is set in the actual landscape of Perth and Scone Palace. Its theme of town and country is identical to the theme of Robert Fergusson's poem, 'Hame Content', written at just the same

time and when the two men were on terms of close friendship. Fergusson's poem is an important theoretical statement in which he identifies the natural with the native and Scottish, and contrasts it with the artificial and alien. In this he echoes closely Ramsay and also, in a different way, Thomson and Blackwell (see below, pp176 and 178). The connection of Fergusson's poem, with its stress on the native, the simple, the spontaneous and the natural, with Runciman also provides another gloss on the painter's intention to capture these qualities in his Ossian paintings. Fergusson also celebrated the paintings directly in his poem, *On first seeing a Collection of Pictures by Mr Runciman* and he probably imitated them in his *Ode on the Rivers of Scotland*.

When Runciman died in Edinburgh in 1785 he was not yet fifty. He was appointed Master of the Trustees' Academy in 1772 and he held the post for the rest of his life. He was disappointed in the hope expressed at the time of his appointment, that the success of the Penicuik pictures and of his paintings for the Episcopal Chapel would lead to more commissions of the same kind.[17] He did decorative paintings in the Edinburgh Theatre and in the Royal Infirmary and he had various other projects, but none of these matched the scale of his major works. He continued to paint ambitious easel pictures however and to exhibit them in London. Several of these survive and others are known from drawings, notably *Satan touched by Ithuriel's Spear* (RA 1773, Private Collection), *The Death of Dido* (1778) and *Agrippina landing with the Ashes of Germanicus* (RA 1781; both Private Collection).

Even though the last picture was not

Plate 99. ALEXANDER RUNCIMAN, *The Spey and the Tay*, DETAIL OF *The Hall of Ossian*, 1772

exhibited till 1781, like the others it refers back to Runciman's experience in Rome. Agrippina was the subject of the major painting that Gavin Hamilton was engaged on when Runciman was there and there are drawings by him that show that he was planning his own version of the subject at the time. Among his exhibited pictures though, as well as subjects from Ossian, there were a number of pictures taken from more modern history, the *Abdication of Mary Queen of Scots* (RA 1782 lost; drawing NGS), though here too he was anticipated by Hamilton who executed a picture of this subject for James Boswell (Glasgow University), and *The Parting of Lord and Lady Russell* (RA 1781, lost; drawing NGS). For both of these there are drawings. The latter was obviously an ambitious painting, but the continuing unconventionality of Runciman's style was not to the taste of one English reviewer who dismissed it as 'all brick dust, charcoal and Scotch snuff'.[18] In spite of his disappointment, Runciman's reputation survived in Scotland

and he was influential in a number of ways, on those whom he taught directly such as Raeburn and Nasmyth and later also on David Scott. As one of the earliest pioneers of certain distinctively modern attitudes towards painting he also has a place in the history of European art however.

The reputation of John Brown (1749–1787), another member of the Scots circle in Rome, has also suffered from his association with Fuseli. Brown was in Rome throughout the entire decade of the 1770s. Before he went to Rome he had studied in Edinburgh with Delacour, but his art and his very clear convictions about it were certainly formed in Rome, in association with Runciman and Fuseli, perhaps, rather than in any direct dependence on either. For the last few years of his life he worked in both Edinburgh and London. His renewed acquaintance with Runciman in Edinburgh is celebrated in the vivid and idiosyncratic double portrait that Runciman painted of them together in 1784 (SNPG).

Plate 100. ALEXANDER RUNCIMAN, *Ossian Singing*, SKETCH FOR *The Hall of Ossian*, 1772

Brown's entire surviving oeuvre is in pencil or ink. Much of it consists of straightforward work as an academic draughtsman, recording classical objects for a number of leading collectors. Latterly he also worked as a portrait draughtsman producing pencil drawings of his sitters in a neo-classical taste akin to that of James Tassie's paste medallions. An important group of these were done for the Society of Antiquaries, recording the members of the society founded by the Earl of Buchan who included among their number a good few of the Cape Club circle. Brown's most interesting and original work though is in his imaginative compositions. In some of these he is close to Fuseli, but in others with genre subjects he is strikingly original. In such pictures as *The Stilleto Merchant* (Pierpoint Morgan Library) and *Woman Standing among the Friars* (Cleveland Museum of Art), (*Plate 103*) he manages to combine a sense of actuality with a sinister atmosphere that suggests the modern cinema rather than anything between.

Of this generation it was, however, David Allan (1744–1796) who had, along with Runciman, the most lasting effect on painting in Scotland.[19] Allan came from Alloa and was a student at the Foulis Academy in Glasgow before he went to Rome in 1767, supported by the Erskine family. In Rome he may have been formally a pupil of Gavin Hamilton. He was certainly close to him and for some of the ten years he spent in Italy he aspired to succeed as a history painter in emulation of Hamilton. His efforts in the genre are not very distinguished however, though they did win him a prize for history painting in the Concorso Balestra at the Academy of St Luke in 1773. Hamilton was president of the Academy at the time. The subject of the composition, no doubt set by him, was *Hector's Farewell to Andromache* and Allan's prize-winning picture is remarkably like Hamilton's own treatment of the same subject (Academia di San Luca, Rome). Allan's most successful history painting of the period is his version of *The Origin of Painting*, a small oval picture, less ambitious than Runciman's treatment of the same theme, but an indication of their common interest (1775, NGS). Back in Scotland Allan practised as a portrait painter, specialising in conversation portraits, usually set in the open and modelled on Zoffany's painting in the same genre. These are balanced rather uneasily between neo-classical simplicity and naïvety but they do have considerable charm.

It was as a genre artist though that Allan made his reputation. In Italy he spent some time in Naples where he painted the portrait of

Plate 101. ALEXANDER RUNCIMAN, *Fingal and Conban-cârgla*, c. 1772

Plate 102. ALEXANDER RUNCIMAN, *The Allegro*, 1773

Sir William Hamilton (NPG). The Neapolitan painter, Pietro Fabris was also a member of Sir William Hamilton's circle. He too painted Sir William's portrait and collaborated with him on a study of Vesuvius. Fabris was an accomplished genre painter in the Neapolitan manner and it seems to have been his example which started Allan on his career as genre artist. In Naples he painted a number of scenes of popular entertainments and events, a *Neapolitan Dance* and various popular games for example (undated, Margaret Sharpe Erskine Trust). In Rome he did a series of large drawings of the *Carnival* which, when Allan was in London, were bought and published as prints by Paul Sandby (1775, HM the Queen). These record the details of the scene and the behaviour of the people, often in a quite comical way, but with a serious documentary intention as well.

He also produced in Rome a series of drawings of the *Seven Sacraments* (Margaret Sharpe Erskine Trust) which are of special interest because he takes the grand theme of Poussin's series and treats it as a study in the simple faith of ordinary people. The analogy with Poussin suggests that at this point Allan was moving on from the model of Neapolitan genre and already thinking of the possibility of turning it into something more serious, as he subsequently declared was his intention in the illustrations that he did to Allan Ramsay's 'Gentle Shepherd'.[20] In the *Seven Sacraments* Allan's subject is simple piety. In the *Neapolitan Dance*, in a similar way, it is simple grace. In the principal figures he captures attitudes which

he presents as though they were unconscious, natural echoes of a piece of classical sculpture, or a figure on a Greek vase, an idea that had a notable exponent in Lady Hamilton who was famous for her 'attitudes', classical poses struck in diaphanous costume. Allan's subjects present the innate qualities of unaffected behaviour, a pure sensibility surviving as part of the quality of life where that has not been distorted by the impact of civilisation.

With a similar end in view Allan made numerous studies of costume, especially on the islands of Capri, Procida, Ischia and Minorca. It seems to have been a widely held view that folk costume was unchanging, perhaps it was an argument that depended on contrast with the notorious mutability of fashion. Allan may also have been in agreement with James Byers, whom he certainly knew in Rome, who believed that the islands of the Mediterranean were of special interest in the study of ancient customs because they would have provided a refuge from the Flood and would subsequently have been protected from radical change by their isolation.[21] James Macpherson produced similar arguments for the way ancient traditions would have been preserved in the Highlands of Scotland. 'If tradition could be depended upon,' he wrote, 'it is only among a people from all time free from intermixture with foreigners. . . . Such are the inhabitants of the mountains of Scotland. . . . Their language is pure and original, and their manners are those of an ancient and unmixed race of men.'[22]

Plate 103. JOHN BROWN. *Woman Standing among the Friars*

Allan, like Macpherson in Scotland, was pursuing a kind of living archaeology in his study of customs and costumes in the Mediterranean and it was one that he could very easily transfer to Scotland, as indeed he did. Soon after his return to Scotland after a brief spell in the south, he wrote to Sir William Hamilton in Naples saying that he had painted 'at Athole for myself a highland dance as a companion to the Neapolitan, but the Highland is the most picturesque and curious'.[23] He went on to say that he intended to paint several such pictures, as indeed he did. There is not only *The Highland Dance* to which he refers in his letter to Hamilton (*c.* 1780, Margaret Sharpe Erskine Trust), (*Plate 105*) but there is also *The Highland Wedding* (undated, Private Collection, drawing NGS) in which he recorded all the curious customs then still associated with such celebrations. He does this in a way that combines charm with genuine documentary interest. Nor did he limit himself to the Highlands. He produced a variety of drawings of life in and around Edinburgh, ranging from single figures of city types which were fashionable throughout Europe at the time, as in Wheatley's *Cries of London* for example, to more ambitious compositions of a less familiar kind like the *Coalminers' Celebration* (Marquess of Linlithgow, Hopetoun House). Taking his cue from Hogarth he also turned such drawings into prints which combined social observation with mild satire as in *The Stool of Repentance* (NGS).

The documentary interest of Allan's Scottish drawings is considerable, but the ambition to turn genre into something more serious, first apparent in his *Seven Sacraments*, stayed with him. Like Runciman he responded enthusiastically to the perception of Scottish rural society as ancient and unspoiled. This underlay the acceptance of Ossian, but it was not the exclusive property of Macpherson. David Herd for example remarked in the introduction to his collection of Scottish ballads, published in 1769, that the tradition of popular music in Scotland derived its unusual strength from the 'romantic face of the country and the pastoral life of the great part of its inhabitants'. Robert Fergusson upheld this view throughout his poetry, but especially in 'Hame Content' and

while Peggy laces up her bosom fair
we a blue snood Jenny binds up her hair
Glaud by his morning ingle takes a beek
the rising sun shines motty thro the reek
a pipe his mouth the Lasses pleas his een
and now & then his Joke maun intervein

Plate 104. DAVID ALLAN, *Glaud and Peggy*, SCENE FROM *The Gentle Shepherd*, 1789

'The Farmer's Ingle' where he allied it, on the one hand to poetic theory and on the other, echoing Goldsmith's 'Deserted Village', to a view of the place of the peasantry at the heart of the nation's well-being in contrast to the meretricious town dwellers with their neurotic pursuit of wealth whom he characterised so vividly in 'Hame Content':

> Some fock, like bees, fu' glegly rin
> To bykes bang'd fu' o' strife and din,
> And thieve and huddle crumb by crumb,
> Till they have scrapt the dautit plumb,
> Then craw fell crowsly o' their wark,
> Tell o'er their turners mark by mark
> Yet darna think to lowse the pose,
> To aid their neighbour's ails and woes.

Burns accepted the same contrast as the basic framework for much of his poetry and it is not at all surprising to find that Burns and Allan did actually collaborate. From 1792 onwards Allan was producing illustrations to the songs that Burns was either composing, editing, or amending for a collection that George Thomson was making of Scots songs, a collection for which Thomson also commis-sioned settings from Haydn and Beethoven. The three-way relationship between Burns, Thomson and Allan is recorded in a series of letters between Burns and Thomson and from these it is clear that Burns felt that Allan's charming oval vignettes, of which more than a hundred survive, exactly fitted the spirit of his songs (the largest group is in the RSA).

Allan's association with Scottish poetry and song did not begin with the work that he did for Thomson however. The idea of producing a series of illustrations of Scots songs pre-dated that relationship and may have begun with a project of illustrating David Herd's collection of ballads. Certainly a significant number of his illustrations are to songs published by Herd. *The Highland Dance* itself is very much a picture of music and the fiddler in it is identified as Neil Gow, the foremost fiddler of his time.

It was the same kind of interest that was the inspiration of Allan's most celebrated work, his illustrations to Allan Ramsay's *The Gentle Shepherd* published in 1788. (*Plate 104*) This project may very well have begun with the younger

Plate 105. DAVID ALLAN, *The Highland Dance*, 1780

Plate 106. DAVID ALLAN, *The Penny Wedding*, 1795

Ramsay who had always wanted to produce a fine edition of his father's famous pastoral, but the book was dedicated to Gavin Hamilton. In this dedication Allan makes it clear that the twelve whole-page etchings with which he illustrated the work were not, in his view at least, utterly remote from Hamilton's own illustrations to Homer. He too, he claims, had copied from nature and his pictures have a special authenticity: 'It is well known he composed ['The Gentle Shepherd'] in the neighbourhood of the Pentland Hills, a few miles from Edinburgh, where the shepherds to this day sing his songs, and the old people remember him reciting his verses. I have studied the same characters on the same spot, from Nature.'

Allan equates his own fidelity to nature with Allan Ramsay's authentic pastoralism. Ramsay has become one of his own 'good old Bards', a poet at one with nature and the natural way of life of unspoiled country people. According to Allan, his claim to the authentic voice of poetry is in fact the same as Ossian's, or even Homer's, though he is a modern, and Allan's own claim to similar authenticity, though himself a modern too, is an intriguing one. It does not consist merely in recording in a documentary way the lives of the ordinary country folk. It involves imitating in his art the values which they are held to represent. In the same dedication he says of his own technique in the use of the new method of aquatint: 'It will be easily seen that I am not a master in the mechanical part of this art; but my chief intention was not to offer expensive, smooth engravings, but expressive and characteristic designs.' He was perhaps the first modern artist to claim that it was the very lack of sophistication, the naïvety of his art that was the basis of its expressiveness and so of its claim to consideration.

Looking carefully at his prints in terms of style it is possible to see that he was trying to do the same thing in the way that he composes them as he claims to do in the execution. Though never a master of complex and sophisticated composition, he makes a virtue of simplicity, avoiding sinuous lines, dramatic poses, or strong chiaroscuro. Without elaboration he clearly distinguishes the types of his characters and he incorporates enough directly observed detail of costume, furnishings etc. to locate the scenes he depicts firmly in place and time. The illustration of *Glaud and Peggy* (*Plate 104*), for example, includes all sorts of detail of a cottage interior such as an open hearth, hams hanging to smoke in the rafters in the company of chickens, details of the girls' toilet and ballad broad-sheets pinned to the wall. It is interesting that he sees such documentary fidelity to detail as compatible with this kind of naïvety and it is an approach very much in contrast to most eighteenth-century pastoralism. He really does come very close to imitating visually Ramsay's own account of the virtues of simple, native poetry that he had attempted to emulate in his pastoral whose naturalistic detail was likewise remarkable in the context of the pastoral tradition. It also explains further Allan's affinity with Burns, in so many ways Ramsay's heir and for whom a belief in the special qualities of naïvety and spontaneity in folk poetry and music was combined with an unshakeable sense of the importance of the concrete, the specific and the local.

The affinity between Allan and Burns can be carried a little further too. One of Allan's most memorable works is *The Penny Wedding* painted in 1795 (NGS). (*Plate 106*) It shows a popular wedding taking place in a barn, The scene is dominated by a young couple, dancing with all the natural grace of youth to the music of fiddlers. The subject looks back, not only to Allan's own earlier dance compositions, but to

Jacob de Wet and beyond him to Breughel whose *Peasant Wedding*, a penny wedding too, is the ultimate inspiration of the picture. Allan's picture is also a direct variation on his own composition, *Tullochgorum*, one of his oval illustrations to Scots songs.

The idea that music and dance were natural forms of expression which, as their basis is harmony, had played a part in ordering the very first societies, had some currency in the eighteenth century. James Barry gave it memorable expression in his paintings for the Society of Arts, *The Progress of Human Culture guided by the Arts*, in which Orpheus with his lyre is the law-giver, the original bringer of harmony. Allan's principal group of dancers seems to echo Barry's composition in that series, the *Grecian Harvest Home*. The series was in progress when Allan was in London at the end of the 1770s. That the separation of music from its original social role was a measure of the decadence of modern society was argued by John Brown of Newcastle in the magnificently titled *Dissertation on the Rise, Union and Power, the Progressions, Separations, and Corruptions of Poetry and Music* (London, 1763) and his arguments may also have some bearing on Allan's watercolour. A penny wedding was an occasion when the guests at a rural wedding contributed their penny to cover the costs of the entertainment and to help the young couple set up home. It was a model of self-help among equals, of cooperation. In the picture in the right foreground, where two men are shown guzzling, greed creates ugliness. In a detail of two dogs it creates outright discord. They are the brute creation, impervious to the music, quarrelling over a bone, symbol of the divisive power of property. The music and the dance are therefore also symbols of the harmony of a natural society based on cooperation, not competition. It is a view of the world that Wilkie in turn inherited from Allan and Burns.

THE BIRTH OF
SCOTTISH LANDSCAPE

lexander Runciman's *Hall of Ossian* could be seen, with almost equal justice, either as the last painted ceiling in the seventeenth-century tradition of the painter-decorators, or as the first major painting in the modern tradition in which art defies convention in order to reach a new level of imaginative expression. The most important landscape painters in the next generation, Alexander Nasmyth (1758–1840) and Jacob More (1740–1793), were both Runciman's pupils. They also both served as apprentices in the painters' trade, More to Runciman himself and Nasmyth to his close friend, James Cumming. While he was an apprentice with Cumming, Nasmyth also studied with Runciman at the Trustees Academy. The landscape painting of these two younger painters shares something of the Janus character of Runciman's main work. Landscape was still the principal form of decorative painting and Nasmyth and More carried on directly from this decorative tradition, even while they drew new inspiration from ideas of poetry and history. In this way a distinct tradition of landscape, with its roots in the art of the decorative painters, continued well into the nineteenth century. For this reason the later part of this chapter overlaps chronologically with Chapter XI which examines the development of romantic landscape painting.

Although he was the most ambitious, Runciman was not the only artist in his own generation to have served an apprenticeship with Robert Norie, James Norie's eldest son. Although Robert studied in the south with the English landscape and decorative painter George Lambert, a group of four classical landscapes signed by him in 1741 at Holyrood,

make it clear that he simply carried on in his father's style.[1] Nasmyth's first master, James Cumming, was an apprentice of Robert Norie at the same time as Runciman. He followed in the old tradition of the Scottish painter-decorators to become a herald and herald painter. In keeping with this he was also an antiquarian, as were so many Scottish painters in the succeeding century, and he became a leading member of the Society of Antiquaries when it was founded in the early 1780s. Enough of his decorative painting is identifiable to see that he worked in a landscape style akin to that of Runciman and to attribute to him the remarkable portrait of *William McGregor* (c. 1780, CEAC), an Edinburgh porter and possibly a Gaelic singer, whom he painted to look like Ossian (discussed above p88). (*Plate 107*)

Another painter who, from his style and circumstances it seems must also have been an apprentice with Robert Norie at the same time as Runciman and Cumming, was Charles Steuart (*fl.* 1762–1790). Steuart exhibited in London in 1762, as did Alexander Runciman. Both painters sent landscapes to the Free Society exhibition. Runciman was still working with Robert Norie at the time (James Norie died in 1757) so it seems very likely that the two young painters were linked and that they developed their ambitions in parallel. Steuart's principal work is a very striking set of decorative landscapes at Blair Castle done between 1766 and 1778.[2] The Nories had worked at Blair before him and several views of Blair Castle and its surroundings by James Norie are recorded but do not survive. Steuart's decorations develop this kind of painting – he chose picturesque spots around Blair Atholl for

Plate 107. JAMES CUMMING, *William McGregor*, c. 1780

his subjects. There is, for example, *The Black Lynn, Fall on the Bran* (1766, Duke of Atholl, Blair Castle), (*Plate 108*) and a dramatic view of *The Falls of Bruar* (1777). He also worked for the Earl of Bute, and at Taymouth Castle for the Earl of Breadalbane where he again followed the Nories.

Jacob More also began his career as an apprentice to Robert Norie, but after Norie's death in 1766 he continued his apprenticeship with Alexander Runciman until the latter left for Rome in 1767. In 1769 More did stage scenery for the new Theatre Royal in Edinburgh which brought him some celebrity. Then after spending some time in London, he travelled to Rome in his turn in 1771, where he settled to remain for the rest of his life. His early paintings from before he left Scotland such as *Rosslyn Castle* (c. 1770, Earl of Wemyss and March), (*Plate 109*) like those of Charles Steuart, relate directly to the decorative painting of the Nories, even to the limitation of colour. *Rosslyn Castle* is boldly and simply constructed in a greeny-grey tonality and the same

qualities are still apparent in More's most famous and most successful paintings, the series of *The Falls of Clyde* of 1771.

These pictures, *Cora Linn* (NGS), (*Plate 110*), *Bonington Linn* (Fitzwilliam) and *Stonehouse Linn* (Spink & Son), are of special importance. They are not unique, as some of Steuart's waterfalls at Blair Castle anticipate them in date. They are nevertheless among the earliest really ambitious celebrations of the national landscape. There is a heroic intention in them which is still clearly legible and which is really only matched in some of Richard Wilson's Welsh views which are of similar date. More's pictures celebrate the genius of place in terms of the great natural phenomenon of the falls themselves, but also in terms of their associations. Burns, in his *Common Place Book*, describes the landscape of his native Carrick and makes a direct connexion between the topography of the country and the deeds it has witnessed, of Wallace and of the Covenanters.[3] Wallace was associated with the Falls of Clyde too. So also was James Thomson whose friend, Dr Cranston, had an estate along the Clyde by the falls and Thomson described them in 'The Seasons' in both 'Summer' and 'Winter':

> Smooth to the shelving brink a copious flood
> Rolls fair and placid; where collected all
> In one impetuous torrent, down the steep
> It thundering shoots, and shakes the country round.
> At first an azure sheet, it rushes broad;
> Then whitening by degrees, as prone it falls,
> And from the loud-resounding rocks below
> Dash'd in a cloud of foam, it sends aloft
> A hoary mist, and forms a ceaseless shower.
> Nor can the tortur'd wave here find repose;
> But, raging still amid the shaggy rocks,
> Now flashes o'er the scattered fragments, now
> Aslant the hollow channel rapid darts;
> And falling fast from gradual slope to slope,
> With wild infracted course, and lessen'd roar,
> It gains a safer bed, and steals at last,
> Along the mazes of the quiet vale.
> 'Summer'

> Wide oe'r the brim, with many a torrent swelled,
> And the mix'd ruin of its banks o'erspread,
> At last the roused up river pours along:
> Resistless, roaring, dreadful, down it comes,
> From the rude mountain and the mossy wild,
> Tumbling through rocks abrupt, and sounding far;
> Then o'er the sanded valley floating spreads,
> Calm, sluggish, silent; till again, constrained
> Between two meeting hills, it burst a way,
> Where rocks and woods o'erhang the turbid stream;
> There gathering triple force, rapid and deep,
> It boils and wheels, and foams, and thunders through.
> 'Winter'

With such credentials the genius of place stood

Plate 108. CHARLES STEUART, *The Black Lynn, Fall on the Bran*, 1766

too for the genius of the nation and to a contemporary the comparison between More's treatment of the Falls and Runciman's treatment of Ossian would have been obvious.

More may also have had links with one of Thomson's Scottish followers, James Beattie. Beattie was an accomplished nature poet as well as a philosopher. He was also a friend of Joshua Reynolds who seems to have taken an interest in More when he was in London in early 1771. It may therefore have been partly the influence of Reynolds that persuaded More to abandon the dramatically specific character of his early paintings in favour of a generalised, academic approach to landscape which to modern eyes appears to be little more than a pastiche of Claude. Whatever the source of this change of style, More exploited it to great advantage. Known as 'More of Rome' he became the most celebrated British landscape painter of his time, though he was totally forgotten within a generation of his death.

More's formally constructed landscapes, suffused with the glow of a low sun which dictates the colour key of the whole composition, for example *Morning* and *Evening* (1785, both GAGM) certainly had an important influence on Alexander Nasmyth (1758–1840) who encountered him in Rome. In Scotland Nasmyth seems also to have come into contact with George Barret, a visitor from the south and a practitioner of the neo-classical style of landscape popularised by the French painter, Claude Joseph Vernet. It was a style to which More's own painting was also very close. Both Barret and Nasmyth worked for the Duke of Buccleuch at Dalkeith Palace where Nasmyth painted two views on the Esk in Dalkeith Park which are unusually romantic forest scenes (both Duke of Buccleuch, Bowhill). Barret's work is characterised by Ellis Waterhouse as 'particularised to the nearest milestone'[4] and it is a good description, for it conveys the way in which he manages to describe a particular place, yet with a degree of generalisation in detail. This was the formula which Nasmyth made his own.

Plate 109. JACOB MORE, *Rosslyn Castle*, c. 1770

In 1774 Nasmyth had left James Cumming to become an assistant with Allan Ramsay. He stayed with Ramsay till 1778 and then, after working in Scotland again for a while, he travelled to Rome in 1782 where he met up with his old master, Ramsay, who was in Rome on his last journey, and also with Jacob More. It was probably in Rome too that Nasmyth became friendly with Henry Raeburn, forming a friendship that lasted till Raeburn's death in 1823. An equally important friend for Nasmyth after his return to Scotland, though, was Robert Burns. It was Nasmyth who painted the classic portrait of the poet (SNPG) and they shared a patron in the banker Patrick Miller. They had much else in common too. Nasmyth was a lively minded man with wide interests and like Burns he was politically a radical. Working as a portrait painter in a manner akin to David Allan in the late 1780s and early 1790s, he abandoned portraiture abruptly in 1792 because his views were incompatible with those of his patrons. He was at this date already working as a landscape painter though and indeed his portraits, for example the lovely picture of the Rosebery family at Dalmeny, were chiefly notable for the beauty of their landscapes. Giving up portraiture meant specialising in landscape and also in scene-painting which he practised with great success for the rest of his career. Landscape was his main occupation though and he went on to become, as David Wilkie called him, the founder of Scottish landscape painting.[5]

An inventor and a landscape-gardener, as well as a landscape painter, Nasmyth witnessed at first-hand the whole development of Scottish painting from *The Hall of Ossian* to Wilkie's late style and he played no small part in it all. Although he never gained the position of Master

Plate 110. JACOB MORE, *The Falls of Clyde: Cora Linn,* 1771

Plate 111. ALEXANDER NASMYTH, *A Farmyard Gate*, 1807

of the Trustees Academy, he was an important teacher to whom most of the younger landscape painters were indebted. He was also a very important link between Allan Ramsay and the younger generation. Far more than his fellow assistants with Ramsay, David Martin, or Philip Reinagle whose landscapes are similar to his own, Nasmyth had the intellectual stature and flexibility of mind to pass on to the younger generation, especially to Wilkie, but also significantly to Ruskin's father and so to Ruskin himself, Ramsay's grasp of the imaginative potential of visual truth. For Nasmyth as for Ramsay, drawing was the vehicle by which this could be realised. It was drawing which 'educates the eye and hand and enables the artist to cultivate the faculty of definite observation.'[6] It was this in particular which Nasmyth passed on to Wilkie and which through Wilkie became one of the definitive characteristics of Scottish art at least till the death of Orchardson in 1910.

Nasmyth's own drawings are often superb in a robust and straightforward way, for example *A Farmyard Gate* (1807, NGS), (*Plate 111*), but in his paintings, though this basic visual discipline is always there, he was much more willing to generalise, particularly in his treatment of foliage where he shows no more than the most perfunctory regard for the season or the variety of vegetation. It is as though it was the bones of the landscape that mattered to him and such things as trees and bushes were merely its attire. His painting is never vapid however. It is constructed with a broad and generous sense of the space of the open landscape, lit by a warm and very positive light as in his views of *Loch Tarbert* for example (*Plate 117*) or his *View of Castle Huntly with the Tay* (*c.* 1800, Dundee Art Gallery), or his two magnificent views of *Culzean Castle* (NTS, Culzean Castle). His landscapes are usually designed around the siting of a dominant building, *Stirling Castle* (Smith Institute, Stirling) for example, or *Arniston House* (Private Collection). These are pictures which celebrate the grandeur of a landscape where man has a presence, but does not dominate.

His interest in the siting of buildings may reflect the influence of his master, Ramsay, whose main preoccupation when Nasmyth knew him was to discover the site, near Rome, of Horace's Sabine Villa. This involved a close analysis of poetry and landscape in which at one point Ramsay was assisted by Jacob More. The idea of landscape as both the inspiration

of poetry and, through history, its witness, finds its most familiar expression in the poetry and novels of Walter Scott, but Scott was developing ideas already familiar in the eighteenth century in such things as Ramsay's investigations, or even in Runciman's paintings which in their time were seen as reflecting history as well as poetry.

Nasmyth's early antiquarian interest is present in one of his first drawings which is of Dunfermline Abbey (1774, NGS) and it is clearly apparent in a list of his works made by Burns's friend, Robert Riddel, c. 1790. Nasmyth's older contemporary, John Clerk of Eldin, amateur etcher, a younger son of the Clerks of Penicuik and brother-in-law of Robert Adam, was an assiduous recorder of ancient monuments. A small, but strongly designed image like the etching of *Clackmannan Tower* (*Plate 112*) is typical of these. As a topographer perhaps Clerk continues in the tradition of Slezer, but his rugged views of Scottish houses, castles and historic buildings are informed by a sense that history is part of the anatomy of the landscape itself.

This study of history in landscape was extended dramatically in time by Clerk's collaboration with James Hutton. He provided the illustrations to Hutton's *Theory of the Earth*, published in 1796, which revolutionised, not just geology, but our whole perception of time and of ourselves within it. Hutton's theory began with landscape as something to be observed and understood. In assisting him therefore Clerk was not just providing a technical service. The two men were collaborating in a common pursuit. The magnificent drawings that Clerk produced are just one of several similar examples of the very close relationship of art and science at this period. Robert Strange's superb engravings for William Hunter's *Anatomy of the Human Gravid Uterus* (1751– 1775) is another example of this relationship as too is Charles Bell's *Anatomy of Expression* of 1806. (See below, pp166–168.)

This relationship was one that Nasmyth also upheld. He was a talented engineer and he assisted Patrick Miller on the design of his first successful steamship which sailed on Dalswinton Loch in 1788, according to one account with both Burns and Nasmyth on board on her

Plate 112. JOHN CLERK OF ELDIN, *Clackmannan Tower*, c. 1780

maiden voyage. He is credited with inventing, though not exploiting commercially the compression rivet and the shaft-driven propeller. He also designed and built several bridges including that at Almondell in 1811 and devised the bow and string bridge which was widely used by engineers in the nineteenth century. As evidence of his scientific preoccupations his engineer son, James, remembering the atmosphere of his childhood home, recalled walks in the company of Sir David Brewster and Sir John Leslie, leading men of science, which included on-site discussions of geology.

If Nasmyth shared such attitudes then he presents the exact contrary of the old chestnut that in the Romantic era painters turned to landscape in reaction to the unsightly march of progress. The central place of buildings in his painting gives it very much a human focus. In this respect early works like *The Falls of Clyde* (1989, Christie's) or the paintings that he did in Dalkeith Park are not typical of his mature work. More indicative of the way that he was to develop is a beautiful watercolour of 1789 of *Edinburgh from Arthur's Seat* (NGS). It is spacious and luminous showing the Old Town of Edinburgh crowned by the castle to the east and with Holyrood laid out at its foot. What is striking about the picture is how Nasmyth manages to make this urban mass seem both compact and coherent. He may also have been inspired by Robert Barker's first *Panorama*, a view of Edinburgh from the Calton Hill painted and put on view in 1788 (see below, p145).

Nasmyth may have given up landscape painting along with portraiture in 1792, but by the turn of the century he had established a successful practice both as a landscape painter and also as a landscape consultant. In this capacity he laid out the grounds and advised on the siting of a number of Scottish houses, at

Plate 113. ALEXANDER NASMYTH, *Inveraray from the Sea, c. 1801*

Dalmeny, for example, and at Inveraray. Inveraray was also the site of one of the first planned new towns and Nasmyth painted it in one of his most beautiful paintings, *Inveraray from the Sea* (c. 1801, Private Collection). (*Plate 113*) The picture, which was painted in connection with Nasmyth's work for the Duke of Argyll, laying out the grounds of the castle, presents the planned human order of town, castle and grounds, not apart from, but very clearly part of the wider order of the natural world. The water of Loch Fyne and the hills surrounding are the context in which it is all set in perfect harmony.

The picture is an expression of the philosopher Thomas Reid's idea of man taking his place within the order of nature through the proper exercise of his gifts, an idea which had its greatest expression in the building of Edinburgh's New Town. Nasmyth, like Raeburn, and his own pupil Andrew Wilson, played a part in the layout of the later stages of the New Town and its gardens, but his main contribution was to record it in its partnership with the medieval city in a series of paintings of which

two are of special importance. Both were painted in 1825 and were perhaps the crowning achievement of Nasmyth's career. They are *Edinburgh from Princes Street with the Royal Institution under Construction* (1825, Sir David Baird), (*Plate 114*) and *Edinburgh, from Calton Hill* (1825, Clydesdale Bank PLC). (*Plate 116*)

Such views of the city had clear precedents in views by David Allan of both Edinburgh and Glasgow and also in Barker's *Panorama*. They also follow in the tradition of Canaletto's views of London (and those of his followers Samuel Scott and John Collet) as well as French and German paintings of the same type. There were also more immediate precedents for such pictures of Edinburgh in the various paintings that were undertaken to commemorate the visit of George IV in 1822. Scott stage-managed the visit of the king to the city which became a stupendous theatrical event. It was recorded, for example, by John Ewbank (1799–1847), himself a pupil of Nasmyth, who painted a view of the ceremonial procession from the identical spot on the Calton Hill that Nasmyth chose

(CEAC). Alexander Carse painted *George IV landing at Leith* (CEAC) and there were artists from elsewhere who came to the city for the occasion, including Wilkie and Turner. Unlike his contemporaries, however, Nasmyth pointedly ignored the opportunity offered by the royal visit, and instead – in a way that is unlike the work of any of his contemporaries at home or abroad – he captures the feeling of the people's city. In both paintings the openness of the sky and of the landscape beyond the immediate context of the architecture together give to the scene a grandeur worthy of the ideals enshrined in the building of the New Town. Through the interpenetration of nature with the city, the city itself is seen as a natural organism.

It is consistent with this view that what is especially striking in both pictures is the way in which the people are at home in their city. In the view of Princes Street looking east it is the middle of the day and they are going about their business. This is focused in the scene to the right in the foreground where the new building of the Royal Institution is underway, Edinburgh's first purpose-built building devoted to art. (*Plate 115*) Constructed on an artificial mound, it was quite a feat of engineering. The architect William Playfair, in black coat and top hat, is directing the work. Above him two builders are lowering a massive stone drum into position. They are using a block and tackle and the manifest ease with which they are manoeuvring the great weight of the stone demonstrates the power of mind as Reid described it and as Nasmyth himself so much enjoyed it in his own interest in engineering. It is a scene that is iconographically almost the same as in Boccioni's futurist painting, *The City Rises*, painted nearly a century later.

In the other picture, looking west along Princes Street from up on the Calton Hill, the citizens sit and take their leisure in the midsummer sunset. In the foreground the Calton Jail stands as a symbol, not as one might expect of law and order seen as an expression of authority, but as an instrument of social reform. Nasmyth and his contemporaries had an optimistic view of the social function of prisons.[7] At the exact centre of the composition, however, is a symbol even more central to

the Enlightenment. The ideal of philosophy is represented by the cylindrical tower of the monument to David Hume in the Calton cemetery, designed by Robert Adam – so the philosopher from his grave continues to order the life of the people. Philosophy is appropriate in the picture too as a symbol of the utility of leisure. The people are not merely idle. Recreation is part of their claim to be civilised. Leisure, the essential condition for improvement, is in Nasmyth's view no longer the prerogative of the rich alone. It is part of the life of all the citizens in a well-ordered state. As the other picture anticipates Boccioni's *The City Rises*, this one anticipates Seurat's *La Grande Jatte* which also celebrates the dignity of the justified leisure of ordinary citizens.

The Edinburgh pictures are a high point of Nasmyth's art. As well as these two there are a number of others, a magnificent *View of Leith from the sea* (CEAC), a *View of the High Street* (HM the Queen) and a *View of Edinburgh from St Anthony's Chapel* (Earl of Rosebery, Dalmeny). These were all painted within a few years of each other, almost as if Nasmyth was aiming to document his city. If he was, perhaps there is an analogy with Walter Scott. By 1820, Nasmyth had already designed the sets for the theatrical adaptation of Scott's *The Heart of Midlothian*, his novel of Edinburgh *par excellence*. Indeed Nasmyth had watched the demolition of the Old Tolbooth in company with Scott and it was this event which is reputed to have inspired Scott to write the novel. Nasmyth worked with Scott on other occasions too. He also contributed illustrations to the *Waverley* novels in 1822 and also to the *Antiquities of the Scottish Border* in his best manner of topographical accuracy combined with grandeur. Nasmyth's wonderful paintings of the Highlands, like his four pictures of *East* and *West Loch Tarbert* (c. 1802, Private Collection), (*Plate 117*), among the first really grand accounts of Highland landscape, would have appealed to Scott too. Indeed such pictures might almost have been the inspiration for *The Lady of the Lake*, but Nasmyth's vision seems in the end to have been too sunny for Scott the Romantic. This perhaps may also reflect the political difference between the two men. Scott's historical determinism reveals a very different view of

Plate 114. ALEXANDER NASMYTH, *Edinburgh from Princes Street with the Royal Institution under Construction*, 1825

progress to Nasmyth's Utopianism. Nevertheless perhaps Nasmyth's own later work also reveals a shift towards a more Romantic vision. In *Distant View of Stirling* commissioned for the Royal Institution in 1827 (NGS) and the prob-

Plate 115. DETAIL OF *Edinburgh from Princes Street*

ably contemporary *Windings of the Forth* (NGS), for example, the paint is richer and looser and we are asked to contemplate a mood based on atmosphere rather than something built up from an analysis of the tangible.

Nasmyth's activity as a teacher, both formal and informal, was very important. He evidently kept an open house and he certainly exerted an important influence on Wilkie and David Roberts whom his son James describes as his pupils, although Nasmyth did not apparently actually teach them formally.[8] The same may be true of Walter Geikie. Andrew Wilson (1780–1848) on the other hand was formally a pupil. He spent a number of years in Italy and also taught in England, before returning to Scotland *c.* 1817 and becoming Master of the Trustees Academy in 1818. He returned to Italy in 1826 where he died. Many of his landscapes are of Italian scenes and in a manner recognisably akin to that of Nasmyth. He also dealt in pictures, on several occasions in partnership

with Wilkie, most notably in the purchase in Genoa for the Royal Institution of the *Lomellini Family* by Van Dyck now in the National Gallery of Scotland.

Other pupils of Nasmyth, according to his son, included William Allan, Andrew Geddes, William Lizars and John Thomson of Dud-dingston, though the latter seems to have spent only a very short time with him. (These painters are discussed below, Chapter X.) As well as John Ewbank who came from Newcastle, his friend, Thomas Fenwick (*fl.* 1835–1850) was attracted to Edinburgh from the south by the reputation of Nasmyth's teaching; so too was another English landscape painter, Clarkson Stanfield (1793–1867). As noted earlier, the fact that Ruskin's father also studied with Nasmyth is an important link between Ruskin and Scottish artistic thought.

Nasmyth's numerous children all painted, an important element in addition to his own geniality in attracting other young artists to his studio. Of his six daughters, Elizabeth (*b.* 1793), Charlotte (*b.* 1804) and Anne (*b.* 1798) seem to have been gifted and they all assisted their father with his art teaching, but though there are pictures attributed to Charlotte and to Elizabeth in the National Gallery of Scotland, the young Nasmyths also sometimes painted cooperatively and the work of these daughters has still not been disentangled from that of their father and the rest of the family. James, in becoming an engineer was following in his father's footsteps too, but of the children only Patrick (1787–1831) has been identified as an independent artist, no doubt partly because he left Edinburgh to work in the south.

Something of the relationship of father and son, and of Alexander's personality, is captured in an anecdote related by James Hogg. He was out walking with them and describes Alex-ander's approval of the fact that a pretty girl making hay had caught Patrick's eye while he himself was enthusing over the formal beauties

Plate 116. ALEXANDER NASMYTH, *Edinburgh, from Calton Hill,* 1825

of a landscape.[9] Patrick may in fact have had some influence on his father's later work though he began very much under his shadow as in the small painting of *Edinburgh Castle from the West* (EU), or the painting of the *Falls of Clyde* (Bourne Fine Art), but in London where he was established from 1810, he turned increasingly to the inspiration of the Dutch, especially Hobbema and Ruisdael, choosing the kind of forest subjects that they used for their most picturesque compositions. In this he may have been influenced by Hugh William Williams (1773–1829) who in his etchings (*c.* 1808), (*Plate 118*) was inspired very much by Ruisdael. These etchings include some superb forest studies, probably of Cadzow Forest, which may well have been the starting point for Patrick Nasmyth's treatment of such subjects which he made his own.

Patrick Nasmyth travelled to find real woods and forests to paint. (*Plate 119*) His plein-airism in doing this is very close to what we know interested Wilkie at this time. In Wilkie's correspondence with his friend, the landscape painter Perry Nursey, there are frequent references to working out of doors around 1811 and 1812.[10] It is worth remembering that Constable too commented on Wilkie's habit of 'doing everything from the life' at an even earlier date.[11] There may therefore be a significant input into English painting from the Nasmyth circle. Such a suggestion also has a possible bearing on the development of French landscape at Barbizon a decade or so later. The freshest of Patrick's paintings have a quality of genuine atmosphere, too, that parallels what is seen in Horatio McCulloch's pictures of Cadzow Forest of the 1830s.

At his best, Alexander Nasmyth could superbly combine a convincing view of a real place with a sense of grandeur if not of romantic drama. It is not surprising, therefore, that he became the centre of a school of painters distinct from the old-fashioned picturesque topography on the one hand and from the modern romantic vision of Turner on the

Plate 117. ALEXANDER NASMYTH, *West Loch Tarbert, looking North, c.* 1802

other. What these painters had in common was a sense of the role of landscape as documentary. George Walker (*fl. c.* 1777–1815), for example, like Nasmyth a pupil of Runciman, created a gallery of Scottish scenery and in a letter to the Earl of Buchan in 1804 indicated that it was about to be sent to London.[12] John Knox (1778–1845), painter of Glasgow, was in effect a follower of Nasmyth even though he was apparently not his pupil. Knox's best known picture, *The First Steamboat on the Clyde* (GAGM), (*Plate 120*) even echoes Nasmyth's passion for ships and machinery. Knox's lovely paintings of Glasgow, *The Trongate*, and *Glasgow Green* also pay direct homage to Nasmyth's Edinburgh views (*c.* 1826, GAGM). Hugh William Williams became known as Grecian Williams because of the collection of views of Greece that he made during his travels there between 1816 and 1818 which he exhibited in Edinburgh in 1819 and published as *Travels to Italy, Greece and the Ionian Islands* in 1820 (see below, pp220–222). David Roberts (1796–1864) became one of the best known of all topographical artists in the first half of the nineteenth century with his views first of Spain, where he travelled 1832–3, and then of the Middle East which he visited in 1838–9.

The importance of topography for this group of artists reflects the continuing importance of the antiquarian tradition and the whole idea of the role of art as one of the principal means of the acquisition and analysis of knowledge of the world about us. The panorama was the most widely experienced form of visual art in the nineteenth century and its appeal lay very much in this area of information. The word 'panorama' and the visual form associated with it, 180- or 360-degree paintings on a scale sufficient to give an illusion of actually experiencing the view represented, were an Edinburgh invention. Robert Barker, born in Ireland in 1739 and settled in Edinburgh where he was working as a portrait painter, presented the first panorama in the city in 1788 and invented the word to describe it. It was a view from the top of the Calton Hill. Barker's first *Panorama* was 180 degrees. His second described a full circle. It was what Barker called a 'total view' of the city. Panoramic views of one kind or another were

not new. Significantly Runciman had made a 360 degree view of the city from a chimney stack in the High Street. What was novel about Barker's *Panorama* though was his success in adapting the perspective so that the complete painting could be curved to create the illusion for the spectator of actually being there. To display his picture Barker had to make a special construction to enable the spectator to stand at the centre of the painting.

In 1789 he launched his *Panorama* in London with a view of that city from the Albion Mills drawn by his son, Henry Alston Barker. It was a great success and started a fashion for this kind of visual entertainment that endured until it was finally superseded by the cinema. Many artists followed Barker's example. John Knox, for example, painted a panorama of Loch Lomond from the top of Ben Lomond which survives in the form of two canvasses which repeat its composition in two dimensions (GAGM). David Roberts produced a grand panorama of the *Battle of Navarino* in 1827 and, in collaboration with Clarkson Stanfield, he also produced two dioramas (a variation of the panorama using transparencies to create atmospheric effects).

Roberts (1796–1864), the subject of a memorable portrait by Robert Scott Lauder (SNPG), like Nasmyth and in a long tradition of Scottish painters, had begun his career as an apprentice house-painter. Like Nasmyth and

Plate 118. HUGH WILLIAM WILLIAMS, *In Hamilton Woods*, ETCHING, 1808

Plate 119. PATRICK NASMYTH, *A Woodman's Cottage*, 1825

Runciman, too, he had also worked extensively for the theatre before establishing himself as a landscape painter. His early work includes Scottish topography, but following the success of Turner's continental tours, in 1824 he began to travel regularly on the Continent. Early voyages took him to the Low Countries and France. *The Church of St Maclou, Rouen,* (*c.* 1829, Tate Gallery) and *Abbeville* (*c.* 1830, Merchant Taylors Co.), are typical of the kind of work that he produced at this time. They have, in the height of the buildings, a sense of drama which derives from Turner, but are very Dutch in the detail and in the way that they are painted.

In 1832, following the visit that his friend Wilkie had made to Spain in 1827, Roberts set out on a year's journey through France to Spain and on to North Africa. The Spanish subjects that he exhibited over the following years, like the intensely theatrical *Interior of the Cathedral of Seville during Corpus Christi,* (1833, Downside School) established his reputation. Such pictures also perhaps reflect a Scottish Protestant

fascination with the Catholic ceremonial which Wilkie also felt on his first sight of a Catholic service at Rouen in 1815 and which is present in such paintings as his *Cardinals, Priests and Roman Citizens Washing Pilgrims Feet* (1827, GAGM). It is perhaps seen even earlier in David Allan's *Seven Sacraments* too.

Wilkie's enormously successful Spanish paintings established a fashion that was followed not only by Roberts but by John 'Spanish' Phillip (1817–1867) (see below, p214), a painter from Aberdeen, and which endured through much of the nineteenth century. Roberts's own expedition to the Near East in 1838–9 however, perhaps inspired by the success of Hugh William Williams with his Greek subjects, in turn inspired Wilkie to make the journey to the Holy Land in 1840 from which he never returned. Roberts was not actually a pupil of Nasmyth, but he acknowledged the formative influence that the older painter had on him. In the finished pictures that resulted from his Middle Eastern tour, like his superb views of the *Portico of the Temple at Baalbec*

Plate 120. JOHN KNOX, *The First Steamboat on the Clyde*, c1820

(1839, Walker Art Gallery, Liverpool, and 1850, Private Collections), as well as in his small watercolours done on the spot, of *Thebes, Karnac* (1838, Manchester City Art Galleries), (*Plate 121*) or of the *Ruins of Luxor from the South West* (c. 1838, Earl of Shelburne), the sense of order and balance, and the feeling that the excitement of the scene is not a result of the artist's subjective state of mind, but of the intrinsic interest of the place represented, are things that still identify him with Nasmyth.

Hugh William Williams (1773–1829), older than Roberts, studied with David Allan. His relationship with Nasmyth is not clear (though James Nasmyth names him as one of his father's pupils),[13] but from his earliest works he shows a close affinity to Nasmyth, not only in his subject matter which is topographical and antiquarian, but also in his use of drawing. The great majority of his paintings are watercolours and these are based on pencil drawing of a kind very similar to Nasmyth's. Williams's on-the-spot

watercolour drawings both in Scotland, like his *View of Dunfermline* (c. 1795, Private Collection) and in Italy and Greece, have a sensitive clarity that is very beautiful. In the works that he developed from these, however, Williams shows himself at times to be much more interested in subjective feeling, in the mood generated by the association of ideas, than were the other painters in the Nasmyth circle. It is here that it would be interesting to know more about his technique as a painter in oil. The few known examples, such as *The Falls of Bran* (RSA), suggests that this side of his art may have been highly developed and have had a significant influence on his friend, the Reverend John Thomson of Duddingston whose work is discussed below (p222).

There are other artists whose work belongs in this context. William Lizars (1788–1859), perhaps a pupil of Nasmyth's and certainly influenced by him, who is best known as an engraver, was also a painter and a superb

Plate 121. DAVID ROBERTS, *Thebes, Karnac,* 1838

topographical draughtsman. His lithographs of the scene of devastation in the Old Town of Edinburgh after the great fire of 1824 are dramatic testimony to that event, and are also among the earliest examples of the use of lithography as a reporting medium in which the artist could use the freedom granted by the technique, to create a sense of immediacy and spontaneity. Walter Geikie (1795–1837), best known as a genre artist, was a gifted topographical draughtsman as well. His drawings of half-ruinous buildings in and around Edinburgh are amongst the most vivid evocations of what the physical environment of the city was like at the time.

PORTRAITS OF THE ENLIGHTENMENT
Raeburn and his Contemporaries

The years from the mid-eighteenth to the early nineteenth century, known in Scotland as the Enlightenment, were certainly a remarkable period. It was, too, one in which the artists played a full part and the sheer number of landscape painters discussed in the previous chapter is a vivid illustration of the way that the art world in Scotland changed during these years. If the end of the previous century had seen the beginning of the process that established the individual artist as a professional distinct from the trades-man-painter, the end of the eighteenth century saw the profession established with the full collective implication of the noun. It was portrait painting which remained the artist's best means of securing a livelihood from his art, at least until under the joint influence of Wilkie and Scott narrative painting, both genre and history, developed a new and wider popular market, a development in which engraving played an important part, but the economy of art was already becoming increasingly complex before that. For instance George Walker, writing to the Earl of Buchan in 1806, remarked that when Runciman sent him his first pupil twenty-five years before there had been only two art teachers in Edinburgh, now there were thirty.[1] Most of these teachers were catering for the increasing amateur interest in art which was a reflection of the new taste for landscape, and this taste also provided work for the engravers. They flourished as intermediaries between the artists and the Edinburgh publishers in an increasing flood of topographical publications, particularly after the beginning of the nineteenth century.

William Lizars was the most successful and the best known of the engravers working in Edinburgh in the first half of the nineteenth century, but from the time of Richard Cooper senior there had been a developing tradition of engraving and print-making. Cooper's pupil, Sir Robert Strange (1721–92), in spite of a nearly disastrous involvement with the Jacobites through his marriage to Andrew Lumsden's sister (Lumsden was secretary to Prince Charles Edward Stuart), rose to a knighthood, the first native-born Scottish artist to be so honoured. Cooper's son Richard, friend of the Runcimans and a landscape painter close in style to Alexander Runciman as well as an engraver, followed Strange by going from Edinburgh to finish his training in Paris. Cooper, who later succeeded Cozens as art master at Eton, was the first British engraver to record old masters in Spanish collections.

Engraving was not by any means limited to topography however. Working in the service of publishing, the engravers provided an important vehicle of Enlightenment thought. Some of Sir Robert Strange's most impressive works, for example, are the medical plates that he engraved for William Hunter (see above, p139). Lizars was the artist first chosen by Audubon for his *Birds of America*, though for contractual reasons he did not complete the commission, and he too produced important medical illustrations. John Clerk of Eldin's illustrations to James Hutton's *Theory of the Earth* represent a similar link between the art of landscape and scientific thought (see above, p139) and through the work of Jacob More and Alexander

Plate 122. ARCHIBALD SKIRVING, *John Clerk of Eldin*, c. 1795

Nasmyth and his circle this was extended, not only to poetry and to history, but even perhaps to philosophy, the central discipline of the Enlightenment.

The central figure in Scottish portrait painting was of course Raeburn and through him, in portraiture too, the link with the Enlightenment was direct. Raeburn created the most memorable record of what so many of the leading figures of the period looked like, but also, like Ramsay before him, he reflected in his art the central concern of Enlightenment thought, the study of human nature. He was heir to the tradition of Ramsay and what might be called the philosophic portrait, the kind of portrait that depended on the fully integrated view of human nature elaborated by Hume and his successor in Scottish empirical philosophy, Thomas Reid. Like Ramsay too, Raeburn understood the far-reaching implications for painting of some of the most important philosophical discussions of the time, particularly Reid's radical account of the processes of perception.

Raeburn was not Ramsay's immediate heir however. (It is perhaps as much a comment on the importance of Ramsay as a painter in Scotland, in spite of his London base, as it is on the slowness of the native market to develop, that no major portrait painter had emerged as a rival or successor to him in Scotland until Raeburn himself entered the market, coincidentally in the year of the older painter's death.) David Martin, after working with Ramsay from 1752, had established his own practice in Edinburgh in the early 1770s and was the most ambitious portrait painter based in Scotland at the time (see above, pp109–110). There were also, however, artists outside the conventions of large-scale portraiture who were of real talent. John Bogle (c. 1746–1803) was a superb miniaturist in the conventional style of the small watercolour portrait, while James Tassie (1735–1799), who used a more unusual medium, the glass-paste portrait-medallion, although, like Ramsay based in London, was almost as comprehensive a recorder of the men of the Enlightenment as Raeburn himself. The list of his sitters is like a roll-call of the period; David Hume, Joseph Black, James Hutton, Robert Adam, Adam Smith, Thomas Reid, Raeburn himself, are all recorded in miniature sculpture in Tassie's elegant neo-classical portraits. These were made from a special, white vitreous paste. The sitters are seen in profile in low relief, the image based on a silhouette. Tassie was a student at the Foulis Academy in Glasgow at the same time as David Allan. The two men remained friends and collaborated on the catalogue of Tassie's copies of gems after antique originals, his other major enterprise, in which he also exploited his patent vitreous paste.

John Brown also created a distinctively neo-classical type of small-scale portraiture, likewise characterised by refinement and extreme limitation of means. Where Tassie only used white paste, Brown only used pencil. Historically the most interesting portraits that Brown produced are the series of drawings of the members of the Society of Antiquaries, including the Earl of Buchan, founder of the society, William Smellie, George Paton, David Deuchar and, posthumously, Alexander Runciman (all RMS). Archibald Skirving (1749–1819) was another portrait artist with a neo-classical style. He likewise limited his means, though not so drastically as either Brown or Tassie, working only in chalk or crayon. He began as a painter in miniature, but while he was in Italy between 1786 and 1794,

he changed the scale of his work. Skirving produced beautiful and often very informal portrait drawings in red chalk which carry on Ramsay's use of that medium in a manner that is by no means unworthy. He also worked in full colour. His portraits of *Gavin Hamilton* (SNPG) done in Rome and that of *John Clerk of Eldin* (Adam Collection), (*Plate 122*), which is later and in which Raeburn's influence is clearly apparent, are among the finest British pastel portraits.

Like Skirving, Raeburn, who was born in 1756, began his artistic career as a miniature painter, having been originally apprenticed to a goldsmith, James Gilliland, in 1772. Miniatures were usually presented in cases made by goldsmiths and so miniature painting was a natural extension of Raeburn's chosen trade. Several of his early miniatures can be identified and two are of particular interest, one of *David Deuchar* (1776, SNPG) and one of *Andrew Duncan* (Royal Edinburgh Hospital), pioneer of the modern treatment of mental illness. It is from Andrew Duncan, writing at the time of Raeburn's death, that we have a first-hand account of him working in Gilliland's shop[2]. Deuchar (1745–1808) was a seal engraver, but also an amateur etcher. According to family tradition it was Deuchar who encouraged the young Raeburn to develop the talent that he saw in his earliest essays in miniature painting.[3] There is a considerable gap in Raeburn's early career however, for the number of miniatures attributable to him is tiny, though the latest, of *Earl Spencer* (Earl Spencer, Althorp), was painted in Rome as late as 1786 while the earliest full-scale portrait cannot be dated much before 1782.

It may be that there is a considerable body of work unidentified, or alternatively that Raeburn stuck to his trade as goldsmith for longer than has been supposed. His marriage in 1780 to Anne Leslie, a comparatively well-off widow, twelve years older than him, may have given him leisure, but does not of itself explain the absence of identifiable work over a period of several years. One thing is certain. The full-length painting of *George Chalmers of Pittencrieff* in the City Chambers, Dunfermline, which has traditionally been dated to 1776 following an inscription on the frame, and which has

consequently been taken to show that he was already painting in his mature style at that early date, is in fact a painting of the early 1790s. The inscription is posthumous and the date meaningless.[4] Another tradition of Raeburn's early career is that he learned from David Martin, but this is unsupported by any other evidence. Raeburn did study with Runciman however, as another painter, William Robertson, recalled working alongside Raeburn under his instruction.[5] Robertson himself went on to become, with his brother Archibald, founder of an art academy in New York, and it was through the Robertsons that Raeburn's reputation was transmitted to America. Andrew Robertson (1777–1845), a younger brother of William, who became the most successful miniature painter of his generation, studied with Raeburn and Nasmyth in 1792.

A nineteenth-century commentator, J. H. Benton, remarked of Runciman's portraits that they were marked by 'deep artistic power and noble simplicity'.[6] Runciman's portrait style is only known from his *Self-Portrait with John*

Plate 123. RAEBURN, *James Hutton*, c. 1782

Plate 124. RAEBURN, *Neil Gow, c. 1793*

Brown (1785, SNPG), and the sadly overcleaned portrait of the *Earl of Buchan* (1785, Perth) though there is also a remarkable, visionary head of *Robert Fergusson* (SNPG). The first two present a portrait style of vigour and imagination as one might expect from his other painting. They also show that he worked very directly, relying on the energy of his brushwork and the liveliness of his colour to convey a sense of the presence of the sitter, though his drawing is rough and ready. This is exactly how Raeburn painted throughout his life. He was a great colourist, dramatic in his handling of the brush whose whole approach seems to have depended on the notion that spontaneity, imparted by the painter to the image in the execution, would be read by the spectator as life in the picture.

Raeburn also learned from David Deuchar. There are clear echoes in his early works of Deuchar's etchings which are mostly after Dutch masters, though some are also of his own composition. Deuchar published these as

a collection in 1803, but they were clearly the product of at least twenty years' work as a number are dated to the early 1780s. In Raeburn's portrait of *James Hutton* (SNPG), (*Plate 123*), for example, which is probably from about 1782, the pose and the angle at which he is sitting, together with his strange, withdrawn, abstracted gaze, and his stiff, upright pose both recall an etching by Deuchar after Ostade of two figures seated side by side, hands folded, in identical poses. It was an image that Wilkie also used in a small painting of his parents (one version in NGS). Raeburn's most famous image, the *Rev. Robert Walker skating on Duddingston Loch* (NGS) also has a precedent in an etching of Deuchar's of a man skating, alone against a low horizon. Though Deuchar's figure is seen from behind and lacks the elegance of Raeburn's, both show the same studied nonchalance. Raeburn's portrait of *Neil Gow* (c. 1793, SNPG), (*Plate 124*) likewise has a model in Deuchar, an etching of a man sitting alone playing the fiddle. Such links are important, for Deuchar's principal models were Ostade and Rembrandt. Establishing the part that this kind of inspiration played in Raeburn's early career gives a valuable and unexpected perspective on his work, as superficially he would appear to be an artist in the grand manner, like Lawrence.

The Grand Manner did of course play a part in Raeburn's art from an early date. According to Allan Cunningham he had contact with Reynolds in London on his way to Italy in 1784 and James Northcote remembered dining with Raeburn at Reynolds's house.[7] He certainly had first-hand knowledge of several works by Reynolds painted around this time. There is a close analogy between his portrait of *Lord President Dundas* (Arniston House), painted in 1787, and Reynolds's *Lord Chancellor Thurlow* of 1781. Even more striking is the analogy between Raeburn's *Neil Gow* and Reynolds's remarkable portrait of *Joshua Sharp*. Both are pictures of someone intensely absorbed and turned inwards upon themselves. One of the arguments for the date of the portrait of *George Chalmers of Pittencrieff*, too, is its debt to Reynolds's painting of *Dr John Ash* of 1788. In Italy, however, Raeburn encountered the Grand Manner at first hand. Velasquez's *Pope*

Plate 125. RAEBURN. *Sir John and Lady Clerk of Penicuik*, 1792

Innocent X and Raphael's *Pope Julius II*, its model, seem to have made a life-long impression on him. Paintings of a scholar sitting in his study – portraits so often of friends and equals – constitute a genre in which Raeburn excelled. Edinburgh University has a superb sequence of such pictures from *Principal William Robertson* dated 1792, but completed in 1794 after Robertson's death, to *John Playfair* (c. 1817), they all acknowledge the inspiration of their great Renaissance original.

Although they have some charm, as in the portrait of *Janet Dundas* (c. 1790, Arniston House), and occasionally considerable force as in the portrait of *Lord President Dundas*, her father, there is nothing in Raeburn's painting of the years immediately after his return from Italy to prepare us for the extraordinary painting of 1792, *Sir John and Lady Clerk of Penicuik* (National Gallery of Ireland), (*Plate 125*), or of the tour de force of the previous year, *Dr Nathaniel Spens* (RCA), the first of many brilliant

full-lengths of men in costume or highland dress. Spens, in the uniform of the Royal Company of Archers, is drawing his bow against a brilliantly painted landscape of trees and sunset sky. At his feet is a spectacular thistle. Although it is handled with great verve and informality, the Spens portrait belongs recognisably in the tradition of the grand full-length, but the Clerk picture, although it has a model in a portrait by Reynolds of the Earl and Countess of Egremont, really challenges the pomp and display of that tradition. Instead of rhetoric, Raeburn makes the large-scale painting a celebration of intimacy. Sir John and his wife are seen against the landscape of their estate. With a gesture of his right hand, distinctly reminiscent of Michelangelo's *Creation of Adam*, he points towards this open space. His other arm is around his wife's shoulder. The intimacy of this is enhanced by their expressions which reflect their mutual attention and the light reinforces their relationship.

The setting sun crosses his shoulder to shine on her face and white dress and then reflects back to light him. The treatment of the faces is free and very frank. He has not glossed his picture with any false politeness to compensate for the effects of the fall of light, nor indeed to bring his sitters' physiognomies closer to any imaginary ideal norm.

Raeburn rarely painted such intimacy between his sitters, though he did at least once create a comparable image in the beautiful double portrait of *General Francis Dundas and his Wife Eliza Cumming* playing chess, painted probably in 1812 (Private Collection). (Detail, *Plate 129*) All his portraiture, however, is marked by a kind of intimacy, by a sense of the immediate presence of his sitter. This is partly a result of his directness, in which he was heir to Ramsay, and partly of the liveliness of his technique.

Raeburn most likely met Ramsay when he was in Italy. He and Nasmyth were there together at the same time as Ramsay who was in the last year of his life. Nasmyth would certainly have been in contact with his old master as a genuine friendship seems to have existed between them. Raeburn's own homage to Ramsay is seen in his willingness to copy the older painter with great fidelity as he did for example in the portrait of the *Earl of Hopetoun*, done to commission, possibly quite late in his career (Hopetoun House). The difference in their manners of execution disguises the affinity between these two great Scottish portrait painters, but it is clearly seen in their painting of women. Raeburn's portrait of his wife, *Anne Leslie* (Countess Mountbatten), looking at the painter with almost maternal pride is as tender and real as Ramsay's portrait of *Margaret Lindsay*. He is equally frank with the plain *Elizabeth Sheldon* (c. 1805, Arniston House) and the gorgeous *Isabella McLeod, Mrs James Gregory* (c. 1798, NTS, Fyvie Castle). (*Plate 126*) He does not patronise the one or flatter the other. Together with Ramsay's *Martha, Countess of Elgin* or his *Elizabeth Montague*, such pictures are outstanding amongst all female portraits because we see the sitters so completely as people, as women certainly, but their humanity not blurred by any stereotype.

This quality really starts at a level deeper than painting, in respect for the individual, in respect for the paramount importance of experience and so too for the inviolability of observed fact. If it were not a contradiction in terms, this might be called the ideology of empiricism, but it does at least have an ideological origin, in the ideology of the Reformation. Its aesthetic implications are set out by Archibald Alison, a mutual friend of Raeburn and Dugald Stewart. Stewart, a pupil of Thomas Reid and Professor of Moral Philosophy at Edinburgh University, was the leading philosopher in Raeburn's circle. Alison was an Episcopalian clergyman, but was likewise a close follower of Thomas Reid. It was Alison who worked out, in his *Essays on the Nature and Principles of Taste* published in 1790, some of the aesthetic implications of Reid's thought. Challenging the idea of ideal beauty, Alison wrote:

> If in the human countenance and form there were only certain colours or forms or proportions, that were essentially beautiful, how imperious a check would have been given, not only to human happiness, but to the most important affections and sensibilities of our nature! . . . The regards of general society [too] would fall but too exclusively upon those who were casually in possession of those external advantages, and an Aristocracy would be established even by Nature itself, more irresistible, and more independent either of talents or of Virtue, than any that the influence of property or of ancestry has ever yet created among mankind.[8]

Alison seems to have been influenced by Ramsay's *A Dialogue on Taste* and he echoes very closely here what Ramsay says about ideal beauty. Like Ramsay too he sees a direct connection between aesthetic ideas and those of Radical/Whig politics. Such views reinforce the link between Raeburn and Ramsay. Alison's writing also helps to clarify the nature of the affinity between these painters and their philosopher contemporaries, first between Hume and Ramsay, and now too between Raeburn and Dugald Stewart, Thomas Reid's principal interpreter and student. This is not a matter of a painter reading a few books of philosophy, but of a common pursuit in the study of human nature through the medium of perception.

Reid was Hume's successor in Scottish philosophy and was, like him, a figure of European stature. In the emotive question of faith versus scepticism, Reid was seen as a critic of Hume, but in fact he developed Hume's arguments from the same premises and he belongs

Plate 126. RAEBURN, *Isabella McLeod, Mrs James Gregory*, c. 1798

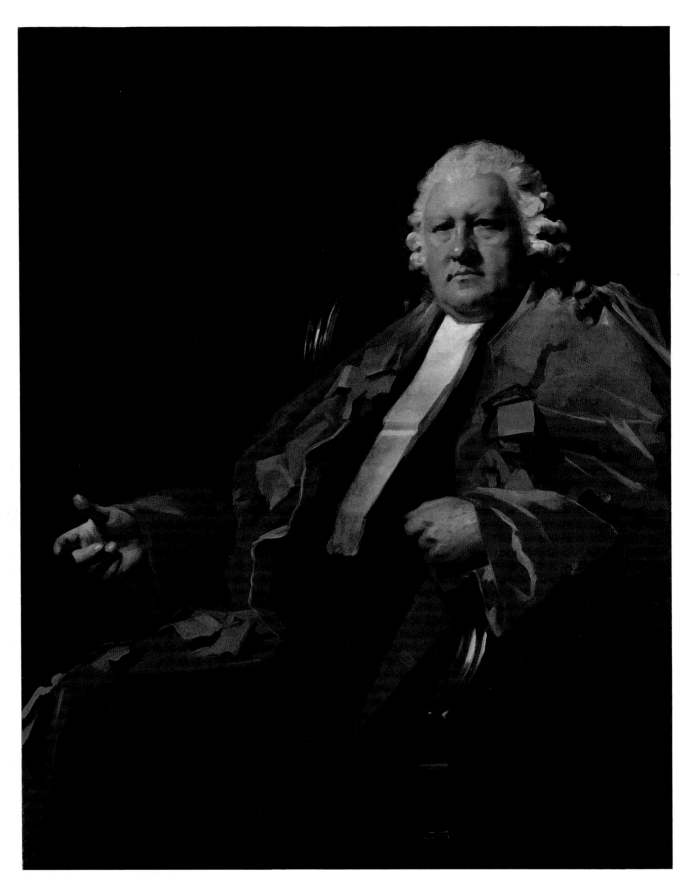

Plate 127. RAEBURN, *Lord Newton*, BEFORE 1806

squarely in the empirical tradition. That being so, perception is at the centre of his philosophy, and his contribution was to bridge the gap between perception and the processes of thought by proposing that the agent of perception was intuition, not ideas as Hume had supposed. Thus the external world could operate directly on the mind. Though Reid confessed that he did not know how this could be, he was clear that it was a physiological process.[9] Therefore, the actual mechanics of perception became of much greater interest with consequences both for medicine and for art. It was in direct response to Reid, and to the teaching of Dugald Stewart, that Charles Bell, combining the lessons of art and medicine, made his revolutionary discovery of the nature of the nervous system. It was he who recognised that it is the nerves that mediate between the mind and the external world.

One reason why art was of especial importance in all of this was that for Reid, and even more for Stewart, in the study of perception sight had pride of place. Stewart begins his monumental *Elements of the Human Mind*, published in 1792, with the discussion of sight, and Stewart and Raeburn were friends. Raeburn painted the philosopher several times. Indeed he also painted Reid himself in a memorable portrait (NTS, Fyvie Castle), done shortly before the philosopher's death in 1796, at the request of James Gregory for whom Raeburn also painted the portrait of *Isabella McLeod, Mrs Gregory*. Reid dedicated his *Essay on the Intellectual Powers of Man* of 1785 to Stewart and Gregory together.

What Reid, and following him Stewart, contributed to the history of art was of fundamental importance to the way that it has developed since, even to the present day. By removing ideas from the process of perception, Reid is able to argue that the business of the painter is not to impose order on the world of experience. It is simply to record the raw material of perception. It is the spectator who finds order in what the painter records.[10] Thus painting no longer reflects, as had always been held hitherto, the orderly world of shared ideas projected by the artist. Instead it belongs in the chaotic world of perception before it is ordered by the mind. (That it must then be ordered

subsequently by the spectator's subjective experience of it is a further consequence of this idea, with profound implications for aesthetics.) Reid was clear that this made the painter's job more, not less, difficult. 'The visible appearance of an object is extremely different from the notion of it which experience teaches us to form by sight,' he wrote, and then, 'If he [the painter] could fix the visible appearance of objects without confounding it with the thing signified by that appearance it would be as easy for him to paint from the life . . . as it is to paint from a copy.'[11]

The implication of such ideas for painting is clear. The painter's view of the world is different from other men's because he must concern himself with the signs, not with what they signify, and the signs by themselves do not constitute a rational order. In the more familiar account of the history of art these ideas are associated especially with French painting of the 1860s and seventies and there is almost certainly a direct link. The ideas of Reid were adopted into French philosophy, first by

Plate 128. Raeburn, *Baillie William Galloway*, 1798

Royer-Collard in a series of lectures in 1811–13, and then by Victor Cousin in a series given in 1819 and subsequently published as *La Philosophie Ecossaise*.[12] Through Cousin especially, therefore, a central part of French thought – that part which, through the theory of perception, had most direct bearing on painting and which also led directly to Bergson (see below, p314) – was derived from the Scottish 'common-sense' school and was proud to acknowledge its origins. In addition French education was reformed by Cousin under Louis Phillipe. One of the planks of his educational reform was the introduction of philosophy at the centre of the curriculum in France and in 1842 the *Works* of Thomas Reid became a set book. A generation later this teaching emerged as a set of common assumptions among painters. This link may go some way to explaining the manifest affinity between Raeburn and the impressionists, especially Manet, Manet, a link which

Plate 129. RAEBURN, *Francis Dundas*, DETAIL FROM *Gen. Francis Dundas and his Wife*, c. 1812

in turn lay behind Raeburn's great popularity at the turn of the century.

It is not necessary to argue that Raeburn was literally applying a theory of perception to his painting. To begin with, if he started his career under the influence of Runciman, his approach was anyway intuitive. Runciman's spontaneity, his use of colour and his lack of formal finish together stressed the importance of non-rational modes of apprehension as they were perceived in the primitive art of Ossian or Homer. The ancestry of such an idea in poetry and painting, going back as it did to Francis Hutcheson's equation of the aesthetic and the moral, was very similar to the ancestry of Reid's philosophy. Painting and poetry were first cousins of philosophy. In a conversation between Dugald Stewart and Raeburn it would have been the common ground that was striking, not the remoteness of their specialisations.

The effect on Raeburn's painting of this kind of intellectual background was to strengthen and clarify his ideas and this is apparent as his development proceeds. By 1790 he was already painting very freely, but the lighting of some of his smaller portraits of that date, such as *Christian Forbes* (NTS, Fyvie Castle) is still arbitrary and the construction very loose. Even the dramatic full-length of *Sir John Sinclair of Ulbster* (NGS) of similar date is not rationally lit. The great Clerk portrait is an exception and it is only in the middle and later 1790s that he begins to light his pictures consistently and so to create patterns of brushwork that give the impression of having been dictated by an objective analysis of perception. Of course Raeburn was never as disciplined in this as Velasquez or Vermeer, but it is very striking that Wilkie, who knew Raeburn well, when he was in Spain recognised his affinity with Velasquez and the comparison makes sense looking at a portrait like that of *Isabella Gregory*. She is a real figure set in real light and real space. The vividness of the picture depends on the way that the artist's brushwork imitates the fleeting approximations of actual vision. Raeburn's brush does not pause to investigate detail any more than our eyes would do in conversation with the actual person.

The Gregory portraits, for Raeburn also painted her husband (also NTS, Fyvie Castle),

Plate 130. RAEBURN, *Macdonell of Glengarry*, 1812

may have been especially important given Gregory's connection with Reid. They probably also coincide closely in date with Raeburn's creation of a purpose-built studio in York Place, Edinburgh, where he was a neighbour of Nasmyth. The studio survives and is a remarkable room, almost square and lit by a massive window to the north. This window is designed to let in the maximum possible light. Although it keeps its Georgian proportions it actually extends above the level of the ceiling, but it is also equipped with shutters which would have enabled the painter to control the fall of light to a very fine adjustment.

Over the next decade his art matured and grew in confidence. It was in this period that he painted classic male portraits like *Lord Newton* (Dalmeny House), (*Plate 127*) and *John Robison* (EU) (both before 1806). In such pictures he uses a very broad brush and in the costume, long sweeping brushstrokes. The extent to which these are disciplined by a real analyis of perception is seen in the heads where the handling is hardly less broad, but is commanded by an extraordinary sureness of touch. The approximations, around Lord Newton's eyes for example, so closely match how we actually see that, far from feeling that we are being sold short by a master of sleight-of-hand, we get a vivid sense of the concrete presence of the sitter. This is enhanced too by Raeburn's increasingly dramatic use of strong and simple colour – John Robison is wearing a spectacular red, striped dressing-gown for example. Isabella Gregory by contrast is wearing a white dress, white bandeau and green sash. Raeburn is not all drama, however, and the quality of these portraits would not be the same if he did not also preserve frankness and honesty in his treatment of the face as it is seen in more homely portraits, like *Baillie William Galloway* (1798, Merchants Company of Edinburgh), (*Plate 128*), sharp-eyed and toothless, or such charming, mature ladies as *Mrs Campbell of Park* (GAGM) and *Mrs James Campbell* (Private Collection).

In 1808 Raeburn suffered bankruptcy, not through any fault of his own, but through involvement in his son's affairs. Unlike Scott he seems to have recovered his financial stability fairly quickly, but it may have shaken his

confidence. The attempt by the portrait painter George Watson to set himself up as a rival to Raeburn in the Society of Artists, the first serious attempt to establish an Edinburgh exhibiting society, at much the same time may further have jaundiced his view of life in Edinburgh. Whatever the reason, in 1810 he was in London prospecting for a practice, where there might have been a vacancy in the market after the death of Hoppner. Nothing came of the projected move. He enjoyed a sojourn in London with Wilkie as guide and returned to an unchallenged position as doyen of Scottish artists.

In London, though, contact with Thomas Lawrence may have stimulated his ambition. Certainly the last decade or so of his life saw some remarkably grand designs. He sometimes leans too far towards Lawrence to be consistent with his own high standard of visual conviction, though not without spectacular results as in the justly celebrated half-length of *Mrs Scott-Moncreiff* (NGS), but where he combines effect with his own sense of conviction he is without rival. The double-portrait of *Gen. Francis Dundas and his Wife*, for example, is as grand a picture of intimacy as the Clerk portrait and it is more surprising because of the extreme summariness of treatment of the General's head (*c.* 1812, Private Collection). (*Plate 129*) He is after all one of the principals in a large-scale commissioned portrait, yet on close examination his face is described without detail in scarcely more than half a dozen strokes of the brush.

That picture was probably exhibited in 1812. In the same year he exhibited the full-length in highland costume of *Col. Alasdair Macdonnel of Glengarry* (NGS), (*Plate 130*) and two years later *The McNab* (Distillers Company) likewise in full highland dress. Scott, according to his biographer Lockhart, took inspiration from the Mcdonnel portrait for the character of Fergus McIvor, the doomed hero of *Waverley*, and there is a curious ambiguity about both pictures. Neither is simply heroic as Raeburn subtly conveys the fragility of his sitter's grandiloquent self-image. He cannot abandon the sitter as Lawrence might have done, or Reynolds too, in favour of a mere display of bravura.

He had been less confident in dealing with

a similar problem in his first portrait of Scott, painted in 1810, seated on a ruin, a romantic border landscape behind him, a book of verse in his hand and a poetic look in his eye (Duke of Buccleuch, Bowhill). The picture was commissioned by Constable, Scott's publisher. Raeburn was evidently asked to paint Scott as a poet and while he could paint the man perfectly well, and did so at the very end of his life, in this picture the abstract idea of the poet gets in the way.

In spite of the relative failure of the Scott portrait however, Raeburn's finest later paintings are of his distinguished contemporaries. *George Bell* (Faculty of Advocates) for example or the magnificent portrait of Raeburn's own lifelong friend, the judge and connoisseur, *John Clerk of Eldin* (1820, SNPG), or the later portrait of Scott himself that was one of the last that Raeburn painted (SNPG). Faced with an account of the visible presence of another human being, so complete that it suggests the secondary signals that accompany any such encounter, it is meaningful to talk of the tradition of Rembrandt.

Raeburn does seem to have become increasingly interested in Rembrandt during these years. The influence of the Dutch painter gave greater rotundity and tangibility to his painting and the figures are set in a deeper space with a stable and positive light. Instead of the sharp, slashing brushstroke, in male portraits at least he sometimes uses a shorter, less directed stroke. In the very late *John Pitcairn of Pitcairn* (c. 1823, RSA), (*Frontispiece* and *Plate 131*) this has an extraordinary effect of somehow combining substance and its absence. In such a picture Raeburn approaches as profound a commentary on the nature of perception and through it on the very mystery of existence, as did Ramsay in his late paintings, or even Rembrandt himself. In the end the link between the two greatest Scottish portrait painters is much stronger and more profound than the difference of their styles would suggest.

Raeburn was a tall and genial man, good-looking with an impressive presence. Andrew Robertson, describing his first meeting with him, said that to his youthful eyes he looked like Apelles himself.[13] He was a good conversationalist and this surely had some bearing on his success as a portrait painter, for with so direct and natural a style it was essential that his sitters were at their ease. He had a wide range of interests. For example, he shared a passion for shipbuilding with Nasmyth and designed and built model boats. He was a golfer and also a keen and knowledgeable gardener. He was well equipped to take his place as an equal among the remarkable men of the Scottish Enlightenment of whom he has left such a memorable and fitting record.

In the moves to establish a Scottish exhibiting society which eventually bore fruit in the foundation of the Scottish Academy in 1826, Raeburn naturally played a central part. He and Nasmyth seem already to have been involved in the earliest moves to set up an academy in the mid-1780s and Nasmyth had endeavoured to set up an exhibiting gallery in 1791.[14] The first successful attempt at such an organisation, though, was the Associated Society of Artists whose first exhibition took place in 1808. That was the year of Raeburn's bankruptcy, but in the following years, 1809–13,

Plate 131. RAEBURN, *John Pitcairn of Pitcairn*, c. 1823

Plate 132. GEORGE WATSON, *A Girl Drawing*, 1813

the exhibition took place in his painting rooms. This arrangement carried on when the Associated Society was replaced by the Edinburgh Exhibition Society from 1816–19 and the next stage in the evolution of this professional association was the foundation of the Institution for the Encouragement of the Fine Arts in Scotland in 1821, to which Raeburn also gave the same practical support. Subsequently, with money from the Board of Trustees, a splendid building was put up, begun in 1822, to house the Institution, but it also gave a permanent home to the Trustees Academy. The building, originally known as the Royal Institution, is seen being constructed in Nasmyth's painting of Princes Street of 1825. It was later enlarged by its architect, William Playfair, and is now known as the Royal Scottish Academy. As part of its function the Institution exhibited both old master and contemporary paintings. The artists found, however, that they were to be effectively excluded from control of the Institution and Raeburn took a leading part in their just quarrel with it, a quarrel which eventually resulted in their secession and the creation of the Scottish Academy in 1826. It became the Royal Scottish Academy ten years later and from 1835 had rooms in the Royal Institution's building.[15] In 1859 the adjacent building was opened that is

now the National Gallery of Scotland. It was also built by Playfair and partly with money from the Trustees, and it originally housed both the new National Gallery, which was founded in 1850, and the Royal Scottish Academy.

Such activity is a clear indication of how art-life in Scotland had developed. Nasmyth and Raeburn were symbolically the two pillars of its edifice, but they were at the centre of an increasingly diverse community. The number of landscape and topographical artists has already been seen. The number of portrait painters was comparable. The most substantial talent among those close in age to Raeburn himself, apart from Skirving who has been discussed above, was certainly George Watson (1767–1837), as Watson himself evidently believed, to judge by the events in the Society of Artists in 1808. At his best, as in the portrait of *A Girl Drawing* (1813, Countess of Sutherland), (*Plate 132*) or the large group portrait of *The Children of the Earl of Elgin with their Nurse* (c. 1805, Earl of Elgin), Watson shows himself to be a painter of considerable skill. He does not really distance himself enough from Raeburn, however, to be granted much originality and one can sympathise with Raeburn if he felt that Watson's claim to supersede him was unjust.

Raeburn himself trained several of the younger painters. His first pupil, already mentioned, was the miniature painter Andrew Robertson. Robertson's early works evidently included a number of copies of Raeburn's works in miniature, including one of *Neil Gow*, and some at least of these were sent to America. In his later style he remained remarkably faithful to Raeburn. As late as the 1830s it is still possible to see quite clearly, even in the scale of a miniature, the continuity with Raeburn's sense of the individual, achieved by broad modelling and clear and simple lighting.

At the end of Raeburn's life, John Syme (1795–1861) was working with him as an assistant and completed some of his works after his death. Syme continued to work in a creditable version of Raeburn's manner though he ceased to exhibit portraits around 1840. Colvin Smith (1795–1875) was another younger painter whose style was effectively formed by the example of Raeburn. William Nicholson

(1781–1844) moved from Newcastle some time before 1820 and became a successful portrait painter, working in watercolour as well as oil. William Yellowlees (1796–c. 1859) also worked on a small scale. Both these two were painters of some talent. Nicholson's *James Hogg* (Private Collection), for example, is a lively and sensitive painting, but apart from Robertson the most substantial talent to emerge from Raeburn's immediate circle was undoubtedly Sir John Watson Gordon (1788–1864).

Originally plain 'John Watson', he added Gordon to distinguish himself from George Watson, his uncle. Watson Gordon spent some time with Raeburn. An exquisite small portrait on panel of *Thomas Clerk and his Wife* (c. 1820, RCA), (*Plate 133*) is signed John Watson and so was painted before he adopted the name of Gordon in 1826. The couple are standing at full-length against an atmospherically painted, but simple landscape. It shows how close he was to Raeburn, but also it has a delicacy which is quite distinct. The only place in Raeburn's work that anything comparable is seen is in the portrait of the *Rev. Robert Walker Skating.*

Watson Gordon did not take to full-time portrait painting till immediately after Raeburn's death however. Before that he had exhibited genre and history pictures. He obviously intended, successfully as it turned out, to step into the master's position as the dominant portrait painter in Scotland. He was an efficient and prolific painter whose consistency has sometimes been taken to mean that he was simply boring, but that is not so. The lovely small portrait of *Margaret Oliphant of Gask* of 1829 has a gentle sensitivity (Private Collection). Of much the same date his portrait of *James Hogg* (SNPG), one of a remarkable group, commissioned by William Blackwood, of the contributors to *Blackwoods Magazine*, is among the most memorable portraits of Scottish poets. Unlike Raeburn's first portrait of Scott, the apparatus of his status as poet, his rustic dress and the landscape setting, do not come between us and the frank and vivid characterisation.

In the 1840s and Fifties Watson Gordon shows signs of the influence of photography. The light in his paintings is cool and the colour muted. A good example is the splendid full-length of *Principal Lee* (1847, EU), a late

example of the true grand manner which combines memories of Reynolds and Raeburn with this sense of a modern light. In 1855 Watson Gordon won a gold medal at the Paris Universal exhibition with his portrait of *Roderick Gray* (1852, Merchants Company of Edinburgh). (*Plate 134*) It was the occasion at which Courbet held a one-man show in rivalry to the main exhibition. Even in the context set for art history by Courbet, Watson Gordon's prize was not unworthy. Roderick Gray was factor for the Edinburgh Merchant Company of their estate at Peterhead. The portrait is a strong and unsentimental picture which hangs in the Merchant Company's Hall in Edinburgh, alongside Raeburn's splendid *William Galloway* of 1798 and indeed Aikman's equally gritty portrait of *George Watson* of 1718.

John Graham-Gilbert (1794–1866), slightly younger than Watson Gordon, carried on the tradition of good academic portrait painting in Glasgow where he was born and worked from 1834. He played an important part in putting

Plate 133. JOHN WATSON GORDON, *Thomas Clerk and his Wife*, c. 1820

Plate 134. JOHN WATSON GORDON, *Roderick Gray*, 1852

Academy, though his elevation may have reflected his genteel birth as much as his distinction as a painter. Nevertheless the tradition of portrait painting carried on. Some of the most distinguished paintings of the 1840s were the portraits of Robert Scott Lauder and, even after the death of Watson Gordon, painters in the younger generation like W. Q. Orchardson and John Pettie were still able to paint portraits that succeed, as Raeburn's do, and are at the same time grand and honest.

Through Ramsay and Raeburn and their followers, portrait painting therefore has a central place in any assessment of the art of the Scottish Enlightenment. To compare Rembrandt with Ramsay at his best reveals a genuine affinity, while to look at Raeburn and Frans Hals together uncovers a similarity that is not just a trick of style. Portraiture, through these comparisons, focuses the concern with individual experience and with human nature which links the Scottish Enlightenment as a whole most closely with its antecedents in the Reformation. It is this continuity which shaped the art of David Wilkie who is the subject of the two following chapters. It is a continuity in what are essentially moral ideas and though there are various views as to when the Enlightenment came to an end, it should therefore not be surprising that Wilkie turned to religious painting, or that the crisis that eventually followed the Enlightenment, the Disruption in the Church of Scotland, was also a religious one. It perhaps should not be surprising either that the most immediate pictorial products of that crisis should have been the photographs of D. O. Hill and Robert Adamson (see below, pp194–197). As a realisation of the latest scientific thought and amongst the first great works of art-photography, they are thoroughly modern, yet they also clearly look back to Raeburn and beyond him to Rembrandt who was also Wilkie's great model.

painting in Glasgow on to a professional footing, as did his younger contemporary Daniel Macnee (1806–1882). Macnee, also born in Glasgow, was a pupil of John Knox, as was his close friend Horatio McCulloch. With McCulloch, Macnee was helped in his early career by William Lizars in Edinburgh. In 1830 however he returned to Glasgow and worked there until in 1876, when he was elected President of the Royal Scottish Academy becoming Sir Daniel Macnee, he moved to Edinburgh. Francis Grant (1803–1878) took the Scottish tradition of portrait painting south with great success. Becoming Sir Francis Grant, he was the first Scottish President of the Royal

CHAPTER IX

THE POETRY OF COMMON LIFE
David Wilkie

It was from the Edinburgh of Raeburn and Nasmyth, and of the Enlightenment that David Wilkie (1785–1841) rose to be the most successful artist of his time and, too, next to Hogarth, the British artist with the most far-reaching European influence. Wilkie was the son of a minister in Fife and he studied at the Trustees Academy with John Graham (1754–1817) between 1799 and 1804. Graham, who was appointed to the Trustees Academy in 1798, may himself have been a pupil of Runciman. After finishing at the Academy, Wilkie moved to London in 1805 and the city remained his base till his death on board ship returning from the Holy Land in 1841. Over his whole career Wilkie's art was very diverse. It includes small-scale genre painting, large-scale history painting, grand portraiture and even some landscape, but the basis of his fame was the genre paintings that he executed in the first part of his career. His reputation was established early in London by the success of such paintings as *The Village Politicians* (Earl of Mansfield), painted for the Earl of Mansfield in 1806 who commissioned it on seeing his painting of *Pitlessie Fair* of 1804 (NGS), (*Plate 135*), *The Blind Fiddler* also of 1806 (Tate Gallery), (*Plate 137*) and *The Rent Day* of 1807 (RA 1809, Private Collection). (*Plate 138*) In these pictures Wilkie saw himself as the heir to David Allan, but he was not the first painter to follow in Allan's footsteps.

By the end of the eighteenth century, genre painting in the Dutch manner was something of a Scottish speciality. Alexander Carse and Walter (or William) Weir were already working in a style derived from Allan's in the 1790s and David Deuchar's enthusiasm for the Dutch masters that he copied in his etchings was also an important part of this development in taste. There were also a number of genre artists among Wilkie's own immediate contemporaries, but good though some of these are, beside theirs Wilkie's art is wide and deep, capable of bringing together and unifying diverse streams of thought. It is so important that it has to be treated first in any discussion. Their work is dealt with in the following chapter, even though this results in some inconsistencies in strict chronology.

The direction of Wilkie's art was apparent from a very early date. His earliest surviving picture is an illustration to *The Gentle Shepherd* (Allan Ramsay's pastoral comedy) in the manner of David Allan (before 1797, Kirkcaldy Museum and Art Gallery). In his genre painting he remained loyal to this inspiration all his life. This loyalty is particularly apparent though in his work up to 1818 when he painted *The Penny Wedding*. Up to that date the tradition that *The Gentle Shepherd* itself had first established, and that had been carried on by Fergusson and Burns, clearly shaped Wilkie's art. It is incomprehensible without this background, a fact which has created a constant problem for him with his English audience to whom it was and still is quite unknown. Indeed in one of his earliest pictures he specifically identified himself with Burns. Its subject was Burns's poem 'The Vision'. Though we do not know what the picture looked like, Burns's subject was his reconciliation with – and his justification of – his aspirations as 'a rustic bard':

> Yet all beneath th'unrivalled Rose,
> The lowly Daisy sweetly blows;
> Tho' large the forest's Monarch throws
> His army shade,
> Yet green the juicy hawthorn grows,
> Adown the glade.

Then never murmur nor repine;
Strive in thy humble sphere to shine;
And trust me, not Potosi's mine,
Nor King's regard,
Can give a bliss o'er matching thine,
A rustic Bard.

Wilkie's painting *Pitlessie Fair* of 1804 reflects very closely Burns's viewpoint in 'The Vision' though it is also inspired by Burns's poem 'The Holy Fair' and perhaps too by Fergusson's poem 'Hallow Fair'. It takes the rustic, social landscape of Wilkie's own home village as its subject and so is consciously domestic and unheroic. If it were not too early in date, one might almost think that Wilkie was distancing himself from the heroic tendency in poetry epitomised by Scott's first poems. It is interesting that Constable, who at the time already was and remained a close friend of Wilkie, made a very similar choice when he turned his back on the grand, romantic inspiration of the Lake District which he visited in 1806 and decided instead to concentrate on the humble and unheroic landscape of his Suffolk home, just as Wilkie had done in *Pitlessie Fair.*

Wilkie's training at the Trustees Academy under John Graham was in a rather different spirit to this however. Graham recommended to Wilkie 'never to paint on your principal work without you have nature before you'[1] – and this was important advice that Wilkie stuck to – but Graham was also a believer in history painting. Wilkie held him in respect and throughout his life was troubled by the feeling that he should aspire to be a history painter and not just a 'rustic Bard'. Graham's teaching could not by itself have shaped Wilkie's career however and the real academy was Edinburgh. Looking at Wilkie's early pencil drawings, at his studies for *Pitlessie Fair* for example (NGS), they are very close indeed, both in style and function, to Nasmyth's drawings, while Wilkie in his early *Self-Portrait* (c. 1804, NGS), for which there is a study on the same sheet as the *Pitlessie Fair* drawings, pays homage to Raeburn by using a square brush. In addition David Deuchar published his collected etchings in 1803, and not only did Wilkie use ideas from these as late as his painting of *The Cut Finger* (1808–9) (S. C. Whitehead), but he retained throughout his life a special affection for Ostade, Deuchar's main inspiration and source.

Beyond the practical inspiration that artists could provide, there was the stimulus of talk. At the beginning of the nineteenth century Edinburgh was still a very sociable place, not quite as bohemian as it had been thirty years before in Runciman's time, but still a place in which people of different interests met constantly and exchanged ideas. The kind of interaction between painting and philosophy that is represented by the relationship between Dugald Stewart and Raeburn is something to which Wilkie would also have had access even though he was so young. The miniature painter Andrew Robertson testified to the friendliness of Raeburn and Nasmyth when he too was a young student and a stranger in the city a few years before Wilkie.[2] Wilkie was at a later date on close, friendly terms with both Raeburn and Nasmyth. The influence of Raeburn was not therefore just a matter of admiration at a distance and of using a square brush. The friendship of the older man would have given Wilkie an insight into the way painting could work, much deeper than questions of technique. Likewise his friendship with Nasmyth could give a different dimension to his understanding of Burns and of the social utility of art, an ideal to which Wilkie remained loyal throughout his life. George Thomson could help here too. He was secretary to the Board of Trustees and Wilkie established a friendship with him at an early date which continued after Wilkie had settled in London. Thomson passed on ideas that he had shared with Allan and Burns when the poet and the painter were collaborating with him on his collection of Scots songs (see above, p130).

Philosophy was the centre of Scottish intellectual life. It gave Scottish thought a convergent, not a divergent character, and at its centre in turn was still Reid's discussion of perception. It was Charles Bell (1774–1842) who took the vital step in solving the conundrum of the intuitive theory of perception, the move from speculation into physiology, and so towards a practical explanation of how the mind interacts with its environment through the physical apparatus of the body. Bell was himself a surgeon as was his brother George, a

Plate 135. WILKIE, *Pitlessie Fair*, 1804

close friend of Raeburn, but Charles had also studied drawing with David Allan. Drawing and model-making were very important instruments in his analytical surgery, so much so that his use of these techniques recalls James Nasmyth's account of his father's view of the role of drawing in cultivating the faculty of definite observation.[3] Model-making was equally a passion of Nasmyth's. It seems likely therefore that Bell, like Wilkie, was a member of Nasmyth's circle. It was certainly not just David Allan's teaching that inspired him to write his first major intellectual enterprise, *Essays on the Anatomy of Expression in Painting*, a book that has a direct bearing on Wilkie's art. Bell's career, which revolutionised medicine, began as much in the milieu of art as of medicine itself therefore and his book is not an intervention from medicine into art, but a product of the convergence of thought in which medicine and art shared common ground in philosophy.

Bell began with Thomas Reid who observed how perception and expression are complementary. In so doing, Reid relates both to the business of painting. On expression he writes, echoing very closely what he says about perception (see above, p157):

There are other external things which nature intended for signs; and we find this in common to them all, that the mind is disposed to overlook them, and to attend only to the thing signified by them. Thus there are certain modifications of the human face, which are natural signs of the dispositions of the mind. Every man understands the meaning of these signs, but not one of a hundred ever attended to the signs themselves or knows anything about them, . . . An excellent painter or statuary can tell, not only what are the proportions of a good face, but what changes every passion makes in it. This however is one of the chief mysteries of his art, to the acquisition of which infinite labour and attention, as well as a happy genius are required. But when he puts his art into practice, and happily expresses a passion by its proper signs, everyone understands the meaning of these signs without art and without reflection.[4]

Here, in the context of the discussion of expression Reid makes the essential distinction for painting between the sign and the signified that he also makes in his discussion of perception. He provided a prescription for Wilkie at the same time as for Bell who echoes this passage very closely when, describing what he means by anatomy, he says that it will help the artist to 'direct his attention to appearances that might otherwise escape his notice'.[5]

Bell and Wilkie knew each other in London. Both were only recently arrived in the city when Wilkie drummed up support for a series of lectures that Bell gave on anatomy for artists. According to Wilkie's close friend and

Robert Haydon, Wilkie also provided at least one of the illustrations for Bell's book which was published in 1806,[6] though it had existed in draft before Bell left Scotland in 1804. It is inconceivable that the two did not know each other in Edinburgh. Bell's book is therefore not a prescription that Wilkie followed, but an expression of their common concerns. Their relationship is clearly illustrated in one of Wilkie's earliest pictures, *Diana and Callisto* (Chrysler Museum, Norfolk, Virginia) which he painted while he was still under Graham's teaching in 1803–4. In his picture Callisto is hiding her face in shame at her pregnancy as she is cast out by Diana. John Burnet, who was also in the class, commented on the way that Wilkie had painted the blush in her neck. This was an involuntary, physiological expression of her distress of precisely the kind that interested Bell, though Burnet recalled that it gave Graham an opportunity to enlarge on the 'difficulties of introducing the peculiarities of familiar life into the higher branches of art'.[7]

For Bell the specific point of contact between painting and physiology lay in the 'study of the influence of the mind on the body', of the interaction of the material and the immaterial. His enquiry would also make it easier for the painter 'to make the mind apparent in the body'.[8] The shift from the study of the processes of perception to those of expression thus reintroduces narrative because expression is circumstantial. This is the essence of the difference between Wilkie and Raeburn. Their art represents two different aspects of the same inquiry into the relationship between the mind and the external world.

This parallel is vividly illustrated in Wilkie's brilliant painting of 1804, *Mr and Mrs Chalmers-Bethune and their Daughter Isabella* (NGS). (*Plate 136*) This painting, brought to light only a few years ago, is remarkable by any standards as the work of a nineteen-year-old boy and its quality is a measure of the richness of inspiration available to Wilkie. Naturally he is influenced by Raeburn. This is apparent in the colour and in the frankness of the characterisation too, most strikingly in the great, red face of the father which is such a

startling feature of the picture, but it is equally remarkable how independent of Raeburn Wilkie is. The picture, in a way that is unlike anything that Raeburn painted, is a study of expression. In the faces of father and daughter we can read their awareness, not just that they are being painted, but of the young painter himself.

In the expression of Isabella, the little girl, as she responds to the artist with lively, innocent curiosity, we can also read something of Wilkie's aesthetic ideas however. She is the best kind of art critic because she comes without preconceptions and so she reminds us of a passage in Ramsay's *A Dialogue on Taste* where he argues that art should be accessible because it should be natural. When a young girl says of a picture by La Tour that it is 'vastly natural . . . she has shown that she knew the proper standard by which her approbation was to be directed, as much at least as she would have done, if she had got by heart Aristotle and all his commentators'.[9] Robert Wood, writing at the same time as Ramsay (the two men knew each other) having to his satisfaction successfully separated Homer from the age of Aristotle and the schoolmen, expresses exactly the same sentiment when he remarks: 'That Homer should escape so entire out of the hands of the Lawyers and Grammarians is a piece of good fortune to letters.'[10]

It is this belief in the value of the unsophisticated in matters of taste that lay behind the belief in the superiority of folk music and poetry, apparent in so many different ways, but expressed nowhere more forcefully than by Raeburn in his portrait of *Neil Gow* (*Plate 124*). The force, dignity and simplicity of Raeburn's picture literally personifies this whole attitude, remembering that Gow himself was a folk musician who was celebrated, not only as the greatest of all the Scots fiddlers, but also for his bluntness of manner and for the fact that he had no use for written music – celebrated in other words for his lack of conventional sophistication.

In his portrait of *Neil Gow* Raeburn shows from a different angle the underlying unity of what we might otherwise see as two different concerns, concern with intuition as the basis of perception on the one hand, and concern with

Plate 136. WILKIE, *Mr and Mrs Chalmers-Bethune and their Daughter Isabella*, 1804

the implications of aesthetic, and therefore also, following Hutcheson, moral simplicity, or intuition, on the other. In effect, in the portrait of Gow, Raeburn likens his own painting to Gow's music and so he identifies with folk music the aesthetic character of his own approach to perception. The painting is simple, forceful and direct and its qualities can be understood intuitively, without recourse to any sophisticated arguments. Perhaps in his image of the disarming simplicity of Isabella Chalmers-Bethune, Wilkie made a similar claim for his own art and there is other, parallel evidence that he might have done so. A relation, William Wilkie, professor at St Andrews, poet and patron of both Wilkie's father and Robert Fergusson, had developed just such an argument in his poetic *Fables* of 1768. Fable in primitive society, he argued, preceded the more sophisticated uses of language and in consequence, by its lack of sophistication:

It won the head with unsuspected art
And touched the secret springs that move the heart.

These ideas are basic to Wilkie's aesthetic (see also discussion of *The Letter of Introduction* below pp176–8), but what might be termed his serio-comic pictures also have an express affinity with Burns who habitually presents a serious message in the context of sharp observation and the humour of pithy language. The language is perhaps what Wilkie tried to match in the emphatic drawing of face and figure in his early genre pictures (and notably not in the Chalmers-Bethune portrait), just as Runciman and Allan respectively tried to match visually the poetic styles of Ossian and Allan Ramsay. The earliest extant examples of such pictures by Wilkie, after *Pitlessie Fair*, are *The Blind Fiddler* and *The Village Politicians*. The latter existed in a different version before Wilkie left Scotland and took its theme from Hector MacNeill's poem 'Will and Jean'. This was a sermon against the two inflammatory evils of drink and radical politics which had already been illustrated by David Allan. The impact of the picture's serious message though depends on the vividness with which Wilkie has captured character and expression, the point in which he already parts company with Allan in *Pitlessie Fair*.

Because of the small scale of the figures and the element of exaggeration, this mimetic quality is read immediately as comedy, though, and it was there that Wilkie's success lay, particularly since to an English audience his Scottish peasants were as remote and unreal as Teniers's Flemish boors. The deeper part of his message really escaped attention, but it was clearly his intention in *The Village Politicians*, just as it was Hector MacNeill's intention in 'Will and Jean', to present a serious subject in a light-hearted, humorous and immediately accessible form as William Wilkie recommends.

Wilkie makes specific reference to William Wilkie's *Fables* in *The Letter of Introduction* (see below, p176), but their inspiration seems to be already present in a detail of *Pitlessie Fair*. It is an autobiographical picture. Pitlessie was Wilkie's home village. By his own account most of the figures are portraits of the inhabitants and his biographer, Allan Cunningham, called it 'a portrait of a village'.[11] It was exactly like Courbet's *Burial at Ornans* painted nearly fifty years later in the way it included his own family and all the village worthies. In the picture, amidst all the cacophony of noise, which includes a blind fiddler and a bagpiper – though he is blowing his nose, not his pipes – a boy is playing a jew's harp. One of his companions is intruding raucously with a tin trumpet, but he is being hushed so that the others can listen. It is a little island of calm, but also of genuine aesthetic appreciation. In a world preoccupied by commerce and its own mundane affairs, it is the children who preserve the simplicity of true civilisation and who can make worthwhile art, even, or perhaps especially, on the most primitive of instruments.

Wilkie returned to this theme of unsophisticated art for an unsophisticated audience several times later on, in *The Jew's Harp* (Walker Art Gallery, Liverpool) for example, which derives directly from this incident in *Pitlessie Fair*, and in *The Rabbit on the Wall* (lost) where he translates the story of the origin of painting into the most elementary form of representation, a shadow play for children. He developed the theme immediately though in *The Blind Fiddler*, exhibited in 1806 and painted for Sir

George Beaumont. (*Plate 137*) *The Blind Fiddler* himself has stepped directly out of the background of *Pitlessie Fair*, but we have moved from the world of children to that of adults, though child art on the wall and the appreciative children in the audience are a reminder of the connection between the two.

Burns in the 'Jolly Beggars' writes:

> I am a bard of no regard,
> Wi' gentle folk and a' that;
> But Homer like the glowran byke,
> Frae town to town I draw that . . .

It is the ballad singer not the fiddler who says this in the poem, but it could equally apply to both, and Wilkie's blind fiddler is certainly just such an itinerant relic of an ancient tradition. A little earlier Burns makes the same point of contrast between the great bardic tradition and its modern plight when he calls the ballad singer 'a wight of Homer's craft'. When Wilkie painted the picture he was not only aware of Burns's poem, but he was also very much aware of the celebrated paintings that Runciman's friend, James Barry, had done for the Council Room of the Society of Arts, *The Progress of Human Culture Guided by the Arts*, because he had copied them for an engraver in 1805. The series opens with Orpheus, the first bard, bringing civilisation to ancient Greece with his music. Fuseli was teaching in the Royal Academy schools where Wilkie went to study in the same year and the first time that he spoke to Wilkie, knowing that he came from Scotland, he asked after Runciman's *The Hall of Ossian*.[12] In its origins and bardic theme Runciman's painted ceiling was closely parallel to Barry's paintings and the conversation must have recalled to Fuseli the experience that he had shared with both of them in Rome more than thirty years before. As a student in Edinburgh Wilkie had actually lodged in the very modest flat that had been Runciman's and so he was well aware of his lack of worldly success. In February 1806 though, Barry died in actual poverty. Wilkie's picture was commissioned by Sir George Beaumont in April, two months later.[13]

The circumstances of Barry's death were in poignant contrast to the high ideals of his paintings and this contrast is most telling if

Orpheus, the first itinerant musician and the image of the artist as law-giver, is compared to the real position of the artist as Barry's death revealed it. Wilkie's blind fiddler, the heir of Orpheus as of Homer, can only find an audience among the very poorest members of society and is himself beyond even that margin. He is homeless and so impoverished that, for his family, luxury is the simple warmth of a fire around which they huddle, oblivious to the music. The simple pleasure of his audience on the other hand, including the children, is a further reminder of Wilkie's belief that it is sophistication that has corrupted taste.

In *The Rent Day* Wilkie used the same comic style, but his subject should have been more clearly apparent. In the picture farm tenants are paying their rent to a mean-looking factor. The principal scene is an argument between this individual and one of the younger tenants, evidently over the injustice of the charge that he has put upon the property of an old man who stands by helpless. Others wait in a queue, including a young widow with children, and in the background another group enjoys the landlord's annual hospitality – custom ironically dictated that he gave even while taking away. Wilkie's biographer, Allan Cunningham, remarked that the picture offers 'a distinct image of the oppression which the aristocracy exercises over the children of the clouted shoe'.[14] Cunningham was writing thirty years later, but this aspect of the picture

Plate 137. WILKIE, *The Blind Fiddler*, 1806

must have been pretty obvious at the time it was painted, even though made acceptable by its humour.

Wilkie's inspiration in *The Rent Day* was Burns's poem the 'Twa Dogs', a serio-comic conversation between two dogs, a collie belonging to a farmer and an exotic New-foundland belonging to a laird (Burns's model was in Sir David Lindsay's 'Complaint and Publict Confession of the Kingis Auld Hound etc'.) The dogs discuss the strange behaviour of human beings and particularly comment on poverty, injustice and the lack of correlation between wealth and happiness, familiar themes in Burns. Two similar dogs appear in Wilkie's picture, a hungry collie begging at the table and a well-fed exotic pug or French bull-dog sleep-ing in front of the fire. The greedy factor and the helpless tenants, just as Wilkie sees them, are described by the Newfoundland, Caesar (a good classical name):

> Poor tenant bodies scant o' cash,
> How they maun thole a factor's snash;
> He'll stamp and threaten, curse and swear,
> He'll apprehend them, poind their gear,
> While they maun stan' wi' aspect humble,
> An' bear it a', and fear and tremble.

Wilkie returned to this verse a few years later when he embarked on his most ambitious picture to date, and one of the most important pictures of his career, *Distraining for Rent* (1815, NGS), (*Plate 140*), whose subject is the poin-ding (distraining) of gear referred to in the fourth line. In the poem the collie, Luath (a non-classical, Ossianic name), offers a comment on this line when he says:

> There's many a creditable stock
> O' decent, honest, fawsont folk,
> Are riven out baith root an' branch,
> Some rascal's pridefu' greed to quench.

The scene in this picture is a tenant farmer's kitchen. The bailiff and his clerks are distrain-ing his goods for unpaid rent. The farmer himself sits at the table, his head in his hands with the same distracted despair as the Rake in the prison scene, plate 7 of Hogarth's *Rake's Progress*. The farmer's wife, like the Rake's faithful Sarah, faints in despair, while the gesture and expression of the Rake's harridan

wife, also in the same plate, are transferred to the violent indignation of one of the farmer's neighbours, protesting at the injustice of the distraint.

These Hogarth links are important. In 1814 there was a major exhibition of Hogarth's work which Wilkie visited and he commented to his friend Perry Nursey, 'Hogarth outshines every master that has gone before him.'[15] Two years earlier Charles Lamb wrote a most important essay *On the Genius and Character of Hogarth* in which he argued for the first time the case for the profound seriousness of Hogarth's art, comparing him to Poussin, to Poussin's dis-advantage. This kind of discussion encouraged Wilkie to believe that he too could be taken seriously in his own genre and not merely treated as a comic painter. His friend, the engraver Abraham Raimbach, remembered that after the picture's mixed reception, Wilkie 'expressed satisfaction at having made the experiment and thereby proved that he was not to be estimated merely as a painter of comic scenes which he felt was doing him less than justice.'[16]

The link with Hogarth and the ambition of this picture are even clearer when it is realised that it was conceived as one of a pair in sequence, representing 'Before and After', or more precisely 'Past and Present'. Its pendant, *The Penny Wedding* (1818, HM the Queen), (*Plate 139*), a happy scene of music, dancing, and feasting, is set in the past, some fifty years earlier, though confusingly it was actually painted three years later. (The relationship between the pictures, painted quite separately, as with Gavin Hamilton's Homer paintings, would have been apparent in the engravings.) Wilkie must have had the subject in mind since it had been suggested to him by George Thomson in 1807, however, and it had also been the subject of an unfulfilled commission in 1810.[17] *The Penny Wedding* (at first called *The Scotch Wedding*) is of course a homage to David Allan as well as to Hogarth, to Raeburn (Neil Gow is providing the music for the dancers just as Raeburn painted him) as well as to Allan, and beyond them to Allan Ramsay and to the ballad tradition. Thomson, discussing the subject in his letter of 1807, and clearly remembering similar discussions with David

Allan, quotes a stanza from the ballad, 'Muirland Willie':

> Sic hirdum dirdum and sic din,
> Sic laughter, quaffing, and sic fun,
> The minstrels they did never blin
> Wi' meikle drink and glee,
> And aye they bobbit and aye they beckit.

David Allan himself had earlier used the same composition that he used for his version of *The Penny Wedding* in an etching illustrating the song 'Tullochgorum' which Robert Fergusson invoked memorably in the following lines from 'The Daft Days':

> *Fidlers*, your pins in temper fix,
> And roset weel your fiddlesticks,
> But banish vile Italian tricks
> From out your quorum,
> Nor *fortes* wi' *pianos* mix,
> Gie's *Tulloch Gorum*.
>
> For nought can cheer the heart sae weil
> As can a canty Highland reel,
> It even vivifies the heel
> To skip and dance:
> Lifeless is he wha canna feel
> Its influence.

Allan Ramsay, too, invoked the moral power of dance and its special symbolism in a wedding in the stanzas that he added to 'Christ's Kirk on the Green', stanzas perhaps inspired by Jacob de Wet's painting of *The Highland Wedding*, and from which Allan Cunningham quotes when describing Wilkie's picture.[18]

All this is present in it. In addition he adds a very important detail – in the right foreground sits a smartly dressed old lady with a companion in a tie wig, whereas in Allan's picture the assembly, true to its ultimate inspiration in Breughel, is an assembly of only peasants. In Wilkie's picture, in a phrase that he himself uses in the context of his painting of *John Knox Administering the Sacrament at Calder House*, (*Plate 154*) 'gentle and simple are there'.[19] Elizabeth Grant of Rothiemurchus uses the same phrase to describe just such a party in her childhood at Kinrara in Strathspey: 'fiddles and whisky punch were always at hand, and then gentles and simples reeled away in company.'[20]

Wilkie is not just being sentimental in invoking such things. The deliberate contrast

Plate 138. WILKIE, *The Rent Day*, 1807

with *Distraining for Rent* makes his point. He is comparing a harmonious society held together by human relationships, to one that is governed by abstract values of law and profit. The background to the pictures is the whole history of the agricultural revolution, of rural dispossession and enclosure in the name of improvement. It is the constant theme of Fergusson's poetry. Burns comments on it in the 'Twa Dogs' and elsewhere. Closer in time Hector MacNeill commented bitterly on the consequences for the people of the Highlands of the Clearances, mass dispossession in the name of improvement:

> They're now nae langer in affection
> Screened by their Laird's ance warm protection,
> But driven out helpless, naked, bare,
> To meet cold poortith's nipping blast,
> And on the wide world houseless cast
> To beg for help.
> 'Bygane Times and Late come Changes'[21]

Closest of all to Wilkie, however, is John Galt. The structure of his novel, *The Annals of the Parish* (1821), is the same fifty-year span that Wilkie uses. In his annal for 1807 (the year incidentally that Galt showed Wilkie his draft of the *Annals*), Mr Balwhidder, minister of the parish and author of its annals, describes a pay-wedding (or penny wedding) in terms that exactly match Wilkie's picture:

> There was . . . a great multitude, gentle and semple, of all denominations . . . and the jollity that went on was a perfect feast of itself, though the wedding-supper was a prodigy of abundance. The auld carles kecklet with fainness, as they saw the young dancers; and the carlins sat on their forms, as mim

Plate 139. WILKIE, *The Penny Wedding*, 1818

as May puddocks, with their shawls pinned apart to show their muslin napkins. But after supper when they had got a glass of punch, their heels showed their mettle, and grannies danced with their oyes, holding out their hands as if they had been spinning with two rocks.

In stark contrast to this happy, old-fashioned scene, the following year sees the collapse of the new cotton-mill, symbol of the new money economy. Balwhidder paints a stark picture of the alienation of the modern world as it intrudes upon and disrupts so brutally the quiet ways of the village:

> On the Monday, when the spinners went to the mill, they were told that the company had stopped payment. Never did a thunder-clap daunt the heart like this news, for the bread in a moment was snatched from a thousand mouths. It was a scene not to be described, to see the cotton spinners and the weavers, with their wives and children, standing in bands along the road, all looking and speaking as though they had lost a dear friend or parent.[22]

The theme of 'Past and Present' that Wilkie shares with MacNeill and Galt was developed under just that title, *Past and Present*, little more than a decade later by Thomas Carlyle.

Through Carlyle it was taken up by Ruskin. It became one of the dominant themes of the mid-nineteenth century and was central to the Arts and Crafts movement, so the form of Wilkie's restatement of the idea of social responsibility in art was prophetic.

It was not well received however. *The Penny Wedding* was bought by the Prince Regent, but *Distraining for Rent* was very coolly received. Wilkie's friend Haydon said of its reception: 'the aristocracy evidently thought it an attack on their rights. Sir George [Beaumont] was very sore on the private day, and said Wilkie should have shown why the landlord had distrained; he might have been a dissipated tenant.'[23] Wilkie was, nevertheless, the only artist to have attempted to confront one of the central issues of the nineteenth century; the social dislocation that was a consequence of the agricultural revolution and on which the industrial revolution was founded. It was made clear to him though that there was no way forward through such direct confrontation. He turned subsequently to a religious or spiritual

Plate 140. WILKIE, *Distraining for Rent*, 1815

solution to this crisis of conscience and in this too he was prophetic. These issues underlay the spiritual crisis of the Disruption in Scotland and, throughout the middle decades of the century, it was spiritual regeneration through art that Ruskin preached as the cure to society's ills.

In these pictures Wilkie uses a style of the most elegant and accomplished naturalism based on drawings ranging from tiny, rapid compositional sketches to beautiful studies of details of individual figures, even down to hands though the figures themselves are no more than a few inches high. No one did more justice to the ideal of the anatomy of expression than he did here, but these qualities are not only limited to the observation of expression and movement. The account that he gives of light and space is also masterly and is based on an acute analysis of how things are and not just on how pictorial convention says they ought to appear. The setting of *Distraining for Rent*, for example, is a spacious farm-kitchen described in such a way that we are made aware of this

space and of the variety of kitchen objects that it contains, without any insistence on detail beyond the level of awareness that we would have if we were actually participating in the scene. He achieves this by varying the focus from sharp detail in the principal objects to a much broader treatment of the background achieved with free, semi-transparent, stainy paint which suggests but does not describe. In *The Penny Wedding* the scene in the background of the company sitting at table is a masterpiece in this balance of summariness and precision. He gives an account of things that accords closely with experience because visual focus is interdependent with the set of priorities by which we select what we focus on at any given moment, the priorities upon which narrative depends. Wilkie fully understood the way in which perception and expression are complementary as they mediate between the mind and the external world.

These two paintings are a high point in his career, but they are also a central point in the history of Scottish art. Somehow in them so

many of the different streams of Enlightenment thought converge. Fed by this convergence, Wilkie here stands alongside Burns and Scott. Scott indeed explores exactly the same opposition in *The Heart of Midlothian* as Wilkie does here. Scott was writing the novel at the same time as Wilkie was painting *Distraining for Rent* and during this time the two men also met. In the novel the simple strength of natural human feeling represented by Jeanie Deans, whose old-fashioned, rustic, simplicity of character Scott constantly stresses, is pitted against urban corruption and the impersonal might of the law. Tragedy is only avoided when Jeanie Deans penetrates through the layers of the social hierarchy to make personal contact with the individual at the top in whose name the law is administered, thus restoring the claim of humanity over abstract power.

The background to Wilkie's early style is therefore Edinburgh, painting in Edinburgh first, but beyond that a whole intellectual milieu. As he rose rapidly to a position of celebrity in London, his painting continued to evolve from that same base until at least 1818 in a series of increasingly complex and

sophisticated pictures, though already by 1809 he was trying in parallel to adapt to an English market in deliberate emulation of Teniers in the *Village Festival* (completed 1811, Tate Gallery), or to create a simply more neutral, anecdotal kind of painting in *Blind Man's Buff* of 1811 (HM the Queen), or *Boys Digging for a Rat* also of 1811, his Diploma picture for the Royal Academy (RA).

Wilkie was nevertheless very conscious of his own aesthetic position as a disciple of the Scottish tradition, working in the rather different environment of England and he reflected on it in one of his loveliest and most subtle pictures, *The Letter of Introduction* (1813, NGS). (*Plates 141* and *142*) It is painted with the same command of the relationship between perception and awareness that marks *Distraining for Rent* or *The Penny Wedding*. The composition of the picture is inspired directly by a painting by Terborch, one of the painters from whom Wilkie learnt this subtlety, but also quite clearly by an engraving that is the frontispiece to William Wilkie's *Fables*. In the picture a boy, like Wilkie himself eight years earlier, recently come to town from the country, presents a letter of introduction to an old man who, rather than welcoming him, looks thoroughly suspicious, an attitude that is echoed by his dog. The picture depends on the contrast between these two, observed with delicate precision, the boy, fresh-faced and awkward in his town clothes, but energetic and healthy looking and full of possibility, and the old man, shut away from the sun in turban and slippers, plainly thinking selfishly, and lazily, of how to limit his commitment. This same contrast is drawn in Fergusson's poem 'Hame Content'. (Fergusson's poem is also closely paralleled in Runciman's painting of exactly the same date, *The Allegro*.)

The contrast is between natural simplicity and decrepit artificiality. Fergusson describes his wish to live among simple, country people 'careless o' cash' and enjoying health and happiness. He then contrasts their life with the unhealthy life, divorced from nature of those of 'gentler banes':

Plate 141. WILKIE, STUDY FOR *The Letter of Introduction*, 1813

> On easy chair that pampered lie,
> Wi' banefu' viands gustit high,
> And turn and fald their weary clay,
> To rax and gaunt the livelong day.

Plate 142. WILKIE, *The Letter of Introduction*, 1813

Ye sages tell was man ere made
To dree this hatefu' sluggard trade?
Steekit frae Nature's beauties a'
That daily on his presence ca'.
 'Hame Content'

Burns in the 'Twa Dogs' echoes Fergusson very closely,[24] but it is Fergusson to whom Wilkie is closest. His old man is shut off from nature's beauties, he is 'steekit frae Nature' in his windowless room. In place of a taste for domestic nature are such exotics as the prominent Imari vase in the foreground. (The same vase is the eponymous subject of a little painting a year or two later, *The Broken Vase*, (V & A).) This detail too has an echo in Fergusson and in Burns who both remark on the passion for exotica and foreign travel of the gentry[25] in terms reminiscent of Ramsay's condemnation of 'imported trimmings' and 'foreign embroidery'. The sword on the wall in Wilkie's picture also suggests that the old man has pretensions to gentility of the kind that Fergusson and Burns also both condemn. In addition to these links between Wilkie, Fergusson, Burns and Ramsay, however, this passage in Fergusson's poem paraphrases a passage from William Wilkie's *Fables* (as too does the equivalent passage in Burns's poem):

Are natural pleasures suited to a taste,
Where nature's laws are altered and defaced?
The healthful swain who treads the dewy mead,
Enjoys the music warbl'd o'er his head;
Feels gladness at his heart while he inhales
The fragrance wafted in the balmy gales.
Not so SILENUS from his night's debauch,
Fatigu'd and sick, he looks upon his watch
With rheumy eyes and forehead aching sore.
And staggers home to bed to belch and snore.

Finally these various verses also all recall Thomas Blackwell's remark: 'Nay so far are we from enriching poetry with new images drawn from nature that we find it difficult to understand the old. We live within doors, covered, as it were, from nature's face; and passing our days supinely ignorant of her beauties.'[26] In this key picture, therefore, Wilkie states his aesthetic position and in doing so sums up very deliberately the central concerns of almost a century of Scottish poetry and painting. It is a declaration of allegiance. Exploring the extensive literary connections here and of *The Penny Wedding* and *Distraining for Rent* reveals how Wilkie saw the place of art in the moral universe as at a point where actual and moral perception intersect. In this way his art is at the same time natural and naturalistic. It is a synthesis of the qualities of David Allan, or Runciman with those of Allan Ramsay or Raeburn.

Like Ramsay before him, too, Wilkie finds no place for the agreeable without the exact and as his study is human behaviour then his exactness of observation has to be applied to the whole psychology of expression as it embraces both physiognomy and movement – body language in the modern term. Nobody was ever more subtle than Wilkie in this and it is an aspect of his work that was enormously influential. The idea which he formulates, of narrative art based on unaccented observation of actual human behaviour, runs through nineteenth-century painting, in England from Mulready to the Pre-Raphaelites, in France from Meissonier to Degas, and among Scottish painters from George Harvey to Orchardson and so into the present century. In *The Penny Wedding* Wilkie added another element to this formula, too, by setting the scene in the past and in carefully correct period costume. If he did not invent it, he certainly created here the best known and most influential model for the countless costume genre paintings of the nineteenth century.

GENRE, HISTORY AND RELIGION

Wilkie's Contemporaries and his Later Work

During the first two decades of the nineteenth century Wilkie's art focused on some of the central concerns, not just of art in Scotland, but of the whole culture of the Enlightenment. His influence was far-reaching too, but it was not his influence alone that was responsible for the popularity of the kind of painting in which he specialised during the first part of his career. There were already other Scottish artists before him in the 1790s following the lead of David Allan and producing pictures of common life. Alexander Carse (*c.* 1770–1843) for example seems to have been a pupil of Allan and his watercolour of *Oldhamstocks Fair* (NGS) painted in 1796, the year Allan died, is a worthy tribute to the older artist. There are other similar works from this period by Carse too, closely observed and full of life, such as *Leith Races* (Private Collection) and *Return from Leith Races* (CEAC), both dated 1794. There are also topographical drawings by him, such as *South View of Leith* (NGS), and he was clearly already a mature artist, capable of continuing in Allan's vein. For some reason, however, in 1801 Carse chose to enrol in the Trustees Academy where he was a contemporary of Wilkie. It is difficult thereafter to differentiate between his own natural development and the impact that Wilkie's art had on him, particularly as Carse followed Wilkie to London in 1812, returning however to Edinburgh in 1820.

It would be a mistake to see Carse as merely a follower of Wilkie though, for there are several occasions where chronology gives him the advantage in a particular pictorial invention. His best known and most original picture, for example, is *The Visit of the Country Relations* of 1812 (Duke of Buccleuch, Bowhill). (*Plate 143*) It is a fascinating sociological study. A country family is entering the door of the flat of their town relations. There is probably no difference in their relative prosperity and the town family's flat is modest in size, but it is filled with the latest fashionable furniture to match the fashionable clothes of the girls – all observed with a sharpness of wit reminiscent of Osbert Lancaster. The two men greet each other with a warmth that is unaffected by any of these superficial differences, but the women, and especially the girls, are acutely conscious of them. The confident superiority of the town girls in their elegance and the mortification of their country cousin, so self-conscious in her rustic dress, are beautifully observed. The picture predates Wilkie's *The Letter of Introduction* by two years and although that is a much deeper and more reflective picture, the situation it describes is very similar.

Carse's *The Penny Wedding* (1818, Private Collection) was exhibited in the same year as Wilkie's picture of the same subject. That may be coincidence, but it could equally reflect either rivalry or an exchange of ideas between the two. Carse also worked as a topographical painter and his most ambitious painting, *The Arrival of George IV at Leith* (1822, CEAC), an extensive view of the port, the ceremonial and the crowds, almost rivals a panorama in its scale and detail.

Another of Wilkie's older contemporaries, Walter (or William) Weir (*fl. c.* 1782–1816), one of Raeburn's fellow pupils with Runciman, also

Plate 143. ALEXANDER CARSE, *The Visit of the Country Relations*, 1812

produced work in a style deriving from Allan including, for example, two drawings illustrating 'Hallowe'en' by Burns, (1816, NGS). Robert Brydall quotes a rather unfair obituary of Weir and this has affected his reputation, but he had a modest talent.[1]

Weir and Carse were older than Wilkie, but his immediate contemporaries also included a number of genre artists. William Lizars (1788–1859) the engraver, for example, was a student alongside Wilkie at the Trustees Academy and showed considerable promise as a painter. He was patronised by the Earl of Buchan and painted a rather remarkable portrait of Buchan in 1808. Its full title is the *Earl of Buchan presenting Henry Corrie with a medal at Corrie's Rooms* (Lord Cardross) and it is a very ambitious essay in the grand manner. He did exhibit other full-length portraits around this time, but the most remarkable portrait that may be by him is a painting of an Edinburgh beggar, *John Cowper* (formerly attributed to Wilkie, Fitzwilliam Museum, Cambridge). (*Plate 144*) The picture is inscribed 'John Cowper an old soldier, now a beggar in Edinburgh, 1808, aged 87'. It is a remarkably frank and unaffected portrait of a humble individual.

There are not so many such portraits. The painting of an Edinburgh porter called *William McGregor* (CEAC), attributed to James Cumming, Runciman's friend, seems to be a record of one of the Gaelic singers among the highland porters and chairmen of Edinburgh (see above, p133). A little later, in 1817, the Duke of Buccleuch commissioned portraits of several members of his household from a painter, John Ainslie (*fl.* 1807–1817), (Duke of Buccleuch Drumlanrig), rather as the chief of the Clan Grant had commissioned pictures from Richard Waitt (see above, p88). Ainslie is otherwise known only for a handful of genre pictures, but the existence of such pictures as

these portraits of ordinary people without claim to wealth or status is part of this same tradition of Scottish genre painting, distinguished by its lack of affectation in the treatment of the people which are its subject. They are not, like George Morland's country people for example, inhabitants of a different world of reduced individuality, though they do have a precedent in some of the work of the English painter John Opie who was admired by the younger Scottish artists.

The attribution to Lizars of the portrait of *John Cowper* depends on comparison with two genre paintings that he exhibited in 1811, *A Scotch Wedding* and *The Reading of the Will* (both NGS). (*Plate 145*) They are strongly painted, vigorous pictures, full of humorous observation. They relate to early genre pictures by Wilkie such as *Pitlessie Fair* and *The Village Politicians* where he used a blunt, emphatic style. Lizars, turning to this kind of genre, may have been imitating Wilkie's successes, but he could also have been reflecting their shared inspiration.

Like Carse, Lizars here dealt first with subjects that Wilkie subsequently made famous. Wilkie's *The Penny Wedding* of 1818 was first called *The Scotch Wedding* and in 1820 Wilkie painted his version of *The Reading of the Will* (Alte Pinakotech, Munich). It was commissioned by the King of Bavaria, however George IV decided he would like it and put Wilkie in the embarrassing position of having to arbitrate between two crowned heads of state. Honourably, with the help of Sir Thomas Lawrence who was very much the courtier, he decided in favour of the original commissioner, the King of Bavaria. This picture is also often invoked as representing the relation between Wilkie and Scott. It relates to a very similar scene in *Guy Mannering* published five years earlier in 1815, but this was four years after Lizars had exhibited his picture, so perhaps both Scott and Wilkie were indebted to him.

Lizars turned to engraving as a full-time profession shortly after he painted these, his two most celebrated genre pictures, but he continued to paint and to exhibit from time to time until 1830. His only other known painting of similar character and ambition though is an unfinished *Interior of a Church* (RSA) of unknown date. It is a strongly painted study of the

congregation gathered in the nave of a tall, Gothic church. It bears some resemblance to Wilkie's small, unfinished *The Soldier's Grave* of 1813 (Nottingham Castle). Without a date for Lizars's picture it is impossible to say who should have precedence, but it is another interesting example of the closeness between them.

Wilkie's immediate contemporaries in Scotland also included William Shiels (1785–1857) who is best known as an animal painter. His work includes a superb series of paintings of cattle undertaken as a serious study of breeds (EU and RMS), (*Plate 146*), but he also regularly painted and exhibited genre pictures. Shiels visited America where in 1817 he painted a portrait of President John Quincey Adams (whereabouts unknown, exhibited Scottish Academy 1827). James Howe (1780–1836), though less accomplished than Shiels, was another artist whose work as a genre painter has a strongly agricultural dimension. Those who were closest to Wilkie, however, were his personal friends John Burnet (1784–1868), William Allan (1782–1850), Andrew Geddes (1783–1844) and Alexander Fraser (1786–1865). Burnet, Fraser and Allan were Wilkie's contemporaries at the Trustees Academy, but Geddes was self-taught. Burnet and Fraser actually worked closely with Wilkie in London and both Allan and Geddes also remained in

Plate 144. ATTRIBUTED TO WILLIAM LIZARS, *John Cowper, an Edinburgh Beggar*, 1808

Plate 145. WILLIAM LIZARS, *Reading the Will*, 1811

close touch with him throughout his life. Allan became Master of the Trustees Academy and later President of the Royal Scottish Academy. He was well placed to pass on Wilkie's influence and Wilkie in turn kept close links through him with art in Scotland even though his base was London.

Alexander Fraser was Wilkie's assistant for many years from 1813 and his hand is recognisable in the beautiful still-life in some of Wilkie's later pictures such as *The Irish Whiskey Still* of 1840 (NGS). Fraser also painted independently though. His pictures are usually humorous and small in scale and often show the direct influence of Wilkie, as in *The Scotch Fair* (c. 1834, Dundee Art Gallery) or *Music Makers* (Bukowski Gallery, Stockholm), (*Plate 147*), though in his later career he also came under the influence of the Pre-Raphaelites. Burnet too was a genre painter in his own right, but was mainly important as the engraver of a number of Wilkie's earlier works. He greatly assisted the spread of Wilkie's reputation, for the distribution of engravings, eventually throughout Europe, played a crucial part in this.

William Allan left Scotland in 1805 for Russia where he remained till 1814. While he was there he travelled widely. He was the first of several Scottish artists, including Wilkie himself, to make such an exotic journey and long after his return he exhibited exotic subjects like

The Slave Market, Constantinople (1838, NGS). (*Plate 148*) Such pictures stand between the serious-minded ethnography of David Allan and the frank eroticism of Ingres and Delacroix in treating such subjects. Allan's career, though, was very much shaped by his friendship with Wilkie. In 1821 he exhibited the *Murder of Archbishop Sharpe* (whereabouts unknown) and the following year *Mary Queen of Scots Admonished by John Knox* (Private Collection), both subjects directly inspired by Wilkie who may have begun his own painting of *Knox Preaching at St Andrews* by this time and was also contemplating painting the *Murder of Archbishop Sharpe*. In *Mary Queen of Scots Admonished by John Knox* Allan is clearly emulating the way Wilkie constructed narrative through precisely observed expression. Genre pictures by Allan in the Wilkie manner are less typical, but his *Christmas Eve* (undated, Aberdeen Art Gallery) is a charming variation on Wilkie's *The Penny Wedding*, though it also looks back to David Allan's interest in popular customs.

Allan was close to Walter Scott and he provided illustrations for an edition of Scott's novels published in 1820. Wilkie, in his own approach to history as a subject of painting, and encouraging Allan as he did, was also quite consciously promoting the idea of developing the painting of Scottish history in parallel to Scott's novels. Allan lacked Wilkie's talent of accurate observation though, and his historical compositions always seem a little stagey. They were, however, of the greatest importance in shaping the art of the younger generation, particularly after 1826 when Allan was appointed to the Trustees Academy. His loyal interpretation of Wilkie and Scott helped shape much of the art of the mid-century. His position of prominence in Scotland was confirmed when in 1838 he became President of the Royal Scottish Academy and in 1841 he followed Wilkie as Queen's Limner in Scotland. He was knighted in 1842.

Andrew Geddes was also a close friend of Wilkie, but unlike Wilkie and Allan he did not attend the Trustees Academy. Instead he was mostly self-taught. His work is very diverse and includes a number of ambitious failures like an altarpiece of the *Ascension* for a church in London where he was resident from 1814 (St James, Garlickhythe), and the *Education of Pan*

Plate 146. WILLIAM SHIELS, *A Wild Welsh Cow*

(Kirkcaldy Museum and Art Gallery). In these he anticipates Wilkie's own later preoccupation with the imitation of the old masters. He is much better when he is closest to Wilkie's inspiration in Dutch painting as in his portrait of *Andrew Plimer* (1815, NGS) which is a superb study of light and warm shadow in the manner of Rembrandt. A year later though he painted an equally fine, small portrait of Wilkie himself with a richly coloured delicacy of treatment more reminiscent of Rubens (NGS). (*Plate 149*) It is one of the finest pictures of Wilkie. It shows him in a gorgeous dressing-gown, standing leaning on a chair which also appears in his painting, *The Letter of Introduction*, painted three years earlier. Geddes made something of a speciality of such cabinet-sized portraits, though he also painted full-sized portraits like those of *Thomas Chalmers* and his wife, *Grace Pratt* (Private Collection), a commission that he was given through Wilkie's intervention. Geddes also painted landscapes and shared with Wilkie an interest in etching.

Beyond the immediate circle of his friends Wilkie's influence was equally strong. Artists like William Kidd (1796–1863) who was a pupil of James Howe, William Bonnar (1800–1853), William Simson (1800–1847) and Walter Geikie (1795–1837) all took the comic style of his early pictures as their starting point. The first three also all worked at various times in London, and with Fraser, Burnet, Geddes and Carse there too for a while, there was a recognisable, Scottish school gathered round Wilkie. Simson as a pupil of the landscape painter, Andrew Wilson, was more interested in landscape in his earlier career. After a visit to the Low Countries in 1827 he painted several very fine essays in the Dutch manner of large-sailed boats on calm water against a low horizon, but his *Solway Moss – Evening* (1830, NGS) by contrast is a moody and atmospheric landscape of genuine power. Subsequently though, he painted more closely in the manner of Wilkie, or perhaps in the version of Wilkie's style developed by Alexander Fraser. His *Goatherd's Cottage* (NGS) for example is comparable to Fraser's *Highland Sportsman* (NGS). Simson also specialised to

Plate 147. ATTRIBUTED TO ALEXANDER FRASER, *Music Makers*

some extent in sporting scenes of men, dogs and ponies. In 1834–5 he visited Italy and thereafter also exhibited Italian subjects like *Capuchin Monks giving Alms at Rome* (1837, Thirlestane Castle).

William Kidd and William Bonnar both worked in a style very similar to that of Simson, a slightly florid version of Wilkie's genre in which the greater richness of Wilkie's late style is applied to the humorous and domestic 'cottage genre' of his early work. Like Alexander Fraser, Kidd was an accomplished still-life painter, while Bonnar's lovely small portrait sketch of the three daughters of Thomas Chalmers (Private Collection) shows what a direct and informal approach underlay the painting of all these artists. It was in the work of Walter Geikie, however, that these qualities were most conspicuous.

Geikie is best known for his etchings, though some of his paintings also have real quality. His work is sometimes directly derivative from Wilkie, but Geikie stayed on in Edinburgh and his inspiration was Wilkie seen from Scotland. The exhibition of *Pitlessie Fair* in Edinburgh in 1821, for example, seems to have been important for him and the picture provided the

inspiration for several of the comic etchings that are his most familiar production. He was also an artist of independent mind however. He was a powerful draughtsman and at times his drawings – two for example which are possibly of the same girl, May Rennie, working in the kitchen, peeling potatoes and scouring a pot lid (*c.* 1831, NGS and Private Collection), (*Plate 150*), can stand beside any drawings of such subjects in the nineteenth century. They are close to the work of the French Realists of the 1850s such as Bonvin and Ribot and it is interesting in that context that amongst various pictures of labour by Geikie there are several of a stonebreaker, including a drawing (1825, NGS), an etching (1831) and a lithograph (1825). *The Stonebreaker*, painted by Courbet in 1850 became almost the symbol of social realism.

Geikie's best etchings, which are of simple groups, have the same powerful simplicity, *They are real comfortable* for example shows an old couple sitting on a step. The man is dozing while she sews. In *Our Gudeman's a Drucken Carle*, (*Plate 151*) a drunken man is helped home by two friends. It is based on the principal group in Wilkie's painting, *The Village Festival*, but it has neither the forced jollity nor the

disapproval of such behaviour that Wilkie shows in his picture. Instead Geikie has also taken inspiration from Rembrandt's *Deposition* of the 1630s to create a humane and sympathetic image. Geikie worked in the streets of Edinburgh and this particular group of etchings was published in 1831. Their titles preserve the authentic vernacular of the city and their frank treatment of urban subject-matter makes them unusual in the nineteenth century.

Geikie also explored the implications of Wilkie's images of children and child art in several remarkable pictures. The most interesting is an etching of a child drawing in the dust. It derives from a detail in Rembrandt's etching *Christ Preaching the Remission of Sins*. The same image was used by Deuchar in an extraordinary etching of three old crones, apparently acting the part of art critics discussing a portrait of a cat in the artist's studio while a child draws innocently near by. Deuchar was a constant source of ideas to Geikie as he was also to Wilkie himself. Geikie, however, has turned this idea into an image of the innocent eye, for in his picture the adults do not ignore the child,

but look on admiringly. It prefigures Courbet's use of the same motif in the *Artist's Studio*.

After the pioneering work of Andrew Duncan in the treatment of mental illness, Edinburgh was an important centre for early psychiatry, including phrenology, and Geikie himself, who was deaf and dumb, was a beneficiary of advanced ideas about disability. He was taught to read and write through the revolutionary approach to the teaching of the deaf pioneered in Edinburgh by Thomas Braidwood which may have involved encouraging pupils to draw. Geikie also had links with Sir Alexander Morison, a follower of Andrew Duncan in early psychiatry, who used several of his drawings in *The Physiognomy of Mental Diseases* (London, 1840). These include a grotesque nymphomaniac who might have stepped out of Burns's 'The Jolly Beggars'. It was Morison who, as physician to the London Bedlam, encouraged Richard Dadd to paint, an early example of art therapy.

In Scotland the influence of Wilkie's early work did not stop with his own generation however. It is the basis of much of the work of

Plate 148. WILLIAM ALLAN, *The Slave Market, Constantinople*, 1838

Plate 149. ANDREW GEDDES, *David Wilkie*, 1816

George Harvey (1806–1876) and a little later of the early work of John Phillip (1817–1867). The sentimental cottage scenes of Tom Faed (1826–1900) whose success was established with the exhibition at the Royal Academy in 1855 of the *Mitherless Bairn* (National Gallery of Victoria, Melbourne) also derive directly from Wilkie. Erskine Nicol (1825–1904) was another practitioner of this 'kailyard' painting which was a debasement of Wilkie's early work. There is a curious dissociation of sensibility apparent in his pictures and in Faed's, a discrepancy between the high quality of the still-life and accessory painting and the sentimentality of the figures which diminishes their humanity (see below, p217).

The influence of Wilkie's early work in England is also well documented. It is seen in the work of William Mulready and even in works of Turner and of Constable, such as Turner's *Sun Rising through Vapour* or Constable's *Boat Building at Flatford*. Wilkie's influence overseas is less well known, but in France in the 1830s Phillipe Auguste Jeanron's *Paysans Limousins* of 1834 (Musée de Lille),[2] is an early example of an awakening interest in the sympathetic representation of peasant culture, while in the same decade the Leleux brothers, Armand and Adolphe, painted Breton subjects in direct emulation of Wilkie's Scots peasants, just as Balzac turned to the royalist rising in the Vendée as an equivalent to the 'Forty-five for *Les Chouans*, his early novel in imitation of *Waverley*. Wilkie's possible influence on Courbet is touched on below.

The next stage of Wilkie's development was equally far-reaching in its influence. In 1817 he visited Scotland preparing the painting of *The Penny Wedding*. He stayed with Scott at Abbotsford and painted a little portrait of him with his family, an innocent portrait of the author in the role of Border farmer (SNPG) in the tradition of Ramsay the shepherd and Burns the ploughman, which, however, aroused quite startling hostility when it was shown in London.[3] Scott certainly prompted him to think about history, but meeting Thomas Chalmers, the future Evangelical leader, in Glasgow also prompted him to think about religion. Scott's *Old Mortality*, his novel of the Covenanters, published the previous year, had provoked a furious debate because of his unsympathetic treatment of them. Wilkie may already have been thinking of painting a straightforward genre picture based on some contemporary religious occasion, for he did several drawings of this character while he was in Scotland. *Tent Preaching, Kilmartin* (1817, NGS), for example, is a view of an open-air gathering such as Burns described in 'The Holy Fair', though rather more decorous. The eventual result of this visit however was the painting *The Preaching of John Knox before the Lords of Congregation, 10 June 1559* (1832, Tate Gallery), a choice of subject that clearly shows the impact on him of Chalmers and the current religious debate. Though it was not completed till 1832 it was probably actually conceived on this trip to Scotland and certainly existed as an oil sketch by 1822 (NT, Petworth).[4] (*Plate 153*) Even as a sketch it was influential as the first important application to painting of Scott's

idea of history as fiction, that is to say of the creation of a psychologically and historically authentic account of an actual event.

In preparing the picture Wilkie undertook extensive research in order to get the details right and his painstaking attempt to recreate history, from the inside as it were, had numerous imitators. In Scotland after William Allan's *John Knox Admonishing Queen Mary* a host of similar pictures followed, leading into what is really a sub-genre of nineteenth-century painting, the illustration of Scott's novels and, in a spirit rather different from that of Scott, the illustration of Scottish religious history which became increasingly topical as the crisis in the Kirk advanced. Wilkie's *Knox Preaching* was well known and even Bonington and Delacroix's small narrative paintings of the 1820s may owe something to his model. Delacroix came to London in 1825, when he visited Wilkie and saw the sketch of the *Knox* in his studio.[5]

The illustration of Scott had a major boost in the publication by Cadell of the illustrated edition of the *Waverley* novels, which began in 1829 and to which Wilkie and many other artists contributed illustrations as part of the effort to redeem Scott's fortunes. Following this, for example, one of Robert Scott Lauder's first major compositions was the climactic scene from *The Bride of Lammermoor* (1831, Dundee) and he painted numerous other subjects from the novels. Artists made their whole careers out of this kind of narrative history painting. In 1841 Thomas Duncan (1807–1845), one of the best painters of the generation after Wilkie, but sadly short-lived, exhibited a very fine *Entry of Prince Charles Edward and the Highlanders into Edinburgh after the Battle of Prestonpans* (Lady Buchanan-Jardine, Castlemilk). James Drummond (1816–1877) painted a series of extremely detailed reconstructions of Scottish history such as *The Porteous Riots*, 1855, *The Departure of Mary from Edinburgh, 16 June 1567*, 1870, and *Montrose led to Execution*, 1859, (all NGS). He also painted simpler scenes from the past such as *Sabbath Evening* (1847, CEAC), (*Plate 152*) and though they lack dramatic conviction, such pictures have considerable documentary interest. They gave a new dimension to the relationship betwen art and antiquarianism. Drummond's

own antiquarian drawings of costume, arms and armour, celtic stones and historic buildings are of very high quality and are an important documentary record. His drawings of sculptured monuments of Iona and the West Highlands were actually published by the Society of Antiquaries of Scotland in 1881 as a volume of *Archaeologia Scotica*. His studio, like those of William Fettes Douglas and Joseph Noel Paton, was a minor museum.

Religion was more important than history in Wilkie's *Knox Preaching* however. In 1817 Thomas Chalmers was already famous as a reforming preacher. He subsequently became leader of the Evangelical party in the Kirk. Wilkie himself was of course a son of the manse. His father, superbly captured in the

Plate 150. WALTER GEIKIE, *A Girl Scouring a pot lid*, c. 1831

Plate 151. WALTER GEIKIE, *Our Gudeman's a Drucken Carle*,
ETCHING, 1831

artist's moving portrait of his parents (1807, Private Collection, 1813 version, NGS), was an old-style minister, but Wilkie's own position vis-à-vis the Kirk may have been very like Chalmers's own. Chalmers was an up-to-date Scottish intellectual, teaching the new scientific ideas in St Andrews and Edinburgh, when he underwent a spiritual crisis. He subsequently devoted himself to his parish, first in Fife and then in Glasgow, actively promoting the idea of social reform through pastoral care and spiritual regeneration. In this move he did not turn his back on the Enlightenment however.

The religious revival in Scotland was originally an extension of the Enlightenment. If it was a reaction at all, as in Wilkie's own *Distraining for Rent*, it was against the consequences of some of the economic developments and their social consequences that followed from the ideas of the Enlightenment, not against the ideas themselves. That picture after all clearly focused a long tradition of Enlightenment thought. It is important to recognise this in approaching Wilkie because, for all his success as a fashionable painter in England, the relation of art to religion as a means of realising his

sense of social responsibility became a central preoccupation of his later life. Part of the reason why he remained so much the leader of art in Scotland was the way his art continued to relate to events there as the religious crisis deepened to lead eventually to the Disruption in 1843.

Wilkie's position was a logical one. Scottish art since Ramsay and Hamilton had been concerned with the relationship between actual and moral vision. It was a relationship that was increasingly under tension and Wilkie had already taken a step towards expressing that tension in an art that could actually apply itself to moral issues with *Distraining for Rent*. The step to perceiving that the solution to this tension must be spiritual was logical in the context of Christian morality. (Hindsight may tempt us to see this as a wrong turning, but history is surely not so simple.) It was also natural to see this in historical terms. From Hamilton onward the idea of a return through history to reconstruct a morally valid art from first principles had been accepted. The idea of a similar return through history to reconstruct the Kirk from the purity of first principles was launched by Thomas M'Crie in the *Life of Knox* (1812), the book from which Wilkie took the text for his picture of Knox preaching. M'Crie presented Knox as a hero and man of action and also pointed out very forcibly the close relationship between the early reformers and the development of democratic thought. Democracy within the Kirk was seen as one of its most sacred principles, yet it had been one of the first victims of the Union in the Patronage Act of 1712.

M'Crie's Knox is a hero in Carlyle's sense, a man of action who decisively changed history for the better and he was actually one of those celebrated by Carlyle in *On Heroes, Hero-Worship and the Heroic in History* published in 1841. This is how Wilkie presents him in his picture in which he uses rich, dark paint (now sadly spoiled by bitumen) and strong chiaroscuro in the manner of Rembrandt to create a sense of dramatic immediacy. The scene is St Andrews Cathedral on 10 June 1559. Defying the threat against his life uttered by the Archbishop of St Andrews – ominously represented by a group of armed men in the picture – Knox is preaching the sermon that rallied the Protestant cause and

led to its eventual triumph. It was genuinely the turning point of the history of the Reformation in Scotland. It was also not a coincidence that Wilkie should have chosen to exhibit the picture for the first time in 1832, the year of the Reform Bills, English, Scottish and Irish. He clearly saw the topicality of Knox as a democrat.

Wilkie began a second Knox picture towards the end of his life, but it was never finished. The subject, also taken from M'Crie, though also thoroughly researched by Wilkie himself, was *John Knox Administering the Sacrament at Calder House* (c. 1839, sketch and unfinished panel, both NGS), an event that symbolised the institution of the Sacrament of the Reformed Kirk. The two pictures would have been pendants, but there are two others which also deal with what Wilkie himself called the primitive Kirk,[6] *The Cotter's Saturday Night* (RA 1837, GAGM), (Plate 155), and *Grace before Meat* (1839, City of Birmingham). The four pictures together constitute an equivalent to Poussin's *Seven Sacraments*, translated into Protestant terms. Preserving the balance between lay and ecclesiastical so essential to Presbyterianism, they represent sermon, communion, prayer and bible reading, four key elements in worship, but each represented, like Poussin's *Sacraments*, in an original or primitive form. The two historical pictures are clearly concerned with the origins of the Kirk. The primitivism of the other two is equally important, however, as they represent the dignity of simple piety without ceremony. Beyond the appearance of the pictures themselves the case that this is so lies in Wilkie's choice of *The Cotter's Saturday Night* to illustrate family worship.

In choosing to illustrate Burns's poem, Wilkie was probably consciously paying homage to Allan as well as to the poet, for David Allan had painted the subject for Burns with his portrait in the title role. The scene in Wilkie's picture is the same as that chosen by Allan and also by Alexander Carse (drawing, NGS):

> The cheerfu' Supper done, wi' serious face,
> They, round the ingle form a circle wide;
> The Sire turns o'er, with patriarchal grace,
> The big ha'-Bible, ance his father's pride;
> His bonnet rev'rently is laid aside,
> His lyart haffets wearing thin and bare;
> Those strains that once did sweet in Zion glide,
> He wales a portion with judicious care;
> 'And let us worship GOD!' he says with solemn air.

Plate 152. JAMES DRUMMOND, *Sabbath Evening*, 1847

> They chant their artless notes in simple guise;
> They tune their hearts, by far the noblest aim.

Even though the poem fell out of fashion, the reverent simplicity of the lines is still telling and in the nineteenth century it was very popular. Chalmers himself cited it in the context of his own reinstitution of family worship.[7] What Burns does is to propose that the values of primitive simplicity in poetry and music are equally valid in religion. There is an implicit contrast between the simple purity of genuine popular religion and the established Kirk so vividly chastised in the 'Holy Fair' or 'Holy Willie's Prayer'. By this route Wilkie's picture develops his own earlier genre painting and identifies the common ground between art and religion.

The Cotter's Saturday Night is a masterpiece. Like *The Penny Wedding* and *Distraining for Rent*, but moving forward from them, it draws together into a perfectly resolved image a range of ideas whose unity was there but was perceived by very few, and by none with such luminous clarity. Each character in the picture is drawn with great care so as to reveal the different ways that they participate in the occasion. Wilkie does this with subtlety and tact. As a result, although piety is the subject, it is seen as an aspect of ordinary human feeling. Wilkie has paid conscious homage to Rembrandt in the picture, in the lighting and in the composition itself, and few painters have come so close to Rembrandt in describing

Plate 153. WILKIE. *John Knox Preaching at St Andrews*, SKETCH,
c. 1822

the dignity and humanity of such unaffected feeling.

It was Wilkie's urge to create an authentic, modern religious painting, like that of Rembrandt, that took him at the end of his life on a journey to the Holy Land. In 1839 he was planning to paint a major biblical subject *Samuel in the Temple* which only exists as a watercolour sketch (NGS). Many years previously, in 1818, he had painted a small *Bathsheba*, but this was the first time that he had tackled anything so ambitious. While he was preparing it, David Roberts came back from the Middle East and inspired Wilkie to follow his example to collect material for his painting. What Wilkie was looking for though was not just landscape settings, it was authenticity of costume and character. In 1840 he travelled to Constantinople, then on to Jerusalem and Alexandria. Returning from Alexandria he died at sea. What is left of this journey is a series of superb coloured drawings, one or two small oil paintings and sketches for paintings, including several ideas for religious pictures. Wilkie was followed to the Holy Land thirteen years later by the Pre-Raphaelite painter, Holman Hunt, who inherited his ambition to create a modern religious art. Hunt enjoyed enormous success with the paintings that he did as a result of his trip, especially *Christ among the Doctors* and so, although Wilkie himself did not live to fulfil

his own ambition, it became an important aspect of Victorian art.

Through engravings Wilkie's major compositions were well known on the Continent.[8] The reputation they enjoyed is of particular interest in the case of *The Cotter's Saturday Night*. It was perhaps inimitable, but it may have inspired one major painting a decade later. Courbet's *L' Après Diner à Ornans* is really Wilkie's picture secularised. The fiddle on the wall that is just visible in the background of *The Cotter's Saturday Night* has been taken down and is now being played. The table has been moved, but the distribution and gestures of the four main figures are almost identical. Both pictures owe something to Rembrandt's *Supper at Emmaus* in the Louvre, but the resemblances between them are too close for it to be simply a matter of a common source, and the family occasions represented by the two modern painters have more in common than either does with Rembrandt's representation of spiritual drama. The resemblance is an intriguing one for it points to other parallels between the two painters. Both were outsiders in the metropolis, marketing an art which declared its origins in their own native culture (the unpleasant modern word is regional) in a way that was openly autobiographical. Both drew on analogies with child art and folk music as part of their aesthetic, and both as a result successfully launched genre painting as a serious rival to the dominance of history. Wilkie's priority in this is another argument for seeing Scottish painting in this period, like Scottish philosophy and Scottish literature, as at the centre of European culture, not on the periphery.

Wilkie's two Knox paintings had enormous influence and found many imitators. This was of course partly because of their topicality. The whole question of the relationship of art and literature to the traditions of the Scottish Kirk had been reopened in *Old Mortality* where Scott had depicted the Covenanters as fierce, joyless fanatics whose inhumanity was about balanced by their incompetence. It was a piece of black propaganda and was highly topical when Wilkie visited Scotland in 1817. He described travelling with the book in his hand over the sites of the actions it depicted.[9] If he kept his

Plate 154. WILKIE, *John Knox Administering the Sacrament at Calder House*, STUDY, *c.* 1839

own counsel when talking to Scott himself, his reaction to *Old Mortality* may well have played a part in the decision to vindicate the traditions of the Kirk by creating a religious art which, because it was appropriate to the needs of the new Kirk, would also replace that which had been lost at the Reformation. Perhaps he was also thinking about reconciliation for, although in his religious pictures Rembrandt is his principal inspiration, in *Knox Administering the Sacrament* the composition also directly echoes Leonardo's *Last Supper*. Thus Wilkie brings together in a single image the two traditions of western art that had come to represent the opposite sides in the division of Europe.

He was certainly thinking about iconoclasm when he embarked on his first Knox picture and commented in a letter that the variety of religious images that are visible on the pulpit and elsewhere in his picture would be 'no bad indication of some of the labour which his [Knox's] preaching destroyed'.[10] He had the Covenanters and *Old Mortality* very much in his mind too, for the murder of Archbishop Sharp that he was thinking of

painting in 1822 is one of the central events in the novel, though it happens off-stage.[11] William Allan exhibited a picture of this subject in 1821. The idea had almost certainly come from Wilkie who was generous to his friends both with encouragement and ideas. Sharp's murder had happened even closer to Wilkie's birthplace at Cults than Knox's sermon at St Andrews, itself scarcely a dozen miles away.

It was of course not just Scott who made the history of the Covenanters topical. In spite of him they were held as heroes of the history of the Kirk, and as the Disruption crisis deepened the whole question of the conflict between the state and the principles of a free religion became increasingly acute. In 1843 at the Disruption Assembly, the Seceders, in memory of the National Covenant of 1638, declared their autonomy, and in the manner of the excluded ministers of 1662 and those who followed them to become the Covenanters, marched out into a life of field preachings, if not of persecution. James Drummond and others produced a folio of prints documenting

the field preaching of the new Free Kirk with the ironic title *Illustrations of the Principles of Toleration in Scotland* (1846).

It is not surprising that in this climate some of the best paintings of the period are of Covenanting subjects. George Harvey, for example, who had been painting minor genre pictures, painted *The Covenanters' Preaching* (GAGM), (*Plate 156*) in 1830 and in 1831 *The Covenanters' Baptism* (Aberdeen Art Gallery), two pictures which helped to make his reputation. In 1836 he painted the *Battle of Drumclog* (GAGM), in 1840 *The Covenanters' Communion* (NGS) and in 1848 *Quitting the Manse* (NGS), recording the dispossession of the seceding ministers following the Disruption, a subject also painted by William Allan (whereabouts unknown). In these pictures, although they are very accomplished, Harvey reverted to Wilkie's early comic style, apparently in an attempt to capture the simple sincerity of the Covenanters, but this weakens the dignity of the subject. That this should be so is all the sadder because the studies that he did of individual figures are quite outstanding and have telling simplicity and dignity (NGS and Smith Institute, Stirling). (*Plate 157*) John Phillip probably took his cue from Harvey rather than from Wilkie himself when he painted *Presbyterian Catechising* (1847, NGS) and also *Presbyterian Baptism* (1850, RA), a distinct echo of Greuze's *Accordée du Village* in the latter picture, however, shows how quickly this kind of painting could sink into sentimentality (see below, p214 for further discussion of Phillip.)

In spite of Harvey's success it was his close contemporary Thomas Duncan who painted the most memorable picture in this genre, *The Death of John Brown of Priesthill* (GAGM), (*Plate 158*), exhibited in 1844. It records a tragic incident in 'the Killing Times', the death of an innocent man at the hands of Claverhouse and his soldiers. It is a large picture, composed with a sense of drama that stops short of melodrama, and painted with a broad fluency that is not showy.

Thomas Duncan left unfinished at his death a large painting of *George Wishart Administering the Sacrament in the Prison in the Castle at St Andrews, 1546*. In 1845 James Drummond also painted a subject from the life of George

Wishart, *Wishart Administering the Sacrament for the First Time According to the Protestant Form* (Dundee Art Gallery). The titles reveal very clearly the origin of both pictures in Wilkie's unfinished painting of *John Knox Administering the Sacrament at Calder House*, the sketch of which, together with the unfinished panel, had been acquired by the Royal Scottish Academy in 1842. Other direct derivatives from Wilkie's picture are Orchardson's first major picture *Wishart's Last Exaltation* of 1853 (University of St Andrews) and, actually identical in subject and date, William Dyce's *John Knox Administering the Sacrament at Calder House* (c. 1838–9, John Knox's House, Edinburgh) which may in fact have been part of an attempt to pirate Wilkie's own design and is an unexpected picture from Dyce who was an Episcopalian.[12]

The most far-reaching result of Wilkie's religious history paintings however was the impact that they had on D. O. Hill (1802–1870). Like all of Edinburgh, Hill was a witness to the drama of the actual Disruption when virtually half the ministers and elders of the Kirk marched out from the Assembly Hall, across the Mound and down Hanover Street to the Tanfield Hall at Canonmills. There they held their own Assembly and founded the Free Church. The full impact of this event, which reverberated throughout Scotland for the rest of the century, and in which so much of Scottish history was enshrined, has sadly been forgotten. What is also forgotten is the extent to which what might be called liberal opinion was united in support of the Seceders. They were seen to stand for the old Scottish belief in the importance of principle and so, like those who signed the Covenant in 1638, to uphold the dignity and identity of Scotland in a gesture that was political as well as ecclesiastical, for the Disruption was not just a minor upset in the Kirk. It was also the expression of a nationwide crisis of conscience over the changes in Scotland brought about by the agricultural revolution, but which could find no political expression. The way in which the old fabric of Scottish society was being torn apart in the name of material progress had been the subject of much of the poetry of Fergusson and Burns, and more recently and with greater

urgency, it had inspired some of the most important work of Wilkie, John Galt and Thomas Carlyle. It is this unspoken dimension which explains the tone of the most vivid contemporary account, that given by Henry Cockburn. The men he describes were putting conscience before interest and in this they stood for the nation:

> The Disruption is as extraordinary, and in its consequence will probably prove as permanent, as any single transaction in the history of Scotland, the Union alone excepted. The fact of above 450 clerical members of an establishment, being above a third of its total complement, casting it off, is sufficient to startle anyone who considers the general adhesiveness of churchmen to their sect and their endowments. But when this is done under no bodily persecution, with no accession of power, from no political motive, but purely from dictates of conscience, the sincerity of which is attested by the sacrifice, not merely of professional status and emoluments, but of all worldly interests, it is one of the rarest occurences in modern history. . . . They have abandoned that public station which was the ambition of their lives, and have descended from certainty to precariousness, and most of them from comfort to destitution, solely for their principles.[13]

It was this drama of modern history that D. O. Hill set out to record when in 1843 he embarked on the picture that he finally completed more than twenty years after the event that it commemorated, *Signing the Act of Separation and Deed of Demission* (1843–67, Free Church of Scotland). (*Plate 159*) This was its final form, but some of the early sketches show that the original subject was Thomas Chalmers, as Moderator of the Free Church, preaching to the Assembly. If that subject had been chosen the link between Chalmers and Knox would have been immediately apparent through the analogy with Wilkie's picture of *Knox Preaching*, which was Hill's starting point. He also incorporated into the image the centralised arrangement of Wilkie's *Knox at Calder House* however, and this survives in his final composition which has Chalmers at the centre, though the main group to which he belongs is almost lost in Hill's

Plate 155. WILKIE, *The Cotter's Saturday Night*, 1837

Plate 156. GEORGE HARVEY, *The Covenanters' Baptism*, STUDY 1831

enormous picture which contains more than four hundred figures. Hill was also indebted to Wilkie in another respect too, however.

In *Distraining for Rent* Wilkie pioneered the modern, moral subject which became such an issue with the Pre-Raphaelites in the early 1850s. In his painting of the *Chelsea Pensioners reading the Despatch from Waterloo* (1822, Apsley House) painted for the Duke of Wellington and completed in 1822, he moved this into the realm of modern history. In *George IV Receiving the Keys of Holyrood* (1822–30, HM the Queen, Holyrood) which he painted to record the visit of George IV to Edinburgh in 1822, in several of his Spanish subjects, especially *The Defence of Saragossa* (1828, HM the Queen), (*Plate 160*), and in the massive *Sir David Baird discovering the body of Sultaun Tipoo Sahib* (1835–38, NGS) Wilkie had endeavoured to take this further to create a genuine, modern history painting. Hill's cumbersome group portrait, as his Disruption picture turned out to be, does not readily suggest that category, but that is certainly how it was conceived.

The problem that Hill faced was subtly different from that which Wilkie had faced in his modern history pictures however. Hill was a witness of an actual event whereas Wilkie's problem was one of reconstruction, except in *George IV Receiving the Keys of Holyrood*. In that picture Wilkie was also a witness of what he painted, but it was an event that was anyway so stage-managed that it fitted easily into the

conventions of royal iconography and Wilkie frankly borrowed from Rubens's paintings of Marie de Medici and Henry IV. In *The First Council of Queen Victoria* (1837–8, HM the Queen) Wilkie had also had the problem of trying to incorporate a large number of portraits into a semi-historical picture, but at least the composition was naturally dominated by the Queen,[14] but Hill was trying to record an event whose very nature was anti-hierarchical.

The Disruption hinged on the question of intrusion, of patronage. The seceders stood for the right of a congregation to choose its minister rather than have him imposed by a patron. What was at stake was the democratic ideal that was the very basis of the Kirk. Hill could not use the conventional language of history painting therefore because it is naturally hierarchical. It places stress on leading characters whereas he had to show how the event was a cooperation of equals. J.-L. David had an identical problem of reconciling ideology and composition when he set out to record *The Oath of the Tennis Court* of 1789, another moment of democratic crisis. Both painters had to try to accommodate a very large number of portraits and to give them all roughly equal stress. David's painting was never finished, though as a sketch it became well known. There was a historical analogy, both with the original Covenanters and with the French Revolution, in the action of the Seceders and there seems to be a reference to David in Hill's picture. There is a rather striking detail of spectators looking in from high windows in both paintings, but Hill adopted a dramatically modern way of resolving the principal ideological problem that he shared with David. He turned to photography.

As a landscape painter Hill had some talent. He is also to be remembered as the energetic and devoted secretary of the Scottish Academy who did so much to establish that institution, but his most important achievement was in partnership with Robert Adamson (1821–1848) with whom he created what are really the first, and are still among the most enduringly beautiful, of all art photographs. Hill was a pupil of Nasmyth's. It was a scientific friend who had also been a friend of Nasmyth, Sir David Brewster, who suggested that he use the new invention of the calotype – the first

photographic process that used a negative – to record all the portraits that he needed to include in his proposed picture.

Brewster's own main interest was in optics. As with Charles Bell this was an interest which originated in the philosophic study of perception and which therefore from the start had important common ground with painting. He was in close touch with the research that led to the invention of photography, particularly that of Henry Fox Talbot. He had already experimented himself with the new process and was in a position to pass on to Hill something that was absolutely brand new, but it was also something that fitted perfectly into the aesthetic tradition of Scottish painting.[15] Raeburn and even Ramsay would have expressed no great surprise at the invention of photography and none at all at the use Hill made of it. The paper negatives which the calotype process used gave a broad, grainy texture and it is the way that Hill exploits this in lighting his photographs that gives them their special quality, but it also marks their continuity with Raeburn.

One reason for the artistic command that is so striking in them is just this, that they belonged in and so could draw upon, an established artistic tradition dedicated to capturing an image of the world exactly like that which they provided.

There is another side to Wilkie's later art however. His religious pictures certainly reflect his ambition to succeed as a history painter, but his efforts to establish a new kind of religious painting with the emotional and spiritual verisimilitude of Rembrandt also reflected deeper and more personal convictions. In parallel he tried to create a more superficial art that would fulfil the traditional ambitions of academic painting without losing touch with his English market. As early as 1811 in *The Village Festival* there is an indication that he was conscious of this, which in a way is still the dilemma that was focused in Burns's 'The Vision'. The picture, also called *The Alehouse Door*, is of a scene outside an inn. At the centre a man is pulled between a drunken friend who wants him to stay drinking and his wife and family who want him to come home. It was this group that

Plate 157. GEORGE HARVEY, *The Covenanters' Preaching*, 1830

inspired Geikie's etching *Our Gudeman's a Drucken Carle*. Its origin is in the classical iconography of the choice of Hercules beween virtue and vice. J. J. Angerstein had commissioned *The Village Festival*[16] and Wilkie's immediate inspiration was a picture in his collection, Reynolds's painting of *Garrick between Tragedy and Comedy*. It shows the famous actor torn between the tempting frivolity of comedy and the high seriousness of tragedy.

Although *The Village Festival*, like *The Village Politicians*, was exhibited with a text from MacNeill's 'Will and Jean' and had as its ostensible subject the evils of drink, at another level therefore it clearly reflected Wilkie's own dilemma. His use of Reynolds to present this was very significant. Reynolds's reputation and influence as champion of a somewhat confused notion of the academic ideal in painting remained powerful in the first part of the nineteenth century in England. Both Constable and Turner, for example, felt constrained to accommodate it. It is not surprising that Wilkie should feel the same pressure, especially as with success he came increasingly into the public eye and his picture, deliberately set in an English village and with English characters, was his first serious attempt to adapt his Scottish genre style to an English market.

Wilkie's personal success story developed from the sale, first of *Blindman's Buff* in 1811 and then in 1818 of *The Penny Wedding* to the Prince Regent. After the accession of the Prince to the throne as George IV, Wilkie was appointed first King's Limner in Scotland, on the death of Raeburn in 1823, and then Painter in Ordinary in 1830. These appointments involved him quite extensively in official painting, including full-length portraits of *George IV* wearing highland costume (1829), *William IV* (1834, both HM the Queen) and *Queen Victoria* (1838–9, Lady Lever Art gallery, Port Sunlight). He also painted a number of other full-length portraits during his career, but, though they are accomplished and even grand, they are not the happiest of his productions.

Wilkie's greatest public success was the *Chelsea Pensioners reading the Waterloo Despatch* painted for the Duke of Wellington between 1816 and 1822. The Duke paid the enormous sum of 1,200 guineas for the picture and it was immensely popular, but it caused Wilkie endless trouble and in the end seems forced and artificial. It is a large painting, but its basic compositional idea looks back to *The Village Politicians* where a group are gathered round a newspaper at an inn, though now they are out-of-doors, like *The Village Festival*, not

Plate 158. THOMAS DUNCAN, *The Death of John Brown of Priesthill*, 1844

Plate 159. D. O. HILL, *Signing the Act of Separation and Deed of Demission*, 1843–67

indoors like *The Village Politicians*. Chelsea Hospital in the background establishes the location. The original commission was for a picture of a group of old soldiers outside an inn in Chelsea and the principal figures are mostly either Chelsea pensioners or are in military uniform. One of the pensioners is reading out the news of the victory at Waterloo. The reactions of those close by are excited. Others further away react with curiosity, interest or enthusiasm according to the extent to which they have understood what the excitement is about. The scene, though imaginary, reflects a major historical event, and thus Wilkie has introduced a historical subject indirectly into a genre context. He has returned to the formula of *The Village Festival*, but even more clearly than in that picture he is trying to edge his own art closer to the academic idea of elevated subject-matter. The execution is elegant for the same reason and for the first time he has posed several figures in ways that are plainly not observed from the natural responses of people to such an occasion, but are chosen instead, in the academic manner, because they are pictorially effective.

The painting *George IV Receiving the Keys of Holyrood* with its explicit reference to Rubens and the 'grand manner' follows logically from *The Chelsea Pensioners*, but although begun the year that picture was finished it was not completed till 1830. Like the painting of *Knox Preaching*, work on it was interrupted by what appears to have been a nervous breakdown and between 1825 and 1828 Wilkie travelled as

a convalescent on the Continent. There had been a similar interruption in his work from unexplained illness in 1810. This second breakdown was very severe and for a long time he could not paint at all. Then, after nearly three years studying the old masters in Italy, France and Spain, he embarked on a series of paintings that paid deference to the old masters both in style and technique in ways that were anticipated in *The Chelsea Pensioners*, but which met even more closely than anything he had done previously the criteria of Reynolds for the 'grand manner'.

His new style was launched with four Spanish pictures which were all bought by the king. Three of these are a development of his earlier genre paintings in subject, the fourth, *The Defence of Saragossa* though, is heroic and historical. It represents a moment in the seige

Plate 160. WILKIE, *The Defence of Saragossa*, 1828

Plate 161. WILKIE, *The First Earring*, 1835

manner of execution that is entirely different from the naturalism and the precise observation, not only of his earlier work, but even of contemporary paintings like *The Cotter's Saturday Night.*

Wilkie's non-Scottish subjects of his later career, though consistent in style, were not all so heroic however. The other Spanish pictures, for example *The Spanish Posada* or *The Guerrilla Council of War, The Guerrilla's Departure* and *The Guerrilla's Return* (all 1827/8, all HM the Queen) represent scenes of the Spanish resistance during the Peninsular War, but, although more richly painted and exotic in costume and character, they are studies in the psychology of situations akin to his earlier genre painting. The way that he tries to adapt his earlier style to a foreign context to broaden its appeal parallels what Scott tried to do in his non-Scottish novels like *Ivanhoe* or *Quentin Durward* and the results seem equally a little strained. Wilkie developed this, however, into such paintings as *Josephine and the Fortune Teller* (NGS), *The First Earring* (1835, Tate Gallery), (*Plate 161*), and in the pictures resulting from a tour in Ireland, such as the *Irish Whiskey Still* (1840, NGS).

What all these late pictures have in common is the use of rich colour – frequently applied in glazes – long flowing contours and sweeping brushwork. Many of them have suffered from excessive use of bitumen, adopted to emulate the brown glow of the old masters, but which does not add to their attractiveness. They were, however, successful at the time and they were an important example. It was this painterly side of Wilkie's later art that was developed by one of the most influential artists of the next generation, Robert Scott Lauder (1803–1869). He passed it on in turn to the painters who dominated much of the later nineteenth century in Scotland whose common characteristics were a similar use of colour, though it was controlled by observation of the actual, and thus Wilkie's lifelong loyalty to the discipline of drawing also continued to bear fruit long after his death.

of that city in 1808 when, on the death of one of the defenders, his wife took his place manning a gun – a subject that had also inspired the seventh plate in Goya's *Disasters of War.* Although the picture is not exceptionally large, the figures are large within the composition and are expressly heroic in pose and gesture. In several ways the picture anticipates Delacroix's *Liberty at the Barricades* painted two years later and it certainly led on to Wilkie's own most ambitious attempt to create a heroic history painting in the 'grand manner' and his largest painting, *Sir David Baird discovering the body of Sultaun Tipoo Sahib.* Celebrating a modern Scottish military hero, Wilkie really created a convincing idiom for what Baudelaire later called 'the heroism of modern life', though to do so he had had to move into a scale and

PART THREE
THE VICTORIAN ERA

Plate 162. ROBERT SCOTT LAUDER, *J. G. Lockhart and his Wife, Sophia Scott*, AFTER 1837

ARTISTS OF THE MID-NINETEENTH CENTURY

There are few aspects of Scottish painting in the nineteenth century that are not touched by the influence of Wilkie. The effect of his approach to his subject has already been discussed and it became increasingly important as the nineteenth century progressed. It would be a mistake, however, to see Wilkie as responsible for pushing painting into the kind of literary backwater into which critics of the early twentieth century were inclined to dump all British nineteenth-century art. Literary links were important for him, but those with Scott and John Galt, for example, reflect a genuine affinity between his painting and the novel, and a common concern with the nature of society, not a dependent relationship of art on literature. Both depend on the observation of human action, though in this in fact Wilkie is closer to Galt than to Scott. He and Galt adopt a position of social criticism that is very different from Scott. Wilkie also shares with Galt a gift of wonderfully sharp and precise observation that can be telling without drama, and can be very funny, simply by being accurate. In painting this is a kind of mimetic gift, and Wilkie was himself a gifted mimic. It was these qualities that gave his art authority. Without the extraordinary visual integrity of his best work, Wilkie's invention of subject would have been nothing, and he would have had no narrative skill. It was therefore on the compelling example of his technique and not just his worldly success that his influence was built.

Wilkie's art was based on drawing. This was not unique to him, but was a feature of the Scottish tradition going back to Ramsay through the example of Nasmyth. Nasmyth's teaching was carried into the Trustees Academy by his pupil Andrew Wilson. Walter Geikie, for example, though he was originally a pupil of John Graham, drew in a way that suggests that Nasmyth was his model and he probably continued to study with Wilson who succeeded Graham. The next teacher at the Academy after Wilson was William Allan. Allan and Wilson were both friends of Wilkie, but Allan had also been his fellow student and had shared the education on which Wilkie's own art was based. This succession of teachers was perhaps by itself enough to establish drawing as the basis of art in Scotland, but Wilkie developed it beyond Ramsay and Nasmyth through his admiration for Rubens and his study of the old masters.

Robert Scott Lauder (1803–1869) studied at the Trustees Academy under Andrew Wilson for two years from 1822. He then spent a period in London before returning to Edinburgh in 1828. It was about this time that he painted a superb portrait of his younger brother, James Eckford Lauder, who was himself also a painter (NGS). This subtle and beautiful painting shows how strongly independent Lauder's talent was. Raeburn's influence is there in the lighting, Wilkie's in the fineness of the handling of colour, and Reynolds's *Nelly O'Brien* as well as Rubens's *Chapeau de Paille* may have had something to do with the striking use of the shadow of the hat, but the image itself is memorably Lauder's own.

In 1833, after marriage to the daughter of John Thomson of Duddingston, Lauder went to Italy with his new wife and stayed there for five years. Rome had very much changed for Scottish artists over the Napoleonic period. The death of Cardinal Henry of York in 1807, the last of the Stuarts, finally broke the link

with the old order in which Scottish artists had had a privileged place in the city. Nevertheless the Scots continued to form a distinctive part of the international community there. In 1827 they held a grand dinner for David Wilkie. William Dyce (1806–1864) on his second visit to Italy had recently spent three years there. John Zephaniah Bell (1794–1885) had been in Rome 1825–6. David Scott (1806–1849) was there when Lauder arrived. William Simson visited Rome in 1834–5 as did William Leighton Leitch, and the sculptor Lawrence Macdonald became a permanent resident there about this time.

Dyce, Scott and J. Z. Bell were all influenced by the German Nazarene painters while they were there, the revivers of what was called the 'early Christian style'. This was particularly important in Dyce's case for he became the principal intermediary between the Nazarenes and the Pre-Raphaelites. He also became the leading British expert on the art of fresco that was revived by the Germans, though Scott and Bell also learned this skill. Bell, who had also studied in Paris with Gros, left an important example of fresco painting in Muirhouse, Granton. It is the survivor of two ceilings that he painted there in 1833 and is a remarkable perspective view of a group of people sitting on the edge of an opening in the ceiling, seen against the sky. Stylistically the Granton ceiling is closer to Tiepolo than to the Nazarenes though. Bell taught in Manchester and then settled in London. He exhibited historical paintings throughout his life in which traces of Nazarene influence are still apparent. He also painted some distinguished portraits such as *John Crichton* (1841, Dundee Art Gallery) in which the influence of the Nazarenes is apparent in a distinctive clarity and sharp analysis.

Lauder, however, does not seem to have been interested in the German enthusiasm for the early Renaissance that was to become the dominant vehicle for the expression of the idea of primitive purity in painting by the mid-century. Instead, like Wilkie he made good use of the opportunity to study the art of the High Renaissance and its successors in the seventeenth century, marking his taste by a *Self-Portrait* in seventeenth-century costume (Patrick Allan Fraser Trust, Hospitalfield). Lauder made a little money in Rome by painting portraits. He also painted a second version of the *Bride of Lammermoor* (Private Collection), the picture that he had exhibited in 1831, and some very

Plate 163. ROBERT SCOTT LAUDER, *Christ Teacheth Humility*, SKETCH, c. 1845

fine genre paintings in the Wilkie tradition. These included a version of a subject that went right back to David Allan, *Pifferari playing to the Madonna* (HM the Queen). Yet another Scot in Rome at this time was Patrick Allan Fraser who had been a fellow student of Lauder's, but who married well and was able to build up a collection of the work of his friends and contemporaries, including the *Self-Portrait* painted by Lauder in Italy and a later subject painting, *The Gow Chrom escorting the Glee Maiden*, a scene from *The Fair Maid of Perth* painted twice by Lauder, in 1846 and again in 1854, the version bought by Fraser. Fraser left his house, Hospitalfield, including his collection, to found an art college which in a modified form survives to the present day. The collection encapsulates the taste of the mid-century very well.

After his return to Britain Lauder settled in London where, disappointed in his ambition to be elected to the Royal Academy, he became one of the leading figures in the Free Society of the late 1840s, a counter to the Academy's monopoly of exhibition opportunies. He was also disappointed in his ambition to be chosen as one of the artists selected to decorate the new Houses of Parliament, a selection that was conducted in a series of competitions whose one enduring legacy is the modern use of the word 'cartoon'. *Punch* made such merciless fun of the cartoons (for frescoes) submitted, that ever since the word has meant a comic drawing. Lauder painted a large and very majestic painting for the competition of 1847, *Christ Teacheth Humility* (NGS). (Sketch, *Plate 163*) Although Wilkie himself never completed a proper biblical subject, it was his ambition to do so that took him to the Holy Land. Lauder did not go so far, but he clearly had Wilkie in mind when he embarked on a religious picture that would be at once both grand and humane. Lauder's subject, *Christ Teacheth Humility*, recalls Rembrandt's subject in the etching, *Christ Preaching the Remission of Sins*, while his composition shows the inspiration of Rembrandt's *Christ healing the Sick*, the 'Hundred Guilder Print'. Both of Rembrandt's subjects stress the humanity of Christ. The way Lauder pays homage to this aspect of Rembrandt's art shows a deep sympathy with Wilkie's motives in attempting to create a humane and accessible

Plate 164. ROBERT SCOTT LAUDER, *David Roberts in Eastern Costume*, 1840

form of religious painting. The link with Wilkie is confirmed by a similarity between the grouping in Lauder's painting and Wilkie's painting of *Knox Administering the Sacrament at Calder House*. Lauder's own originality is powerfully present in his picture though, in the intense, but superbly controlled handling of colour and in the striking skyscape of sunset and rolling grey clouds. Perhaps there is an echo here in this skyscape and in some of the details of the composition, of Runciman's central panel at Penicuik, *Ossian Singing*. David Scott turned to Runciman's Penicuik paintings for inspiration at just the same time in his *The Discoverer of the Passage to India rounding the Cape of Good Hope (Vasco da Gama)* (1842, Trinity House), an even bigger painting than Lauder's. It must have been at about this time too, and having the Westminster decorations in mind, that David Laing described Runciman's paintings as 'truly national designs'.[1] They were a fitting model

Plate 165. DAVID SCOTT, *Puck Fleeing Before the Dawn*, 1837

for Lauder in his own ambition to create a painting of just such status, and no other artist before Lauder, Wilkie not excluded, had been so bold a colourist as Runciman evidently was at Penicuik.

Magnificent though *Christ Teacheth Humility* undoubtedly is, and Lauder painted other large-scale religious pictures subsequently, it is his portraits of the 1840s that are probably most to modern taste. These include the superb portrait of *David Roberts in Eastern Costume* (1840, SNPG). (*Plate 164*) Roberts was a life-long friend of Lauder and was to him much as Wilkie was to Allan and Geddes, from his own position of secure success, a generous supporter and concerned adviser to a less successful friend, though with Roberts and Lauder this inequality led to eventual bitterness. The natural sympathy that existed between artist and sitter as friends (as they then were) lifts this portrait above the dazzle of brilliantly painted exotic costume to the heights of true portraiture. Lauder's portrait of *Prof. John Wilson*, the 'Christopher North' of the *Noctes Ambrosianae* (1843, EU), is one of the most ambitious and also successful full-length essays in the true grand manner. Using no less a model for the pose than Michelangelo's *Moses*, Lauder combines it effortlessly with a sense of the complete veracity of the portrait. It is a *tour de force* that might have puzzled Reynolds, but which Ramsay would have applauded unreservedly.

The picture that more than any other puts Lauder alongside Ramsay and Raeburn though is his haunting portrait of *John Gibson Lockhart and his Wife, Sophia Scott* (after 1837, SNPG).

(*Plate 162*) Lauder had painted Lockhart for Blackwood before he went away to Italy and in this painting he may be represented as slightly younger than he actually was, for the painting of Sophia is posthumous. She died on 17 May 1837. Lockhart wrote of her: 'Of all her race she most resembled her father in countenance, in temper, and in manners' – paying her the highest compliment he knew.[2] That the portrait of Sophia is posthumous perhaps explains the strange lack of a clear spatial relationship between the two figures. She is not there, but is as he remembered her. It must have been almost unbearable for Lockhart to be presented with such a poignantly beautiful and vividly alive portrait of his dead wife.

Lauder's subject pictures are on the whole less happy though he set great store by them, encouraged by Roberts. He lacked dramatic sense and if they had been actors in dramatic productions of *The Fair Maid of Perth* (1848 and 1854), *Quentin Durward* (1851), *The Heart of Midlothian* (1842), or *Guy Mannering* (1843 and 1855), to list only those of Scott's works that inspired pictures that Lauder exhibited at the Royal Scottish Academy, they would rightly be accused of overacting.

In 1852 Lauder was invited to take over the Mastership of the Trustees Academy, a post he had already filled on a temporary basis in William Allan's absence in 1829. He held the position until he was disabled by a stroke in 1861. He was much upset, however, by a successful move by the Academicians, led by Watson Gordon, to demote the Trustees Academy and the Mastership, in favour of the Royal Scottish Academy's own schools in 1858. They took over the Life class while the Academy, affiliated to the Department of Science and Art, South Kensington, offered no more than an elementary course. Lauder's last years were further embittered by his lack of success, rubbed in by financial problems. Nevertheless he was an inspired teacher who left a permanent mark on Scottish painting by his teaching as well as by his own art. Those he taught in his brief tenure of the Trustees Academy post are still known as the Scott Lauder School.

Two painters, contemporaries of Lauder, who stood outside the vast penumbra of

Wilkie's influence, though they shared his conviction of the seriousness of art, to a fault in the case of one of them, were David Scott and William Dyce. Scott is almost a tragi-comic figure.[3] Like B. R. Haydon whom he knew, he had huge ambitions, frustrated by the limitations of his own talent, or perhaps, more kindly, by the shortfall between his conviction of the abstract and intellectual potential of art and the necessarily concrete nature of the business of painting. His position was very much that championed by James Barry. Consistent with that, William Blake was a formative influence on him. Scott's father, the engraver Robert Scott, was an admirer of Blake and owned a copy of Robert Blair's *The Grave* with his illustrations and perhaps other works engraved by Blake himself. Of all Scottish painters too, David Scott was the one who saw himself as carrying the mantle of Runciman's historical ambitions which were of course closely linked to Barry's. Runciman's expressive, but erratic drawing may have been the justification of Scott's own massive, eccentric and often clumsy execution. Delacroix too, whom Scott admired, was prepared to sacrifice conventions of formal order in the interest of greater expressiveness and so Scott's refusal to

subject his drawing to the conventions of academic discipline and his erratic wildness, like Runciman's, is perhaps a reflection of a precociously modern attitude to art.

Another formative influence on Scott was the series of five gigantic canvases by the English painter, William Etty, three of them bought and two actually commissioned on D. O. Hill's initiative by the newly created Scottish Academy between 1829 and 1831. They have long since degenerated, in Blake's phrase, into a 'superabundant blackness', but were at the time an imaginative and daring piece of patronage of modern art. Scott's picture *The Agony of Discord, or the Household Gods Destroyed* (1833–39, lost, formerly Leathart Collection), painted in Rome, was a development of the theme of one of these, *The Combat*, as well as of the *Laocoon* which Scott had seen and been profoundly impressed by in Rome.

Scott's work includes direct homage to Fuseli and to Barry respectively in his choice of subjects from *The Iliad, The Sleep of Sarpedon* (1832, NGS) and *Philoctetes* (1840, NGS). His historical ambitions were confirmed during two years spent in Italy, 1832–4. It was there that he painted one of his most attractive pictures, *The Vintager* (1833, NGS). Its flat areas

Plates 166, 167 and 168. DAVID SCOTT, *The Wallace*, 1843

of light-toned colour reflect the influence of the fresco painting of the German Nazarenes, but though he learnt the technique of fresco from them his subsequent painting shows little sign of the influence of their calm and spiritual art. Instead he carried on in the idiom of wild expression and portentious meaning which, both before and after his visit to Italy, did occasionally produce images of real, if awkward, power such as *Traitor's Gate* (1842, NGS), *The Poles did nobly and the Russian General craved an Armistice to bury his Dead* (1832, Hunterian) – a strange interpretation of an event in the contemporary struggles of the Poles for independence from the Russians – and the remarkable, surrealistic *Puck Fleeing Before the Dawn* (1837, NGS). *(Plate 165)*

Scott's relationship to Runciman surfaces constantly in his work. In 1835 he painted, for the cost of materials, an altarpiece for St Patrick's Catholic Chapel, *The Descent from the Cross* (lost, small replica NGS). The congregation later moved to the Cowgate Chapel where Runciman's painting of *The Ascension* had been obliterated when Scott was a boy and he must have been conscious that he was taking up Runciman's mantle in attempting such a public demonstration of large-scale religious painting. Scott's composition derives from Rubens's *Deposition* in Antwerp Cathedral, but the elegance of Rubens's design is turned into a characteristic tumble of over-large figures. One of Scott's most ambitious pictures was *The Discoverer of the Passage to India rounding the Cape of Good Hope (Vasco da Gama)*, 1842, a subject taken from the Portuguese epic, *The Lusiads* of Camoens, though probably via Thomson's *Seasons*.[4] The picture was bought by a subscription organised by Scott's friends just before his death, and finding nowhere else more suitable, or with a wall big enough, they presented it to Trinity House, Leith, the sailors' charity. It is an enormous painting whose main motif, the confrontation on the deck of a ship between Vasco da Gama and the aerial spirit of the storm, derives directly from Runciman's compositions, *Cormar and the Spirit of the Waters*, and *Fingal and the Spirit of Loda* in *The Hall of Ossian* at Penicuik. Scott had actually treated the latter subject himself in 1829.

During the last ten years of his life Scott reflected the current shift in taste, led by Wilkie, towards more immediately historical subject-matter. He painted such pictures as *Mary Queen of Scots Receiving the Warrant of her Execution* (1840, GAGM) and *Queen Elizabeth viewing the Merry Wives of Windsor at the Globe Theatre* (1841, Covent Garden Theatre Museum). Scott was not content to illustrate anecdotes from history however and his emulation of the national aspirations of Runciman's Penicuik pictures found expression in his massive triptych, *Sir William Wallace, Scottish War: the Spear* and *English War: the Bow* (1843, Paisley Museum and Art Gallery), *(Plates 166, 167 and 168)*, an allegory of Scottish independence. The picture was perhaps also Scott's answer to Wilkie's painting of *Sir David Baird* which was exhibited in 1839. Scott professed a low opinion of Wilkie and one can see that his rather simple vision of imperialist heroics in *Sir David Baird* might have seemed to Scott to fall well short of what a true, national history painting required. The central panel of Scott's picture shows Wallace in battle against the English king. The left-hand panel shows a Scottish bard exhorting the spearmen who confront the bows of the English in the right-hand panel where a monk kneels on a bard's harp. These references to the role of the bards echo not only Runciman's *Ossian*, but in the historical context of the subject – the Wars of Independence against Edward I of England – the bard here is also reminiscent of Blake's painting illustrating Gray's poem 'The Bard'. The poem is a curse uttered against Edward who, recognising their importance as spiritual leaders, had ordered the Welsh bards to be massacred. Naïvely Scott had earlier submitted a subject from Wallace's struggle against the English to the Westminster competition of 1841. It was rejected.

Scott kept alive the neo-classical tradition of the suite of illustrative engravings that had begun with Hamilton and had been carried on by David Allan. Popularised by John Flaxman in the 1790s, it reached its high point in Blake's *Book of Job*. Scott's first essay in this idiom was his *Monograms of Man*, a set of six emblematic designs published in 1831. In 1837 he followed this with a folio-sized *The Ancient Mariner*, the first illustrations of the poem and much influenced by Flaxman's line-engravings. He

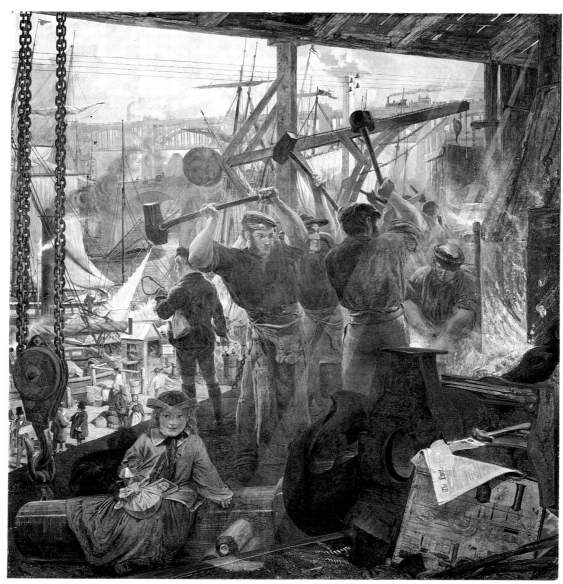

Plate 169. WILLIAM BELL SCOTT, *Iron and Coal*, 1861

illustrated *The Pilgrim's Progress*, though this was published posthumously, the illustrations etched by his devoted younger brother, William Bell Scott, and in 1848 Scott produced a commissioned set of illustrations for J. P. Nichols's *Architecture of the Heavens* published in 1850. The strange, emblematic illustrations to this book of popular astronomy propose a metaphoric communion between art and science that suggests the seventeenth-century worldview of the likes of such magus figures as Athanasius Kircher. Perhaps here Scott is being genuinely original in his response to the spiritual crisis of post-Enlightenment Scotland.

Scott's brother, William Bell Scott (1811–1890), was also a painter. He became a close friend of D. G. Rossetti and through him David Scott was known and admired by the Pre-Raphaelite group as one of the champions of their ideal of the high seriousness of art. W. B. Scott spent much of his life as teacher at the School of Design in Newcastle. He was patronised by James Leathart, one of the greatest collectors of the Pre-Raphaelites, but it was for Sir Walter Trevelyan that Scott painted his best remembered work, the series of wall paintings of Northumbrian history at Wallington Hall which includes his famous image of *Iron and Coal* (1861, NT), (*Plate 169*), an image whose popularity is partly explained by the extreme rarity of such scenes of industry in Victorian painting. It was certainly exceptional in its stress

on modernity. It is packed with images of industrial progress from top to bottom. Four men in an open shed, identified as part of the factory of the great Newcastle engineer, Robert Stephenson, are engaged in hammering hot iron. There is a huge crane behind them and an engineer's drawing of a locomotive on the ground beside them. A gun manufactured by Armstrong's of Newcastle lies in the foreground with a child sitting on it. A massive lifting-chain and pulley hangs down from a beam above her. Telegraph wires cross the composition against a background of smoke and, as well as the busy traffic on the river and the wharves, a train steams across the bridge at the top of the picture.

Scott was the only member of the Pre-Raphaelite circle to realise the ambition expressed by F. G. Stephens in their magazine *The Germ*[5] that painters should do justice to the modern world with its engineering and its steam trains, but the picture's ultimate precedent was Nasmyth's scene of construction in his great painting of Princes Street. Eighteenth-century precedents, like Joseph Wright of Derby's *Iron Forge*, lack the real urban environment that distinguishes both Nasmyth's and Scott's pictures. Scott's wall paintings have an important place as a series in the history of the development of mural painting too, however, as do the wall paintings that he did on a spiral stair at Penkill Castle, of James I's poem, 'The King's Quair'.

William Dyce, like David Scott, was a very cerebral artist, though where Scott is extravagant Dyce, a graduate of Marischal College in his native Aberdeen, was very much an intellectual. Dyce spent a brief period at the Royal Academy schools in London before going to Italy in 1825. He returned to Italy in 1827 and again in 1832, spending some time on the last occasion in the company of David Scott. During one of these visits Dyce met Overbeck and the other German painters who were known as the Nazarenes. This contact established the 'early Christian' direction that his art took eventually, that is to say he took his inspiration, like the Nazarenes, from the art of the Renaissance before Raphael came under the influence of Michelangelo, the moment from which the evolution of academic art was believed to have begun.

Much of Dyce's early work is unfortunately lost, unidentified or undated. Working in Edinburgh between late 1832 and 1837 as a portrait painter he produced a considerable number of portraits in a style that clearly shows his knowledge and understanding of Rembrandt, Titian and Reynolds, but which have very little reference to early Christian art. Some of the best of these are child portraits. One of the most memorable paintings from this time is the portrait of a father and son, *John Small and his Son, John Small* (EU), a picture in which the response of the sitters to the artist is recorded with something like the same vivid immediacy that is so striking in Wilkie's portrait of the Chalmers-Bethune family. It was towards the end of this period that Dyce must have produced his version of Wilkie's *Knox Administering the Sacrament at Calder House*.[6] It was in direct imitation of Wilkie, whose opening up of religious subject-matter clearly played a part in stimulating Dyce to do the same thing in his own terms subsequently.

At this stage Dyce was within the same orbit as Scott Lauder and even Watson Gordon, but during the 1830s he was much concerned with 'Christian Art' of the kind that the Nazarenes made fashionable and in 1837 he exhibited *Paolo and Francesca* (NGS) which is distinctly Nazarene in style. Its full title is *Omnia Vanitas, Francesca da Rimini*. The picture has been cut down and a figure removed from the left-hand end. The figures are sharply delineated against a low horizon and it is light in tone with sharply defined local colour in the manner of the Nazarenes, or of the French painter, Ingres, who was also much influenced by the Nazarenes.

Also in 1837 Dyce wrote an essay in collaboration with Charles Heath Wilson, *A Letter to Lord Meadowbank* on the question of Schools of Design, which resulted in his being invited to London to become Superintendent of the new Schools of Design there. There are a number of pictures in his new style which must date from the time of his move south and from the early 1840s. There is a *Madonna and Child* in the Tate Gallery, for example, and other paintings of the same subject in Nottingham Castle Museum and in the Royal Collection, all painted with a sinuous suavity that again recalls

Ingres and the early work of Raphael rather than any more 'primitive' art. *Joash shooting the Arrow of Deliverance* (Kunsthalle, Hamburg) is another painting from this period and can be definitely dated to 1844. It is rather different in subject though not in style. In it there are two figures in sharp outline against a plain stone wall, a young man and an old man in biblical costume though semi-nude. Their poses are in subtle counterpoint as the young man draws his bow to shoot out of a window, just visible to the right, and the old man encourages the arrow on its way with raised hands. The light is clear, the colour bright, and the overall feeling is distinctly neo-classical. This is a fine picture though, and with Thomas Duncan's *John Brown of Priesthill* painted in the same year, Scottish painters clearly did not lack direction in the years after Wilkie's death.

In keeping with what had become by this time a Scottish tradition, Dyce was a superb draughtsman. Like his young English contemporary, Alfred Stevens, though, to whom he can be compared in some ways at this period, his drawing was based on the direct emulation of Renaissance models. He also used Renaissance techniques. A superb *Madonna and Child* signed and dated 1848 (NGS), (*Plate 170*), for example, is in silver-point touched with white. The Renaissance technique in which he was an acknowledged expert however was fresco. He painted a fresco for Prince Albert at Osborne in the Isle of Wight of *Neptune resigning to Britannia the Empire of the Sea* (1847) which is an ambitious, but rather frigid essay inspired by Raphael's *Galatea*. Through Albert's intervention too, Dyce was given an important role in the decorations of the Houses of Parliament at Westminster. He decorated the queen's robing room with scenes from the legends of King Arthur illustrating the Virtues, a project on which he worked between 1851 and 1864, leaving it incomplete at his death. He also executed a series of frescoes for All Saints Margaret Street, London, completed in 1859. Dyce was also among the pioneers of the revival of stained glass. His grandest essay in the medium is a window for St Paul's Church, Alnwick, of *Paul and Barnabas preaching in Antioch* (1853).

Dyce befriended the young Pre-Raphaelites. In 1850 it was he who persuaded Ruskin to

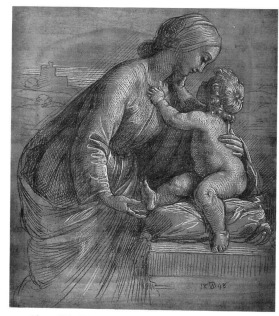

Plate 170. WILLIAM DYCE, *Madonna and Child*, 1848

take their work seriously and his influence is apparent in their work, particularly that of Holman Hunt. Although it was much repainted, Hunt's *Christ and the two Marys* of 1847 for example, still reveals the influence of Dyce's way of painting with a dry, flat surface and his angular drawing. The two main figures in Hunt's masterpiece, *The Hireling Shepherd* of 1852, also bear more than a passing resemblance to Dyce's *Jacob and Rachel* of which the first version was exhibited at the Royal Academy in 1850.[7] Given the equally profound influence that Wilkie had on Hunt in both technique and subject-matter, the Scottish input into Pre-Raphaelitism was considerable. Dyce, however, was himself also clearly influenced by the Pre-Raphaelite style of naturalism that was launched in 1852 with *The Hireling Shepherd*, Millais's *Ophelia* and Ford Madox Brown's *Pretty Baa Lambs*. His most original paintings, dating from the last ten years of his life, seem to have been stimulated by this, though it is a mistake to see them as simply a spin-off from Pre-Raphaelitism and so to see Dyce, as he is often represented, as a kind of follower of the Pre-Raphaelites.

These late paintings are all landscapes; some of them are pure landscapes of great beauty. Dyce had always painted landscapes. Some of his early ones, like *Westburn* (1827, Aberdeen Art Gallery) and *Fisherfolk* (1830,

Private Collection) belong with Horatio McCulloch and E. T. Crawford in the post-Nasmyth Scottish tradition. His watercolours, however, clearly painted on the spot, are direct and natural, for example, the *Rhone at Avignon* painted in France in 1832 (BM). In his later landscapes there is an increasingly precise realism. In the extraordinary *Scene in Arran* (*c.* 1859, Aberdeen Art Gallery), for example, the photographic quality of the light and the cool tonality and even distribution of interest in the subject are quite unexpected in a picture of this date. There are other similar pictures by Dyce, like *The Highland Ferryman* of 1858 (also Aberdeen Art Gallery) and *Welsh Landscape with Two Women Knitting* of 1860 (Private Collection). Together these pictures suggest that Dyce's interest in his friend D. O. Hill's new art of photography was more than casual. The result is a cool, objective realism which is quite different from the intensity of Pre-Raphaelite naturalism which depends so much on colour.

There are other late paintings though which are what might be called poetic landscapes. They have subjects of considerable complexity, though they are superficially simple. One of the first of these takes up the old theme of child art and the origin of painting. *Titian Preparing to Make his First Essay in Colouring* (1857, Aberdeen Art Gallery) is based on a story in Ridolfi's sixteenth-century life of Titian of how as a boy he extemporised colours by using crushed flowers. In the picture the young Titian is contemplating an uncoloured statue of the Madonna, flowers in his hand and an open book before him. Dyce presents the child artist inspired at once by nature and by spirituality. In *George Herbert at Bemerton* (1861, Guildhall, City of London) he treats a similar theme, though in this picture it as an adult poet who finds spiritual exaltation in the contemplation of nature. Both pictures are clearly reminiscent of Ruskin's idea of the spirituality of the true love of nature, but they also clearly extend the arguments of Archibald Alison (see below, pp219–220).

Plate 171. WILLIAM DYCE, *The Man of Sorrows*, 1860

Plate 172. WILLIAM DYCE, *Pegwell Bay: A Recollection of October 5th 1858*, 1859

The most remarkable of these pictures by Dyce are those in which he uses the low-keyed quality of the landscape to most advantage, as in *Christ and the Woman of Samaria* (1860, Birmingham City Art Gallery), *The Garden of Gethsemane* (c. 1855, Walker Art Gallery, Liverpool), *David* and *The Man of Sorrows* (1859 and 1860, both NGS). (*Plate 171*) In all of these the composition is almost casual. In the latter, for example, Christ is sitting to the left, almost off the edge of the picture, and facing away from its centre. He is completely alone in a wilderness. Neither he nor any other detail is accentuated. The landscape clearly continues beyond either edge of the picture. The artist is apparently indifferent to our expectation of compositional focus and the countryside is plainly a Scottish moorland. No attempt has been made to dress it up as the Holy Land. It is a contemporary wilderness not distanced by history or geography, and Christ is therefore also Christ in the present and real world. What

makes the picture so telling is this explicitly modern way of seeing. Dyce suggests that it is possible to find God even in the world empirically described and so confronts the central issue for his generation, the reconciliation of religion and the new revelation of empirical science.

This theme in *The Man of Sorrows* is also the theme of Dyce's greatest painting, the last great painting of this whole period of Scottish art in which the relationship of art to the wider framework of the intellectual climate can be so clearly seen. The full title of this picture is *Pegwell Bay: A Recollection of October 5th 1858* (1859, Tate Gallery). (*Plate 172*) It is a picture of great beauty with a strange and haunting mood, created by the wistful evening light and by the even focus that is characteristic of all this group of paintings. The composition follows very closely a watercolour of the same view, evidently done on the spot, but in the painting Dyce's own family have been introduced in the

foreground, three women and a girl. Two of the women are collecting shells and the child is gazing into the distance as she idly drags her spade. The fourth person, Dyce's wife, looks out of the picture towards us but in a strangely distant way. The date in the title refers to the presence of a comet in the sky, just visible, but its nucleus exactly on the picture's centre line.[8] Astronomical time is invoked by the comet, geological time by the strata of the cliffs behind, so clearly marked. Against such immensities how do we see ourselves and those closest to us? It is no wonder that the picture is pervaded by a mood of intense sadness. The figures in the foreground, so important to Dyce himself, are like people glimpsed from a train. Their whole reality is no more than an instant of time. That Dyce, the believer, painted such a picture as *Pegwell Bay*, is a measure of his intellectual and imaginative strength.

It is true of all three of these painters, Dyce, David Scott and Lauder, that, although Dyce and Lauder at least produced some superb paintings, their art is insecure, or at least their careers are incomplete. For all their genuine vision they seem not to have been constantly guided by a clear perception of their goals in the way that the older generation had been. Perhaps this insecurity is already apparent in Wilkie's work, but it still has a core of clear direction.

The problem was perhaps partly a reflection of the changing status of artists and the corresponding change in what was expected of them. The mid-century saw an enormous expansion in the art market which pushed artists more and more in the direction of becoming something like a service industry. The market was so powerful that instead of leading taste, they had to serve the taste of the public that employed them. Wilkie felt this already in the move from Scotland to England, but he did not succumb to it as others did, like Tom Faed for example, who lived happily on a formula throughout his life without, apparently, feeling any intellectual disquiet. Lauder on the other hand, though his subject pictures were geared to a market, nevertheless despised commercialism and criticised David Roberts indirectly for producing 'modern trash'. Indeed the quarrel between him and Roberts was partly over the issue of the market and commercial viability.

In taking this attitude, Lauder was not just being cussed. There was a deeper problem underlying the question of the necessary compromises of commercialism. Lauder was aware that his painting still represented a broad, humane view of art, rooted in the ideals of the Enlightenment and capable of expressing the artist's consciousness of the issues of his time, and that this was under attack. In the mid-century, after the excitement of the Disruption, the alliance between the true evangelicals and the representatives of the intellectual traditions of the Enlightenment began to break down. The tension between faith and empirical thought was very real and became more acute as the social consequences of economic change became increasingly apparent. It was because he could not reconcile the two sides of his belief that Hugh Miller, stone-mason, pioneer geologist and leading publicist of the Free Church, committed suicide. The same tension is clearly apparent in Dyce's late work and is explicitly the subject of *Pegwell Bay*. Indeed Miller's death in December 1856, which shocked Scotland, may well have been part of the genesis of that painting, so pointedly dated and with geology so conspicuously present in it.

George Davie has shown how in the 1850s a retreat into dogma away from the continuing challenge of empirical thought, and from the conditions of the real world reflected both these and the much deeper underlying tensions brought about by the agricultural and industrial revolutions. In response to this crisis there was something like a *coup d'état* in the universities which successfully ousted the old philosophy.[9] The attack on Lauder's position in the Trustees Academy was a reflection of the same shift of opinion. 'The lurid "glow of the Disruption" was parching the land, and in its heat there had faded the fine quality of moderation hitherto associated with Scottish academical debate.'[10] Lindsay Errington has called the attitude that Lauder was up against 'priggish and Calvinistic'[11] and part of Lauder's sense of injury was the knowledge that the painters who moved against him, James Drummond, Joseph Noel Paton and James Archer, in a report

prepared for the Royal Scottish Academy in 1858, were far narrower men than he. They were content to see art's function limited to the service of fixed ideas and to teach accordingly with a degree of self-righteousness. It was the great good fortune of art in Scotland that, when this happened, Lauder had already found a gifted group of students. He had been able to teach them for long enough, too, to pass on the old faith that art was one of the branches of thought, one of the tools of the imagination by which we explore experience and that, shackled to preconceptions, it is bound to wither. It was the belief voiced by Wilkie in Rome at a dinner given in his honour in 1827 when he said: 'As artists the younger students should be aware that no art that is not intellectual can be worthy of Scotland.'[12]

It was in this generation that the bourgeois Calvinism which has been so often used since as a stick with which to beat the whole Presbyterian tradition, if it was not created, certainly came into the ascendant. It was this generation too that invented the modern image of Burns, reduced from his true grandeur to a caricature which would have seemed quite at home in a painting by the painters like Tom Faed or Erskine Nicol discussed at the end of this chapter.

It is not that the generation of Lauder's rivals were neccessarily bad painters, but they were undoubtedly lesser ones, and what in the art of Lauder or Dyce appears as a reflection of genuine intellectual doubt, appears in theirs as complacently accepted limitation. Noel Paton (1821–1901), for example, at the beginning of his career produced a number of pictures of quality. He studied at the Royal Academy schools in London where he became a friend of Millais, though the English painter was eight years his junior. Back in Scotland, Paton painted the two pictures for which he will be best remembered, the *Quarrel* (1849, RSA) and the *Reconciliation of Oberon and Titania* (1847, NGS). The latter won a prize at the 1847 Westminster competition, when Lauder's *Christ Teacheth Humility* failed to do so. Both Paton's pictures present a remarkable display of female nakedness, miniaturised and set off by the attentions of various dwarves and gnomes. The inspiration of both pictures though lies directly in Fuseli's two pictures, *Titania Awakes*

and *Titania and Bottom*. Paton followed Millais's conversion to Pre-Raphaelitism very closely and painted some of his best pictures directly under the influence of the movement. *The Bluidie Tryst* (1855, GAGM), (*Plate 173*), for example, is worthy of Millais himself in its balance of sharp observation and sensitive execution. In his later career, loaded with honours, Paton painted some of the worst paintings of the late nineteenth century, worse even than Millais's worst. Paton's *The Man with the Muckrake*, for example, closely modelled on Hunt's *Shadow of the Cross*, which is already a pretty bad painting, must certainly qualify for any prize given for sanctimonious trash.

James Drummond (1816–1877) who has already been mentioned in the context of painting from Scottish history (see above, p187 and *Plate 152*), shared Paton's rather hard, cold drawing, apparently based on neo-classical models. Where Drummond's meticulous drawing does appear to advantage though is in his careful and by no means ineloquent records of the buildings of Old Edinburgh, about which he cared passionately, and which provided the backdrops for his best remembered pictures.

Plate 173. JOSEPH NOEL PATON, *The Bluidie Tryst*, 1855

James Archer (1823–1904) left at least one first-class painting, *Summertime, Gloucestershire* (NGS). Archer was likewise influenced by the Pre-Raphaelites and particularly by Millais who, perhaps because of his Scottish connection through his wife, enjoyed a particular reputation in Scotland. The landscape in this picture is painted with some freedom and it is sufficiently lively to suggest that McTaggart may have paid some attention to him.

Some of the other painters in this intermediate generation were more considerable artists. John Phillip (1817–1867) followed Wilkie first in sentimentalised Scottish genre paintings like the *Scotch Fair* (1848, Aberdeen Art Gallery), but then in 1851 he made his first visit to Spain where he developed Wilkie's Spanish genre subjects with great skill and immediate success. His *Letter writer of Seville*, following Wilkie's *Turkish Letter Writer*, was given by Prince Albert to his wife for Christmas 1853. Queen Victoria responded by giving Albert, Phillip's equally impressive *The Dying Contrabandista* for Christmas in 1858.

Phillip was a very accomplished technician and like many such was often at his best when he was trying least hard, in small portrait studies for example, or a single figure genre picture like *The Spinning Wheel* (1859, GAGM), but his set pieces are nevertheless extremely impressive. *La Gloria* (1864, NGS), (*Plate 174*), for example, his most famous picture (when it was bought in 1897 it was the most expensive picture that the National Gallery of Scotland had ever bought) is a quite brilliant exercise in light, colour and composition. It shows a Spanish wake for a dead child. The mother mourns in the shadow near the body of her child. Friends try to persuade her to join the celebration in the sunlight which occupies the right-hand side of the picture. The theme is perhaps a real one, the conflict between the tangible finality of death and the insubstantiality of the promises of faith. Where it fails to modern eyes is in the way that the subject treats private emotion as legitimate spectacle. We are not engaged with the mother's feelings as though she were our equal. We are implicitly reassured that this is only how they do things in Spain. Phillip made his last visit to Spain in 1860–61. It is testimony to the durability of

Wilkie's genius as much as to Phillip's own that there was so much mileage still to be made from his art.

In spite of the place that art had in their education, before the art schools were liberalised towards the end of the century, women seem to have had less opportunity to take up painting seriously in the nineteenth century than they had had in the eighteenth. One exception to this was Jemima Wedderburn who became Jemima Blackburn (1823–1909). She was yet another connection of the Clerk of Penicuik family – one member of the family, her cousin, the physicist James Clerk-Maxwell was a particularly close friend. Her relationship to the Clerks was similar to that of her predecessor, Anne Forbes, but unlike Anne Forbes in the eighteenth century she had no formal training. She painted principally in watercolour. This and the character of the great quantity of sketches that she left, recording daily life much in the manner of a visual journal, might rank her as an amateur, but she rises far above amateur status in her best work. She certainly saw herself, and was seen in her time as a professional artist, particularly as an illustrator.

One of her first exhibited pictures, shown at the Royal Academy in 1849, was the subject of a long, well-meaning, but heavy-handed and profoundly patronising, critical letter from Ruskin with whom, the letter makes clear, she was on friendly terms.[13] The picture is lost. Its subject was a *Plough Horse Startled by a Railway Engine*, rather an adventurously modern choice which offended Ruskin deeply as he explained at great length. Blackburn's choice of subject sounds innocent enough, but Ruskin's attitude gives some idea of the pressure which artists of the mid-Victorian era met if they tried to confront directly, even in such an innocent image, some of the implications of progress. Nominally encouraging her, he spent several pages telling her how he disliked everything about the picture. She did exhibit subsequently in the first Female Artists Exhibition in London in 1857, but it is not surprising that after such treatment she stuck almost entirely to illustration. It is difficult to imagine that Ruskin would have been quite so patronising if she had been a man.

Plate 174. JOHN PHILLIP, *La Gloria*, 1864

One of Ruskin's recommendations, however, was that she should look at the work of Mulready as an example, and she may have done so as there is some similarity to Mulready in her more ambitious compositions like the magnificent watercolour *Building a Haystack, Roshven* (c. 1857, Private Collection). (*Plate 175*) She was also on friendly terms with Millais and knew Pre-Raphaelite painting at first-hand, but there is nothing very Pre-Raphaelite about her own painting except in the way that she worked from nature.

As an illustrator Blackburn experimented adventurously with print-making techniques. For example, in collaboration with her husband who was a keen and very early photographer, she tried the newly invented *cliché-verre* process for book illustration. It involved drawing directly on to a photographic plate. Blackburn's greatest achievement, however, was as an ornithological painter. In 1862 she published *Birds from Nature* which she republished in an improved form in 1868. The plates were lithographic and her drawings in watercolour,

on which they were based, were all done from the life. She was a true scientific observer. For example, Darwin acknowledged the fact that it was she who first recorded how the young cuckoo ejects its rivals from the nest. Her ornithological drawings rank as among the very best of their kind and were widely recognised, but their qualities only reflect the attitude which she adopts in all her drawings and which gives them so much documentary interest, not only for the record of life in her house in Moidart, where the family spent much of its time, but also more occasionally in Glasgow where her husband, Hugh Blackburn, was professor of mathematics.

Erskine Nicol, the Faed brothers and William Fettes Douglas also belonged to this mid-century generation. Fettes Douglas (1822–1891) made his reputation as a narrative painter and a subject like *George Wishart preaching against Idolatry* (1871, NGS) shows to what extent his frame of reference was still that established by Wilkie, but in a painting like *The Conspirators* (1866, Royal Bank of Scotland)

he shows an independent skill in creating a dramatic mood in a historical setting. In a gloomy room or cellar, a group of men in sixteenth-century costume are gathered in a conspiratorial huddle round a table. There is a single light between them. One of them has just become aware of an intrusion and behind a hanging over the door we can see a group of men entering to apprehend them. This kind of picture was the starting point for the costume-genre which Pettie and Orchardson made their own and Pettie's *Treason* (Graves Art Gallery, Sheffield) of the following year is really a variation of Fettes Douglas's subject and composition.

Fettes Douglas also developed a more esoteric line of subject-matter with pictures of alchemists, magicians or money-lenders as in the *Money-Lender* (1861, Royal Bank of Scotland). Among the best of these is *The Spell* exhibited in 1864 (NGS). In the centre of a shadowy room a magician is conducting a mysterious rite with a magic circle drawn on the floor and a skull at its centre. Fettes Douglas exploited his love of still-life in this kind of picture. Piles of leather-covered books and strange, antique objects sometimes take over the composition, almost overwhelming the figures as in *The Antiquary* (1874, Dundee

Plate 175. JEMIMA BLACKBURN, *Building a Haystack, Roshven*, c. 1857

Art Gallery), (*Plate 176*) illustrating Scott's novel of the same name, or *Adding Glory to the Saints* (1870, Royal Bank of Scotland), where two monks are painting small religious statues in the midst of an overflowing still-life of books, boxes, paints and carvings. There is a similar superabundance of still-life in the portrait of Fettes Douglas's friend, a real antiquary, *David Laing* (1862, SNPG). Fettes Douglas was himself a considerable antiquarian and many of the objects in his pictures were from his own collections. He also painted simpler scenes of ordinary life with great charm though, as in *Models at their Dinner, Rome* (1878) and *On the Housetop, Rome* (1874, both Royal Bank of Scotland). The latter is a study of the artist's wife sitting at a window with a view over the Roman rooftops. He brought the same quality of simplicity to his very fine watercolours which he seems to have done as a relaxation.

Erskine Nicol (1825–1904) modelled his style closely on that of Wilkie and he followed Wilkie's example too by travelling in Ireland. He gathered material during an extended stay in the country, which he continued to exploit for much of his career, although he returned to Edinburgh in 1851. Some of his straightforward studies, like a watercolour, *Blowing a Light* (Private Collection), of a man sitting on a bank lighting his pipe from a tinder-box, are frank and matter-of-fact and on the face of it he might seem to be doing in Ireland what Geikie had done in Edinburgh, but the comedy in his pictures sometimes has the unpleasant flavour of the 'Irish joke' as in *An Irish Emigrant Landing at Liverpool* in which a very rustic-looking Irishman is mocked by a group of small boys (1871, NGS).

Tom Faed (1826–1900) in some ways represents the nadir of the history of Wilkie's far-reaching influence on Scottish painting, though he was an extremely successful artist who was not without talent. Both he and Erskine Nicol certainly influenced the younger generation, though many of them were far better painters. Faed's older brother John (1819–1902) was equally talented and also slightly less prodigal in wasting his talents. The second of the brothers, James (1821–1911), was an engraver and miniature painter. John also began as a miniature painter and was always a sensitive portrait painter. His late portrait of his

wife, Jane (GAGM), is a memorable portrait of a strong-minded lady. There is similar quality in his role portrait, *The Rabbit Catcher* (David Guthrie James, Torosay Castle), which pays homage to Wilkie's *The Gamekeeper* (Private Collection) and which by its sharpness of observation stops short of sentimentality. *The Young Duchess* (1870, The Art Institute of Chicago) is another picture whose quality depends on a quiet reticence. It is a full-length, back view of a woman in a brocade dress, standing before a mirror from which her reflection looks out at us. The room is in shadow, but she is lit from a window. The same quality applied to landscape in *The Trysting Place* (1848, NGS) creates a small masterpiece. John Faed followed his younger brother into the field of Scottish genre with less happy results.

Tom Faed studied at the Trustees Academy where he enjoyed immediate success. He chose from the start to follow George Harvey. His early painting, *The Patron and Patroness's Visit to the Village School* (Dundee Art Gallery), is closely akin to Harvey's *The Village School* (1826, whereabouts unknown) and *A School Skailing* (1846, NGS) and all these pictures presumably relate back to an unfinished picture by Wilkie called *The Village School*. Faed's picture is also closely comparable to John Phillip's contemporary *Presbyterian Catechising* (1847, NGS). The snowy-haired and impossibly benign patriarch in both Faed's and Phillip's pictures appears to derive from Greuze and this failure to cope with human reality stayed with Faed for the rest of his career. There are real qualities in the *The Patron and Patroness's Visit to the Village School* though, especially in the light and the handling of surface. The same mixture of strength and weakness marks Faed's first great success, *The Mitherless Bairn* of 1855 (National Gallery of Victoria, Melbourne). It is a cottage interior of the type that goes back to Wilkie and even David Allan. The cottage itself, the space, the light and the details of still-life, even of costume, are handled with a kind of eloquent skill that does justice to things as they are and that Wilkie would have appreciated. Even the theme of charity among the poor is a direct memory of *The Blind Fiddler*, but whereas that picture reaches wider issues through the sharply observed experience of credible

Plate 176. WILLIAM FETTES DOUGLAS, *The Antiquary*, 1874

individuals, in this picture they are comic stereotypes, less than human.

This 'dissociation of sensibility', an inability to treat people adequately while being brilliant in dealing with the material world, marks almost all Faed's work and gets more pronounced as the years go by. Perhaps this is partly because he painted his Scottish low-life pictures from London where he moved after the success of *The Mitherless Bairn*. Certainly he belongs with the 'kailyard' in literature, exploiting a grossly over-simplified version of Scottish culture and history which, however, becomes topical in his treatment of the theme of contemporary emigration, *Sunday in the Backwoods* (1859, Montreal Museum of Fine Arts, version Wolverhampton), *The First Letter from the Emigrants* (1849), *Oh Why have I left my Home?* and *The Last of the Clan* (1865, GAGM). (*Plate 177*) Although the latter is a large, well-painted and solemn picture and one of the very few direct, contemporary comments on the continuing tragedy of the Highland Clearances and the emigrations of the mid-century, when it is compared to the treatment of a similar theme in *The Last of England* by Ford Madox

Plate 177. TOM FAED, *The Last of The Clan*, 1865

Brown, or William McTaggart's pictures of emigrants from later in the century, it is difficult not to see Faed's picture as exploitation. Nevertheless, because of both his success and his skill Faed's influence was considerable. In Scotland McTaggart and Chalmers seem to have taken him as a starting point for their own treatment of Scottish cottage genre and looking at such single figures by Faed as *Ere Care Begins* (RA) and *The Reaper* (Aberdeen Art Gallery), both of which are painted with considerable freedom and with a marvellous feel for atmosphere, it is possible to see why.

The painting of these artists compels reflection on the way that, after Wilkie's attempt to confront the social issues of the nineteenth century in *Distraining for Rent*, no other painter

was so bold. The best artists of the mid-century, Dyce, Scott Lauder and even David Scott, preserved, though with a struggle, the tradition that art must engage with reality at some level to be valid, and they passed this belief on to a younger generation. Nevertheless the fractured vision of these lesser painters like Erskine Nicol, or Tom Faed and others like them, by its very incompleteness reflects the tensions of the Victorian conscience as clearly as if their paintings showed images of rickety, bare-foot children in the slums of Edinburgh, or of the poisonous smoke clouds of Glasgow. Faed and Nicol, indeed, were still painting when, in the 1880s, Patrick Geddes began to preach a crusade for art against these very evils (see below, Chapters XV and XVI).

THE ROMANTIC LANDSCAPE

From his correspondence with Perry Nursey it is clear that Wilkie was among the pioneers of 'plein-air' landscape painting, though the paintings that he mentions do not appear to survive and there are only a handful of landscapes by him at all.[1] Through Nursey's son, Claude Lorraine Nursey, this approach to landscape was passed on to Holman Hunt and the Pre-Raphaelites. We know too from Constable that at an even earlier date he was intrigued by Wilkie's habit of drawing from nature,[2] but there is otherwise no evidence that Wilkie's far-reaching influence stretched to cover landscape painting. The same is not true of Walter Scott however. There can be no doubt that both Scott's poetry and his novels had, and still have, a profound influence on the way we see the Scottish countryside and especially the Highlands. Scott's whole literary achievement is set in landscape as much as it is in history, or perhaps what is most characteristic of it is the conjunction of these two things. In seeing their interrelationship he was of course not moving in uncharted waters. The whole antiquarian movement was rooted in the study of landscape, as Scott himself gently satirised it in his account of the researches of Jonathan Oldbuck, *The Antiquary*, hopefully interpreting as ancient earth-works, features of the landscape that had actually been made within living memory. Nevertheless Scott was responsible for a qualitative change in the way people saw landscape and the kind of landscape that they felt could qualify as beautiful. Wilkie put his finger on the change in taste when, on his return from a visit to Scotland in 1817, he wrote: 'Scotland is most remarkable as a volume of history. It is the land of tradition and poetry, every district

has some scene in it of real or fictitious events, treasured with a sort of religious care in the minds of the inhabitants and giving dignity to places that in every other respect would, to the man of the world, be considered barren and unprofitable.'[3]

When he wrote that, Wilkie was fresh from visiting Scott and travelling round the scenes of *Old Mortality*, but he was also paraphrasing the writer who was equally an influence on Scott himself, Archibald Alison. Alison's *Essays on the Nature and Principles of Taste* has been discussed in Chapter VIII in the context of portraiture and ideal beauty (see above, p154), but the real preoccupation of his book is landscape.[4] He attempted to work out for painting an aesthetic that could justify the imitation of nature in the absence of the notion of ideal beauty which had underlain the Aristotelian view of art, dominant since the seventeenth century, but which was now demolished by Hume and Reid.

As a pupil of Reid, as well as an Episcopalian clergyman, Alison had also set himself the task of reintroducing God into his aesthetic scheme, exiled by Hume's scepticism. Using an intellectual apparatus devised by Hume himself, the idea of association, Alison did this in a way that was widely influential. His argument was essentially that what we perceive as beautiful, we do because of the associations it holds for us. The implication that Burns saw immediately was that anything could now qualify as beautiful.[5] The key conclusion for Alison, though, lay in his remark: 'Wherever we observe the workings of the human mind, whether in its rudest or its most improved appearances, we everywhere see the union of devotional sentiment with sensibility to the expressions of natural scenery. It calls forth the

Plate 178. HUGH WILLIAM WILLIAMS, *The Temple of Poseidon, Cape Sunium*, 1828

hymn of the infant bard, as well as the anthem of the poet of classical times.'[6] Reid commented to Alison with some satisfaction: 'I am proud to think that I first, in clear and explicit terms and in the cool blood of a philosopher, maintained that all the beauty and sublimity of objects . . . is derived from the expression they exhibit of things intellectual, which alone gives original beauty.'[7] For Alison this is the exhibition of mind, and the mind is that of the Creator. Constable and Ruskin both followed him closely in this important, spiritual justification of landscape.

Where Alison speaks for Scott, however, is in the way he describes the associations of history interacting with our feeling about landscape: 'the beauty of natural scenery is often exalted by the events it has witnessed; and that in every country the scenes which have the deepest effect upon the admiration of the people are those which have become sacred by the memory of ancient virtue or ancient glory.'[8] Ruskin paraphrases this passage very closely when he writes: 'The charm of romantic association can only be felt by the modern European child . . . it depends for its force on the existence of ruins and traditions, on the remains of architecture, the traces of battlefields, and the precursorship of eventful history.'[9] Wilkie in 1817 was not drawing on Ruskin of course, but his remark to Perry Nursey, quoted above, when it is compared to Ruskin's is a reminder of the extent to which it was Scottish landscape and Scottish history, used as a poetic vehicle by Walter Scott, which gave universal currency to Alison's idea of association.

The effect of this approach applied to landscape was not just to enlarge the variety of scenery appropriate to the painter. It was also to make the painter's own feelings, the associations that the scene had for him in particular, not only a legitimate part of what he represented, but really the point of the representation. Constable summarised it when he remarked that for him 'painting was just another word for feeling'. It is a point on which Turner and Constable differ to some extent, for place was the essence of what he painted to Constable, whereas Turner began in the rather different and less personal tradition of the picturesque topographer. (It is ironic therefore that Ruskin should have chosen Turner as his hero and have ignored Constable.)

Taking this intuitionist approach to painting makes it impossible to maintain the artificial distinction between subjective and objective. In Scotland the first signs of this new

Plate 179. JOHN THOMSON, *Glen of Altnarie, Morayshire,* 1832

attitude finding expression in painting are in the work of Hugh William Williams (1773–1829) and his close friend, the Rev. John Thomson of Duddingston (1778–1840). While Williams's on-the-spot sketches of Greece have beautiful, objective simplicity, the compositions that he worked up from them are sometimes wildly subjective, using dramatic exaggerations of scale and weather effects. Here he was clearly influenced by Turner, but the letterpress which accompanied the published engravings of his works, under the title *Travels to Greece, Italy and the Ionian Islands* (1822), is full of ideas of association and echoes of Alison (see above, p147).

The Temple of Poseidon, Cape Sunium (1828, NGS), (*Plate 178*) is a good example of how Alison's ideas are reflected in Williams's painting. The ruined temple stands on a headland above the sea. Not only has Williams exaggerated its height and the wildness of sea and sky, and in this he was clearly influenced by Turner, but he has also deliberately suggested analogies between the ruined forms of the temple, the rocks on which it stands and the columns of rain beneath the storm clouds in the distance. It is almost an illustration to Alison who writes: 'In the landscape of the painter, the columns of the temple, or the spire of the church, rise amid the ceaseless luxuriance of vegetable life, and by their contrast, give the mighty moral to the scene.'[10] The work of man both emulates the divine creation and in its impermanence falls far short of it. The contrast to which Alison refers is between the reminder of immortality in nature and of mortality in the works of man.

Plate 180. JOHN THOMSON, *Dunure Castle*

It is a text which Constable illustrated directly several times, most notably in *Salisbury Cathedral* (1823) where like Williams he stresses the analogy between the forms of the religious building and the forms of nature in the trees. He is even closer to Williams though in his interpretation of Alison in the later *Salisbury Cathedral with a Rainbow* and especially in his late watercolour *Stonehenge* (1836) with its stress on the relative impermanence of even the most ancient works of man.

Williams dedicated the first volume of his *Travels* to John Thomson. Thomson was minister of the parish of Duddingston, hence he is always known as the Reverend John Thomson of Duddingston. He was an amateur and out of respect for his congregation was scrupulous in maintaining his amateur status even though he was reputed to have been making a very comfortable living from his painting at the height of his career. He was certainly a prolific and hard-working painter, though it is perhaps a reflection of his amateur status that he was also a very uneven one. His formal training seems to have consisted of a brief spell with Nasmyth. He was, however, a good friend of Raeburn and that friendship constituted an informal training that played a more important part in shaping his style. Dramatic freedom of handling is the outstanding characteristic of his painting. Raeburn keeps his landscape backgrounds in their place. They are nevertheless handled with great breadth and freedom. Thomson's execution is really unlike that of any of his other contemporaries but makes sense in this context.

As important, however, as Thomson's friendship with Raeburn and Williams, was his friendship with Scott. This began when Thomson was still a student at Edinburgh University and lasted till Scott's death in 1832, and, in spite of the part that Scott played in the inspiration of Turner's Scottish pictures, in a way it is Thomson's painting that is closest to a pictorial expression of Scott's own interpretation of landscape. Scott's landscapes seem specific, but he uses real landscapes as the basis for a poetic or narrative improvisation, developing the associations of place far beyond prosaic description. Thomson likewise broke with the descriptive limitations of the topographical art

Plate 181. ROBERT SCOTT LAUDER, *View in the Campagna*, c. 1833

of the Nasmyth tradition. His paintings, like *Glen of Altnarie, Morayshire* (SA 1832, Duke of Buccleuch), (*Plate 179*) for example, look extemporised and a contemporary wrote of him: 'His landscapes are intensely Scotch in their character, and yet scarcely one of them approaches to a facsimile of any known locality. He has left views of particular places; but they are all representations of the scenes under the influence of accidents and as the momentary mood of his own mind has represented them.'[11] Writing to Scott about one of his most atmospheric pictures, the *Martyrs' Tombs at Loch-in-Kett* (1828, whereabouts unknown), Thomson himself commented on the importance of the associations of the subject, the graves of Covenanters in a wild and lonely landscape.[12]

Thomson's career is difficult to chart as he rarely signed or dated his works, and there is no established chronology. His reputation was enthusiastically promoted in *Blackwood's Magazine*, especially in *Noctes Ambrosianae*, and after his death by his two biographers, William Baird and Robert Napier. From all this, and in the absence of a modern study,[13] it is very difficult to form a clear assessment of his achievement. It seems, however, from his exhibition record that although he painted from early in his career – indeed he seriously wished to pursue painting rather than the ministry – he may not have developed his ambitions to compete at a semi-professional level till around 1820. It is consistent with that view of his development that his large-scale landscapes take Turner as

their principal model. Pictures like *Urquhart Castle* (Earl of Stair) and *Loch Scavaig and the Cuillins* (New Club, Edinburgh) exaggerate scale dramatically in a way that forcibly recalls Turner. Both these pictures, however, also suggest that Thomson looked beyond Turner to Richard Wilson.

In *Loch Scavaig* there is a strangely shaped rock of indeterminate size, on the left, which is very like a similar feature in Wilson's *Destruction of the Children of Niobe*, one of Wilson's most theatrical inventions, while in *Urquhart Castle* the mass of foliage on the right is distinctly reminiscent of Wilson, both in its general shape and in the way the paint is handled. In Thomson's *Fast Castle on a Calm Day* (James Holloway), the way that a solid mass of cliff is set in the middle of the composition, confronting the spectator, also recalls a particular compositional idiosyncrasy of Wilson's, seen in *Dolbadarn Castle* and in numerous other of his compositions. The *Niobe* was celebrated as an engraving and Thomson's knowledge of the picture is easy to explain. His wider knowledge of Wilson's work would really depend on his having seen the Wilson exhibition at the British Institution in London in 1814. Wilson's reputation was high at the beginning of the nineteenth century. Fuseli wrote very warmly of him in Pilkington's *Dictionary* and Edward Dayes[14] called him 'this giant of the English school'. Although Thomson met Turner, Wilson was a much more likely model for an amateur than the modern artist.

Plate 182. HORATIO McCULLOCH, *The Blasted Tree*, c. 1838

This kind of link with Wilson is also apparent in a rather wobbly classicism which sometimes makes Thomson's pictures seem strangely old-fashioned, though they are often so innovative technically. He paints freely and broadly, often using the palette-knife as in the remarkable *Dunure Castle* (formerly *Landscape Composition*, NGS), *(Plate 180)*, or a little sketch made on Salisbury Crags entirely with the palette-knife.

It is this kind of dramatic execution used on a large scale that is such a striking feature of his best known work, *Fast Castle from Below* (1824, NGS). This dark, dramatic picture recalls Turner in scale but its wild, broken surface is quite unlike Turner. Light-toned paint is laid on with brush and palette-knife against a dark ground. The result is so wild and fragmented that it is almost incoherent. It is a melodramatic picture that compares very favourably with Williams's *Temple at Sunium* to which it bears an obvious resemblance. *Fast Castle from Below* seems to have been exhibited in 1824. That is five years before Constable's *Hadleigh Castle* to which it also bears some resemblance, but it does not appear to have been exhibited in London, so there is nothing to link the two pictures, except perhaps a similar response to a common idea. It is in a painting like this that Thomson's originality is seen most clearly. At his best he is capable of a strikingly free and expressive use of paint, to evoke a highly subjective mood.

Fast Castle in Berwickshire is generally held to have been Scott's model for 'Wolf's Crag Castle' in *The Bride of Lammermoor* and Thomson in fact presented to Scott a view of *Fast Castle from the Landward Side* (Abbotsford). Christopher North, in *Noctes Ambrosianae*, called him a patriotic painter.[15] He was seen as creating an iconography of landscape painting to match Scott's vision of Scotland, not analytical, but highly emotive. Patriotism was a genuine force in Scottish painting and this subjective interpretation of its reflection in the landscape remained a pattern for landscape painters till the end of the century. Fortunately, however, some of them were men of genuine talent, and mist, heather and highland cattle never quite blotted out the real landscape. Thomson's personal influence went beyond the example of his

reputation though. His daughter's marriage to Robert Scott Lauder provided a direct link, not just to the immediately younger generation, but through Lauder's teaching to the generation beyond. William McTaggart shows an affinity to Thomson, not only in the freedom of his technique, but in his approach to landscape as an art of association. Lauder's own landscapes, though rare, are very distinguished. The background of *Christ Teacheth Humility* is a striking example and may owe something to his father-in-law's sense of drama, though, like his pure landscape, *View in the Campagna* (*c.* 1833, Private Collection), *(Plate 181)*, it is much more disciplined. It was the Glasgow painter Horatio McCulloch (1805–1867), however, who was Thomson's most immediate heir.

With McCulloch the west of Scotland takes a central place in this story. In the previous century, the important initiative of the Foulis Academy seems to have borne little fruit for Glasgow. Its two principal products, Allan and Tassie had gone away to Edinburgh and London and for the next half-century Edinburgh continued to supply artists as they were needed. In

Plate 183. HORATIO McCULLOCH, *Castle Campbell*, 1853

Plate 184. HORATIO MCCULLOCH, *The Clyde from Dalnottar Hill*, 1858

the 1760s even scene-painting at the Glasgow Theatre had been done by Delacour and Alexander Runciman. Nasmyth and then David Roberts and Clarkson Stanfield had carried on this tradition. Hugh William Williams worked in Glasgow as a landscape painter in the 1790s. Williams may also have had something to do with the early career of John Knox who was the first native Glasgow painter to stay in the city and at the same time make a significant contribution to painting in Scotland generally (see above, p145). In 1821 when Knox was at the height of his reputation, the first Glasgow exhibition was held under the patronage of the Glasgow Institution for the Promotion of the Fine Arts. There was not another exhibition till 1828, but after that they happened with some regularity.

John Knox also taught and McCulloch was one of a number of younger painters associated with him who made reputations for themselves. McCulloch's friend, Daniel Macnee was definitely Knox's pupil. McCulloch's own relationship with Knox is not quite as clear-cut, but throughout his life he retained an underlying approach to painting that reflects Knox's, and so behind Knox, Nasmyth's sense of the order

and clarity of a landscape and of the need to base it on direct observation. A contemporary of these two in Glasgow, William Leighton Leitch (1804–1883), like McCulloch, may not actually have studied with Knox but was influenced by him. Leitch became a successful watercolour painter and was drawing master to Queen Victoria.

In the mid-1820s McCulloch and Macnee left Glasgow for Edinburgh where they found employment with William Lizars. It was at this time that McCulloch was befriended by Thomson of Duddingston and his early works show clearly the influence of Thomson's loose, atmospheric handling of paint and his much more approximate approach to the structure of landscape space. What McCulloch learned from Thomson, and also from Williams who was at the height of his reputation when McCulloch was in Edinburgh, was a sense of the dramatic possibility of the landscape of association, especially of the Highlands, and his best known works like *Glen Coe* (1864, GAGM) or *Inverlochy Castle* (1857, NGS) which date from late in his career still owe as much to Thomson in this respect as they do to Turner.

Another debt that McCulloch may have owed to Thomson was the friendship and patronage of Prof. John Wilson, the Christopher North of *Noctes Ambrosianae*, a valuable friend to a young painter seeking to make his reputation.

McCulloch returned to Glasgow around 1827 or 1828 and created some stir exhibiting there. He then spent a few years living in Hamilton before returning to Edinburgh in 1838, the year he was elected to the Royal Scottish Academy. Hamilton was a base from which Cadzow Forest was readily accessible and some of McCulloch's most remarkable early pictures were painted there. The earliest of these pictures actually dates from 1834, the year before he moved to Hamilton, and Sheena Smith suggests that easy access to the forest where Williams had worked before him was a motive for this move.[16] If that is so, it is a rather remarkable parallel to the French move to Barbizon, or Samuel Palmer's move to Shoreham. The Cadzow Forest paintings of 1834 and others like *The Blasted Tree* (*c.* 1838, Orchar Collection, Dundee Art Gallery), (*Plate 182*) are clearly painted on the spot. They have all the precision of light and structure which is associated with Knox and Nasmyth, but they also have a richness and texture which may derive from Thomson. However these pictures are painted with such respect for the actual forms of nature that McCulloch has clearly

moved away from any direct tutelage of the older painters. The only possible comparison is with the work of Patrick Nasmyth, but even his art is not marked by such spaciousness and undramatised, natural grandeur.

The same informal naturalism marks much of McCulloch's work of the 1840s. There are several beautiful and quite unexpected views of Edinburgh. In *A Panoramic View of Edinburgh from the South*, *c.* 1840,[17] the city is a faint blue outline beyond a field of standing corn and a line of trees. It is almost anti-dramatic for a large painting so much is the city subordinated to these casual incidents.

Although there are links to the painting of artists like D. O. Hill, what distinguishes McCulloch, as in his Cadzow pictures, is his feeling for the variety of the incidents of light and shade and the casual structure of a scene. This remains true of some of his grander subjects of the 1850s too. There is a beautiful *Castle Campbell* of 1853 (Private Collection), (*Plate 183*) where the eye reaches the castle three-quarters of the way up the picture after traversing a wonderful green hillside, covered in real trees which respect both the rules of growth and the rules of scale. The whole scene is lit by the light of day. This picture may well have been painted on the spot. His biographer, the landscape painter Alexander Fraser, comments on the contrast between McCulloch's 'slow and

Plate 185. HORATIO MCCULLOCH, *The Clyde from Dalnottar Hill*, SKETCH, 1857

Plate 186. HORATIO McCULLOCH, *Loch Lomond*, 1861

'thoughtful' studies from nature and the relative swiftness of his studio work.[18]

This distinction observed by Fraser towards the end of McCulloch's career might owe something to the influence of Ruskin, but there is enough evidence of the quality of his plein-air work from earlier in his career, to see it as a long-term habit reflecting an attitude of mind in which improvisation in the studio served a different purpose to working from nature. It was for McCulloch, as it had been for Thomson, a way of allowing the intuitive processes of association to work on a picture in the studio. It would be misleading to suppose that his studio work was wild and slapdash however. What distinguishes his best large pictures is the care and justness with which observation is recorded. The superb painting of 1858, *The Clyde from Dalnottar Hill* (Clydesdale Bank PLC), (*Plate 184*), is a good example. There is an on-the-spot painting from the previous year of the same view (Private Collection). (*Plate 185*) In adapting this for the larger painting he has reorganised the foreground completely, but he has lost nothing of the feeling of light and air and has gained a sense of space without seeming at all to exaggerate. It is only when the two are put side by side that we are aware of McCulloch's adjustments. This picture may also pay homage to Nasmyth's drop curtain for the Glasgow Theatre which represented a similar view. It was very celebrated. David Roberts, for example, admired it greatly and Nasmyth's sense of order still seems to inform McCulloch's grand painting.

It is not an accident that McCulloch is represented in the main public collections by large compositions of highland scenery from the end of his career. These pictures really made his reputation, but because of a later generation's suspicion of romantic highland scenery, their real qualities were later overlooked. Ironically therefore it was because he was only known by once popular pictures like *My Heart's in the Highlands* (1860, GAGM) that his reputation declined, though the title of this grand landscape is misleadingly sentimental.

His large-scale highland landscapes have a grandeur that is unusual, but highland scenery is not confined to his later work. He had

painted important romantic landscapes in the 1830s such as *Landscape with a Waterfall* (Royal Scottish Academy of Music and Drama) painted under the influence of Thomson. In the late 1840s in a picture like *Misty Corries: Haunts of the Red Deer* (1847, Shipley Art Gallery, Gateshead), however, there is a new sense of scale and dramatic atmosphere. Turner's influence is apparent, but perhaps it was mediated by Ruskin. *Loch Lomond* (1861, GAGM), (*Plate 186*), *Glencoe* (1864), *Loch Katrine* (1866, Perth City Art Gallery), or *Loch Maree* (1866, GAGM) all illustrate, almost better than Turner himself, Ruskinian ideas of truth. But such pictures also illustrate better than anything that had come between, the view of landscape expounded by Wilkie in 1817 and inspired by Scott and Alison. McCulloch established a canon for landscapes of the Highlands which served well till at least the end of the century in the painting of artists like MacWhirter, Peter Graham and Joseph Farquharson.

Of McCulloch's contemporaries William Leighton Leitch has already been mentioned. D. O. Hill, famous for his photographic partnership with Robert Adamson, was primarily a landscape painter. He was much influenced by Turner as well as by McCulloch and was at his best in a moody Turneresque landscape like *Edinburgh from Calton Hill* (c. 1860, Royal Bank of Scotland). E. T. Crawford (1806–1885) was also an interesting painter. He trained in Edinburgh at the Trustees Academy under Andrew Wilson. James Caw did not think much of him and so he has had rather a bad press.[19] He travelled to the Low Countries for the first time in 1831 and there is some similarity between his paintings of this period and the early landscapes of several of his contemporaries including Roberts (see above, pp145–6), William Dyce and William Simson whose *Solway Moss-Evening* of 1830 is one of the best Scottish landscapes of the period (see above, p183). They all reveal a distinctively Dutch quality which parallels the Dutchness of contemporary Scottish genre painting. Crawford made rather a speciality of Dutch scenes of boats and shipping. Like Patrick Nasmyth he continued to be inspired directly by Dutch art, but the kind of Dutch painting that he favoured was simple and direct, painters like Berkheyde

for example, or the Van de Veldes. He continued exhibiting into the 1880s and so he provides an interesting link forward to the generation of Scottish painters who were interested in the Hague school later in the century.

McCulloch was an amiable man who encouraged younger painters. Arthur Perigal (1816–1884) was much influenced by him, though also by Pre-Raphaelite painting. Alexander Fraser (1827–1899) who wrote McCulloch's biography was associated with him in his later years. Fraser's work is sometimes very close to that of the older man, though he has a freer way of painting both in oil and in watercolour. Fraser painted conventional landscape subjects like *Bothwell Castle* (1863, Dundee Art Gallery) but he is often at his most attractive when, like McCulloch, he is at his most informal, for example *The Entrance to Cadzow Forest* (NGS). (*Plate 187*) Fraser was following McCulloch's example working in Cadzow Forest and he produced some of his best painting there. A picture like this or *A Glade in Cadzow Forest* (c. 1857, NGS) could be favourably compared to contemporary paintings by the French Barbizon painters, but springs from a native tradition.

Another landscape painter who enjoyed a great reputation was Sam Bough (1822–1878). Bough was born in Carlisle and was self-taught, though encouraged by Macnee to take up landscape. He lived in Hamilton between 1852 and

Plate 187. ALEXANDER FRASER, *The Entrance to Cadzow Forest*, c. 1860

Plate 188. SAM BOUGH, *St Andrews*

1854 and worked in Cadzow with Fraser. *In Cadzow Forest* (1857, Bourne Fine Art) is a magnificent portrait of two ancient trees and is a good example of the kind of painting that resulted. It is evidence too of the enduring influence of McCulloch. Bough himself moved to Edinburgh and he subsequently quarrelled with McCulloch (a quarrel in which the artists' dogs apparently also took sides), though the older painter's influence survived this breach. Bough was also much influenced by Turner however, especially Turner's paintings of seaports, a subject which Bough made his own. He conveyed with great skill all the detail and incident of a busy scene as in *St Andrews* (Noble Grossart), (*Plate 188*), or *The* Dreadnought *from Greenwich Stairs: Sun sinking into Vapour* (1861, Private Collection) which is both ambitious and a direct homage to Turner. Bough was admired by R. L. Stevenson and painted a view of his house at Swanston. Stevenson wrote a warm and affectionate obituary of him.[20] The free, luminous painting practised by both Bough and Fraser in the 1860s was an important inspiration to the greatest landscape painter of the later nineteenth century, William McTaggart and was the link between McTaggart and his predecessor McCulloch.

Waller Paton (1828–1895), younger brother of Noel Paton, represents a rather different approach to landscape to any of these, though in its own way profoundly romantic. He was much influenced by Ruskin and the Pre-Raphaelites and throughout his life, painting usually in watercolour, he remained loyal to the Pre-Raphaelite ideal of finish. Like his brother, the world he describes is sometimes too good to be true, but as W. D. McKay remarks, he was often at his best in small informal watercolours and when he tried least hard.[21]

THE HIGH VICTORIANS

The second half of the nineteenth century saw a further increase in the level of art activity in Scotland. In the late 1870s and early Eighties for example, the number of exhibits at the Royal Scottish Academy rose to more than a thousand, a figure that it had not reached before and has not reached since, and it was no longer the only exhibiting society. Exhibitions in Glasgow were growing in importance and in Edinburgh the foundation of the Royal Scottish Society of Painters in Watercolours in 1878 was followed by the foundation in 1891 of the Scottish Society of Artists. Within all this activity a dominant place was held by one group of painters, the pupils of Robert Scott Lauder who had studied with him at the Trustees Academy between 1852 and 1861. The principal members of this group were William Quiller Orchardson (1832–1910), John Pettie (1839–1893), William McTaggart (1835–1910), George Paul Chalmers (1833–1878), John Mac-Whirter (1839–1911), Tom and Peter Graham (1840–1906 and 1836–1921), Hugh Cameron (1835–1918), John and Alexander Burr (1831–1893 and 1835–1899), and Robert Herdman (1829–1888). They did not represent any kind of radical break with the past, but Scott Lauder encouraged his students to create their own discipline on the basis of observation. He kept alive the spirit of the greatest Scottish painters of earlier generations without reducing what they stood for to a set of precepts.

Lauder's pupils formed a close circle of friends which was not broken by the removal of many of them to London during the 1860s. Although in Edinburgh the two leading painters of the group were McTaggart and Chalmers, and in London Pettie and Orchardson – and

these two pairs do represent distinct approaches to painting – north and south did not really divide along stylistic lines. The Burr brothers, for example, who moved to London in 1861, continued to produce Scottish cottage genre in a style that has links with Tom Faed and Erskine Nicol and so also with the early work of McTaggart and Chalmers, while MacWhirter settled in London in 1869 and continued from that base to produce highland landscapes. His version of McCulloch's naturalism caught Ruskin's eye. Peter Graham who stayed in Scotland till 1877 was also a landscape painter whose moody landscapes, like MacWhirter's, carry on the tradition of McCulloch more directly in fact than do those of McTaggart. Pettie and Orchardson together with Tom Graham developed the costume-genre picture to a degree of refinement in London, but Robert Herdman did something rather similar in Scotland.

Of all the group however, Pettie, Orchardson, McTaggart and Chalmers were certainly the most gifted and original painters. Orchardson was the oldest of all Lauder's pupils. He was already an independent painter when he returned to study at the Trustees Academy with its new master in 1852. In 1853 he exhibited *George Wishart's Last Exhortation* (University of St Andrews) which he had painted before he returned to the Academy. If it is compared with a mature picture by Orchardson like *Jeanie Deans* of 1863 (Private Collection) or an early masterpiece like *The Broken Tryst* (1868, Aberdeen Art Gallery), *(Plate 189)* the effect of Scott Lauder's teaching can be clearly seen. *Wishart's Last Exhortation* has the hard, cold drawing typical of leading Academicians like James Drummond or Joseph Noel Paton and like their

work it has an elaborate, additive composition. In the other two pictures the drawing is precise without being rigid. The poses are natural, without rhetoric. The compositions are apparently simple, but held together by the subtlety with which Orchardson handles light and space. *The Broken Tryst*, where a girl is waiting forlornly for a lover who has not kept their assignation, has a narrative subject, but instead of an elaborate, literal account of a story, or a demonstrative, rhetorical pose, we are left to infer her state of mind from the visual evidence, from signs of a kind that are familiar to us from ordinary life. Orchardson takes us back to the difference between the sign and what it signifies, a distinction which is quite lost in the painting of his older academic contemporaries.

The difference between these pictures is not entirely due to Lauder's teaching though. In fact because of his openness, his pupils were perhaps more, rather than less, ready to accept outside influences, but his teaching was certainly a key factor in the way they all developed and though they are very different as painters each from the other, they do have a basic common ground. This is seen in their sense of colour and the way in which their paintings are unified by light and atmosphere, no matter how much detail they contain.

In the evolution of Orchardson's style, as with the others in the group, the influence of Pre-Raphaelitism and in particular of the painting of Millais played an important part. For example, in 1863 he showed at the Royal Scottish Academy a painting of *Little Nell and her Grandfather* (Graves Art Gallery, Sheffield) which exhibits this very clearly. Five years earlier in 1858 McTaggart and Hugh Cameron had exhibited *Going to Sea* (Kirkcaldy Art Gallery) and *Going to the Hay* (NGS) and in 1859 Pettie had exhibited *The Prison Pet* (James Holloway). In all of these pictures the artists take their lead from the meticulous, daylight painting of the Pre-Raphaelites. Their knowledge of Pre-Raphaelite painting was derived partly from the presence of works by Millais at the Royal Scottish Academy, *Mariana* and *Christ in the House of His Parents* in 1852, *Ophelia* in 1853, *Ferdinand and Ariel* and the *Return of the Dove to the Ark* in 1854 and so on, to include in 1858 *The Blind Girl* and *Autumn Leaves*. Several of the group also

took the opportunity to go to Manchester in 1857 to see the great *Art Treasures* exhibition there, where, amongst so much else, the spectacular display of the Pre-Raphaelites – of modern art – was of special interest to them.

In approaching Pre-Raphaelite painting, the Scots had a certain predisposition to sympathy for they were trained in the Wilkie tradition of accurate observation which was an element in the formation of Pre-Raphaelitism itself. As pupils of Lauder they could also take naturally to the high-key colour which was such a marked feature of Pre-Raphaelite painting, though less of Millais's work than of that of Holman Hunt and Ford Madox Brown. In fact considering the importance of colour to Lauder, it is ironic that all these early works by the Scots have the relatively muted colour, or at least the rather dry surface, typical of paintings by Millais like *The Return of the Dove to the Ark*, rather than the lush intensity of hue of Holman Hunt's *Hireling Shepherd* for example.

Where the Scots had an advantage over the English painters was in their training in lively drawing, in how to unify a picture by observation of the fall of light and how to reconcile detail with overall unity. Looking at their early pictures, even Pettie's *The Prison Pet* which is so close in many ways to Millais's *Return of the Dove* has greater freedom of handling and a sense of a warm, unifying light that owes something to Rembrandt. Orchardson's lovely portrait of Pettie's wife, *Elizabeth Bossom, Mrs John Pettie* (Manchester City Art Gallery), was painted as a wedding present to the couple in 1865. In it, the delicate outline of her face set against a dark ground still faintly recalls the angular drawing of Millais, the face of the girl in his painting *The Huguenot* for example, but it is part of such a beautifully integrated image of the whole person that one is inclined to think of Wilkie or even Ramsay rather than any English model.

In the portrait of *Mrs Pettie*, Orchardson sets the single figure in the frame with such ease and elegance that we scarcely notice how beautifully it is arranged, nor how little detail we are actually given. Here again, however, Millais's example may have played a part. In 1860 a new journal, *Good Words*, was published in Edinburgh. In its second year it moved south to London. In the 1850s the Pre-Raphaelite

group had broken new ground, exploiting as artists the technique of wood-engraved illustration which had been introduced in large circulation magazines like *Punch* and the *Illustrated London News* in the 1840s. *Good Words* was the first 'serious' magazine to use the technique and to employ artists as illustrators. So it had an up-market, visual, as well as literary content. It provided employment for a number of the Scott Lauder pupils, for Orchardson, Pettie, Tom Graham and McTaggart, but Millais also contributed.

Millais's first essays in the new technique had been for the edition of Tennyson published by C. Moxon in 1857. (Years later, in 1872, Orchardson married Moxon's daughter, Nelly.) His Tennyson illustrations were wonderfully refined and simple and he was rapidly learning to use the technique with great freedom, using an open, cursive style of drawing. McTaggart in his contribution to the new magazine in 1861 cheerfully reverts to Walter Geikie for a model,[1] but Pettie and Orchardson in their illustrations are clearly striving to come to terms with the potential of wood-engraving as an informal medium as Millais had done. This in turn eventually fed into their painting and when Orchardson painted *The Broken Tryst* in 1868, the emptiness of the composition and the placing of the figure which so effectively evoke the psychological state of the poor girl, and even the scribbly marks with which he has filled in the background, recall this style of book illustration.

This diversification out of painting was of special importance to Orchardson because his was truly a narrative art. Of all nineteenth-century painters after Wilkie he comes closest to the great novelists of his time. The reason is that like Wilkie he was a master in the observation of the minute nuances of behaviour which betray a person's feelings and state of mind. Unlike Wilkie however, he does not try to go beyond the immediate human interest of the situations that he describes in order to embrace broader issues of right and wrong. In 1883, for example, he painted *The Morning Call* (Private Collection). In it a woman waits a little anxiously while a servant takes her calling card to his mistress. As he disappears through the door he can be seen examining the card with

Plate 189. W. Q. ORCHARDSON, *The Broken Tryst*, 1868

an air of doubt, confirming that the woman's position is not entirely secure. She is young and perhaps she is new to the district, her credentials still unproven.

It is *The Letter of Introduction*, but set in a different, no less real, but much narrower social framework. To broaden the incident into metaphor is not the purpose of the picture. It is rather to define sharply the social mores by which the woman knows she is circumscribed and within which she is nevertheless subject to the full range of human feeling. It is very much a novelist's view of life, but if Wilkie should be seen alongside Scott, or Galt, Orchardson is a worthy contemporary of Trollope, an author illustrated with great effect by Millais. He is, however, also something of a Jane Austen, in painting, for her era and its mores provided the context and inspiration for many of his costume pictures. As with Jane Austen, moral issues are there because of the acuity of his observation and because they are part of the human condition, but they are also local and circumstantial, not questions of principle.

Orchardson moved to London in 1862. Pettie moved in the same year and they shared a studio. Pettie's success was more rapid than his friend's however. He became Associate of the Royal Academy in 1866 and Academician in 1873. Pettie made his reputation with costume pictures of a kind that relate clearly to the work of George Harvey and especially Fettes Douglas. *The Drumhead Courtmartial* (1865, Graves Art Gallery, Sheffield), for example, is set in the period of the Civil War. He uses character, situation, and period detail exactly in the manner of historical novels like *The Children of the New Forest*, which were the numerous progeny of Scott's potent example. His pictures also tend to have the same oversimplified characterisation set in the midst of a great deal of circumstantial detail. It was perhaps for this reason that Pettie was so quickly popular. He was, however, by no means a negligible painter. *The Disgrace of Cardinal Wolsey* (Graves Art Gallery, Sheffield), (*Plate 190*), for example, of 1869, is brilliant theatre, brilliantly stage-managed, but it is also brilliant painting. Wolsey stands with the message of his dismissal in his hand. His bulky figure is isolated both by the space around him and by his scarlet robe whose splendour as visibly mocks his new condition as the ironic bow of the messenger who has brought the news of his disgrace.

Pettie is often as good as this in his handling of colour and his evocation of situation, but in the end his talent is perhaps quite fairly assessed on the basis of such well-known paintings as *Two Strings to her Bow* of 1887 (GAGM). A girl promenades with two admirers, one on each arm. They are ill-at-ease in each other's company, though she is enjoying herself. It is a costume piece, but only in order to lend the charm and simplification of distance to the scene. In fact the sentiment behind much of Pettie's use of period costume is summed up in the title of another of his pictures, *The World Went Very Well Then* (Orchar Collection, Dundee Art Gallery). It is a curious exchange that is implied. The noble ideal of the eighteenth century, the aspiration to recover the grandeur and simplicity of an unspoilt, primitive past, has been replaced by an unspoken unease with the world of the late

nineteenth century looking back to the eighteenth century itself as a cosy age of certainty.

When Orchardson left Edinburgh, he was making a name for himself painting portraits. He continued to paint portraits throughout his career as did Pettie. Pettie is at his best in informal portraits of friends, or of himself as in *The Warrior* (Aberdeen Art Gallery), a self-portrait in sixteenth-century armour, but Orchardson also produced some of the finest formal portraits of the time, for example *The Marquess of Lothian* (1899, Royal Bank of Scotland). Orchardson's genre paintings, like *The Flowers of the Forest* of 1864 (Southampton Art Gallery), or *Jeanie Deans* of 1863 were like the country genre pictures of McTaggart, whose *Spring* (NGS), (*Plate 195*) and *Autumn* (Private Collection) were also exhibited in 1864, though the *Jeanie Deans* is still very reminiscent of Millais. Turning to costume genre in the later 1860s, as in *Hamlet and Ophelia* of 1865 (Private Collection), Orchardson is very close to Pettie on the other hand, exploring a kind of painting that had a long pedigree in England and in Scotland.

Orchardson's painting remained close to Pettie's into the 1870s. It was really only with his painting *The Queen of the Swords* of 1876–7 (Forbes Magazine Collection) that he began to evolve a really distinctive style of his own. The picture represents a scene from Scott's novel *The Pirate*. It is set in the eighteenth century, the period that from this time forward was Orchardson's favourite setting. In his approach to it he became as much an antiquarian as any of his Scottish contemporaries, collecting furniture and costumes as props for his pictures. The scene is set in Norway and a long passage from the novel was included in the Royal Academy catalogue, though Orchardson has made it rather more elegant than Scott described it. What is taking place is an elaborate sword dance. The heroine is Minna Troil. Scott describes the scene and writes that the 'moment when the weapons flashed fastest and rang sharpest round her, she was most completely self-possessed and in her element.'[2] This is the moment that Orchardson has chosen. Although, as he presents her, Minna Troil is very different from any of the Swinburnian females who inhabit so much art post-Rossetti, there is a slightly *fin-de-siècle* feel

to the scene. It is distinguished from the work of most of his contemporaries however by its complexity. It is even quite distinct from Pettie's painting, involving far more figures than Pettie was inclined to use, and also beside Pettie's, Orchardson's mature art is elegant, yet marked by acute observation of manners.

In *The Queen of the Swords*, Orchardson was continuing a long tradition of illustrating Scott, but there is also an interesting memory of Wilkie's *The Penny Wedding* in the picture. He seems to have been consciously returning to his origins. Even his drawings at this date begin to recall Wilkie's, both in style and purpose. Wilkie's painting of course underlies the whole tradition of this kind of costume genre, but here the memory is more specific. *The Penny Wedding* is invoked by the number of figures, the way that they are divided up into different groups within a deep space, the scene of a folk-dance itself and in the most direct reference, the group of musicians and their placing high to the left of the picture. Also typical of Wilkie, not only in *The Penny Wedding* but in *Distraining for Rent* and *The Letter of Introduction* too, is the

way that the space is enclosed by walls only partially defined and described by transparent, dark paint, stained over a lighter ground. This becomes a constant characteristic of Orchardson's later painting. It shows how carefully he was studying Wilkie, though in this picture he had not quite mastered the technique.

In one of his most ambitious pictures, *Voltaire* (NGS), (*Plate 191*) exhibited in 1883, six years after *The Queen of the Swords*, the description of space is masterly however. The whole upper part of the picture is described in this way, just scribbled, dark paint over light, yet perfectly located. The picture, with more than a dozen figures in it, is typical of the tact with which Orchardson handles detail. The subject is an incident from the life of Voltaire. The guest of the Duc de Sully, he has been called to the door, seized by his enemies and horse-whipped, presumably for his beliefs, or the lack of them. Returning to his host to seek assistance, his plea is met with a display of eloquent indifference.

The picture bears a marked resemblance, but equally marked contrast, to Millais's *Lorenzo and Isabella*, painted in 1849, but

Plate 190. JOHN PETTIE, *The Disgrace of Cardinal Wolsey*, 1869

Plate 191. W. Q. ORCHARDSON, *Voltaire*, 1883

exhibited again, for the first time in London, in 1881, two years before *Voltaire*. In both pictures there is a long table, seen from one end, with two rows of people in profile facing each other. The figure in the left foreground strikes an attitude which separates him from the rest, while the figure in the right foreground turns to face us. There is a standing figure to the right. In Millais's painting it is a servant, but in Orchardson's it is Voltaire himself. There is a contrast with Millais made implicit by the comparison though. It is not just in the wordly subject – should we favour Voltaire's scepticism or his host's cynicism? – it is in the way that Orchardson handles detail. In contrast to the bright, clear painting of Millais, the marvellous still-life on the table in Orchardson's picture is almost lost in the shadow. The profiles are as strongly differentiated as they are in Millais's picture, but they, too, fade into the shadow. Raeburn would have appreciated such tact and reticence, a refusal by the artist to put prior knowledge before present observation, though the approach is more Wilkie's than Raeburn's.

Wilkie was evidently still in Orchardson's

mind when six years after the *Queen of the Swords* he painted *The Morning Call* with its memories of *The Letter of Introduction* and perhaps that picture lies behind the development in the 1880s of Orchardson's most characteristic kind of work. In *The Letter of Introduction* Wilkie takes an invented scene which is apparently quite without dramatic interest, then by the subtlety of his account of the minute nuances of expression and body language makes us aware of the social, even psychological tensions that can underlie a simple encounter. In *A Social Eddy; Left by the Tide* (1878, Aberdeen Art Gallery) and *Her First Dance* (1884, Tate Gallery), it is the state of mind of a girl exposed and vulnerable in a social situation that she cannot command that is the real subject of the picture. In the first picture a girl is left seated and alone while the company moves on into the next room. In the second she and her partner are dancing alone, watched by the assembled company. In both pictures he stresses the vulnerability of inexperience, with which we sympathise painfully, by his use of composition in which large empty spaces visibly

Plate 192. W. Q. ORCHARDSON, *The Rivals*, 1895

isolate the girl. In the first picture she is left alone without a partner, in the other, though she has a partner, she is acutely aware of her conspicuousness before an inquisitive audience.

The mechanics of such a picture are the subject of the picture itself in *An Enigma* of 1891 (Kirkcaldy Art Gallery). Two figures sit on a couch, a man and a woman out of social contact. She is abstracted. He is looking at her in baffled curiosity. One of Orchardson's best pictures in this particular social mode is *The Rivals* of 1895 (NGS). (*Plate 192*) A girl is sitting slightly apart from three young men, each as interested in her as they are uninterested in each other. Orchardson's account of body language makes this a masterpiece in the study of social awkwardness, and the fact that this is in effect the same subject as Pettie's *Two Strings to her Bow* underlines the difference between these two painters in their maturity.

All these pictures are set in the past but, nevertheless, his elegant account of the *beau*

monde, though of a hundred years before, suggests that Orchardson was not indifferent to the example of the French painter, Tissot, who settled in London about this time. Tissot himself was influenced both by Pre-Raphaelitism and by Whistler and at times Whistler's own influence may lie behind the economy of some of Orchardson's pictures. What Tissot practised however was very much painting of modern life, and Orchardson only rarely turned to this kind of subject, sadly because when he did, he produced some of his finest paintings.

In 1883 Orchardson exhibited *Mariage de Convenance* (GAGM) and in 1886 its pendant, *Mariage de Convenance, After!* (Aberdeen Art Gallery), (*Plate 194*). They show two stages in a marriage between a young wife and a much older husband. In the first the couple sit at either end of a long and sumptuously laden table. He is uneasy and she is plainly bored. In the second picture, by her absence and the old man's dejection it is plain that she has followed

Plate 193. W. Q. ORCHARDSON, *Solitude*, UNFINISHED

nature to find love elsewhere. The title and the narrative relationship of the two pictures clearly pay homage to Hogarth, though it is in *The Rake's Progress*, not *Marriage à la Mode*, that Hogarth presents the marriage of youth and age as against nature. Orchardson echoes Hogarth quite closely as the contrasting ages of the couple are in effect, as in the fifth scene of *The Rake's Progress*, a metaphor for the fact that their marriage is a union conceived not in love, but in an illusion of social or material advantage. The moral is there in Orchardson's two paintings, but it is not drawn satirically, rather in terms of human suffering, as indeed is the whole moral of the tragedy of *The Rake's Progress*. *Mariage de Convenance, After!* is a picture in which Orchardson, too, touches genuine tragedy and shows compassion rather than censure.

The picture is a study in loneliness. Everything contributes. The old man is sitting in front of a fireplace, so angled that even if it is giving warmth we are not aware of it. The same expectation of warmth and comfort which is then denied runs through the picture. The overall colour seems to be warm, but it is shot through with cold green which neutralises it. The table is richly set, but there is no conviviality to give it life. The great space of the grand room, and the expanse of Turkish carpet emphasise the old man's loneliness and he sits in an attitude of worn-out dejection, reminiscent of the lassitude of the young husband in the second scene of Hogarth's *Marriage à la Mode*, but a state of mind now, not of body. At the end of his life, Orchardson touched a similar depth of feeling with even greater economy in the painting *Solitude* (Andrew McIntosh Patrick), (*Plate 193*) that he left unfinished. A woman in black, a widow, sits alone in an open carriage. The curve of the carriage is cut off at either end by the frame. There is nothing else in the picture. Although it was unfinished it is difficult to

imagine that much more was intended. As a painting of a widow, iconographically this picture belongs in the Victorian tradition of sentimental subject-matter that not only dictates the spectator's response, but transcends it. The brilliant simplicity of the composition, the effect it achieves of transitoriness, of something glimpsed at a distance, makes it a moving metaphor of solitude and human detachment.

In *The Last Dance* (Private Collection), also left unfinished, and in *The Borgia* of 1902 (Aberdeen Art Gallery), Orchardson shows similar pictorial inventiveness to that seen in *Solitude*, but that picture and *Mariage de Convenance, After!* are nevertheless perhaps the last great paintings in the tradition that goes back at least to Ramsay in which the instruments provided by the empirical understanding of the nature of vision are used, but are used in the pursuit defined by Hume: the study of human nature. The difference between Orchardson and Degas for example lies in the way that the French, following the logic of Reid's account of perception, had recognised that it is neutral.

According to that view of perception there is no longer any logical basis by which people can be differentiated by the painter from the other phenomena of experience. This is the position so eloquently described in a picture like Degas's portrait of *Diego Martelli* of 1879. In such a picture the enigma of Orchardson is no longer a local statement of a particular social situation, but the whole position of painting. The world subjectively experienced is unknowable, but perhaps in *Solitude* Orchardson is approaching this position with a metaphor that is, however, also still human.

In the late nineteenth century Orchardson's subtlety and his unrivalled command of the machinery of visual narrative in painting set him apart even from his Scottish contemporaries. His close friend, Tom Graham, in such pictures as *The Landing Stage* (V & A) and *Alone in London* (Perth Art Gallery), successfully takes Orchardson's 'state of mind' painting out of doors and into a modern urban context which gives his pictures some originality, but does not really move him out of Orchardson's

Plate 194. W. Q. ORCHARDSON, *Mariage de Convenance, After!*, 1886

Plate 195. WILLIAM McTAGGART, *Spring*, 1864

shadow. In Scotland Robert Herdman carried on the tradition of historical narrative painting and in pictures like *The Interview between Effie Deans and her Sister in Prison*, 1872 (Private Collection), he does this with reticence and tact not unlike that of Orchardson, but too often his painting, especially when Mary Queen of Scots is the subject, resorts to stereotypes reminiscent of Delaroche, the French painter of sentimental history. It is really only McTaggart, as a landscape painter, who shows a similar range of development to that achieved by Orchardson.

McTaggart of course did not work alone. He was sustained, like Orchardson, by the friendship of his colleagues, in his case especially that of Chalmers who was also a brilliant painter, though his career was cut short by his death in 1878, apparently murdered. In the 1860s these two and Hugh Cameron were very

close. McTaggart from an early date painted portraits to sustain himself and he continued throughout his life to paint portraits occasionally. He also painted a considerable number of genre pictures in his early career. *The Past and The Present* (Sir John MacTaggart Bt) for example, of 1861, shows a group of children playing among ruins. They are building a house from old bricks. It is an open-air genre picture, rather than a landscape. In mood and in its relationship to Pre-Raphaelite models, like Arthur Hughes's *Home from the Sea*, it is closely comparable to Hugh Cameron's painting the *Italian Image Seller* (Private Collection) exhibited the following year. Both are pictures of children. In Cameron's picture a group of children examine with curiosity the plaster saints and madonnas of an itinerant salesman, displayed on a wall as he sleeps in the sun. The innocence of childhood is confronted by history. This is the

ruin in McTaggart's picture. In Cameron's the images that once excited so much hostility as idolatrous are now the innocuous objects of childish curiosity.[3]

McTaggart's first major painting and the first real indication of his potential as a landscape painter, *Spring* (NGS), was exhibited in 1864. Two young children are sitting idly in a sunlit landscape. There are sheep and lambs in the distance. The innocence of the children personifies the season, but they are so much part of the landscape that the personification is more symbiotic than symbolic. They give us access to the simple delight of the beauty of spring through the innocence of childhood. The companion to *Spring*, *Autumn* (Private Collection), is an evening scene, wherein the youth of the children is contrasted to the age of an old woman sitting with them. In the artist's own words, 'a figure in the autumn of life'.[4] She is knitting, a reference no doubt to the thread of life.

In execution *Spring* is especially lively and free. The colours are brilliant and belong to true daylight. The painting of Holman Hunt and Madox Brown, both pioneers of the painting of pure sunlight, must lie behind these qualities, but the painting is completely different in finish from the Pre-Raphaelites. The reflected light in the faces of the children for example is achieved with transparent brown shadows instead of the continuous paint-surface of Pre-Raphaelite painting. The effortless unity of the picture's atmosphere that results from this freedom, and its freshness and spontaneity are already his own, though the broad and sketchy treatment may have been influenced by Alexander Fraser's outdoor painting which McTaggart admired.

In 1864 George Paul Chalmers began his largest and most ambitious picture, *The Legend*, but it was left unfinished at his death (NGS). He never abandoned it. He simply kept changing his mind. Although the execution belongs in large part to Chalmers's later career and is richly Rembrandtesque, the picture was planned when he and McTaggart were still working in similar ways. Its theme is like that

Plate 196. G. P. CHALMERS, *The Legend*, 1864–78

Plate 197. G. P. CHALMERS, *The End of the Day*, c. 1873

of *Spring* or even more that of *The Past and the Present*. It is a cottage interior, primitive and shadowy, lit from a small, square window and from the fire by which an old woman is sitting. She is leaning forward, engrossed in a story that she is telling to a group of children. They are enthralled, if not a little scared by the tale. The innocent imagination of the child meets the collective imagination of the folk. The picture marvellously evokes the appeal of the oral tradition.

Although the painting may have begun as an illustration to Scott's *The Pirate*,[5] its final form suggests that Chalmers had in mind Fergusson's lines in the 'Farmer's Ingle' where he describes just such a scene of an old woman telling a story of ghosts and graveyards that enthrals and scares her childish audience:

 In rangles round before the ingle's low;
 Frae gudame's mouth auld warld tale they hear;
 O' Warlock's louping round the Wirrikow,
 O' gaists that win glen and Kirk-yard drear,
 Whilk touzles a' their tap, and gars them shak wi' fear.

This link opens up another line of connection between Chalmers's generation and its predecessors in the eighteenth century, as also, through the rural and agricultural imagery of Fergusson's poem, it is linked to the new painting of the younger generation in Scotland. The Scots were conscious of the tradition in which they belonged. Implicitly Chalmers in his picture identifies the childish imagination with the tradition of folk-tale and with the business of the painter in a way that Wilkie would have appreciated. Twenty years after Chalmers's death McTaggart returned to a closely related theme in his large painting, *Consider the Lilies*

(Kirkcaldy Art Gallery) – the survival of folk-memory in children's games.[6]

Both Chalmers and McTaggart were criticised for lack of finish. Indeed *The Legend* itself was the subject of great debate after Chalmers's death as to whether, being actually unfinished, it could be acquired for the National Gallery, but for both men the breadth and freedom of execution which provoked such criticism was a necessary part of the way in which their imagination could work in the painting. For McTaggart this reflected his desire to capture the transience of light, but for Chalmers it was more to do with mystery. The shadows in the old woman's cottage in *The Legend* are the fields and forests of the imagination where the population of her stories has its home.

Chalmers was also a distinguished landscape painter, but not in the heroic tradition of highland landscape as it was maintained by MacWhirter and Peter Graham. Chalmers's landscapes are close in focus and very atmospheric. In 1867, for example, he painted the small *Girl in a Boat* (Orchar Collection, Dundee Art Gallery) which is an informally composed study of sunlight on water. The girl is in the stern of the boat. She is set against the dazzling light, but in spite of the contrast that this creates, the two elements in the composition are unified by the loose brushwork, so that the flickering light of the sun on the water also breaks up the areas of shadow in the boat. This command of light is very close to McTaggart's painting in *Spring*, though McTaggart did not achieve such command of sea painting until the next decade. Chalmers's later landscapes like *The Head of Loch Lomond* (Orchar Collection, Dundee Art Gallery) and *Gathering Water Lilies* (Private Collection), for example, have a light, misty atmosphere. This absorbs much of the detail leaving a fragmentary composition of a boat at a jetty, or in the middle of an expanse of luminous water. These are very individual pictures. They show the influence of George Reid's landscape painting developed on the Continent and it was probably through Reid's example that they resemble Corot. Their silvery light is shot through with accents of quite strong colour though, and this gives a distinctive mood. In another picture, *The End of the Day* (James Holloway), (*Plate 197*), dark birds

seen against a smoky sunset create poetry with an ominous undertone like that in Millet's drawing of *The Harrow* (GAGM).

Though McTaggart's fame is as a landscape painter, in the 1860s he might well have appeared to be a genre painter like Chalmers. He favoured outside settings, but he was also still painting interiors. These are less ambitious than *The Legend*, but similar in layout. Alongside *Spring* and *Autumn* for example he exhibited *Helping Grannie* (GAGM), which shows the interior of a cottage, rather in the manner of Tom Faed, with an old woman knitting with a small child by her knee, but he never used the deep chiaroscuro that characterises *The Legend*. In much of his work, including some of his portraits, Chalmers also favoured interiors, especially the smoky gloom of cottage interiors. For inspiration in this he was certainly looking, as Wilkie had done, to Rembrandt, but the 1860s also saw the beginning of the establishment of a European consciousness in painting, of the idea of 'modern' art perhaps. The international exhibitions that had begun with the Great Exhibition in 1851, the beginnings of the illustrated art press, the ease and cheapness of travel by train and steamer, all led to a growth in the international art market and to much greater fluidity in the exchange of ideas, often through personal contacts. The reputation of French painting had been growing over the past years and Barbizon was becoming an international centre. Dutch painting, stimulated by contact with the art of the Barbizon painters and that of Millet and Courbet, had evolved a dramatic new large-scale realism. But English, Dutch and Scottish models had also played a part in the final establishment of *les petits genres* in France. Wilkie and Constable, and in the 1850s Whistler and the Pre-Raphaelites all contributed to the overall complexion of European art. Scotland was not on the periphery, nor however was Paris at this stage the unquestioned centre of gravity in European art. The position was more complex. Scottish artists having a strong native tradition were able to draw nourishment from this fertile, new, international soil and it was from this that the later art of McTaggart and Chalmers sprang, as did that of the Glasgow Boys in the next generation.

Access to development of art overseas came to the Scots through those of their number who travelled and studied abroad and through the taste of collectors in Scotland. Foremost among these was John Forbes White in Aberdeen who was buying Hague School and Barbizon pictures from the early 1860s. It was through White that the Aberdeen painter, George Reid (1841–1913), went to study in Holland with G. A. Mollinger in 1866, going on to study in Paris for a year, and returning to Scotland in 1869. At this date Reid was a landscape painter, producing rather beautiful, tonal landscapes whose matter-of-fact subject-matter as it is seen in *Evening*, 1873, for example (Orchar Collection, Dundee Art Gallery), (*Plate 198*), was in contrast to the prevailing taste of Scottish landscape painting, but reflected Reid's own admiration for Daubigny as well as the Dutch painters. Reid painted one of his most distinguished portraits in 1871 however, the dark, dramatic and Rembrandtesque portrait of *Thomas Keith* (Royal College of Surgeons), and from that time forward his career as a portrait painter developed, leaving landscape as an occasional relaxation. His later portraits retain the Dutch feeling, but he was also responsive to the lighter, tonal painting of Bastien-Lepage, in spite of his public hostility to the Glasgow Boys from his position as President of the Royal Scottish Academy to which he was elected in 1891.

Reid had studied at the Trustees Academy perhaps as early as 1857, certainly in 1862, and was a friend of Chalmers. Amongst the circle of Dutch painters with whom he was on friendly terms, Josef Israels was the most

Plate 198. GEORGE REID, *Evening*, 1873

Plate 199. G. P. CHALMERS, *The Artist's Mother* c. 1869

celebrated. His reputation had been established in Britain in 1862 when he exhibited in London his large painting *Fishermen carrying a drowned Man*, a picture which was subsequently bought by another Aberdeen collector, Alexander Young. It was typical of Israels's style and of his inspiration in Millet with its gloomy subject and sombre mood, but not in its complex multi-figured composition. More typical of his work in this respect was the single figure in a cottage interior, a genre that was of course very familiar in Scotland. Shared iconography and common pictorial objectives were the basis of mutual understanding when in 1870, at White's invitation, Israels travelled to Aberdeen, and Reid, Chalmers and Hugh Cameron met him there. The three Scots actually collaborated on a portrait of him. Chalmers met Israels again in the Netherlands in 1874, and McTaggart met him there on a trip with White in 1882.

The interest of the Scottish painters in Israels is well attested, but so is Israels's admiration at least for Chalmers. His later work, for example the portrait study *Meditation* (Rijksmuseum) of the 1890s, is uncannily like Chalmers's free, informal head studies, his study for the portrait of *John Forbes White* for example (c. 1872, James Holloway), or his

portrait of his mother (GAGM). (*Plate 199*) Although *The Legend* looks very like some of Israels's cottage interiors such as *Growing Old* exhibited in 1884, the dates are such that it cannot be automatically assumed that the influence was all one way. A comparative chronology might well confirm that the priority lay with Chalmers.

Hugh Cameron, however, was certainly influenced by Israels and through him by Millet. In *A Lonely Life* (1873, NGS), (*Plate 200*) and *Gleaners Returning* (Orchar Collection, Dundee Art Gallery), Cameron treated themes of the hardness of rural life, and the heavy labour so often borne by women. He softens the harshness of the continental's depiction of such scenes though. He uses warm colours and a gentler light to suggest the timelessness of the pastoral which had been seen, since the eighteenth century, as providing some compensation for hardship in stability.

McTaggart's painting, *Dora* of 1867 (RSA), is in part a similar pastoral, as in the middle ground harvesters are working through the corn, but it also illustrates Tennyson's poem of the same name, a poem for which Millais had contributed two illustrations to the Moxon *Tennyson*. With a little boy, Dora waits all day by the harvest field for his grandfather, the farmer, to recognise and acknowledge the boy whose dead father he has disowned. He eventually does so on the second day of her vigil. *Dora* shows a woman and a child seated exactly as Tennyson describes it 'upon a mound/That was unsown where many poppies grew'. The woman and child are dark figures against an open landscape bathed in sunshine. The farmer acknowledges his grandson on the second day of their vigil when she 'made a little wreath of all the flowers/That grew about and tied them round his hat'. On the previous day she had sat till evening and this was the scene that McTaggart originally painted with an evening light and a mood like the wistful atmosphere of Millais's *Autumn Leaves*. In its finished form, set in the full light of day, it is Millais's *The Blind-Girl* which has provided the model however. McTaggart's treatment of the face of the woman has the flat treatment and sharp outline that we see in Millais. This is in contrast to the freedom of his own earlier *Spring*. The

background of *Dora*, however, in place of Pre-Raphaelite, additive detail, is an almost featureless expanse of dazzling light.

Though McTaggart remained loyal to the Pre-Raphaelite idea of the poetic subject, *Dora* was a transitional picture. It was after this that he began more and more to concentrate on landscape, or more often seascape. Like Constable and Suffolk, perhaps his preference for seascape has something to do with the scenes of his boyhood, for he was born near Machrihanish and brought up in Campbeltown at the foot of the Mull of Kintyre and he regularly returned there to paint. His early essays in sea painting are pictures like *Enoch Arden* (1866, whereabouts unknown) and *The Murmur of the Shell* (1867, Richard Green, Blue Chip Travel, Ltd). In the latter he uses a similar composition to *Dora* with its overtones of Millais. Pictures like these are also very similar in subject to a group of paintings by Israels such as *Children of the Sea*, 1863, which show children playing on the beach against a wide background of sea and he may well have been influenced by Israels. He was, however, already moving away both from the Pre-Raphaelite approach and from Dutch solidity towards something more relaxed and informal.

This development in his art is seen fully evolved in the *Bait Gatherers* (NGS) of 1879 which is on the face of it similar to *The Murmur of the Shell*. A group of three children are gathered on a rock which is half awash. One of them, a boy, is standing in the water with a basket on his hip. A girl beside him is sitting, leaning on one elbow and a younger child behind her is crawling. The figures have no contours. Their faces are scarcely defined and indeed the blue of the sea actually runs through the figure of the standing boy. They are so much at home in the world that McTaggart creates, that they are literally part of it and it is the distant lines of breaking waves and the wide blue horizon which dominate the picture.

McTaggart had always drawn out of doors, making extraordinary visual notes often only legible to himself, yet from which the germ of some of his greatest paintings can be seen to have grown. In the 1870s however he had taken to making finished paintings in watercolour out of doors. As Caw, McTaggart's biographer

Plate 200. HUGH CAMERON, *A Lonely Life*, 1873

and son-in-law, observes[7] this had a direct impact on his painting in oil as it had done with Turner. The influence of watercolour is clearly apparent in *Through Wind and Rain* of 1880 (Orchar Collection, Dundee Art Gallery). A fishing boat in a flurry of spray sails close-hauled across a rain-laden wind. The picture is one of an 'effect' of weather and the feeling is conveyed by the fluency of the artist's technique. As a contemporary reviewer put it: 'The artist has with great strength conveyed the impression of a bleak day at sea'[8] and indeed the picture is almost entirely painted in greens, greys and blacks. There is scarcely even blue, nor any warm colour in the faces of the men clearly visible in the boat.

McTaggart's command of such effects increased as his technique improved and perhaps also as he absorbed the lessons of Whistler's light, free paintings.[9] In 1881 he painted *The Wave* (Kirkcaldy Art Gallery). (*Plate 202*) It is a painting of wonderful simplicity

and transparency; a single crest, just breaking out of a hazy tranquil sea, rolls towards an empty shore. A few scraps of seaweed in the foreground are the only other incident in the painting. Characteristically though, they provide touches of red and purple to make a kind of visual drama quite unlike Whistler. Instead McTaggart describes the complexities of light and atmosphere. It powerfully evokes a mood because 'it compels us to regard the *total* rather than the *focal* unity of the picture'.[10]

McTaggart treats the same mood in a work of 1894, *Noontide, Jovie's Neuk* (ECAC). (*Plate 201*) (The title is given by Caw, but the position of the sun, and the red and orange lights in the sky as the painter looks west towards Edinburgh from East Lothian, suggest the high sun of northern summer evenings.) From the early 1880s McTaggart had been taking his easel out of doors and this relatively small picture has all the feeling of being painted quickly and on the spot. *Jovie's Neuk* is painted on a tinted canvas, an increasingly common feature of his later works which reflects his knowledge of a collection of Constable sketches that were on view in the Royal Scottish Museum from 1883 till 1887, an artist whom he greatly admired according to Caw.[11] The warm-coloured ground underlays the sparkling colours with a note of sultry heat. Although the eye perceives it as a picture with a dominant blue tonality, it is constructed from purples and

Plate 201. WILLIAM McTAGGART, *Jovie's Neuk*, 1894

Plate 202. WILLIAM MCTAGGART. *The Wave*, 1881

even reds as well as blue and much of the sea is white, not the white of breaking waves, but of the dazzling light of the sky on tranquil water. The buff of the canvas is visible in much of the sea. It echoes the dapple of the clouds and sets off the sparkling white.

Like *The Wave*, this picture is almost without incident. Sky and sea are in harmony, separated by a narrow, dark line of horizon, beyond which the hills merge with the blue. It is a perfect example of what Constable called the 'chiaroscuro of nature'. In the foreground of the picture two children are lying on the sand and a rowing boat is grounded at the water's edge, but such is the strength of the light all these details are dissolved into it. These are purely visual effects, observed and recorded with a miraculous dexterity and sureness of touch, but the children are there to identify the subjective mood of innocent tranquility that is the picture's real subject.

In such a painting, effect, and the superb singleness with which it is conveyed, are part of the description of feeling. Constable and Archibald Alison would both have understood the picture, and like his predecessor, Thomson of Duddingston, McTaggart is using landscape to convey a subjective state. Unlike Thomson this is not focused through historical association, but it is nevertheless clearly continuous with Archibald Alison's view of the significance that nature has for us which, beyond the matter of fact, is touched by religious awe. Although he travelled occasionally, McTaggart apparently never painted outside Scotland which is therefore always his subject. As Christopher North described Thomson, McTaggart too is a patriotic painter.[12] What he celebrates though is not the details of history nor the clichés of Scottish landscape, but creation itself and his own experience of it, though so often seen through the eyes of children. This is why the figures are both constantly present and constantly subordinate in his paintings. The grimness of Israels's or of Millet's view of the human condition has no place in painting which, like that of Constable, actively celebrates the natural world in a way that is quasi-religious.

Plate 203. WILLIAM McTAGGART, *Harvest Moon*, 1899

McTaggart's approach to landscape is certainly not merely hedonistic though, for the world he records is by no means uniformly gentle. Some of his most characteristic paintings are of the sea broken by rough weather as in *North Berwick Law from Cockenzie* (1894, Kirkcaldy Art Gallery). The extreme example of this kind of painting though is *The Storm* (1890, NGS), begun in a smaller version in 1883. In the final painting everything is subordinated to a single effect in which the raging wind dominates the senses. The focus of the picture is a human drama; left of centre the houses and nets of the fishing community can just be made out through the spray. Near them, and also near the spectator, on the cliff top with which they merge, members of the community are gathered anxiously to watch as a rescue boat is launched to assist a fishing boat in distress, barely visible in the white water, right of centre. The complete subordination of all this human interest and incident to the omnipotent storm is remarkable, particularly if the picture is compared to contemporary paintings of the life of fishermen, like Stanhope Forbes's *The Hopeless Dawn*, which stress the human side of just such a story. McTaggart is closer to Turner's *Steamer in a Snow Storm*.

McTaggart's vehicle for the expression of feeling was the 'chiaroscuro of nature' just as Constable described it, 'the influence of light and shadow upon Landscape, not only in its general effect on the whole . . . but . . . as a medium of expression.'[13] Like Constable, McTaggart achieved this by breaking down the integrity of detail in his paintings. Unlike Constable, however, he did this in terms of colour. Close-to pictures like *The Storm* are a dazzling mesh of pure colour. Such a technique was of course superbly adapted to painting the sea and light on water, but especially after 1889 when he moved to live at Lasswade in the country to the south of Edinburgh, McTaggart also painted rural landscapes. Some of these, like *Hayfield, Broomieknowe*, (1889, Kirkcaldy Art Gallery) are wonderful, dappled landscapes that make the analogy with Constable even more apparent.

The Storm is one of a group of large, late paintings which are clearly heroic in feeling and Lindsay Errington has suggested that this new scale and the ambition that it reveals may also have been a response to seeing Constable's full-size sketches of *The Hay Wain* and *The Leaping Horse* which were displayed at the Edinburgh International Exhibition in 1886.[14] *Consider the Lilies*, 1898, is the last of this group, but it gives an important clue to McTaggart's thinking. It is a picture of children playing in the garden of McTaggart's house at Lasswade. They are playing ring-games and Errington connects this with contemporary interest in children's games which were recognised as survivals of ancient adult rituals.[15] The picture

is therefore about time, memory and the unrecognised voice of the past. It reflects on ancient Scottish culture in a way that is similar to Turner's reflection on classical culture in his painting *The Bay of Baiae with Apollo and the Sybil* and it is certainly to Turner and beyond him to Claude, rather than to Constable, that we must look to find a precedent for the ambitious approach to subject in these late pictures.

This sequence of major pictures includes *The Emigrants* (Tate Gallery), like *The Storm*, begun in 1883 and finished in 1890, *The Emigrants: America* (1891–4, Miss Flure Grossart) and *The Sailing of the Emigrant Ship* (1895, NGS). (*Plate 204*) There are also two paintings of

Plate 204. WILLIAM McTAGGART, *The Sailing of the Emigrant Ship*, 1895

Plate 205. WILLIAM MCTAGGART, *The Paps of Jura*, 1902

Columba, *The Coming of St Columba* (1895, NGS)[16] and the *Preaching of St Columba* (1897, ECAC) in which the themes seem to be parallel and all these pictures can now be seen, following Lindsay Errington's interpretation of them, to be linked in a commentary on the rise and fall of McTaggart's own people, the Gaels. His parents were both Gaelic-speaking and so presumably was he by upbringing. Though he became a naturalised east-coaster he never lost his love for his own part of the world and its people which both occur constantly in his painting.

There had been a terrible fishing disaster at Eyemouth in Berwickshire a little while before McTaggart began *The Storm* and which may have been part of his inspiration. He has, however, set his picture on the west coast so that it represents the condition of life for the Highland people *in extremis*, forced by the Clearances from their ancient way of life to pursue a perilous and marginal existence from the sea, a story told by Neil Gunn in *The Silver Darlings* more than fifty years later. The St Columba pictures present the beginning of their history, and its end is in the emigrant pictures which reflect the contemporary emigration and depopulation of the Highlands. Significantly the beginning of this series also coincides with the passing of the Crofting Act in 1883 which finally, and too late, brought an end to the Clearances.

The Coming of St Columba shows a small boat with a white sail in the middle of a transparent expanse of blue sea. There is a headland beyond it. Carrying Columba, the boat is entering a bay on the Mull of Kintyre, watched with idle curiosity by a father while his wife makes daisy chains with their child in the grass. This group recalls Puvis de Chavannes's *Poor Fisherman*, the best known modern French painting of the time. If this tragic, semi-religious depiction of a fisherman and his family struck a chord with McTaggart, it underlines the seriousness of his theme. Although Columba's boat is driven by a good breeze, it is a brilliant day, suitable for a new beginning. *The Preaching of St Columba* shows the saint on the shore of the same bay. He is a tiny figure, almost lost against the blue of the sea. He is turned towards us to address an audience which, though it is numerous, is also partly absorbed into the landscape. If a mountain were to be substituted for the sea, the scale and setting of the scene of preaching would more clearly recall Claude's *Sermon on the Mount* and this would not be surprising for it is to the level of the classical landscape at its most heroic that McTaggart is aspiring in these pictures.

The Emigrants of 1883–90 and *The Emigrants: America* of 1891–94 are two versions of the same scene of a group of people gathered by the shore engaged in the sad business of departure and farewell. One boat has already set out and others stand by to take the emigrants to a ship standing offshore. In the larger and later of the two the word 'America' in the title appears on a box in the foreground. Both are dramatic, but this is a picture of quite extraordinary visual excitement. In the first it is a grey-blue day of uncertain squalls, but in the second it is a day of strong wind and fast-moving cloud, unstable and rapidly changing. This is interpreted by the painter with a violence of execution and such strong colour that the scene has an almost apocalyptic feeling. A lurid fragment of rainbow against a dark cloud symbolises hope, but communicates no feeling of it. The figures in the foreground are numerous, but their individual definition is completely broken up. Some are no more than part of a disembodied face which is just a splash of colour in a wider field of paint. We are given different fragments of their experience, held together by the loose continuum of the paint surface into a single event whose theme, however, is just this, dislocation; the dislocation

and fragmentation not of the lives of individuals alone, but of a whole people.

The Sailing of the Emigrant Ship of 1895 is a more upright composition. The ship, its sails set, is moving towards the horizon and towards the light which is breaking brilliantly at the centre of the picture from beneath a dark cloud. To the right though, an orange glare suggests that it may be sunset. Against the cloud a fragment of rainbow is visible, but this ray of hope is contrasted to the desolate emptiness of the foreground. The figures here, even more fragmented and dissolved into the landscape than in the other paintings, are barely more than scraps, the detritus of a departing tide: 'A sadly dwindling minority are these fag-ends of a once mighty race.'[17] Just legible are an old couple looking out to sea, a young woman, her head bowed in grief, with a baby in her arms, and a dog, its head back, howling in desolation, but much of the foreground is literally blank. Its broken surface merges with the sea as though the land itself, and the people with it, were dissolving into the uncertainty of light and water.

What is extraordinary about this group of pictures is the way that they tackle themes that were topical, moving and of deep personal significance to the artist himself, yet they ignore completely the Victorian conventions of narrative and instead develop McTaggart's own landscape of subjective mood, created by the description of nature, to the point where it can realise by almost abstract means a series of images of tragic grandeur.

The dissolution of the figures in these late pictures is something that evolved gradually in his work and for which he was and still is criticised (as is Turner). Another feature of many of his late pictures is that they have been enlarged while he was painting them. He evidently expected this, as one view of Machrihanish left unfinished at his death actually has fully a foot of canvas spare at either end (Private Collection). He was more and more unable to see a clear lateral edge to his painting. Like Monet, his exact contemporary, in his late water-lily paintings, McTaggart it seems realised intuitively that, following the

Plate 206. WILLIAM McTAGGART, *Christmas Day*, 1898

inexorable logic of the description of experience proposed by Hume, in the end the objective and the subjective cannot be differentiated. Painting can only reflect experience by combining them in a single image. In this combination time and space, if they are not identical, are so closely akin that they form a single continuum and this continuum has no natural boundaries. McTaggart's over-running his canvas is exactly the same as Proust's over-running a single volume. McTaggart looks straight into the heart of modern art. It is only a short step from *The Emigrants: America* to William Johnstone's *Fragments of Experience* painted seventy years later, or indeed to some of the paintings of Johnstone's American contemporaries.

In some of his late paintings McTaggart departed completely from any conventional vision. In some cases the execution is so summary that the state of finish is not clear, but he had never cared about finish and he knew now that he had left the market far behind him. McOmish Dott, who supported him loyally, suggested to him in 1901 that perhaps Paris might be more receptive to his modernity, but he rejected the idea.[18] He was therefore working largely for himself and he adopted a summary treatment in his large-scale paintings that had hitherto been reserved for the tiny pencil drawings that he used to record the essence of a scene. The results are extraordinary, for example in *Harvest Moon Broomieknowe* (1899, Tate Gallery), (*Plate 203*) or in *Christmas Day* (1898, Kirkcaldy Art Gallery). (*Plate 206*) In *Snow-scene* (Nora Fisher), a similar painting of the landscape at Broomieknowe under snow and which one might expect would be predominantly white, he creates a complete account of the scene with a few marks of red, blue and white in a field provided by the ground of the canvas which is primed a pinkish buff. Such a radical treatment of landscape suggests an analogy with Monet's late painting.

A lot of argument has been expended on the question of McTaggart's possible relationship to impressionism, but this fixation is really a reflection of our limited vision of art history. McOmish Dott was right to suggest Paris as a place where McTaggart's late painting might be seen to advantage though. In late landscapes like *And All the Choral Waters Sang* (Orchar Collection, Dundee Art Gallery) or *The Paps of Jura* (1902, GAGM), (*Plate 205*), both views from Machrihanish across to Jura, lines of white breakers run from edge to edge of the canvas like Monet's *Waterlilies*. The mountains of Jura on the horizon are only an incident in the blue distance. It is a majestic answer to the anxieties expressed by Dyce. The transience of the waves and the permanence of geology have become equal. Existentially their substance does not differ. All the careful differentiations of the qualities of matter that were such an important preoccupation to the philosophers of empiricism dissolve in a description of experience as continuum or flux. The artist carries to its logical conclusion the removal of the distinction between seeing and knowing that follows Reid's account of the nature of intuition. He responds immediately to experience with action and his painting becomes gesture. McTaggart, like Monet, but drawing on his own intellectual and artistic traditions, reaches through the conventional vision of contemporary painting to an independent and authentic statement of western self-perception at the threshold of modernism.

EAST AND WEST
The Rural Scene

McTaggart was a dedicated painter of Scottish scenery, but he turned away from the conventions of the 'Scottish landscape', from the idea of 'the land of the mountain and the flood' which went back to Scott. He achieved epic effects without choosing obviously poetic subject-matter and he once remarked: 'After all, it is not grand scenery that makes a fine landscape. You don't find the best painters working in the Alps. It's the heart that is the thing. You want to express something that appeals to our common humanity.'[1] If he painted mountains, it was at a distance. The Paps of Jura peeping over a far horizon are not obviously part of the language of the sublime. This was something that he had in common with the younger generation though.

His close friend and the father of his second wife, Joseph Henderson (1832–1908), specialised in sea paintings which are far less dramatic than McTaggart's and without the personal connection they could be seen as directly influenced by Hague School painting. Gemmel Hutchison (1855–1936) combined the imitation of McTaggart with an even more direct imitation of Israels to create a saleable, but undistinguished series of beach and sea paintings. Sir James Lawton Wingate (1846–1924) carried the McTaggart tradition well into the twentieth century, but he was a more varied painter. He came from Glasgow and began his training at the Glasgow School of Art. In 1867–68 he travelled in Italy and was painting in a way that was influenced both by Ruskin and by the Pre-Raphaelite tradition as it was seen in Scotland in the work of painters like Waller Paton. He became friendly with W. Darling McKay, however. Following McCulloch,

Fraser and Sam Bough, they met working in Cadzow Forest in 1872 and Wingate then moved to Edinburgh where he studied at the Royal Scottish Academy School.

Wingate regarded a meeting with Hugh Cameron in 1873 as a turning point in his career. Cameron's influence, together with McKay's and also perhaps that of the Hague School, underlay the painting of scenes from rural life that Wingate did between 1874 and 1887 in the small Perthshire village of Muthill. He actually lived there between 1881 and 1887 and painted some of his most interesting pictures there, such as *Interior of a Barn: Making Straw Ropes* (1880, RSA), (*Plate 207*), which are directly observed but freely painted. After 1887 Wingate came increasingly under the influence of McTaggart. This is seen in pictures of dramatic skies and light on water like *Sea and Beach under a Stormy Sky* (Kirkcaldy Art Gallery) or *Kilbrennan Sound* (NGS). Sir David Murray (1849–1943) was an equally successful landscape painter in the same generation if a little more academic in his approach than Wingate. He was much influenced by Constable and Corot. Corot's influence is clearly seen in a painting like *The Ivy, the Oak and the Bonnie Birken Tree* (1929, Bristol Art Gallery) for example. Slightly younger painters like John Campbell Mitchell (1862–1922), William Stewart MacGeorge (1861–1931) and William Miller Fraser (1864–1961) were more responsive to French models and developed easily into a fully-fledged impressionist style from the background in Scottish landscape painting that was provided by painters like McTaggart and Wingate and before them Fraser and McCulloch.

Wingate's identification with Muthill in the

Plate 207. JAMES LAWTON WINGATE, *Interior of a Barn: Making Straw Ropes*, 1880

1870s and eighties was typical of a group of artists of his generation and was perhaps shaped not only by the fashion for Barbizon, but also by the reputation of Constable. At a deeper level too it was an earnest and unsentimental attempt to find a role for art through reidentifying with the land. In some of these pictures the artist is so closely involved in the details of what he describes that it is almost as though he was, as an artist, cooperatively engaged in the labour of the people in the fields. W. Darling McKay (1844–1923) was probably the leader in this.

From the late 1860s McKay's painting is closely identified with his native East Lothian. Like Wingate, he was influenced by McTaggart, but also by French and Dutch painting. He painted deliberately unsentimental agricultural pictures in the 1870s and early eighties, for example *Turnip-Singlers: A Hard Taskmaster* (1883, RSA). (*Plate 208*) (McKay was also the author of *The Scottish School of Painting*, 1906, an important early book on Scottish art.) J. Campbell Noble (1846–1913) and his younger cousin Robert Noble (1857–1917) were part of an East Lothian group around

McKay and it is important in considering links with the older generation that the Nobles' home of East Linton was also the home of the Pettie family. In the 1860s J. C. Noble's early work clearly reveals Pettie's influence. McKay and J. C. Noble both visited Holland early on however and some of Noble's best pictures of canals and shipping are worthy of the Hague School, even though they are not always set in Holland, for example *On the Tyne* (1883, Private Collection). The inspiration of Dutch art had never entirely gone out of fashion since Wilkie's time however. E. T. Crawford, for instance, still exhibiting in 1880, had been painting both Dutch and agricultural subjects since the 1830s.

These East Lothian painters, however, pioneered a trend towards a much closer focus on the details of rural life. One of Robert Noble's finest pictures, for example, is *Potato Picking at East Linton* (Private Collection). Robert McGregor (1847–1922) was a member of the East Lothian group and he continued to paint this kind of rural subject matter throughout his career. Arthur Melville (1858–1904), who went on to become one of the most distinguished painters of this generation, came from East Linton. An early work, *A Cabbage Garden* (Andrew McIntosh Patrick), (*Plate 209*), painted in 1877, is a striking and original picture and reveals Melville's close relationship to the Nobles. In the next year, 1878, W. D. McKay exhibited *Field Working in Spring: The Potato Pits* (NGS). Like *Turnip-Singlers: A Hard Taskmaster* this is a very unromantic view of women working in the fields. John Robertson Reid (1851–1926) was also producing pictures of agricultural labour at this time, for example *The Old Gardener* (1878, Private Colection), (*Plate 210*), and William Stewart MacGeorge painted *A Galloway Peat Moss* in 1888 (NGS). Though a little later, this picture of peat-cutters at work is typical of such paintings in the faithfulness with which it documents the details of agricultural labour. Sir David Murray's *Betwixt Croft and Creel* (1885, Oldham Art Gallery) takes a similar approach to the details of nets, floats and other fishing equipment which occupy the foreground of a coastal landscape. All these pictures are unsentimental in treatment, but they are mostly fairly small

and so are not pictures of a heroic, suffering peasantry of the kind painted by Millet, Jules Breton, or even Josef Israels.

In Scotland this kind of subject-matter was still very much an extension of landscape painting and the large-scale figure-painting of scenes of rural life, originally pioneered by Courbet and given dramatic new popularity by Bastien-Lepage, first appeared in Scotland in the late 1870s in paintings by Robert McGregor such as *Gathering Stones* (CEAC), *The Knife-Grinder* (1878, Dundee Art Gallery), (*Plate 211*) and *Doing the Provinces* (c. 1879, GAGM). McGregor had not studied abroad, but he had certainly understood very well the chief characteristics of this kind of painting in France. These were first of all a tendency to construct compositions in terms of an overall grey tonality, called respecting 'tonal values'. As colour is subordinated to the grey scale, it gives an effect of light very similar to that of black and white photography. It was perceived as a distinctive feature of French painting, though Whistler and the later work of Millais both contributed to its evolution. There was in addition a tendency deriving from Courbet to reduce the foreground so that the figures come close to the picture plane. This increases the sense of their bulk, an effect that is further enhanced by the use of rather dry, thick paint.

Bastien-Lepage was the acknowledged master of this technique, but he did not really launch his career as a 'realist' painter till 1878 when he exhibited the painting *Les Foins*. His reputation spread very quickly in Britain and was confirmed by an exhibition in London and a visit to the city in 1880. McGregor seems to have developed independently of his influence from his background in the painting of the East Lothian rural painters, however. These qualities in his style are already apparent in a picture exhibited in 1876 of a little girl left alone to watch the baby. Its folksy title, 'When a' the lave gae to their play/Then I maun sit the lee-lang day/And jog the cradle wi' my tae,' makes it clear how difficult it is to separate old traditions in Scottish painting from new ideas (1876, Forrest-Mackay).

Against this background the claim of the young painters in Glasgow at the beginning of the 1880s, men like James Guthrie

(1859–1930), W. Y. Macgregor (1855–1923), James Paterson (1854–1932), William Kennedy (1859–1918), E. A. Walton (1860–1922) and all the others, known since their own time as 'the Glasgow Boys', to represent something quite new in Scottish art is exaggerated though not groundless. It is a claim implicit in the way they rejected the older generation as 'glue-pots'. This was forgivable youthful hyperbole, but it also reflected contemporary response to them. They were seen as somehow foreign and there can be no doubt that they represented something new in art in Scotland for all the important connections that they had with the painting of the older generation.

In the last two or three decades of the nineteenth century Glasgow was at its zenith as a city. Since the beginning of the century it had been home to the first public art museum in Scotland, the Hunterian founded by the bequest of Ramsay's friend, Dr William Hunter, to Glasgow University. Whether this played any part in it, there was certainly a tradition of collecting in Glasgow from that time forward. In 1855 Archibald McLennan left his collection to the city. It formed the nucleus of the present very distinguished municipal art gallery.

Plate 208. W. D. McKay, *Turnip-Singlers: A Hard Taskmaster*, 1883

256 SCOTTISH ART

From 1811 there had been a series of attempts to found a permanent exhibiting society. The most long-lasting of these were the Glasgow Dilettanti Society which flourished from 1828–1838 and the West of Scotland Academy which ran from 1841–1853 with the portrait painter John Graham Gilbert as its president. These were eventually succeeded by the Glasgow Institute founded in 1861.[2] It provided a regular exhibition, not only for Glasgow artists, but also for artists from elsewhere and for collectors to show their recent acquisitions. By the later decades of the century there were enough collectors to support several important dealers such as Craibe Angus and Alexander Reid. These men had close connections with modern art on the Continent. Reid for example, a friend and colleague of

Plate 209. ARTHUR MELVILLE, *A Cabbage Garden*, 1877

Theo Van Gogh, at one time shared a room with Vincent and was the subject of a famous portrait by him.[3]

Collecting and dealing were a particularly important element in the development of painting in Glasgow because until Francis Newbery (1855–1946) became principal in 1885 and revitalised it, Glasgow School of Art did not play a major role in the art life of the city. James Guthrie, for example, spent time in London with Pettie, establishing an important early link with the East Lothian painters. W. Y. Macgregor also studied in London, spending a period at the Slade with Alphonse Legros. James Paterson travelled to France and took part in the cooperative education of the Paris ateliers. He also studied for a time at Glasgow School of Art however. So did E. A. Walton, but for these four their real education seems to have lain in the work that they did together, for the basis of the Glasgow Boys as a group was a series of friendships. The young painters took to working in each other's company in the summer months and so enjoyed mutual influence and support. Paterson and Macgregor were early friends as were Walton and Guthrie. These two were joined by Joseph Crawhall (1861–1913) who came from Newcastle, and later by George Henry (1858–1943) and so the group grew.

There are not many paintings by any of the Boys that survive from before 1881 or 1882, but the most accomplished amongst those that do are the landscapes of E. A. Walton. As early as 1879 he was choosing for subjects an undistinguished corner of a field, or a bend in a river, its prosaic arrangement enhanced by some detail such as an upturned boat, or cows in a meadow. The whole effect in such pictures depends on direct and simple execution to capture the tones, though less the colours, of a sunlit landscape. *A Summer Morning*, 1879, is typical (Sir Norman MacFarlane). It shows a tidal creek in flat country beneath a bright sky. It is edged by reeds and low trees. In the foreground on rough ground there is an upturned boat. Another boat is drawn up to the water's edge in the middle ground and beyond it sheep are grazing. There are no picturesque features. The whole picture is a harmony of greys and greens. The lightest tone is the silver light on

the water and the darkest, the black boat at the water's edge. The ultimate ancestor of such a painting is Constable's *Boat-Building at Flatford*, but in the Scottish context of the late 1870s this painting must have immediately looked foreign. Where the traditions of subject-matter were so strong, this would seem to be a picture without incident or interest, and the translation of light into a simple and static pattern of tones was quite at variance with the sort of colour and handling which had become typical of Scottish painting in the generation of the followers of Scott Lauder.

Walton's early landscapes have parallels in the early works of the other Glasgow painters, but by 1881 there was a perceptible shift towards something more dramatic in their painting, not by way of a return to narrative subject or poetic content, but in a more vivid confrontation with reality. It is a shift towards the existential way of painting seen in the work of the followers of Courbet, both French and Dutch. It is 'realist', but it is concerned less with illusion than with using both the image and the surface of the picture to create a sense of the immediate, physical presence of the thing represented.

W. Y. Macgregor's painting, *The Joiners' Shop* of 1881 (Private Collection), (*Plate 212*), is a good example of this. Done to commission, iconographically it relates to the painting of Bonvin and Ribot in France, for example Bonvin's *Blacksmith's Shop*, though also to Scottish paintings like Wingate's *Interior of a Barn: Making Straw Ropes* also exhibited in 1881. Even the French painters, though, were rarely so matter-of-fact as Macgregor. This may reflect the fact that it was a commission, but the picture is also a critique of the most famous English painting of a carpenter's shop, also 'realist' in intention, Millais's *Christ in the House of his Parents* which was shown that year in London. Both pictures start from the same point. A carpenter's bench blocks entry to the picture, except for an opening round a salient corner to the right. The floor is covered with shavings and there is a variety of apparatus stacked against the back wall, but thereafter they part company absolutely. Instead of Millais's centralised composition, Macgregor has casual asymmetry. His figures are lost in the space and absorbed in

Plate 210. JOHN ROBERTSON REID, *The Old Gardener*, 1878

their occupations. In the place of Millais's judiciously scattered shavings there is a real joiner's mess. By this contrast Macgregor declares a cardinal point of belief for all the Boys, his independence of the whole tradition of the picture as a vehicle for narrative. His picture instead reflects reality without comment, a position anticipated by Thomas Reid and adopted by Raeburn in the context of portraiture a hundred years before, and which had never quite died out in Scotland as the painting of the East Lothian group makes clear. There can be no doubt that this long pedigree helped the Glasgow painters to absorb the lessons of modern European painting.

The first really ambitious painting by any of the Glasgow Boys was Guthrie's large and sombre *A Funeral Service in the Highlands* (GAGM). (*Plate 213*) Begun while he was staying at Brig o'Turk in Stirlingshire in company with Walton and Macgregor in 1881 and prompted by the death by drowning of a boy in the village, the picture was completed the following year. Outside a cottage, on a grey, snowy day a small

Plate 211. ROBERT MCGREGOR, *The Knife-Grinder*, 1878

coffin is supported on two chairs. To the left the minister raises his hand in blessing. A line of dark-clad men stand to the right, their bare heads forming a high horizon against the grey of the sky. There are no women present, in accordance with custom. The line of the men is broken by one figure standing forward of the rest and by a boy, a single friend of the drowned child, standing by the coffin. In spite of the circumstantial origins of the painting there is a general similarity in the subject to a painting by Frank Holl called *Her First-Born, Horsham Churchyard* which had been exhibited in 1876, but the austerity of treatment, and to a certain extent the frieze-like arrangement with its restrained punctuation also recall Courbet's *Funeral at Ornans*. It was a very topical picture for it was exhibited in Paris in 1881 and entered the Louvre the following year.

Courbet's enormous picture though, beside Guthrie's, is almost colourful and the extreme sombreness of Guthrie's painting, its emphasis on the cold and comfortless environment are typical of Israels. An interest in the Dutch painter is something that Guthrie shared with the Scott Lauder group to whom, of all the Glasgow painters, he was closest because of his association with Pettie. The execution and above all the acute perception of mood through the observation of expression are things that associate this picture with Orchardson though,

perhaps even more than with Pettie. Wilkie, who experimented with such subjects of religious observance in the open air in drawings like *Tent Preaching at Kilmartin*, would have appreciated the picture which is so much in the tradition of *The Cotter's Saturday Night*. The intervening influence of continental art had eliminated from Guthrie's painting the sentimentality that vitiates so many of the Scottish pictures of religious scenes that followed Wilkie's, like Harvey's Covenanting pictures for instance, and so Guthrie reinstates the dignity of Wilkie's inheritance.

Guthrie's picture had one important successor, John Henry Lorimer's *The Ordination of the Elders* (1891, NGS), (*Plate 214*), painted ten years later. Lorimer (1856–1936) was rather a chameleon figure, a reluctant but successful portrait painter who also made a considerable reputation in France. He trained at the Academy in Edinburgh where Chalmers and McTaggart were among his teachers. In his maturity he modelled himself very much on Millais. Considering Lorimer's Pre-Raphaelite leanings, his French reputation, the parallels his picture has in French paintings of popular religion, like Legros's the *Ex-Voto* of 1860, and its background in Scottish painting going back to Wilkie, *The Ordination of the Elders* provides a fascinating commentary on the intertwining traditions of Britain and France.

If *A Funeral Service in the Highlands* shows Guthrie's Scottish inheritance, it was painted just at the moment that the Glasgow painters were turning more clearly to continental models. In 1882 Guthrie and Walton both show the influence of Bastien-Lepage. During these years John Lavery (1856–1941), Alexander Roche (1861–1921), Thomas Millie Dow (1848–1919) and William Kennedy, who all became members of the Glasgow community, had been studying in France. These four probably all went together in 1883 and again in 1884 to Grez-sur-Loing where the presiding genius was Bastien-Lepage. Lepage's closest English follower, William Stott, seems to have been instrumental in their choosing to go there.

Bastien-Lepage's enormous reputation in the early 1880s is a little difficult to understand at this distance. Pictures like *Pas Mèche*, 1882, and *Pauvre Fauvette*, 1881, look to modern eyes like sentimental 'gamin' paintings, different in technique but not in intention from pictures like Tom Faed's *The Scottish Peasant's Family* (Ashmolean, Oxford). Technique was however an important part of Bastien-Lepage's appeal. He was the supreme exponent of French tonal painting. His pearly greys and greens, and overcast skies gave the illusion of a matter-of-fact and unsentimental vision of reality. He also adopted the technique developed by the Impressionists of adapting the patterns of brushstrokes to the purposes of description. He used it selectively however to suit the needs of his subject, reserving a rather smooth, photographic treatment for the heads and setting them in a ground of broader, 'honest' painting. The most obvious feature of this 'honest' painting was his use of a square brush to give a flat surface, supporting the sense of frontality that he tended to give his compositions. *Pas Mèche*, for instance, stands to confront us directly without any foreground. Behind him a broken fence closes the middle ground, so the figure is held right up to the picture plane. The effect of all this was to give a sense of a tangible reality captured.

The extent to which this was as much a psychological illusion as a visual one is illustrated by the importance that was attached to the fact that Bastien-Lepage was painting real people, identifiable individuals from his own native village of Damvillers. Though the same

Plate 212. W. Y. MACGREGOR, *The Joiners' Shop*, 1881

might be said of Wingate in Muthill, or the Nobles in East Linton, it is Bastien-Lepage's claim to belong, to be himself a peasant, that was the basis of his appeal. George Clausen, himself an admirer, writing in the *Scottish Art Review* puts this very clearly:

> Damvillers is, I believe, a small village not more picturesque or paintable than any other French, or many an English village, and yet a few things, truly seen and recorded there have made a considerable mark in art history. It was that the man had a seeing eye, and a great love for things with which he had all his life been familiar. It is not a comic countryman, nor a sentimental countryman as seen from a townsman's point of view, but his own home life that he paints – one feels in his work a deeper penetration and a greater intimacy with his subject than in the work of other men.[4]

Clausen uses the same arguments that David Allan had used exactly a hundred years before to demonstrate the authenticity of Allan Ramsay's *The Gentle Shepherd* and so of his own illustrations (see above, p131). It is the myth of the peasant-painter again, the myth put out about himself by Courbet and implicit in the early art of Wilkie, that if the painter can somehow share the simplicity of peasant life, this gives a special authenticity to his painting. If in Wilkie's time, however, this expressed anxiety about the processes of alienation that were dividing society in Scotland, surely the rural painting of the eighties expressed a response to the divisions of society that were now fact.

The difference between Bastien-Lepage and Tom Faed, for instance, is that though they painted the same kind of people, they did so from a different distance. Faed's peasants are subtly distanced so that his spectators can accept the reassuringly simplified view of

Plate 213. JAMES GUTHRIE, *A Funeral Service in the Highlands*, 1882

humanity that he proposes. The complexities of rural poverty are smoothed away in a gentle wash of stock, sentimental platitudes. Bastien-Lepage appears to cut out the reassuring distance to give us an authentic reality of which he is himself a part. Instead of the confident separation of bourgeois from peasant, the image is shaped by an equally artificial, nostalgic yearning for reidentification with the 'reality' of the sons of the soil. The Glasgow painters following Bastien-Lepage are not so far from the kailyard as they might seem to be, though at their best they are less guilty than he is of exploitative sentimentality.

Of all the Glasgow painters, John Lavery was probably closest to the Frenchman and perhaps particularly to his British followers, William Stott and Frank O'Meara. Lavery, however, used Bastien-Lepage's approach to create more distant images, not exactly landscapes, but pictures in which the figures are treated with a degree of detachment as in *On the Loing: An Afternoon Chat* (1884, Ulster Museum, Belfast) in which three figures, set well back, are seen against a back-

ground of the bridge and river at Grez where Lavery spent most of that year. His masterpiece, painted in 1885 after his final return to Glasgow, is *The Tennis Party* (Aberdeen Art Gallery). (*Plate 215*) It is a superbly detached picture. A long, open composition, the foreground and middle ground are in strong light, but there are no shadows and this suggests a bright, overcast day. The background is a line of dark trees and against this the figures are distributed in an extended, inconsequential scatter. The two principals, a man and a woman exchanging shots, are distinguished by their energetic attitudes and white clothes, but the whole effect of the cool colours and the casual composition is a wonderful, animated tranquillity. The mood of *The Tennis Party* is summed up by an elegant young man in plus-fours, leaning on one of the posts of the containing fence and smoking his pipe.

Most of the other painters were more resolutely pastoral than Lavery is in this superb image of late-Victorian leisure. Guthrie in 1882–3 first took up the challenge of Bastien-Lepage in *To Pastures New* (Aberdeen Art

Gallery), (*Plate 216*) a picture of a little goose-girl and her geese which escapes being merely sentimental by virtue of his boldness of design. It has neither foreground nor background, but is simply divided into two, the bottom half is ground and the top half sky. The gaggle of geese are cut off by the edge of the canvas as they disappear out of the picture and the goose-girl stands out in strong light against the sky, her eyes hidden by the sharp shadow of her hat.

The execution as well as the subject suggest Bastien-Lepage. Guthrie has used his square brush and his putty-like textures, but the brilliant light and colour of *To Pastures New* indicate a quite different influence at work. The detail of the strongly shadowed eyes of the girl beneath the brim of her hat appears in a painting exhibited by Arthur Melville (1855–1904) at the Royal Scottish Academy in 1880, called at the time *A French Peasant*, now known more portentuously as *Paysanne à Grez* (Private Collection). (*Plate 217*) This brilliant, small picture is of a woman picking grapes, against a wall in

strong sunlight. She is wearing a scarf over her bonnet so that her face is almost hidden in shadow. The picture was one of a group exhibited by Melville in Scotland from France where he had gone in 1878. It is painted in flat areas of colour. They are dominated by the light tone of the sunlit wall, but are all in a high key. Melville had also painted in 1880 a larger picture very similar in subject to Guthrie's, called *Homewards* (CEAC) which shows a goose-girl leading her charges home from their pond at the end of the day. It is a scene by evening light. In this, and in its dark tones it recalls the Barbizon painter, Daubigny, but in handling, like *A French Peasant*, it is already an impressionist picture. Although Melville did not return to Scotland till late in 1882, his influence clearly went ahead of him.

Melville is one of the most original British painters of his generation. Since his untimely death from typhoid contracted in Spain in 1904, his reputation has not really been equal to his achievement. Two factors have contributed to

Plate 214. J. H. LORIMER, *The Ordination of the Elders*, 1891

this. One is that he is known principally for his watercolours, and they are still not rated as highly as oil paintings in the public mind. The other is the determination of art historians to treat him as a member of the Glasgow Boys which obscures his individuality. Although he had close contact with some of the Glasgow painters this was not till 1883 or '84 by which time he himself was already a mature and established painter.

Melville was originally destined for his father's grocer's shop in East Linton where the Petties also kept a shop. He studied at Edinburgh, but it was the influence of the Nobles that shaped his early style. In 1878 he went to Paris where he studied at the Academie Julian and that same summer he seems also to have gone to Grez where he encountered Robert Louis Stevenson, an indication of how important the area was already both for the Scots and internationally. Melville returned there to stay the next summer. While in Paris he took to painting in watercolours and the essentials of his watercolour style seem to have been formed there, but the origins of his watercolour technique, or even of his interest in watercolour, are obscure. His biographer, Agnes Mackay, states that he was inspired to try the medium by a demonstration that he saw in Paris, but she does not elaborate and we do not know who his contacts were in Paris.[5] Looking at Melville's home background, though, McTaggart had

started to exhibit watercolours at the Royal Scottish Academy in 1877 and the Royal Scottish Society of Painters in Watercolour (RSW) had been founded just before Melville left Scotland.

He had some success with his entries to the Royal Scottish Academy in 1880 and later that year set out on a journey that was to take two years. He followed in the footsteps of Wilkie, David Roberts and, more recently, J. F. Lewis, who was also a brilliant watercolourist, to the Middle East. He went first to Cairo where he spent more than a year. After falling ill and suffering an unhappy love affair, he travelled by sea as far as Karachi and then returned up the Persian Gulf and on to Baghdad. From Baghdad he went overland through Turkey to Constantinople, an adventurous journey, for he was pursued by bandits, robbed, and arrested as a spy. He recounts these events in the journal that he kept at the time, with admirable *sang froid* and this seems to have been typical of him.[6] He was an affable, energetic and courageous man, qualities which were all part of the impression that he made on the Glasgow Boys. It was however his painting alone that established his reputation.

From Cairo he had exhibited some eastern subjects at home in 1882, but it was in 1883 that he made most impact with watercolours from his journey from Cairo to Constantinople. When these were exhibited in London, the

Plate 215. JOHN LAVERY. *The Tennis Party*, 1885

Plate 216. JAMES GUTHRIE, *To Pastures New*, 1883

Magazine of Art coined the term 'blottesque' to describe them, calling them 'loose, blottesque and stainy'.[7] They were seen as dubiously French and the *Daily Chronicle* said of them that they 'might be by Degas with an exhibition of whose works we are shortly threatened'.[8] Some of the pictures that Melville exhibited may have qualified for the epithet, impressionist, but *The Call to Prayer, Midan Mosque, Bagdad* (whereabouts unknown), for example, which in his journal Melville himself commented was the most successful of the works that he had done to date on his journey,[9] was actually a quite highly finished watercolour. It is interesting that it should have appeared impressionist in the context of English art at the time.

Melville soaked his paper in chinese white, then worked on this, often using very wet paint and paper, and frequently blotting out with a sponge so that this first stage was glowing and transparent. When it was dry, he then added pure colour in blobs and patches which he was careful bore no trace of the movement of the brush, but kept their liquid shape. He established a brilliant, scattered pattern of accents of light and colour.[10] Although in his less formal early works like several done at Grez in 1880, or *Wedding Party, Paris* (whereabouts unknown) also of 1880, he used a similar tech-

nique, it was not till considerably later that he was prepared to use it in a large-scale painting. In 1884, for example, he painted watercolour portraits of his friend and patron, *Arthur Sanderson* and his wife (NGS). They are handled with great freedom, but they are virtually monochrome, painted in greys and browns. They strongly recall the watercolours of Israels and the painting of G. P. Chalmers.

In Scotland in 1883 the biggest sensation that Melville made, however, was with the portrait in oils of the Sanderson's daughter, Evie, that he exhibited in Glasgow as *Evie, the Flower Girl* (whereabouts unknown). This is a full-length portrait of a young girl in a black dress with a white ruff collar. She has short golden hair, a rose in her hand and a great vase of roses at her side. The stark reduction of colour suggests the influence of Whistler, but her hair and her black patent-leather shoes have sharp highlights and this gives a different feeling. Her figure is boldly blocked out in a way that together with the sharp harmonies of pink roses and black and white dress suggests Manet. In particular the strange frontality of the girl, and her colouring recall the girl in *The Bar at the Folies Bergères*. This was exhibited at the Salon in 1882 and so Melville, who came home from the east via Paris, would very likely have seen it.

Plate 217. ARTHUR MELVILLE, *A French Peasant*, 1880

If *Evie* was indeed such an up-to-date picture, it is not surprising that it was criticised for its impressionist breadth of handling. The *Dundee Courier*, true to form, was particularly vitriolic: 'The average art critic who has not yet sounded the secret depths of the artistic mind will simply gasp in wonder at the strange spectacle presented in the picture called Evie.' Even the frame came in for comment: 'Four railway sleepers, caught wild, mitred, stained black and clamped together . . . we confess we have never witnessed a similar atrocity.'[11] What might be acceptable in a watercolour of Arabs, or even in a portrait study like the picture called *Augusta* that Melville exhibited at the Royal Scottish Academy that year, was not acceptable in a formal full-length of a well-brought-up little girl.

Evie brought Melville again to the attention of the Glasgow Boys and from that time forward he was on friendly terms, particularly with Guthrie, Walton, Crawhall and Henry. In

1884 he joined them at Cockburnspath in Berwickshire which Guthrie made his base, a choice that certainly reflected the influence of the East Lothian painters. It was near Melville's home, East Linton, and J. C. Noble moved to nearby Ayton at just this time. In 1885 Guthrie went to Orkney with Melville. He went again in 1886, and in 1889 they went to France, together with other members of the group. From 1883 until 1889, when Melville moved from Edinburgh to London, and even thereafter, there was close and regular contact between him and this group of the Glasgow painters.

The influence of Bastien-Lepage has a place in the genesis of Guthrie's first really modern seeming picture, *A Hind's Daughter* (NGS), (*Plate 218*) in 1883, but given the importance of Melville, the French painter should not be seen as its sole or even its principal inspiration. The painting is of a single figure set near the picture plane and looking directly at the spectator just as Evie does in Melville's picture. She has a curiously direct and enigmatic gaze, again just as Evie does and which may, therefore, also reflect Melville's inspiration in Manet. The hind's daughter is both a child and a girl, and so should have all the potential sweet appeal that Bastien-Lepage gives to *Pauvre Fauvette*. Instead she is a square and stocky little person who treats us and the artist with self-contained indifference.

Guthrie, though he has enclosed the background in the way that Bastien-Lepage does in *Pas Mèche*, by giving the picture a high horizon, has actually set the girl back in the space. The foreground is occupied with some robustly painted vegetables. Thus he respects her privacy, nor has he set her apart in the way that he has painted her, subtly stressing his patronising interest in her as Bastien-Lepage would have done. Instead the painting of her apron merges with the ground and so she is part of the landscape.

In *A Hind's Daughter*, rather than using close-toned greens and greys, Guthrie has built up his picture of patches of colour, often in quite strong contrast with each other. The result is a remarkable, almost abstract pattern of patches of pink, blue, green, purple and ochre. These patches include the detail and the

Plate 218. JAMES GUTHRIE, *A Hind's Daughter*, 1883

ground against which it is set. It is a technique that Melville uses, though Guthrie, by choosing the grey light favoured by Bastien-Lepage, makes something quite different out of it. The rich pattern of secondary tints that he achieves, utterly different from anything painted by Bastien-Lepage and his followers, becomes a genuine account of the colour values of Scottish light. The effect of this is to give richness and strength to the painting which however remains a human document. Raeburn and Wilkie would have been proud to acknowledge kinship with it; Raeburn for its visual directness and Wilkie for the dignity that Guthrie finds in the pastoral image.

A Hind's Daughter was painted at Cockburnspath which became the summer home of a colony of Glasgow painters during the following years. George Henry painted a very beautiful homage to Guthrie's A Hind's Daughter there in 1885, the watercolour A Cottar's Garden

Plate 219. ROBERT NOBLE. A Fisher Girl, 1879

(Hornel Trust). E. A. Walton was also one of Guthrie's regular companions, painting there for example the Berwickshire Field-worker in 1884 (Tate Gallery). It is of a woman standing in strong sunlight, outlined against a high horizon. She is wearing the strange head-dress of East Lothian and Berwickshire women farm-workers called an 'ugly'. It was a kind of basket tied with a scarf that projected over the eyes so that the face was almost completely hidden. It is a detail of costume that Breughel would have loved, but the way Walton uses it in this picture clearly indicates the inspiration of Melville's A French Peasant.

Guthrie had described the same costume in a sketch of potato-pickers the year before (Private Collection). Five years earlier W. D. McKay had painted the same scene as Guthrie of women field-workers opening up the pits in which potatoes have been stored for the winter in Field Working in Spring: The Potato Pits. McKay's picture is visibly influenced by McTaggart. Arthur Melville was also an admirer of McTaggart. There is a little picture dated 1879 by Robert Noble, too, of a fisher-girl standing against a sunlit wall, holding a basket, which is not unlike Melville's Paysanne à Grez, but was painted a year earlier (Private Collection). (Plate 219) Such parallels are a reminder of the danger of treating the different aspects of Scottish painting as though they were in watertight compartments, or indeed of looking to France for the origin of all new inspiration in Scotland.

In 1884 Melville, based in Edinburgh, joined Guthrie at Cockburnspath and there began a picture which took him several years to complete. Called Audrey and Her Goats (1889, Tate Gallery), (Plate 227), it is an ambitious subject picture that had a far-reaching influence, not just in Scotland, but possibly further afield as well, for it was one of the Scottish pictures that were exhibited by invitation in Munich in 1890 to an enthusiastic reception. Melville's picture was not completed till 1889 however. One can only guess, therefore, at the influence that it may have had on the painting of his friends in Cockburnspath five years earlier. E. A. Walton's important watercolour Grandfather's Garden (Private Collection), painted at Cockburnspath in 1884, is a picture of figures in dappled shadow very like

Plate 220. W. Y. MACGREGOR, *The Vegetable Stall*, 1884

the finished *Audrey*, but *Audrey* is also rather like *A Hind's Daughter* which Guthrie had painted the year before. Shakespeare's Audrey from *As You Like It*, though a simple goat-girl, like *A Hind's Daughter*, is very far from the kind of stock rustic purveyed with so little conscience by the like of Tom Faed.

The adventurousness of Guthrie's major painting of 1883, *A Hind's Daughter*, is matched in some of his other works of the same period. *Hard at It* for example (GAGM), a small, on-the-spot study of one of his fellow painters working on the beach in strong sunlight, beneath an umbrella, is painted with broad, rich strokes and in strong colour. It is in this kind of sketch that Guthrie comes closest to W. Y. Macgregor who was the other leading figure among the Glasgow Boys. The two painters in an informal way formed two centres for the Boys in their early days. Macgregor in the winter months in his studio in Glasgow held informal classes from which, though, Guthrie stayed away, but he in his turn at Cockburnspath became the

nucleus for the Boys, out of town as it were, though Roger Billcliffe remarks that it would be a mistake to see them as consisting of two distinct groups.[12] In 1884, for example, Macgregor himself was in Dunbar and so he also certainly visited Cockburnspath nearby and there was constant coming and going of this kind.

Macgregor's masterpiece is *The Vegetable Stall* of 1884 (NGS), (*Plate 220*) and it is undoubtedly one of the most remarkable paintings done by any of the group. It is a large painting, a still-life of vegetables, leeks, turnips, carrots, etc., their greens and browns set off by the red of rhubarb and the purple of red cabbage. Maximum value is derived from the rich colours of the still life and it is painted with great square, chunky strokes of the brush which divide the surfaces up into faceted planes almost reminiscent of Cezanne. In its original form this picture included a figure of a girl to the right. There is still a slight weakness in the composition where she has been painted

Plate 221. E. A. WALTON, *The Game-Keeper's Daughter*, 1886

out and replaced by two bunches of onions. Billcliffe points out that with the figure the picture would have been rather similar to Guthrie's *To Pastures New*.[13] As a still-life however, and we must accept Macgregor's intention as the picture that he exhibited, it is quite dramatically original.

Still-lifes are unusual among the work of the Glasgow painters, indeed in Scottish painting generally, though Stuart Park (1862–1933), another of the Glasgow Boys, later specialised in rather stylised flower paintings. The only picture at all comparable to Macgregor's *The Vegetable Stall* is a richly painted still-life by Alexander Mann (1853–1908) (Fine Art Society), but it is a much more conventional composition. Its existence only stresses the originality of Macgregor's painting which however appears to be unique among his surviving works, though a similar picture with dead game is recorded.[14] The existence of this other picture helps identify both as a type of painting popular in the early seventeenth

century. These are Dutch, Flemish and Spanish 'bodega' or shop paintings by painters like Peter Aertsen and Joachim Bueckelaer. A figure to one side, usually the shopkeeper, and almost dwarfed by the abundance of the still-life, is typical of these. So too is the way that the still-life is tipped towards us, almost tumbling out of the picture.

During the mid-1880s the Boys continued to paint rural life. Guthrie painted *Schoolmates* in 1884–5 (Musée des Beaux Arts, Ghent). It shows a group of three country children walking to school, treated in the same unsentimental way as *A Hind's Daughter*. Walton moved away from his lovely plein-air landscapes of the early 1880s to figure subjects like *A Daydream* of 1885 (Andrew McIntosh Patrick). A boy and a girl sit under trees, caught in a moment of abstraction. Guthrie's *In the Orchard* of 1885–6 is a similar composition (Private Collection) and both owe something to Melville's *Audrey and her Goats*. It was in that picture, at least as it was completed, that the idea of a woodland scene treated as an all-over pattern of leaves and light was given its definitive shape, and it seems likely that even before it was completed the picture influenced several similar compositions. It is a type of subject in fact that became almost a formula in the later work of some of the Boys. E. A. Hornel (1864–1933) for example lived off increasingly mannered variations on this theme in later life, and his indebtedness to Melville is implicitly

Plate 222. JAMES PATERSON, *Autumn, Glencairn*, 1887

Plate 223. JAMES GUTHRIE, *Pastoral*, 1887-8

acknowledged in one of his earliest paintings in this mode, *The Goatherd* of 1889 (Private Collection). (*Plate 229*)

In 1885 George Henry who had worked with Guthrie at Cockburnspath went to work at Kirkcudbright for the first time and the South West became in turn a centre for the Glasgow painters. Guthrie joined him there on several occasions and it was there in 1886 he painted his portrait of *Old Willie, a Village Worthy* (GAGM). It is a strong and simply painted picture. The old man in sombre colours is seen against a strongly lit white wall. His head is modelled in square dabs of paint whose broken surface suggests a weather-beaten complexion without actually pausing to dwell on detail. It is a way of painting that is reminiscent of Raeburn whose reputation was in the ascendant at this time. There was for instance a major Raeburn exhibition in 1876 and he was shown regularly in Edinburgh in the 1880s. Guthrie's *Old Willie* is matched by Walton's lovely watercolour study of a girl's head of the same year, *The Game-Keeper's*

Daughter (GAGM). (*Plate 221*) If there is a hint of patronage in Guthrie's picture, Walton's has a quiet and impressive dignity. The girl's social status has no bearing on the artist's image of her. It is she alone who is its subject. E. A. Hornel's *The Bell-Ringer*, also of 1886, forms the third in a trio of character studies (Private Collection).

Walton's use of watercolour which is so distinguished in *The Game-Keeper's Daughter* is also a feature of his earlier painting, for example the beautiful *Victoria Road, Helensburgh* of 1883 (Private Collection). This reveals not only a direct link to Melville, but also to Joseph Crawhall who had been a close friend of Guthrie's since 1879 and had been a regular visitor to Cockburnspath. Crawhall came from Newcastle and his principal association with the Boys was through his friendship with Guthrie in the 1880s, but he is generally treated as a Glasgow painter. Melville was a major inspiration to him, so much so that he spent time, like the older painter in North Africa. He is best known for his exquisite watercolours,

Plate 224. JAMES GUTHRIE, *Causerie*, 1892

especially of birds and animals, from these later years which are marked by his admiration for Japanese art, but in the 1880s his painting was still close to Guthrie and Walton.

Walton's landscapes on the other hand are a link with the painting of James Paterson who was the only one of the Glasgow artists who remained a dedicated landscape painter. Both Walton and Paterson use the same French tonal language in their landscapes. Corot was enormously admired. Both Walton and Paterson clearly reveal their admiration for him in their use of subdued light and silvery tones. Typical of Paterson's landscapes are *The Last Turning, Winter Moniave, 1885*, (GAGM) and *Autumn, Glencairn* (1889, NGS). (*Plate 222*) A trick that he uses, reminiscent of Corot, is to paint the light areas of the sky over the dark edges of the trees to enhance contrast though Wingate does this too in *A Summer's Evening* (1888, NGS), for example. In *Autumn, Glencairn*, however, Paterson uses intense colour within this subdued overall tonality. There are areas of brilliant red and orange in the trees. There is smoke in the distance and it is bright blue. The soft way that he paints is like Guthrie's painting in *A Hind's Daughter*, and seen in the context of a

broader view of landscape it is a reminder of how this aspect of Glasgow painting is a response to the real light and colour of Scotland. He describes the even tones of this Scottish light whose softness lacks contrast, but gives as much value to intermediate hues as to primaries.

One of the most remarkable landscapes of the period is Guthrie's painting *Pastoral* (NGS), (*Plate 223*), now dated by Billcliffe to 1887–8, rather than the traditional date of 1885. It has the same subtlety of observed colour. The plane of the field of grass is articulated in green, blue, ochre, and pink. There is even bright red in the distance. Guthrie has tackled the representation of intense light dissolving form – such a striking feature of Melville's watercolour technique – and he describes the patterns made by sheep moving across a meadow, their individual forms dissolved in strong sunlight, in an almost abstract way. These effects are real, but the way they are described loosens up the spatial discipline of the picture to stress the surface patterns in a way that is remarkably modern. Bits of the picture look like Cezanne. The title *Pastoral* implies a musical analogy and so also reflects Guthrie's undoubted admiration for Whistler. He himself never developed this direction though and it was just about this time that he first turned to portrait painting which was to absorb him increasingly. In later life he became a producer of richly painted portraits of the board-room type. Before the end of the century he did produce some remarkable pictures though, more directly impressionist than anything produced earlier in Scotland. This is especially true of a series of pastels which began in 1888 with the *Ropewalk* (Private Collection). Among the best of them is *Causerie* (1892, Hunterian). (*Plate 224*) Guthrie's *Pastoral* is nevertheless something of a watershed picture in the history of Scottish painting. With it we have to face the whole complicated question of international symbolism and post-impressionism which makes the later 1880s and the nineties such a rich and confusing period of art history.

THE CLAIMS OF DECORATIVE ART

A Crisis of Conscience

Guthrie's *A Hind's Daughter* takes up themes that had been familiar in the eighteenth century. In subject it is pastoral in a way that David Allan would have understood, while in execution the artist is clearly striving for the same kind of visual objectivity that underlay the painting of Raeburn. Since that time the pastoral image has undergone unkind interpretation on grounds of social history, but as Burns or David Allan used it at least, it was a metaphor for the idea that a style free from sophisticated modes of description could give direct, intuitive access to the imagination, the seat of man's moral nature. On the other hand, however, Reid's idea of the role of the artist which underlay Raeburn's painting was that he had to discard preconceived ideas and record objectively his perception. The picture thus became autonomous and was also therefore morally neutral. These two ideas that were originally complementary aspects of one single idea, and which have played a central role in the development of modern art, contained from the start therefore a contradiction. It seemed impossible that a direct account of the world as it is intuitively perceived could be imaginative and therefore also moral. In the 1880s this dilemma became a matter of acute concern to a generation of artists for whom the social role of their art was central. It was the crisis of conscience that Wilkie had anticipated.

In 1883 William Morris became a Socialist. In Paris in the same year Seurat painted *La Baignade* in an attempt to create a monumental painting celebrating the life of modern urban man with the same dignity as Piero della Francesca in the fifteenth century. These two events were not unconnected for all European painting was going through this crisis of conscience. Guthrie's *A Hind's Daughter*, also of 1883, like his move to Cockburnspath and the painting of W. D. McKay and the other East Lothian painters that inspired it, was undoubtedly likewise inspired by the wish to get closer to the life of ordinary people and by doing so to achieve a purer and more honest way of painting (the modern word would be 'relevant'). Compared to Bastien-Lepage, whose popularity reflected just this sentiment, Guthrie's picture is far from dishonourable, but if the problem lay with the moral neutrality of perception, then simple representation could not provide the solution. A more abstract approach would re-engage the imagination and as Guthrie's own *Pastoral* suggests, the solution to the dilemma lay with rather different kinds of painting.

In France the Symbolists and in Britain the Arts and Crafts movement, though otherwise very different, had in common the wish to see art somehow reintegrated with society, not simply as a commodity, but in the service of a moral ideal remarkably like that which had been familiar a hundred years before and to whose development Wilkie had contributed so substantially. In Britain the Arts and Crafts movement was of central importance in this. Its champions were Morris himself and Walter Crane, and in Scotland Patrick Geddes (1854–1932). The European phenomenon of the rise of romantic nationalism, which had begun in Scotland with Walter Scott, was given fresh stimulus by the enormous vogue for Wagner. It was also a feature of the Arts and Crafts movement, especially in the field of architecture, though in this it was not restricted to adherents to Arts and Crafts ideas. Mackintosh in

Scotland, Frank Lloyd Wright in America, Saarinen in Finland and Gaudí in Barcelona were all interpreters of Owen Jones's idea of a new architecture based on an intelligent and creative interpretation of national, traditional forms and methods. Patrick Geddes adhered to this view, not inspired only by ideas about architecture though, but by a whole philosophy of history as an aspect of society's self-awareness and self-esteem.

In Scotland the picture of what happened in painting in the later 1880s and nineties, anyway complicated, is further confused by the tendency to treat Edinburgh and Glasgow as though they were a thousand miles apart. There is an internal logic that runs through the painting of Guthrie to Henry, Hornel and J. Q. Pringle in the 1890s which gives a certain autonomy of style to Glasgow painting, but the links with the east coast, which had been so important in the early years of the Glasgow Boys, continued as new ideas emanating from the social concerns of the Arts and Crafts movement began to play a role in the way painting developed. A key event in the introduction of Arts and Crafts ideas into Scotland was the formation in Edinburgh in 1885 of the Edinburgh Social Union by Patrick Geddes. It was dedicated to the improvement of the quality of life in the city, particularly in the Old Town which had fallen into decay since the creation of the New Town more than a hundred years before.[1]

Geddes, who had been a student there, had returned to Edinburgh in 1880. He was a botanist by training, but the basis of his originality was the way in which he argued outwards, from botany to biology and from biology to sociology, to treat human society as a system of biological organisation. He was a pupil of Thomas Huxley and he followed the logic of Huxley's contention 'that no natural boundary separates the subject matter of Psychology and Sociology from that of Biology' into fields that Huxley might not have dreamt of, economics, art and ultimately town-planning, the field in which his contribution is best remembered. In this development which so aptly echoed the convergent thinking of the Enlightenment a hundred years before, Geddes was also profoundly influenced by Ruskin. He developed

Ruskin's economic and social thought within his new biological model of society to argue that economics was an integral part of human biology and art an integral part of economics. Economics could not be treated as a matter of mere supply and demand, of consumption and profit, but was an element in the whole complex ecology of human society.

His vision of human ecology involved architecture and art, as well as the merely physical conditions of living. 'Art criticism,' he wrote in 1884 in a paper on Ruskin, 'is a special province of the practical economics of production and consumption, it belongs to it as food analysis does.'[2] These processes also involved cultivating the community's sense of itself, and so he saw history as an aspect of identity, which had a bearing both on the style and the content of art as well as on the style of architecture.

Geddes had a vivid and persuasive view of the need for social 'synergy', a word that he favoured, and the potential of art was at the heart of his vision of a renaissance:

> The sorely needed knowledge, both of the natural and the social order, is approaching maturity; the long delayed renaissance of art has begun, and the prolonged discord of these is changing into harmony; so with these for guidance men shall no longer grind on in slavery to a false image of their lowest selves, miscalled self-interest, but at length as freemen, live in Sympathy and labour in the Synergy of the Race.[3]

He was, however, also a man of action. He had a vision of the reintegration of Edinburgh, once so unified and creative, but now visibly divided between the slums of the Old Town and the gentility of the New Town and of the new, outer suburbs. Later Geddes built the Outlook Tower on Castle Hill as 'the world's first sociological laboratory'.[4] From it the camera obscura gave a single panoramic view of the whole of Edinburgh metaphorically reunited, and in this view Geddes was heir to Nasmyth as well as Reid. It was a local and tangible metaphor for his analysis of the ills of society. He believed in renaissance as a result of cooperation and the proper application of new knowledge. He was heir to the utopian strand in Thomas Reid.

The Edinburgh Social Union was organised into committees each with a different area of responsibility. They took over and restored buildings, and they were also involved directly with art. One of the committees was

concerned with its teaching – at a later stage Geddes created his own Edinburgh art school – and another with the promotion of schemes for the introduction of decorative art into various public buildings. These schemes were often quite modest, involving for instance the placing of copies of Millais's *Parables* in a Grassmarket Mission Hall. Others were more ambitious. The Union commissioned the history of corn in six panels from Charles Mackie for example, and it was no doubt a by-product of Geddes's enthusiasm that the proprietor of the Café Royal bought from Doulton's their principal exhibit at the 1886 International Exhibition in Edinburgh, a series of large ceramic pictures of the great inventors which had been made the previous year for an exhibition of inventions. He installed them in his pub where they have provided inspiration to a century of Scottish drinkers.

One of the first major projects undertaken by the Social Union was the decoration of the mortuary chapel of the Sick Children's Hospital undertaken by Phoebe Traquair (1852– 1936) in 1885.[5] She was Irish born and Dublin trained and came to Edinburgh with her zoologist husband, Ramsay Traquair. She was a versatile craftswoman, producing very high quality work as a book illuminator, bookbinder, embroiderer and enamellist as well as a mural painter. She was well equipped therefore as an interpreter of Geddes as a leading apostle of the Arts and Crafts movement, for he was a firm believer in the importance of the applied arts.

Her original decorations for the Sick Children's Hospital were greatly altered when the hospital was rebuilt a few years later and her work is best judged by the next decoration that she undertook, the painting of the Song School of St Mary's Cathedral Choir School. This was begun in 1882 and finished in 1889, (*Plates 225 and 226*) The Song School is a single Gothic interior, lit by lancet windows on the long walls. The decoration is rich and elaborate in a flat Gothic style, but including portraits of people involved with the cathedral and those whom the artist admired, all united in a hymn of praise. The Song School decorations were followed by the decoration of the Edinburgh Catholic Apostolic Church, begun in 1893, and

which took many years to complete.

Concurrent with the early history of the Social Union in Edinburgh, in 1886 in London the New English Art Club was founded by artists of the French tendency in England. This was important for the Glasgow painters who thus found a sympathetic audience in London, but at the same time George Clausen, Walter Crane and Holman Hunt launched the idea of a truly national art exhibition to rival the Royal Academy. The results of this move were the Arts and Crafts Exhibiting Society and in 1888 the first *International Congress for the Advancement of Art in Association with Industry* which was held in Liverpool. Geddes was reported in the *Scottish Art Review* as delivering a notable address alongside Holman Hunt, Walter Crane, and William Morris, and in response to his initiative the second *International Congress* was held in Edinburgh the following year.

Such events, and Geddes's part in them, did not escape the attention of the Glasgow Boys. Francis Newbery, the progressive Head of Glasgow School of Art, was a member of the Edinburgh Social Union from 1887. Gerard Baldwin Brown, first incumbent of the Watson-Gordon Chair of Fine Art at Edinburgh University and a close associate of Geddes on the Social Union, later wrote what was in effect the official history of the Boys,[6] nor did they escape the attention of Geddes himself. In 1888 he published a pamphlet reviewing the art at the Glasgow International Exhibition. It went under the title *Every Man his own Art Critic* and followed a similar critical account of the Manchester Exhibition of the previous year. After noting particularly Lavery and Roche, he concluded with some very warm remarks about the Glasgow Boys, a cutting condemnation of the Royal Scottish Academy, and some advice to Glasgow:

Of this young Glasgow school it would be premature to make any personal prognostications yet . . . there is enough to show that we have to do with the most important contemporary movement in Scottish, perhaps even British, art. . . . Glasgow has here an opportunity of becoming a great centre of art . . . This would be brought about . . . through a few judicious citizens quietly administering some steady employment as far as possible of a public and permanent decorative kind, in halls and schools especially.[7]

The Boys had started their own art magazine, the *Scottish Art Review*, in 1888. In June of

the following year Geddes himself contributed an article on the 'Political Economy of Art' which is largely a scathing attack on Adam Smith as 'frankly destitute . . . of civic sentiment on the one hand and the slightest artistic knowledge, sympathy or sentiment on the other', and corresponding praise of Ruskin.[8] Walter Crane also contributed an article, 'The Prospects of Art under Socialism', and in January 1889 Baldwin Brown took up the subject of decorative art in the magazine with an article on recent mural painting in Edinburgh in which he states: 'It is no secret that the first incentive [in promoting mural painting] has been due to Mr Patrick Geddes, who set himself the task of securing some form of interesting and instructive pictorial decoration for the interiors of certain halls and mission rooms in the crowded parts of the town as well as in the Royal Infirmary.'[9] He then gives a brief account of the work of the Social Union and a fuller description of that undertaken by Phoebe Traquair which earns

his special approbation because of its inherent decorative qualities.

In Glasgow, in addition to the enthusiasm generated by Geddes, the Kyrle Society of Glasgow had been formed with similar objectives to the Social Union. The society had commissioned mural paintings from various of the Boys, for the Prisoners' Aid Society and other suitable locations. Four of the Boys had likewise been commissioned to provide mural panels for the Glasgow International Exhibition of 1888 and rising to the challenge of a major new public building they started a campaign to decorate the new Glasgow City Chambers, a campaign that finally bore fruit ten years later with work by Walton, Henry, Lavery and Roche.

Thus in the late eighties the question of decorative art was being debated in Scotland as energetically as anywhere else. This was not just a matter of fashion. It was a highly charged question in which the whole status and

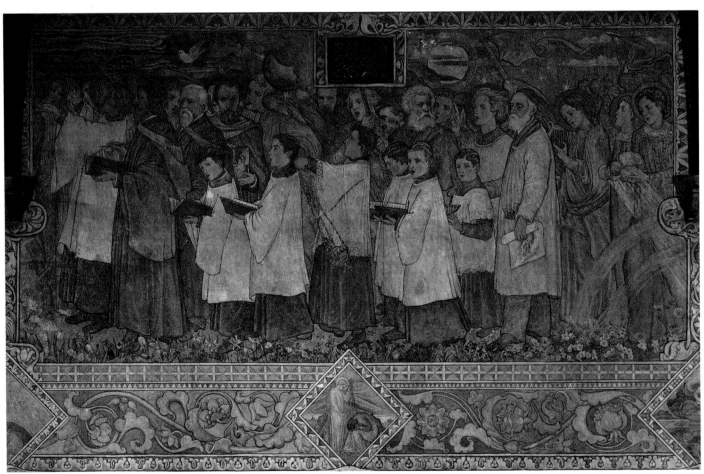

Plate 225. PHOEBE TRAQUAIR, *St Mary's Song School*, SOUTH WALL CENTRE-LEFT, 1882–89

function of art was under discussion. The seriousness of the question has perhaps been obscured by the term decorative, but to Walter Crane or to Geddes this term encompassed the highest purposes of art. For Crane the Royal Academy was a monstrous shop and the whole status of art was called into question by its becoming movable property, a commodity:

> The decline of art corresponds with its conversion into portable forms of property, or material or commercial speculation. Its aims under such influences become entirely different. All really great works of art are public works – monumental, collective, generic – expressing the ideas of a race, a community, a united people; not the ideas of a class. It is evident enough in our own time that art needs some higher inspiration than that of the cash box. She suffers from a lethargy that cannot be cured from a prescription from a cheque book; these are at best but stimulants that force an unnatural excitement, a feverish and brief activity at the expense of the whole system. Private ownership may be able to command both skill and beauty, no doubt . . . [but] the art of a people as expressed in their public buildings and monuments expresses a kind of immortality.[10]

On another occasion Crane remarked simply that 'the decoration of public buildings should be the highest form of popular art'.[11] The realisation of such objectives entailed both questions of style and of content. Crane implies both in the phrase 'a visible and picturesque logic to satisfy the mind'.[12] In his essay on Edinburgh mural painting, Baldwin Brown also offers some guidance on the question of style. He was critical of the work of three of the artists he discussed, A. G. Sinclair, Robert Nisbet and Garden Smith, 'considered from the point of view of decoration', though he regarded it as perfectly satisfactory otherwise as painting. Easel painting could not be simply transferred to the walls, a practice that he regrets is common in France. Phoebe Traquair on the other hand he praised for the specifically decorative qualities of her work as it had developed. Her first work, in the Mortuary Chapel, was 'a little hard, the effect thin and cold', but in the Song School it had 'increased simplicity and strength, and improved architectural feeling'. To earn this approbation in the Song

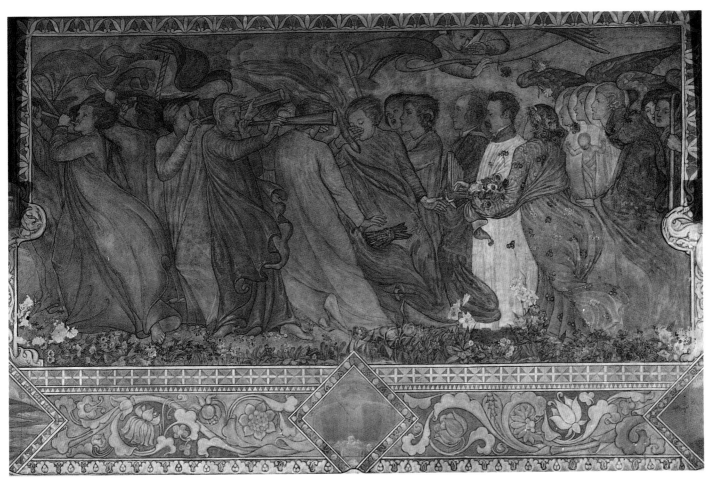

Plate 226. PHOEBE TRAQUAIR, *St Mary's Song School*, SOUTH WALL CENTRE-RIGHT, 1882–89

School she had followed the lead established by Rossetti and had used an essentially non-representational kind of painting. It is not actually abstract, but applies to painting a syntax of shallow space and flat colour. On the other hand she had in Brown's view evidently avoided what Crane dismisses as 'the flat-ironed primulas and the genus of enfeebled flora and fauna generally which so often do duty as decoration. As if decorative art was a voracious but dispeptic being and required everything . . . to be thoroughly well boiled down before it could be properly assimilated.'[13]

Crane had little time for impressionism and realism which he called the 'Art of Accident'. 'Everything is being sacrificed to the attainment of fact . . . and painting has almost ceased

to be an art of design.'[14] Geddes on the other hand was more tolerant and he saw merit in both realism and idealism as he called them, being roughly the followers of Bastien-Lepage and of Burne Jones respectively, though he also had a high opinion of Orchardson's essay in modern subject-matter, *Mariage de Convenance, After!*, which he saw at Manchester and regarded as a realist painting. (He was, however, dismissive of Faed, Alma-Tadema and others like them.) He left open to the painters therefore the possibility of adapting to the needs of decorative art the methods of modern representational painting. That this was indeed the way the Glasgow painters were seen to turn is confirmed by a contemporary witness. When Arthur Melville and the Boys exhibited

Plate 227. ARTHUR MELVILLE, *Audrey and Her Goats*, 1884–89

together in Munich in 1890 to great acclaim, it was the decorative quality of their art that was particularly noted by one critic. Contrasting their work to that of Manet, the Impressionists and Bastien-Lepage, he comments: 'But here there burst out a style of painting which took its origin altogether from decorative harmony, and the rhythm of forms and masses of colour.'[15]

This shift in style towards a flatter, more enclosed image is first apparent in Guthrie's *Pastoral*, but he in turn was indebted to the painting of Arthur Melville. It was in this direction too that Henry and Hornel began to move in 1888. They were influenced by both Guthrie and Melville, who had returned to his painting *Audrey and Her Goats* about this time, certainly in time for it to be completed in 1889 (Tate Gallery). (*Plate 227*) Looking at it, with its flat, vertical composition and strong colour, Melville too was clearly influenced by the current decorative debate and his picture was a very significant contribution to it. The subject of *Audrey and Her Goats* is from Shakespeare's *As you Like It*. Audrey is a simple country wench, a kind of speaking hind's daughter, and a foil for the pompous and verbose Touchstone who courts her. He declares with eloquent condescension: 'I am here with thee and thy goats, as the most capricious poet, honest Ovid, was among the Goths.' Her response a few lines later is presumably the motto of the picture: 'I do not know what "poetical" is: is it honest in deed and word? Is it a true thing?'[16] It is a wonderfully apt question, coming from such a person at the high point of the rural realism of the early 1880s when the picture was conceived. Touchstone's reply is a paradox, but still very apposite to Melville, especially in the context of the later eighties when style as a vehicle for poetry had become so topical: 'No truly; for the truest poetry is the most feigning.'

Guthrie and Walton went to Paris in the company of Melville in 1889. It was, however, Henry and Hornel who showed most clearly the influence of this painting which he resumed on his return.[17] Henry and Hornel were working in close contact with each other, taking inspiration from the Galloway countryside that Hornel had made his base. In his small painting, *Autumn*, of 1888 (GAGM), (*Plate*

228), Henry shows the direction of their common ideas. It is a small picture, broadly painted. A figure in a straw hat, grey cloak and red scarf is standing amongst silver birch trees. The leaves and patches of light make a camouflage pattern within which the figure plays a kind of visual hide-and-seek. Apart from Melville's inspiration, the picture reveals the influence of Monticelli who had figured prominently at the Edinburgh Exhibition in 1886 and again at Glasgow in 1888. This is clear in the way Henry lays on paint with his palette-knife in broad, broken streaks. By the even distribution of these areas of light and colour over a dark ground, and by the way that he stresses their shape, he creates an enclosed web that holds the figure within it. Hornel in his *Goatherd* (Private Collection), (*Plate 229*) painted the following year does something very similar, though instead of using a dark ground, he builds up his picture from contiguous patches of flat colour. He also pays frank homage in subject as well as execution to Melville's *Audrey*. In the picture a billy-goat eyes a pretty little shepherdess. He has great curling horns and a sinister, dark face. He is distinctly

Plate 228. GEORGE HENRY, *Autumn*, 1888

Plate 229. E. A. HORNEL, *The Goatherd*, 1889

Pan-like. Perhaps the subject was more than a simple pastoral scene.

The most remarkable of this group of Glasgow pictures is Henry's *A Galloway Landscape* also painted in 1889 (GAGM). (*Plate 230*) Even before its much debated status as a precocious piece of post-impressionism is considered, it is one of the most beautiful Scottish landscapes of its time and to see it in that light does immediately reveal its continuity with Guthrie's *Pastoral* of two years earlier. Like Guthrie's picture it is an evocation of the mood of a sunlit landscape, peopled by grazing beasts. They are so much at home that they literally merge with the field to become hardly more than patches of shadow in the warm sunlight. The whole picture is composed of such patches; clouds, trees, the light

on the grass, and it is this which gives such wonderful harmony and unity.

The only slightly odd feature is the sinuous burn in the foreground, winding away around the base of the hill, which is both more definite and more abstract than the rest of the picture. Henry clearly had a problem with his foreground. Guthrie in *Pastoral* had resolved the same problem by the conventional device of a mass of shadow and a prominent plant. James Paterson in the same year painted a view of *Glencairn*.[18] In it the river crosses the foreground, hidden by the depth of the bank and then turns back on itself. The line of the bank forms an almost perfect geometric curve. There may be a connection between the two pictures. Paterson's line is however not assertive and can be accepted as the natural

Plate 230. GEORGE HENRY, *A Galloway Landscape*, 1889

configuration of the ground, but the curving burn that solves the problem of the foreground for Henry follows unambiguously the flat, curling line of Hokusai.

Whether this reflects contemporary, very similar developments in French painting centred on Pont Aven it is for the moment impossible to say but, a year or so later, Charles Mackie (1862–1920), a close associate of Geddes who had worked for the Social Union, met Gauguin in Paris, and he certainly painted in a way that reveals this contact (see below, p309). His earliest dated picture of this kind is *The Bonnie Banks of Fordie*, a little sketch, dated Rouen 1891, and subsequently carried out as a large painting in a slightly less radical style.[19] (*Plate 231*) The sketch for *The Bonnie Banks of Fordie* distinctly resembles Serusier's *Talisman*, the touchstone of the Nabis, Gauguin's

followers, which was painted alongside Gauguin in the Bois d'Amour, Pont Aven, in October 1888. It was through Mackie that Serusier later contributed a drawing to Geddes's review, *The Evergreen*. Mackie's picture (which was also used as an illustration in *The Evergreen*) resembles Hornel's paintings *The Brook* (Walker Art Gallery) and *Summer* (Hunterian) both also of 1891. *Summer* created a furore when it was bought by Liverpool in 1892, because of its modernity. There was probably some contact between Mackie and Henry and Hornel at this time therefore.

In considering these connections it is worth remembering, not only the great interest in French painting in Scotland, but also that exactly the same debate was taking place at the same time in France as in Scotland and in England. It underlay the dramatic shift by

Plate 231. CHARLES MACKIE, *The Bonnie Banks of Fordie*, 1893

Gauguin in 1888 in the *Vision after the Sermon* (NGS) from a kind of impressionism to painting that was intended to be both decorative and spiritual. It is a measure of the extent to which this was a shared debate that Gauguin's decision to seek his earthly paradise in the South Seas was influenced by Owen Jones's pioneering advocacy of the 'primitive art' of the South Seas in *The Grammar of Ornament*, a book that was widely influential at this time, though it had been published nearly forty years before. Puvis de Chavannes, on the other hand, was the most widely admired French painter in Britain because of his command of an austere style suitable for mural painting of an elevated kind.

There is no suggestion that Henry's *A Galloway Landscape* was ever intended to be a decorative painting, though as such it would have met the criticism voiced by Baldwin Brown of the inappropriateness of conventional landscapes as decoration.[20] There is equally little evidence for a specific decorative intention in two remarkable pictures that Henry and Hornel painted in collaboration in 1890 and 1891, *The Druids: Bringing Home the Mistletoe* (*Plate 232*) and *The Star in the East* (both GAGM), but both pictures fit precisely

the requirements of decorative painting, not only in style, but also in content. The fact that they were collaborative was also significant, for collaboration between artists in the supposed manner of the medieval craftsmen earned high commendation from the spokesmen of the Arts and Crafts movement. Crane for example contrasted the anonymous medieval artist working cooperatively to the decadent egoism of the Renaissance tradition. A cathedral – a high point of European achievement – he said 'represents the collective art, work, and thought of centuries'.[20]

Ideas about continuity of national tradition and collective experience had a direct bearing on subject-matter. They were also very topical. Robert Brydall's *History of Art in Scotland* was published in 1889. The Scottish National Portrait Gallery had been founded in 1882 and in 1889 was housed in a splendid new building. Its first director, John Gray, was another champion of Scottish art and the Portrait Gallery has ever since stood as much for the importance of art in Scottish history as for the simple collection of portraits which was its original writ. It is certainly not a coincidence that both Lavery and Roche chose to exhibit historical subject

Plate 232. GEORGE HENRY AND E. A. HORNEL, *The Druids: Bringing Home the Mistletoe*, 1890

pictures in 1888. Lavery's was a Scottish subject, *Dawn, 14 May 1568* (whereabouts unknown). It represented Mary Queen of Scots sheltering in a wood after the battle of Langside. It was topical because of the tercentenary of her execution. Geddes in particular was interested in Mary because of the Auld Alliance. The first meeting of the Franco-Scottish Society which he promoted was chaired by Louis Pasteur. Roche's picture, simply called *Shepherdess* (whereabouts un-known), was calculated to appeal even more directly to this interest though, for his *Shepherdess* was Joan of Arc. The story of her *garde écossais* and the association of various Scots with her story had been recounted by Michel in his book, *Les Ecossais en France* in 1862, including the story that the only known portrait of her had been painted by a Scottish painter called Hames Poulevoir, or James Polwarth.[21] Roche's picture, says Geddes, was 'thrilling with those voices of nature and the spirit world which are calling the little shepherd lass to be Joan of Arc'.[22] Billcliffe says on the strength of a contemporary description of the lost picture that it 'shows that in it Roche had finally moved away from naturalism'.[23]

Henry and Hornel's choice of subject in *The Druids* was more exotic, but was obviously comparable in subject. In his concern with origins Geddes went back to the eighteenth century and to the generation of Ossian, and the subject of *The Druids* reflects this, but such nationalistic ideas were extremely fashionable throughout Europe. Indeed in the *Scottish Art Review* James Paterson devoted a rather sour article to combating the current enthusiasm for nationalism in art which was in part at least a by-product of the enormous vogue for Wagner.[24] Henry and Hornel's picture is Wagnerian as much as it is Celtic, but it is a remarkable achievement. The picture has the decorative logic of the flat colour of the paintings of the previous year and the composition is a vertical stack of figures. The massive accoutrements of the druids are gold-tooled decoration applied to the surface of the canvas.

If Wagner played a part in the genesis of *The Druids*, the painters were nevertheless looking for their own native *Niebelung*. The picture's inspiration was reputed to have been in an account of a vision given by an old man called Sinclair in Galloway who went into a trance clutching a piece of the mystic stone, blue-John.[25] The year before, Hornel had painted a strange little fairy picture, *The Brownie of Bled-noch* (GAGM), and these two were clearly interested in folk-tale and tradition. Hornel spent time hunting out prehistoric ring and cup marks on megalithic monuments in Galloway, a remarkably early interest in the ultimate primitive art. Though there is no evidence of his trying to exploit this inspiration in his painting, it has a bearing on the subject of *The Druids*.

The second picture that Henry and Hornel painted together, *The Star in the East*, 1891, is a nativity and it may be linked to *The Druids*. Both represent the Winter Solstice, one pagan, the other Christian and so they are complementary. The second picture is treated in a very modern way, but it is less successful than *The Druids*. In it, the mysterious blending of figures and landscape successfully suggests, not a fancy-dress reconstruction, but the permanent presence in the modern landscape of the mysterious splendours of the past. It anticipates William Johnstone's *A Point in Time* in some of its concerns (see above, pp355–6).

In 1889 another young Glasgow artist, David Gauld (1865–1936), produced a painting of *St Agnes* (GAGM) which is on the face of it an even more startling solution to the problem presented by the new decorative ideal. In this case however he was almost certainly working for a specific decorative purpose, for a very similar painting of the same date, *Music* (Private Collection), was certainly produced as part of a commission for stained glass.[26] The purposes of stained glass were perhaps slightly specialised, but the results of this particular exchange between painting and decorative art were nevertheless startling, particularly when the role of the patterns of stained glass in the painting of Gauguin and his circle is borne in mind. In these two paintings Gauld combined the rich, flat, painted surface that Henry used, with a sharp, angular delineation of shapes, including both objects and shadows within the same system of outlines. This derives directly from Rossetti's watercolours of the 1850s and

Plate 233. GEORGE HENRY, *Landscape at Barr*, 1891

Rossetti was regarded by Geddes as the founder of the return to idealism.

Gauld's designs were produced for the firm J. & W. Guthrie and he worked for them over the next few years. In 1896 he produced his own version of *The Druids* for a window in Rosehaugh House. During these years he shared a studio with another Glasgow painter turned stained-glass artist, Harrington Mann (1864–1937). They were just two of a number of Glasgow artists working in the medium in the 1880s and nineties, and stained glass was perhaps the field in which the decorative ideal was most fully realised in Glasgow.

Henry and Hornel did not paint any other cooperative pictures after *The Star in the East*, however. Hornel continued to develop the pastoral imagery of *The Goatherd* and *The Brook*, in *Summer* also of 1891 and *The Dance of Spring* of 1892 (GAGM). In these pictures, particularly the latter two which include dancing children,

the way the rhythms incorporate the figures into the landscape suggests an intention to capture a pagan identification with nature. Geddes wrote of a little sketch of *Boys Bathing* by McTaggart in the Glasgow Exhibition that it showed 'an element of idyllic joyousness we too rarely see' and we should not underestimate the importance of McTaggart.[27] The figures in landscape that both Henry and Hornel were producing at this time, like Henry's *Through the Woods* (Angus McLean) or Hornel's *The Dance of Spring*, though different in texture, are akin to McTaggart's paintings of figures absorbed into the surrounding landscape.

Henry was ill in 1892, but he did paint one quite exceptional picture, *Landscape at Barr*, in 1891 (NGS). (*Plate 233*) It is freely painted, with brilliant colours, put down with seeming abandon. If it had been painted at any time in the first half of the twentieth century it would have looked acceptably modern. Painted when

Plate 234. GEORGE HENRY, *Japanese Lady with a Fan*, 1894

it was, it is almost more remarkable than *A Galloway Landscape*, but it, too, is perhaps a reminder of the importance of McTaggart.

In 1893 Henry and Hornel embarked on a trip to Japan. They were financed by Alexander Reid. When Reid knew Van Gogh in Paris, he too was dreaming of a trip to Japan, so Reid well understood the Glasgow painters' ambition to visit the country which provided so much inspiration to painters in the 1880s and nineties. In Glasgow Whistler and Whistler's influence were also an important element in this fashion for Japan. He was extremely topical there, where thanks to the support of the painters, the city had just bought his portrait of Carlyle which was for Whistler a precious piece of public recognition. His example, particularly through his *Ten O'Clock Lecture*, as a champion of modern painting was extremely important, but his practical influence has perhaps been overestimated, though there can be no doubt that the great revival of print-making in Scotland which began in the 1880s began with him and his influence is often apparent in individual pictures by Glasgow painters. In 1887 for example Henry painted a small picture, *Sundown* (Hunterian), of a spectacular golden sun setting against a dark blue sky and reflected in dark blue water. It is a nocturne in direct imitation of Whistler and in Japan it is Henry who is closest to the spirit of Whistler and indeed to Japanese art. Hornel carried on with the dense, overall painting that he had developed in Scotland. The evidence is slightly unbalanced however for many of Henry's oils were damaged irreparably on the return journey. One that does survive is a lovely study of a geisha turning away and seen in *profil perdu, Japanese Lady with a Fan* (1894, GAGM), but on the whole the production of their epic voyage is disappointing.[28] (*Plate 234*)

Indeed it is perhaps not unfair to say that all the later work of the Boys is disappointing. Not perhaps picture by picture as it were, but as a whole their later work lacks the creative excitement of the 1880s. Guthrie and Walton produced some lovely, frankly impressionist pictures, like Walton's *Bluette* (c. 1891, NGS) and Guthrie's pastels. The latter are the best impressionist pictures produced by any British artist. Pictures like these, or Henry's landscape

at Barr, have some parallel in the brilliant, luminous landscapes of John Campbell Mitchell (1862–1922) working on the east coast. They are the progenitors of such Scottish impressionist paintings as the early work of James Kay, and of the Colourists, but perhaps it is true to say that they do not break new ground in the way that Guthrie had done in *A Hind's Daughter* or *Pastoral*, or Henry in *A Galloway Landscape*. Guthrie and Henry both turned to portraiture increasingly as the nineties advanced and in doing so showed most clearly the influence of Whistler.

Lavery began his career as a society painter in 1888 with a well-judged speculative venture. He painted the Glasgow Exhibition and recorded Queen Victoria's state visit. He moved thereafter into society portrait painting in which he too was very much influenced by Whistler with whom both he and Walton were on intimate terms. Guthrie also produced some very fine portraits that are fastidious in the manner of Whistler, but his later work lacks this refinement. Walton and Roche also turned to portrait painting, though Walton continued to produce landscapes as did Paterson.

In 1890 the Glasgow Boys showed for the first time as a group in London at the Grosvenor Gallery. The exhibition was a success. It established their reputation as a group and led to a string of overseas exhibitions through

Plate 235. ARTHUR MELVILLE, *Banderilleros à Pied, c. 1896*

Plate 236. ARTHUR MELVILLE, *A Mediterranean Port*, 1892

which they earned an international reputation and also exerted an international influence. Pictures like Melville's *Audrey*, or Henry and Hornel's *Druids* may have been the earliest works in the new style of international symbolism to have been seen in places like Munich and St Petersburg and so they should perhaps be taken into account when considering the early work of painters like Kandinsky. Perhaps however the Glasgow Boys were successful at the wrong moment. None of them developed the promise of their most adventurous work of the years on either side of 1890. It was left to the younger generation, to C. R. Mackintosh and his friends in Glasgow, to build on their symbolist experiments. Arthur Melville's work continued to develop until his untimely death of typhoid at the early age of forty-nine, however. His watercolours of the 1890s are spectacularly beautiful.

Melville's painting of *Audrey* is described by his biographer as 'a striking decoration in crimson, green and gold'.[29] With it, Melville seems to have begun to evolve a style that would have the autonomy of decorative art and from 1889

his watercolours became increasingly simplified. This tendency had already been apparent in smaller works such as the watercolours he painted in Orkney in 1885, but from 1890 onwards he began to visit Spain and North Africa more or less annually and these visits provided subject-matter that lent itself to this radical simplification of his style. *Banderilleros à Pied* (Aberdeen Art Gallery), (*Plate 235*), painted in Seville probably in 1896, is a good example. The wall of a bull-ring curves round on the right. Beyond it the crowd is schematically indicated. Within the curve a group of figures is gathered around the bull. As the ring opens out to the left, the figures dissolve in a blaze of sunlight. He uses the same method in other bull-ring studies and in North African pictures too, like *The Captured Spy* (GAGM). In these paintings he has refined his technique to the point where it consists of nothing but sheets of transparent tone punctuated by small blobs of either intense colour or intense shadow.

In *A Mediterranean Port* (GAGM), (*Plate 236*) which may be dated 1892, though, he uses saturated colour. The area of sea is a flat surface

of intense blue, so strong that it seems to absorb the light. The colours of the houses and boats dance in dazzling contrast to it. In *A Moorish Procession* (1893, NGS) on the other hand, everything takes place in shadow. A crowd of people are moving through a narrow street. The sun is visible on the wall of a high house behind, but the street itself is in shadow. He describes the crowds with a wash of umber, painted in, sponged away and then touched over with almost random spots of colour. These spectacular late watercolours were not limited to exotic subject-matter however. At Loch Lomond and in the Trossachs he painted some beautiful autumn landscapes, and on Mull he painted a brilliant, small sketch of the *Horse Fair, Salen* (whereabouts unknown).

Melville continued to paint in oil, however, and his paintings in this medium are no less adventurous than his watercolours. *The White Piano; Portrait of Miss Margerison* (Preston Art Gallery) of 1892, for example, is by its title a portrait, but the likeness of the sitter is of secondary importance to considerations of decorative composition. She is seated at a white piano, turning away from it towards us so that she is almost in profile. The piano is cut off to the right. The area of white of the piano itself is extended upwards by an open book of music. (Melville has ignored the perspective of the piano keys.) This background puts the upper part of the sitter into silhouette. Her dress and the wall-paper behind the piano are both strongly patterned. The picture is thus cut up into sharply demarcated areas allowing very little depth. This approach has something in common with Whistler and Albert Moore and some analogy, too, with Vuillard in France, but it would be a mistake to see it as derivative. The way that he articulates the whole surface of his canvas within a very shallow space is original and very bold. His smaller oil paintings, such as *The Contrabandista* (1892), *The Chalk Cutting* and *Apple Blossom by Moonlight* (all Private Collections), for example, all show the same bold flatness and formal originality.

At the end of his life Melville took to working almost entirely in oil and returned to the ambition to work on a large scale in a series of monumental canvases to which he devoted much of his last years. The first and largest

of these was *The Return from the Cross* (Leeds Art Gallery) and it was followed by four pictures of the Christmas story which he called 'his Christmas Carols'. They were *Christmas Eve* (NGS), *The Nativity*, *The Adoration of the Shepherds*, and *The Adoration of the Kings*. This is a choice of subjects that suggests a link with Henry and Hornel's *Druids* and *Star in the East*. None of his pictures was finished however and according to W. Graham Robertson who was working with Melville at the time and who posed for the crucified Christ, Melville continuously reworked *The Return from the Cross* in his determination to get it right.[30]

The most nearly completed of the pictures was *Christmas Eve* (1900–04, NGS). (*Plate 237*) Mary and Joseph are at the door of the inn. It is night and the scene is moonlight. To capture the effect Melville followed Holman Hunt's example and painted the picture by actual moonlight. Robertson describes the picture: 'It represents realistically an actual happening to actual human beings, yet is so charged with mystery, with tenderness, with reverence . . . that its deep import is unmistakeable. The canvas is soaked in moonlight.'[31] Clearly, in painting pictures that combine decorative quality with such eloquent command of narrative, Melville was adhering closely to the principles outlined by Crane and others. He

Plate 237. ARTHUR MELVILLE, *Christmas Eve*, 1900–1904

interest in Japanese art is posed in these brilliant paintings (a question which Melville articulated in the quotation from *As You Like It* that accompanied his painting of Audrey). They achieve complex effects by a superb combination of fastidiousness, economy and dexterity. The fact that light is still so much part of Melville's subject-matter makes it conventional to see these as impressionist paintings, but in Britain, just as in France, the reaction against impressionism in the late 1880s and early nineties involved very consciously the question of style as a vehicle for thought. In Crane's memorable phrase it was the business of painting to provide 'a kind of visual and picturesque logic to satisfy the mind'.[33] The influence of decorative art on Melville's own painting is an indication of how much he was aware of this and it was in this area that his influence is most clearly apparent on the work of his friends and contemporaries, especially Henry and Hornel.

Several watercolour painters followed in the steps of Melville. Robert Burns (1869–1941) for example, best known for his art-nouveau and decorative designs, travelled to North Africa and produced beautiful paintings in which his account of intense light is clearly related to Melville's. William Russell Flint (1880–1969), too, made a speciality of Spanish scenes much in the manner of Melville. Unfortunately he is best known for his Spanish ladies who are mainly remarkable for the variety of the opportunities that they find to bare their ample bosoms. These later paintings do not do justice to the quality of his early works though, nor to the tradition from which they derive. Closer still to Melville is James Watterston Herald (1859–1914).[34] Herald's watercolours are distinctly 'blottesque' in the manner of Melville, but he was less influenced by the economy of Melville's style than by the richness of decorative effect that it could achieve. This gives to Herald's best work a distinctive quality seen in *Arbroath Harbour* (GAGM), (*Plate 238*) for example. The most original watercolour painter to emerge from this background, however, was Charles Rennie Mackintosh. He is of course primarily known as the greatest architect of his generation, but he produced watercolours throughout his life and in his last years he worked exclusively as a watercolour painter.

Plate 238. JAMES WATTERSTON HERALD, *Arbroath Harbour*

was emphatically rejecting Whistler's hostile attitude to subject-matter in favour of Crane's definition of the role of symbolism in painting: 'No touch or conception of life but is made more emphatic and comprehensible by being cast into a concrete image.'[32]

The inventiveness of Melville's late painting is outstanding. His close friend Crawhall seems limited in range and ambition beside him, but they may have supported each other. Crawhall, like Melville, was technically inventive. In *The White Drake* (NGS) and similar paintings he used watercolour on fine-grained cloth. Melville is reputed to have tried out the effect of colours on a sheet of glass before applying them. There was no room for error in his technique. Crawhall's was the same. Each brush stroke counts, leaving its exact profile as it does in oriental calligraphy.

Interest in Japanese art is clearly apparent in Crawhall's work. It is, however, also obviously an important element in the way in which Melville exploits empty space in his watercolours. The whole question of the nature of style and of stylisation which underlay the

PART FOUR

THE MODERN AGE

Plate 239. C. R. MACKINTOSH, *Fritillaria, Walberswick*, 1915

THE 1890S
The Opening of the Modern Era

When in 1891 Charles Rennie Mackintosh (1868–1928) returned from a trip to Italy that he had made on a travelling scholarship from Glasgow School of Art, he exhibited some of his watercolours in a student exhibition at the school. James Guthrie, judging the exhibition, when he was told that the author of these drawings was an architect, is reputed to have said to the head of the school, Francis Newbery: 'This man ought to be an artist.'[1] As his painting shows, though, Guthrie was by then much less in tune with Arts and Crafts enthusiasms than some of his colleagues, otherwise he would not have made such a remark. The fashionable opinion was that architecture subsumed painting. William Morris remarked at the Edinburgh Congress of 1889 (see above, p273): 'Painting is of little use, and sculpture less, except where their works form part of architecture.'[2] Morris was referring to the status of painting as decoration, but his remarks could apply equally to the status of the painter vis-à-vis the architect. To be a painter without some practical involvement in decoration and so in architecture itself, was not enough. Ideally a painter should be actually involved in architecture too, or at least in a craft. Morris himself was the first example of the shift, but in the 1890s many who had started their careers as painters and graphic artists moved into architecture. On the Continent, for example, Bruno Taut and Peter Behrens, both of whom, like Mackintosh, are given a place in the early history of the modern movement in architecture, started as graphic artists. That Mackintosh should not only be interested in painting, but also good at it, was therefore completely in tune with his ambitions as an architect.

Mackintosh's inspiration as a painter must therefore also be looked for in the area where architectural and artistic ideas merged. While he was in Italy he produced fairly straightforward watercolours of buildings. In 1892, however, he produced the first of a series of pictures which are so little representational and so purely symbolic that they are almost emblematic; *The Harvest Moon* (GSA), (*Plate 240*), on the face of it, is a very strange picture indeed. A great, golden moon, crossed by two attenuated clouds, hangs low above a tangle of thorny vegetation. Its globe is echoed in the red, green and purple fruit, berries or leaves (it is not clear which they are) on the branches beneath. An angel supported on the clouds stands within the circle of the moon and on the central axis of the picture. The angel's wings meet at their tips to form a complete circle around the moon. The patterns in the foliage are very like the patterns that Arthur Melville sets up in his watercolours, and the way that the figure of the angel appears through the foliage has something in common with a picture like George Henry's *Poppies* of 1891 (CEAC). In several later pictures Mackintosh shows a similar relationship to contemporary painting. In *In Fairyland* (1897, Private Collection) or in *Part Seen, Part Imagined* (1896, GAGM), for example, though in a much more stylised form, he plays the same game of visual hide-and-seek as Henry and Hornel do in their pictures, but although stylisation is a feature of the work of these older painters, he goes far further than they do, and to understand what he is doing it is necessary to look at the origins of his ideas as an architect.

Owen Jones's *The Grammar of Ornament* (1856) had inspired William Morris a generation earlier. It remained, or had perhaps

Plate 240. C. R. MACKINTOSH, *The Harvest Moon*, 1892

become again, one of the most influential books in the field of architecture and the decorative arts. Jones's 'General Principles in the Arrangement of Form and Colour in Architecture and the Decorative Arts' set out in a series of propositions at the beginning of the book, were really the text book of art nouveau. Mackintosh was to be a follower of Jones in several ways, most importantly in his attitude to historic styles. Here Jones argued passionately that a new architectural style must eventually emerge that is proper to the modern world. When it did however, and he was clear that it could not be produced by his own generation, architects would learn from the art of the past without imitating it. In a lecture on the Great Exhibition of 1851 he remarked: 'The great works of the past are our inheritance and are not to be lightly thrown aside, yet they should not be slavishly copied. The principles of art which successive ages have evolved belong to us, not so the results; it is taking the end for the means.'[3] He modified his stern view of imitation only to concede that 'Style in

Architecture is the peculiar form that expression takes under the influence of climate and materials at command.'[4] It followed that an architect could learn most from the traditional forms of architecture in his own environment.

In the way that he forged a new style from a union of traditional and novel forms, Mackintosh followed Jones very closely, as indeed did Gaudí in Barcelona. The common debt to Jones of these two, amongst the greatest architects of the late nineteenth century, is a reflection on the originality and flexibility of his ideas. Mackintosh also, however, had a more immediate inspiration in Patrick Geddes. At a later date they certainly knew each other and were friends, but given the association between Geddes and Francis Newbery it is unlikely that Mackintosh, Newbery's star pupil, did not meet him early in his career. In Edinburgh in the early 1890s Geddes was promoting the revival of vernacular architecture (on exactly the grounds argued by Jones) in Ramsay Gardens and elsewhere, but he was also a botanist and it was as a painter of flowers that Mackintosh excelled.

Jones also had a direct bearing on Mackintosh's work as a painter however. This is clearly seen in drawings dated, 1893 and '94. They are *Stylised Plant* and *Cabbages in an Orchard* (both GSA). Both are conventionalised representations of natural forms. The subject-matter and to some extent the handling are still linked to the decorative painting of Melville and those associated with him, but Jones's Proposition 13 in *The Grammar of Ornament* states: 'Flowers or other natural objects should not be used as ornaments, but conventional representations founded upon them sufficiently suggestive to convey the intended image to the mind, without destroying the unity of the object they are employed to decorate.' Elsewhere Jones exhorts the creators of the new style of the future to whom he constantly addresses himself: 'Let them go to nature's ever bounteous works and conventionalise for themselves. Why should the acanthus leaf keep the field against all comers?'[5]

In two watercolours of 1895, *The Tree of Influence* and *The Tree of Personal Effort* (both GSA), (*Plate 241*) Mackintosh develops the theme of conventionalised natural forms in a symbolist context. These two highly stylised

drawings of trees reflect in an ironic way upon his choices as an architect. It is clear which is preferable in spite of his obvious pessimism. The first is inscribed: 'The Tree of Influence, the Tree of Importance, the Sum of Cowardice.' The green of the tree is washed over and obscured by a sickly, pinkish purple. Its branches are etiolated and asymmetrical. The other is inscribed: 'The Tree of Personal Effort, the Sum of Indifference.' The tree is a flourishing, symmetrical growth with fruit and flowers. The design fills the whole rectangle and is silhouetted in the central part against a square of blue sky on which is centred the circle of the moon.

The use of natural, and in particular flower forms, was one of the characteristics of Mackintosh's mature design, but in these two watercolours he is loyal to two more of Jones's basic principles of practical design, that all lines should grow out of a parent stem and that all ornament should be based upon a geometrical construction,[6] but he goes beyond Jones in his use of an emblematic or symbolic visual language and his tree symbolism was a link with Geddes. The cover of *The Evergreen*, designed by Charles Mackie, was just such a stylised tree and as an end-paper to the first number, Geddes himself designed an *Arbor Seculorum*, a tree of history, a metaphor for his organic view of human life. In addition, though, W. R. Lethaby in *Architecture, Mysticism and Myth*, published in 1892, proposed a symbolic language underlying all architecture. He devoted a whole chapter to the symbol of the jewelled tree. He also devoted space to the importance of the square and the circle as the two basic, perfect shapes.

Mackintosh's approach to symbolism was shaped by this kind of architectural idea and he painted several similarly reduced images such as *Winter* (Hunterian) and *The Descent of Night* (GSA). His famous posters for *The Scottish Musical Review* translate this formal language directly into the field of design. He also constantly used conventionalised flower motifs in his furniture and interior design, the rose, the tulip and the willow for example. To charge his imagination he drew flowers from nature and this became a self-sufficient activity after *c.*1900 as his drawings became more elaborate and more botanical. They are if anything more beautiful, but they are also still conventionalised.

It was from the inspiration of these wild flowers, like the fritillary for example, that he derived his most typical decorative motifs. (*Plate 239*) The chequerboard that he used in such a variety of ways, especially in his later work, is one of these. It first appears in a design on a clock at Hill House in 1903 and is based on a stylised fritillary. In its economy, simplicity and modernity it is the most elegant interpretation of the principles of Jones achieved by any of his contemporaries.

Some time in 1893 Mackintosh met the sisters, Margaret (1864–1933) and Frances Macdonald (1873–1921) and also Herbert Mac-Nair (1868–1955). He subsequently married Margaret while MacNair married her sister. In the mid-nineties they were seen very much as a group and their work was very closely linked. Mackintosh remained a more austere and abstract artist than either of the Macdonald sisters however. Frances's painting of 1893 called *Ill Omen*, or more poetically *Girl in the East Wind with Ravens passing the Moon* (Hunterian), already shows the sisters' interest in macabre

Plate 241. C. R. MACKINTOSH, *The Tree of Personal Effort*, 1895

Plate 242. FRANCES MACDONALD MACNAIR, *'Tis a Long Path which Wanders to Desire c.* 1909–15

and fantastic poetry that was typical of a certain strand of the art of the nineties popular throughout Europe. Its origins lay in the inspiration offered by older painters like Rossetti, Burne-Jones and Gustave Moreau. The magazines of the nineties, especially *Studio* which first appeared in 1893, established this as an international style. It is possible to find links in their work with Beardsley, with the Dutch symbolist Jan Toorop, and with a variety of other contemporary artists known from the pages of *Studio*, but their best work remains wholly individual and recognisably Glasgow. This is particularly true of their decorations. The beautiful gesso panels made by Margaret Macdonald, for instance *The Red Rose and the White Rose* (Private Collection), have little coloured blobs on them which on the one hand look like jewels, but are also recognisably akin to the kind of surface patterns used by Arthur Melville and the Glasgow painters.

The Macdonald sisters continued to produce some very striking works.[7] For example Frances's *'Tis a Long Path which Wanders to Desire* (Hunterian), (*Plate 242*) from the years just before the First World War, is a haunting symbolist image akin to Munch. A naked, female figure stands at the centre of an empty landscape. Her hair flows out into the horizon then flows back into the landscape to form a curling path that unites the female figure with two others standing alone behind her. The symbol of her hair forms an interchange between landscape and mindscape that is close to the surreal. Such urgency is unusual. More typical is Margaret Macdonald Mackintosh's *La Mort Parfumée* (1921, Private Collection), (*Plate 243*), marking the death of her sister, or *The Mysterious Garden* of 1911 (Private Collection). In the latter she creates a shimmering, insubstantial fairy-figure by sponging and wiping out watercolour against a trellis-like background. This kind of image became the hallmark of the group of Glasgow illustrators that formed round Mackintosh and the Macdonald sisters.

Jessie M. King (1875–1949), Annie French (1872–1965) and Kay Cameron (1874–1965) were the three best known of these, but in the younger generation Cecile Walton, daughter of E. A. Walton and Mary Newbery, daughter of Francis Newbery, brought up in the circle of Mackintosh and his friends, were both much influenced by this group (see below, Chapter XVIII). Jessie M. King and Annie French are best known as illustrators and in this they kept the Glasgow style alive well into the twentieth century, but they both diversified into other areas of painting and the applied arts. King, for example, painted landscape and townscape extensively in her later career and some of these, were published in the form of illustrations. (*Plate 244*) Kay Cameron, who was the sister of D. Y. Cameron, was also an illustrator but her chief energy went into botanical painting which, like Mackintosh, she brought to a very high standard.

The Macdonald sisters and their contemporaries belonged to the first generation of women artists to be allowed to enjoy a proper art education and to regard themselves as professionals. The fact that they tended to work in watercolour and as illustrators perhaps reflects the continuing pressure on them to conform to a particular idea of the qualities that a woman

Plate 243. MARGARET MACDONALD MACKINTOSH, *La Mort Parfumée*, 1921

artist should cultivate. They did not all submit to this pressure however. Bessie MacNicol (1869–1904) who also trained in Glasgow and then went on to Paris, became a painter to compete with her male contemporaries. One of her finest paintings of a female nude beats them on their own ground,[8] and in *The Green Hat* (c. 1902, CEAC), (*Plate 245*) she specifically anticipates the Colourists.

The amateur painter, J. Q. Pringle (1864–1925), also belongs in this second generation of Glasgow painters. He worked almost all his life as an optician and from 1896 he ran his own business, but for more than ten years from 1885 he attended evening classes at Glasgow School of Art where he was a contemporary of Mackintosh and the others. His production as

a painter is not great which is not surprising given the other demands on his time. Nor did he paint on a large scale. Some of his work is actually in the form of miniature paintings and it all has an exquisiteness which is very appealing. The origins of his style lie in the decorative painting of the older Glasgow painters. He uses patterned brushwork just as Henry and Hornel did and like them he sometimes plays hide-and-seek by allowing the pattern of brushwork to overwhelm the integrity of the figures as in *Two Figures at a Fence* (1904, GAGM). This technique creates a similarity to the work of the pointilliste followers of Seurat which is very close in his more atmospheric pictures such as *Tollcross, Glasgow* (1908, Hunterian), but in *Children at Play* of 1905 (Hunterian) on the

other hand the spotty pattern of autumn leaves is identical in its decorative purpose to the decorative patterns used by Frances Macdonald or Jesse M. King.

Pringle is at his most original when he treats such everyday scenes as *Poultry Yard, Gartcosh* (1905, SNGMA) which has an eloquent balance between decorative delicacy and the matter-of-fact. The colour that he uses in this picture shows his awareness of post-impressionism and as a result when he deals with such unromantic subjects, which he did not do exclusively, almost by accident he comes close to the painting of the Camden Town school with whom in fact he exhibited in 1914. At the very end of his life Pringle gave up his optician's business and painted some of his most memorable pictures, a number of intensely seen still-lifes for example,

Plate 244. JESSIE M. KING. *Nuremburg,* 1902

and *The Window* of 1924 (Tate Gallery). (*Plate 246*) Painted in Shetland, this latter composition consists of the rectangle of the window embrasure enclosing the double rectangle of a sash window, further subdivided by a blind and a section of flat horizon. Within this severe pattern delicately observed qualities of colour and reflected light in the interior lead out to a landscape of grass, sea and sky.

In Edinburgh the later career of Phoebe Traquair paralleled that of the Glasgow women artists. She practised a whole range of applied arts including embroidery, book-binding, enamelling and manuscript illumination. In all of these she excelled. Her enamels and her illuminations are amongst the most exquisite of their kind from the period. This was recognised at the time and her status as an applied artist reflected the continuing importance of Arts and Crafts ideas in Edinburgh where Geddes remained the dominant figure throughout the 1890s. He continued to promote mural painting energetically. University Hall, Ramsay Gardens, a pioneering student residence, was decorated by artists and students together, culminating in the decoration of the common room by John Duncan (1866–1945) from 1895 or 1896. Before this however Duncan, together with Charles Mackie, had decorated Geddes's own flat in Ramsay Gardens, which he had taken over in 1891.

Duncan's decoration there was a history of pipe music. Mackie's was a series of pastorals. Sadly all that survives is a group of reproductions in an article on the decorations published in *Studio* in 1897.[9] From these though it is clear that Mackie's decorations were in a style akin to Pont Aven symbolism that appears elsewhere in his work. Duncan's painting was flat and dramatically stylised and two small panels of 1897 and '98, *The Glaive of Light* and an untitled scene from Celtic mythology (University of Dundee), show that he experimented with an almost abstract use of colour. This aspect of Duncan's work is echoed in the work of his pupil, George Dutch Davidson (1879–1901), who in his short career produced some remarkably unconventional images, a symbolist *Self-Portrait* for example in which a disembodied head floats in a field of abstract shapes and some purely abstract designs based on Celtic motifs (Dundee Art Gallery).

John Duncan himself was certainly influenced by Puvis de Chavannes in his decorations, but in a painting like *St Bride* of 1913 (NGS), *(Plate 247)* he uses a brilliant palette and an almost completely flat composition in keeping with the ideals of decorative art. The unearthliness of the picture of St Bride, carried miraculously across the sea to Bethlehem by two angels, is enhanced, not diminished, by the way in which the angels' wings overlap the frame. Robert Burns's decorations for Crawford's Tearooms in Edinburgh show a similar decorative inventiveness, though they are untouched by Duncan's mysticism (RSA and Private Collection). (See below, *Plate 279*)

In the Ramsay Gardens common room, when Duncan's decorations were described in 1897, six panels had been completed and a seventh was to be the final part of the decoration. In the end, however, there were twelve panels, though it is not clear when they were eventually completed. The series was planned by Geddes and was one of the pageants of history that he was so fond of, but one which stressed two things in particular, the Scottish scientific tradition and the role of the Scots in Europe.[10] Geddes and Duncan later collaborated on a description of the pictures. The twelve scenes are *The Awakening of Cuchullin; The Combat of Fionn; The Taking of Excalibur* (a scene set in Duddingston Loch); the three first were therefore pagan Celtic history. With the next, *The Calling of St Mungo*, Glasgow was brought in to match Edinburgh and the series entered the Christian era. The next two, *Johannes Scotus Erigena* and *Michael Scot*, both represent the role of the Scots in the international culture of medieval Europe. Johannes Scotus, established at the court of Charles the Bald, was 'an illustrious product of the Celtic culture which was still foremost in Europe', while Michael Scot, student at Oxford, Paris and Toledo, found a home at the court of Frederick II. In addition, Michael Scot, as translator of Aristotle and enquirer into scientific matters, including sex and reproduction, 'suffered as a man of science before his time'. The seventh scene, incomplete in 1897, was *The Admirable Crichton* described as a kind of Renaissance scholar-gipsy, but also the type therefore of the European Scot. For Geddes Scotland's tradition of European links

Plate 245. BESSIE MACNICOL. *The Green Hat* c. 1902

was vital. *The Admirable Crichton* was followed by *Lord Napier*, the inventor of logarithms (and pioneer of calculating machines). *Napier* was followed by *James Watt, Walter Scott*, seen like his homonym, *Michael Scot* as a wizard, *Charles Darwin* whose justification for inclusion was presumably a short time spent at Edinburgh University, and finally *Lord Lister* for whom the note is quite short but to the point: 'It may be questioned whether any single individual has ever rendered greater service to humanity than Lord Lister.'

It is worth giving this list in detail for the fact that these decorations are mainly known only from the incomplete account given in *Studio* which has given support to the view that Geddes was a kind of Celtic Revival mystic, but he himself says in a prefatory note to the description: 'These things are not ancient and dead, but modern and increasing.' Lord Lister therefore represents a climax in a vision of

human progress which is continuous from earliest times. Geddes, while taking a stand on the social function of art, was also committed to the idea of the distinctiveness of the modern world. It is essential to understand this to understand his far-reaching influence on Scottish twentieth-century culture. Part of the strength of Geddes's vision of modernity, however, lay in his belief that life in the present, if it is cut off from the past, loses a vital source of intellectual and imaginative nourishment.

In his view of Scottish history, Geddes therefore stressed the importance of continuity, but he also stressed the importance of the Scots tradition of seeing themselves as fully participating in a wider European culture. A contemporary commented on his attempts to 'foster the incipient Celtic Renascence and – what is more interesting to outsiders – the revival and development of the old continental sympathies of Scotland'.[11] It was in this spirit that Geddes embarked on the organisation of a series of international summer schools which ran through the 1890s and which were a small-

Plate 246. J. Q. PRINGLE, *The Window*, 1924

scale antecedent to the Edinburgh Festival. It was in this spirit also that he launched *The Evergreen*, a journal in four seasonal numbers, 'Spring', 'Summer', 'Autumn' and 'Winter', which ran, though not in that order, through 1895 and 1896/7.

The Evergreen took its title from Allan Ramsay whose house formed the central block of Geddes's building of Ramsay Gardens on Castle Hill and whose ideas Geddes believed that it perpetuated. The journal was consciously international in outlook and visual in presentation. It invites comparison with *The Yellow Book*, but it was very different in tone. The same commentator said that the contrast between the two was 'as the green of spring set against yellow decadent leaves'.[12] The visual make-up of *The Evergreen* is unambiguously modern even though it includes Celtic elements. Full-page illustrations like Charles Mackie's *When the Girls come out to Play* (*Plate 248*) and *Hide and Seek* are expressly 'modern' in their flat image and strong, swinging contours. Also striking is Hornel's *Madame Chrysantheme*, one of his Japanese compositions rendered to great effect in black and white. Robert Burns's *Natura Naturans* is the most famous illustration in the journal however. Composed several years earlier in 1891, it is a vigorous art-nouveau image. The naked female figure of Nature stands at the centre of a composition of swinging wave forms that flow outward from her hair and which include within them birds and fishes. Burns uses black and white to great effect, but so too do the head-pieces and tail-pieces which adorn the book throughout, designed by Duncan and several of his pupils. (*Plate 249*) In these there are distinct Celtic overtones, but the designs are often quite startlingly bold and modern looking.

Geddes himself contributed several articles to *The Evergreen*. These included an essay on megalithic monuments which does not reflect a preoccupation with a remote and ill-defined past, but stresses continuity.[13] He proposes implicitly a longer time-scale within which the apparently insuperable discontinuities of Scottish history, caused first by the Reformation and then by the Union, might be put into a manageable perspective. In a key article in 'Spring', 'Life and Its Science', he set out his

Plate 247. JOHN DUNCAN, *St Bride*, 1913

belief in a new culture based on the reunion of art and science. It had a far-reaching influence. It was still topical in 1950 when Thomas Robertson published a book called *Human Ecology: The Science of Social Adjustment* and Hugh MacDiarmid reviewed it.[14] The most enduring thing in all *The Evergreen* and closely linked to this belief in a new culture was the idea of the 'Scots Renascence', the title of another article by Geddes also in 'Spring'. It summed up his belief in the possibility of a viable Scots culture, not as something inward-turning, but as confident and international.

Geddes's ideal of a Scottish Renascence became the ambition of a group of poets and artists in the years after the First World War, but it could have been argued that something closely

akin to Geddes's own perception of it and, to a great extent already influenced by him, was underway in the visual arts in the closing decades of the nineteenth century. This was not only in painting and decoration however. One of the most striking developments of the time lay in the work of the Scottish etchers and print-makers who emerged to become leaders in the revival of etching initiated by Whistler.

Etching had never been entirely extinct in Scotland since the Runcimans and David Allan had practised it so effectively in the late eighteenth century. Wilkie and Geddes had taken an interest in the art and had both produced some fine etchings. Lizars had experimented with print-making techniques and had used lithography very effectively. It was no

Plate 248. CHARLES MACKIE, *When the Girls Come out to Play*, 1895

doubt under his guidance that the antiquarian Charles Kirkpatrick Sharpe kept alive the tradition of the amateur etcher established by John Clerk of Eldin and David Deuchar. The landscape painters Hugh William Williams and David Roberts also produced important series of etchings while the Scott brothers, whose father was the engraver Robert Scott, both used print techniques extensively. David Scott's illustrations to *The Ancient Mariner* for example are in a mixture of etching and engraving, but the revival of etching as a graphic medium in its own right, untouched by the needs of reproduction, was the achievement of Whistler.

Whistler's influence in promoting etching as a free and spontaneous medium especially suited to the description of landscape and

Plate 249. JOHN DUNCAN, DECORATION FROM *The Evergreen*, 1896–7

townscape, began with his etchings of the Thames of 1859 and '60. He combined freedom and precise description. This was something that he learnt from his French contemporaries, especially Charles Meryon, from the study of the print-makers of the seventeenth century and to some extent too perhaps from the advances made in engraving under the supervision of Turner. In this way Whistler set the agenda for British etching for the next seventy years till the bottom fell out of the market in 1929. His influence was institutionalised, as it were, by the appointment of his friend, Alphonse Legros, as Professor at the Slade School in 1876, by the publication in the same year by P. G. Hamerton of *Etchers and Etching* which gave a comprehensive history of the art, and by the formation of the Royal Society of Painter-Etchers and Engravers, in 1880. Hamerton's book was especially important as it gave to a whole generation of print-makers easy access to the work of the great print-makers of the past. Their familiarity with Rembrandt, Piranesi and Goya is a feature of the work of the artists of the etching revival and one that gives their art a different frame of reference to that of their contemporaries in painting.

William Strang (1859–1921) who was born in Dumbarton went from Glasgow to the Slade School in the year of Legros's appointment. Following the lead of Legros he became a

powerful and highly individual etcher. In the 1880s Strang's prints show his admiration for Rembrandt and Millet. In *The Carpenter's Shop* (1884), for example, an old carpenter stands behind his work-bench. The ground behind him is dark and deeply etched. In front, his young wife is sitting against the bench while her child leans out to touch a half-made coffin. The identification with the Holy Family and the reference to the Passion are there by implication to give permanent association to an image of gritty reality. He used a similar style in the same year to create a strikingly anti-sentimental picture of *Tam o' Shanter*. In it he drew on the strange, solemn grotesqueness of Rembrandt's late etchings to expel from his image all the kitsch accretions that had gathered round Burns's poem.

Strang was a socialist and in the nineties he developed this kind of social realism into such powerful and unexpected images as *The Cause of the Poor* (1890), *Socialists* (1891) and *The Fish Stall* (1891, BM), (*Plate 250*), which find echoes in the art of John Bellany and his followers nearly a century later. His socialism was a link with the convictions of the leaders of the Arts and Crafts movement and he became particularly friendly with Charles Ricketts and Charles Shannon.[15] Encouraged by them, in the nineties he produced a number of illustrated books and sets of illustrations. These include a set of twelve etched illustrations to his own ballad, *Death and the Ploughman's Wife*. In place of the direct realism of his earlier work, an increasingly fantastic and macabre element appears in some of these. A print called *Grotesque* (1897), for example, records a weird dream in an image both reminiscent of Goya and anticipating surrealism. The dominant feature of the composition is a human skull with ram's horns. A man and a woman appear in the mouth, the woman leaning out as though it were a window. In *The Slaughter House*, where four men are engaged in pole-axing an ox, a similar effect is achieved through a more direct image.

In the nineties Strang also produced powerfully drawn, etched landscapes and began the series of portraits which have probably remained his best known achievement. These included memorable images of *R. L. Stevenson* and *Rudyard Kipling* for example and of

Plate 250. WILLIAM STRANG, *The Fish Stall*, ETCHING, 1891

Geddes's collaborator on *The Evergreen*, William Sharp (who wrote under the name of Fiona Macleod). The volume of Strang's etchings decreased after 1900, but the volume of his painting increased correspondingly. It includes some strikingly simple portraits which reveal an exchange with contemporary French art after the post-impressionist exhibitions in London, but also perhaps with the Colourists as in the late painting *The Jazz Hat* (1920, Private Collection). Equally interesting is a series of symbolic or emblematic paintings, like *Laughter* (1912, Victor Arwas) and *Bal Suzette* (1913, Private Collection) which extend the symbolist interest of his etchings of the 1890s. Superficially the latter is a hedonistic picture. A group of three figures in theatrical costume are the object of the attention of a group of men in evening dress, but a grim-faced puritan in an anachronistic stovepipe hat looks on like a ghostly reminder of sterner values.

A minor figure, though of interest in the context of print-making, in which he provides some parallel to Strang, was James Joshua Guthrie (1874–1952), founder of the Pear Tree Press and not to be confused with James Guthrie, the Glasgow painter. He was one of the leading figures among the hand-printers of the

Plate 251. D. Y. CAMERON, *Berwick*, ETCHING, 1890

'little presses' of the early part of the century, but he was also an etcher of considerable skill and originality whose principal inspiration was in the art of William Blake.[16] Another individualist of the same generation was James Pryde (1866–1941). He collaborated successfully with his brother-in-law, William Nicholson, in a partnership that they called the 'Beggarstaff Brothers', producing prints and posters with characteristic, simple, black shapes formed by using cut-outs as the basis of the design. As a painter Pryde is remembered for his almost obsessively repeated images of tall, dark buildings and interiors which draw on the inspiration of Piranesi and painters like Magnasco.

William Strang was out of Scotland from an early age, but his reputation at home was such that he qualifies for inclusion in this account of Scottish art. It is an indication of this that one of his early etchings, *The Sower* of 1884, was printed as the frontispiece for the *Scottish Art Review* for December 1888. The first direct follower of his example was the young Glasgow painter D. Y. Cameron (1865–1945). Though born in Glasgow, Cameron was partly trained in Edinburgh. He made his first etchings in 1887 and was introduced to the medium by

George Stevenson, an amateur etcher and a friend of Francis Seymour Haden. Haden was Whistler's brother-in-law and, though also an amateur, he was a gifted etcher and a major influence on the revival of etching. Cameron's first etchings, *Paisley Abbey* (1887), for example, show an interest in architecture that remained the dominant feature of his art, but he launched himself as a print-maker in 1889 with the *Clyde Set*, a series of etchings whose title frankly acknowledges the inspiration of Whistler's etchings of the Thames which were called the *Thames Set*. It is an ambitious series which traces the Clyde from its source out into the Firth of Clyde to end with views of Arran and Ailsa Craig. Some of the best images are the most Whistler-like, exploring the intricate interplay of masts, buildings and reflections in the busy harbours of the Clyde in its heyday.

Whistler's influence remained an important part of Cameron's inspiration, in etchings done in Holland in 1892 and in north Italy in 1894 for example (the latter published as the *North Italian Set* in 1896), but Cameron's own interest in architecture and antiquities and his own characteristic way of dealing with them developed rapidly, especially in views around Scotland. *Berwick* (1890, Hunterian), (*Plate*

251), for example, is a view down the estuary of the Tweed to the formal geometry of the railway viaduct seen against the light, and the *Trongate Glasgow* is a detailed study of a group of seventeenth-century houses. Cameron frequently looks back to David Roberts in such direct portraits of buildings, in *St Marks* (1900), for example, or *Tewkesbury* (1915), where the drama of his account raises the image far above mere description, yet is firmly rooted in fact.

Technically though, Cameron was inspired in the way in which he used etching and drypoint by the French artist, Charles Meryon, whose work was represented in Glasgow in the important collection of B. B. MacGeorge. From Meryon he learnt to use an intense black line, achieved either by simple etching, by drypoint, or by both in combination. This gives a sense of extraordinary definition to his architectural subjects, but it was turned to a different purpose when from 1911 Cameron began to produce Scottish landscapes both as paintings and as etchings. In etchings like *Nithsdale* (1911), or *Kincardine* (1914), this definite line is

used to give structure to a sparse, horizontal landscape. The economy of these images is equally apparent in his paintings such as *Ben Ledi* (1911, NGS), for example, in which he uses dark colour within a strongly drawn outline. He is determinedly disciplined in dealing with the vertical features of the landscape, avoiding all exaggeration. It is almost as though Cameron was deliberately exorcising from Scottish highland scenery the last ghosts of nineteenth-century romanticism.

In spite of Cameron's eminence the most powerful and original etchings of the whole period were the work of his younger contemporary, Muirhead Bone (1876–1953). Bone was likewise born in Glasgow. Serving an apprenticeship in an architect's office, he studied as an evening pupil at Glasgow School of Art. There he was encouraged by Francis Newbery to turn to art as a full-time career. From the beginning his aptitude was as a draughtsman and a number of his drawings were published from 1897 – in *The Yellow Book*, the *Scots Pictorial*, the *North British Daily Mail* and in 1902 and '03 in the *Architectural Review*. More than any artist

Plate 252. MUIRHEAD BONE, *The Great Gantry, Charing Cross*, ETCHING, 1906

from the Glasgow School he was a chronicler
of the city and he proved that the austerity
of black and white, whether of etching or
drawing, was peculiarly apt, not just to record
architecture, but to capture the whole mood of
the contemporary city. In this he belonged in
the tradition established by the reporter-
illustrators of the *Graphic* and the *Illustrated
London News* which had begun with Lizars's
lithographs of Edinburgh after the fire of 1824
as much as in the tradition of fine art print-
making.

Bone fulfilled Baudelaire's ideal of the
'painter of Modern life' – an artist of the city
– as no British artist had done before him, even
though it is architecture, not people, that is his
principal subject. Much later in his career he
remarked 'Glasgow's tenement life, Glasgow's
working life, is a superb feast for any artist . . .
the Broomielaw, the shipyards, our old Clyde
steamers, the nocturnal city, the melancholy
flats of Garngadhill . . . I bless the Academy I
found in the Glasgow streets. The grand indif-
ference of the great city taught one concentra-
tion and gave one solitude.'[17] His ability to
capture 'the grand indifference' of the city
was something that set him apart from his con-
temporaries and the fact that he was not

Plate 253. MUIRHEAD BONE, *Demolition of the Old Sugar
Exchange, Glasgow*, 1910

stylistically a modernist has obscured his real
modernity. Bone's art was rooted in the
prevalent conditions of a modern city, Glasgow,
at the height of her industrial eminence.

He began in the tradition founded by
Whistler, but in 1899 he published *Six Etchings
of Glasgow* which established his individuality.
This Glasgow set includes such powerful and
accomplished images as *The Old Jail* and *The
Drydock*. In the latter we look down into the
dock. The centre of the composition is a small
puffer, an old fashioned steamer with a tall
funnel, but it is dwarfed by the bow of a much
larger, ocean-going ship just visible to the left.
The foreground is criss-crossed by timber
props. The horizon is a tangle of masts and is
dominated by a single, smoking chimney. Small
figures swarm all over. The absence of
picturesque incident and the apparently casual
composition show the artist's willingness to
let such a scene dictate its own aesthetic, an
impression that is enhanced by the black and
white medium.

In London in 1899 these prints brought
him to the attention of Legros and Strang
amongst others. He did not settle in London
however till 1901, but after that move he soon
established himself as one of the leading print-
makers of his generation. Some of his greatest
prints were produced in the next few years.
These included *Building* (1904), *Demolition of St
James's Hall, Interior* (1906), and *The Great
Gantry, Charing Cross* (1906). (*Plate 252*) All
three of these are scenes of building or demoli-
tion. Bone in each case uses scaffolding as the
principal feature of his design. This is some-
thing that Meryon did but, like John Runci-
man's print of the *Taking down of the Netherbow*
or Alexander Nasmyth's painting of *Princes
Street with the Royal Institution under Construc-
tion* (*Plate 114*), Bone's etchings are not just pic-
turesque scenes, but are scenes of activity.
What he is describing is the vitality of the city
expressed in the way that it makes and remakes
itself.

Bone's account of the urban scene recalls
very closely a commentary on the task of
cleansing and renewing the modern city, the
human hive as he calls it, written by Patrick
Geddes in his essay 'Life and Its Science' in *The
Evergreen*:

The task begins with the humblest drudgery, the scavenging of dirt, the disposal of manure. Soon however they will grapple with the central and supreme art possible to mortals, the very Mystery of Masonry itself, which has its beginnings in the anxieties of calculation and the perplexities of plan, in the chaotic heaps of quarry, in the deep and toilsome labour, the uncouth massiveness of the foundations; yet steadily rises to shelter and sacredness of hearth, to gloom of tower and glory of pinnacle, to leap of arch and float of dome.[18]

To take just one of Bone's prints as an example, *The Great Gantry, Charing Cross* (also published as a drawing in the *Art Journal*, March 1907) is an image of extraordinary grandeur and complexity with all the heroic feeling implicit in the last part of Geddes's remark. After the collapse of part of the roof of Charing Cross station a huge scaffold was erected within the great arch of the roof, spanning the platforms. Bone's viewpoint is such that we look out to the distant daylight under the shadow of this mighty structure. The tiny figures of the construction workers enhance the effect of scale. The drama of interior scale, of light and shade and of the complex scaffolding with its rigging-ropes and tarpaulins all reveal very clearly how much Bone both admired and understood Piranesi, but it is a remarkable achievement to capture such drama as Bone does without seeming to stray from the observed facts.

Bone's etchings were in their turn widely influential. Amongst others who imitated them was Stanley Cursiter (1887–1976) who in 1913 produced a very fine lithograph of the restoration of the interior of Kirkwall Cathedral which shows the ancient nave of the church filled with scaffolding like Bone's *The Great Gantry*. This was one of a series of lithographs of scenes in Orkney which Cursiter made at this time. Others are *The Lighthouse* and *The Fair Isle* which are very different in character from his futurist paintings of the same year (see below, p335).

It was not only by his etchings that Bone made his reputation though. His skill as an etcher was based on his skill as a draughtsman and, taking advantage of modern methods of reproduction, he published in book form several collections of drawings. The most important before the war was *Glasgow, Fifty Drawings*, published in 1911.[19] The drawings in this collection constitute an extraordinary portrait of a city, an illustration of Geddes's text

'Life and Its Science', and totally without false glamour – 'a grey vague mass smouldering under its veil of smoke'.[20] *The North Wall, Duke Street Prison*, for example, is a drawing of a high, blank wall stepping down a long, empty street, right across the centre of the composition. It is relieved only by a handful of pedestrians and some small scaffolding up against it, half hidden in its shadow. Much of modern Glasgow is shown as the ruin of the old city. *House at Port Dundas*, for example, is an old house by the canal, its windows bricked up. *The Old Sugar Exchange* is an eighteenth-century building, once elegant, but now with its windows all broken and ruinous. In a drawing a little later in the series, *Demolition of the Old Sugar Exchange*, it is reduced to a hole in the ground. (*Plate 253*)

Perhaps the most laconically anti-romantic image in the series is a drawing simply called *St Rollox*. (*Plate 254*) It is a portrait of a slag-heap, vast and grey in the grey light, the monotony of its outline relieved only by three small figures hurrying across the empty foreground and a group of tall, shadowy chimneys in the distance beyond (the tallest in Europe). St Rollox was the site of Tennent's bleach and chemical works. It was an unsavoury place and as an image of industrial dereliction it could not illustrate more eloquently Geddes's pessimistic account of the state of modern cities under the control of technology and commerce without the regulation of the human sciences or a clear perception of human need: 'The physical sciences,

Plate 254. MUIRHEAD BONE. *St Rollox*, 1910

[and] their associated industrial evolution, have created a disorder they are powerless to re-organise.'[21]

The Glaswegians themselves do not figure largely in the series, though there is a drawing, *Barrow Market, Albert Bridge*, that is worthy of Geikie, but Bone captures the animation of the city and beside his unsentimental vision, Boccioni's first major futurist painting, *The City Rises*, which is exactly contemporary, seems positively romantic. Bone sees the city, just as Geddes had described it in his essay in *The Evergreen* with its dung carts and its holes in the ground, not as a conglomeration of buildings, some interesting, others less so, but as a mighty organism, rooted in the past, capable of growth and self-renewal, but now sadly haphazard, without direction and inhumane.

Throughout the nineteenth century, not only in Scotland, artists had conspicuously avoided any extended commentary on the contemporary city and the originality of Bone's view seems to reflect in some detail Geddes's developing ideas of town planning and his relentless criticism of the state of modern cities. The year 1909, when Bone was preparing his Glasgow drawings, had seen the passing of the Town and Country Planning Act, the first modern planning act, thanks largely to Geddes's advocacy. This was followed in 1910 by a town-planning exhibition in London, in which Geddes's presentation of Edinburgh played a major role, and in 1911 by a second exhibition called *Cities and Town Planning* which was Geddes's own project, again based on his study of Edinburgh. Bone's drawings amount to a similar presentation for Glasgow.

In 1916 Bone's commentary on the modern world took a new direction. In recognition of his status and his unique qualifications, he became the first war artist. He worked first on the Western Front. He himself later said that he felt that his drawings were not wholly successful.[22] From the point of view of those who wanted to use them as propaganda perhaps this was true and one can see how he might have felt that he had failed to produce anything sufficiently heroic to fulfil his obligations as a war artist, but the best of his drawings, published in *The Western Front*, in 1917, are moving precisely because of their terse matter-of-factness (BM).[23] Adapting Ramsay's dictum and still loyal to his aesthetic, Bone could have argued that you could no more describe the disagreeable than the agreeable, except through the exact.

Occasionally among these drawings he produced a heroic image as in *Tanks* which celebrates the new war-machine, but this is uncharacteristic, and far the greater number of the drawings are of the devastation of war, of the awful power, in Geddes's term, of the 'necrologist', of Mr Hyde, the dark side of modern science run amok because separated from the needs of humanity.[24] It is on the awful destruction that Bone comments. He describes a devastated environment in which humanity no longer has any place. Shattered buildings and shattered landscapes are purged of all picturesque reference. *A Ruined Villa near Peronne*, for example, is a crazy ruin of a house, still just recognisable for what it once was, but wrecked by such violence that it can no longer support any of those associations that go with human habitation and which had for so long been exploited by artists in the iconography of ruins. In *A Via Dolorosa: Mouquet Farm* (1916) (*Plate 255*), a series of makeshift crosses in a sea of churned-up mud mark improvised soldiers' graves. A pile of stones on the horizon, just distinguishable from the surrounding mud, is all that is left of the farm for which they died. Their individual sacrifice was as meaningless as is the landscape itself, now devoid of any feature that is recognisable as belonging to the natural world.

Faced with such powerful and graphic images of war one naturally thinks of Goya's *The Disasters of War*, but though Bone is by no means unworthy to be discussed in the same context as Goya, the difference between them is striking. *The Disasters* on the whole record individual suffering, heroism and brutality. Bone conveys the terrible anonymity and the sheer scale of modern war. A telling image is *British Troops on the March to the Somme*. A line of tiny figures stretches into the picture from the horizon on one side of the drawing, snakes across the middle ground and disappears on the horizon again in the opposite corner. No soldier in this huge army is more than a minute pencil mark and each is as easily

Plate 255. MUIRHEAD BONE, *A Via Dolorosa; Mouquet Farm*, 1916

effaced. In *The Loos Salient: Burning Lens*, the burning town of Lens is only one plume of smoke among many in a vast panorama of desolation, reminiscent of Koninck, but so big and empty that it seems to have no end. In several drawings of the wounded, even they are no more than bundled, anonymous figures lying in rows like the Londoners in Henry Moore's shelter drawings. Where an individual is represented, as in a superb portrait of *A Highland Officer*, he is anonymous and vulnerably human.

There is nothing 'modernist' about the style of these spare drawings, but they are profoundly modern. They do not for one moment glorify war. Instead they state with a force that would have been diluted in any artistic elaboration and with a prophetic relevance that has lost none of its urgency, the awful capacity of man's technological skill to unleash powers of destruction that can reduce the very earth itself to meaningless, denatured chaos.

Subsequently, on the Home Front in 1917, Bone worked in the munitions factories, in the shipyards of the Clyde and with the Fleet. Some of these drawings were included in *The Western Front*, but he also published three sets of lithographs taken from them, *Building a Ship, On the Clyde* and *With the Grand Fleet* (1917). These lithographs such as *Battleship at Night* or *Cranes, Start of a new Ship*, are highly successful, and they inspired Stanley Spencer to produce some of the best war paintings of the Second World War when he too worked on Clydeside which he may have done directly on Bone's prompting.[25]

Perhaps what he saw in the war sickened Bone of such subjects. In the following years certainly he turned away from his earlier inspiration except in 1923 when he went to New York where he produced several striking images such as the drypoint *Manhattan Excavation*, reminiscent of his earlier etchings of building in London. In the Second World War Bone again served as a war artist. His ability to make drama out of the documentary had not faded and perhaps the closest analogy in this context is not with any contemporary fine artists, but with John Grierson and the development of the documentary film.

Bone shared the reputation that he enjoyed in America with his younger contemporary,

Plate 256. JAMES McBEY. *The Moray Coast*, ETCHING. 1914

James McBey (1883–1959). McBey came from the North East and he taught himself to etch. In 1902 he printed his first plate, using a domestic mangle and then built his own press. At that time he was working in a bank in Aberdeen and attending evening classes. He continued to work in the bank till 1910 by which time he had moved to Edinburgh. His earliest etchings reflect his amateur status to some extent, but some of them are already very striking. *Mending Nets, Portsoy* (1902), *Charlotte Square*, or *New Town, Edinburgh* (both 1905), are all images in which he avoids the obvious to create a strikingly atmospheric image. In *Charlotte Square*, for example, the dome of the church and the horse and rider on the Albert Memorial float as dark shapes in lesser darkness while a few sketchy figures hurry by, barely discernible in the dusk. The print is a nocturne and as such acknowledges Whistler's influence, but it is highly individual.

When he left the bank in 1910, McBey travelled to Holland, the following year to Spain and in 1912 to North Africa. His etching style continues to vary according to his subject. His Spanish etchings, like *Banderilleras* for example, use an abbreviated, shorthand style rather like Arthur Melville's watercolour technique. *The Skylark* is almost a homage to Rembrandt, but overall his work shows a development towards greater lightness and freedom. Prints done in the North East in 1914,

for example, like *The Moray Coast* (Aberdeen Art Gallery), (*Plate 256*) or *Sea and Rain*, are reminiscent of McTaggart in the airy lightness of the first, which is a view out over the sea from a cliff with children playing in the foreground, or the wild, storm effect of the other, a view of a harbour in rough weather. (Such was contemporary spy-mania that, as was Mackintosh in East Anglia, McBey was arrested while drawing on the Moray coast at this time.)

In 1916 McBey was called up and while serving in France produced some of his most memorable prints. *The Somme Front*, 1917, is a small, intense image of a ruined landscape with two guns and a few shattered trees seen against the sky and is worthy of comparison with Bone. *The Sussex* is a view of a troop-ship, torpedoed and beached near Boulogne, her bow blown open. These prints were produced in his spare time, but the following year he was officially appointed a war artist and was sent out to Egypt where he produced some of his best known prints.

In the history of etching in Scotland McBey's exact contemporary E. S. Lumsden (1883–1948) must also be mentioned. Whereas Bone and McBey moved south, Lumsden was an Englishman who came to teach in Edinburgh in 1908 and the city, which he recorded in a number of memorable images, remained his base thereafter, though he travelled widely including two years spent in India. Lumsden may on occasion actually have worked for Geddes who was increasingly involved in India from 1914. Like McBey, Lumsden was self-taught. He published *The Art of Etching* in 1925 and his championship of the art from his position as chairman of the Society of Artist Printmakers, to which he was elected in 1929, played an important part in keeping interest in print-making alive in Scotland through the difficult years of the thirties. Through Ian Fleming, who was one of the leading members of the society as it was led by Lumsden, there is a direct link to the post-war revival of print-making, for Fleming played an important role in the formation of Peacock Printmakers in Aberdeen in the 1970s.

THE COLOURISTS

From the early 1880s, if not earlier, Scottish painters had been willing to do things in the interest of their art that did not necessarily win immediate public acclaim. The Glasgow painters were part of this, but they were not alone. In 1892, after something of a rebellion in the Royal Scottish Academy, associate members won the right to vote which gave to the younger artists a much stronger voice. At the same time, in 1891 the Society of Scottish Artists had been formed with a view to creating a more modern and outward-looking exhibiting society. Arthur Melville was closely involved in these moves even though he was now based in London and it was an indication of the new society's intentions that in 1894 Degas and Rodin were invited to exhibit with them.

The artists associated with Geddes and *The Evergreen* were very much part of this movement. Charles Mackie has already been mentioned and deserves further consideration, though the details of his career are hazy. His earliest work shows his interest in Barbizon painting and he was certainly in France in 1891. He became friendly with members of the Nabis group and on a subsequent visit in 1893 he met Gauguin. His work in the nineties is characterised by strongly drawn outlines and rhythmic curves related to Nabis work. Mackie however never seems to have subscribed to the deliberate primitiveness of Gauguin's followers. His use of colour too, although Caw criticises him for excessive subscription to colour theory, is by no means outlandish.[1] Laura Knight, who encountered him when she was young and in need of encouragement, remembered his precepts with gratitude.[2] In the early years of the century he returned to a more straight-forward impressionist style of painting, seen in *La Piazzetta, Venice* (1909, CEAC), (*Plate 258*), for example, though the sketch for the picture (also, CEAC) is very free. He also produced a series of coloured woodcuts which are very remarkable for their freedom, high colour key and concentrated intensity of effect. (*Plate 257*)

One or two of these woodcuts were after drawings by William Walls (1860–1942) who was also a contributor to *The Evergreen*. He is best known as an animal painter, but some of his landscape sketches qualify him for inclusion among what are rather loosely called the 'Scottish Impressionists'. J. Campbell Mitchell (1862–1922), William Marshall Brown (1863–1936) and William Miller Frazer (1864–1961) for example were all working in a style that combined the tradition of McTaggart with the ideas of the impressionists with brilliant results, for example in a work by Mitchell like his luminous view of summer twilight, *Bass Rock at Sunset* (Private Collection). There were also artists like James Kay (1858–1942), Alexander Jamiesone (1873–1937) and George Houston (1869–1957), who in the nineties and the first years of the twentieth century were developing an even more informal, atmospheric and colourful kind of landscape painting. James Kay was producing brilliant, free pictures in a high colour key well before the turn of the century. He went on to become chronicler of the Clyde in lovely, informal paintings like *Tarbert, Loch Fyne* (*c.* 1910, Private Collection), (*Plate 259*), but his early work includes some very vivid Parisian street scenes and he made a considerable reputation in France.

George Houston belonged to much the same generation as the four who are now called the Colourists, but Kay and Jamiesone were

Plate 257. CHARLES MACKIE, *Bassano Bridge*

actually of an age with the Glasgow Boys. Together with painters like Mackie, Lavery, Walton, Bessie MacNicol, Alexander Roche and James Paterson, they remained independents in the wider British scene well into the twentieth century. Most of this group in fact exhibited alongside painters like Steer, Orpen, Strang and Tonks in the British Independent Exhibition in 1906. Alexander Jamiesone earned considerable acclaim on this occasion. Significantly McTaggart exhibited his *Emigrants leaving the Hebrides* of 1894 at this exhibition, taking his place at the end of his life at the head of a school of luminous and colourful landscape painting.

Two painters who both died young but who painted with such distinction that they would certainly now be counted with the Colourists were Robert Brough (1872–1905) and William Yule (1869–1900). Brough was born at Invergordon and studied in Aberdeen. Precociously gifted, he also studied in Edinburgh and in Paris, where he was in company with S. J. Peploe. Brough contributed an illustration to *The Evergreen* and was back in France again in 1895. He worked for a while as a portrait painter in Aberdeen, but eventually settled in London where, as a friend and neighbour of Sargent, he developed a portrait style of great

brilliance as in the portrait of the *Marquess of Linlithgow* (Hopetoun House) or more informally *Miss Bremner* (c. 1900, Private Collection). (*Plate 260*) In 1904 Brough travelled through Spain to North Africa where he produced watercolours reminiscent of Melville. The painting *The Spanish Shawl* (1904, whereabouts unknown) was probably a result of this trip. It is a full-length portrait of a woman in white with a brilliantly coloured shawl and which shows his affinity to Peploe as well as Sargent. Sadly Brough died in a railway accident in 1905, aged only thirty-three.

William Yule was three years older than Brough and had less reputation in his lifetime, but was equally a painter of talent. His most familiar work is his portraiture. In this, like many of his generation, he was influenced by Whistler, but he used a range of low-key colours to great effect. More unusual are his landscapes. In at least one of these, *By the Burnside, Evening*, dated 1892 and painted in Ceres (Private Collection), (*Plate 261*), he seems to show a knowledge of Seurat's sketch style as well as of Nabis painting. A small picture, it is nevertheless an indication of how adventurous Scottish painters were prepared to be in the 1890s.

It is really artificial therefore to isolate from the broader stream of Scottish painting the four individuals who went from this background to make their reputations under the name 'Colourists', S. J. Peploe (1871–1935), J. D. Fergusson (1874–1961), F. C. B. Cadell (1883–1937) and Leslie Hunter (1877–1931). In the end the justification for continuing to treat them separately though is their collective achievement and the international reputation that they have earned as four of the most gifted painters of their generation in Britain.

The term 'Colourist' seems to have been invented by the critic of *Studio* writing about Cadell in 1915[3] and it was not limited in its application until T. J. Honeyman wrote his book, *Three Scottish Colourists* in 1950. Fergusson was not included in Honeyman's account, either because he was still alive or because his art was at times too risqué for Honeyman's taste. Perhaps also it was because Honeyman recognised that there was a polemical quality in Fergusson's art that set him apart

from the other three and in fact, as well as isolating them from the rest of Scottish painting, the term is misleading to the extent that it suggests that they were a homogeneous group. The four were not presented as a group until 1923 when Fergusson's friend John Ressich was instrumental in setting up a show in Edinburgh and Glasgow which subsequently went on to Paris, thanks to Alexander Reid. As it was first proposed this exhibition seems to have consisted of only Fergusson, Peploe and Hunter.[4] Cadell must have been invited to join at a late stage.

Of the four now identified as the Colourists, Peploe was the first to emerge as an artist with an independent style, though he and Fergusson were close friends from an early date. Peploe trained briefly in Edinburgh and then in Paris in 1894. There is a group of early works by him, mostly studio studies and still-lifes, characterised by dark tones and limited colour, but strong and fluent brushwork. According to Cursiter who was writing long after Peploe's death, but who had known him for many years, when he was in Paris as a student in 1894 Peploe had been deeply impressed by Manet;[5] Manet's influence is apparent in a still-life such as *Coffee and Liqueur* (GAGM, Burrell Collection), but his figure paintings are more original. The most ambitious of these is the life-size portrait of *Tom Morris* with pipe and glass (*c.* 1898, GAGM). In this picture as in several others, both of this period and a little later, Peploe has successfully captured the mobility of expression and gesture. The image of Tom Morris with his glass raised recalls the painting of seventeenth-century Holland – in 1895 Peploe had been on a trip to Holland where he was very taken by Hals.

Plate 258. CHARLES MACKIE, *The Piazzetta, Venice*, 1909

In 1896 R. A. M. Stevenson published a book on Velasquez which became quite famous. It was really the key document in a reassessment of seventeenth-century painting, according to the aesthetics of impressionism. Stevenson used his study of Velasquez to argue that impressionism was not a temporary phenomenon, but part of the permanent aesthetic apparatus of western art. Thus Velasquez himself became an impressionist and impressionism was rendered respectable, though in a rather simplified form – it was Stevenson who, to describe Velasquez's impressionist realism, coined the phrase 'a slice of life' – to be incorporated into the common aesthetic where it has held its position tenaciously ever since. Stevenson's argument extended to Hals and also to Raeburn whose reputation enjoyed a spectacular rise in consequence. There were not many other British painters who could qualify for inclusion in this new canon. Hogarth was squeezed in on the strength of just one picture, *The Shrimp Girl*, and several paintings of laughing girls that Peploe did before he moved to Paris in 1910 clearly recall Hogarth's picture, though in the way that these pictures seem to be concerned with the representation of time they are remarkably modern. Peploe's models were first Jeanie Blyth and later Peggy Macrae, but Raeburn was especially topical for Peploe when in 1905 he moved into Raeburn's studio in York Place.

In 1896 Alexander Roche moved to Edinburgh. He had recently been in Spain where he had discovered Velasquez at first hand. According to Haldane Macfall he became as a con-

sequence one of the 'highest living authorities on the works of the great Spaniard'.[6] J. D. Fergusson recalled how Roche, having kindly intervened to help sell some of his watercolours from the Royal Scottish Academy, invited him to his studio.[7] Fergusson was very taken by a sketch he saw there of a work by Velasquez which Roche then lent him to copy, and the influence of Velasquez and Roche, though also of Manet, is clearly apparent in Fergusson's work of this period, in *Still-Life with Jonquils and Silver* for example, (Robert Fleming Holdings Ltd).

Roche was at the height of his fame. He had won a gold medal at Munich and was enjoying enormous success in America. Though he was moving rapidly towards becoming a fashionable portrait painter, he was also painting luminous seascapes and single and group studies of women and girls. Indeed Peggy Macrae sat to him as she sat to Peploe. One of Roche's finest paintings of the period, *The Window Seat* of 1895, was sold when exhibited in America in 1899 (formerly Carnegie Institute, Pittsburgh). It is a painting of three women in light-coloured dresses sitting at a window looking out over sunlit water. The reflections from the water fill the room with brilliant, broken light. This picture, and the contemporary painting *The Looking Glass* (whereabouts unknown), of a woman in a hat looking at herself in a cheval-glass, both find numerous echoes in the work not only of Peploe and Fergusson, but of Cadell too.

In 1903 Peploe held his first one-man show, at Aitken Dott's in Edinburgh and it was a great success. Fergusson's first one-man show did not follow till two years later. Peploe had been to Paris again in 1900. The spectacular series of still-lifes like *The Black Bottle* (*c.* 1903, NGS), (*Plate 262*) and *Still-Life with a Coffee Pot* (Fine Art Society), which he may have shown in 1903, followed this visit. In both pictures he uses a sparkling white table-cloth against a dark ground. Then against this simple tonal opposition he sets accents of brilliant colour with a confidence and precision that is quite breathtaking. His admiration for Hals is still apparent, though Robert Brough was cultivating similar technical brilliance alongside Sargent at just the same time.

Plate 259. JAMES KAY. *Tarbert, Loch Fyne, c.* 1910

It is Peploe's commanding use of still-life, however, which suggests that his main inspiration still lay in Manet and that from him he had learned something new to Scottish painting. Still-life, in spite of W. Y. Macgregor's heroic essay in the genre (see above, p267), was still not a popular subject among Scottish painters. Peploe's adoption of it was an important step in the direction of the pure painting advocated by the exponents of impressionist theory like Stevenson. It represented the final, decisive break with subject-matter and ideas of association which had underlain all Scottish painting up to this time, for even Melville's spectacular Spanish and North African watercolours, which might to modern eyes seem the purest of pure paintings, reflected the imagined intensity of Spanish or Arab ways of life. Still-life, however, had no iconographic burdens to carry. Peploe used it here, just as the cubists did a few years later, as a neutral vehicle. It was the start of a tradition of self-sufficient *belle peinture* which endured in Scotland, and particularly in Edinburgh for much of the twentieth century. In spite of the unfamiliarity of still-life, McOmish Dott of Aitken Dott was very keen on this kind of picture and much regretted Peploe's move into a lighter and freer kind of painting.

From 1904 Peploe seems to have worked in France for part of each summer until shortly after his marriage in 1910 he moved permanently to Paris, where he remained resident until 1912. The change in his painting probably coincides with his first sojourn in Brittany with J. D. Fergusson in 1904, though there are odd hints in paintings done in Barra, possibly as early as 1897, and in Comrie in 1902, of a rather tentative, divided brushstroke that suggest that he was by then already interested in Van Gogh and in painting based on pure colour. From 1904 or '05 to 1910, his studio painting and his plein-air landscapes are somewhat different however. In pictures like *A Girl in White: Peggy Macrae* (1907, Fine Art Society) or *Reflections*[8] it is possible to see the importance of the indoor daylight that he enjoyed in Raeburn's old studio, though it is to McTaggart rather than Raeburn that the breadth and freedom of these paintings should be compared. They are luminous, flooded with light

Plate 260. ROBERT BROUGH. *Miss Bremner*, c. 1900

till the figure is almost dissolved, but it is a cool, north light of blues, greens and whites. The visual logic of such pictures as these, or a small study like *Lady in a White Dress* (Robert Fleming Holdings Ltd), (*Plate 263*), is quite breathtaking. Gathering up Hals, Velasquez, Raeburn, Manet and McTaggart as he does, Peploe is only claiming his birthright as a Scottish and a European painter.

The beach scenes that Peploe painted alongside Fergusson at Paris Plage or Etaples in 1906, '07 or '08 are also dominated by the blue of daylight, but it is accented by the intense colours of direct sunlight. In *Beach Scene, Paris Plage* (Private Collection) painted in 1908 an orange boat stands against a horizon that separates a brilliant, blue sea from a pink sky. The high point of this development came in the

Plate 261. WILLIAM YULE, *By the Burnside, Evening*, 1892

small pictures painted in the harbour at Royan in 1910 (SNGMA), (*Plate 264*), at Cassis which he visited in 1911 and again in 1913, and in the streets and parks of Paris during these years. This kind of painting is still also comparable to the work of McTaggart and Melville, but Peploe, aware of both Van Gogh and his followers among the Fauves, turns up the colour key just so far that it stays within the bounds of a credible description of the experience of intense sunlight.

Sadly, however, Peploe lost the luminous tranquillity of these pictures, and only touched it again occasionally in the land and seascapes that he painted on Iona in the company of Cadell in the early twenties. Perhaps the anxieties of marriage and parenthood made it difficult for him to be so carefree, for in spite of some successes he was having great difficulty in making a living from his paintings. His first son was born in 1910 and a second followed in 1914. Perhaps at a deeper level, coming from a tradition that in the hands of an artist of his stature was still capable of such a clear formulation of aims, and to which he had already given such complete expression, the imaginative leap into the seeming anarchy of modernism was simply too great.

Confronting the development of modernism, Peploe faced the dilemma that Cezanne had faced, the problem of time. Fergusson remembered that time was a subject that they discussed,[9] and logically empiricism in painting has to come to terms with it. It underlies Cezanne's painting, and it was because the

philosopher, Henri Bergson, proposed a single model for time and space that he was taken up so enthusiastically by the Cubists and the Futurists. Peploe's early pictures of movement and fleeting expression are explicitly concerned with the representation of time, yet there is no sign of such a debate in his Paris paintings. Fergusson was certainly pursuing this line of thought, but curiously, considering that Paris was Peploe's base in these crucial years and considering also how advanced his own art was in comparison to what was happening in England, after 1912 when he painted some clearly experimental pictures, Peploe's approach to modernism seems to be shaped by Roger Fry's very static view of post-impressionism. This was presented to the British public in the two post-impressionist exhibitions that Fry organised in 1910 and 1912, at the Grafton Galleries. Peploe and Fergusson, however, were not included in his selection, presumably from ignorance rather than prejudice.[10]

Peploe and his family stayed in Paris till 1912 when they returned to live in Edinburgh. It may be from this moment that still-life again became the central preoccupation of his painting. His open-air painting remained free, but in his studio still-lifes the intricacies of pictorial structure and surface increasingly preoccupied him. There is, for example, a *Still-Life* in the National Gallery of Scotland that was exhibited at the Scottish Society of Artists in 1913 where it earned the adjective 'cubistic' from the *Scotsman* critic.[11] It shows a faceted jug, a bottle, a bowl of fruit and some other props laid out on a crumpled cloth. The whole surface is built up out of interlocking planes with very little depth. These planes are bounded by strongly drawn lines in blue and black. It is this flatness and jig-saw puzzle construction that appeared cubist to the critic, but the integrity of the individual objects is not broken, except in the very background where a wheel-back chair and the wall behind form a passage of pure cubist painting.

Peploe painted landscapes at Kirkcudbright between *c*. 1916 and 1919 and still-lifes from the same years which show a sensitive and thoughtful study of Cezanne, who was being energetically promoted by Fry and others as

providing the whole answer to the dilemmas of modern painting. He was presented as the exponent of a new kind of academic classicism. What this interpretation missed was the ferocious energy that was only just contained in his painting by the discipline of form. The savage liberation of modern art was shelved and instead Cezanne became the excuse for blandness. Peploe still rises above this. In *Kirkcudbright* (1916, Fine Art Society) or *Still-Life with Tulips* (c. 1919, Private Collection) he uses brilliant, almost flat colours, primary reds and blues, and secondary oranges and greens set off by white in the still-life, to create a musical, balanced harmony. Increasingly though, the essential vitality that creates tension within the balance is lacking. He began to use an absorbent, gesso ground which gives a rather chalky quality and some of the still-lifes of the twenties are in the end as bland as the work of any of Fry's followers.

Peploe rises above this most clearly when he gets back into the sunshine. In 1920 with Cadell he made the first of what became regular summer visits to Iona. Cadell had first gone there in 1912, but it had been established as a place of pilgrimage for artists by John Duncan who went there to paint landscapes as early as 1908. (The use of an absorbent ground was also almost certainly suggested by John Duncan who experimented with tempera and gesso grounds.) In the intensity of the light on Iona, Peploe recovered some of the brilliance of his earlier painting. In *Green Sea, Iona* (c. 1931, Robert Fleming Holdings Ltd), (*Plate 265*), for example, the rhythms of Cezanne are still discernible in the structures of rocks, but the whole feel of the painting is enlivened by light, by the translucence of air and water captured in blues and whites, and by the interpenetration of forms dissolved in sunlight. His paintings done in the south of France have the same qualities, but with a wider spectrum of colour.

In the last few years of his life Peploe occasionally touched a new note in his painting. His palette is much more limited, dominated by blues and greys and he builds up a thick paint-surface by reworking again and again. He uses a broad brush which, although it conveys a sense of urgency, has none of the fluency of his earlier

Plate 262. S. J. PEPLOE, *The Black Bottle*, c. 1903

sketch technique. In *Still-Life with a Plaster Cast* (c. 1931, SNGMA), for example, the surface seems unfinished. He is approaching the sense that Cezanne's painting gives, that somehow only a provisional solution can be reached even at the end of an enormous struggle to capture the complexity of things as they are. In *Still-Life with Pewter Jug* (c. 1931, Robert Fleming Holdings Ltd), (*Plate 267*) intense colour in the fruit is set off against areas of earth colour. A *Still-Life of Fruit* [12] is in silvery greys and blues, also shot with earth colours. The painting is plainly under tension and beneath surface order there is a glimpse of anarchy. This is seen in several other late still-lifes like *Still-Life with Fruit* (Gracefield Arts Centre) for example, but also in landscapes painted at Rothiemurchus (1934, Private Collection) and in Perthshire (1934, Robert Fleming Holdings Ltd).

By the time of his death Peploe had attained a considerable reputation. For him, as for Fergusson and Leslie Hunter at the same time, there was a peculiar sweetness in the recognition that came from France in 1924 when works by all three were bought by the French State from the exhibition organised by Alexander Reid at the Galerie Barbazanges in Paris under the title *Les Peintres de l'Ecosse Moderne*. Peploe, his reputation established, in the last year of his life taught at Edinburgh College of Art. It was a small link, but his vocabulary of landscape and still life had already become the

Plate 263. S. J. PEPLOE. *Lady in a White Dress*

common currency of the Edinburgh painters of the younger generation, especially Gillies, Redpath and MacTaggart.

Peploe and Fergusson were already close friends in the 1890s and when Fergusson decided to settle in Paris in 1907 Peploe continued to join him each summer until he too moved to Paris. During these early years their art is naturally very close. In 1910 for instance there are pictures of Royan Harbour that must have been painted with them sitting side by side. There are also pictures by Fergusson such as *Mademoiselle O*,[13] a head of a laughing girl, which is very much the same type of image as Peploe was painting at the same time, *c.* 1905/6, and it is touched by similar memories of Hals and Hogarth. In Fergusson's picture there is the same sense of expression captured in transition as is seen in similar pictures by Peploe. It is almost

as though the girl's face had continued to move under the surface of the paint, but Fergusson uses rich, dark colours where by this time Peploe was using bright daylight. Fergusson's girl is of the cafés and the Paris night. The paint surface is as much sensual as descriptive. The girl's head is at a coquettish angle and in her black fox-fur she is a real vamp. Peploe's daylight pictures are positively chaste in comparison.

This sensuality is present beneath almost all Fergusson's painting. Even his still-lifes, much less numerous than Peploe's, have a feeling of overflowing abundance. This is a quality of the man. It is vividly present in his letters to the dancer Margaret Morris who in 1913 became his lifelong companion and who, after his death, wrote a memoir of their life together, but from his direct involvement with contemporary art in France Fergusson sought to find an ordered

means of expression for his passionate percep-
tions. In fact throughout his life, in spite of the
overt sensuality of much of his painting,
Fergusson kept in view a sense of the intellec-
tual objectives of his art.

Of Fergusson's background in Edinburgh in
the 1890s we know of his contact with Roche.
We know too that throughout his life he
admired Arthur Melville and, at a greater
distance, Whistler. In 1899 in emulation of
Melville he went to North Africa and in 1901
to Spain. The paintings from these trips are in
the manner of Melville. In a passing remark he
also refers to Robert Burns talking about Paris
and Montparnasse, in a way that suggests that
they were on familiar terms. Burns was at this
time working closely with Geddes and
Fergusson's enduring Celticism, which even-
tually brought him to settle in Glasgow because
it was a Highland city, suggests that Geddes was
a formative influence on him.

In Paris in 1907 he was not a tyro, eager
to learn, but was a mature artist. The artistic
situation there between 1907 and 1913 when
he moved to the south of France, has been
the subject of so much discussion that it is
almost impossible to achieve an imaginative
perspective of what it was actually like to be
part of it. The tendency is to assume that for
someone in Fergusson's position his perception
of the scene would have been very much as it
has subsequently been described. The real
situation, however, was much more confused.
There are analogies between Fergusson's work
and that of a number of his contemporaries
with whom he was friendly, but in a situation
of so much give and take the judicious appor-
tioning of influences – the conventional tax-
onomy of art-history – is more than usually
unrealistic.

Fergusson knew Picasso, but his base was
in Montparnasse and on the Left Bank, not

Plate 264. S. J. PEPLOE, *Boats at Royan*, 1910

Montmartre. On the advice of the editor of *Studio* he showed at the Salon d'Automne, with such success that he became a Sociètaire in 1909, showing six pictures that year on a wall to himself. It was the Salon d'Automne that had been the setting for the exhibition in 1905 when Matisse and his associates had earned the label, 'Les Fauves', and it was with this group that Fergusson's sympathies lay initially. He was friendly with Othon Friesz for example. Dunoyer de Segonzac was another good friend. Many years later he wrote a touching tribute to Fergusson for the catalogue of the memorial exhibition held in 1961.[14] In the informal atmosphere of Paris, Fergusson obviously knew many of the other artists who have subsequently been recognised as leading players in the drama of modernism and, when he did not know them personally, he certainly knew their work.

Not surprisingly it is difficult to trace in detail Fergusson's development in the first two years that he was in Paris. His summer work is parallel to Peploe's, but Fergusson is less concerned with atmosphere and luminosity. He comes close to Marquet for example, and uses flatter areas of colour and dark outlines which have been seen as linking him in particular to the painter, Auguste Chabaud. His studio work on the other hand is initially more formal. There is direct continuity, for example, between paintings like his first portrait of the

Plate 265. S. J. PEPLOE, *Green Sea, Iona, c.* 1931

American painter *Anne Estelle Rice: Hat with Bird* of 1907 (GAGM) and his earlier single figures of women like *The Feather Boa*. In two other portraits of the same sitter however he uses a looser technique which is much less reminiscent of Manet. His use of brilliant green in the shadows of the face in *Anne Estelle Rice: Closerie des Lilas* (1907, Hunterian) reveals his admiration of Fauve painting and this is even more marked in *In the Sunlight*, (*c.* 1908, Aberdeen Art Gallery), a portrait of an unknown girl of much the same date. These are still essentially impressionist in their respect for light and form, but in 1910 he painted Anne Estelle Rice in a very different way in the dramatically simplified painting *The Blue Beads* (Tate Gallery). (*Plate 266*) The bold flatness and the reduction of detail, eschewing all elegance, makes this, with the contemporary *Voiles Indiennes* (University of Stirling), the closest any British painter came at the time to accepting the real primitivism which, amounting almost to brutality, earned the Fauves their name, 'wild beasts'.

La Terrasse, Café d'Harcourt (Private Collection), (*Plate 268*), however, is a major painting, probably done in 1908–9, but different in effect. Its lively observation of people in a café is like Fergusson's own rapid, on-the-spot drawings of scenes and individuals in the Paris streets and cafés. The central figure is a beautiful woman who has caught Fergusson's attention, wearing a superb pink dress with a pink hat and roses. These pinks are echoed elsewhere in the composition, complemented by yellow, brilliant green, and white that shades through violet to blue grey. All these vivid colours are orchestrated against black and very dark green. The marvellous elegance of the woman in pink sets the tone. What Fergusson seems to have learned from his experience of contemporary painting is a new decorative freedom, but the pink spots of roses repeated throughout the picture are also reminiscent of Jessie M. King who was in fact in Paris at this time. It is a reminder of how important the decorative tradition still was in Scotland.

La Terrasse, Café d'Harcourt seems to have been a transitional picture. In 1910 John Middleton Murry, while an undergraduate on a reading vacation, met Fergusson. In his autobiography he describes Fergusson's immaculate

Plate 266. J. D. FERGUSSON, *The Blue Beads*, 1910

Plate 267. S. J. Peploe, *Still-Life with a Pewter Jug*, c. 1931

studio as reflecting the sense of order and purpose in his life. He also refers to a recent change of style, confessing that he himself preferred the earlier work, but as an example of Fergusson's sense of himself, he describes how he 'stuck to his guns and faced without flinching the unpopularity that he knew was coming to him through abandoning his earlier and very saleable style'.[15]

Murry was in Paris to read Bergson, the philosopher of the moment.[16] When he first met Fergusson it was in the Café d'Harcourt. Murry, young and inexperienced, was having a difficult time entertaining a skittish coquette and was embarrassed to be observed by Fergusson and Anne Estelle Rice. In his confusion at discovering that they were English-speaking, he describes how he somehow plunged straight into a discussion of Bergson. This first encounter concluded with an invitation to visit Fergusson to see his paintings 'which he [Fergusson] believed to be somehow related to Bergson's philosophy'.[17] Murry also recalled a conversation about Plato and Fergusson's belief that 'his non-representational, decorative art was exempt from the condemnation accorded mimesis'.[18]

The picture which seems to relate most closely to these conversations is *At my Studio Window* of 1910 (J. D. Fergusson Foundation).

A naked woman is standing, apparently framed by the edge of a window and a billowing curtain, but the pattern of the curtain merges with the pattern of the trees and sky behind her. The integration of the figure and ground is emphasised by the way that the silhouette of the figure is broken into its component curves which are drawn flat and so echo the curves of the curtain. It is a cubist picture, though it stops short of the extreme decomposition of the figure that Picasso reached that year in his portrait of *Kahnweiler* for example. The decorative way that the elements of the composition are used suggests that it was not failure of nerve that stopped Fergusson going the whole way with Picasso, however, but a different intention.

Bergson was a fever in 1910. His concept of interpenetration was really the catalyst by which the fully developed cubist style evolved from the imitation of Cezanne, but another catchword for the student of Bergson was 'rhythm'. Bergson used it to identify the fundamental nature of the relationship between knowledge, which has to separate the moments of existence, and reality which is continuous process. As he put it: 'Our perception manages to solidify into discontinuous images, the fluid continuity of the real.'[19] For this reason rhythm is also the basis of all aesthetic experience, the connection between the discontinuity of knowledge and the continuity of feeling. 'The poet is he with whom feelings develop into images, and the images themselves into words which translate them while obeying the laws of rhythm.'[20]

Clearly such an idea is open to emotive interpretation. There can be good rhythms and bad rhythms. Good rhythm is when the moments of knowledge are in tune with the rhythms of life's continuity, and it is in exactly this meaning of Bergson's concept that Murry describes Fergusson using 'rhythm' as a catchword with a whole range of applications in 1910. The following year he went on to paint a picture called *Rhythm* (J. D. Fergusson Collection, University of Stirling), (*Plate 269*) to exemplify the idea. The picture either became, or was subsequently developed from the cover of the eponymous journal *Rhythm* launched in the same year with Murry as editor and Fergusson as art editor.

Plate 268. J. D. FERGUSSON. *La Terrasse, Café d'Harcourt*, c. 1908–9

Fergusson's painting, *Rhythm*, is also a picture of Eve, the feminine principle of instinct and intuition as they were defined by Bergson, and in this interpretation it closely parallels an illustration of *Creation* contributed to the second number of *Rhythm* by Derain. Fergusson's picture shows a robustly built, naked woman sitting beneath a real or a painted tree (it is not clear which it is) – the tree of knowledge. She has a bowl of fruit beside her and an apple in her hand. For Bergson the field of art is also instinct and intuition, which represent a mode of knowledge distinct from intellect.

Intellect goes all round life taking from outside the greatest possible number of views of it, drawing it into itself, instead of entering into it. But it is to the very inwardness of life that *intuition* leads us. . . . Our eye perceives the features of the living being, merely as assembled, not as mutually organised. [This is an echo of Reid and Hume.] The intention of life, the simple movement (the rhythm) that runs through the lines, that binds them together and gives them significance, escapes it. This intention is just what the artist seeks to regain, in placing himself back with the object in a kind of sympathy, in breaking down, by an effort of intuition, the barrier that space puts up between him and his model.[21]

'Instinct is sympathy', however, and Bergson himself implies that this is a feminine principle. Fergusson's figure of Eve is visibly united with everything else that he includes in the picture. She embodies instinct, intuition and the principle at the beginning of life itself in opposition to the external, masculine principle of intellect. To Fergusson the more cerebral art of cubism proper might well have seemed to

Plate 269. J. D. FERGUSSON, *Rhythm*, 1911

reflect too exclusively this masculine, intellectual approach.

Rhythm, instinct, sympathy and the lifeforce itself are all the subject of Fergusson's most ambitious painting, *Les Eus* (J. D. Fergusson Foundation, on loan to Hunterian). (*Plate 270*) It was exhibited for the first time in 1914, but it was finished before Fergusson left Paris for Antibes late in 1913. Given its size, it is twelve feet across, and its complexity, it may well have taken two years to complete. Indeed the figure drawing, which is slightly cubist, is closer to *At My Studio Window* of 1910 than to the sculptural simplicity of the figure in *Rhythm* of 1911. The picture represents a group of two men and four women, life-size and naked. They are dancing together in a bower of trees laden with fruit and flowers. There is a sunlit landscape and blue sky just visible behind them. Fergusson's own account

of the meaning of his title, *Les Eus*, is the 'Well People'. Various conjectures have been made as to where he got it from. The best guess is that, rather than being an eccentric derivation of a noun from the past participle of *avoir*, it is related to the use made of the Greek prefix '*Eu*' by Emile Jacques Dalcroze in the word that he invented as the name for his new science of dance, 'Eurhythmics'.[22]

Dance was very topical. The Ballets Russes performed for the first time in Paris in 1909. In 1910 they premièred *The Firebird*, in 1912 *L'Après Midi d'un Faune* and in 1913 *The Rite of Spring*. Isadora Duncan danced in Paris in 1911. The artists, Fergusson and Peploe included, enjoyed all these things. Margaret Morris whom Fergusson met in 1913 was a dancer and he collaborated with her in designing both dance and costume. Dance was also Bergsonian. It plays a central role in Bergson's exposition of his aesthetic ideas and of the part that rhythm plays in them in *Time and Free Will* which was reprinted in 1910. Discussing grace he proposes that it is rhythm that connects dancer and spectator. With grace, rhythm establishes sympathy between them and this in turn is analogous to moral sympathy.[23] Fergusson is therefore using the dance just as David Allan and Wilkie had done, as a social symbol as well as a physical one. His dancers are a community in sympathy, in rhythm with itself and with nature. The nakedness of the dancers may also be pointed. It would not be surprising if it reflected the nascent naturist movement also concerned with the idea of the harmony of life and nature, and there is certainly a hint of this in Fergusson's use of the nude from this time forward. His own comment on his picture is certainly earthy enough. Writing to Margaret Morris in London when the picture was shown in 1914 he remarked, 'Of course I knew your friend would not like my show. What I was wanting to know was if the "big thing" excited her sensually, touched the spot, so to speak. That was all.'[24]

Les Eus is without doubt one of the most original and ambitious British paintings of its time. It has obvious precedents in its subject in French painting, in Matisse's and Derain's paintings of dance, and perhaps also in Matisse's *Luxe, Calme et Volupté* in its hedonism, but

it is very different in style from either of these. Instead of Fauve simplification, Fergusson has used an all-over design that derives from cubism, but which also recalls Scottish decorative painting of the 1890s. In his wish to make a general statement in a monumental picture, Fergusson still belongs to that tradition. The social metaphor in this picture and the philosophical complexity of both it and of *Rhythm* fulfil the aims of decorative art. They truly constitute figurative art in the sense that Walter Crane gives the term – 'a kind of visible and picturesque logic to satisfy the mind'.[25]

If the above discussion of Bergson recalls earlier discussion of Thomas Reid and intuition (see above, pp157–8), that is not entirely coincidence. Bergson was a major figure in the ongoing discussion of the nature of knowledge and of the relationship between knowledge and experience, the fundamental issue of empiricism, and it was in this field that his influence on the visual arts was most strongly felt. The 'common sense' school of Scottish philosophy that had begun with Reid and that was carried on by Sir William Hamilton and others remained vital well into the second half of the nineteenth century. In French philosophy, after the lectures that Victor Cousin gave in Paris in 1819 on Scottish philosophy, during the nineteenth century links with Scottish thought remained close and commentary on the Scottish school of common-sense philosophy was an important element in philosophical debate. Bergson's master, Ravaisson, belonged in this philosophic tradition and so Bergson himself had intellectual links back to Reid more fundamental than simple common interest.[26]

To return to Fergusson however, there is continuity in his work, with Geddes, too, in

Plate 270. J. D. FERGUSSON, *Les Eus*, *c.* 1910–13

Plate 271. J. D. FERGUSSON. *Damaged Destroyer*, 1918

his interpretation of Bergson's idea of rhythm. The magazine *Rhythm* has more in common with *The Evergreen* than it does with more conventional art journals of the time. Also, in 1914, shortly after his return to London at the outbreak of war, Fergusson painted another *Rhythm* picture, *Rose Rhythm*, in which he gives a Celtic twist to the word. The picture was of a girl called Kathleen Dillon. She had come in wearing a hat with a rose in it.

> Looking at K [Kathleen Dillon] I soon saw that the hat was not merely a hat, but a continuation of the girl's character, her mouth, her nostril, the curl of her hair – her whole character – (feeling of her) like Burns's 'love is like a red red rose'. So she like Burns again lighted up my jingle and I painted 'Rose Rhythm' – going from the very centre convolutions to her nostril, lips, eyebrows, brooch, buttons, background, cushions, right through. At last this was my statement of a thing thoroughly Celtic.[27]

Fergusson had first tried sculpture in Paris in 1907 and he returned to it in the latter part of 1915 in Scotland in a work that was also of Kathleen Dillon and so was related directly to the painting.

In London C. R. Mackintosh and his wife became close friends of Fergusson and Margaret Morris. Mackintosh designed a theatre for Margaret and they were involved together in a project to build studio flats. Neither project bore fruit and the frustration

contributed to Mackintosh's decision to give up architecture and concentrate on painting. There was also some artistic exchange between painter and architect. There is, for example, a painting of *Begonias* of 1916 by Mackintosh (Private Collection) which is reminiscent of the flowers in some of Fergusson's paintings of the preceding years. Fergusson also describes how Mackintosh brought him a present of a pot-plant consisting of two intertwining twigs which became the inspiration for his sculpture *Dryad*. In an essay called 'Art and Atavism' that he wrote for *Scottish Art and Letters* in 1944 he used this sculpture as the occasion for a comment on Celticism and the nature of tradition. 'Tradition to me is the spirit of the race, or nation, which is always there and ready to help, as long as it is kept alive and nourished by creative contributions,' he wrote.[28]

He enlarged on the same theme of the continuity of tradition in an account that he wrote of another sculpture, the bronze head of *Eastra*, Saxon goddess of spring that he made in 1924. He felt that the Celtic peoples were the most creative.

> Since Edinburgh days, I have been interested in Celtic design. The head [of Eastra] is composed entirely of sections of a sphere . . . the brass head is in effect the sun. . . . Art is not Saxon . . . the sculptor-painter is not Saxon, and rather or completely the opposite; he's a pure highland Scotsman, definitely a Celt. He still has a great sympathy with Celtic sculpture and on the celtic crosses there are bosses, round shapes – half-spheres that express for him 'Suns', fullness, open eyes, women's breasts, apples, peaches, health and overflow – something to give, and depending on the sun for its ripeness and usefulness.[29]

Mackintosh was friendly with Geddes and, writing to congratulate Fergusson on the success of a show in 1925, he remarks that he and his wife were going on to stay at Montpellier 'with Prof. Pat Geddes'.[30] Geddes had established, or re-established the Scots College at Montpellier. There is nothing to connect Fergusson directly with Geddes, but the spirit of these remarks made at the end of his life do suggest that they were very closely in sympathy. It is a measure of the complexity of the interrelationships in Fergusson's art on the other hand that the bronze head of *Eastra* can equally well be seen as belonging in the same artistic tradition as Boccioni's classic essay in the spatial dynamism of Bergson, *Development of a*

Bottle in Space of 1912. (*Ile de France* by Maillol made the following year, in 1925, also has a very similar head.) There is also a suggestion of futurist ideas of simultaneity in Fergusson's account of *Rose Rhythm*. In London where he was friendly with Wyndham Lewis, he was obviously conscious of the vorticists' adoption of futurist ideas, ideas which were at least in their mature form another interpretation of Bergson. His own representation of movement was at times very close to the vorticists.

At the end of the war in 1918 Fergusson spent six weeks in Portsmouth painting the dockyards. The pictures that he produced, such as *Damaged Destroyer* (GAGM), (*Plate 271*) are not at all futurist or vorticist though, in spite of their subject-matter. Instead he creates out of ships and dockyards a rather grand, classical, architecture of modernist structures. In 1922 he went on a tour of the Highlands with John Ressich and produced from this a series of luminous and atmospheric landscapes which are somewhat similar in character. *In Glen Isla* (whereabouts unknown), for example, is a view across fields to hills and clouds. The patterns of the landscape build up and echo each other in this progression in a very striking way, strongly marked by Cezanne's influence. These highland landscapes are among the most original pictures of his later career and they clearly reflect the feeling for Scotland that eventually brought him back to make his home in Glasgow.

He also continued to paint the figure and above all the female nude. In *Spring 1914*,[31] a memory of the days before the war began that he spent with Margaret Morris in the south of France, a naked woman reclines against an open window. The view beyond is of blue sea, mountains and palm trees. Sometimes these figure paintings are almost reminiscent of Léger in their simplicity, but they are far more sensual. In *Megalithic* (1931, Private Collection), for example, a naked, statuesque female figure seems to grow out of a standing stone beside her. This picture also reflects his interest in the idea of deeper continuities and a mystical relationship between the nude and the landscape, an idea that he discussed much later in 'Art and Atavism' and that links him with William Johnstone (see below, p354). Compositionally this picture echoes *At My Studio*

Plate 272. J. D. FERGUSSON. *Still-Life*, c. 1920

Window of twenty years earlier, but his painting is now much lighter and more delicate.

Perhaps influenced by Mackintosh, Fergusson took to using watercolour. In some of the watercolours he painted of the sea and landscape of the south of France, and in some of his studies of nudes or still-lifes, he captures a lyrical intensity worthy of the best of his earlier work (c. 1920, Cyril Gerber). (*Plate 272*) But although he returned to France every year and lived in Paris again permanently from 1929–39, he seems not to have been able to recover the commanding vitality of his painting from before the war. In his later years though, first in London in the twenties and then in Glasgow, he continued to play a key role in the development of Scottish painting. His intellectual leadership was central in much that happened and he became deeply involved in the promotion of Scottish art from his base in Glasgow, whither he moved in 1939. (See below, Chapters XIX and XX.)

Fergusson and Peploe were the most ambitious Scottish artists of their generation. This is sometimes presented as a simple product of their proximity to French painting, as though this was capable of measurement. The experience of France and the painting that was going on there – by no means all of it French – was central to their achievement as painters, but they did not go to France naïve. The tradition of Scottish painting in which their ambitions were formed was already

woven from a mixture of strands, some native and some international. It was their ability to draw on these that gave their painting such strength and originality. The two other Colourists, Cadell and Hunter are not such complex artists, though both were men of real talent. They were younger and to that extent naturally followed where Peploe and Fergusson had led.

Thanks to the advice of Arthur Melville, Cadell studied in Paris at the age of sixteen, but the turning point in his career as a painter came only in 1909–10. This may coincide with his meeting Peploe who had a profound influence on him and who remained a close friend. Although he had held his first one-man show in Edinburgh in 1908, his first works in what may be called a colourist style are the brilliant, small pictures that he painted when visiting Venice in 1910. (*Plate 273*) In the years that followed he painted some equally vivid larger paintings such as *Reflection: Silver Coffee Pot* of 1913 (Private Collection) where his use of primary colours and rough execution recalls Van Gogh, but he went on to paint a series of studio pictures which, like Peploe's York Place paintings, are conceived as symphonies in white in the manner of Whistler. Their subject, though, is elegance, the elegance of clothes and the elegance of interiors. *Reflections*, (*Summer*) (1913, Private Collection), (*Plate 274*), for example, shows a woman leaning against a mantelpiece and reflected in profile in a mirror behind. The whole composition is in blues, silvers, and lilacs that are almost white, but

which are set off by sharp, true whites in her gloves and collar, by the black band of her broad hat and the carmine of flowers. The handling, like Peploe's, has the summariness of Hals, while the colour has the impact and economy of Manet. There are many variations on this theme, often with the same titles. The best are the least formal and when he tries to achieve a higher degree of finish he comes close to the glossy elegance of the fashionable painting of Sargent or De Laszlo.

In 1912 Cadell went for the first time to paint on Iona, following John Duncan's lead. Interrupted by the war, Iona became the place for his regular summer painting season. It was an emotive place for anyone interested in Scottish history but, initially at least, its attraction for Cadell was the light and colour, blue sea and sky and white sand. These inspired some of his most memorable paintings including brilliant watercolours. Cadell was a sociable person and as well as John Duncan who continued to paint on Iona, Peploe, William Glass (1885–1965), John McLauchlan Milne (1886–1957) and a number of other painters took to working there. These younger painters developed a second generation of colourist painting.

Cadell rarely dated his works. There is therefore some doubt as to the course taken by his painting after his return from the war in 1919. Apart from the pictures that he painted during the summers in Iona, the best were a series of brilliantly coloured and highly formal still-lifes and interiors. Some of these achieve an astonishing intensity. In *The Red Chair* (*c.* 1920, Private Collection), (*Plate 275*), for example, an orange and a lemon sit side by side against a blue jug on the yellow seat of a chair which is an intense orange red. A cloth draped across it is in green and pink-violet stripes. The background is black. The chair is cut off, top, bottom and side by the edge of the canvas so that the abstract pattern of shapes is stressed.

Although this picture and others like it have been dated to near the end of Cadell's life, they are actually quite close to Peploe's still-lifes of *c.* 1919 and a picture not unlike *The Red Chair* appears in the painting of the interior of his studio by Cadell known as *The Gold Chair*, which is dated to 1921 (Portland Gallery). In 1923 and '24 Cadell went to Cassis in the south

Plate 273. F. C. B. CADELL, *St Marks Square, Venice*, 1910

Plate 274. F. C. B. CADELL, *Reflections, (Summer)*, 1913

of France, on the second occasion in the company of Peploe, and these intense colours, flatly applied as they are in *The Red Chair*, appear in some of his Cassis paintings. It seems more likely that these pictures all belong to this immediately post-war period therefore. Some of his paintings of interiors achieve a similar reduction, *The Orange Blind* for example (GAGM), but later, in both still-lifes and interiors, the immediacy of the best pictures is too often replaced by a kind of glassy perfection which in the last few years of his life gives way to a slightly laboured impressionism as in *Interior, the Croft House* (1932, Private Collection).

Leslie Hunter is the most enigmatic of the four Colourists. T. J. Honeyman wrote a chatty biography of him but, as he knew Hunter, it gives an outline which must be at least broadly reliable. Born in 1879 and taken to California while he was still a boy, Hunter worked first as a magazine illustrator in San Francisco. He was in Paris and Glasgow sometime between 1903

and '05 and he contributed drawings of scenes in and around Glasgow to the *Society Pictorial* in those years. He began his career as a painter in America, though, and was planning an exhibition in San Francisco when he lost all his work in the earthquake of 1906 which was presumably what prompted his again returning to Scotland. Back in Britain he continued to work as an illustrator in Glasgow and in London. He lived a hand-to-mouth existence, but he travelled to France on occasion and he was there when war broke out in 1914. In Glasgow he attracted the notice of Alexander Reid who gave him his first one-man show in 1913. Although always canny, Reid was a very important source of support and encouragement to all four painters and after the merger of his gallery with that of Lefevre in London, he was able to offer them practical support in London as well as in Glasgow.

In spite of his familiarity with Paris, Hunter seems to have been principally inspired at this time by the older post-impressionists and

even by seventeenth-century painting. Certain still-lifes that he painted in the war years and immediately afterwards, which are freely executed in strong colour and against a dark background, like Peploe's early paintings, contain a memory of Manet and beyond him Dutch still-life painting. Honeyman[32] remembered his admiration, *c.* 1923, for a still-life by Kalf in Glasgow Art Gallery. Hunter's *Still-Life with a Green Tablecloth* (GAGM), (*Plate 277*), was presented to the gallery by his patron William McInnes in 1921 and in it there is an accumulation of objects: two silver dishes, a Chinese jar, a fan, a rose and three different kinds of fruit of just such a kind as is seen in the work of seventeenth-century painters like Kalf. In the context of his landscapes too Hunter talked about 'the Northern landscape tradition' and until about 1926, although he certainly knew the work of Matisse, he remained very much an old-fashioned post-impressionist.

From 1919 he worked regularly in Fife. There are a number of very beautiful pictures and studies in watercolour of farm buildings,

Plate 275. F. C. B. CADELL, *The Red Chair*, *c.* 1920

streets and harbours in various parts of East Fife often reminiscent of Van Gogh. The colours are natural. He uses the red of the pan-tiled roofs of Fife to great effect. These are well-integrated paintings, done on the spot in a straightforward fashion. In 1922 he travelled to Italy stopping in Paris where he revealed himself out of sympathy with modern developments. He commented on 'the sickness of the art of to-day', and in Paris again the following year he said of the Salon des Indépendants 'the new school does not paint from nature and there were things in consequence fearfully and wonderfully made'.[33] In 1922, however, he had also had the opportunity to see an important Matisse exhibition and he produced in Venice some of his most beautiful small works. Their colour range is light and brilliant and they have a concentrated richness of effect comparable to the pictures painted there by Cadell more than ten years before. This new luminosity bore fruit in a series of paintings done by Loch Lomond in 1924.

In 1922, although he evidently already knew Peploe, Hunter apparently met Fergusson for the first time. Fergusson's friend, John Ressich, was also a friend and promoter of Hunter. It was Ressich who was pushing the idea of a Scottish show in Paris and in 1924 all four finally showed together in the exhibition at the Galerie Barbazanges. They showed together again in 1925 in London at the Leicester Gallery. Hunter returned to Italy and the south of France in 1926 and from then until 1929 spent most of his time in France, based at St Paul de Vence which was very near to Matisse.

In a note to himself which must be from about this time, Hunter suggests the direction in which his art began to move around 1926: 'Seek harmony not contrast. Go from light to dark, not from dark to light. Your work is never light enough. The eye seeks refreshment in painting. Give it joy not mourning. Give everything a distinct outline. Avoid overfinish – an impression is not so robust but that its first inspiration will be lost if we try to strengthen everything with detail.' Then he adds enigmatically: 'Gauguin.'[34] He might more appropriately have said 'Matisse' for some of what he says is remarkably like Matisse's famous remark that a painting should be like a comfortable armchair.

Plate 276. LESLIE HUNTER, *Reflections, Balloch*, c. 1930

Hunter's work from the first part of his stay in France was typically light and open. He often painted in watercolour and frequently over pen drawing, using a broad-nibbed pen. His technique still recalls Van Gogh, but also shows that he was now paying close attention to the painting of his contemporaries in France. Fergusson was in the habit of working each summer at Antibes and it seems to have been at this time that Hunter really became familiar with the painting of the Fauves and of associates of Fergusson like Segonzac and Dufresne. He had an exhibition in 1929 in New York and the dependence of his art on Matisse was noticed. Hunter himself actually recorded with pride the remark of an American friend that 'he was a more powerful colourist than Matisse'.[35]

That was hyperbole, but clearly he was now being seen as a painter to be judged in the context of Fauvism.

Hunter's painting developed rapidly during the last five or six years of his life. Reid did not like the light, free drawings that he did during the first months of his stay in France, but they led to a much more open and spontaneous way of painting. The whole tonality of his pictures is lighter and the paint is not worked, but left flat, almost like watercolour, so that strong colour is able to sparkle with brilliant intensity. This quality of paint and colour is very close to Matisse as the American critics observed. The lovely Matisse in Glasgow, *La Nappe Rose*, was bought by William McInnes on Hunter's prompting. This was an act of homage and

Plate 277. LESLIE HUNTER, *Still-Life with a Green Tablecloth*,
c. 1921

it was this kind of painting by Matisse that particularly inspired Hunter's late still-lifes like *Still-Life with Chair and Vase of Flowers* (Trustees of the late Fulton Mackay).

The pictures that Hunter painted at Balloch in 1930 or '31 likewise show this influence from Matisse, but they also show how Hunter remained his own man. These pictures, *Reflections, Balloch* (*c.* 1930, SNGMA), (*Plate 276*), for example, are still very much paintings from nature, but in describing what is in front of him Hunter has managed to combine spontaneity with exactness. Colour, tone, the shape and size of brush-stroke and the texture of the surface are all perfectly judged without seeming to have cost any premeditation. He has managed beautifully to balance description with the autonomous language of paint. Sadly, however, these were his last great paintings. Back in the

south of France in 1929 after visiting New York, he suffered a breakdown and had to return to Glasgow. He recovered his health, but after a brief sojourn in London where he was proposing to move, he died in Glasgow at the end of 1931. His last project, typically, was a new departure, an exhibition of portraits which in the end took place posthumously.

Pictures like his late paintings of Loch Lomond show how much more than the other Colourists, Hunter was an intuitive painter. This was part of his appeal to younger painters. The major retrospective of his work held after his untimely death in 1931 was an important landmark in the history of the relationship with Matisse that was a feature of so much subsequent Scottish painting with its stress upon intuitive colour. Hunter's lyrical improvisations on themes from Matisse provided a model which has proved durable, from Anne Redpath to David Michie and David McLure.

Hunter's relationship to the younger generation was a reflection of the way that his relationship to French painting was different from that of Peploe and Fergusson, and, by association with them, Cadell. By the time that Hunter became familiar with it, Fauve painting had settled into the luminous, lyrical colourism of Dufy for example, or the mature painting of Matisse. Almost neo-classical in its sense of order and its relationship to perceived reality, this kind of painting was now quite distinct from the cubist tradition, but also from surrealism. Peploe and Fergusson, in Paris during the critical years of the evolution of modernism before the first war, were not faced with a simple choice between Fauvism and cubism. They were involved directly in what was happening as no other British artists were. Hunter, on the other hand, seems to have been quite untouched by cubism though he was an admirer of Cezanne. In a way, therefore, he was a whole generation behind his colleagues, but as a result he provided a much easier guide for younger painters to the complex, shifting developments of painting in the early decades of the century.

MODERN ROMANTICS
James Cowie and the Edinburgh Group

The four Colourists were among the British painters most closely in tune with the developments that took place in painting in Paris in the years before the First World War, but to look at twentieth-century painting, either in Scotland or in England, in the perspective provided by that development alone is a distortion. A mix of romantic symbolism with the tradition which Walter Crane called decorative was still the mainstream of British art. In the 1920s men like Robert Burns and John Duncan were not dinosaurs, strange antique survivors from another age. They were still leaders and they still had followers. John Duncan remained an active influence and Robert Burns's most dramatically effective decorations were those that he carried out for Crawfords Tearooms in Edinburgh in 1923–27. In the Arts and Crafts tradition, Burns was interested in the relationship of art to commerce and industry and the Crawfords decorations were a classic exercise of this kind. He organised a team of sculptors and painters in a comprehensive design that extended to every detail of the decor. His own contribution, paintings of the scattered ships of the Spanish Armada that made their way round the coast of Scotland in 1588 (RSA), (*Plate 279*), were a brilliant example of decorative design.

Although strictly outside the scope of painting, an even grander contemporary project deserves mention in this context. The National War Memorial in Edinburgh Castle designed by Robert Lorimer was the most complex undertaking in the field of public art, perhaps in the whole of Britain. This was a massive work of collaboration involving a large number of sculptors and other craftsmen in a total of more than sixty separate works of art

including the remarkable stained glass of Douglas Strachan. Lorimer as a young man had been a member of the committee of the Edinburgh Social Union and he remained loyal to its ideals, going beyond any contemporary architect in his encouragement of artists and craftsmen. Almost as a result of his enterprise alone a vigorous school of sculptors grew up in Edinburgh between the wars, including Pilkington Jackson, Alexander Carrick, Percy Portsmouth, Phyllis Bone, Alison Meredith Williams and her husband, and the wood-carvers, the brothers Alexander and William Clow. This tradition carried on in the next generation too in the work of Tom Whalen, Hew Lorimer who is Robert's son, Elizabeth Dempster and others.

In Edinburgh John Duncan's closest follower was Eric Robertson (1887–1941) who was the most colourful figure in the group of painters who, after exhibiting together in 1912 and 1913, exhibited as the Edinburgh Group in 1919, 1920 and 1921. Cecile Walton (1891–1956), daughter of E. A. Walton, whom Robertson married in 1914, was also a member of the Group. The marriage eventually failed and in failing virtually brought an end to Cecile Walton's career as a gifted painter. W. O. Hutchison (1889–1970) another member, was a close friend of Robertson. A very successful academic portrait painter, he returned to Scotland after a period in London to become Director of Glasgow School of Art and was subsequently knighted as President of the Royal Scottish Academy. Hutchison married Margery Walton, Cecile's younger sister. Mary Newbery (1892–1985), daughter of Francis Newbery, was working as an applied artist and exhibited with the Edinburgh Group in the early twenties. She

Plate 278. J. R. BARCLAY, *The Towpath*, 1927

later turned to botanical painting and was much influenced by C. R. Mackintosh whom she knew as a close family friend. She, also, married another member of the Group, the landscape painter, Alick Sturrock (1885–1953). D. M. Sutherland (1883–1973) is remembered for his teaching, especially at Aberdeen where he was Head of Gray's School of Art from 1933–48. He was a good landscape painter in a slightly academic way and his best paintings belong to the period of the early twenties, *Breton Dancers, Concarneau* (1920 or '24, Private Collection) for example. Continuing these marital convolutions, Sutherland married Dorothy Johnstone (1892–1980). She was one of the most gifted members of the Group, but her talent was sadly sacrificed to the marriage. She continued to paint, producing landscapes and paintings of her family, but her best pictures belong to the early years of her career.[1]

The remaining members of the Group were J. G. Spence Smith (1880–1951) and J. R. Barclay (1884–1964). Spence Smith was a landscape painter rather like Sutherland, but in the twenties Barclay painted scenes of rural labour in a bold, flat and distinctly modernist way, for example *The Towpath* (1927, Calton Gallery). (*Plate 278*) He was also a distinguished printmaker. Keith Henderson's masterpiece *Wool Waulking* (1927–8, EU), (*Plate 280*) is a similar modernist, rural image. Henderson (1883–

1982), born in the south, came to Scotland about this time. William Glass (1885–1965), a landscape painter who in the twenties frequently worked alongside Cadell on Iona, exhibited with the Group. Cadell himself, the young Anne Redpath and, from Glasgow, Archibald McGlashan and the sculptor Benno Schotz also all exhibited with the Group.

Robertson, Walton and Johnstone were the three leading painters of the Edinburgh Group and their styles were closely linked, but the Group as a whole did not have a distinctive style and had plenty of common ground with other painters. Stanley Cursiter, for example, painted in a way that was similar to that of W. O. Hutchison. In 1913 he had a brief flirtation with futurism, but the year before he had painted *An Intermezzo*,[2] a portrait of a girl in elegant costume reclining on a couch and he quickly returned to this fashionable manner to become an accomplished, academic portrait painter. James Gunn (1893–1964), a friend of Hutchison who came from Glasgow and worked mostly in the south, was also a successful, professional portrait painter though at times, as in his portrait of *James Pryde* (1924, CEAC), he rises well above the limitations of the academic portrait. (One of Hutchison's finest portraits is of Gunn.) Donald Moodie (1892–1963), Penelope Beaton (1886–1963), and Adam Bruce Thomson (1885–1976) all worked principally as landscape painters in styles that were similar to those of Sutherland or Sturrock. All three also taught at Edinburgh College of Art where David Alison (1882–1955) was Head of the School of Drawing and Painting throughout this period.

The Edinburgh Group gained considerable celebrity, not to say notoriety, from their exhibitions of 1919 and 1920. One reviewer wrote in 1920: 'Usually people look to the Edinburgh Group, as we know them, for something unique, rather than universal; for something of pagan brazenness rather than parlour propriety. Half Edinburgh goes to Shandwick Place, secretly desiring to be righteously shocked, and the other half goes feeling deliciously uncertain it may be disappointed by not finding anything sufficiently shocking.'[3] This salacious interest was certainly partly inspired by the singularly involved lives of some of its

Plate 279. ROBERT BURNS, *A Ship of the Armada*, 1923–7

Plate 280. KEITH HENDERSON, *Wool Waulking*, 1927–28

members, especially Eric Robertson who was, it seems, in sexual matters a notorious non-conformist. Like several others of the Group, Robertson was a pupil of John Duncan and an admirer of the older man. Robertson's earlier works, like the drawings *Lilith*, and *The Temple of Dreams*, both of 1909, and *From out the Revellers of Love's Delight* of 1911 (all Piccadilly Gallery) seem to have cost him Duncan's good opinion, though, because of the suggestive way he used the nude. The painting *Love's Invading* of 1919 (CEAC), (*Plate 282*) is one of five related pictures of similar character derived from a drawing of 1915, *The Daughters of Beauty* (Private Collection).[4] (Between 1915 and 1919 Robertson served in France with the Friends' Ambulance Service.) Only one other was completed, *Le Rond Eternel* (1920, Private Collection).

Love's Invading still owes more than a little to Duncan as it is compositionally very close to his painting *The Coming of the Bride* (GAGM) of much the same date, but in its paganism Robertson's picture also has an affinity with such pictures by William Strang as *Laughter* of 1912 (Victor Arwas), in which a naked female leads a group of others who are fully-clothed. This is the situation in Robertson's painting. Against a background of trees, five female figures are dancing, while a sixth looks on. They are all exotically dressed except the foremost figure who is naked but for a rose and a mane of hair. The painting is flat and simplified with a timeless setting, but a shaft of real sunlight strikes across the figures, picking up

detail, outlining the breasts and legs of the leading figure and creating a natural pattern of shadow. Suddenly, without any loss of mystery, the dream becomes reality. The light snaps the image out of the etiolated world of symbolist, decorative flatness into palpable reality and gives startling, erotic force to the nakedness of the leading girl. The hint of pagan excitement is given more piquancy, too, by the fact that the figures to left and right are real people. They are Cecile and Margery Walton so the central figure is unlikely to have been a figment of the artist's imagination.

It is not just the light, it is also the quality of the drawing which has this effect in Robertson's picture. There is a beautiful pastel study for it which is clearly done from the life (Piccadilly Gallery). In it he has preserved the neo-classical discipline of his early work, but he has combined it with a refined naturalism. This is even more striking in another drawing, called *Youth on the Mountains* (1922, Piccadilly Gallery). (*Plate 281*) It is an erotic scene with a naked girl, her clothes lying in a heap, dancing before a group of her friends. They are dressed in everyday clothes, except for one male figure who is also naked. The setting is the Cairngorms near Aviemore. The girl is identified as Anne Finlay and the scene seems to parallel an occasion when Robertson and Anne Finlay left the company of their friends, including his wife Cecile, while out walking. They rejoined the company dressed in each other's clothes.[5] The quality of the drawing is disciplined and intense. It is mostly in line, but one area has been worked up into a delicate chiaroscuro very like that seen in contemporary paintings by Dorothy Johnstone. The interaction of real experience with the unreal clarity and incisiveness of execution gives the drawing a memorable quality.

The erotic tone of some of Robertson's paintings has a parallel in *The Breakdown* (1926, destroyed), the most remarkable picture painted by John Bulloch Soutar (1890–1972), a contemporary from the North East. Soutar was trained in Aberdeen and shortly after the first war moved to London. In *The Breakdown* a black musician in evening dress and top hat is playing the saxophone, seated on the fragments of a broken statue that looks suspiciously like Britannia. A white girl is dancing beside him in

nothing but her earrings. Her clothes are scattered in abandon. A silk stocking and a high-heeled shoe are visible in the foreground. The picture is painted in a sharp, neo-classical way that suggests that Soutar was aware of de Chirico, though there is nothing surreal in its structure. It was withdrawn from exhibition at the Royal Academy, however, at the request of the Colonial Secretary because 'it is feared it will increase our difficulties in ruling coloured people'[6] (a response not unlike that which greeted Wilkie's *Distraining for Rent* more than a century before). Soutar destroyed it, but he repainted it many years later (1962, Private Collection). (*Plate 283*) The rest of Bulloch's work, much of it portraiture, does not match up to the startling implications of this painting, but a portrait of his wife, Christian, painted in 1925 is of very great beauty (Private Collection).

Eric Robertson's *Dance Rhythm* (1921, Private Collection), (*Plate 284*) is one of several pictures in which he developed further the theme of the dance and its title suggests that he may have been conscious of J. D. Fergusson's work. It shows a line of dancers, high-kicking beneath

stage-lighting. Their half-naked bodies, the patterns of costume and the beams of the spotlights are reduced to semi-abstract, repeated, rhythmic shapes in a distinctly art-deco way. In fact the style has become so familiar that we can easily overlook the way in which Robertson has precociously translated the staccato of vorticism into the new sensuous elegance that was to become the style of the twenties.

Robertson himself painted a more directly vorticist picture in 1919, *Shell Burst* (CEAC), a memory of his experience of the war, but the decorative quality of *Dance Rhythm* has an affinity with the group of paintings that Stanley Cursiter did in 1913 in response to the futurist works that had been in Roger Fry's second post-impressionist exhibition. A small group of these had also been shown subsequently at the Royal Scottish Academy in Edinburgh. In these pictures, for example *Princes Street on a Saturday Morning* (James Holloway), or *The Ribbon Counter* (Private Collection), Cursiter turns the dynamic language of futurism into an elegant decorative device in a way that also anticipates art deco. One of them, *Yachting Regatta* (SNGMA), is in fact rather like Robertson's

Plate 281. ERIC ROBERTSON, *Youth on the Mountains*, 1922

Plate 282. ERIC ROBERTSON, *Love's Invading*, 1919

picture, but a more potent inspiration is Seurat's strange painting, *Le Cahut*. The rhythmic idea is the same and Robertson has made his dancers grotesque, just as Seurat had done. Except for landscape, this was the manner in which Robertson worked from this time forward, though his life was increasingly unhappy and disrupted. After the break-up of his marriage in 1923, he left Edinburgh for Liverpool where he executed a number of murals, but the volume of his work declined.

Cecile Walton's best work is likewise concentrated around the years of the Group's post-war exhibitions. She began under the tutelage of Jessie M. King in Paris when she was there as a student aged seventeen in 1908. Her first published illustrations were for an edition of Hans Andersen's *Fairy Tales* in 1911. She produced book illustrations until the end of her life and her work as an illustrator continues to reveal her link with King, for example in her illustrations to *Polish Fairy Tales* by A. J. Glinski, exhibited in 1920 and published the same year. Like Eric Robertson, Cecile Walton joined the circle of John Duncan in Edinburgh before the war and she also painted on a much more ambitious scale in a classically ordered, realist style similar to Robertson, as in *Suffer the Little Children*, originally a mural for a children's home in Humbie, East Lothian (*c*. 1925, Piccadilly Gallery).

Walton's most outstanding work, however, is both personal in subject and individual in treatment. This is the painting, *Romance* (1921, Private Collection). (*Plate 285*) It shows the artist lying stretched out on a bed, clad only in a towel around her hips. She is holding up in her arms her new-born son, while her first son looks on and a nurse is washing her feet. The expanse of white sheet, the position of the nurse and her own nakedness recall Manet's *Olympia*, or indeed its original, Titian's *Venus of Urbino*, but instead of the sexual tension where the woman presents herself to an implied male gaze, this is a magnificently self-assured feminine picture where the artist sees herself in her own way, as woman and mother. She does this by eliding two iconographic traditions, usually rigorously separated, the nude and the mother and child. The effectiveness of her picture depends on the clear drawing of simplified, but

Plate 283. J. B. SOUTAR, *The Breakdown*, 1926–62

closely observed shapes. There may be something of Cadell in this, and Cadell had exhibited with the Group the year before, but it most closely reveals her sympathy with her friend, Dorothy Johnstone.

Dorothy Johnstone's iconographic range was not so great, but she makes up for this in the quality of her painting. Her best pictures, *September Sunlight* (1916, EU), (*Plate 286*), *Green Apples* (September, 1921) and *April Sunshine* (1920) (both Private Collection), are all variations on the theme of a single girl, seated in bright sunlight and lost in reverie. Johnstone brings to this theme a unique combination of limpid clarity of vision, based on well-articulated drawing, and a delight in light and colour.

In Glasgow in the post-war years the situation was similar to that in Edinburgh. Maurice Greiffenhagen (1862–1931) had been in charge of the Life School at Glasgow School of Art from 1906. As a close friend of Francis Newbery, he was part of the background to the Edinburgh Group too. He was a versatile, academic painter in the manner of late nineteenth-century English romanticism. (Henry Lintott who taught at Edinburgh was a rather similar figure.) Under Greiffenhagen, the composition of figure subjects was much stressed at Glasgow. In 1914 he

Plate 284. ERIC ROBERTSON. *Dance Rhythm*, 1921

was joined by Frederick Cayley Robinson (1862–1927), also a friend of Newbery and a more considerable painter than Greiffenhagen. Cayley Robinson was deeply influenced by Puvis de Chavannes and his art blends the neo-classical formality of Puvis with Pre-Raphaelite romanticism, a mixture that especially influenced James Cowie among the Glasgow painters. Both Robinson and Greiffenhagen, though they held permanent positions, were only visitors to Glasgow, remaining based in London. Nevertheless they provided a stimulus similar to that provided by Duncan in Edinburgh. As a result a group of painters emerged in Glasgow with similar preoccupations to the Edinburgh Group and who formed themselves into the Glasgow Society of Painters and Sculptors in 1919. Its founder members were James Cowie (1886–1956), Robert Sivell (1889–1958), Archibald McGlashan (1888–1983) and the sculptor Benno Schotz. As in Edinburgh, this was not a group of young artists, fresh from college. They were all already in their thirties, but their careers had been interrupted by the war, spent in Cowie's case as a conscientious objector. Two of the Glasgow artists, McGlashan and Schotz exhibited with the Edinburgh Group by invitation. When D. M. Sutherland

became Principal of Grays School of Art, Aberdeen, in 1933, he immediately invited Cowie and Sivell to join him, so the links between Edinburgh and Glasgow were close.

Robert Sivell prided himself on his draughtsmanship which he saw as in the Renaissance tradition. All three of these Glasgow painters shared an interest in drawing and in the figure, which seems at first to have been inspired by Augustus John and the current English style associated with the Slade School. Sivell's work, for example, is strongly reminiscent of both Henry Tonks and Augustus John and lacks either the neo-classical quality of Eric Robertson's drawing, or the severity of Cowie's later work. His most characteristic paintings are of single female figures as in *Girl in a Wood* (1933, SAC) and sometimes this has symbolic overtones. He is seen at his best though, and also closest to Cowie and McGlashan, in a simple genre study like *The Reading Book* (1934, McLean Art Gallery, Greenock) in which a mother supervises her child reading. Between 1938 and 1952 he carried out a series of monumental decorations for the Students Union of Aberdeen University.

McGlashan's work was close to that of Sivell, but, though he too was influenced by the current English academic style, his art was tougher and less affected by the suavity of John. He painted children as in *The Sleeping Child* (c. 1928, CEAC) and *Child in a Cot* (GAGM) with a delicate strength that is closest perhaps to Gerald Brockhurst among his English contemporaries. *Mother and Child* (c. 1931, GAGM), (*Plate 287*) shows him at his best and has a genuine Renaissance quality.

McGlashan, Sivell and Cowie had much in common, especially in the twenties, but the other two lack the complexity of Cowie and it was he alone who developed into a major figure. He was a farmer's son from the North East and took to painting, against parental resistance. He was training to be a teacher in Aberdeen where, instead of English, his intended subject, he turned to painting under the encouragement of James Hector. After a spell of teaching he went to Glasgow School of Art in 1912. Greiffenhagen was already teaching there. Frederick Cayley Robinson did not come to Glasgow until 1914, the year Cowie finished,

but after the war Cowie took up the position of art master at Bellshill Academy, near Glasgow, and so remained very much a member of the Glasgow circle.

Cowie's most characteristic work from the years that he spent at Bellshill Academy was a series of paintings of his girl pupils, posing in the art-room, but arranged in compositions of considerable complexity. The earliest of these is *In the Classroom* of 1922 (Aberdeen Art Gallery). Another similar picture is *Summer Day* of 1925 (RSA). In both pictures the girls are set against open windows. Iconographically they are closely related to Dorothy Johnstone's pictures of girls like *September Sunlight*, and Johnstone herself painted *Rest Time in the Life Class* in 1923 (CEAC). The most ambitious of these early pictures by Cowie is *Sumer is icumen in* of 1925–6 (Private Collection). It is freely painted in a way that is close to Robert Sivell, but also to Sickert, while the drawing of the figures is reminiscent of Augustus John. The title of this picture is the opening line of the first poem in the *Oxford Book of English Verse*, a wonderful celebration in thirteenth-century English of the transition from spring to early summer, and the picture is a poetic subject in the Pre-Raphaelite manner of a kind that Cowie made his own. Three adolescent girls, at the same moment of transition in their lives from spring to summer, are walking on a road which drops away behind them into a June landscape. In the context established by the title the road seems to be the road of life. The hill is so steep that the middle ground is cut out and the landscape appears as a backcloth.

In spite of the abbreviated space, there is too much incident in the execution itself to allow the poetic intention of *Sumer is icumen in* to be clear. Perhaps Cowie was conscious of this weakness in his most ambitious picture to date, for in the late twenties and thirties he reformed his style on the basis of a disciplined approach to drawing closely comparable to that of Eric Robertson a few years earlier. Both artists achieve the same uncanny balance between observation and formality. There is an erotic undertow in much of Cowie's work and

Plate 285. CECILE WALTON, *Romance*, 1921

so he was probably fascinated, too, by the frank eroticism of Robertson. His drawing from the late twenties has certain analogies with the drawing of Wyndham Lewis and also Stanley Spencer, but like Robertson, who was also interested in vorticism, he is more rigorous in his observation and he went on to develop a use of line that is unique in its intensity. When he uses formal distortion, as he does in a beautiful study for *Falling Leaves* (*c.* 1934, Hunterian), (*Plate 288*), for example, it is not simply to provide an easy answer to a pictorial problem. It is dictated by the internal logic of the image and he displays an understanding of Cezanne not matched by many of those willing to imitate the master, in his generation. His use of drawing in preparing a composition, though, seems to be consciously modelled on the art of the Italian fifteenth century and his approach to Cezanne therefore may have been via Berenson's analy-

Plate 286. DOROTHY JOHNSTONE, *September Sunlight*, 1916

sis, in *Italian Painters of the Renaissance*, of form in Masaccio and Piero della Francesca which parallels Roger Fry's interpretation of Cezanne.

Armed with this new command of drawing Cowie embarked on a series of highly formal compositions of schoolgirls in the early thirties, *Two Schoolgirls*, *Falling Leaves* (both 1934 and both Aberdeen Art Gallery) and *Intermission* (1935, Walker Art Gallery, Liverpool). There are numerous working drawings for all these pictures, many of them very beautiful, in which he studies in great detail a small aspect of the composition, a head, a figure, or a piece of drapery. Although the pictures were all finished within two years, it seems likely, considering his working method, that they were the product of several years' application. They are all superb paintings, but the one that seems to summarise this period in Cowie's career is *Falling Leaves*. (*Plate 289*) In it he returns to the theme of *Sumer is icumen in*, adolescence, but in a more wistful form. He had already hinted at the subject of the transience of youth in *In the Classroom*, where through a window behind the girls and visible against the sky, swallows gathering on the telephone wires are, like the girls in the classroom, preparing to fly away. Now however he has arrived at a metaphor of a poetic complexity matched by very few painters at the time.

Two girls are posed against a wall beneath an open window. Leaves are falling outside. Stacked against the wall to the right and above are blank canvases, or white drawing-boards. In front of these is a plaster model of Michelangelo's *Dawn*. It is monochromatic and only partially defined in paint, so that we move from the blank sheet to an image that is still only inchoate. The first girl is dressed in soft, recessive greys. She is softly painted, her face is in shadow and she is looking up with an expression of innocent wonder. She is set in front of the figure of *Dawn*, but behind the second girl, who partially screens her, so that as the eye reaches the second girl at the left of the picture, it comes to the front of the composition. The left arm of this girl describes a long, flat curve, springing from the very front edge of the canvas, thus locating her precisely at the picture plane. She is dressed in strong red and blue, densely painted. Her heavy tunic is like a drapery in Giotto. She looks out and upwards

with a complex and wonderfully observed expression, somehow both hesitant and determined. It seems to evoke both the power and the privacy of the dawn of sexuality as she sits poised to draw on the blank sheet of paper on her knee. Thus the picture moves from the blue sky, through progressive stages of definition to this wonderful image of a girl on the edge of womanhood and about to shape her own life.

Falling Leaves shares its theme of girlhood seen against the inevitability of the passage of time with Millais's painting, *Autumn Leaves*. It was a picture that Cowie knew and admired for he included a reproduction of it as a detail in a small woodcut still life of about this date. It is an act of homage that reminds us how important the Pre-Raphaelite tradition was in this whole context of figurative painting between the wars, but Cowie does far more than compose a variation on a Pre-Raphaelite theme. Millais's picture is a simple juxtaposition of youth and beauty against a landscape symbolic of the passage of time. If it were not so beautifully painted it would be banal. Cowie's image has the complexity of Dyce's *Pegwell Bay* – and Dyce was also a North-Eastern artist – but seen in terms of sexual awakening and the life of the individual, not the conflict of science and faith.

The picture's modernity lies in this introspective intensity. Its closest parallel is perhaps in Lewis Grassic Gibbon's *Sunset Song*, written at just the same time and set in the countryside of Cowie's boyhood. In fact the precise setting of the novel was barely twenty miles from Arbroath where Cowie moved in 1936. The picture is exceptional too in the complete confidence with which the Pre-Raphaelite tradition is incorporated into the artist's understanding of post-impressionism. Only an artist of genius could first have grasped the way that in Cezanne's late painting the question of finish, or the impossibility of achieving finish, assumes temporal significance; how it poses, but does not resolve the whole problem of the presence of time in painting, and then have turned it into a poetic metaphor of such poignancy and precision. In so doing Cowie upsets the orthodoxies of art-history and restores a true balance by treating Cezanne and Millais as equal contributors to, or partners in, his inspiration.

Given the intensity of such a picture as *Falling Leaves* and the way that, through the manipulation of imagery, it enters into the exploration of states of mind that are shaped by forces in the psyche over which we have no control, it is not surprising that Cowie took an interest in surrealism. He seems to have become acquainted with surrealist ideas through the work of English painters like Paul Nash and Edward Wadsworth, but through them he also discovered de Chirico who made a profound impression on him. This was an interest that he shared with Edward Baird (1904–1949) who graduated from Glasgow School of Art in 1927. After a year travelling in

Plate 287. ARCHIBALD MCGLASHAN, *Mother and Child*, c. 1931

Italy he returned to live and work in Montrose where he painted in the early thirties such surrealist compositions as the *Birth of Venus* (1934, Private Collection). A naked female figure is standing in the water at the edge of the sea. She is dwarfed by an assemblage of shells and other objects of half-concealed identity and vaguely suggestive shape. The picture was painted as a wedding present for Baird's friend, James McIntosh Patrick though and is perhaps exceptionally ambitious in its combination of the figure and surrealist still-life.

Cowie shortly afterwards became a neighbour of Baird. In 1936 he moved from Aberdeen where he had been for only a year, to Hospitalfield near Arbroath only a fewmiles from Montrose. Hospitalfield was the house of Patrick Allan Fraser which, originally set up as

Plate 288. JAMES COWIE, STUDY FOR *Falling Leaves*, c. 1934

an art school, had become a summer college for the four Scottish art schools. Cowie's position was that of full-time warden. At Hospitalfield he succeeded George Harcourt (1868–1947) who was a portrait painter, but also painted ambitious figure compositions such as *The Founding of the Bank of England*, one of three wall-paintings in the Royal Exchange, London. In the summer months at Hospitalfield, Cowie had students to teach and for company, and through this contact he exercised a considerable influence on the younger generation.

The interest in surrealism that Cowie shared with Baird is most clearly seen in the very remarkable still-lifes which he seems to have begun in the early thirties. Pictures like Wadsworth's *North Sea* of 1928 which includes a still life of shells must have inspired pictures like Cowie's little *Study of Shells* (Scottish Gallery), or the small and very beautiful, *Still-Life, two shells and a Vermeer* (Ian Fleming), but this picture by Wadsworth also demonstrates the potential drama of setting a complex still-life against a simple landscape, or seascape in this case. This was a formula that Cowie used with great effect in *The Looking Glass* (1934, Private Collection and later version GAGM) for example, or in *High Noon* (1944, Private Collection). From hints like these derived from English surrealism, Cowie created a kind of still-life that was his own. Whereas in some of the English surrealist paintings the rather indecisive execution suggests that the painters are just manipulating ideas, Cowie brings such intensity to his description of objects that they become tangible, belonging to the real world and so it is reality itself that seems to bend and shift. Thus he created an extraordinary kind of mindscape like *Composition* (1947, SNGMA and drawing, called *Transparencies*, RSA). (*Plate 290*) It seems at first sight to be a collage of intersecting images, but it was actually a still-life, created from sheets of glass propped together like a house of cards, with postcards or other reproductions fixed between them. There is also a pile of books, a piece of wax-fruit behind the glass and there are two figurines, a Tanagra figure and a faun, a clay model made by Cowie himself, standing inside this glass structure. The whole thing is

Plate 289. JAMES COWIE, *Falling Leaves*, 1934

set against a landscape which of course is visible both through and around the edges of the glass. Translated into a painting of great beauty, this becomes an almost unanalysable metaphor for the way that we see and experience the world, our minds constantly charged with overlapping perceptions and remembered images, with interpenetrating impulses and ideas.

Cowie did not use this metaphysical language for still-life exclusively. There are two ambitious compositions, *The Evening Star* (1943–44, Aberdeen Art Gallery), (*Plate 291*) and *An Outdoor School of Painting* (*c.* 1938–41, Private Collection) which have a similar, pervading sense of mystery. The latter began as an essay in large-scale figure composition. A group of students (Robert MacBryde was one of them), with canvases and easels, are posed against a landscape. He called the picture *A Frieze* when he exhibited it in 1947 and he uses the frieze-like structure to explore ideal systems of proportion. The principal caesura in the composition seems to fall on the line of the golden section, for example, and these proportions are repeated elsewhere. The composition recalls some of Puvis de Chavannes's frieze-like paintings such as *Inter Artes et Naturam* and

Plate 290. JAMES COWIE. *Composition*, 1947

Cowie was of the generation to whom Puvis was a hero. *An Outdoor School of Painting* is unfinished however. At some point he began to introduce into the background a different set of images which, unresolved, remain ambiguous and suggestive. He did something rather similar too to the background of the haunting *Portrait Group* (SNGMA) which he had first painted *c.* 1932, but reworked some years later.

The Evening Star, like *An Outdoor School of Painting*, is a composition with strong echoes of the early Renaissance. It was the picture which Cowie himself felt best represented his achievement.[7] The subject is a combination of *The Three Graces* and *The Judgement of Paris*. Three nude female figures and a kneeling child are posed in a cave-mouth, against a view of the sea and a prominent rock. The setting is a rock formation on the cliffs near Arbroath called Dickman's Den,[8] but it also directly invokes the setting of Leonardo's *Virgin of the Rocks*. It seems typical of Cowie to take such a reference, match it to a real place and then turn it back into the world of dream. He does the same thing by suggesting the matter-of-fact environment of the studio. The three figures are three models standing among the studio easels just like Seurat's *Les Poseuses*. There are also other references in the picture to Leonardo and to Piero della Francesca, while the woman on the left who is adjusting an earring is an extraordinary combination of Vermeer's *Lace-maker* with Ingres's *La Source*. In Puvis de Chavannes's *On the Seashore* three women are posed against the sea, just as they are in *The Evening Star*. This complex set of art-historical references were the company that Cowie kept in his imagination, but they extend beyond artists to the poets too. Richard Calvocoressi has identified the subject of *The Evening Star* as from Byron's invocation to Hesperus in Canto VIII of *Don Juan*:[9]

> Oh Hesperus! thou bringest all good things –
> Home to the weary, to the hungry cheer,
> (Canto VIII v.107)

and comments on the theme of repose after labour in this passage from *Don Juan*, but in fact Byron embarks on his discourse on

Hesperus, the Evening Star, in the context of repose after love:

> The lady and her lover left alone
> The rosy flood and twilight sky admired;
>
> (Canto VIII v.101)

The two most prominent figures in the picture, the woman in the middle and the woman on the left, distinctly recall the two principal figures flanking Pan in the painting by Signorelli of *The Triumph of Pan*. This was destroyed in Berlin in the war, but was one of the most famous paintings of the early Renaissance with a frankly pagan subject. Pan, fertility god, god of the woods, was associated with love in its most carnal form. A little later Byron epitomises the sensuality of evening with the marvellous line: 'Soft hour! which wakes the wish and melts the heart' (Canto VIII v.108). Cowie's picture is an erotic dream, but it is eros in the context of a deep reflection on art and poetry, the real and the imaginary. His art is not one of separations

Plate 291. JAMES COWIE, *The Evening Star*, 1943–44

Plate 292. JAMES COWIE, *Noon*, 1946

and for him, as for Byron perhaps, eros, art and intellect interpenetrate.

The late picture *Noon* (1946, SAC), (*Plate 292*) carries on the theme of *The Evening Star*. It is equally highly charged, but is more accessible and is more perfectly finished. In it too he returns to the subject of adolescence. A girl is lying sleeping in the long grass. The stillness of midday heat envelops her in a shimmering, almost empty landscape, but a male figure of a faun has materialised beside her, Pan himself, summoned by her imagination. (This is a clay figure made by Cowie, though in his painting he has added a fig-leaf.) He is floating and incomplete, a creature of her imagination. His faun's tail is visible in a diamond of mirror that is suspended above the girl as though in her mental space. The subject is *L'Après Midi d'un Faune*, but Debussy's composition draws on the traditional, classical iconography and the pagan eroticism of nymphs pursued by satyrs.

Here it is a modern girl. Inspired by the sensual languor of noon she has herself conjured up this potent male figure.

Cowie's most direct account of himself is in his late *Self-Portrait* (EU). The composition seems to be based on Poussin's *Self-Portrait* in the Louvre, but Cowie has added a still life to Poussin's austere and geometrical arrangement. He has also put two pictures on the wall behind himself. Immediately behind his head is Poussin's *Coronation of the Poet* and to the left, only partially visible, is a strange picture, one of a group of sixteenth-century French paintings of the Fontainebleau School, of women bathing. Characteristically though, the face in the *Self-Portrait*, though it has a strong presence, is unresolved. It is not unfinished, as the hands clearly are, but the features seem still to be fluid. The portrait is extended in time. Cowie scorned impressionism. He regarded it as mere copying of nature. He said that for him a picture 'must be an idea, a concept built of much that in its total combination it would never be possible to see and copy'.[10] It is a difficult formula to apply to a self-portrait, but he comes closer to succeeding than many of his contemporaries would have done and not just among those in Scotland.

The verse from Byron's *Don Juan* that follows and develops the invocation to Hesperus that inspired Cowie's *The Evening Star* is a translation of the opening verse of Canto VIII of Dante's *Purgatory*. Cowie, student of literature, would surely have spotted this. It was a famous verse that inspired Thomas Gray's *Elegy in a Country Churchyard*. A few lines later Dante writes three lines that Cowie himself might have chosen for us as a motto in approaching the veils and transparencies of his unique, poetic paintings:

Sharpen thy sight now, Reader, to regard the truth,
For so transparent grows the veil,
To pass within will surely not be hard.
Purgatory VIII l. 19–21[11]

THE SCOTS RENASCENCE
Artists from between the Wars

The generation of artists that came of age towards the end of the First World War inherited a changed and more troubled world. Up until then the status of professional artist had offered the possibility of a reasonable living and it is fair to say that the general professional standard was high, but in 1936 Cadell had to apply to the Royal Scottish Academy's *Alexander Nasmyth Benevolent Fund* for financial support. Peploe taught in the last year of his life. Hunter, when he died in 1931, was apparently pretty well penniless. Fergusson, who returned to Scotland in 1939, passed the last years of his life in modest circumstances in a flat in Glasgow which a stroke of luck had enabled him and Margaret to buy. The Colourists were 'advanced' so perhaps their position might not be typical, but their main source of financial support was a small group of wealthy collectors. If these people could not support them, then support for art generally was indeed at a low ebb. The collectors were looked after by dealers like Alexander Reid in Glasgow and London and P. McOmish Dott of Aitken Dott's in Edinburgh. Like the habit of collecting, dealers like these had begun in the previous century. Though they managed to keep things going through the twenties, it was in a deteriorating economic climate. Art is always a sensitive barometer of economic change and the decline of Scotland's industrial base was already foreshadowed in the struggles of her artists in the inter-war years.

The immediate cause of the difficulties of the thirties was the crash of 1929/30, but none of the Colourists had ever made large sums by their painting. The slump that followed the crash, in Scotland at least, was really a final jolt to a dead stop at the end of a long period of slowing down. The art market had peaked with Scotland's prosperity in the last decades of the nineteenth century and it was probably already true by the end of the First World War that there was no longer the wealth available to support a large community of artists. Fashion was changing too. It was not just that artists were producing difficult, 'modern' art. At one time even the most modest interior arrangement would not have been complete without at least some pictures, but the advanced fashions of the nineties spread, and bare walls and empty spaces left no room for serried ranks of gold frames; a change in taste ironically promoted by the artists themselves.

One indicator of the change was the place of art-teaching in the economy of art. In the sixty-odd years from the death of Scott Lauder to the end of the First World War, excepting the artists involved with Geddes in his art school, Burns and Duncan who both went on to teach at the new Edinburgh College of Art, very few major painters were dependent on teaching for their livelihood. Since the end of the First World War the opposite has been true. Most artists have had to teach for at least some part of their lives in order to survive. The art colleges and also the schools have in consequence been indirectly the principal patrons of art and the centres for the artistic community.

In spite of the depressed economic climate, through travelling scholarships, established by far-sighted men like Andrew Grant in Edinburgh in 1924, Scottish artists were not condemned to provincialism. The colleges were still able to provide for their best students the European experience which had been such a vital part of the education of the previous generation, and between the wars this was still

linked to the studio system in Paris. William Gillies, William Johnstone, William Crozier and Anne Redpath were all beneficiaries of travelling scholarships.

The European experience did not swamp native traditions however. Symbolist figure painting remained a sufficiently vital tradition to produce an artist of the stature of James Cowie, and he, like his contemporary, Eric Robertson, represented the continuing vitality of a form of art too often regarded as marginal in the light of what is seen as the inevitable march of European modernism. Of course, neither of these painters was unresponsive to the new ideas. They both participated in the dialogue that was taking place in the twenties and thirties between the tradition that they represented and art from the Continent. New ideas were not seen as hostile to a native Scottish tradition. On the contrary Patrick Geddes continued to champion the idea of a truly modern, national art and his vision found a willing response with the artists. The First World War had provided a terrible example of what he had prophesied was bound to happen to a society where art and science do not work together in 'synergy', but the gifts of technology become instead an all-devouring Moloch, the province of the necrologist as he called it, the Professor of Death. It was not that Geddes rejected either science or technology. His argument was that unless the human sciences were developed in parallel to them, the consequence would be a fatal imbalance. It was against this background that the idea of a 'Scots Renascence', as Geddes had proposed it in *The Evergreen*, was taken up by a new generation led by Hugh MacDiarmid.[1] The 'Scots Renascence' in poetry has been universally recognised as one of the main cultural phenomena in Scotland during the middle decades of the twentieth century. The idea of a similar movement in painting is less familiar, but is just as significant and its impact can be clearly seen from the twenties well into the post-war period. MacDiarmid was a key figure for painting as well as for poetry through his close friendship with William McCance and William Johnstone, but in painting J. D. Fergusson also had a far-reaching influence.

In 1955 Hugh MacDiarmid named Patrick Geddes, together with Francis George Scott, the composer, as amongst those who had been of especial importance to him at the outset of his career.[2] Throughout his life MacDiarmid remained loyal to three of Geddes's central ideas, synergy, modernity and, combining the first two, a national art under the banner of the Scots Renascence. Meanwhile the first champion of Geddes's idea of a Scots Renascence was F. G. Scott. He had been MacDiarmid's school-teacher and they met up again in 1922. Through Scott, MacDiarmid met William McCance and William Johnstone who, with J. D. Fergusson, came to represent the ideals of the Scots Renascence in the visual arts.

McCance (1894–1970) was a conscientious objector. Johnstone a few years younger was enlisted briefly at the very end of the war. McCance was trained at Glasgow School of Art and then completed teacher-training in 1916. He married a fellow student at Glasgow, Agnes Miller Parker (1895–1980), and he and his wife exhibited with Cowie, McGlashan and Sivell in Glasgow. His work at the time was in a bold, post-impressionist style. Debarred from teaching as a conscientious objector, in 1919 he moved to London. There he belonged to the same circles as J. D. Fergusson and Wyndham Lewis. In 1916 he, too, had become friendly with F. G. Scott and his approach to modernism in art was shaped by the nationalist beliefs that he shared with him, beliefs which he also articulated in his writings, as he worked throughout his life as a critic.

Drawings done in London such as *Women on an Elevator* (1925, Cyril Gerber) and a portrait of *Joseph Brewer* (1925, SNGMA) reveal McCance's debt to Wyndham Lewis. One or two of his other surviving paintings of the twenties such as *Conflict* of 1922 (GAGM), which is a dynamically conceived, abstract composition, also have overtones of vorticism, but he was not simply a late follower of Lewis. Writing about McCance and his wife in 1925 in the *Scottish Educational Journal*, MacDiarmid cites the renaissance spirit of 'alignment with ultra-modern tendencies manifesting themselves internationally' and 'accord with fundamental elements of distinctive Scottish psychology'.[3] He also puts words into the artist's mouth to comment on the role of the

engineer and the importance of the machine aesthetic. He cites McCance as believing that there has been too great a cleavage between Engineering and Art: 'Let us no longer alienate our engineers from art. Let us advise our senti-mentalists in art to migrate to spiritualism or let us equip an expedition for them to explore the possibilities of the Celtic Twilight . . . let them give up cumbersome paint and canvas and take to photographing fairies on an unin-habited island.' He also speaks of the 'necessity of coming to terms with the third factor, the Machine, and no longer confining ourselves to the overpast condition of affairs in which only two factors had to be reckoned with, Man and Nature.'[4]

The tone of McDiarmid's prose is reminis-cent of the combativeness of the vorticists, but the stress on a new union between artists and engineers adapts Geddes's ideal of synergy to a vocabulary reminiscent of Léger and the purists, Ozenfant and Le Corbusier, for whom the engineer was to be like the priest of a new religion. In 1925 MacDiarmid proposed a book on *Scots Art* to Blackwoods which was to include a chapter by McCance[5] and in recom-mending him he mentions that McCance has both connections and a reputation in Paris. In addition, Léger's essay *L'Esthétique de la Machine, l'Objet Fabriqué, l'Artisan et l'Artiste* was published in English in the *Little Review* in 1923, a journal that MacDiarmid cites with approval.

McCance's most original images of the twenties are a series of abstract prints with a distinctly machine aesthetic, such as the lino-cuts *Moloch of the Machine; or the Machine Gods* of 1923 and *The Engineer, his Wife and their Family* (1925), (*Plate 293*), and a group of equally mechanistic sculptures, or projects for sculptures such as *Study for Colossal Head* (1926, SNGMA). In the flat, abstract structure of the prints the link to Léger's paintings of the same period is clear. McCance also painted a large mural for the *Daily News* about this time. Unfortunately its appearance is not recorded, but it too was an enterprise very much in the spirit of the purists, though also of course a reminder of how much they perpetuated the ideas of Geddes and the Arts and Crafts movement.

McCance and his wife shared a flat in London for a short time in 1924 with William Roberts. Roberts was the English painter most influenced by Léger and Agnes Miller Parker's pictures of these years are actually quite close to those of Roberts. *The Round Pond* for example is a scene of people promenading in the park.[6] Their figures are rounded into quasi-geometrical shapes and the perspective is steep in a way that is similar to Roberts's paintings of the later twenties. McCance himself is more radical though. In *The Engineer, his Wife and their Family* he uses the rough simplification of lino-cut to give a primitive urgency to his image that is akin to Picasso's *La Danse* of the same year. McCance uses a similar primitivism to give hieratic presence to images like *Study for Colossal Head* as though they were indeed the idols of the primitive, machine religion of a new age; fierce gods that must be propitiated and who are served by a new priesthood of artist-engineers. These images stand on their own in the context of British art of the twenties.

Plate 293. WILLIAM McCANCE, *The Engineer, his Wife and their Family*, 1925

MacDiarmid explains this primitivism in a specifically Scottish context, arguing in his account of McCance's work that, whereas France and England were now decadent cultures, Scotland was poised to create a new culture. An important part of the argument to support this contention was the place of heavy engineering in Scottish life, of the Forth Bridge and of shipbuilding for example. He argues that such works are actually art forms. There was, therefore, he maintained, the base in Scotland for a culture in which sentimentality was exiled and art and science would work in harmony.

McCance himself voices these ideas in an essay called *The Idea in Art* published in 1930:

> In my opinion Scotland is the great White Hope of European art . . . When the Scot can purge himself of the illusion that art is reserved for the sentimentalist and realise that he, the Scot, has a natural gift for construction, combined with a racial aptitude for metaphysical thought and a deep emotional nature, then out of this combination can arise an art which will be pregnant with Idea and will have within it the seeds of greatness. Beside the awareness of this potentiality, however, the Scot must break through his narrow provincial barriers and gain a knowledge of what is actually taking place in the world.[7]

McCance himself moved out of London in 1930. His wife specialised increasingly in wood-engraving at which she was very accomplished and together they concentrated on typography and book production. These arguments reappear, however, in J. D. Fergusson's polemic *Modern Scottish Painting* which was written in 1939, though it did not appear till 1943. Fergusson in 1939 was on the point of returning to Scotland after ten years in France and in choosing to return to live in Glasgow he

Plate 294. WILLIAM JOHNSTONE, *Abstract*, 1927

was acting on the principles outlined by McCance. He chose Glasgow, he says, in a chapter devoted to art and engineering, because 'Glasgow creates things and not imitations of old things, but ships like the *Queen Elizabeth* and yachts like the *Britannia*'.[8] Fergusson's status was considerable. He was the only British artist who could claim to have been one of the pioneers of modernism and he had already explored this kind of machine imagery in paintings like *Damaged Destroyer* of 1918. (*Plate 271*) It is unlikely therefore that he was simply following McCance and MacDiarmid in a line of thought to which he made such a practical commitment. It is more probable that he himself had played a part in formulating this particular brand of Scottish modernism in London in the years just after the end of the First World War.

These ideas were restated with passionate conviction by Ian Finlay in *Art in Scotland* published in 1948 and by MacDiarmid himself in his essay *Aesthetics in Scotland*.[9] Published posthumously, this was written in 1950 at a time when Fergusson and MacDiarmid were actually collaborating on the journal *Scottish Art and Letters*. MacDiarmid quotes almost verbatim from Fergusson's essay and all three place a stress on the role of shipbuilding in establishing this special Scottish claim. As they present them, the great ships of the Clyde, products of skill in the dignity of cooperative labour, should be seen as a modernist equivalent to the cathedrals as they had been described by Walter Crane, the collective artwork of anonymous craftsmen.[10] Finlay in fact paraphrases Crane when he writes: 'A ship, like a medieval church, is the creation of many minds and of a still larger number of hands, and if it achieves beauty this is not to be denied simply because it was not produced in the studio of a single man of genius.'[11] Nor was it only in Scotland that Crane's ideas were topical. Miró's friend, the architect J. L. Sert, published an article in 1950 on the theme of public art, 'Quand les Cathédrales étaient Blanches', ('When the Cathedrals were White') which even by its title upholds for contemporary art Crane's model of the anonymous, collective art of the Middle Ages.[12]

There is a mix of two things in these ideas

Plate 295. WILLIAM JOHNSTONE, *A Point in Time*, 1929–38

put forward by Fergusson, MacDiarmid, McCance and Finlay. On the one hand there are nationalism and the determination to create an art that is specifically modern and so can meet the needs of its own time. On the other hand there is a clear consciousness of the need to come to terms with science and technology, and this mixture of ideas does seem to be a specifically Scottish phenomenon. It has its origins with Patrick Geddes and, though no longer in the framework of nationalism, continues to find expression in the art of Eduardo Paolozzi. Though Paolozzi has always been very much his own man, there is an important link between him and this Scots Renascence group through William Johnstone with whom Paolozzi taught at the Central School in London from 1949–1955.

William Johnstone (1897–1981) studied at Edinburgh College of Art in the years immediately after the war and his earliest important painting, *Potato Diggers, Millerhill* (1922, estate of the artist), is close in style and subject to some of the work of J. R. Barclay. F. G. Scott was Johnstone's cousin, however, and through Scott he had met MacDiarmid when he was still a student. Johnstone does not mention McCance in his autobiography, but when he

went to Paris in 1925 with a travelling scholarship from the Royal Scottish Academy, he went first to see Ozenfant and Le Corbusier.[13] Astutely, he saw the continuity of what they stood for with the Arts and Crafts movement, but nevertheless, feeling they were too far from painting, he went on from them to see Léger. He paid tribute, in words that recall Geddes, to Léger's place in the evolution of 'a new urban art . . . based on modern science and city development'.[14] In the end, however, he chose Andre L'Hôte as the artist offering the best practical training. William Crozier (1897–1930) and William Gillies (1898–1973) also went to L'Hôte's studio. William MacTaggart (1903–1981), who was at Edinburgh College of Art at the same time, was also meant to study there, but for health reasons did not do so. L'Hôte was by this time, if such a thing is possible, an 'academic cubist'. According to Johnstone he was an efficient teacher, but what he taught was essentially formal and the kind of orderly, tonal cubism that he himself practised is clearly seen in the early work of all three painters, while Crozier remained faithful to it in its essentials for the rest of his short career, for example *Edinburgh from Salisbury Crags* (1927, SNGMA). Even MacTaggart painted a

portrait of Crozier in a style distinctly reminiscent of L'Hôte.

Gillies subsequently discounted his experience of Paris. Ironically he had been given his travelling scholarship by Edinburgh College of Art in preference to Johnstone and against the wishes of the external examiner, Sir George Clausen, but for Johnstone, Paris, when he did eventually get there a year later, was a vital formative experience. While Gillies was shy and retiring, he was energetic and outward-going. In Paris too he had as a companion an American sculpture student, Flora Macdonald, whom he married in 1927. She was in the studio of the sculptor Antoine Bourdelle, but she had been in Edinburgh to study stone-carving with Alexander Carrick. It was probably the celebrity of the enormous sculptural project of the National War Memorial, in which Carrick played an important part, that had drawn her to Edinburgh from Paris.[15]

Johnstone was a Border farmer's son. His introduction to painting had been with the watercolour painter, Tom Scott (1854–1927). Johnstone attended Edinburgh College of Art, though he professed to have learnt little from the experience. He never had a regular career as an exhibiting artist and he made his living largely by teaching. He sold very few of his works at the time of their creation and lost or destroyed a good many. He also had the habit of repainting pictures, so his career is difficult to chart in detail. His painting *A Point in Time* (SNGMA), (*Plate 295*) exemplifies this problem. It is one of the most important Scottish pictures of the century and one of the most remarkable pictures by any British painter in the period. He was somewhat vague about when it was begun, however. In his autobiography he says it was in 1927, but talking to him he also described how he began it immediately after he had returned from America in 1929.[16] It was certainly complete in some form in 1933 when Hugh MacDiarmid wrote a poem about it (not published till 1963), but it does not seem to have been exhibited in 1935 when Johnstone held one-man shows in London and in Edinburgh, though it was certainly shown in London in 1938 and again in 1939 when he showed with Reid and Lefevre. (The second Reid maintained his father's admirable tradition of supporting

the best and most original Scottish painters.) Johnstone seems to have been still working on the picture in 1938 when he described the reaction to it of the Catalan sculptor, Gonzalez, a friend from his Paris days who saw it in his studio during a visit to London.[17] He must have begun the picture in 1929, but have worked on it over a period of nine years.

A Point in Time is an extraordinary picture. In it there are three elements which overlay each other. First there is a landscape. Its sweeping, green and blue shapes recall the Border hills. The mysterious symmetry of the Eildon Hills near his birthplace fascinated Johnstone much as the Wittenham Clumps fascinated Paul Nash. Indeed he once said that it was the Eildon Hills that had made him a painter[18] and there are several paintings of the hills that are dateable to *c.* 1929 or 1930 (GAGM, and Penelope Allen). (*Plate 296*) The second element in the picture is an abstract structure of flat, interlocking curves. In a painting called *Selkirk, Summer, 1927* (SNGMA) there is a similar pattern with an underlying wheel shape. In it, as in *A Point in Time*, the elements change from positive to negative as they cross each other in the manner of celtic interlace. The third element is more a process than something concrete. The shapes in the picture are in metamorphosis as though there were human figures taking shape in the landscape. There is a similar effect in *Ode to the North Wind* (Private Collection) and in *Garden of the Hesperides* (lost), both the subject of poems by Mac-Diarmid in his collection, *Poems to Paintings by William Johnstone*. What is outstanding about *A Point in Time*, though, is the way in which these three quite disparate conceptions combine their powers of suggestion and association.

In 1928 Johnstone and his wife went to California to try to make a living. He began to make his way there, but after a year decided to return to Scotland. Amongst the pictures that he had painted before he went to America was a picture called *Rhythm* (now lost). It was a semi-abstract composition of naked figures dancing, like Eric Robertson's painting *Dance Rhythm* exhibited in 1921, but also like Fergusson's *Les Eus*. Behind Fergusson and his implied Celticism there was once again Geddes. At Edinburgh College of Art, too, Johnstone had

as one of his teachers, John Duncan, a close associate of Geddes and an apostle of Celticism. H. Harvey Wood, a student at the College at the same time as Johnstone, says of Duncan: 'in John Duncan it [the College] had an idealistic, insatiably curious, widely, if oddly read scholar'[19] and according to Cecile Walton 'he was one of the few people in Edinburgh with whom she could discuss philosophical matters'.[20] Harvey Wood also adds that Duncan was the only member of staff genuinely interested in modern art.

Whereas McCance, building on the Arts and Crafts tradition of the artist and artisan, turned towards a machine aesthetic for his new art, Johnstone built on the way that the symbolist tradition underlay surrealism, to establish a link between it and the Celtic Revival. When he was in Paris, Johnstone counted among his friends Giacometti and Gonzalez both of whom were linked with surrealism. As well as his early essays in the cubist style of

L'Hôte, surrealist ideas are apparent in the abstract shapes and symbolism of Johnstone's picture *Conception* (1928, lost), for example, and in a number of surrealist 'automatic' drawings done by him some time between 1926 and the early thirties. (*Plate 294*) *A Point in Time*, however, is not simply a surrealist picture. Already, in Edinburgh, Flora had introduced Johnstone to the new American painting.[21] 'Rhythm' was the subject of a series of articles by Thomas Hart Benton in *The Arts* in 1926–7,[22] an American magazine to which Flora subscribed. In 1927 Johnstone painted a picture called *Folies Bergères* in which he used schematic forms similar to the diagrams illustrating Hart Benton's articles. A picture, which he called a study for *A Point in Time*, *Seed (Germination)* (1927, estate of the artist) is an enlarged painting of a seed pod, very like a painting by the American, Georgia O'Keefe. So when he was in the United States the new American painting was of more than passing interest

Plate 296. WILLIAM JOHNSTONE, *The Eildon Hills*, c. 1929

to him and the big, abstract shapes suggesting landscape in his finished picture are very like the paintings of Arthur Dove.

The Americans, much like the Scots, were trying to create painting which was 'modern art', but which was also wholly American. To do this they identified with the traditions of Indian and pre-Columbian art. These, they thought, represented the collective unconscious of the land. In America Johnstone responded to these ideas and seeing Navajo sand-paintings, much admired by the American artists, brought it home to him that the solution to his own problem could lie in the ancient art of Scotland. He saw the possibility of a national art whose roots were in landscape and in the art associated with its primeval history, the art of the Picts and Celts. This was the catalyst in his decision to return home to Scotland.[23]

There are further complexities in *A Point in Time*. The title records preoccupations shared by Johnstone and MacDiarmid who were once again together in London in the early thirties. Johnstone called the picture 'a primordial landscape'.[24] Primordial was a word much used by A. N. Whitehead whose discussion of time in *Process and Reality*, published in 1929, was

abstruse, but it was also very topical and in the draft of his autobiography Johnstone mentions being introduced to it by a young mathematician.[25] At a more popular level Johnstone also mentions another contemporary book with time as its theme, J. W. Dunne's *An Experiment with Time*. Dunne explores the possibility of simultaneous, temporal states. Time, in fact, was the fashionable topic of the period as Anthony Powell observes in *Casanova's Chinese Restaurant*.[26] Johnstone's picture is a poetic statement, not a philosophic one however. Its theme is the way in which time past and time present eternally coexist and the physical landscape is their witness. The figures hidden in his landscape are the ancestral peoples whose art is the stones of Picts and Celts. He, as a child of the same countryside, is one with them in the perpetual present.

Johnstone comes very close to the ideas expressed by Fergusson in 'Art and Atavism' (see above, p324), but the best known expression of these ideas from the thirties is in T. S. Eliot's *Four Quartets*. Their theme is time. Eliot and the two Scots, Johnstone and MacDiarmid, were on close and friendly terms during these years, so the connection is not just coincidence.

Plate 297. WILLIAM JOHNSTONE, *Fragments of Experience*, 1979

Plate 298. WILLIAM GILLIES, *Wester Ross*, c. 1934

The first *Quartet*, 'Burnt Norton', published in 1936, opens with the declaration:

> Time present and time past
> Are both perhaps present in time future,

A little later come the lines:

> At the still point of the turning world. Neither flesh nor
> fleshless;
> Neither from nor towards; at the still point, there the
> dance is.

One can compare MacDiarmid in his poem on Johnstone's picture:

> How the boundless dwells perfect and undivided in the
> spirit,
> How each part can be indefinitely great and Infinitely
> small,
> How the utmost extension is but a point.

In his second poem, however, 'East Coker', Eliot shifts back in time to describe the ancient country rituals of the dance as a living memory in the landscape:

> In that open field
> If you do not come too close, if you do not come too
> close,
> On a summer midnight, you can hear the music
> Of the weak pipe and the little drum
> And see them dancing round the bonfire
> . . .
>
> Keeping time
> Keeping the rhythm in their dancing
> As in their living in the living seasons
> The time of the seasons and the constellations

The dance in *A Point in Time* is the dance of time itself. Johnstone's achievement in the picture is to create a unique, prior, and so quite autonomous pictorial equivalent to some of the most memorable poetry of the period, but it has another literary analogy too. In 1932 Lewis Grassic Gibbon published *Sunset Song*. The following year he wrote an essay, *The Land*. In it he elaborated on the idea of the presence of history

Plate 299. James McIntosh Patrick, *Autumn, Kinnordy*, 1936

in landscape that underlay *Sunset Song*. He was a keen archaeologist. His essay is arranged in four seasons, like *The Evergreen*, and in 'Spring' after describing the current archaeological theory of the colonisation of Scotland in the Bronze Age, he concludes with an imaginative description of the arrival of the Maglemosians, the first settlers, at the end of a long march across the land bridge from the Continent:

> It is strange to think that, if events never die . . . but live existence all time in Eternity, back through the time-spirals, still alive and aware in the world seven thousand years ago, the hunters are *now* lying down their first night in Scotland. . . . Over in the west a long line of lights twinkles against the dark. Whin-burning or the camps of the Maglemose?[27]

Both Johnstone and Lewis Grassic Gibbon create a landscape that, because of its extension in time, embodies in our experience of it the collective unconscious. Johnstone's originality in the context of the rest of British art is striking. Nor was it without effect. Nash's first essays in this type of landscape date from 1934 and Johnstone himself recounts with relish how after Gonzalez had visited him and had seen the

picture, Henry Moore came knocking on his door having heard about it from Gonzalez.[28]

In the dialogue between British art and European modernism, Johnstone's was one of the clearest and most committed voices and he remained to inspire a new generation in the post-war years. His career as a teacher, first as Head of Camberwell School of Art and then of the Central School, both in London, is a separate story that cannot be told here, but he had a profound impact on British art-teaching. Inevitably though, the volume of his production as a painter was affected by the weight of his commitments until he returned to Scotland and to full-time painting in 1960. He was a man of such energy however that he remained a creative painter nevertheless, and it was only in the first years of the war that there was a complete break in his output.

Landscape is the theme to which he constantly reverts, but there are also several mysteriously beautiful portraits like that of his second wife, Mary, painted around the time of their marriage in 1944 (estate of the artist).

There is a portrait of MacDiarmid from c. 1943[29] and a late self-portrait (Camberwell School of Art). The interchange between figure and landscape was one of the underlying themes of his painting from his first pictures of the Eildon Hills. In dark pictures of the mid-forties his subject is frequently the smooth, suggestive shapes of the Surrey Downs. In *Sacred and Profane Love* (1948, Lord Astor) he developed this theme in a commentary on Titian's picture, one of the most beautiful associations of figure and landscape in Renaissance painting.

His later painting, though, was freer and more direct. Landscapes like *Yellow Field* (c. 1948; Mr and Mrs Alan Stark) or *Landscape with Stell* (a stell is a border sheep fold), (1952, estate of the artist) lead up to grand, almost wholly abstract paintings like *Red Spring* (1958–9, EU). The title and certain shapes still suggest landscape, but much of the painting

is gestural. He records his response to the landscape intuitively, without any intermediate stage of translation into formal design and so he moved into the purely gestural work of pictures like the great, black, abstract painting, *Northern Gothic* (1959, Dundee Art Gallery).

The last period of Johnstone's painting follows his return to Scotland in 1960 and to the Borders where he had bought a farm in 1955. After the move he built on the experience of pictures like *Northern Gothic* to develop a kind of gestural expressionism that has analogies with American and French painting of the fifties. He may have been stimulated by the Jackson Pollock exhibition in 1959 in London, one of a series of American exhibitions at the Whitechapel Gallery, but this was not a sudden conversion. He had explored the possibility of purely gestural pictures at various stages in his career, particularly in the 'automatic' brush

Plate 300. Ian Fleming, *Gethsemane*, Engraving, 1931

drawings that had first appeared in his work in 1926 and to which he had returned in the early forties. His background was similar to that of Pollock, too. He had links both to surrealism and American painting as well as an early interest in Thomas Hart Benton, Pollock's three principal sources of inspiration. He had a natural sympathy for what the American was doing therefore. What he learnt from him was the effectiveness of such freedom on a grand scale and the first really ambitious painting in which he used this kind of freedom, *Northern Gothic*, was in effect a scaling up of one of his own early wash drawings. He went on to paint with increasing confidence pictures that are still inspired, if not always by landscape specifically, certainly by nature and the natural world. *Fragments of Experience* (1979, EU), (*Plate 297*) can stand for these marvellous last pictures. Its magical, evanescent colours call to mind lines written by MacDiarmid in 1932 in *Scots Unbound* in which he celebrates the colours of Scotland and the Scots vocabulary of colour:

> Syne let's begin
> If we're to dae richt by this auld leid
> And by Scotland's kittle hues
> To distinguish nicely, 'twixt sparked and brocked,
> Blywest and chauve, brandit and brinked,
> And a' the dwafill terms we'll need
> To ken and featly use,
> Sparrow-drift o' description.

Unlike MacDiarmid or McCance, Johnstone was not a political person, but the idea of a Scottish consciousness underlay his painting as it underlay that of many of his contemporaries. It found expression in landscape which was the common interest of Johnstone's contemporaries who stayed in Scotland, William Gillies (1898–1973), William MacTaggart (1903–1981), Adam Bruce Thomson (1884–1976), William Wilson (1905–1972), Ian Fleming (*b.* 1906), James McIntosh Patrick (*b.* 1907), John Maxwell (1905–1962) and others. Anne Redpath (1895–1965) was part of this generation, but was away in France for much of the inter-war period with her husband and family and did not return to Scotland till 1934.

Because of the Auld Alliance, Geddes, the Colourists, and the Glasgow Boys there was a sense in which maintaining links with France was seen as part of the Scottish tradition, but in 1931 in Edinburgh an exhibition of landscapes by Edvard Munch was the catalyst in a move by younger artists to see themselves as belonging also to the expressionist, northern tradition of Munch, Ensor and Nolde. There are several works from the early thirties by Gillies, for example, such as the superb watercolour of *Wester Ross* of *c.* 1934 (Mr and Mrs John Houston), (*Plate 298*) that are reminiscent of Munch.

This group of painters were also aware of recent developments in English painting, for painters in the south too had been working to establish an identity for their art distinct from the continental tradition. The painting of Paul Nash, Christopher Wood, the early work of Ben Nicolson and the work of the primitive painter, Alfred Wallis, had a far-reaching influence on both Gillies and Maxwell who frequently worked together in the thirties. This is apparent in the adoption by both artists of a consciously naïve approach. They treat the surface of the picture as flat and organise it in a loosely structured way. Perspective is quirky and often deliberately eccentric as in Maxwell's *Church and Houses* (Paisley Art Gallery) or Gillies's *Kyleakin* (George Neillands) both of the mid-thirties. In *Kyleakin* too the drawing is deliberately naïve. Relative scale is ignored and the shapes are only roughly brushed in so that there is no clear contour.

A slightly younger painter, Wilhelmina Barnes-Graham (*b.* 1912), acting on the advice of the principal of Edinburgh College of Art at the time, Hubert Wellington, actually moved to St Ives in 1940 and settling there permanently became a member of the St Ives school. In the forties she developed as a notable abstract painter. Talbert McLean (*b.* 1906) in the postwar period also turned to an austere and formal abstract painting similar to that of the St Ives school, though teaching in Arbroath, James Cowie was also a great influence on him. Scottish painting was not just a provincial extension of the St Ives school however and a full picture of what was new in the art of the early thirties has to include William Wilson, Ian Fleming, James McIntosh Patrick and a number of others whose main work at this time was as printmakers. Here too, though, the English connection is strong and these artists belong in the

revival of print-making and of the use of craft methods such as line-engraving, wood-engraving and chiaroscuro wood-cuts, that was such a feature of British art as a whole in the twenties and thirties.

A good many of these print-makers were trained in Glasgow. Wood-cut and wood-engraving were taught there by Chika McNab, sister of the wood-engraver Ian McNab (1890–1967). He studied at Glasgow after he was invalided out of the army in 1917 and in 1925 went to work in London where he played a part in the revival of wood-engraving. His prints like *A Southern Landscape* of 1933 or six illustrations to *Tam O'Shanter*, strongly designed to use the black and white of wood-engraving to maximum advantage, are amongst the best of their kind in the period. Chika McNab and Ian Cheyne (1895–1955) were responsible for a great interest in these techniques and especially in the coloured wood-cut in which Cheyne specialised. The McKenzie sisters, for example, Winifred (*b.* 1905) and Alison, both students at Glasgow, though they went on to study in London, produced some superb colour wood-cuts in the thirties, like Winifred's *Waterfall*. William and Mary Armour also produced some good prints at this time, for example William Armour's woodcut, *Craigangawn Quarry* of 1933 whose closely structured design is reminiscent of Mackintosh's late landscape watercolours.

Etching was taught at Glasgow by Charles Murray (1894–1954) and McIntosh Patrick was the first of a new generation of etchers. He enrolled at Glasgow in 1925 and was producing distinguished prints while he was still a student. *Ramparts, Les Baux* (1927), for example, is a view from above, looking down on the ramparts and houses of the town and beyond them over a deep valley to rocky mountains. The place and nature of the subject and the way the drawing is developed so that it forms a continuous pattern, both suggest the influence of Mackintosh's watercolours which is very likely. William Johnstone mentions meeting Mackintosh at the Royal Scottish Academy in the early twenties. His reputation among the young was high and this was clearly even more likely to be the case in Glasgow than in Edinburgh.

Patrick developed this kind of highly wrought image in his etchings of the early thirties, drawing inspiration from the detailed execution and high viewpoint adopted by certain sixteenth- and seventeenth-century artists. This established the pattern for his painting too, a pattern to which he has remained loyal ever since. He has specialised in landscape, almost invariably choosing a scene of cultivation, though with hills beyond. *Winter in Angus* (1935, Tate Gallery) is a typical early work. It is strongly reminiscent of Breughel in the way that detail is observed and in the patterns of dark trees and white landscape, but he uses a palette derived from impressionism to create a delicate description of light and tone. The effect can be very spacious as in *Autumn, Kinnordy* (1936, Dundee Art Gallery), (*Plate 299*) and in his best pictures there is a powerful sense of mood derived from this tension between detail and breadth of light. In this respect, though, perhaps his masterpiece is the lovely painting *A City Garden* (1940, Dundee Art Gallery). It is a view out over a drying-green with a shaft of golden, winter sunshine falling between the houses and through the bare trees onto lines of white washing. Some of Patrick's most characteristic works though were produced in response to a commission from the railways in the fifties. They were seen on railway stations throughout the country and became familiar to a huge public.

Plate 301. WILLIAM WILSON, *Loch Torridon*, ETCHING, 1936

Plate 302. WILLIAM WILSON, *St Monance*, ETCHING, 1937

McIntosh Patrick's very long career as a painter has been paralleled by two of his younger contemporaries David Donaldson (*b.* 1916) and Alberto Morrocco (*b.* 1917). Donaldson was already teaching at Glasgow School of Art in 1938 and he rose to become Head of Painting there nearly thirty years later in 1967. It was a position from which he exercised considerable influence, upholding a way of painting that still reflected the influence of the Colourists in some very fine still-lifes, for example *Black Radish*, (1982, Private Collection). Donaldson also carried on the figurative tradition in Glasgow of Sivell, McGlashan and Cowie, not only in his works of the thirties, but also much later in figure compositions like *Susanna and the Elders* (*c.* 1978–82, GAGM) and he is a good academic portrait painter. Alberto

Morrocco trained at Gray's School, Aberdeen, when James Cowie and Robert Sivell were both teaching there and he has handed on something of the tradition that they represented. In some ways a similar figure to Donaldson, Morrocco is a lively and colourful painter. He has worked extensively as a portrait painter and has shown that the academic portrait need not be a tired and lifeless production. From 1950 for more than thirty years he was Head of Painting at Duncan of Jordanstone School of Art, Dundee, and from that position, like Donaldson in Glasgow, he exercised a wide influence on the younger generation.

William Wilson and Ian Fleming who were close friends were particularly important printmakers in the thirties. Wilson was working in Bartholomews the map-printers and attending

evening classes at Edinburgh College of Art when his talent was recognised by Adam Bruce Thomson, who gave him both support and encouragement. A fellowship from the College enabled him to study art full-time. He was then given a travelling scholarship which took him to the Continent. On his return he began work with the stained-glass artist James Ballantyne (1878–1940), and himself became in due course the leading stained-glass artist in Scotland and one of the finest of his generation in Britain. It was always a disappointment to him and a loss to the nation that Basil Spence never honoured a promise to give him a window in Coventry Cathedral. In the early thirties, however, it was as a print-maker that he did his best work.

Around 1930, through Adam Bruce Thomson, Wilson met Ian Fleming who had studied at Glasgow School of Art and was at the time teaching print-making there. The two worked very closely together and both became members of the Society of Artist Print-makers which was led at the time by E. S. Lumsden. The society had started in Glasgow, but had moved to Edinburgh under Lumsden's chairmanship. It had a wide membership, including artists from the south. Lumsden was himself a distinguished print-maker of the generation of Muirhead Bone. There had been a great boom in etching and the collapse of the market in 1929 had been correspondingly intense. It was Lumsden's self-appointed task to see print-making through the crisis.

Ian Fleming was a fellow student of McIntosh Patrick and he too was precocious for he was assisting Charles Murray to teach etching before he had completed his own studies.[30] Fleming's first major work, and still one of his most impressive was the line-engraving, *Gethsemane*. (*Plate 300*) Completed in 1931, this is an astonishing performance. Not only is it a virtuoso treatment of a large plate, it is also a beautiful and very inventive image. *Gethsemane*, the Agony in the Garden, is set in an environment that is partly modern Glasgow and partly imaginary. The figures of Christ and his disciples are in modern dress. The compositional idea is paralleled in McIntosh Patrick's painting *The Egoist* (1927, the artist), and as also in McIntosh Patrick's etchings, the strength and

clarity of Fleming's drawing as well as the nature of the landscape evoke memories of the engravings of the early sixteenth century, especially those of Durer and Mantegna. This early Renaissance severity is seen in a number of print-makers of the late twenties, nevertheless it gives this print a distinctive quality and its combination of modernity and timelessness is more reminiscent of F. C. Robinson's painting, for example *The Call of the Sea* of 1925 (Private Collection), than of Stanley Spencer's well-known work in a similar idiom to which it is more likely to be compared. The severity and strength of the drawing are reminiscent of Cowie, however, and if there is no direct influence, there is considerable community of idea between Fleming and the older man.

Links with English print-makers were close too, however. Fleming's close friend William Wilson produced some of his finest etchings of the early thirties, *The Harrow*, for example, and the *The Threshing Machine*, working on the edge of Epping Forest alongside an English print-maker friend, Edgar Holloway. The particular

Plate 303. WILLIAM GILLIES, *March, Moorfoot*, 1951

quality of Wilson's rural images suggests too that he was not immune to the current vogue for Samuel Palmer's mystical landscapes of his Shoreham period, but these prints also reveal Wilson's interest in early print-makers. *The Harrow*, for example, is a variation on Durer's print, *The Cannon*, deliberately converted from a warlike to a peaceful image, not a sword into a ploughshare exactly, but something very close.

Breughel was an artist whom Wilson and Fleming, like McIntosh Patrick, held in profound respect. Fleming still speaks of Breughel's *Hunters in the Snow* as his favourite picture. Wilson's etching of *Loch Torridon* of 1936 (*Plate 301*) pays homage to Breughel in the high view-point, the bold simplicity of the drawing, and, too, in a detail of the artist sitting in the left foreground, though these things are united with a cubist treatment of space to achieve a strongly atmospheric quality. From the early Renaissance, Wilson and Fleming learned a way of responding to the detail of the actual world. They used all the intricate discipline that was essential to print techniques, but copying the techniques of the old masters they freed themselves from the cult of technical virtuosity that had become typical of modern etching in the tradition that derived from Whistler.

Pride in virtuosity had led conspicuously to a fall in print-making. A reaction in favour of greater humility in the face of nature was understandable, and this was part of the same shift of taste that led Gillies, like the St Ives painters, to emulate the naïvety of Alfred Wallis. Fleming, Wilson, and Gillies had all travelled to the Mediterranean. They all went to Italy and Fleming and Wilson also went to Spain, much favoured by print-makers. Back in Scotland they found an equivalent to the ordered disorder of southern towns and villages in the Scottish fishing ports, especially those of Fife, though the similarity between the harbours of Fife and Cornwall no doubt also played a part.

Wilson's etching of *St Monance* of 1937 (*Plate 302*) is a classic image of this kind. Compared to the work of one of the great architectural etchers among his contemporaries, like Henry Rushbury for example, Wilson has stressed the human character of the place, the way that it has been shaped by use over many generations. The scene is dominated by the ancient gothic church of St Monance, but the rest of the buildings are in harmony with it and are quite timeless, even a black, corrugated-iron hut in the middle ground. The ancient and unchanging technology of the fishermen, the nets and the boats, further stress this continuity and the buildings lean together to shelter the figures. Wilson has used a semi-cubist structure, steep, flat, and faceted, but this is qualified by his intense observation of individual elements which is like that of a painter of the early Renaissance. It is this which makes it such a human image.

Ian Fleming produced some equally strongly perceived and composed images of Glasgow tenements and in the early forties of Glasgow streets in the blitz. These were not simply picturesque images. They were, like Wilson's *St Monance*, about the humanity of townscape; the way it is shaped by familiarity and use. This is an engaged art, engaged with honouring the way people live and the way their work shapes their environment, for better or for worse; there is an etching and related painting (whereabouts unknown) by Fleming of a slag-heap, for example, that is reminiscent of Muirhead Bone's drawing of *St Rollox*. (*Plate 254*) Fleming has remained loyal to this ideal of engagement both as a painter and as a print-maker, producing in later life prints like *Spaghetti Junction: The Dear Green Place* which comments on the wreck of Glasgow by the building of the motorways. His magnificent etching *Thistles in the Sun* (1974, Private Collection), (*Plate 1*) symbolises the optimism of Scotland in the seventies before the referendum.

Fleming was one of a small group of artists to record unsentimentally the urban environment. The interest in Italy that this generation transmitted to their students therefore was not just an interest in Italian art, though this was important, it was this idea of the harmonious integration of townscape and landscape which was still such a conspicuous feature of Italy, a visual image of a social model that Geddes had preached. It was so strong an influence that Italy, as much for its landscape as its art, replaced France as the first destination for

students on travelling scholarships under the teaching of Gillies.

Gillies was not a print-maker and so the sort of intricacy that was a necessary part of the prints of Wilson and Fleming is not seen in his art, though in the thirties the three were very close – compare Gillies's paintings of *St Monance* in 1932 (RSA) or in 1935 (water-colour, Robin Philipson), for example, to paint-ings or prints by either Wilson or Fleming of the same place. Like them he explored the use of cubist or post-cubist ways of handling space to create a sense of intimate immediacy. He too was a draughtsman, especially in dealing with the landscape of the Lothians as in the superb black and white drawing, *March, Moorfoot,* (1951, SNGMA). *(Plate 303)* He drew with a wiry line that could emulate perfectly the way that a dyke, marching over a bare hillside, describes the broad contour, yet is sensitive to its minute variations, as in *Old Bridge, Luggate* (1950, RSA), or could capture the stark silhouette of winter trees. His landscape drawings and water-colours are among his most characteristic works and the discipline of drawing that he shared with the print-makers underlies his work and makes its informality deceptive.

Gillies was immensely prolific. In his life-time he exhibited over a thousand works. Inevitably therefore his work is uneven. His still-lifes have considerable charm, but they are frequently derivative, from Picasso, Braque, Bonnard, or Matisse, and though the result is often convincing in its simplicity, he seems most ill-at-ease when he is being most ambitious. He also painted a small number of portraits, mostly of those closest to him and including a very fine self-portrait (1940, SNPG).

Plate 304. WILLIAM GILLIES, *Tweeddale,* 1959

Plate 305. WILLIAM MacTaGGART, *Winter Sunset, Red Soil*, 1956

The core of his achievement is unchallenged however. This was the creation of a kind of landscape painting that could capture the spare beauty of the Scottish lowland hills and their upland farms and villages, for example, in the watercolour *The Moor* (1950) or *Hillside, Peebleshire* (1953).[31]

In 1939 Gillies moved from Edinburgh to Temple in Midlothian. It remained his home for the rest of his life and the surrounding country-side of the Lothians and Borders provided the inspiration for his most characteristic work. After 1939, too, he ceased to use the more extravagant effects of irrational perspective seen in his painting of the thirties and turned to a much cooler way of painting that only occasionally shows the expressionism of some of his early work. Typical of his work from this time forward are close-toned landscapes handled in flat paint. Economical drawing establishes the patterns made by the line of a river, the intersections of fields and dykes, or the shelter bands of trees. Then he explores the colour which gives life to the scene. Many people make the mistake of seeing as grey what in the Scottish landscape is actually evenness of tone. Gillies was a master at catching the subtle variations of hue, the pinks, greens and blues – intermediate colours which can have quite startling intensity in the soft light. Bonnard was an important inspiration to him in this. Pictures like *Tweeddale* (1959, RSA), (*Plate 304*) or *Dusk*

(1959, Aberdeen Art Gallery) are typical of the best works of the latter part of his life.

Gillies was a quiet person. He lived with his mother and sister, his mother outliving his sister to die, aged a hundred, only a few years before Gillies himself. He was a determined person and although not loquacious, he was an effective teacher. On the staff of Edinburgh College of Art for forty years, retiring as principal in 1966, he left a very powerful mark on the younger generation. John Houston, Elizabeth Blackadder, Perpetua Pope, Earl Haig, Robert Henderson Blyth and others all show a clear debt to his example in the formation of their own styles even though they were not all actually his pupils. He and William Wilson, who both took a great interest in young artists, though Wilson did not teach, together provided a distinguished example of dedication to their art which was as strong an influence as any direct teaching.

John Maxwell studied in Paris with Léger and Ozenfant after finishing at Edinburgh but, like Gillies, this experience left little obvious mark on his art. He taught alongside Gillies at Edinburgh from 1929–1933, from 1935–1946 and from 1955–1961. They were close friends and Maxwell returned to teaching for the last period at the invitation of Gillies. Maxwell enjoyed an enormous reputation amongst his contemporaries and was a major influence on them, though now much of his work looks more dated and less individual than Gillies's. The two worked closely in parallel, but from an early date Maxwell began to develop not only towards a still looser and more expressive way of painting, but also towards a free and associative imagery. As early as 1934 in *Three Figures in a Garden* (Collection Joanna Drew), (*Plate 306*) he created a visual fantasy. Three naked figures, two light-skinned and one dark, are standing in an environment of loosely painted flowers. There is no narrative, just a dream-like suggestion of a simpler and happier world. It is almost a variation on a theme from Gauguin. He drew inspiration from a variety of sources including the work of English painters like Graham Sutherland and John Piper and he is closely comparable to his contemporary, the Anglo-Welsh painter David Jones. Like Jones he was especially interested in Chagall and this is

Plate 306. JOHN MAXWELL, *Three Figures in a Garden*, 1934

clearly seen in his painting of 1938, *The Falling Vase* (Private Collection), in which a woman floats in front of a window, defying gravity like the figures in Chagall's pictures.

He developed a kind of painting in which colour, imagery and handling are all part of an overall decorative effect. His favourite pictorial elements are flowers and female figures, usually in a random, dream-like association. Two watercolours of 1937 for example, *Requiem for a Decayed Affection* and *Figures in a Garden* (both SNGMA) are typical. They are drawn in pen. Watercolour is laid very freely over this so that the ink smudges, and colour and drawing blend in a dream-like harmony. Though it is dream-like, it seems untouched by surrealism. There is no sense of any reference beyond the painting. The imagery is not drawn

from some deeper level of consciousness. Its associations are vague and imprecise. It is really only a series of motifs on which the artist develops a set of visual variations, but the results at their best are exquisite as in the magical painting *Flowers by Night* (Mrs Montagu Douglas Scott).

Also closely associated with Gillies in the early years was William MacTaggart. Like Gillies he was inspired by the example of Munch, but it was the painting of Matthew Smith that set him in the artistic direction which led him later to find inspiration in Rouault, Ensor and other manipulators of heavy paint and strong colour. During the first part of his career he continued to work from a motif as Gillies did, and he produced landscapes in which the use of strong colour and thick paint

Plate 307. ANNE REDPATH, *Still-Life with Orange Chair*, c. 1944

live in France. Her early work shows affinity with the watercolours of Robert Burns who was Head of Painting at the Edinburgh School of Art, though she, like Johnstone, regarded Henry Lintott most highly among those who taught there. Some of her painting done in the south of France suggests, too, that she may have known of Mackintosh's work there. During her years in France she never gave up painting, but her output was greatly diminished until she returned to Scotland in 1934 with her three sons. She lived first in the Borders and then once more in Edinburgh from 1949.

Her work from the forties, in pictures like *Still-Life with Orange Chair*, (c. 1944, Robert Fleming Holdings Ltd), (*Plate 307*), clearly reveals her knowledge and admiration of Matisse. She uses colour as he does, balancing areas of strong, flat colour within a framework of clearly articulated drawing. She also incorporates areas of pattern into her design without however losing completely its spatial construction. Her approach to Matisse is very like that of Leslie Hunter's later work though her actual choice of colour is very like Cadell's, in *Red Slippers* (c. 1942, Private Collection) or *Still-Life with Red Chair*, for example, (see above, *Plate 275*) and in looking at the relationship of this generation to French painting it is important to remember the role of the Colourists as intermediaries. Matisse's view of painting might be described as a rhapsody on the real. Though he had his subject in front of him, he was not bound by its appearance. His intention was more to make a pictorial equivalent to the feelings that it aroused in him.

Redpath remained loyal to this view of painting more than did either Maxwell or Mac-Taggart, but, particularly after her return to Edinburgh in 1949, she developed a much freer and more consciously emotive approach, very like that of Maxwell. As travel began to become possible again in the late forties and early fifties, she began to explore new kinds of effect. Texture became a more important part of her image. *Rain in Spain, Ubeda* (1951, Private Collection), for example, is composed in flat greys and chalky whites relieved by gold and black. It recalls Utrillo. Her colour became stronger too as she evidently felt less and less need for precise articulation of form.

laid on energetically capture a genuine poetic intensity like *Winter Sunset, Red Soil* (1956, Arts Council Collection), (*Plate 305*) or *Sunset Humbie* (EU). Like Maxwell, however, as his painting became more autonomous and he worked without outside reference, the rationale of his pictures becomes less apparent. One of his most frequent subjects was the view from his window looking out over Drummond Place gardens in Edinburgh. He would set up a still life of flowers, and paint in dark, powerful colours pictures that, as he struggles to inform them with meaning from sheer force of sentiment, waver on the edge of incoherence.

MacTaggart's late work in its strong colour and strong handling has much in common with Anne Redpath's work after her return to Edinburgh. Redpath had exhibited with the Edinburgh Group at the very beginning of her career, but left Scotland with her husband to

Plate 308. ANNE REDPATH, *Landscape, Kyleakin*, 1958

In these late pictures a variety of influences are at work. Roualt, for example, who also greatly influenced MacTaggart, is part of the inspiration of some of her paintings of religious subjects like *S. Nicolo dei Mendicoli* (*c.* 1964, Private Collection) which is a view of a crucifix hanging over an altar. What distinguishes her as a painter, however, is the way that she remained open to new ideas and continued to develop up until the end of her life. In her latest works she pushes her own work to the edge of abstraction. This move may perhaps have been in response to the example of French and American painting. Willem de Kooning for example was an inspiration to a number of painters in Scotland in the late fifties, including Robin Philipson, Joan Eardley and John Houston. Redpath's *Daisies in a Vase* (1964, Private Collection) strongly recalls de Kooning, but she remained loyal to her own ideals. In her late watercolours, for example *Flowers in a White Vase* (*c.* 1962, Private Collection), she achieves a magical and quite independent freedom. *Landscape, Kyleakin* (1958, SNGMA), (*Plate 308*) is a view of highland cottages and boats. They are stark accents of grey and white set in a turbulent flow of black and fiery red. This drama recalls Clifford Still's abstract landscapes, but it is quite autonomous. Colour and texture coalesce around the image, but the picture is an equivalent, not a representation, just as a piece of music similarly titled might be. The result of the American influence was to give her painting a new freedom which MacTaggart never achieved. In his late work his relationship to his subject-matter sometimes seems unresolved and it remains earthbound. Redpath in her best work manages to touch the transcendental.

Plate 309. JOAN EARDLEY, *Children, Port Glasgow*, c. 1955

THE SECOND WORLD WAR AND THE POST-WAR PERIOD

It was really Redpath, MacTaggart and Maxwell whose art provided the basis for the view that Scottish painting in the mid-century was dominated by colour. It was an idea that provided a certain continuity with the previous generation amongst whom it was Leslie Hunter who most closely anticipated their approach to painting because of his closeness to Matisse. This sense of continuity was very important during the dark years of the forties, and in a way perhaps the extreme aestheticism of much of their painting, its withdrawal from any kind of overt social or intellectual commitment, was a necessary husbanding of resources in order to preserve the vital core of a sense of national tradition. Certainly by the fifties these three, with Gillies and Wilson, were established in the public mind as the nucleus of a Scottish school. Younger painters like Earl Haig, David McLure, David Michie, John Houston and Elizabeth Blackadder, distinct though they are from each other, all paint in ways that are recognisably akin to work of these older artists. The very strength of this group identity also meant that it was something to react against. In the late forties William Gear, Eduardo Paolozzi, Alan Davie, in the sixties John Bellany and Alexander Moffat, and even the Edinburgh generation of the seventies, all started from the rejection of the Edinburgh approach.

In spite of the undoubted success of those whom in 1945 T. Elder Dixon[1] called the 'East Coast painters', however, in the war years it was in Glasgow that the spirit of the Scots Renaissance was kept alive. This was in part due to the presence of several artistic refugees. They included Josef Hermann and Jankel Adler from Poland, but the real catalysts were J. D.

Fergusson and Margaret Morris. When Fergusson decided that he would make his home in Glasgow at the outbreak of the war, he did not do so as a matter of convenience. He chose Glasgow because of its tradition of heavy engineering, because it was a celtic city and because it did not suffer from what he saw as a stultifying academic tradition. 'It is not natural for them [the Glaswegians] to be academic. What we would like to see is West Coast Glasgow art in the same class as the Queen Elizabeth,' he wrote in 1939.[2] It was his intention to try to make this happen.

In Glasgow Fergusson and his wife soon found a number of people with whom to make common cause and, remarkably, the war years saw something of a golden age for the city which has left permanent memorials in the Citizens' Theatre, the Cosmo Cinema and Scottish Ballet. The latter grew from Margaret Morris's foundation of the Celtic Ballet and many of the artists who gathered round the couple in fact owed allegiance to theatre and dance as well as to painting. Anne Cornock Taylor who exhibited as a painter had trained with Margaret Morris. Marie de Banzie (b. 1918) also trained as a dancer, while a number of the painters collaborated at various times on theatre design and decor. William Crosbie (b. 1915) designed the decor for the first production of Celtic Ballet. Crosbie's interest in surrealism had been apparent in his early work. *Heart Knife* (1934, SNGMA) for example, painted when Crosbie was still a student at Glasgow School of Art, is an essay in surrealism. In the intervening years he had painted murals for the Glasgow Empire Exhibition (1938) and the Glasgow Police Headquarters (1940). He was already

Plate 310. MILLIE FROOD, *October*, 1946

committed therefore to the idea that the artist should be publicly engaged. He maintained his interest in surrealism throughout the forties too.

There were others among Fergusson's associates who fitted his ideal of the artist-engineers, builders of the *Queen Elizabeth*. William Crosbie's father was a marine engineer, but Tom MacDonald (*b.* 1914) and T. S. Halliday actually were marine engineers themselves, while in a new and different branch of science in 1947 Tony St Clair was engaged in writing a book on atomic energy.

Fergusson's first move was the foundation in 1940 of the New Art Club which was a democratic and informal discussion and exhibiting society. Three years later a second organisation was formed, with Fergusson as president, called the New Scottish Group. Its first exhibition was in April 1943 and it continued to hold regular exhibitions for a number of years.[3] Fergusson's book *Modern Scottish Painting* was published in Glasgow by William McLellan, the left-wing and nationalist publisher who was an important ally of artists and poets in the forties. In it Fergusson included the prospectus for his earlier project of a British Salon des Indépendants, a prospectus that included Mackintosh's name amongst others, and in these Glasgow organisations he saw the realisation of his dream of creating such an equivalent to the independent French society. His stress was on freedom and he quotes the Declaration of Independence of 1315 as a model for artists.[4] It was in keeping that, in spite of his experience and the force of his

personality, he did not impose any stylistic conformity on the group of artists surrounding him. Closest to him in style was Donald Bain (1904–1979),[5] but Bain, in pictures like *The Striped Vase* (1943),[6] crowds his canvas with rich colour and heavily worked paint. It is distinctly expressionist and in so far as there is a common style in the work of members of the group it seems to reflect the expressionism of Van Gogh and Soutine.

Marie de Banzie and Isabel Babianska (*b.* 1920) worked in similar styles. They had studied together at Glasgow School of Art and had gone on to Hospitalfield in 1941. Babianska's *Fiesta* (1943),[7] for example, is a group of grotesque faces crowded together in a tall, narrow canvas in a way that is distinctly reminiscent of Soutine. Marie de Banzie qualifies this expressionism with her admiration for Gauguin seen very clearly in her painting of 1945, *Shadow*, in which a dark-skinned, naked girl crouches, like one of Gauguin's Tahitians, against the background of an exotic shore.[8] This kind of expressionism is seen at its most extreme in the work of Millie Frood (1900–1988). In some of her landscapes such as *October* (1946, Private Collection), (*Plate 310*) and *Turning Hay* (Cyril Gerber), both images of rural labour, she combines violent dislocation of the space with intense colour and patterns of brushwork reminiscent of Van Gogh.

Jankel Adler had arrived in Glasgow in 1941. He was a Pole but he had been working in Paris. He stayed in Glasgow for two years and provided an important contact with the very free methods of picture-making that had evolved in Paris in the thirties from the confluence of cubist and surrealist ideas and this is reflected in these paintings. Millie Frood also painted urban scenes at this time like *The Bus Queue* and the *Ice-Cream Stall* (both Cyril Gerber) where she uses this kind of technique to create a startling and grotesquely realistic image of urban humanity.

The element of social realism in Millie Frood's paintings both of town and country, or in a painting like George Hannah's *The Charwoman* (1943),[9] a rotund lady seen from behind, scrubbing some steps, reflects both the left-wing sympathies of this group and the influence of Josef Herman who settled in

Plate 311. BET LOW, *Blochairn Steelworks, c.1946*

Glasgow in 1940 and stayed till 1943. Hannah was a self-taught artist. Remarks on his painting, quoted in the left-wing review *Million* alongside a reproduction of his *Charwoman*, give a good insight into the kind of thinking that inspired, not him alone, but this whole group of painters.

> Art is a common impulse . . . the urge to make something, to design, to paint, carve, sing and dance is latent in all human beings and, in spite of the defects of modern civilisation, in men today. It is this part of our being which prevents us from succumbing to that robot-like dullness which dictators would like to batter us into, and it is from this bubbling inner well that we must derive the strength to transform our lives. Individual experience can only possess depth and solidity if it mirrors communal experience. This experience [is] the spirit, the life-blood of all real art.[10]

His remark about individual experience paraphrases Walter Crane and such links make clear that this movement was not a left-wing attempt to hijack modernism to political purposes, but a genuine development of ideas that were part of its origin.

Josef Herman certainly contributed to the focusing of these left-wing views on painting. He held a one-man exhibition in 1941 and in 1942 designed a pageant on the theme of Russia and the Second Front called *We are this Land*. In 1946 Tom MacDonald (1914–1985) and Bet Low (*b.* 1924), who were married, and

another painter, William Senior, formed the Clyde Group with the intention of promoting a specifically political kind of art. MacDonald said in this context it was Herman's attitude to his subject,[11] as much as his painting, that influenced them in this enterprise and in fact the most distinctive result was not initially social-realist figure painting in the manner of Herman, but a series of industrial and urban landscapes like MacDonald's painting, *Transport Depot* of 1944–45 (Cyril Gerber), or Bet Low's *Blochairn Steelworks* (*c.* 1946, the artist), (*Plate 311*) or *Port Dundas* (*c.* 1945)[12] and her drawings, like *Pinkston Coal Depot* (1945, the artist) which have clear memories of Muirhead Bone. Drawings that Joan Eardley did of Port Glasgow *c.* 1950 are closely comparable. Though later Low turned to landscape painting in a rather formal mode, these early industrial landscapes led on to powerful images like her triptych of 1949, *Sabbath Rosshire* (the artist). In it grim, black figures in a bare landscape are deliberately crudely drawn. Herman's influence is strongly present, but such pictures also have overtones of German social realism from before the war. The young painter Ian Finlay, later Ian Hamilton Finlay, also exhibited alongside this group.[13]

Ian Fleming was not a member of

Fergusson's circle, but his sympathies were very much in accord and it was at this time that he produced his remarkable etchings of Glasgow tenements and of the blitz. Fleming, teaching at Glasgow School of Art, was mentor to two of the most celebrated artists to emerge from Glasgow at this time, the two Roberts as they were known, Robert Colquhoun (1914–62) and Robert MacBryde (1913–66). These two met while studying at Glasgow School of Art where they formed a lifelong friendship. Fleming painted them in a fine double portrait in 1938 (GSA). They travelled together in 1937–9. Colquhoun served briefly in the army. MacBryde was exempted on medical grounds and when Colquhoun was invalided out in 1941, they went to live in London. They had spent a short time at Hospitalfield with James Cowie and between the teaching of Cowie and Fleming they were both accomplished draughtsmen as their drawings of each other done in 1939 make clear (SNPG).

Fleming's own art had close links with the English neo-romantic style and a drawing like Colquhoun's *The Lock-Gates* (1942, GAGM), or *Church Lench* (Arts Council Collection, South Bank), in which landscapes are treated with a detailed, overall design that is almost claustrophobic, could have been produced equally well in Glasgow as in the south. In 1942 the two Roberts exhibited in London alongside Edward Baird, Maxwell, Gillies and Johnstone in an exhibition called *Six Scottish Artists* and they maintained their Scottishness very self-consciously in London, but from 1943 they were living alongside John Minton.[14] Moving in the circle of artists to which he belonged, the impact of contemporary English painting was quickly apparent in their work. Colquhoun's *Tomato Plants* (Private Collection), (*Plate 312*) and MacBryde's *Ave Maria Lane*[15] were shown in the 1942 exhibition. The first is a barren landscape of rocks and sea, lit by a strong but unearthly light in the manner of Dali. Against this a tomato plant appears as an animate and sinister shape. It is a haunting image and clearly reflects the influence of Graham Sutherland's visions of a surreal and threatening natural world. MacBryde's picture on the other hand is a scene of bomb damage, treated not with the stark simplicity of Muirhead Bone, or even of Ian Fleming, but in the almost picturesque manner of John Piper.

In 1943 Jankel Adler left Glasgow and joined the two Roberts in London. He stayed with them in the same house and his art, with its distorted, Picassoesque figures, had a clear impact on both of them. MacBryde's *Two Women Sewing* (SNGMA), (*Plate 313*) is a good example of this. The colours are gentle and poetic, however, and the break-up and interaction of shapes in the picture is dictated by the demands of the composition in a decorative way reminiscent of Braque. At the end of the war, with renewed contact with French painting this became more pronounced and MacBryde's most typical production is a formally elegant still-life in which the elements visibly interact with each other, but in which conflicts are reconciled to create a balanced and pleasing result.

Although the two painters remained inseparable, Colquhoun's work developed rather differently. He invariably painted the figure, but he exploited the distortions that Picasso had introduced into his art in the twenties and thirties, not simply as a new syntax of picture-making, but as the basis of a dark and violent account of the world. *The Whistle Seller* (1945–6, Private Collection), for example, is a picture of a man with one leg, leaning on a crutch while he displays a tray of whistles. His face, looking down and turned to one side, is a tragic mask of suffering. There is a cat beside him, apparently standing on its hind legs, erect, like Puss-in-Boots and in contrast to his, its face is sharp, alert and sinister. Animals frequently play this role in his pictures which have titles like *Woman with Leaping Cat* (1946, Tate Gallery) or *Girl with Circus Goat* (1948, British Council). (*Plate 314*) In *Figures in a Farmyard* (1953, SNGMA) a man and a woman seem impassive and withdrawn, but a pig leers out at us from a ferocious, savage mask.

These pictures are filled with a sense of desolation and despair. In *Girl with Circus Goat* the separate features of the girl's face are beginning to lose their identity in the same way as they do in Francis Bacon's paintings of the same period. Colquhoun died in 1962 and in a series of monotypes that he did near the end of his life, this quality of dissolution has become even more marked, for example *Man with Goat*

(1962, Private Collection). He belongs with Sutherland and Bacon, artists who at the end of the war and in the immediate post-war period translated their own personal angst into something more universal. They evolved an imagery whose desolation reflected, not just a society exhausted by war, but one that had suffered through war to discover even greater horror in the concentration camps, and terror beyond anything hitherto imagined in the atomic bomb whose dark shadow stretched right across the fifties.

Colquhoun and MacBryde left Glasgow too soon to be much affected by the developments that took place there in the forties. The one major artist who did develop against that background where the benign leadership of Fergusson and Margaret Morris encouraged women artists was Joan Eardley (1921–1963). She was a contemporary at Glasgow School of Art of Bet Low and her art springs from the same sources of inspiration. Her early works are specifically social-realist paintings like *The Mixer Men* (Mr and Mrs Peter Simpson) or *Glasgow Backland Near the Canal* (Private Collection), both of 1944, for example. The first is a scene of men labouring on a construction site with the same bulky bodies and hands that are seen in George Hannah's *Charwoman* of the previous year. The second is an unromantic view of a canal and tenements with a pram, and a man asleep in the foreground, for all the world like an urban cousin of Chagall's *Sleeping Poet*. This picture contains the germ of all her subsequent Glasgow pictures. It is also roughly painted on an old piece of hardboard with a wanton disregard for the niceties of technique. Bet Low's *Blochairn Steelworks*, too, is painted on a canvas so coarse that it could be sackcloth and this seems to reflect more than just carelessness, but a rejection of the whole fine-art side of painting.

Eardley was born in England and did not come to Scotland till she was seventeen. She took her Diploma at Glasgow School of Art in 1943 then spent a short time in London and also at Hospitalfield with James Cowie in 1946. Then, somewhat late, she travelled on a scholarship to France and Italy. Her Italian drawings like *Old Italian Woman* (Private Collection) are powerful, wiry and distinctly

reminiscent of Van Gogh, and in this are comparable to drawings of the same date by Bet Low such as *Shawlie* (c. 1950, the artist). In Eardley's drawings of people she is doing more than emulate Van Gogh's techniques, however. She shares with him the attempt to convey sympathy without sentimentality, while depicting patience, endurance and even suffering. It is this quality that makes her paintings and drawings of the street children of Glasgow and its surrounding communities so exceptional.

Children, Port Glasgow (c. 1955, Private Collection), (*Plate 309*) is an early masterpiece among these. It was on her return to Glasgow that she had discovered the industrial landscape of Port Glasgow, Gourock, and she painted and drew there frequently in the early fifties. In a picture of 1952, *Back Street Bookie* (EU), she had already tried to adapt the simplified structures of recent painting to give dignity to the depiction of street life. In that picture, though, the people are lost in the formal arrangement. *Children, Port Glasgow*, is more ambitious and more successful. A group of five boys aged ten or

Plate 312. ROBERT COLQUHOUN, *Tomato Plants*, c. 1942

Plate 313. ROBERT MACBRYDE, *Two Women Sewing*

eleven has just passed some girls of similar age, pushing a push-chair. (An adult behind the girls has been painted out, but is still partly visible.) One boy looks back at the girls and giggles to his companion. The girls though, with the responsibility of the push-chair, are above such things. So described it could almost be a composition by Tom Faed. What is extraordinary though is the way that she avoids that pitfall. The colours of the children's clothes, greys, browns and reds, roughly finished, are echoed in their surroundings and make their urban environment seem their natural habitat. The flat treatment and the rough outlines too express something about the rough-edged vitality of the children and are reminiscent of their own art. For the faces, to avoid sweetness, but to capture individuality, Eardley has turned for inspiration to Colquhoun's grotesque mask faces with extraordinary effect.

Eardley achieved a similar monumentality in some of her studies like *Girl with Baby* (Private Collection) or in her painting *Andrew with a Comic* (Private Collection). A small boy with knobbly knees and outsize boots is sitting sideways at a table, eating and reading a comic. The position of the figure, the still-life on the table and the steep angle of the picture space all recall Degas's portrait of *Diego Martelli* (NGS). It is a remarkable tribute to Eardley that she manages to translate the grandeur of that picture into this image of a child, losing nothing of the dignity of the individual or the respect due to his concentration. In her later child-pictures these qualities are equally apparent, in *Girl with a Squint* (1961, Gracefield Art Centre), for example, or in the various versions of *Children and Chalked Wall* (1961–3). In these she uses graffiti, collage, and an increasingly free technique, to integrate the figures with the ground in a way that was already hinted at in *Children, Port Glasgow*, but which now, with the richness of colour and surface, gives to these images of cheerfully ill-favoured children the dignity of medieval saints. *Three Children at a Tenement Window* (c. 1961, Private

Collection), (*Plate 315*) contains a clear memory of Rembrandt's *Girl at a Window* (Dulwich College) and this is no more an incongruous comparison than that with Degas. In treating the figure in these pictures Eardley takes her place in the tradition of painting in which individuality is celebrated as irreducible. The concept of the grotesque depends on the ideal. Where the ideal is banished, the grotesque equally ceases to exist and becomes instead a celebration of individuality.

Eardley painted landscapes as well as townscapes throughout her life. In 1950 she discovered the North-Eastern coastal village of Catterline. After working there on a number of occasions she eventually found a permanent base there and during the later fifties the landscape and the seascape at Catterline provided increasingly the principal inspiration in her painting. *Cornfield at Nightfall* (Private Collection) of the mid-fifties is a view of a row of low houses over a red cornfield. The houses are grey against a grey sky, punctuated by the lighter disk of the moon. The picture is painted in flat slabs of colour with clearly demarcated edges. In this it reflects her admiration for Nicholas de Staël. De Staël kept recognisable subject-matter in his paintings while exploiting the summariness and simplification of the abstract painting of the School of Paris. It was a position like Eardley's own and was just one example of the influences from both French and American painting that led her to a more direct and summary treatment of the landscape which she had before her. Superficially this brings her at times close to Anne Redpath, but she continued to paint on the spot, no matter what the weather, and her paintings reflect her energetic, sometimes almost violent identification with nature.

This attitude to nature is something that comes close to the position of Alan Davie. It seems to involve the surrender of any conscious approach to picture-making. She never turned to abstract painting however. Instead she developed the seascape to exploit the expressive potential of gestural painting and physically to identify herself with external nature. Some of her late figure paintings, in the summary way that the children she describes are incorporated into the surface of the painting, recall

the late paintings of the elder McTaggart. In her sea paintings she comes even closer to him. Pictures like *Wild Sea* (Robert Fleming Holdings Ltd), *January Flow Tide* (EU), *Stormy Sea No 1* (Private Collection), (*Plate 316*) or *The Wave* (SNGMA), all painted in the last two years of her life, are among the most remarkable paintings of their time.

On the east coast the leading contemporaries of Colquhoun, MacBryde and Eardley were William Gear (*b.* 1915), Robin Philipson (*b.* 1916) and Alan Davie (*b.* 1920). All three served in the war and had studied at Edinburgh College of Art immediately before its outbreak. On their return to painting after its end, all three also reflected in different ways the impact of the new, abstract-expressionist painting that had evolved in Paris and New York. It was in effect the second wave of surrealism. The surrealist ideal of the recovery of human sanity through the unconscious had been given new urgency, and in Paris in the hands of the group of North European painters led by Karel Appel and Asger Jorn, who called themselves COBRA (an acronym of the three cities, Copenhagen, Brussels and Amsterdam), it became the vehicle for a passionate artistic response to the war.

William Gear stayed in the army in Germany until 1947 working on the Commission

Plate 314. ROBERT COLQUHOUN, *Girl with Circus Goat*, 1948

Plate 315. JOAN EARDLEY, *Three Children at a Tenement Window,*
c. 1961

concerned with the preservation and return of
works of art. He knew well, at first-hand, the
consequences of the war for Germany and when
he went on from Germany to Paris he could
share with conviction the sentiments of the
COBRA artists. Stephen Gilbert (*b.* 1910) was
another Scot, like Gear from Fife, in Paris at this
time who also showed with COBRA. Much of
their work was abstract, highly coloured and
violent in execution. It was very different in its
energetic reaffirmation of life to the angst-
ridden painting going on in London, but it was
linked to the new painting in New York. Rothko,
for example, was in Paris, and Gear, in touch
with the Americans, exhibited alongside Pollock
in New York in 1949. Gear stayed in Paris till
1950. In 1947 his painting showed the struc-
tured approach of French painters like
Manessier, for example, in *Spanish Composition
I* (1947, Private Collection). By 1949 he was
painting in a way that was almost purely gestural
as in *The Black Tree* (1949, Private Collection)
and the dramatic result of this developing

freedom is seen in pictures like *Composition
Celtique* (1948, Karel van Stuijvenberg), (*Plate
317*) and *Autumn Landscape, September* (1950,
SNGMA). Vivid in colour, their jagged, abstract
shapes are dictated by the impulsive gesture of
the hand. In 1951 Gear won a prize with one of
these abstract compositions at the Festival of
Britain, a picture which, to judge by the
response, was way beyond public comprehen-
sion. His most exciting paintings belong
perhaps to these years, though he has worked
consistently throughout his life. Stephen
Gilbert's work of the late forties would equally
have been beyond most of his contemporaries at
home. He was painting expressionist pictures
based on figurative elements that were reminis-
cent of both Klee and Picasso, though with an
underlying note of violence. These attracted the
attention of Asger Jorn in 1948 and so brought
Gilbert into the COBRA group. He then moved
on to a pure, gestural abstraction as in *Untitled*
(1951, Karel van Stuijvenberg), which is com-
posed of broad, random strokes of red and black
against a white ground.

Robin Philipson (*b.* 1916) spent the war in
the east, out of touch with European develop-
ments and when he resumed painting it was
with a post-graduate studentship at Edinburgh
College of Art in 1947. This was soon followed
by a teaching post. Naturally Gillies and Max-
well together influenced him profoundly, but it
was Maxwell that he followed most closely in
the way that his art became enclosed, without
reference to the outside world. In the develop-
ment of his own interpetation of this approach,
he was first inspired by Kokoschka and then by
the example of de Kooning, but even more by
the painters of the School of Paris and the
British painters who belonged to that move-
ment, including Gear and by this time also Alan
Davie. This led to Philipson developing tech-
nique as an end in itself. A large view of Edin-
burgh Castle, *The View from my Studio Window*
(1954, Hunterian), (*Plate 318*) for example, is a
handsome and effective tribute to Kokoschka.
Women Bathing in a Swimming Pool[16] from two
years later on the other hand is a variation on
de Kooning's series of paintings of women of
the early fifties. It also has something of de
Kooning's iconoclastic ferocity.

The paintings in the *Fighting Cock* series

Plate 316. Joan Eardley, *Stormy Sea No 1*, c. 1963

which Philipson exhibited in 1958, but had begun six years earlier, and which did much to establish his reputation, maintain this expressive quality, but it soon began to be tempered by elegance of execution in the manner of painters like Georges Mathieu. Uppermost in his pictures, in marked contrast to Eardley's throw-away attitude, is what Philipson himself calls 'the craft of painting'. He used his technical virtuosity to develop a kind of painting that was as autonomous as music without actually being abstract. This can have a disturbing effect. Throughout his life, for example, he has often returned to themes of violence, or implied violence, as in *Women Observed* (1979, Private Collection) in which two women naked, or partly dressed in one panel of a diptych are apparently watched by snarling dogs in the other, but the artist remains curiously detached. The subject-matter in the two opposing panels seems only to be there to stress the visual contrast. The quality of his command of paint is seen paradoxically to much greater advantage when he paints on a small scale, in the small informal studies of women, for example, that he incorporates into

his big set-pieces, rather than these set-pieces themselves, although they were such a feature of the middle years of his career. Recently he has painted some still-lifes such as *Poppies against an Unfinished Painting* (1989, Private Collection), (*Plate 319*) which are quite modest in intention, but brilliant in effect.

Philipson has stood for the idea that painting is a completely self-sufficient art. James Cumming (*b.* 1922) has championed the same ideal, also for many years from a position teaching at Edinburgh College of Art, but this was exactly the opposite of the view championed by painters in Glasgow and by contemporaries of Philipson and Cumming, especially Alan Davie and two younger artists who both studied during the war, but had also spent some time in the forces, Eduardo Paolozzi and Ian Hamilton Finlay. For these artists, true to the surrealist ideal of wholeness of vision, the alienation of art and the consequent fragmentation of our awareness has been a central concern. For Paolozzi and Finlay their resistance to the elitism in modern art also looks back to the Arts and Crafts tradition so strongly restated by the left-wing artists in Glasgow in

Plate 317. WILLIAM GEAR, *Composition Celtique*, 1948

the forties, with whom Finlay at least was directly associated. In keeping with this idea of commitment the origins of the kind of abstract painting from which Philipson's art took nourishment lay, not in any notion of art as self-contained, but in an attempt to reach the deeper levels of our common apprehension of reality by tapping the shared unconscious. Alan Davie, in contrast to Philipson, came to be deeply committed to this latter approach, to the idea that painting is a non-objective art but is nevertheless entirely involved with the universal nature of experience.

Alan Davie (*b.* 1920) was a friend of William Gear and when he travelled to Paris in 1948 Gear was able to introduce him to a new approach to painting and its meaning. What Davie had seen in Paris was endorsed by his seeing works by Klee and others at the Biennale in Venice, where he went from Paris, as well as first-class examples of the new American painting in the collection of Peggy Guggenheim there. His paintings of the previous years like *Woman with Flowers* (1945)[17] are very close to Maxwell and this was still true of work done in Italy in 1948. A painting of *Chiogga*, for example,[18] is in the manner of Maxwell, though perhaps inflected by Manessier, one of the gentler and more decorative French abstract painters. In the new expressionist painting, however, he found a way to break out of the confines of Maxwell's private dream-world towards something that might enable him to reach towards the universal unconscious, though this was not such a dramatic shift as subsequent art-historical priorities would have us believe.

Davie returned to London in 1949. The only painter there qualified to support him in his new approach was William Johnstone, himself a friend of Peggy Guggenheim, and with first-hand experience of both surrealism and American painting. Johnstone, by this time head of the Central School, befriended Davie and eventually employed him. Johnstone's own interest in the preoccupation of the surrealists, the freeing of the unconscious to nourish the conscious and through it to restore the original potential of human nature, had developed, not only in his own painting, but in his approach to education. In 1941 he had published *Child Art to Man Art*. Its objective was in his own words to tackle 'the decline in spontaneous expression as children reach puberty, and how to bridge the gap between the naïve visions of childhood and the sophisticated, intellectual approach of early adulthood'.[19] This had established his reputation as a pioneer of new methods of teaching.

Johnstone's ideas were closely akin to the kind of talk surrounding the new abstract painting and at the Central School Davie found a sympathetic environment in which to develop his own ideas. Amongst the remarkable group of people that Johnstone had gathered round him there was Anton Ehrensweig, later author of a book called *The Hidden Meaning of Art*. In 1951 Davie collaborated with him in experiments in textile printing, and Eduardo Paolozzi was teaching in the Textile Department at the same time. In 1953 Davie was involved in experimental teaching methods at the Central too, an undertaking close to Johnstone's heart and a statement that Davie made on teaching in 1959 shows how very close his ideas were to those of the older man.[20]

Davie's approach to painting was consciously unconscious, though not physically random, like Pollock's late paintings. Instead he allowed the picture to grow in a quasi-organic way. A keen jazz musician, his way of painting in the fifties was akin to jazz improvisation. 'Consciousness,' he said, '. . . is the door that shuts. Our problem is to find a way of "hoodwinking" consciousness during creative work.'[21] He took considerable pains to avoid

following any deliberate development of the image, cultivating pure spontaneity in a trance-like state. Examples of the results of this approach from the early fifties are *Jingling Space* (1950, SNGMA) in which a series of stac-cato brushmarks dance in front of a more rigorous, rectilinear space structure in a way that the title describes, or *Domain of the Serpent* (1951) in which a similar basic structure of rectangular shapes and one circle, in black, red and white is overlaid with rough brushwork. In *Blue Triangle Enters* (1953, the artist) half-a-dozen sweeping strokes of the brush in black, cross each other and swing out to find the edges of the picture. Some of these are rein-forced with red. There are a few yellow scribbles, a yellow circle and the blue triangle of the title. The rest is blank canvas.

In the middle and later fifties some of his images became more violent and incoherent as in *Sacrifice* (1956, Tate Gallery), (*Plate 320*) or the massive, three-part *Creation of Man*, or *Marriage Feast* (1957, the artist); at the same time though, certain elements began to recur, wheels, ladders and stippled, serpentine shapes as in *Entrance for a Red Temple* (1960, Tate Gallery). (*Plate 321*) These interacting, half-formed images imply, but do not describe an inchoate symbolic language. They suggest dimly the mysterious rites of some forgotten religion.

Pictures of this kind deliberately defy analy-sis. They are a process, not an end in themselves

Plate 318. ROBIN PHILIPSON, *The View from my Studio Window*, 1954

Plate 319. ROBIN PHILIPSON, *Poppies against an Unfinished Painting*, 1989

and writing in 1958 Davie said of his painting: 'What I am trying to get at is best expressed by the idea of pure intuition. We could define the function of art as being: to arouse the faculty of direct knowledge by intuition, and what we feel by intuition requires pointers or symbols more than concrete ideas for its proper expression; and these pointers have to be enigmatic and non-rational.'[22] The process of intuition has come a long way from Thomas Reid's definition of its role in perception. It is now closer to the Zen state of depersonalised awareness (and Davie was very interested in Zen), but the thread of continuity from the eighteenth century is neverthless still perceptible. In the text already quoted Davie first of all echoes

Johnstone's view of painting in the thirties: 'Is art a recollection of something hidden, the archetype of the timeless past deeply buried in the soul?' He then goes on, 'The awakening of the creative urge, before finding expression in pictures, doubtless passed through movement of the body in dance and song. It is interesting to speculate that the first art must have preceded thinking, before the growth of intellect, and thought, when it developed, led inevitably to the first writing, communication and abstract thinking. The artist was the first magician and the first spiritual leader.'

It is not just coincidence that these remarks are reminiscent of the kind of thing that Thomas Blackwell, John Brown and Hugh Blair

were saying two hundred years and more before (see above, Chapter VI). This last phase of surrealism and the attempt to find in pure intuition a mode of being, still uncorrupted because it was not only prior to civilisation, but prior to thought itself, was in direct line of descent from those thinkers and the art of their time, just as Davie's definition of intuition was from Thomas Reid. Davie was fired by the belief that had inspired his eighteenth-century predecessors. If only we could reach them, the seeds of human perfectibility still lie within us. Our natural freedom and spontaneity, so apparent in the art of children and primitive people, in civilised adults is buried beneath a carapace of thought that has been forced by countless generations of habit into life-denying channels of convention. The belief that somehow it can still be recovered on our behalf by the artist has been one of the principal motors of modernism.

Davie's paintings were one of the last acts in the drama of eighteenth-century optimism, as Runciman's had been one of the first.

Perhaps however the extreme form of expression reached by Davie is inevitably an unsustainable position. Who could say that Pollock could have sustained the quality of his painting if he had lived? Davie's work became gradually more controlled, though no more accessible, an arcane language of symbols to which there is no key. This is not true, however, of the art of his close contemporary, Eduardo Paolozzi, though the two developed from remarkably similar origins and along very similar lines. Paolozzi (b. 1924) is a Scots-Italian and as he has spent almost his whole adult life away from Scotland, it might be doubted whether in the end he is really a Scottish artist even though he has kept in touch with his native country. What cannot be doubted though is that he was,

Plate 320. ALAN DAVIE, *Sacrifice*, 1956

with Gear, Davie and the sculptor William Turnbull, one of a small group of artists whose art was forged while they were working in Europe in the late forties and who subsequently made a unique contribution to British art. It cannot be a coincidence that they were all Scots. Three of them, Davie, Paolozzi and William Turnbull also made their first impact while they were working with William Johnstone at the Central School. Even Gear showed with Johnstone in 1950.

Paolozzi is of course best known as a sculptor. That might seem to be additional ground for excluding him from this discussion, but at the beginning and the end of the period covered by this book, always artificial, the boundaries between sculpture and the two-dimensional arts are especially blurred. This is particularly the case with Paolozzi. As well as a sculptor he is one of the most important print-makers of his generation and his art, whether in two or three dimensions, is permeated by the pictorial tradition for it is built on the technique of collage evolved by painters.

Plate 321. ALAN DAVIE, *Entrance for a Red Temple*, 1960

After attending evening classes in Edinburgh, Paolozzi went south to the Slade. Inspired by what he had seen of Dada and surrealist work in London he then went on to Paris in 1947. In Paris he enlarged his understanding of these ideas at first-hand and all his later art is most easily understood if its starting point is seen to be in the deliberately shifting realities of Klee, the collages of Schwitters and Ernst, the primitivism of Dubuffet, and above all in the ready-mades and altered images of Duchamp. Paolozzi's earliest works reflect these various sources of inspiration, but his first really original statement was in the presentation of a series of images in a slide lecture (which was a kind of living collage as the images were not sorted and presented in the conventional manner of linear discourse) at the Institute of Contemporary Arts in London in 1952. These were collected over the period 1947–52 and were of the kind that were incorporated into a series of collages later published as screenprints under the title *Bunk* (1950–72). They are images chosen for their content, not for any abstract considerations of colour or texture and when they are assembled together, they are comic, startling, and even shocking, like the image in *Bunk*, *Yours till the Boys Come Home*, (*Plate 322*) in which he juxtaposes two photographs of a strip-tease dancer with a similar sequence of aircraft crash-landing on a carrier.

In this way Paolozzi makes collage into a metaphor for the constant intercutting and overlapping images of contemporary experience. He drew on a huge, untapped reservoir of ephemeral imagery. Mickey Mouse, Hollywood glamour queens, comic book characters, science fiction and horror-movie monsters, motor cars, aero-engines, robots, he recognised them all as legitimate art, and so he went beyond the persistent limitations of fine-art modernism. There is a link with Glasgow too in the way in which he consciously embraced the machine as, for better or for worse, an essential image in any valid expression of the art of our time.

This amounts to a radical attack on the fragmentation of contemporary vision where most of what matters in visual culture, and therefore what charges the contemporary collective unconscious, is excluded from the

business of art. Paolozzi was, with William Turnbull and Richard Hamilton, one of the leading artists of the Independent Group in London which organised a series of exhibitions in the early fifties. The Group as a whole, but Paolozzi in particular, proposed to change the whole cultural base of art from the narrow preoccupations of high art, which had in the modern movement even become consciously exclusive, to the broad base of shared experience which is the genuine culture of our time. This is a democratic move and Paolozzi's exploration of pop imagery, though its results are so different in style, is surely identical in intention to the art of George Hannah, Millie Frood or Tom MacDonald in Glasgow. It is the first step in the critique of modernism that eventually came to be recognised under the label of post-modernism.

Paolozzi's collages, but also his sculptures which were constructed by a kind of collage process, in the way that they appear to arrive at a definite image by a series of random associations, are akin to Davie's paintings. Davie's symbolic language was also closer to Paolozzi's than might at first seem to be the case. In 1962, for example, Davie said of his own symbolism: 'I suppose its roots are in my Celtic heritage. I have always had a deep concern for animalistic things. I am interested now in the symbolism of the modern age. For instance it is well known that ancient man attached great significance to the shape of the wheel. It can have a multitude of meanings; the sun, moon, the female sexual organ, or as a symbol of communication. I believe the machine is an attempt by man to find a most elaborate symbolism.'[23] In 1958–9 Paolozzi had illustrated this remark of Davie's almost literally in a sculpture called *His Majesty the Wheel*, one of the most striking of the series of mysterious standing figures of the period. These, and the prints which parallel them, made by his collage technique from all sorts of mechanical or quasi-mechanical elements, are like totems from some newly discovered primitive society – our own. His conscious adoption of the machine aesthetic in this particular form, though, is remarkably analogous to the kind of polemic that had been produced by McCance, MacDiarmid and others. In the

Plate 322. EDUARDO PAOLOZZI, *Yours till the Boys Come Home*, FROM *Bunk*, 1950–72

early sixties he produced a series of totemic figures made from prefabricated parts, assembled and cast together so that they preserve the style of the machinery from which they derive. He was consciously identifying himself as an artist with the anonymous techniques of the engineer, and indeed he began to produce his sculptures in a factory. These do not have the primitive brutalism of the earlier works, but they have an ominous hieratic presence which, like tribal masks, can also be touched by the comic with no loss of their power.

In 1965 he produced his first major series of screenprints, *As is When*. (*Plate 323*) Based on collage, they are closely akin to his sculptures of the period using found shapes and patterns to build up an image, much as he used prefabricated parts. He had experimented

with screen-printing as a medium in the early fifties, pioneering the artistic use of a modern industrial technique, but with this series he began to produce complex, richly coloured effects. The inspiration of *As is When* was in the life and philosophy of Ludwig Wittgenstein. The title is a reflection, typical of Wittgenstein, on the complex rules that are revealed when (or as) we analyse the apparent overlap between two simple, everyday words. Examination of these rules reveals how between them these two words reflect our whole perception of state, process and simultaneity. Although they overlap, each word occupies and defines its own mental space so clearly that even as (or when) they overlap we can still perceive their distinct meaning. Examination of these words in such terms of space or imagery also suggests how the

same perceptions are exploited in the structure of pictorial images where we understand, through the conventions of pictorial narrative, precisely the same distinctions between state and process, simultaneity and sequence. This was an area on which Paolozzi's own use of collage had already made a radical commentary and on which he had recently enlarged in a collage film, *A History of Nothing* (1960).

In these prints he mixes abstract patterns with elements of identifiable collage, suggestions of some kind of overall shape, and fragments of text which relate the images to events in Wittgenstein's life. In spite of such overt content, though, Paolozzi did not intend any more than Davie to create a kind of image that was to be simply interpreted by linear analysis. His images of the sixties and the seventies represent the processes of thought or preconscious association. Though there are specific references within them, what we see is a metaphor for how we see. They echo the fragmentation of all the different, conflicting kinds of artificial order with which we are simultaneously assailed. The machines, the appearance of our cities, the images of commerce, communication, or art itself, each is separate and each obeys its own rules. They are all permeated by memory and come together in an anarchy of incoherence which nevertheless we somehow perceive as unity of experience.

These preoccupations led to increasingly abstract and austere imagery in the seventies. In the *Ravel Suite* of etchings in photogravure of 1974 for example, and in related relief sculptures, he still uses a collage technique, but one in which the elements are made, not found, and which use delicate and complex interlocking patterns, mostly in monochrome. The dedication of the *Ravel Suite* or *Calcium Light Night*, a suite inspired by the music of Charles Ives, reveals how this departure in his imagery was inspired by the idea of the possibility of a musical analogy for visual art.

One of the high points in this abstract formal period was the commission for a set of four doors in cast aluminium carried out for the Hunterian Art Gallery of the University of Glasgow and completed in 1977. They are in deep relief and their intricate geometry has the

Plate 323. EDUARDO PAOLOZZI, *Wittgenstein in New York*, FROM *As is When*, 1965

mysterious authority of the architectural decoration of the Maya, or some other potent but unknown civilisation. The new Hunterian was built on the site of Mackintosh's house which was subsequently reconstructed as part of the museum, and the work Paolozzi did for Glasgow was linked to the inspiration of one of his finest sets of prints of the period, *For Charles Rennie Mackintosh*, 1974–5 (The artist). (*Plate 324*) This was a set of six woodcuts. Formally they are in the same austere, abstract language of shapes as the doors, a language which, however, now also subtly reflects some of Mackintosh's own favourite, abstract, decorative devices, notably the chequerboard pattern. In execution though, these prints

reflect a new departure. Wood-cut, the earliest form of printing, is quite different from the anonymous uniformity of silk-screen and the other techniques that Paolozzi had used hitherto. Thus he follows Mackintosh (and before him Crane and Owen Jones) who was already one of the acknowledged pioneers of modernism to examine the continuity with the past in modern culture. He begins to abandon therefore what had hitherto been regarded as the essential ground of modernism, the stress on what distinguishes the art of the present from all the art of the past.

In 1979 in a statement called *Junk and the New Arts and Crafts Movement*, Paolozzi expressed a new pessimism and condemned in

Plate 324. EDUARDO PAOLOZZI, *For Charles Rennie Mackintosh*, 1975

Plate 325. EDUARDO PAOLOZZI, *Head*, ETCHING, 1979

forthright terms the contemporary representatives of the modernist tradition for their subservience to the corrupt values of contemporary society: 'Modernism is the acceptance of the concrete landscape and the destruction of the human soul.'[24] It is a critical standpoint that he had already adopted earlier in satirical references to the formal abstraction of Frank Stella for example, but now it has a new urgency inspired by ecological concerns. Artistically this is reflected in a series of powerful prints in which he returns to his own earlier image of the man-machine, but now it is a dark and pessimistic vision. In an etching, *Head* (1979), (*Plate 325*), for example, a projection of a Volkswagen engine provides the features of a face, but also, because it is a cut-away drawing, it suggests that the internal structures are similarly mechanical and dehumanised.

Over the last decade Paolozzi's concern has not weakened, but, continuing his critique of modernism, it has found expression in the assertion of humane values through a return to the figure and the portrait. This evolved out of the heads of the late seventies and from much earlier sculptured heads like *Mr Cruikshank* (1950). His return to a more direct treatment of the figure was also encouraged by his increasing familiarity with the classical sculpture collection in Munich where he taught from 1981. The most remarkable of the works that he has produced from this kind of inspiration are the monumental bronze *The Artist as Hephaestus* and an equally large-scale figure of *Newton* based on Blake's image of the scientist.

These solemn, monumental figures are not just the artist's response to a swing of artistic fashion towards the figure. They restate with urgency the whole rationale of the figure in classical art; that the basis of all understanding depends on our preserving a whole vision of ourselves in nature. We cannot afford to divide up our sensibility and to allow science and art to claim separate spheres of interest. Whereas in his earlier work Paolozzi commented on our fragmentation of vision, now, conscious of its potentially disastrous consequences, he joins Geddes to declare the urgent need for its reintegration.

Paolozzi and Ian Hamilton Finlay have little apparently in common, but they do share a deep conviction that the business of art is not a self-justifying game in which artists accept their marginalisation as an appropriate reflection of their mission of self-absorption. Paolozzi's move away from the pure abstraction of his art of the seventies was significantly linked with his interest in the Arts and Crafts movement. Amongst other public works one of his most important undertakings of the eighties, a series of mosaics for the Tottenham Court Road tube station in London, fulfils in detail its prescriptions. Finlay likewise remains loyal to some of its precepts. He always works in collaboration with other artists and he too has undertaken a series of important public works, most recently the monument in Edinburgh to Robert Louis Stevenson and the aborted monument to the *Declaration of the Rights of Man* in France which was to have marked the bicentenary of the Revolution in 1989. It is perhaps a minor point, but neither artist has taken a conventional approach to the market through a dealer, an attitude equally in harmony with Arts and Crafts ideas. It is surely significant that the closest precedent for the consistently radical attitudes of both of them

and for these echoes of the Arts and Crafts is in the ideas of the Glasgow poets and artists of the forties.

Finlay was born in 1925 and began as a painter. He studied and worked briefly in Glasgow, turned to literature and then came back to visual art in the early sixties by way of concrete poetry. He created works at that time combining words and images like Renaissance emblems. Their punning relationships disrupt the expectations of linear argument and set up instead a mosaic pattern of reference which presents a series of unexpected and witty connections through the conjunction of apparently simple ideas. He developed this kind of imagery in prints, in three-dimensional sculpture and most dramatically in the garden that with his wife he created at Dunsyre, a high, bleak and inhospitable hillside in Lanarkshire.

The garden was begun in 1968 and later he christened it *Little Sparta*. In ancient Sparta, as in Scotland, civilisation was achieved against the challenge of a stern and hostile environment. This was also true of the real Arcadia that is, however, so often invoked by classical gardens as the land of pastoral dream. He chose Sparta too because in his view art in the late twentieth century needs a self-discipline like that of ancient Sparta if it is effectively to combat the consequences of the fragmentation and secularisation of culture, an attitude also shared by Paolozzi who has likewise returned to classical antiquity for inspiration.

In the tradition of the great, symbolic gardens of the Renaissance and the English eighteenth century, Finlay's garden is permeated with references to painting and poetry. Some are eloquent and witty. For example, a small patch of reeds and grasses is signed with Durer's monogram, or a bridge is signed by Claude. (*Plate 327*) Others are in the manner of Finlay's concrete poetry, inscriptions on two adjacent trees for example, *Osiris/Osiers* which punningly exchange the name of the tree and the name of the Egyptian god and judge of the dead.

Throughout the garden, where there are several ponds or small lakes, there is also a frequent use of ship imagery which had played an important role in his earlier work, in 'Ring of Waves' from the collection of poems *Poor Old Tired Horse* of 1968 for example, *Starlit Waters*

Plate 326. IAN HAMILTON FINLAY, *Homage to Modern Art*, 1972

(with Peter Grant, 1968, Tate Gallery), or the screenprint, *Homage to Modern Art* (with Jim Nicholson, 1972, SNGMA). (*Plate 326*) In the garden this takes various forms, a concrete poem which recites the names of different types of traditional craft in the stones of a pathway for example, but there are also military ships. These are partly a reflection of an almost boyish fascination with the complexity of military machinery, charmingly innocuous in a stone aircraft-carrier that is a bird table where the birds are the aircraft.

A black slate monolith above the highest pond is called *Nuclear Sail* (with John Andrew, 1974) and is an example of a deeper meaning however. The shape and title are a reference to the black conning-towers of nuclear submarines, a familiar, but sinister sight on the west coast of Scotland. The shape with the

Plate 327. IAN HAMILTON FINLAY, *View of the garden, Little Sparta*

material makes a different reference too, though, for together they also invoke the kind of minimal sculpture fashionable in the seventies when this piece was made. Thus it questions the disjointedness of a society whose proclaimed aesthetic values, represented by such sculpture, are so remote from its real, though unacknowledged values represented by the nuclear submarine. It is a simple, but disturbing visual analogy and is also akin in meaning to some of the satirical references that Paolozzi makes to abstract painting, in *As is When* for example.

There is an ongoing polemic in Finlay's art of which this is just one example. It concerns the dangerous gap between aesthetics and morality. The ultimate justification for this kind of imagery of warships in stone is in classical antiquity where in ancient Rome the Rostrum, the centre of public debate and political life, was the prow of a warship rendered in stone. This is where Finlay sees his own art functioning. The introduction of such imagery into his garden however, even in such a tame and domestic form as a bird-table or a sundial, is also the expression of something essential to his art. The presence in a garden of imagery of such destructive potency as a modern aircraft-carrier or a nuclear submarine reflects not only the negative, the gap between proclaimed and actual values, but it is in a positive sense the underlying theme of the

Plate 328. IAN HAMILTON FINLAY, *The Poor Fisherman*, 1988

whole garden, how art functions in the essential, creative tension between order and disorder. This is in the true sense a classical ideal and Finlay regards himself as a neo-classical artist. The creation of the garden is in this respect a symbol central to any understanding of his thinking and of what he means by such a term.

The garden is in the original meaning of the word, artificial. It represents the achievement of ordered, creative thought in the face of an unordered, indifferent and therefore fundamentally hostile nature whose resources it must nevertheless exploit. The tendency to anarchy therefore is paradoxically also the source of its vitality. Neo-classicism in Finlay's view is not the representative of bland harmony, but the expression of this creative tension. In any order that is achieved the chaotic energy of nature must also still be present and though this potential violence is contained, it cannot be extinguished.

In the imagery of the garden there are

several references to Claude and Poussin, both heroes of the eighteenth-century landscape gardeners, but Poussin's *Et in Arcadia Ego* is a key image for Finlay. In Poussin's picture the shepherds of Arcadia discover the image of death even in the original home of the pastoral, but Finlay's reworking of the seventeenth-century iconography of the image involves a tank.[25] He goes behind Poussin's elegiac image to evoke, not just the presence of death, but the inherent violence in nature itself, and in human affairs too, which are after all only an aspect of nature as the history of the twentieth must constantly remind us.

In classical antiquity this polarity was recognised in the character of the Olympian deities whose potential benevolence was balanced by their ferocity. At the centre of the garden is a temple to Apollo which bears the inscription 'Apollo, his Music, his Missiles, his Muses'. Apollo is an appropriate presence as patron of the arts and of intellectual activity, but the inscription also refers to his ruthlessness

in the defence of his own divine claims. When Marsyas challenged him to a musical competition, for his temerity he was flayed alive. Apollo's sister Diana was equally ruthless and her revenge upon those who had innocently transgressed is the subject of Titian's two great paintings in Edinburgh, *Diana and Callisto* and *Diana and Actaeon*. In both pictures this ferocity is set in a landscape of magical beauty. This is also the theme of Finlay's garden therefore and amid the ecological anxieties of the late twentieth century this metaphor has new urgency. Human impiety may provoke nature herself to just such revenge.

In his later work Finlay has developed these ideas in an iconography based on the history of the French Revolution, where in modern history he found an inspiration similar to that of his garden; the creative tension between order and anarchy, between the ideal and artifical, and the actual. *The Poor Fisherman* (1988, with Gary Hincks), (*Plate 328*), for example, is a watercolour, modifying Puvis de Chavannes's painting by the simple addition of a revolutionary cockade and tricolour ribbon. Thus the subject of Puvis's picture is enlarged from the natural piety of man dependent on nature, to embrace the revolutionary implications of that relationship as it was formulated by Rousseau at the beginning of the French tradition of revolutionary thought. In the Revolution, too, Finlay found the neo-classical style used as the expression of an ideal order achieved through struggle against the forces of confusion. Of all the figures of the Revolution whom he admires, St-Just has come to stand for these same qualities of fierce, intellectual rigour and Finlay has several times represented him as Apollo, borrowing the flying figure of the god from Bernini's *Apollo and Daphne*.

Finlay has developed garden themes in several important commissions. For the Kroller-Müller Museum he created *Five Columns*, each a combination of a sculptured column base and a living tree and each dedicated to various individuals, including Rousseau, Robespierre, and Michelet. The theme is human intervention in the relationship of formality and order to growth. In Brittany, in the Kerguenhec forest, a series of plaques attached to trees similarly records the names of five famous pairs of lovers and of five species of tree. At the Schweizergarten Museum in Vienna he has created a grove of birch trees which, with inscriptions, create a living poem, *Black and White*. The poem is a play on the colour of the trees and of the patterns of light that they will create: 'White and bark/black and light/bark and light/white and dark/black and white.'

In his garden as in all his work it is just this balance of light and dark that counts. The very elegance of this elegiac image, achieved in collaboration with nature, is itself part of this contrast. His revolutionary imagery is similarly dedicated to this purpose; to the pursuit of clarity and wholeness of vision in which the elegiac and the tragic coexist. This can be uncomfortable. In the grotto of *Dido and Aeneas* in the garden, the scene of their love-making, he uses the double lightning flash of the SS as a dual symbol of Jove's thunder which recalled Aeneas from love to his duty, and of the brutal profession of warrior to which he was recalled. That such a conjunction of love and war is uncomfortable is a reflection of Finlay's capacity to find and to touch the exposed nerve. In this case it is our still unresolved attitude to the Second World War. That he can touch us in this way is a comment on his seriousness as an artist as he strenuously challenges our comfortable and unquestioned assumptions.

THE PRESENT DAY

From 1460 to 1960 is five hundred years, a wide enough span for a book of this kind. To end at 1960, too, would be to end on a high. J. D. Fergusson was still alive then. William Johnstone, newly returned to Scotland, was just beginning his remarkable, late paintings. Gillies was still teaching. Joan Eardley was at the height of her powers, and Paolozzi and Davie were established as two of the leading artists in Britain. To bring the story up to the present day on the other hand poses problems of perspective. Though artists like Paolozzi or Davie have so clearly established their reputations that they can be seen in perspective even though they are still working, this cannot be true of their younger contemporaries. There is also the sheer quantity of artists. With the post-war expansion in education far more people have undergone an artistic training than ever before. Inevitably, therefore, what is said in this closing chapter must be more summary than what has gone before. It can only provide pointers, suggest some continuities and indicate some of the outstanding artists, but the whole point of this book would be lost if the story it recounts was not seen in the context of the present day.

Looking back over the last thirty years of art in Scotland there have been several important structural changes. For instance, the emergence about thirty years ago of the non- or semi-commercial gallery, as an alternative to the dealers on the one hand and to the exhibiting societies on the other, changed the relation of artist to public. The first of these galleries were, in Edinburgh, the 57 Gallery, founded as its name implies in 1957, and in Glasgow the New Charing Cross Gallery founded in 1963. The latter was followed by the Compass Gallery in

1969. Since then their number has increased steadily. In the sixties and early seventies especially, the Demarco Gallery under Richard Demarco played an important role, giving their first one-person show to a large number of artists who have gone on to distinguished careers.

The increase in the number of non-commercial galleries has not been matched by a parallel increase in the number of purely commercial dealers in contemporary art however, though one or two, notably the Scottish Gallery, heir to Aitken Dott's in Edinburgh, and Cyril Gerber in Glasgow have maintained the old tradition of the enlightened dealer. An increasing amount of money has been made from the trade in Scottish painting, but this has been mostly historical painting and has recently been largely for a market outside Scotland. There may have been some increase in the private patronage of art, but the increase in the number of independent galleries was made possible by the creation in 1967 of the Scottish Arts Council in place of the earlier Scottish Committee of the Arts Council of Great Britain, not by any expansion of the market.

The Scottish National Gallery of Modern Art which opened in 1960 was another important new institution. Though it has never become the source of patronage that it might have been, its existence has undoubtedly played a role in the psychology of contemporary art, if not in its economy. The city galleries, especially Aberdeen, though Glasgow and Edinburgh too, have a more creditable record of supporting contemporary art. Another important development made possible by Arts Council patronage has been the establishment of print-makers' workshops in Edinburgh,

Plate 329. JOHN HOUSTON, *Night Sky, Harris*, 1975

Glasgow, Dundee, Aberdeen and Inverness, mostly with associated exhibition space. The existence of these has brought about a minor renaissance in print-making over the last twenty years. Most of the artists mentioned here have made prints, and the revival of the suite of prints which began with William Johnstone's lithographs to poems by Hugh MacDiarmid in 1977 has been carried on with great success in such enterprises as *The Scottish Bestiary* (1986). A suite of twenty prints by seven artists to texts by George Mackay Brown, it was printed by Arthur Watson at Peacock Printmakers in Aberdeen and was the brainchild of Charles Booth-Clibborn, who has gone on to promote several similar schemes.

The effect of the increase in the number of independent galleries has been to make the one-man or one-woman exhibition, or the small group show the principal line of approach of an artist to the public, rather than, as previously, an appearance in one of the annual exhibitions, or in dealer exhibitions for the lucky ones. The existence of the semi-commercial galleries has also drawn a line between the younger artists and the painters of the older generation who have mostly continued to work through the dealers, the Scottish Gallery, for example, the Fine Art Society, or the Mercury Gallery in London. These have all provided steady support for artists like Robin Philipson, Elizabeth Blackadder, James Morrison, David Michie, David Donaldson, Alberto Morrocco and others, though the two last named have also worked very successfully as portrait painters. This particular group have of course remained supporters of the older institutions, especially the Royal Scottish Academy, and these have not completely lost their influence, especially through their links with the four art schools.

The art schools themselves have continued to play a central role through their teaching, but equally importantly through their patronage. This begins at the level of post-graduate scholarships, both resident and travelling, and continues through the provision of teaching posts, full- and part-time. Though there is no doubt much that can be criticised in the way that the art schools have exercised their responsibility,

both as teachers and as a source of patronage, their role has nonetheless been central in keeping alive a sense of a distinctive Scottish tradition.

The more subtle effect of the existence of the Scottish Arts Council and the promotion of a non-commercial climate for art was to encourage the creation of art of a kind that could never go to a private buyer. This has been reflected in things like scale, material and finish, particularly apparent in sculpture, but also more fundamentally in the matter of accessibility. There can be no doubt that the existence of a public support system for the arts reduced the need for the artist to make art that is accessible, even if only to a specialised public. This has of course not been unique to Scotland. The last phase of modernism as a movement was marked internationally by the decadence of the idea that the artist is a bridge from the particular to the universal, as it was described by Alan Davie for example. This noble ideal with its roots in the eighteenth century has decayed instead into the idea of art as the cultivation of an exclusive private language that is understood by the artist alone. According to this view the evidence of the artist's own uniqueness is seen as the ultimate, and often the only test of a work's authenticity. Hence the paradox of the avant-garde in which the inaccessibility of art becomes the chief measure of its value. These are tendencies which have been reinforced by the universal cultivation of subjectivity and of self-expression as the exclusive objectives of art education.

Plate 330. ELIZABETH BLACKADDER, *Amaryllis and Crown Imperial*, 1979

These are the kind of ideas which both Paolozzi and Finlay were beginning actively to challenge in the sixties and seventies, but they had been endorsed since the early sixties by the growth of the idea of a new kind of internationalism. It was bland and generalised. In Scotland it was experienced at one remove in a way that was very different from the participatory internationalism of Fergusson, Johnstone or Gear. With the final breakdown of the studio system in Paris the opportunity for real overseas study declined (though much later the development of Berlin as a centre has provided some compensation). As a result real first-hand experience of art elsewhere was much more difficult for young artists in spite of the system of travelling scholarships and the development of easy modern travel. Internationalism became instead the province of the art magazines and was given local expression in exhibitions brought to Scotland. Exposure of this kind was no doubt a good thing and there have been some major exhibitions, but as the opportunities for Scottish artists to show overseas were, with few exceptions, so much more limited than the opportunities for bringing art into Scotland their relationship to art from elsewhere was compelled to be passive. This disadvantage was compounded by the way that their own native tradition was not readily available to them. The National Galleries became international galleries, concentrating on presenting the conventional view of European art, in

Plate 331. RORY MCEWEN, *Gentian*, 1982

Plate 332. JOHN MOONEY, *Still-Life with Cactus*, 1989

which of course the Scottish tradition had no place. In the years leading up to the referendum of 1979, in spite of this unequal relationship to the outside world, there was a blossoming of self-confidence. The eventual fiasco of the rigged referendum punctured this mood of optimism, but it also perhaps helped to expose the illusion of internationalism.

The native tradition, however imperfectly it was perceived, did still provide a base for the best artists in their response to influence from elsewhere, however. This provided them with new instruments to develop what was their own. The influence of French and American abstract-expressionist painting is apparent in the early sixties in the work of John Houston (*b.* 1930), Elizabeth Blackadder (*b.* 1931), Jack Knox (*b.* 1936) and William Crozier (*b.* 1930), as well as that of Philipson, but although all these painters painted abstract, or nearly abstract, pictures at the time, the native influence of Gillies, Redpath and Eardley remained strong. (The two latter were themselves much

influenced by French and American painting.) Outside influences provided a freer and more open pictorial syntax for these painters through which to construct a kind of painting whose frame of reference was still the perceived world. Crozier, for example, went on to specialise in landscape while Knox by the early seventies was painting characteristically bold and simple still-lifes such as *Three Piles of Cherries* (1975, SNGMA), which recall the synthesis of objectivity and formality that characterises the work of Morandi and the classic tradition of still-life.[1]

This insistence on the concrete was not simply a matter of innate conservatism. Indeed standing by their convictions in this way was not always easy. In the seventies John Houston painted some of his finest landscapes in a series of watercolours which take account of the scale and space opened up by some of the American painters, for example *Night Sky, Harris* (1975, the artist). (*Plate 329*) In the mid-seventies international opinion decreed that painting was finished however. Conceptualism and related approaches had rendered it redundant. Houston found painting very difficult such was the crisis of confidence that this provoked, though in the end he recovered his own sense of direction.

Blackadder in the early part of her career painted mostly landscape, but began in the seventies to concentrate more and more on still-life. The implied space of abstract painting, without conventional pictorial structure, allowed her, using an almost empty canvas or sheet of paper (for she has increasingly used watercolour), to assemble a variety of objects in a free and seemingly random association. These representational elements provide a schema, but the painting is a poem built around them with its own internal logic. This approach is also seen in the work of David McLure (*b.* 1926) and David Michie (*b.* 1928) and its continuity with the work of Gillies, Redpath and Maxwell is clear. By the late seventies, however, the representational elements in Blackadder's paintings included flowers and plants described with exquisite tenderness which in the eighties became frequently her whole subject, as in *Amaryllis and Crown Imperial*, for example, (1979, Private Collection). (*Plate 330*)

In her more complex still-lifes such as *Still-Life, Nikko* (1987, Gillian Raffles), although the tradition of Gillies and Redpath is still important, there is also considerable influence from Japanese art. This is seen in her occasional use of calligraphic gesture, but especially in her use of interval, the space between elements in her pictures which even though it is blank becomes an active part of the composition. This quality, like the beauty of the flowers that she describes in her purely botanical painting, has a profound contemplative dimension.

Blackadder's painting of flowers and plants, based on a description that is so fastidious that it becomes poetic, is not isolated. Rory McEwen (1932–1982) developed botanical painting in a similar way. He used the techniques of miniature painting so that the purity of his image, isolated on a vellum ground and placed with the eloquence of Japanese painting, has an extraordinary intensity, for example, *Gentian* (1982, Private Collection). (*Plate 331*) Eileen Lawrence (*b.* 1946) paints in a similar way, describing with great delicacy the detail and structure of natural forms, plants or feathers for example. In her work too the influence of oriental art has shown her a way to lift such description into an imaginative statement. John Mooney (*b.* 1948) also uses precise botanical painting as one element in a highly individual pictorial language in *Still-Life with Cactus* for example (1989, the artist). (*Plate 332*) The high finish of his pictures constitutes a rejection of painterly display, but he develops the idea of a theme and variations to create a subtle and often ironic series of metamorphoses on a set of given images, an irony that is enhanced by the way in which he contrasts high finish with an expressly artificial mode of composition. Ian Howard's painting (*b.* 1952) works in a similar way, combining an essentially abstract structure with a set of images whose inter-relationship is partly formal and partly depends on reference.

One important group of artists has developed an equally fastidious way of working in which such description also plays a part, but whose common feature is a poetic language of association with the sea. There is a parallel in their work with the symbolism of ships that played an important part in Finlay's work in the

sixties and early seventies. Equally important, however, was the painting of John Bellany in the sixties which reintroduced amongst the younger artists the idea of subject-matter that could reflect the primary concerns of existence as perceived in a Scottish community. Amongst those who shared this preoccupation one of the most original is Will Maclean (*b.* 1941). Maclean studied at Aberdeen where Ian Fleming was still principal, but where Frances Walker (*b.* 1930) was also important as a teacher. Walker has built an art on the scrupulous analysis of the actual, especially of landscape formations on the seashore, as in *Rocks, Tiree*, (1989, the artist). (*Plate 333*) She is also notable as a print-maker. The example of her dedication, and of her severe and disciplined drawing akin to Cowie's, was important to a number of Aberdeen artists.

Plate 333. FRANCES WALKER, *Rocks, Tiree*, 1989

Maclean trained as a painter, but like so many of his contemporaries, and anticipated in this too by Finlay and Bellany, he rejected the display in contemporary painting. His first major statement was an exhibition in 1978 called *The Ring Net*. It was a documentary exhibition on the theme of ring-net fishing on the west coast, from Carradale to Skye, a project that would have intrigued McTaggart. Such documentary projects were fashionable in the late seventies. Glen Onwin (*b.* 1947), for example, had two important exhibitions of this kind, *Saltmarsh* in 1975 and *Salt Works: The Recovery of Dissolved Substances* in 1978. The latter especially was also on a marine theme, though a more conceptual one.[2] It was an exhibition on the theme of salt that ranged from the perfect cube of a single salt-crystal up to the wide horizons of seascape. These documentary exhibitions were perhaps an important stage in the return to the idea of subject-matter. They were also a manifestation of the idea of the exhibition itself as an art form, an idea that would not have been possible without the non-commercial galleries and to which several artists have remained loyal. Glen Onwin himself, Elizabeth Ogilvie (*b.* 1946) and Robert Callender (*b.* 1932) for example have all continued to present thematic exhibitions whose subject is the sea and with titles like *Watermarks* by Callender and Ogilvie (1980), or *Sea Sanctuary* (1989) by Ogilvie.

Will Maclean drew much of his early inspiration from his own memories as in *Memories of a Northern Childhood* (1977, Private Collection), but he enlarged this towards universal themes by exploring the myth and history of the Highlands where many of the people were forced to turn to fishing to survive as a consequence of the Clearances. In their life as fishermen he discovers links with the primeval past, for fishermen are still hunters in touch with nature. In *Man Listening for Herring* (1989, Private Collection), for example, Maclean records the way a man that he knew used actually to listen for the fish, and in the style of this assemblage he has suggested how this parallels the skills in interpreting nature of some of the most primitive peoples. By establishing such a connection, he opens for us the living continuities of myth. It is this which gives such potency to an image like *Skye Fisherman: In Memoriam* (1989, Dundee Art Gallery). (*Plate 335*) A life-jacket, rubber gloves and some other items of fishing paraphernalia are combined in a painted collage. It has a powerful presence as a memorial to an uncle of the artist, but like Puvis de Chavannes's *Poor Fisherman* or like the Fisher King in 'The Wasteland' he is an archetype. Like Eliot, Maclean can reach from the immediate topicality of the present and personal to the permanence of myth. The topicality of his work has a cutting edge too. *Hallaig, Death Fish Study I* (1984, BM), for example, is one of a series of drawings

Plate 334. ELIZABETH OGILVIE, *Letters from the Edge of the World*, 1988

Plate 335. WILL MACLEAN, *Skye Fisherman: In Memoriam*, 1989

Plate 336. JOHN McLEAN, *Muskeg*, 1990

inspired by Sorley Maclean's poetry, and recalling Cowie in execution, in which Maclean associates the militarisation of the west of Scotland and its nuclear submarine bases with the earlier tragic history of the Highlands and the new threat of ecological disaster. In recent works inspired by his experience of America, such as *Nantucket – Front and Back* (1989, Private Collection), he has identified in present society the same dissociation of sensibility which created the moral blindness that in the name of profit destroyed the communities of the Highlands. It is a theme that links him to McTaggart and Wilkie and which makes the Clearances a parable for our time.

Maclean's subject and imagery, like his ecological concern, has continued to have a parallel in the work of Elizabeth Ogilvie and Robert Callender who have for many years taken their inspiration from the far North West where they have worked together in the summer. Both, like Maclean and a number of

others in their generation, began with the rejection of the Edinburgh painterly tradition and turned instead to low-key or monochrome work. Ogilvie in fact, like John Brown two hundred years earlier, rejected the whole tradition of oil paint to work for a long time exclusively in pencil and graphite. Her drawn seascapes and wave studies of the seventies gradually gave way to more animated forms, especially seaweed, as an image of flow. As Eileen Lawrence has done too, and paralleling Blackadder's interest in Japanese art, she has extended this to use scrolls in the Japanese manner to add movement to this kind of imagery. More recently references to her own family origins in St Kilda, in *Letters from the Edge of the World* (1988, the artist), (*Plate 334*), for example, have given her work a more overtly poetic content akin to Maclean's and which, like his, reflects a concern that alienation and dispossession are the uncertain foundations of the wealth of our society.

Callender moved from low-key paintings of the sea and rocks to making ambitious painted constructions from paper. These reproduce with extraordinary faithfulness and to scale those things which suffer a sea-change; the flotsam and jetsam of the sea, or the buoys, harbour piles and lock-gates which are put into the sea and which it then makes its own. Ecological concerns unite these artists in their interest in the sea which is such a major part of Scotland's environment and in 1988, for

Plate 337. KEN DINGWALL, *In Memory, BK*, 1987

Plate 338. BARBARA RAE, *Travertine Quarry, Tuscany*, 1989

example, Glen Onwin presented a major exhibition on this theme, *Revenges of Nature*. The art of John Kirkwood (*b.* 1947) also reflects this kind of concern with equal urgency, but he has pursued a line that is less obviously 'green' and more directly concerned with the social and human environment, using collage and assemblage to evoke the real conditions of post-industrial Scotland.

The insistence on the concrete and the preoccupation with association and history goes right back into the nineteenth-century tradition of Scottish art and is still one of its most distinctive features in the late twentieth century. There have also been a number of purely abstract Scottish artists however. They are perhaps ultimately in the tradition of Davie, Gear and Johnstone, but the influence of American abstract painting of the sixties can also be clearly seen. These painters, like the American Morris Louis, or the Canadian Jack Bush, abandoned the surrealist attempt to penetrate to the unconscious in favour of the belief that formal values in a painting could be self-sufficient. John McLean (*b.* 1939), for example, has practised a pure, formal abstraction influenced by Bush and distinct from Davie's painting in the way that, through colour

Plate 339. DUNCAN SHANKS, *Cora Linn*, 1986

and gesture, he creates an autonomous and accessible visual language that is directly comparable to music, for example *Muskeg* (1990, Francis Graham-Dixon Gallery). (*Plate 336*) Far from belonging to an expressionist tradition, McLean, through his father Talbert McLean, looks back to James Cowie in the discipline with which he has pursued his ideal of pure, visual harmony. McLean has worked in London for much of his career, but in Scotland Derek Roberts (*b.* 1947) has remained loyal to the same ideals. Alexander Fraser (*b.* 1940) for a long time worked in a similar way. Recently he has begun to incorporate the figure into his painting, though without abandoning the essentially musical approach to composition.

A more austere belief in abstraction has been adopted by Ken Dingwall (*b.* 1938) whose intense art in greys and blacks, concealing emotion to give it more charge, for example *Covered Up* (1975, SAC), or *In Memory, BK* (1987, the artist), (*Plate 337*) like the art of Will Maclean and others, is a conscious rejection of the more narcissistic and self-indulgent implications of the colourful painting of some

of the older generation. Dingwall, however, although like John McLean committed to the ideal of abstract art, is much closer to the minimalists, an approach to art to which Alan Johnston (*b.* 1945) has also been loyal and which has been ably supported by the Graeme Murray Gallery in Edinburgh.

In spite of the work of these abstract artists there can be no doubt that a continuing insistence on the concrete and on association has been a major feature of recent Scottish art. This is clearly reflected in the survival of landscape as a primary form. This certainly owed much initially to the influence of Gillies and Eardley, but with John Houston, Ian McKenzie Smith (*b.* 1935), James Morrison (*b.* 1932), Duncan Shanks (*b.* 1937), Francis Walker and Barbara Rae (*b.* 1943), to name only a few, landscape has been shown to be a form still capable of development. John Houston's watercolours of the sea, already mentioned, painted in the seventies, touched by the example of American painting, combine the inspiration of Rothko and Turner in a statement about northern landscape that approaches the metaphysical. These began with paintings like *Evening Sky over the Bass Rock* (1964, the artist), which has a great surging sky in a series of wave-like shapes reminiscent of Munch, and have continued to develop both in watercolours and in a series of large-scale seascapes, in which the Bass Rock is a frequent motif. More recently he has also returned to painting the figure in a free and expressionist manner akin to the work of his friend John Bellany whose portrait appears in several of his pictures.

James Morrison started very close to Eardley with paintings first of Glasgow and then of Catterline. His later works exploit the scale of hills and horizon, at its best when most economical. The painting of Barbara Rae is closer to the spirit of Gillies in its origins. She uses landscape associatively, bringing together in her picture both her observation of fact and her sense of the picture as a decorative object. In *Travertine Quarry, Tuscany* (1989, Scottish Gallery), (*Plate 338*), for example, from a shadowed foreground, across the depth of the abandoned stone-workings, the sun has caught the white of bare stone through the spidery silhouette of rusting iron. Transformed in the picture, this scene of

dereliction has become like a precious object. Duncan Shanks was a pupil of David Donaldson in Glasgow where with Donald Bain and Mary Armour a more expressionist way of descriptive painting was maintained. Like Eardley, Shanks has taken the lessons of abstract expressionism back to the landscape that was its original inspiration however. Particularly over the last decade, he has developed in the painting of water a kind of synthesis between the methods and the autonomy of abstract expressionism on the one hand and the description of the objective world on the other. The result in paintings like his *Cora Linn* (1986, Private Collection), (*Plate 339*) is landscape on a heroic scale. It belongs to the late twentieth century, yet Jacob More would have understood it completely.

In a very different mood and in an ironic gesture of rejection typical of the sixties, but also following the lead of Paolozzi and the Independent Group, Mark Boyle (*b.* 1934) decided to make the ultimate statement on the role of the concrete in art. He did this by making actual-size facsimiles of areas of ground chosen at random on a map. The arbitrariness of his choice was also an attack aimed at the elevation of self that was so much part of the system of art education, for his work underlined the absurdity of elevating the banal act of artistic intervention into a mystery. His contemporary Bruce McLean (*b.* 1944) made a similar gesture of rejection, directed at the same aesthetic ideas that prevailed in art education. He parodied through performance an art whose concerns were entirely self-regarding and whose aesthetic was entirely self-justifying. Though his target was originally art in London, there was much in the art-school tradition in Scotland that might have inspired a similar art of rejection. In the problem of turning their negative into a positive, however, both McLean and Boyle have risked the original irony of their position turning against them. Their art of rejection has been accepted into the canon and made respectable, though McLean, turning to painting, has retained a satirical intention in the way in which the richness and beauty of surface that he creates contrasts with the content of his image as in *Gucci Girls* for example (1987, SNGMA).

The most creative rebel of the sixties was

Plate 340. SANDY MOFFAT, *Sorley Maclean*, 1978

John Bellany (*b.* 1942). He and Sandy Moffat (*b.* 1943) were together at Edinburgh College of Art from 1960. Supported by Alan Bold they rebelled against Edinburgh aestheticism. They were inspired by MacDiarmid and other members of the forties' radicals such as John Tonge whom they met in Edinburgh, and many of whose portraits Moffat subsequently painted. (*Plate 340*) From this base Bellany carried on directly from where the Glasgow painters of the Scots Renascence had left off. Another important influence on both Bellany and Moffat was Alan Davie, though it is important to remember that Robin Philipson, teaching at Edinburgh College of Art, was also much influenced by Davie at that time. Following Davie's inspiration and the current climate of internationalism, they felt at first that they had to be abstract painters. Social ideas represented not only by MacDiarmid, but by Léger and by the writings of John Berger were also part of their inspiration however.

Plate 341. JOHN BELLANY, *My Father*, 1966

Davie himself was not only an abstract painter, he was also a promoter of a Jungian approach to symbolism. Bellany's originality lay in his development of a figurative way of painting that was capable of supporting a powerful, allusive symbolic language of just this kind. One of his first major pictures, for example, was *Allegory* of 1964 (SNGMA). It is visibly dependent on Davie's *Creation of Man, or the Marriage Feast* of 1957. Both pictures are triptychs. In Davie's picture this form is the framework for an implied image of the three crosses. Bellany has made this image explicit and in the place of Davie's inchoate forms he has put the bodies of fish in which the visceral quality of Davie's execution actually reads as fish guts. There is also a distinct memory of Rembrandt's paintings of flayed oxen in the picture and historical painting of this kind was an important part of Bellany's early inspiration. In this way he has not only made the symbolism of Davie's image more explicit, he has also localised it. Beneath these brutal images of the sacrifice that human life exacts from nature are the men of the fishing village of Port Seton, Bellany's own home. They are arranged like the soldiers at the Crucifixion, but they too are victims. It is the human condition to be caught thus between the inseparable and equally exacting demands of physical and metaphysical necessity.

Bellany achieves this kind of universality in a number of superb paintings of the sixties, *Kinlochbervie* (1966, the artist), for example, which presents a table of fish-gutters like a Last Supper, with a fishing boat and its crew behind them, or *The Obsession (Whence do we come? What are we? Whither do we go?)* of 1968 (CEAC), (*Plate 342*) which has a similar iconography. In it he borrows Gauguin's title to present a metaphysical vision of suffering, inspired by a visit to Buchenwald in 1967, and set against a barren and empty seascape of a kind that is paralleled in the painting of John Houston. In *Homage to John Knox* of 1969 (the artist) Bellany is specific about the interpenetration of the physical and the metaphysical, not only at sea but in the marriage bed. Equally impressive from these years are the portraits of his father, for example *My Father* of 1966 (SNGMA), (*Plate 341*), or the double portrait of the same year of father and son against his father's boat in *Bethel*.[3] They

are painted with a solid and undemonstrative touch that reveals his admiration for Courbet and the painting of the Dutch.

Like the painters of the early thirties, Bellany consciously identified himself with the northern tradition. Initially this led him to the German painters of the inter-war years, especially Beckmann whose work he first saw in 1965. Beckmann was one model for the kind of symbolic language that he used in the sixties and for the way that he learned to tackle themes of a social kind without sinking into the banality of social-realism. Typically Bellany uses fish and animals, often now interchanging their features with those of humans. In *Sea People* of 1974 (Arts Council Collection, South Bank), (*Plate 343*) he repeats his image of figures set hieratically against the sea. The two principals are a man and a woman, but she is half fish. The effect is sometimes quite close to Colquhoun as well as to Beckmann, not just as a pictorial device, but also in the effect it achieves, for increasingly he used this kind of symbolism to deal with themes that reflected a more personal angst. This also reflects the influence of Bacon, but subsequently these figures have become like the symbols in Alan Davie's later painting. As we have no access to them, we must regard the drama that they enact as an event of which we are witnesses, but in which we cannot participate. Bellany also developed a much freer technique and a

Plate 342. JOHN BELLANY, *The Obsession*, 1968

looser way of organising a picture more akin to de Kooning, and his symbolism, already allusive and deliberately half-formulated, begins to be submerged in the more immediate impact of an expressionist way of painting.

Bellany's example has had a far reaching effect. If not directly influenced by him Joyce Cairns, June Redfern (*b.* 1951), and Jock McFadyen (*b.* 1950) all paint in ways that can be compared to his. It was not Bellany's influence alone that was responsible for the emergence of a new generation of Glasgow painters in the early eighties however. Painters like Carol Gibbons (*b.* 1935) in Glasgow had maintained an independent tradition of powerful figure painting there. Tom MacDonald, though no longer a social realist, was still painting in an energetic and committed way and Ian McCulloch (*b.* 1935) in paintings like *Lilith* (1963, Hunterian), for example, had throughout maintained the Glasgow tradition of refusing to compromise with academic values. It is not surprising therefore, given in addition the importance

at Glasgow School of Art of the teaching of Bellany's close friend and early associate, Sandy Moffat, that in Glasgow there should emerge among the younger generation a kind of painting which is at times remarkably close to the work of the painters of the forties.

The first of these Glasgow painters to achieve fame was Steven Campbell (*b.* 1953). Campbell's painting though, like that of his younger contemporary Adrian Wiszniewski (*b.* 1958), belongs as much in the fashionable, dealer-led revival of figurative painting in Germany and Italy as it does in a tradition that includes Bellany. This revival was one of the opening moves in the game of fashionable postmodernism. It is really quite distinct from the serious critique of modernism that had been gathering momentum over several decades in the work of artists like Finlay and Paolozzi and indeed the earlier work of Bellany himself. Instead it combines a rather whimsical approach to history with large, bold handling. Campbell though does bring to this approach a

Plate 343. JOHN BELLANY, *Sea People*, 1974

distinctly Scottish perspective. He conceives his images in a casual and deliberately unpremeditated way that recalls the method of Alan Davie, though the comparison also underlines the differences. Instead of a visible struggle to reach through consciousness to some deeper layer of awareness, his paintings seem to take place entirely on the surface. Figures who look like characters from a novel of the thirties, an anachronistic world which is both strange and familiar, are subjected to the arbitrary dispositions of the surreal. They are the tweedy inhabitants of the world of P. G. Wodehouse and they find their cosy, enclosed existence disrupted by the disorder and confusion of the real world. In *Building accusing the Architect of Bad Design* (1984,) for example, two male figures react in horror to the signs of animated hostility that are being shown by a vaguely gothic building. In the collapse of old certainties they are at a loss. This kind of picture is perhaps a comment on contemporary British reality seen from Glasgow, on the world in which the Scots hear the English cricket scores treated as national news.

More recently Campbell has used an increasingly surrealist vocabulary, but his underlying theme has remained the insecurity of masculine ideals, as in *Young Men in Search of Simplicity* (1989, Marlborough Fine Art). (*Plate 344*) Campbell's tweedy figures are male caricatures literally at sea, disoriented perhaps by the collapse of traditional male complacency as women assert their rightful place. There has been a series of major women artists in Scotland, where Frances Macdonald and Cecile Walton pioneered work with a distinct, feminine content. One of the most original younger painters currently is Gwen Hardie (*b*. 1962) who has taken up the challenge, already confronted by Cecile Walton in her painting *Romance*, of adapting the painting of the figure to a feminine perspective. Initially she did this by painting very powerful, enlarged close-ups of the face and parts of the body. Subsequently she turned to a more schematic, but also more overtly symbolic kind of imagery. This is an approach that also brings her closer to another woman artist, Kate Whiteford (*b*. 1952), who uses symbols inspired by iron-age and neolithic models in a kind of land art which, like the work of Will Maclean and

Plate 344. STEVEN CAMPBELL, *Young Men in Search of Simplicity*, 1989

before him William Johnstone and with similar intentions, brings to the surface ancient continuities in the present-day.

Campbell's art, however, reflects the world-view of a new generation for whom, rightly or wrongly, these continuities appear less important; a generation that has accepted that the non-linear, collaged view of experience proposed by Paolozzi has replaced old certainties. For this generation, as old cultural imperatives have faded, there is no longer the gap which art has for so long endorsed between how they actually see the world and how they feel they ought to see it. This gives a much more casual approach to style that seems to an older generation almost promiscuous, but which suggests a welcome transition from 'ought' to 'is', from a culture that claims that it is universal to one that might actually be so. This approach is even more clearly seen in the paintings of Stephen Conroy (*b*. 1964), (*Plate 345*) who shows us himself looking into the past which is identified by the style of the people that he represents as well as by the style in which he paints them.

Perhaps the popularity of this kind of painting lies in the way that, in contemporary culture, style is the principle reflection of an awareness of history, but a history in this case that is so recent that it is still familiar to many.

A different attitude to the past is marked in the painting of Ken Currie (*b.* 1960) however. Together with his contemporary at Glasgow School of Art, Peter Howson (*b.* 1958), Currie has adopted a way of painting that is more directly continuous with the work of Bellany and Moffat in the early sixties. The inspiration of both painters is in Léger, in the social-realist painters of the nineteenth century and of Germany in the twentieth century, in the Mexican Muralists and in the equally political and realist art of the Americans of the 'Ash Can' school in the thirties.

In a series of paintings for the People's Palace in Glasgow in 1987 Currie undertook a revival of history painting devoted to the socialist story of the people of the city, very much in the manner of Diego Rivera, though also, closer to home, to Stanley Spencer's Clydeside paintings. Much of Currie's subject painting is similar in character. The drawings related to this series like *Unfurling Our Banner, Our History, Our River* (Private Collection), (*Plate 347*) are superb and if anything the black and white medium is even better suited than paint and canvas to what he is trying to do. His single figures though, like *Woman from Drumchapel* (1984, British Council), are more direct and are without rhetorical symbolism. Not only Joan Eardley, but even Walter Geikie might have recognised a kindred spirit.

Peter Howson likewise has tried to use the rhetorical language of history painting. It is an attempt that poses enormous problems, though. History painting is so burdened with associations that it is difficult for the image to rise above a commentary on the art history to which it refers. Like Currie however he succeeds brilliantly in dealing directly with the individual, for example in a series of twenty-five etchings of imaginary characters, the *Saracen Heads* (1988) based on a Glasgow pub the 'Saracen's Head', one of the finest sets of recent prints, produced at the Printmaker's Workshop, Edinburgh. These strongly individualised images again focus the problem of history painting though. As Wilkie and D. O. Hill discovered, it is almost impossible to reconcile this vision of individuality with the ideal, formal language that history painting requires. Howson's figure of *The Noble Dosser*, (*Plate 346*), which exists in a number of different media, personifies this conflict between the ideal and the individual. *The Noble Dosser* is outside society. It is a paradox that he is both heroic and an outcast, but logically, as Nietzsche saw, the uniqueness of the individual can only really be fully expressed outside the pressure to conform on which society is based. Rembrandt explored this paradox in an etching of himself as a beggar, and Burns explored it optimistically in 'The Jolly Beggars'. The paradox is not a problem peculiar to representational art however. It reflects the underlying tension between the aesthetic of individualism and the needs of society, but these also represent the horns of the western dilemma; pure capitalism is unacceptable and pure socialism is unworkable.

John Bellany's most recent major work was a series of watercolours recording his experience undergoing major surgery for a liver transplant. They could be seen as a metaphor for the state of art, mortally sick from self-indulgence and in need of drastic surgery with the failure of the ideals of modernism that had grown from the eighteenth-century idea that the imagination was the principal agent in the achievement of moral understanding. According to this view, the cultivation of the imagination was therefore an essential precondition for the establishment of a society based on the ideal of moral order. The cultivation of the imagination was also the province of art, for

Plate 345. STEPHEN CONROY, *The Enthusiasts*, 1987

Plate 346. PETER HOWSON, *The Noble Dosser*, 1987

Plate 347. KEN CURRIE, *Unfurling Our Banner, Our History, Our River*, 1987

seeing and knowing were mutually dependent and moral and physical vision were therefore two aspects of a common process of perception, with imagination essential to them both. To free these perceptions, artists turned to the cultivation of spontaneity and an attack on vision governed by convention and constructed from given images. Perhaps the earliest statements of this position are in the art of Ramsay, Hamilton or Runciman, but its origins lie even further back in the central place of the individual in Reformation thought. It is appropriate therefore that Paolozzi, Finlay and now Bellany should be amongst the earliest artists to alert us to the decadence of this noble idea and its decline into the sterile elevation of the self, no longer the route to universal knowledge, but cultivated as the exclusive objective of art.

Taking the even longer perspective offered by the five centuries of history covered in this book, the St Andrews mace which stands at the beginning of this story is a superb object. It was made to the glory of God, but also to serve, as it still does, for an ideal of knowledge. Ninety-nine years after it was made, Knox preached the sermon that launched the Reformation, also in St Andrews. The pursuit of knowledge that the mace represents was a direct contributor to the Reformation and knowledge was the key issue

of that revolution, knowledge of God and knowledge of man, based not on generalisation, but on the experience of each of us as individuals. Knowledge of man and the nature of individual experience was the substance of the Enlightenment. That this had an inevitable political dimension was already apparent in the politics of the Reformation itself, but was still uppermost when more than two hundred years later Wilkie commemorated Knox's sermon in a painting that also marked the passing of the Reform Bills in 1832. By so doing Wilkie also restated the need for the spiritual dimension in any whole culture. In the Disruption the spiritual dimension took priority over the political. Perhaps this was to Scotland's disadvantage in the short term, but it was also part of the complex of ideas by which Scottish artists seem never altogether to have lost sight of the wholeness of culture; of the belief that to be meaningful art has to operate at a level of awareness that is deeper than the concerns of any one interest group, be they politicians, clerics, art administrators, or the artists themselves. It is a perception that has also kept Scotland part of Europe and of the European tradition, and which is now drawing many of the best of the artists, led by Paolozzi and following the prophecies of Patrick Geddes, to take a stand in the ecological crisis of the modern world, the dark side of this same pursuit of knowledge. On that note therefore the last word in this long account of the Scottish tradition in painting should be given to an artist, J. D. Fergusson:

Tradition generally means something that has been handed down ready made and in a definitely fixed form – any interference with which is, to the traditionalist not to be tolerated on any account.... Tradition to me is ... kept alive by the creative person's contribution; and those contributing may join the main stream, if the artist is free enough from the obfuscations of actuality to be able to take his time, and to discipline himself to an awareness and readiness for the moment when he may get the chance to transmit some of the mystery of life, which goes to make a tradition. In this way he may help to keep his race alive and make a contribution to it, to his country and consequently to the world.[4]

ABBREVIATIONS

ACGB	Arts Council of Great Britain
b.	born
BM	British Museum
c.	*circa,* about
CEAC	City of Edinburgh Art Centre
d.	died
ECA	Edinburgh College of Art
EU	Edinburgh University
EUL	Edinburgh University Library
fl.	flourished
GAGM	Glasgow Art Gallery and Museum
GSA	Glasgow School of Art
Hist. Scot. Lit.	*The History of Scottish Literature* in 4 vols., gen. ed. Cairns Craig (Aberdeen 1988)
Hunterian	Hunterian Art Gallery, University of Glasgow
NLS	National Library of Scotland
NG	National Gallery
NGS	National Gallery of Scotland
NMR	National Monuments Record
NMS	National Museums of Scotland, formerly the Scottish National Museum of Antiquities
NPG	National Portrait Gallery
NT	National Trust
NTS	National Trust for Scotland
PRO	Public Record Office, London
RA	Royal Academy
RCA	Royal Company of Archers
RSA	Royal Scottish Academy
RSW	Royal Scottish Society of Painters in Watercolour
SA	Scottish Academy (became Royal Scottish Academy in 1837)
SAC	Scottish Arts Council
SAR	*The Scottish Art Review*
SAR n.s.	*The Scottish Art Review* new series
SNGMA	Scottish National Gallery of Modern Art
SSA	Society of Scottish Artists
SNPG	Scottish National Portrait Gallery
SRO	Scottish Record Office
TRG	Talbot Rice Gallery
V&A	Victoria and Albert Museum

FOOTNOTES

INTRODUCTION

1. Giovanni Pietro Bellori, *Le Vite de Pittori, Scultori et Architetti Moderni* (Rome, 1672).
2. 'Cosi quando la Pittura volgevasi al suo fine, si rivolsero gli astri piu benigni verso l'Italia, e piacque a Dio, che nell Citta di Bologna . . . sorgesse un elevatissimo ingegno.' Bellori, *Vite,* 'Life of Annibale Carracci', p20.
3. Fillipo Baldinucci, *La Veglia, o Dialogo di Sincero Veri* (Lucca, 1684).
4. In the *Sunday Times* (Scotland) 28 Jan. 1990.
5. Francis Hutcheson, *An Inquiry into our Ideas of Beauty and Virtue* (London, 1726).
6. (Sir George Chalmers) 'Anecdotes of Painting in Scotland', *The Weekly Magazine or Edinburgh Amusement* (16 Jan. 1722) pp65–7.
7. Alexander Campbell, *A Journey from Edinburgh through Parts of North Britain etc* (London, 1810) pp257–278. Campbell, incidentally, commenting on the housing of the Trustees Academy in Edinburgh University, remarks that it is regrettable that art was not taught in universities, a suggestion that was not taken up till more than sixty years later with the foundation of the Watson Gordon Chair of Fine Art at Edinburgh.

CHAPTER I

1. Robert Lindsay of Pitscottie, *Historie,* quoted R. Nicholson, *Scotland, The Later Middle Ages* (Edinburgh, 1989) p503.

2. Stanley Cursiter, *Scottish Art to the Close of the Nineteenth Century* (London, 1949) p14.
3. See Ranald Nicholson, *Scotland, The Later Middle Ages* (Edinburgh, 1989) p442; Alan McQuarrie, 'Anselm Adornes of Bruges, traveller in the East and Friend of James III' *Innes Rev.* XXXIII (1982) p15.
4. Norman Macdougall, *James III: a Political Study* (Edinburgh, 1982) p201.
5. National Museums of Scotland (Royal Scottish Museum), *Angels, Nobles & Unicorns* (1982) p100.
6. Macdougall, *James III,* p158.
7. *Angels, Nobles & Unicorns,* p100.
8. David McRoberts, 'The Glorious House of St Andrew', *Innes Rev.* XXV (1974) p158.
9. Ibid, p158.
10. John Major, *History of Great Britain* (Edinburgh, 1740) p328.
11. Nicholson, *The Later Middle Ages,* p590.
12. A proposal originally made by Friedlander, but repeated by Cursiter; see Colin Thompson & Lorne Campbell, *Hugo van der Goes Trinity College Panels* (NGS, 1974) p43.
13. See David McRoberts 'Notes on Scoto-Flemish artistic contacts' *Innes Rev.* X (1959) pp91–6 and Thompson & Campbell, *Trinity Panels,* p51.
14. Thompson & Campbell, *Trinity Panels,* p50 n6.
15. See p61.
16. See McRoberts, 'Scoto-Flemish Contacts' *Innes Rev.* X, pp91–6 and Thompson & Campbell, *Trinity Panels,* pp50–51 & p51 n6.
17. Thomson & Campbell, *Trinity Panels,* p82.
18. Robert Brydall, *History of Art in Scotland* (Edinburgh, 1889) p68, quoting Pitcairn's *Criminal Trials.*
19. McRoberts, 'Scoto-Flemish Contacts', *Innes Rev.* X, p92.
20. For a full account see George Hay, 'A Scottish Altarpiece at Copenhagen', *Innes Rev.* VII (1956) pp5–10.
21. Quoted Hay, 'A Scottish Altarpiece', *Innes Rev.* VII, p5.
22. Quoted Nicholson, *The Later Middle Ages,* p591.
23. For a full description see Leslie Macfarlane, 'Book of Hours of James IV and Margaret Tudor', *Innes Rev.* XI (1960) pp3–20. The book seems to have been Margaret's personal property for after James's death she gave it to her younger sister. The content of the book clearly reveals a closely supervised Scottish commission. This conjunction in a work of such elaboration suggests a wedding present.
24. Macfarlane, 'Book of Hours', *Innes Rev.* XI, and *Angels, Nobles & Unicorns,* p84.
25. M. R. Apted & S. Hannabuss, *Painters in Scotland 1301–1700; a Biographical Dictionary* (Edinburgh, 1978) pp70–71.
26. McRoberts, 'House of St Andrew', *Innes Rev.* XXV (1974) p122.
27. *Angels, Nobles & Unicorns,* p101.
28. For a full account see David McRoberts, 'Dean Brown's Book of Hours', *Innes Rev.* XIX (1968) pp144–167.
29. *Angels, Nobles & Unicorns,* p77.
30. Apted & Hannabus, *Dictionary,* pp76–7.
31. Ibid, loc cit.
32. Ibid, pp68–69.
33. See note 25.
34. Apted & Hannabuss, *Dictionary,* pp32–33.
35. Ibid, pp40–41.
36. Ibid, p113.
37. James Thomson's description in *The History and Antiquities of Dundee and its Vicinity: From the Earliest Times to the Year 1825* (Dundee, 1829), quoted M. R. Apted, *The Painted Ceilings of Scotland 1550–1650* (1966) p6.
38. Ibid, p5.
39. Apted & Hannabuss, *Dictionary,* pp97–8.
40. See *The Chronikill of Scotland,* Scottish Text Society, 2 vols (1935).
41. Apted & Hannabuss, *Dictionary,* p80.
42. Brydall, *Art in Scotland,* p53.
43. Ferrerius, *Historia Abbatum de Kynlos,* Bannatyne Club (Edinburgh, 1839) p50–1.
44. Nicholson, *The Later Middle Ages,* Chap. 18.

CHAPTER II

1. Quoted David McRoberts, 'Material Destruction caused by the Scottish Reformation', *Innes Rev.* X (1959) pp130–131, from Maxwell, *Old Dundee.*
2. Ibid, p129.
3. Lesley, quoted by McRoberts, 'Material Destruction', p146.
4. Quoted McRoberts, 'Material Destruction', p151.

5. *Diurnal,* (Maitland Club, 1833) p269, quoted McRoberts, 'Material Destruction', pp150–1.
6. Brydall, *Art in Scotland,* p81.
7. Ibid, p82.
8. Ibid, loc cit.
9. Ibid, p52, quoting Douglas, *Account of the East Coast,* quoting Billings, *Antiquities.*
10. Jenny Wormald, *Court, Kirk and Community* (London, 1981) p136.
11. Brydall, *Art in Scotland,* p83.
12. *Hans Eworth, a Tudor Artist and his Circle* (Museums and Art Gall. Leicester, 1965) p22.
13. Sir James Balfour Paul, *Heraldry in Relation to Scottish History and Art* (Edinburgh, 1900) p200.
14. Quoted Duncan Thomson, *Painting in Scotland 1570–1650* (SNPG, 1975) p31.
15. Brydall, *Art in Scotland,* p62; On 21 October 1553 John Acheson, engraver of the Scottish Mint, was given permission to work in the Paris mint, engraving dies and taking proofs of coins from a portrait of the queen taken from a drawing made by him at the court.
16. Helen Smailes & Duncan Thomson, *The Queen's Image,* (SNPG, 1987) p37.
17. Thomson, *Painting in Scotland,* p9.
18. Ibid, p22.
19. Ibid, p26.
20. Quoted ibid, p26.
21. A 'knapskall' is a nightcap; David Calderwood, *History of the Kirk of Scotland,* written before 1648, quoted Thomson p34.
22. Thomson, *Painting in Scotland,* p34.
23. Apted & Hannabuss, *Dictionary,* p111, contradicting Thomson and quoting SRO Register of Deeds 43 f.104.
24. Thomson, *Painting in Scotland,* p41.
25. Brydall, *Art in Scotland,* p64, quoting *Documents Relative to the Reception at Edinburgh of the Kings and Queens of Scotland (1561–1590)* ed. Sir Patrick Walker pp30–31.
26. Same source, quoted Thomson, *Painting in Scotland,* p21.
27. Brydall, *Art in Scotland,* pp71–2, quoting Burton's *History of Scotland.*
28. Apted & Hannabuss, *Dictionary,* p42.
29. For a full account see Duncan Thomson, *George Jamesone* (Oxford, 1974) pp95–101. See also pp62–3.

CHAPTER III

1. David McRoberts, 'A Sixteenth Century Picture of St Bartholomew from Perth', *Innes Rev.* X (1959) pp281–6.
2. M. R. Apted, *Painted Ceilings 1550–1650* (1966) p10.
3. Quoted ibid, p107. For Valentine Jenkin see also Apted and Hannabuss, *Dictionary,* pp52–53, and also R. K. Marshall, *The Days of Duchess Anne* (London, 1972) p58. Marshall gives a very full account of the decorative painters working for Duchess Anne at Hamilton Palace.
4. Brydall, *Art in Scotland,* p65; James Grant, *Old and New Edinburgh,* 3 vols. (London n.d.) III, p106.
5. Quoted M. R. Apted, *Painted Ceilings 1550–1650,* p99.
6. Quoted in translation by Colin McWilliam, *The Buildings of Scotland; Lothian* (London, 1978) p338.
7. Ibid, p336.
8. John MacQueen, *Progress and Poetry* (Edinburgh, 1982) p21.
9. Michael Spiller, in *Hist. Scot. Lit.,* I, p149.
10. Apted, *Painted Ceilings 1550–1660,* p127.
11. Quoted ibid, p20.
12. Thomson, *Painting in Scotland 1570–1650,* p49.
13. Ibid, p50.
14. Ibid, loc cit.
15. D. Thomson, *The Life and Art of George Jamesone* (Oxford, 1974) p133. See also p50.
16. William Maitland, *History of Edinburgh* (1753) p66, quoted Thomson, *Jamesone,* p100.
17. Ibid, p29.
18. Published ibid, pp134–6.
19. 25 Oct. 1634, ibid p134.
20. Correspondence of John Clerk of Penicuik and the Earl of Lothian and Inventories of John Clerk, Register House, Penicuik Papers, GD 18.
21. Quoted MacQueen, *Progress and Poetry,* (Edinburgh, 1982) p21.
22. Ibid, chapter I.
23. Register House, Penicuik Papers, GD 18, from which the following quotations are taken.

24. Lothian names 'The Petrarche, the Louis, the nudities, the droll playing the whistle and the other with the lute, and the Temptation of St. Anthonie, the St. Jerome, the Tobie, the Cavalier and the landskip of Kierens, the picture of Hans van Able, the Mellanchthon, the Inglish Bishop, the Woman and the Gentlewoman.' There was also a portrait of Henry VIII. Although Lothian only mentions one artist by name, they are identifiable in Clerk's inventories as follows: the Petrarch and the Louis by Corneille or Cornello, presumably Corneille de Lyon; the drolls by Broir, or Brouwer; The Temptation of St. Anthony by Frans Franck(en); the nudites could either be Diana and her nymphs by Rotenhammer or Diana and her nymphs 'a naked picture by David de Clerk'; the Kierink, Kierincx, or Cierinx was a landscape with the nine Muses. The others are less easily recognisable.

25. 30 Oct. 1644.

26. Quoted Duncan Thomson, *A Virtuous & Noble Education* (SNPG, 1971) p26.

27. Ibid, pp36–7.

CHAPTER IV

1. NGS, *Pictures for Scotland* (1972) p112.

2. Andrew Hook, *Hist. Scot. Lit.* II, p12.

3. Private information from David Howarth.

4. James Holloway, *Patrons & Painters; Art in Scotland 1650–1760* (SNPG, 1989) p29.

5. Stevenson & Thomson, *John Michael Wright*, (SNPG, 1982) pp63–4.

6. Apted & Hannabuss, *Dictionary*, p84, quoting Caw.

7. Stevenson & Thomson, *Wright*, p63.

8. Apted and Hannabuss, *Dictionary*, p70.

9. Quoted Holloway, *Patrons & Painters*, p43.

10. *Catalogue of Paintings* (Rijksmuseum Amsterdam, 1960) p100.

11. Holloway, *Patrons & Painters*, p62. Norie's *Still-Life* is described by Anon. (Daniel Albert Werschmidt) *James Norie Painter* (Edinburgh 1890) p11: '[It] represents some boarding of a wainscotted room, to which three leather straps are horizontally attached with tacks at intervals, into which are thrust a pair of compasses, a pair of horn eye-glasses, a long quill pen, an ink eraser, a stick of wax, copies of the *Edinburgh Courant*, the *Caledonian Mercury*, and of the *Gentle Shepherd* . . . open at the title-page and much thumbed – and lastly two letters, one with the seal outwards and the other addressed to Mr James Norie, Painter, Edinburgh . . . Attached by a bow of ribbon to the lowest strap is an ivory, or biscuit relief portrait of Charles I in a black wood frame.'

12. Apted & Hannabuss, *Dictionary*, p105.

13. Ibid, p107.

14. Ibid, p43.

15. Ibid, p89.

16. Rosalind K. Marshall, *John de Medina* (NGS, 1988) p4 and passim for an account of Medina's career.

17. Marshall, *Medina*, p8.

18. Ibid, loc cit.

19. Ibid, p29.

20. Ibid, loc cit.

21. See Duncan Macmillan, *Painting in Scotland: The Golden Age 1707–1843* (Oxford, 1986) pp16–17.

22. Joint Incorporation of Wrights and Masons of Edinburgh; the story is given in the minutes of the Incorporation of St Mary's Chapel, transcribed by David Laing (EUL).

23. John Gifford, *Buildings of Scotland; Fife* (1988) p425.

24. See Holloway, *Patrons & Painters*, pp69–74 for a full account of Waitt.

CHAPTER V

1. Aikman to Clerk, 8 Dec. 1720, Register House, Penicuik Papers, GD 18, quoted Macmillan, *Painting in Scotland* (Oxford, 1986) p10.

2. It is printed in full in Brydall, *Art in Scotland*, pp 110–111.

3. Basil Skinner, *Scots in Italy in the Eighteenth Century* (SNPG, 1966) p30.

4. Brydall, *Art in Scotland*, p106.

5. Quoted Macmillan, *Painting in Scotland*, p11.

6. Quoted ibid, p14.

7. See James Holloway, *William Aikman*, (NGS 1986) p6.

8. Skinner, *Scots in Italy*, p30.

9. See Mary Jane Scott in *Hist. Scot. Lit.* II, p84.

10. See Holloway, *Patrons & Painters*, p144.

11. Quoted, *Hogarth* (Tate Gallery, 1971) p55.

12. *A Dialogue on Taste* (1755), called no CCCXXII in *The Investigator* (London, 1762) p29, quoted Macmillan, *Painting in Scotland*, p24, where a full discussion of Ramsay's aesthetic position will be found.

13. *A Dialogue on Taste*, p21, quoted Macmillan, *Painting in Scotland*, p24.

14. Ramsay, *On Ridicule* (1753) in *The Investigator* (London, 1762) p63, quoted Macmillan, *Painting in Scotland*, p24.

15. Quoted Alastair Smart, *Life & Art of Allan Ramsay* (London, 1952) p106.

16. David Hume, *A Treatise of Human Nature* (1739) ed. L. A. Selby-Bigge (Oxford, 1888) p29. For a full discussion of Hume and Ramsay see Macmillan, *Painting in Scotland*, pp23–30.

17. A. F. Steuart, 'Miss Katherine Read, Court Paintress', *Scot. Hist. Rev. 2* (1904) p39. See also Victoria Manners, 'Catherine Read', *Connoisseur* (LXXXVIII and LXXXIX, Dec. and Mar. 1932).

18. Steuart, 'Katherine Read', *Scot. Hist. Rev. 2*, p44.

19. See Sir William Foster, 'British Artists in India', *Walpole Soc.* XIX (1930–31) p63.

20. Ibid, loc cit.

CHAPTER VI

1. See Ian Gordon Brown 'Modern Rome and Ancient Caledonia', *Hist. Scot. Lit.* II, p33.

2. Thomas Blackwell, *An Inquiry into the Life, Times & Writings of Homer* (London, 1735) p34, quoted Macmillan *Painting in Scotland*, p40; a full discussion of Blackwell's significance is given ibid, pp39–40.

3. For a full discussion see Macmillan, *Painting in Scotland*, pp31–42.

4. George Turnbull, *A Treatise on Ancient Painting* (London, 1740) p67.

5. Blackwell, *An Inquiry into the Life etc. of Homer*, p26 & 24, quoted Macmillan, *Painting in Scotland*, p40.

6. John Aikman of The Ross to John Forbes, 29 Aug. 1767. Robertson-Aikman Papers (Private Coll.).

7. For a full discussion of the work of the Runcimans see Macmillan, *Painting in Scotland*, Chap. IV.

8. For Delacour see Holloway, *Patrons & Painters*, pp117–121.

9. Runciman to Sir James Clerk, 16 May 1770, Register House, Penicuik Papers.

10. It is first mentioned in a letter to Lord Shelburne in Dec. 1771 printed in 'Catalogue of Sale at Lansdowne House', (Christie, Manson & Wood, 1930).

11. Runciman to James Cumming, Sept. 1769, (EUL).

12. Hugh Blair, *A Critical Dissertation on the Poems of Ossian*, p4, in *Poems of Ossian*, 3rd ed., 2 vols. (Dublin, 1765).

13. The records of the Cape Club are preserved in the National Library of Scotland.

14. *The Caledonian Mercury*, 28 Apr. 1774.

15. Fuseli to Mary Moser, 27 Apr. 1771, quoted J. T. Smith, *Nollekens and his Times, comprehending a Life of the celebrated Sculptor*, 2 vols. (London, 1828) I, p64.

16. Matthew Pilkington, *Gentleman's & Connoisseur's Dictionary of Painters*, ed. Henry Fuseli (London, 1805) p686.

17. Minutes of the Board of Trustees, Nov. 1772. SRO.

18. *The Earwig*, 1781, quoted, grangerised ed. of Allan Cunningham, *Lives of the Painters*, NLS.

19. See Basil Skinner, *The Indefatigable Mr Allan* (SAC, 1973), for a complete list of Allan's works; see Macmillan, *Painting in Scotland*, Chap. V, for a fuller discussion and documentation.

20. In his dedication to Allan Ramsay, *The Gentle Shepherd* (Glasgow, 1788).

21. See David Ridgeway, 'James Byers and the Ancient State of Italy', *Secondo Congresso Internazionale Etrusco* (Florence, 1985).

22. James Macpherson, 'Dissertation on the Poems of Ossian' in *Poems of Ossian* (London, 1857) p20.

23. 6 Nov. 1780, quoted T. Crowther Gordon, *David Allan of Alloa, the Scottish Hogarth* (Alva, 1951) p32.

CHAPTER VII

1. James Holloway, 'Robert Norie in London and Perthshire', *Connoisseur* (Jan. 1978).

2. See David Irwin, 'Charles Steuart Landscape Painter', *Apollo* XCX (1975).

3. Quoted Macmillan, *Painting in Scotland*, p143.

4. Ellis Waterhouse, *Painting in Britain* (London, 1962) p167.

5. Quoted Allan Cunningham, *Life of Sir David Wilkie*, 3 vols. (London, 1843) III, p279.

6. *James Nasmyth, Engineer: An Autobiography*, ed. Samuel Smiles (London, 1883) pp57–59.

7. See Thomas A. Markus, 'Buildings for the Sad, the Mad and the Bad in Urban Scotland 1780–1830' in *Order and Space in Society* (Edinburgh, 1982).

8. James Nasmyth, *Autobiography*, p50.

9. James Hogg, 'Scottish Haymakers' in *Tales of Love and Mystery*, ed. David Groves (Edinburgh, 1985) p195.

10. Correspondence of Wilkie and Perry Nursey in Dawson Turner MSS, Trinity College Library, Cambridge.

11. Joseph Farington, *Diary*, 12 Dec. 1807, quoted R. B. Beckett *John Constable's Correspondance*, Vol. IV (Suffolk Records Society Vol. X, 1966) p224.

12. George Walker to Earl of Buchan, 18 Dec. 1804, (EUL).

13. James Nasmyth, *Autobiography*, p50.

CHAPTER VIII

1. 12 Apr. 1806 (Laing Coll. EUL).

2. Andrew Duncan, *A Tribute of Regard to the Memory of Sir Henry Raeburn, RA* (Edinburgh, 1824) pp11–12.

3. James Greig, *Sir Henry Raeburn RA* (London, 1911) p xv.

4. See Macmillan, *Painting in Scotland*, p74, for a full discussion of this art-historical chestnut; and the following pages for a fuller account of Raeburn's career.

5. W. Dunlop, *History of the Rise & Progress of Arts & Design in the USA*, 2 vols. (New York, 1834) I, p395.

6. J. H. Benton, *The Scot Abroad* (1864); 2nd ed. (Edinburgh, 1900) p463.

7. T. Whitley, *Art in England 1821–37* (Cambridge, 1930) p48.

8. Archibald Alison, *Essays on the Nature and Principles of Taste* (1790); 2nd ed., 2 vols. (Edinburgh, 1811) II, pp426–7.

9. Thomas Reid, *Essays on the Intellectual Powers of Man* (1785) in *Works of Thomas Reid* (London, 1863) I, p187.

10. Thomas Reid, *An Inquiry into the Human Mind* (1764) in *Works* (1863) I, pp135–7.

11. Ibid, loc cit.

12. Jean-Pierre Cotten, 'La philosophie Écossaise en France avant Victor Cousin; Victor Cousin avant sa rencontre avec les Écossais' in *Victor Cousin; Les Idéologues et les Écossais*, Colloque international de février, 1982, au Centre d'Études pédagogiques, Sèvres, Université d'Edimbourg, Ecole normale superieure de la rue d'Ulm (Paris, 1985); Victor Cousin, *La Philosophie Écossaise*, 3rd ed. (Paris, 1857).

13. *Letters & Papers of Andrew Robertson AM*, ed. Emily Robertson (London, 1895) p4.

14. Alexander Campbell, *A Journey from Edinburgh through Parts of North Britain etc.* (London, 1810) p276.

15. For a history of early exhibiting societies and the RSA see Esmé Gordon, *The Royal Scottish Academy 1826–1976* (Edinburgh, 1976).

CHAPTER IX

1. In a letter written to Wilkie shortly after he had moved to London, quoted Cunningham, *Wilkie*, I, pp117–8.

2. *Letters & Papers of Andrew Robertson*, ed. Emily Robertson (London, 1895) p4.

3. See Chap. VII n6.

4. Thomas Reid, *Inquiry into the Human Mind* in *Works* (1863) I, p163.

5. Charles Bell, *Essays on the Anatomy of Expression in Painting* (London, 1806) p1.

6. The picture of a man laughing.

7. John Burnet, *Practical Essays on various Branches of the Fine Arts etc.* (London, 1848) pp106–7.

8. Bell, *Anatomy of Expression*, p177 and Sir Gordon Gordon Taylor & E. W. Wallis, *Sir Charles Bell, his Life and Times*, (Edinburgh and London, 1958) p21.

9. Ramsay, *A Dialogue on Taste*, p88.

10. Wood, *On the Original Genius of Homer*, p74.

11. Cunningham, *Wilkie*, I, p59.

12. Cunningham, *Wilkie*, I, p78.

13. *Sir David Wilkie of Scotland* (North Carolina Museum of Art, 1987) p115.

14. Cunningham, *Wilkie*, I, p235.
15. Wilkie to Perry Nursey, 9 May 1814, Dawson Turner (Mss. Trinity Coll. Library, Cambridge).
16. *Memoirs & Recollections of the late Abraham Raimbach*, ed. M. T. S. Raimbach (London, 1843) p163.
17. National Library of Scotland Ms 9835 17 2; Cunningham, *Wilkie*, I, p281, records that Sir William Erskine gave Wilkie a commission for a painting of *A Penny Wedding* in Mar. 1810.
18. Cunningham, *Wilkie*, II, p9.
19. Cunningham, *Wilkie*, III, p233.
20. Elizabeth Grant, *Memoirs of a Highland Lady*, ed. Andrew Tod, 2 vols. (Edinburgh, 1988) I, p48.
21. Hector MacNeill, *Bygane Times & Late Come Changes*, 3rd ed. (Edinburgh, 1811) p41.
22. John Galt, *Annals of the Parish* (1821); ed. (Edinburgh, 1980) pp178–180.
23. B. R. Haydon *Diary* quoted William Chiego 'David Wilkie and History Painting' in *Sir David Wilkie* (North Carolina, 1987) p27.
24. Burns, 'Twa Dogs', 1 201–218.
25. Compare Fergusson, 'Hame Content', 1 61–92 and Burns, 'Twa Dogs', 1 155–170.
26. Blackwell, *Homer*, p35.

CHAPTER X

1. Brydall, *Art in Scotland*, p271. Brydall's view is echoed in D. and F. Irwin, *Scottish Painters at Home and Abroad* (London, 1975) p205.
2. Illus. Gabriel P. Weisberg, *The Realist Tradition* (Cleveland, 1981) fig. 19, p10.
3. See Macmillan, *Painting in Scotland*, p170 and n47.
4. For a full discussion of Wilkie's religious painting see Macmillan, *Painting in Scotland*, Chap. IX passim.
5. *Sir David Wilkie* (North Carolina), pxviii.
6. Cunningham, *Wilkie*, III, p233, quoted Macmillan, *Painting in Scotland*, p180.
7. Robert Chambers, *A Biographical Dictionary of Eminent Scotsmen*, n.e., ed. Thomas Thomson, (London 1870) entry on Chalmers.
8. Marcia Pointon, 'From Blindman's Buff to le Colin Maillard; Wilkie and his French Audience', *The Oxford Art Journal*, 7 (1984) pp15–25. See also Arthur S. Marks, 'Wilkie and the Reproductive Print' in *Sir David Wilkie* (North Carolina) p73.
9. Writing to his brother, Thomas Wilkie, 11 Aug. 1817, quoted Cunningham, *Wilkie*, I, p415.
10. Wilkie to Sir William Knighton, 5 Jan. 1831, quoted Lindsay Errington, *Tribute to Wilkie* (NGS, 1985) p71.
11. Hamish Miles, *David Wilkie and Fife*, lecture (St Andrews, 1983).
12. Errington, *Tribute to Wilkie*, p79.
13. *Journal of Henry Cockburn* (Edinburgh, 1874) quoted David Daiches, *Paradox of Scottish Culture* (London, 1964) p50.
14. William Chiego in *Sir David Wilkie* (North Carolina) p41.
15. See Duncan Macmillan, 'Born like Minerva, D. O. Hill and Origins of Photography' in *British Photography in the Nineteenth Century, the Fine Art Tradition*, ed. Mike Weaver (New York, 1989).
16. Lindsay Errington in *Sir David Wilkie* (North Carolina) p10.

CHAPTER XI

1. David Laing, MS 'Notes on Scottish Art' (EUL).
2. J. G. Lockhart, *Life of Sir Walter Scott*, (Edinburgh, 1871) p801.
3. See D. and F. Irwin, *Scottish Painters at Home and Abroad*, Chap. XIV.
4. Mungo Campbell, *David Scott* (NGS, 1989) p15.
5. 'Laura Savage' pseudonym for F. G. Stephens, 'Modern Giants', *The Germ*, (4 May 1850); facsimile reprint, ed. W. M. Rossetti (London, 1901) p171.
6. See above, p192.
7. Present whereabouts unknown – versions in Leicestershire Museums and Art Gallery and Kunsthalle, Hamburg.
8. See Marcia Pointon, 'Dyce's Pegwell Bay', *Art History*, I (1978).
9. George Elder Davie, *The Democratic Intellect* (Edinburgh, 1961) Chap. 13.
10. Davie, *Democratic Intellect*, p297.
11. Lindsay Errington, *Master Class* (NGS, 1983) p36.

12. Cunningham, *Wilkie*, II, p384.
13. Quoted in full, Robert Fairley, *Jemima* (Edinburgh, 1989) pp21–7.

CHAPTER XII

1. See Chap. VII, n10.
2. Chap. VII n11.
3. Wilkie to Perry Nursey, 5 Nov. 1817, Dawson Turner MSS., Trinity College, Cambridge.
4. Archibald Alison, *Essays on the Nature & Principles of Taste*, 2 vols. (Edinburgh, 1790) 2nd ed., 1811.
5. Burns to Alison, 14 Feb. 1791, J. de L. Ferguson, *Letters of Robert Burns*, 2nd ed., G. Ross Roy, 2 vols. (Oxford, 1985), II, p71.
6. Alison, *On Taste*, II, p443.
7. Reid to Alison, 3 Feb. 1790, quoted in *Works of Thomas Reid*, p89.
8. Alison, *On Taste*, II, pp421–2.
9. Quoted Lindsay Errington & James Holloway, *The Discovery of Scotland* (NGS, 1978) p111.
10. Alison, *On Taste*, II, p444.
11. Quoted William Baird, *John Thomson of Duddingston* (Edinburgh, 1895) p139.
12. Thomson to Scott, Mar./Apr. 1831, NLS MS 3917.
13. The most complete modern catalogue is of the collection made by William Telfer and exhibited in Falkirk, 1950.
14. Pilkington's *Dictionary* (1806 and 1810); *Professional Sketches of Modern Artists*, quoted W. G. Constable, *Richard Wilson* (London, 1953) p126.
15. 'Noctes Ambrosianae', *Blackwoods Magazine* (Apr. 1830).
16. Sheena Smith, *Horatio McCulloch 1805–1867* (Glasgow City Art Gallery, 1988) p16.
17. Sold by Christies, Scotland, Glasgow, 11 Dec. 1986, lot 50.
18. Smith, *McCulloch*, p23.
19. James Caw, *Scottish Painting*, pp161–2.
20. Quoted Rachel Moss, *Sam Bough RSA* (Bourne Fine Art, Edinburgh, 1988).
21. W. D. McKay, *The Scottish School of Painting* (London, 1906) p318.

CHAPTER XIII

1. McTaggart contributed 'Crowned Heads', an old couple in a cottage interior, *Good Words*, II (1861) p273.
2. *The Pirate* (2 vols.) (London, 1893) vol. 1, p235.
3. In McTaggart's picture the ruined church seen as just a place to play gives his picture a similar theme, but in his case we know that it was on the insistence of a patron, Robert Craig, that the church replaced his original intention of having a cottage for the background. Lindsay Errington, *McTaggart*, (NGS, 1989) p30.
4. Writing, 6 May 1863, to G. B. Simpson of Dundee who commissioned the picture, quoted Errington, *McTaggart*, p34.
5. Errington, *Master Class*, p83.
6. Errington, *McTaggart*, p102.
7. Sir James Caw, *William McTaggart, RSA* (Glasgow, 1917) p70.
8. Quoted Errington, *McTaggart*, p47.
9. Ibid, p61.
10. P. McOmish Dott, *Notes technical and explanatory on the Art of William McTaggart* (1901), quoted Errington, p98.
11. Caw, *McTaggart*, p208, and Errington, *McTaggart*, p86.
12. Christopher North on Thomson of Duddingston in *Noctes Ambrosianae*, see above, p225.
13. Constable 'Letterpress to English Landscape', *John Constable's Discourses*, ed. R. B. Beckett (Suffolk Records Society, 1970) XIV, p9.
14. Errington, *McTaggart*, p86, see also Caw, *McTaggart*, p134.
15. Errington, *McTaggart*, p102.
16. Ibid, p105, as begun in 1895.
17. Ibid, p112, quoting Magnus Maclean, *The Literature of the Celts, its History and Romance* (1902).
18. Errington, *McTaggart*, p97.

CHAPTER XIV

1. Interview, 1905, quoted Errington, *McTaggart*, p84.
2. See Hamish Miles, 'Early Exhibitions in Glasgow', *SAR* n.s., VIII (1962) p26.

3. See T. J. Honeyman, 'Van Gogh, a link with Glasgow', *SAR* n.s., II (1948) p16.
4. George Clausen, 'Bastien-Lepage and Modern Realism', *SAR* I (Oct. 1888).
5. A. E. Mackay, *Arthur Melville, Scottish Impressionist* (Leigh-on-Sea, 1951) p21.
6. Quoted Mackay, *Arthur Melville*, p56.
7. Ibid, p61.
8. Ibid, loc cit.
9. Ibid, p48.
10. In an article written twenty years after Melville's death, Romilly Fedden describes his watercolour technique (*Old Watercolour Society*, I, 1923–4, p39). The actual technique that he describes is remarkably like a watercolour version of the Pre-Raphaelite technique of painting into wet white, particularly in view of the wet chinese-white ground. With its tonal base it is also not in any strict sense impressionist.
11. Quoted Mackay, *Arthur Melville*, pp63–64.
12. Roger Billcliffe, *The Glasgow Boys* (London, 1985) p42.
13. Ibid, p73.
14. Ibid, p76.

CHAPTER XV

1. Philip Boardman, *The Worlds of Patrick Geddes etc* (London, 1978) pp72–3.
2. Boardman, *Geddes*, p77. For Geddes the problem of human ecology involved environment in the very widest sense. In the same paper he wrote: 'To remain healthy and become civilised . . . [man] must take especial heed of his environment; not only at his peril keeping the natural factors, water and light at their purest, but caring only for "production of wealth" at all in so far as it shapes the artifical factors, the material surroundings of domestic and civic life, into forms more completely serviceable for the Ascent of Man.'
3. Boardman, *Geddes*, p78.
4. Prof. Zueblin, quoted Philip Mairet, *Pioneer of Sociology; the Life and letters of Patrick Geddes* (London, 1957) p72.
5. See Elizabeth Skeoch Cumming, *Phoebe Traquair* (unpublished PhD thesis, EU).
6. Gerard Baldwin Brown, *The Glasgow School of Painters* (Glasgow, 1908).
7. Patrick Geddes, *Every Man his own Art Critic* (Edinburgh & Glasgow, 1888) p38.
8. Patrick Geddes, 'Political Economy & Art', *SAR*, II (June 1889) p2.
9. G. Baldwin Brown, 'Some Recent Efforts in Mural Decoration', *SAR*, II (Jan. 1889) p225.
10. Walter Crane, *The Claims of Decorative Art* (London, 1892) p16.
11. *Art and Life and the Building and Decoration of Cities*, Lectures by Crane and others to the Arts and Crafts Exhibiting Society, 1896 (London, 1897) p138.
12. Crane, *Claims of Decorative Art*, p29.
13. Ibid, p4.
14. Ibid, p129.
15. Quoted Billcliffe, *Glasgow Boys*, p297.
16. *As You Like It*, Act III, scene iii.
17. Billcliffe, *Glasgow Boys*, p241.
18. Sothebys, 27 Aug. 1985, lot 873.
19. Phillips, Edinburgh, 3 Sept. 1982, lot 70.
20. Walter Crane, *The Bases of Design* (London, 1908) p338.
21. Francisque-Michel, *Les Ecossais en France* (2 vols.) (London, 1862) Vol. I, pp274–5, quoted Brydall, *Art in Scotland*, p44.
22. Geddes, *Every Man his own Art Critic*, p34.
23. Billcliffe, *Glasgow Boys*, p212.
24. James Paterson, 'A Note on Nationality in Art', *SAR*, I (1888).
25. Billcliffe, *Glasgow Boys*, p246.
26. See Michael Donnelly, *Glasgow Stained Glass* (GAGM, 1981).
27. Geddes, *Every Man his own Art Critic*, p42.
28. See William Buchanan, *Mr Henry & Mr Hornel visit Japan* (SAC, 1979).
29. Mackay, *Arthur Melville*, p77.
30. W. Graham Robertson, *Time Was* (London, 1931) p302.
31. Ibid, p304.
32. Crane, *Claims of Decorative Art*, p29.
33. Ibid.
34. See *James Watterston Herald*, (Fine Art Society, Edinburgh, 1981).

CHAPTER XVI

1. Roger Billcliffe, *Mackintosh Watercolours*, (London, 1978) p9.
2. *Transactions of the National Association for the Advancement of Art etc.* (London, 1890).
3. 'The Writings of Owen Jones I', *The Architect* (25 Apr. 1874).
4. Ibid.
5. 'The Writings of Owen Jones III', *The Architect* (20 June 1874) p346.
6. Owen Jones, 'Propositions', *The Grammar of Ornament* (London, 1856).
7. See *Margaret Macdonald Mackintosh* (Hunterian, 1984) and *The Last Romantics*, (Barbican Art Gallery, 1989) p178.
8. Christies, Edinburgh, Dec. 1989.
9. Margaret Armour, 'Mural decoration in Scotland, Part I', *Studio X* (1897), p100.
10. Patrick Geddes and John Duncan, *Interpretation of the Pictures at University Hall* (Edinburgh, 1928).
11. Israel Zeignitz, quoted from *Pall Mall Magazine* (1896) by Philip Mairet, *Pioneer of Sociology, the Life and Letters of Patrick Geddes*, (London, 1957) p167.
12. Ibid, loc cit.
13. Patrick Geddes, 'The Megalithic Builders', *The Evergreen*, 'Winter', p142.
14. Hugh MacDiarmid, 'Guide through the Maze', *Scottish Art and Letters*, no 4 (1949) p55.
15. For an up-to-date account of Ricketts and Shannon see J. G. P. Delaney, 'Ricketts and Shannon and their Circle' in *The Last Romantics* (Barbican Art Gallery, 1989) p39.
16. See ibid p170 and *The Private Library*, second series 9, 1976.
17. 'Talks with Great Scots, No 4, Muirhead Bone' *Scotland* (Spring 1937) p17.
18. Patrick Geddes, 'Life and Its Science', *The Evergreen*, 'Spring', (1895), p37.
19. Muirhead Bone, *Glasgow, Fifty Drawings* (Glasgow, 1911), notes by A. H. Charteris.
20. Ibid, Introduction, p5.
21. Geddes, 'Life and Its Science', *The Evergreen* ('Spring'), p36.
22. Letter of 31 March 1929 (1935); quoted Andrew Patrizio (unpublished PhD thesis EU).
23. A smaller selection of the drawings was published in six parts, folio size, in 1917–18 under the title *War Drawings by Muirhead Bone from the collection presented by HM Government to the British Museum*.
24. Geddes, 'Life and Its Science', *Evergreen*, 'Spring', p30.
25. Already in the first war Bone was very active in promoting the claims of such younger artists as Spencer and Epstein to be included among the war artists.

CHAPTER XVII

1. Caw, *Scottish Painting*, p424.
2. Laura Knight, *Oil Paint and Grease Paint* (London, 1936) pp87–8.
3. Tom Hewlett, *Cadell* (London and Edinburgh, 1988) p40.
4. Margaret Morris, *The Art of J. D. Fergusson* (Glasgow, 1974) p150. Morris quotes a letter of 16 Dec. 1923 from Ressich reporting that Reid had agreed to show 'the three of you as a "Groupe Écossais" [Peploe, Hunter, and J.D.F.] to go on to Paris'.
5. Stanley Cursiter, *Peploe, an Intimate Memoir* (London, 1947) p7.
6. Haldane Macfall, 'Alexander Roche RSA', *The Artist* (1906) p210.
7. Morris, *Fergusson*, (Glasgow, 1974) p35. Fergusson borrowed and copied a copy by Roche of Velasquez's *Infanta*.
8. Painted *c*.1908, Christies, Edinburgh, 11 Dec. 1986, lot 204.
9. J. D. Fergusson 'Memoir of S. J. Peploe' written in 1945 and published *SAR* n.s. (Jan. 1962) p8.
10. This omission was commented on at the time by the critic of the *Daily Chronicle* reviewing work shown by Peploe at the Stafford Gallery in 1912. Guy Peploe, *S. J. Peploe* (SNGMA, 1985) p12.
11. Quoted ibid, p12.
12. Sothebys, Hopetoun House, 26 Aug. 1986, lot 858.
13. Sothebys, Hopetoun House, 1989, lot 258.
14. *J. D. Fergusson 1874–1961: Memorial Exhibition of Paintings and Sculpture* (ACGB, Scottish Committee, 1961).

15. John Middleton Murry, *Between Two Worlds: an autobiography* (London, 1935) p135.
16. Ibid, p127; the same year the winner of the philosophy prize in Glasgow University, William Forrester, was the author of an essay on Bergson and he too travelled to Paris in 1910 in the hope of meeting the philosopher.
17. Murry, *Between Two Worlds*, p135.
18. Ibid, p155.
19. Henri Bergson, *Creative Evolution*, ed. and trans. Arthur Mitchell (London, 1960) p319.
20. '. . . we should never realise these images so strongly without the regular movements of the rhythm by which our soul is lulled into self-forgetfulness and, as in a dream, thinks and sees with the poet.' Henri Bergson, *Time and Free Will*, ed. and trans., F. L. Pogson (London, 1959) p15.
21. Bergson, *Creative Evolution*, p186.
22. Elizabeth Cumming et al, *Colour, Rhythm and Dance* (SAC, 1985) p42.
23. Bergson, *Time and Free Will*, p12.
24. Morris, *Fergusson*, p87, quoting letter of 27 Mar. from Antibes.
25. Crane, *Claims of Decorative Art*, p29.
26. See Chap. VIII n12; Davie, *Democratic Intellect*, p287.
27. Morris, *Fergusson*, p103.
28. J. D. Fergusson 'Art and Atavism; the Dryad', *Scottish Art and Letters*, I, (1944) pp47–49. See below, p408.
29. Morris, *Fergusson*, p187.
30. Morris, *Fergusson*, p153, quoting a letter of Mackintosh to Fergusson of 1 Jan. 1925.
31. Whereabouts unknown, reproduced Alexander Watt, 'J. D. Fergusson', *The Artist* (May 1937).
32. Honeyman, *Introducing Leslie Hunter*, (London, 1937) p97.
33. Ibid, p83.
34. Ibid, p79.
35. Ibid, p137.

CHAPTER XVIII

1. For an outline of the Edinburgh Group see John Kemplay, *The Edinburgh Group* (CEAC, 1983).
2. Sotheby's, Hopetoun House, 29 Apr. 1989, lot 247.
3. Quoted Kemplay, *Edinburgh Group*, p7.
4. John Kemplay in *Fifty Years of Scottish Painting* (Bourne Fine Art, 1989)
5. John Kemplay, *Eric Roberston* (Piccadilly Gallery, 1987).
6. Elcy Cruickshank Broadhead née Soutar, *John Bulloch Soutar* (Bourne Fine Art, 1986).
7. Cordelia Oliver, *James Cowie* (Edinburgh, 1980) p56.
8. Ibid, loc cit.
9. Richard Calvocoressi, *James Cowie* (SNGMA, 1979) p13.
10. Quoted Calvocoressi, *Cowie*, p21.
11. Trans. Dorothy L. Sayers.

CHAPTER XIX

1. Geddes, 'The Scots Renascence', *The Evergreen*, 'Spring', p30.
2. Hugh MacDiarmid, *Francis George Scott: Essay on his 75th Birthday* (Edinburgh, 1955) p4.
3. Hugh MacDiarmid, *Scottish Educational Journal* (20 Nov. 1925), reprinted MacDiarmid, *Contemporary Scottish Studies* (Edinburgh, 1976) p58.
4. Ibid, p59.
5. Alan Bold, *Letters of Hugh MacDiarmid* (London, Hamilton 1984) p339.
6. Whereabouts unknown, reproduced in *The Modern Scot*, I, 1930, facing p16.
7. William McCance, 'The Idea in Art', *The Modern Scot*, I (no 2, 1930).
8. J. D. Fergusson, *Modern Scottish Painting* (Glasgow, 1943) p46.
9. Ian Finlay, *Art in Scotland* (Oxford, 1948); Hugh MacDiarmid, *Aesthetics in Scotland*, ed. Alan Bold (Edinburgh, 1984).
10. Walter Crane, *Bases of Design* (London, 1898) p338.
11. Finlay, *Art in Scotland*, p164.
12. *Derrière le Miroir* (Paris, 1950).
13. William Johnstone, *Points in Time* (London, 1980) p82.
14. Ibid, loc cit.

15. Ibid, p104.
16. Ibid, p176, and in conversation.
17. Ibid, p177.
18. In conversation with the author.
19. H. Harvey Wood, *William MacTaggart* (Edinburgh, 1974) pp8–9.
20. John Kemplay, *John Duncan* (CEAC, 1987).
21. Johnstone, *Points in Time*, p104.
22. Thomas Hart Benton, 'Mechanics of Form Organisation in Painting', *The Arts* (Nov. 1926 and following numbers).
23. Johnstone, *Points in Time*, p138.
24. Ibid, p177.
25. MS draft coll. author, p167; A. N. Whitehead, *Process and Reality: an Essay in Cosmology* (Cambridge, 1929).
26. Fontana Flamingo (1984) ed. p37.
27. Reprinted in Lewis Grassic Gibbon, *A Scots Hairst* (London, 1967) pp73–4.
28. Johnstone, *Points in Time*, p177.
29. Whereabouts unknown pub. in D. Saurat, 'Scottish Intellectualism, William Johnstone', *Studio* (Aug. 1943) p3.
30. Ian Fleming, *Peacock Printmakers* (Aberdeen, 1982).
31. See Alastair Smart, 'William Gillies', *SAR* n.s., V (1955) p11.

CHAPTER XX

1. T. Elder Dixon, 'The East Coast Painters', *Scottish Art and Letters*, 2, p24.
2. Fergusson, *Modern Scottish Painting*, p46.
3. James Bridie and others, *The New Scottish Group* (William McLellan, Glasgow, 1947) and Denis Farr, *New Painting in Glasgow* (SAC, 1968) p6.
4. Fergusson, *Modern Scottish Painting*, p95.
5. William Montgomerie, *Donald Bain* (Glasgow, 1950).
6. Whereabouts unknown, reproduced *Scottish Art and Letters*, 1 (1944).
7. Whereabouts unknown, reproduced *New Scottish Group*, pl. 23.
8. Whereabouts unknown, reproduced *New Scottish Group* pl. 43.
9. *Million, 1st Collection*, ed. John Singer (Glasgow, 1943) p40.
10. Ibid.
11. Farr, *New Painting in Glasgow*, p6. See also Cordelia Oliver, *Bet Low* (Third Eye Centre, 1985).
12. Whereabouts unknown, reproduced *Scottish Art and Letters*, 5 (1950) p32.
13 Alec Sturrock, 'Art Exhibition at Community House', *Scottish Art and Letters*, 5 (1950) p32.
14. *A Paradise Lost* (Barbican Art Gallery, 1988) and John Tonge, 'Scottish Painting', *Horizon* (May 1942).
15. Whereabouts unknown, illus. Tonge, *Horizon*, p334.
16. Whereabouts unknown, reproduced T. Elder Dixon 'Robin Philipson', *SAR* n.s. VIII (no 2, 1961).
17. Reproduced Michael Horowitz, *Alan Davie* (London, 1963) pl. 2.
18. Reproduced, Alan Bowness, *Alan Davie* (London, 1967) pl. 15.
19. Johnstone, *Points in Time*, p170.
20. 'Notes on Teaching' (ICA, 1959) reprinted Bowness, *Alan Davie*, p14.
21. Horowitz, *Alan Davie*, n.p.
22. Bowness, *Alan Davie*, p16.
23. Quoted Bowness, *Alan Davie*, p174.
24. *Eduardo Paolozzi* (TRG, 1979).
25. For example, in stone relief with John Andrew 1977; see also 'Footnotes to an Essay' with Gary Hincks and Stephen Bann (Serpentine Gallery, 1977) reprinted Yves Abrioux, *Ian Hamilton Finlay* (Edinburgh, 1985) p209.

CHAPTER XXI

1. For the whole of this period see Cordelia Oliver, *Painters in Parallel* (SAC, 1978) and Keith Hartley, *Scottish Art since 1900* (SNGMA, 1989).
2. Glen Onwin, *The Recovery of Dissolved Substances*, Arnolfini Gallery (Bristol, 1978).
3. Phillips Glasgow, 14 Dec. 1989, lot 33.
4. J. D. Fergusson 'Art and Atavism', *Scottish Art and Letters*, 1, (1944) pp47–49.

LIST OF PLATES

Dates and measurements of paintings are included when known.

88. David Martin, *Provost Murdoch of Glasgow*, c. 1790. Oil on canvas, 91.4×71.1 cms. Glasgow Art Gallery and Museum.
89. Catherine Read, *Helen Murray of Ochtertyre*, late 1750s. Oil on canvas. Private collection. Photo: Joe Rock.
90. Anne Forbes, *Baron Ord*, c. 1775. Oil on canvas. Royal College of Physicians. Photo: Joe Rock.

CHAPTER VI

91. Gavin Hamilton, *Andromache Mourning the Death of Hector*, sketch, c. 1759. Oil on canvas, 64.2×98.5 cms. National Gallery of Scotland.
92. Domenico Cunego, after Gavin Hamilton, *The Oath of Brutus*, 1766. Engraving, 35.6×38.1 cms.
93. John Runciman, *King Lear in the Storm*, 1767. Oil on panel, 44.4×61 cms. National Gallery of Scotland.
94. John Runciman, *The Adoration of the Shepherds*, c. 1766. Oil on panel, 23.5×16.5 cms. Private Collection.
95. Alexander Runciman, *Achilles & Pallas*, c. 1769. Pen and ink, 35.6×22.4 cms. National Gallery of Scotland.
96. Alexander Runciman, *The Origin of Painting*, 1773. Oil on canvas, 61×114.5 cms. Sir John Clerk of Penicuik.
97. Alexander Runciman, *Ossian Singing*, c. 1770. Pen and ink. Private Collection.
98. G. Carelli, after Alexander Runciman, *The Hall of Ossian*, detail of watercolour, 1878, recording the paintings destroyed by fire in 1899. Private Collection. Photo: Joe Rock.
99. Alexander Runciman, *The Spey and the Tay*. Oil on plaster. 19th-century photograph of a detail of the ceiling of *The Hall of Ossian*, 1772. Sir John Clerk of Penicuik.
100. Alexander Runciman, *Ossian Singing*, sketch for the central part of the ceiling of *The Hall of Ossian*, 1772. Pen, brown wash and oil. Oval 46.7×59.9 cms. National Gallery of Scotland.
101. Alexander Runciman, *Fingal and Conban-cârgla*, c. 1772. Etching, 15×24.6 cms. Private Collection.
102. Alexander Runciman, *The Allegro, with a distant View of Perth*, 1773. Oil on canvas, 75×63.5 cms. Private Collection. Photo: Joe Rock.
103. John Brown, *Woman Standing among the Friars*. Pen and wash, 25.8×36.9 cms. Cleveland Museum of Art.
104. David Allan, *Glaud and Peggy*, a scene from *The Gentle Shepherd*, 1789 (version of 1788 illustration). Etched outline and watercolour, 23.1×18.2 cms. National Gallery of Scotland.
105. David Allan, *The Highland Dance, 1780*. Oil on canvas, 101.6×151.7 cms. National Gallery of Scotland, on loan from Margaret Sharpe Erskine Trust.
106. David Allan, *The Penny Wedding*, 1795. Watercolour, 33.4×45.1 cms. National Gallery of Scotland.

CHAPTER VII

107. James Cumming, *William McGregor*, c. 1780. Oil on canvas, 76.2×62.3 cms. City of Edinburgh Art Centre. Photo: Joe Rock.
108. Charles Steuart, *The Black Lynn, Fall on the Bran*, 1766. Oil on canvas, 208.4×179 cms. From His Grace the Duke of Atholl's collection at Blair Castle, Perthshire.
109. Jacob More, *Rosslyn Castle*, c. 1770. Oil on canvas, 73×90 cms. The Earl of Wemyss.
110. Jacob More, *The Falls of Clyde: Cora Linn*, 1771. Oil on canvas, 79.4×100.4 cms. National Gallery of Scotland.
111. Alexander Nasmyth, *A Farmyard Gate*, 1807. Pencil, 14.5×22.6 cms. National Gallery of Scotland.
112. John Clerk of Eldin, *Clackmannan Tower*, c. 1780. Etching, 3.4×8 cms. Photo: Joe Rock.
113. Alexander Nasmyth, *Inveraray from the Sea*, c. 1801. Oil on canvas, 106.7×163.7 cms. Private Collection.
114. Alexander Nasmyth, *Edinburgh from Princes Street with the Royal Institution under Construction*, 1825. Oil on canvas, 119.4×160 cms. National Gallery of Scotland, on loan from Sir David Baird, Bt. Photo: Joe Rock.
115. Detail of pl. 114. Photo: Joe Rock.
116. Alexander Nasmyth, *Edinburgh, from Calton Hill*, 1825. Oil on canvas, 119.9×164.5 cms. Reproduced by kind permission of Clydesdale Bank PLC. Photo: Joe Rock.

117. Alexander Nasmyth, *West Loch Tarbert, looking North*, c. 1802. Oil on canvas, 85.1×122.9 cms. Private Collection. Photo: Joe Rock.
118. Hugh William Williams, *In Hamilton Woods*, 1808. Etching. Photo: Joe Rock.
119. Patrick Nasmyth, *A Woodman's Cottage*, 1825. Oil on panel, 41.×56 cms. National Gallery of Scotland.
120. John Knox, *The First Steamboat on the Clyde*, c. 1820. Oil on canvas, 111.8×158.5 cms. Glasgow Art Gallery and Museum.
121. David Roberts, *Thebes, Karnac*, 1838. Watercolour and bodycolour, 48.3×32.4 cms. Manchester City Art Galleries.

CHAPTER VIII

122. Archibald Skirving, *John Clerk of Eldin*, c. 1795. Pastel, 58.7×49.2 cms. Adam Collection.
123. Sir Henry Raeburn, *James Hutton*, c. 1782. Oil on canvas, 101.6×127 cms. Scottish National Portrait Gallery. Photo: Joe Rock.
124. Sir Henry Raeburn, *Neil Gow*, c. 1793. Oil on canvas, 123.2×97.8 cms. Scottish National Portrait Gallery.
125. Sir Henry Raeburn, *Sir John and Lady Clerk of Penicuik*, 1792. Oil on canvas, 145×206 cms. National Gallery of Ireland.
126. Sir Henry Raeburn, *Isabella McLeod, Mrs James Gregory*, c. 1798. Oil on canvas, 127×101.6 cms. National Trust for Scotland, Fyvie Castle. Photo: Joe Rock.
127. Sir Henry Raeburn, *Lord Newton*, before 1806. Oil on canvas, 127×101.6 cms. Dalmeny House, near Edinburgh. Photo: Joe Rock.
128. Sir Henry Raeburn, *Baillie William Galloway*, 1798, Oil on canvas, 74×61 cms. The Company of Merchants of the City of Edinburgh. Photo: Joe Rock.
129. Sir Henry Raeburn, detail from double portrait of *General Francis Dundas and his Wife, Eliza Cumming*, c. 1812. Oil on canvas, 101.6×140.3 cms. Private Collection. Photo: Joe Rock.
130. Sir Henry Raeburn, *Colonel Alasdair Macdonell of Glengarry*, 1812. Oil on canvas, 241.3×149.9 cms. National Gallery of Scotland.
131. Sir Henry Raeburn, *John Pitcairn of Pitcairn*, c. 1823. Oil on canvas, 101.6×76.2 cms. Royal Scottish Academy.
132. George Watson, *A Girl Drawing*, 1813. Oil on canvas, 76.2×63.5 cms. Countess of Sutherland.
133. Sir John Watson Gordon, *Thomas Clerk and his Wife*, c. 1820. Oil on panel. Royal Company of Archers. Photo: Joe Rock.
134. Sir John Watson Gordon, *Roderick Gray*, 1852. Oil on canvas, 127×101.6 cms. The Company of Merchants of the City of Edinburgh.

CHAPTER IX

135. Sir David Wilkie, *Pitlessie Fair*, 1804. Oil on canvas, 58.5×106.7 cms. National Gallery of Scotland.
136. Sir David Wilkie, *William Chalmers-Bethune, his Wife Isabella Morison and their Daughter Isabella*, 1804. Oil on canvas, 124.5×101.6 cms. National Gallery of Scotland.
137. Sir David Wilkie, *The Blind Fiddler*, 1806. Oil on panel, 57.8×79.4 cms. The Tate Gallery, London.
138. Sir David Wilkie, *The Rent Day*, 1807. Oil on panel. Private Collection.
139. Sir David Wilkie, *The Penny Wedding*, 1818. Oil on panel, 64.4×95.6 cms. HM The Queen.
140. Sir David Wilkie, *Distraining for Rent*, 1815. Oil on panel, 81.3×123 cms. National Gallery of Scotland.
141. Sir David Wilkie, study for *The Letter of Introduction*, 1813. Chalk, 19.8×16.7 cms. National Gallery of Scotland.
142. Sir David Wilkie, *The Letter of Introduction*, 1813. Oil on panel, 61×50 cms. National Gallery of Scotland.

CHAPTER X

143. Alexander Carse, *The Visit of the Country Relations*, 1812. Oil on canvas, 48.2×63.5 cms. His Grace the Duke of Buccleuch, Bowhill. Photo: Joe Rock.

144. Attributed to William Lizars, *John Cowper, an Edinburgh Beggar*, 1808. 75.9×62.9 cms. Fitzwilliam Museum, Cambridge.
145. William Lizars, *The Reading of the Will*, 1811. Oil on panel, 51.5×64.8 cms. National Gallery of Scotland.
146. William Shiels, *A Wild Welsh Cow*. Oil on canvas, 90.7×126 cms. The University of Edinburgh. Photo: Joe Rock.
147. Attributed to Alexander Fraser, *Music Makers*. Bukowski Gallery, Stockholm.
148. Sir William Allan, *The Slave Market, Constantinople*, 1838. Oil on panel, 129×198 cms. National Gallery of Scotland.
149. Andrew Geddes, *David Wilkie*, 1816. Oil on panel, 66×48.2 cms. National Gallery of Scotland.
150. Walter Geikie, *A Girl Scouring a pot lid*, c. 1831. Pencil, 16×10.4 cms. Private Collection. Photo: Joe Rock.
151. Walter Geikie, *Our Gudeman's a Drucken Carle*, 1831. Etching, 15.3×14.7 cms. Photo: Joe Rock.
152. James Drummond, *Sabbath Evening*, 1847. Oil on canvas, 71.2×91.5 cms. City of Edinburgh Art Centre.
153. Sir David Wilkie, *The Preaching of John Knox before the Lords of Congregation, 10 June 1559*, sketch, c. 1822. Oil on panel. The National Trust.
154. Sir David Wilkie, *John Knox Administering the Sacrament at Calder House*, study, c. 1839. Oil on panel, 45.1×61 cms. National Gallery of Scotland.
155. Sir David Wilkie, *The Cotter's Saturday Night*, 1837. Oil on panel, 83.8×108 cms. Glasgow Art Gallery and Museum.
156. Sir George Harvey, *The Covenanters' Baptism*, study, 1831. Oil on paper, 19.6×20.6 cms. Smith Institute, Stirling.
157. Sir George Harvey, *The Covenanters' Preaching*, 1830. Oil on canvas, 82.6×106.7 cms. Glasgow Art Gallery and Museum.
158. Thomas Duncan, *The Death of John Brown of Priesthill*, 1844. Oil on canvas, 132.1×208.6 cms. Glasgow Art Gallery and Museum.
159. D. O. Hill, *The First General Assembly of the Free Church of Scotland. Signing the Act of Separation and the Deed of Demission at Tanfield, Edinburgh, May 1843*, 1843–67. Oil on canvas, 152.5×345.4 cms. The General Trustees of the Free Church of Scotland.
160. Sir David Wilkie, *The Defence of Saragossa*, 1828. Oil on canvas, 94×141 cms. HM the Queen.
161. Sir David Wilkie, *The First Earring*, 1835. Oil on panel, 74.3×60.3 cms. The Tate Gallery, London.

CHAPTER XI

162. Robert Scott Lauder, *John Gibson Lockhart and his Wife, Charlotte Sophia Scott*, after 1837. Oil on canvas, 76.8×64.8 cms. Scottish National Portrait Gallery. Photo: Joe Rock.
163. Robert Scott Lauder, *Christ Teacheth Humility*, sketch, c. 1845. Oil on canvas, 31.1×56.5 cms. National Gallery of Scotland.
164. Robert Scott Lauder, *David Roberts in Eastern Costume*, 1840. Oil on canvas, 133×101.5 cms. Scottish National Portrait Gallery.
165. David Scott, *Puck Fleeing Before the Dawn*, 1837. Oil on canvas, 95.2×146 cms. National Gallery of Scotland.
166, 167 & 168. David Scott, triptych: central panel, *Sir William Wallace planting the Shield of Scotland upon the Body of Cressingham*; left wing, *Scottish War: the Spear*; right wing, *English War: the Bow*, 1843. Oil on canvas, centre, 99.1×76.21 cms, wings, 86.4×50.8 cms. Paisley Museum and Art Gallery, Renfrew District Council.
169. William Bell Scott, *In the Nineteenth Century the Northumbrians show the World what can be done with IRON and COAL*, 1861. Oil on canvas, 185.4×185.4 cms. National Trust, Wallington Hall.
170. William Dyce, *Madonna and Child*, 1848. Silver-point touched with white. 21.63×19.4 cms. National Gallery of Scotland.
171. William Dyce, *The Man of Sorrows*, 1860. Oil on board, 34.9×48.4 cms. National Gallery of Scotland.
172. William Dyce, *Pegwell Bay: A Recollection of October 5th 1858*, 1859. Oil on canvas, 63.5×88.9 cms. The Tate Gallery, London.
173. Sir Joesph Noel Paton, *The Bluidie Tryst*, 1855. 73×65.2 cms. Glasgow Art Gallery and Museum.

174. John Phillip, *La Gloria*, 1864. Oil on canvas, 143.5×217.1 cms. National Gallery of Scotland.

175. Jemima Blackburn, *Building a Haystack, Roshven*, c. 1857. Watercolour, 19×20.3 cms. Private Collection.

176. Sir William Fettes Douglas, *A Scene from The Antiquary*, 1874. Oil on canvas, 124.5×87 cms. Dundee Art Galleries and Museums.

177. Tom Faed, *The Last of The Clan*, 1865. Oil on canvas, 144.7×183 cms. Glasgow Art Gallery and Museum.

CHAPTER XII

178. Hugh William Williams, *View of the Temple of Poseidon, Cape Sunium*, 1828. Watercolour, 61.75×97.15 cms. National Gallery of Scotland.

179. Rev. John Thomson of Duddingston, *Glen of Altnarie, Morayshire*, probably Scottish Academy 1832. Oil on canvas, 89.5×77.3 cms. The Duke of Buccleuch, Bowhill. Photo: Joe Rock.

180. Rev. John Thomson of Duddingston, *Dunure Castle with Arran beyond*. Oil on canvas, 50.8×66.2 cms. National Gallery of Scotland.

181. Robert Scott Lauder, *View in the Campagna*, c. 1833. Oil on canvas, 39×91 cms. Private Collection. Photo: Joe Rock.

182. Horatio McCulloch, *The Blasted Tree*, c. 1838. Oil on canvas, 76.3×54.7 cms. Orchar Collection, Dundee Art Galleries and Museums.

183. Horatio McCulloch, *Castle Campbell*, 1853. Oil on canvas, 53.3×45.5 cms. Private Collection.

184. Horatio McCulloch, *The Clyde from Dalnottar Hill*, 1858. Oil on canvas, 111.5×182.5 cms. Reproduced by kind permission of Clydesdale Bank PLC.

185. Horatio McCulloch, *The Clyde from Dalnottar Hill*, sketch, 1857. Oil on canvas (over pencil), 37.5×75.6. Private Collection.

186. Horatio McCulloch, *Loch Lomond*, 1861. Oil on canvas, 86.5×137.5 cms. Glasgow Art Gallery and Museum.

187. Alexander Fraser, *The Entrance to Cadzow Forest*, c. 1860. Oil on canvas, 64.8×90.2 cms. National Gallery of Scotland.

188. Sam Bough, *St Andrews*. Oil on canvas, 116.9×157.5 cms. Noble Grossart.

CHAPTER XIII

189. Sir William Quiller Orchardson, *The Broken Tryst*, 1868. Oil on canvas, 61×50.8 cms. Aberdeen Art Gallery and Museums, Aberdeen City Arts Department.

190. John Pettie, *The Disgrace of Cardinal Wolsey*, 1869. 99.7×153.7 cms. Reproduced by permission of Sheffield City Art Galleries.

191. Sir William Quiller Orchardson, *Voltaire*, 1883. Oil on canvas, 139.6×198.1 cms. National Gallery of Scotland.

192. Sir William Quiller Orchardson, *The Rivals*, 1895. Oil on canvas, 84×117 cms. National Gallery of Scotland.

193. Sir William Quiller Orchardson, *Solitude* begun c. 1897, unfinished. Oil on canvas, 65.5×91.4 cms. Andrew McIntosh Patrick.

194. Sir William Quiller Orchardson, *Mariage de Convenance, After!*, 1886. Oil on canvas, 113×169 cms. Aberdeen Art Gallery and Museums, Aberdeen City Arts Department.

195. William McTaggart, *Spring*, 1864. Oil on canvas, 45.2×60.4 cms. National Gallery of Scotland.

196. George Paul Chalmers, *The Legend*, begun 1864, unfinished at the artists's death in 1878. Oil on canvas, 102.9×154.3 cms. National Gallery of Scotland.

197. George Paul Chalmers, *The End of the Day*, c. 1873. James Holloway.

198. George Reid, *Evening*, 1873. Oil on canvas, 76.2×127.6 cms. Orchar Collection, Dundee Art Galleries and Museums.

199. George Paul Chalmers, *The Artist's Mother*, c. 1869. Oil on panel, 30.5×24.2 cms. Glasgow Art Gallery and Museum.

200. Hugh Cameron, *A Lonely Life*, 1873. Oil on canvas, 84.5×63.5 cms. National Gallery of Scotland.

201. William McTaggart, *Jovie's Neuk*, 1894. Oil on canvas, 88.9×97.8 cms. City of Edinburgh Art Centre.

202. William McTaggart, *The Wave*, 1881. Oil on canvas, 62×92 cms. Kirkcaldy Museum and Art Gallery.

203. William McTaggart, *Harvest Moon, Broomieknowe*, 1899. Oil on canvas, 129×195 cms. The Tate Gallery, London.

204. William McTaggart, *The Sailing of the Emigrant Ship*, 1895. Oil on canvas, 75.6×86.4 cms. National Gallery of Scotland.

205. William McTaggart, *The Paps of Jura*, 1902. Oil on canvas, 137.5×208.3 cms. Glasgow Art Gallery and Museum.

206. William McTaggart, *Christmas Day*, 1898. Oil on canvas, 98×145 cms. Kirkcaldy Museum and Art Gallery.

CHAPTER XIV

207. Sir James Lawton Wingate, *Interior of a Barn: Making Straw Ropes*, 1880. Oil on canvas, 44.5×31.8 cms. Royal Scottish Academy.

208. William Darling McKay, *Turnip-Singlers, A Hard Taskmaster*, 1883. Oil on canvas, 99×81.2 cms. Royal Scottish Academy.

209. Arthur Melville, *A Cabbage Garden*, 1877. Oil on canvas, 45×30.5 cms. Andrew McIntosh Patrick.

210. John Robertson Reid, *The Old Gardener*, 1878. Oil on canvas, 46×30.5 cms. Private Collection.

211. Robert McGregor, *The Knife-Grinder*, 1878. 76.2×137.8 cms. Dundee Art Galleries and Museums.

212. William York Macgregor, *The Joiners' Shop*, 1881. Oil on canvas, 46×71 cms. Private Collection.

213. Sir James Guthrie, *A Funeral Service in the Highlands*, 1882. Oil on canvas, 129.5×193 cms. Glasgow Art Gallery and Museum.

214. John Henry Lorimer, *The Ordination of Elders in a Scottish Kirk*, 1891. Oil on canvas, 109.2×139.7 cms. National Gallery of Scotland.

215. Sir John Lavery, *The Tennis Party*, 1885. Oil on canvas, 77×183.5 cms. Aberdeen Art Gallery and Museums, Aberdeen City Arts Department.

216. Sir James Guthrie, *To Pastures New*, 1883. Oil on canvas, 90×150 cms. Aberdeen Art Gallery and Museums, Aberdeen City Arts Department.

217. Arthur Melville, *A French Peasant*, 1880. Oil on canvas, 52×30.5 cms. Private Collection.

218. Sir James Guthrie, *A Hind's Daughter*, 1883. Oil on canvas, 91.5×76.2 cms. National Gallery of Scotland.

219. Robert Noble, *A Fisher Girl*, 1879. Oil on board, 22.8×13.8 cms. Private Collection.

220. William York Macgregor, *The Vegetable Stall*, 1884. Oil on canvas, 105.5×150.5 cms. National Gallery of Scotland.

221. Edward Arthur Walton, *The Game-Keeper's Daughter*, 1886. Watercolour, 43.5×34.5 cms. Glasgow Art Gallery and Museum.

222. James Paterson, *Autumn, Glencairn*, 1887. 101.5×127 cms. National Gallery of Scotland.

223. Sir James Guthrie, *Pastoral*, 1887–8. Oil on canvas, 64.8×95.3 cms. National Gallery of Scotland.

224. Sir James Guthrie, *Causerie*, 1892. Pastel, 50.5×57 cms. Hunterian Art Gallery, University of Glasgow.

CHAPTER XV

225. Phoebe Traquair, St Mary's Song School, south wall, centre-left. 1888–1892. Oil and wax on plaster. Detail, *The Procession of the Blessed* (including portraits of Tennyson, Browning, Rossetti, William Morris and G. F. Watts). Photo: Joe Rock.

226. Phoebe Traquair, St Mary's Song School south wall centre-right, continuation of pl. 225. Photo: Joe Rock.

227. Arthur Melville, *Audrey and Her Goats*, 1884–89. Oil on canvas, 204.5×213.5 cms. The Tate Gallery, London.

228. George Henry, *Autumn*, 1888. Oil on canvas, 61×91.5 cms. Glasgow Art Gallery and Museum.

229. Edward Atkinson Hornel, *The Goatherd*, 1889. Oil on canvas, 38×43.2 cms. Private Collection.

230. George Henry, *A Galloway Landscape*, 1889. Oil on canvas, 121.9×152.4 cms. Glasgow Art Gallery and Museum.

231. Charles Mackie, *The Bonnie Banks of Fordie*, 1893. Oil on canvas, 59.5×89.5 cms. Phillips, Edinburgh, 3 Sept. 1982. Lot 70.

232. George Henry and Edward Atkinson Hornel, *The Druids: Bringing Home the Mistletoe*, 1890. Oil on canvas, 152.4×152.4 cms. Glasgow Art Gallery and Museum.

233. George Henry, *Landscape at Barr, Ayrshire*, 1891. Oil on panel, 22.5×30.5 cms. National Gallery of Scotland.

234. George Henry, *Japanese Lady with a Fan*, 1894. Oil on canvas, 61×40.5 cms. Glasgow Art Gallery and Museum.

235. Arthur Melville, *Banderilleros à Pied*, c. 1896. Watercolour, 54.6×64.8 cms. Aberdeen Art Gallery and Museums, Aberdeen City Arts Department.

236. Arthur Melville, *A Mediterranean Port*, 1892. Watercolour, 51.3×78.7 cms. Glasgow Art Gallery and Museum.

237. Arthur Melville, *Christmas Eve; 'And there was no room for them in the Inn'*, 1900–04. Oil on canvas, 190.5×203.2 cms. National Gallery of Scotland.

238. James Watterston Herald, *Arbroath Harbour*. Pastel and watercolour. Glasgow Art Gallery and Museum.

CHAPTER XVI

239. Charles Rennie Mackintosh, *Fritillaria, Walberswick*, 1915. Watercolour, 25.3×20.2 cms. Hunterian Art Gallery, University of Glasgow, Mackintosh Collection.

240. Charles Rennie Mackintosh, *The Harvest Moon*, 1892. Watercolour, 35.2×27.6 cms. Glasgow School of Art.

241. Charles Rennie Mackintosh, *The Tree of Personal Effort*, 1895. Watercolour, 21.1×17.4 cms. Glasgow School of Art.

242. Frances Macdonald MacNair, *'Tis a Long Path which Wanders to Desire*, c. 1909–15. Watercolour, 35.2×30.1 cms. Hunterian Art Gallery, University of Glasgow, Mackintosh Collection.

243. Margaret Macdonald Mackintosh, *La Mort Parfumée*, 1921. Watercolour, 63×71.2 cms. Private Collection.

244. Jessie Marion King, *Nuremburg*, 1902. Pen and ink.

245. Bessie MacNicol, *The Green Hat*, c. 1902. Oil on canvas, 51.4×36.6 cms. City of Edinburgh Art Centre.

246. John Quinton Pringle, *The Window*, 1924. Oil on canvas, 55.8×45.7 cms. The Tate Gallery, London.

247. John Duncan, *St Bride*, 1913. Tempera on canvas, 120.7×143.5 cms. National Gallery of Scotland.

248. Charles Mackie, *When the Girls Come Out to Play*, 1895. Decoration in *The Evergreen 'Spring'*. Wood-engraving, 15.2×8.2 cms. Photo: Joe Rock.

249. John Duncan, headpiece, decoration in *The Evergreen 'Winter'*, 1896–7. 5.6×10.3 cms. Photo: Joe Rock.

250. William Strang, *The Fish Stall*, 1891. Etching. Reproduced by courtesy of the Trustees of the British Museum.

251. Sir David Young Cameron, *Berwick*, 1890. Etching. Hunterian Art Gallery, University of Glasgow.

252. Sir Muirhead Bone, *The Great Gantry, Charing Cross*, 1906. Etching, 28×43.5 cms. Hunterian Art Gallery, University of Glasgow.

253. Sir Muirhead Bone, *Demolition of the Old Sugar Exchange, Glasgow*, 1910. Pencil, from *Glasgow, Fifty Drawings*, (Glasgow 1911). Photo: Joe Rock.

254. Sir Muirhead Bone, *St Rollox*, 1910. Pencil, from *Glasgow, Fifty Drawings*, (Glasgow 1911). Photo: Joe Rock.

255. Sir Muirhead Bone, *A Via Dolorosa; Mouquet Farm*, 1916. Ink and watercolour. From *War Drawings by Muirhead Bone from the collection presented by HM Government to the British Museum* (London 1917). Edinburgh City Library. Photo: Joe Rock.

256. James McBey, *The Moray Coast*, 1914. Etching. Aberdeen Art Gallery and Museums, Aberdeen City Arts Department.

CHAPTER XVII

257. Charles Mackie, *Bassano Bridge*. Coloured woodcut, 51×52 cms. The Scottish Gallery.

258. Charles Mackie, *The Piazzetta, Venice*, 1909. Oil on canvas, 100.7×125.7 cms. City of Edinburgh Art Centre.

A special note of thanks is extended to: Jane Alison at the Barbican Art Gallery; Mrs. Marlee Robinson on behalf of Sir Eduardo Paolozzi; Cyril Gerber; William Hardie; Rab Snowden; Pamela Robertson; Robin Nicolson and Phillip Long.

SELECT BIBLIOGRAPHY

This bibliography is intended to be an extension of the information given in the footnotes and to provide a guide to further reading. It does not include manuscript sources which are however given in the footnotes when cited directly. Following a section on general works, the bibliography is divided into four parts following the major divisions of the book. Each part is then subdivided into three sections: 1. general works specific to the period; 2. works on specific topics or groups of artists; 3. Individual artists listed alphabetically.

General books and articles covering most of the period

Aberdeen Art Gallery and Museum, *Catalogue of the Permanent Collection* (1968)

Armstrong, Sir Walter, *Scottish Painters, A Critical Study* (London 1888)

Bindman, David, ed. *The Thames & Hudson Dictionary of British Art* (London 1985)

Brydall, Robert, *History of Art in Scotland* (Edinburgh 1889)

Bushnell, G. H., *Scottish Engravers; a biographical Dictionary* (London 1949)

Campbell, Alexander, *A Journey from Edinburgh through Parts of North Britain* (London 1810)

Cunningham, Allan, *Lives of the Most Eminent British Painters etc.*, 6 vols. (London 1829–33)

Caw, Sir James, *Scottish Portraits*, 4 parts (Edinburgh 1902)

Caw, Sir James, *Scottish Painting Past & Present 1620–1908* (1908, reprinted Bath 1978)

Chalmers, Sir George, 'Anecdotes of Painting in Scotland', *The Weekly Magazine or Edinburgh Amusement* (16 Jan. 1772)

Chambers, Robert, *A Biographical Dictionary of Eminent Scotsmen*, new ed., 3 vols. (London 1870)

Craig, Cairns, gen. ed. *History of Scottish Literature*, 4 vols. (Aberdeen 1987–88) vol. I, ed. Ronald Jack, *Origins to 1660*, vol. II, ed. Andrew Hook, *1660–1800*, vol. III, ed. Douglas Gifford, *The Nineteenth Century*, vol. IV, ed. Cairns Craig, *The Twentieth Century*

Cursiter, Stanley, *Scottish Art to the Close of the Nineteenth Century* (London 1949)

Daiches, David, ed., *A Companion to Scottish Culture* (London 1981)

Dundee Art Galleries & Museums, *Catalogue of the Permanent Collection* (1973)

City of Edinburgh Art Centre, *Catalogue of the Permanent Collection*, 2 vols. (1979)

Edinburgh University, *The University Portraits*, 2 vols., vol. 1 ed. D. Talbot Rice and P. McIntyre (Edinburgh 1957), vol. 2 ed. Sir John H. Burnett, David Howarth & Sheila Fletcher (Edinburgh 1986)

Ferguson, William, *Scotland 1689 to the Present* (Edinburgh 1968)

Finlay, Ian, *Art in Scotland* (Oxford 1948)

Glasgow Art Gallery & Museum, *Scottish Painting from the Early Seventeenth Century to the Early Twentieth Century* (1961)

Glasgow Art Gallery & Museum, *Summary Catalogue of British Oil Paintings* (1971)

Graves, Algernon, *The Royal Academy Exhibitions 1769–1904* (list of exhibitors), 8 vols. (London 1905–06)

Halsby, Julian, *Scottish Watercolours 1740–1940* (London 1986)

Hardie, Martin, *Watercolour Painting in Britain*, 3 vols. (London 1966–68)

Hare, Bill, et al., *Signs of the Times: Art & Industry in Scotland 1750–1985* TRG & Collins Gallery (1986)

Irwin, David & Francina, *Scottish Painters at Home & Abroad* (London 1975)

Kirkcaldy Museum & Art Gallery, *Catalogue of Paintings* (1965)

McKay, W. D., *The Scottish School of Painting* (London 1906)

Macmillan, Duncan, *Masterpieces of Scottish Portrait Painting*, TRG (1981)

Macmillan, Duncan, 'Notes towards a History of Scottish Art I: 1500–1700', *Cencrastus*, 15 (Dec. 1983)

Macmillan, Duncan, 'Notes towards a History of Scottish Art II: Ramsay to Raeburn', *Cencrastus*, 17 (Summer 1984)

Macmillan, Duncan, 'The Tradition of Painting in Scotland', *Cencrastus*, 1 (1979)

Macmillan, Duncan, 'The University & the Fine Arts: a brief history' in *Quatercentenary of the University of Edinburgh: The Torrie Collection*, TRG (1983)

Marshall, Rosalind K., *Costume in Scottish Portraits 1560–1830*, SNPG (1986)

National Gallery of Art, Washington, *Treasure Houses of Britain* (New Haven & London 1985)

National Gallery of Canada, Ottawa, *Three Centuries of Scottish Painting* (1968)

National Gallery of Scotland, *Catalogue of Paintings & Sculpture* (1957)

National Gallery of Scotland, *Catalogue of Scottish Drawings* (1960)

National Gallery of Scotland, *Illustrations* (1980)

Pinkerton, John, *The Scotish* [sic] *Gallery; or Portraits of Eminent Persons of Scotland . . . with an Introduction on the Rise & Progress of Painting in Scotland* (London 1799)

Rinder, Frank, *The Royal Scottish Academy 1826–1916* (Edinburgh 1917, reprinted Bath 1977)

Royal Academy of Arts, London, (Sir James Caw & others) *Scottish Art* (1939)

Royle, Trevor, *The Macmillan Companion to Scottish Literature* (London 1983)

Scottish National Portrait Gallery *Concise Catalogue* (1977)

Smout, T. C., *History of the Scottish People 1560–1830* (London 1969)

Steel, Tom, *Scotland's Story* (London 1984)

Thompson, Colin, *Pictures for Scotland: the National Gallery of Scotland & Its Collection*, NGS (1972)

Tonge, John, *The Arts in Scotland* (London 1938)

Waterhouse, Sir Ellis, *Painting in Britain* (London 1953)

Wittig, Kurt, *The Scottish Tradition in Literature*, (1958, reprinted Edinburgh 1978)

Part I: Chapters I–IV, The Later Middle Ages & the Reformation

I.1

Apted, M. R. & Hannabuss, S., *Painters in Scotland 1301–1700; A Biographical Dictionary* (Edinburgh 1978)

Macdougall, Norman, *James III; A Political Study* (Edinburgh 1982)

McRoberts, David, ed., *Essays on the Scottish Reformation 1513–1625* (Glasgow 1962)

Nicholson, Ranald, *Scotland: the Later Middle Ages* (Edinburgh 1974)

Royal Scottish Museum, *Angels, Nobles and Unicorns* (1982)

Thomson, Duncan, *Painting in Scotland 1570–1650*, SNPG (1975)

Wormald, Jenny, *Court, Kirk and Community; Scotland 1470–1625* (London 1981)

I.2

Amsterdam, Rijksmuseum, *Catalogue of Paintings* (1960)

Apted, M. R., *The Painted Ceilings of Scotland 1550–1650* (1966)

Beza, Theodore, *Icones, id est Verae Imagines, Virorum Doctrina simul et Pietate Illustrium etc.* (Geneva 1580)

Boece, Hector, *The Chronicles of Scotland*, translated into Scots by John Bellenden, ed. R. W. Chambers et al., 2 vols., The Scottish Text Society (Edinburgh 1936 & 1941)

Borland, C. R., *Descriptive Catalogue of the Western Medieval Manuscripts in Edinburgh University Library* (Edinburgh 1916)

Croft-Murray, Edward, *Decorative Painting in England 1537–1837*, 2 vols. (London 1962 & 1970)

Dalgetty, Arthur B., *History of the Church of Foulis Easter* (Dundee 1933)

Donaldson, Gordon, *The Scottish Reformation* (Cambridge 1960)

Drummond, William of Hawthornden, *The Poetical Works of William Drummond of Hawthornden*, ed. L. E. Kastner, 2 vols., The Scottish Text Society (Edinburgh 1911–12)

Ferrerius, Johannes, *Historia Abbatum de Kynlos*, Bannatyne Club, (Edinburgh 1839)

Grant, James, *Cassell's Old & New Edinburgh etc*, 3 vols. (London n.d.)

Hay, George, 'A Scottish Altarpiece at Copenhagen', *Innes Review*, VII (1956)

Innes, Cosmo, ed., *The Black Book of Taymouth with Other Papers from the Breadalbane Charter Room* (1855)

Innes, Thomas, 'Processional Roll of a Scottish Armorial Funeral etc', *PSAS*, vol. lxxvii (1943)

Innes, Sir Thomas, *Scots Heraldry: A Practical Handbook* (Edinburgh 1956)

Ker, N. R., *Medieval Manuscripts in British Libraries*, 2 vols. (Oxford 1969, London 1977)

Leicester Museums and Art Gallery, *Hans Eworth, a Tudor Artist and his Circle* (1965)

Macfarlane, Leslie, 'Book of Hours of James IV and Margaret Tudor', *Innes Review*, XI (1960)

McQuarrie, Alan, 'Anselm Adornes of Bruges, traveller in the East and Friend of James III', *Innes Review*, XXXIII (1982)

McRoberts, David, *Catalogue of Scottish Medieval Liturgical Books and Fragments* (Glasgow 1953)

McRoberts, David, 'Dean Brown's Book of Hours', *Innes Review*, XIX (1968)

McRoberts, David, 'The Glorious House of St Andrew', *Innes Review*, XXV (1974)

McRoberts, David, 'Material Destruction caused by the Scottish Reformation', *Innes Review*, X (1959)

McRoberts, David, 'A Sixteenth Century Picture of St Bartholomew from Perth', *Innes Review*, X (1959)

McWilliam, Colin, *The Buildings of Scotland; Lothian* (London 1978)

Major, John, *History of Great Britain* (Edinburgh 1740)

Marshall, Rosalind K., *The Days of Duchess Anne* (London 1973)

Marshall, Rosalind K., *Queen of Scots* (Edinburgh 1986)

Millar, Sir Oliver, *The Tudor Stuart & Early Georgian Pictures in the Collection of Her Majesty The Queen*, 2 vols. (1963)

National Museums of Scotland, *Treasures of the Nation* (Edinburgh 1989)

Parry, Graham, *The Golden Age Restored* (Manchester 1981)

Paul, Sir James Balfour, *Heraldry in Relation to Scottish History and Art* (Edinburgh 1900)

Pinkerton, John, *Iconographia Scotica, or Portraits of Illustrious Persons* (London 1795–6)

Royal Commission on the Ancient & Historical Monuments of Scotland, *The City of Edinburgh*, HMSO (1951)

Smailes, Helen, & Thomson, Duncan, *The Queen's Image*, NGS (1987)

Stewart, Ian H., *The Scottish Coinage* (London 1967)

Strong, Roy, *The Elizabethan Image*, Tate Gallery (1969)

Strong, Roy, *The English Icon; Tudor & Jacobean Portraiture* (London 1969)

Thomson, Duncan, *A Virtuous and Noble Education*, SNPG (1971)

Wilson, Daniel, *Memorials of Edinburgh in the Olden Times*, 2 vols. (Edinburgh 1848)

I.3

GOES, Hugo van der; Thompson, Colin, & Campbell, Lorne, *Hugo van der Goes & the Trinity College Panels in Edinburgh*, NGS (1974); McRoberts, David, 'Notes on Scoto-Flemish artistic contacts', *Innes Review*, X (1959)

JAMESONE, George; Thomson, Duncan, *George Jamesone* (Oxford 1974)

MEDINA, John de; Marshall, Rosalind, K., *Sir John de Medina*, NGS (1988)

WRIGHT, John Michael; Stevenson, Sara, & Thomson, Duncan, *John Michael Wright, the King's Painter*, SNPG (1982)

Part II: Chapters V to X, The Enlightenment

II.1

Burke, Joseph, *English Art, 1714–1800* (Oxford 1976)

Holloway, James, *Patrons & Painters, Art in Scotland: 1650–1760*, SNPG (1989)

Macmillan, Duncan, *Painting in Scotland: The Golden Age, 1707–1843* (Oxford 1986)

Marshall, Rosalind K., *Women in Scotland, 1660–1780*, SNPG (1979)

Prado, Museo del, *Pintura Británica de Hogarth a Turner* (Madrid 1989)

Tate Gallery, *Landscape in Britain, 1750–1850* (1973)

II.2

Alison, Archibald, *Essays on the Nature and Principles of Taste*, 2 vols. (1790); 2nd ed. (Edinburgh 1811)

Anonymous, *Compliments to Painters of Eminence in Scotland with a Dissertation on the works of the present Professors of that charming Art in this City* (in verse) (Edinburgh 1797)

Antal, Frederick, *Fuseli Studies* (London 1956)

Antal, Frederick, *Hogarth & His Place in European Art* (London 1962)

Arts Council of Great Britain, *The Age of Neo-Classicism* (1972)

Barbican Art Gallery, catalogue by Scott Wilcox, *Panoramania* (London 1989)

Bell, Charles, *Essays on the Anatomy of Expression in Painting* (London 1806)

Benton, J. H., *The Scot Abroad* (1864; 2nd ed. Edinburgh 1900)

Blackwell, Thomas, *An Inquiry into the Life, Times & Writings of Homer* (London 1735)

Blair, Hugh, 'A Critical Dissertation on the Poems of Ossian' in *The Works of Ossian*, 2 vols., 3rd ed. (Dublin 1765)

Brown, John, (of Newcastle), *A Dissertation on the Rise, Union & Power, the Progressions, Separations & Corruptions of Poetry & Music* (London 1763)

Burns, Robert, *Complete Poems* (Oxford 1969)

Burns, Robert, *Letters of Robert Burns*, ed. J. de L. Ferguson, 2nd ed. G. Ross Roy, 2 vols. (Oxford 1985)

Caylus, Comte de, *Tableaux Tirés de Homère etc* (Paris 1757)

Chitnis, Annand, *The Scottish Enlightenment: A Social History* (London 1976)

Cummings, Frederick, & Staley, Allen, *Romantic Art in Britain 1760–1860*, Detroit Institute of Arts & Philadelphia Museum of Art (1968)

Daiches, David, *The Paradox of Scottish Culture* (London 1964)

Davie, George Elder, *The Democratic Intellect* (Edinburgh 1961)

Davie, George Elder, *The Scottish Enlightenment*, Historical Association General Series 99 (1981)

Drummond, James, McLure, A, et al., *Illustrations of the Principles of Toleration in Scotland* (Edinburgh 1846)

Dunlop, William, *History of the Rise & Progress of Arts & Design in the USA* (New York 1834)

Errington, Lindsay, *The Artist & the Kirk*, NGS (1979)

Errington, Lindsay, & Holloway, James, *The Discovery of Scotland*, NGS (1978)

Fergusson, Robert, *The Poems of Robert Fergusson*, ed. M. P. McDiarmid, The Scottish Text Society, 2 vols. (Edinburgh & London 1954)

Fleming, John, *Robert Adam & his Circle* (London 1962)

Foster, Sir William, 'British Artists in India', *Walpole Society*, XIX (1930–31)

Freeman, F. W., *Robert Fergusson & the Scots Humanist Compromise* (Edinburgh 1984)

Fryer, Edward, *The Works of James Barry, Esq.* 2 vols. (London 1809)

Galt, John, *Annals of the Parish or the Chronicle of Dalmailing during the Ministry of the Rev. Micah Balwhidder* (first pub. 1821, ed. Edinburgh 1988)

Gifford, John, *Buildings of Scotland: Fife* (London 1988)

Gordon, Esmé, *The Royal Scottish Academy 1826–1976* (Edinburgh 1976)

Grant, Elizabeth, *Memoirs of a Highland Lady*, ed. Andrew Tod, 2 vols. (Edinburgh 1988)

Graves, Algernon, *The Society of Artists of Great Britain, 1760–91; The Free Society of Artists, 1761–83* (London 1907)

Hamburg Kunsthalle, *Ossian und die Kunst um 1800* (1974)

Haydon, Benjamin Robert, *Autobiography & Memoirs of Benjamin Robert Haydon*, 2 vols., ed. Tom Taylor (London 1926)

Herd, David, *The Ancient & Modern Scots Songs, Heroic Ballads & c.* (Edinburgh 1769)

Hill, Cumberland, *History & Reminiscences of Stockbridge* (Edinburgh 1874)

Hogg, James, 'Scottish Haymakers' in *Tales of Love and Mystery*, ed. David Groves (Edinburgh 1985)

Hume, David, *A Treatise of Human Nature* (London 1739) ed. L. A. Selby-Bigge (Oxford 1888)

Hutcheson, Frances, *An Inquiry into our Ideas of Beauty and Virtue* (London 1726)

Irwin, David, *English Neoclassical Art* (London 1966)

Iveagh Bequest, Kenwood House, *British Artists in Rome: 1700–1800* (1974)

Johnson, David, *Music & Society in Lowland Scotland in the Eighteenth Century* (London 1972)

Lenman, Bruce, *Integration, Enlightenment & Industrialisation* (London 1981)

Lockhart, John Gibson, *Memoirs of the Life of Sir Walter Scott*, 7 vols. (Edinburgh 1837–8, abridged ed. London 1848)

McCosh, James, *The History of Scottish Philosophy* (London 1875)

M'Crie, Thomas, *Life of John Knox* (Edinburgh 1812)

Macmillan, Duncan, 'The Illuminated Book & the History of Art', *Apollo*, CIV (Aug. 1976)

Macmillan, Duncan, 'Old & Plain: Music & Song in Scottish Art', in *The People's Past*, ed. E. J. Cowan (Edinburgh 1980)

MacNeill, Hector, *Bygane Times and Late Come Changes*, 3rd ed. (Edinburgh 1811)

MacNeill, Hector, *Will & Jean or Scotland's Skaith* (Edinburgh 1795)

Macpherson, James, 'On the Poems of Ossian', in *The Works of Ossian*, 3rd ed. 2 vols. (Dublin 1765)

MacQueen, John, *Progress and Poetry* (Edinburgh 1982)

Markus, Thomas A., 'Buildings for the Sad the Mad and the Bad in Urban Scotland 1780–1830', in *Order and Space in Society* (Edinburgh 1982)

Mercer, Thomas, *Poems by the Author of the Sentimental Sailor* (Edinburgh 1774)

National Gallery of Scotland, *Pictures for Scotland* (1972)

Pilkington, Matthew, *Gentleman's and Connoisseur's Dictionary of Painters* (first published 1770) ed. Henry Fuseli (London 1805)

Pressly, Nancy, *Fuseli and his Circle in Rome*, Yale Centre for British Art (New Haven 1977)

Pressly, William L., *The Life & Art of James Barry* (New Haven & London 1981)

Ramsay, Allan, *The Works of Allan Ramsay*, The Scottish Text Society, 6 vols., vols. 1–2 ed. B. Martin & J. W. Oliver, vols. 4–6 ed. A. Kinghorn & A. Law (Edinburgh & London 1944–74)

Reid, Thomas, *An Inquiry into the Human Mind on the Principles of Common Sense* (Edinburgh 1764)

Reid, Thomas, *Essays on the Intellectual Powers of Man* (Edinburgh 1785)

Reid, Thomas,. *Works of Thomas Reid*, ed. Sir William Hamilton, 2 vols. (London 1863)

Ridgeway, David, 'James Byers and the Ancient State of Italy', *Secondo Congresso Internazionale Etrusco* (Florence 1985)

Royal Academy of Arts, *Reynolds*, ed. Nicholas Penny (1986)

Ruddiman, Walter, 'Editorial', *Caledonian Mercury* (28 Apr. 1774)

Scott, Sir Walter, *Sir Walter Scott's Journal, 1825–32* (Edinburgh 1891)

Scott, Sir Walter, *The Waverley Novels*, illustrated ed. published by Cadell, 20 vols. (Edinburgh 1827–33)

Scott, Sir Walter, *Bicentenary Exhibition* organised by The Court of Session, The Faculty of Advocates & the National Library of Scotland (1971)

Seznec, Jean, 'Diderot and the' Pictures in Edinburgh', *Scottish Art Review*, n.s. 8, p21 (1962)

Shaftesbury, Anthony Ashley Cooper, 3rd Earl of, *Characteristicks of Men, Manners, Opinions, Times etc.*, 2nd ed. 3 vols. (London 1714)

Skinner, Basil, *The Visit of George IV to Edinburgh, 1822*, SNPG (1961)

Skinner, Basil, 'The Faithful Servant: a gallery of Scots domestic portraiture', *Scotland's Magazine*, LVIII (Mar. 1962)

Skinner, Basil, *Scots in Italy in the Eighteenth Century*, SNPG (1966)

Smith, John Thomas, *Nollekens and his Times*, 2 vols. (London 1828)

Stewart, Dugald, *Elements of the Human Mind*, 3 vols. (London 1792–1827)

Tate Gallery, *Hogarth* (1971)

Taylor, Sir Gordon Gordon, & Wallis, E. W., *Sir Charles Bell, his Life and Times* (Edinburgh & London 1958)

Thomson, Derek S., *The Gaelic Sources of Macpherson's Ossian* (Edinburgh & London 1951)

Thomson, George, *A Selection of Original Scots Airs*, 6 vols. (Edinburgh 1793–1841)

Thomson, James, *Poetical Works* (Edinburgh 1853)

Tomory, Peter, *The Life & Art of Henry Fuseli* (London 1972)

Tomory, Peter, *The Poetical Circle: Fuseli & the British* (Australia, New Zealand 1979)

Topham, Edward, *Letters from Edinburgh: 1774–1775* (Edinburgh 1776)

Turnbull, George, *A Treatise on Ancient Painting* (London 1740)

Vertue, George, 'Vertue Notebooks', *Walpole Society*, vols. xviii, xx, xxii, xxiv, xxvi, xxix, & xxx (1930–55)

Walker, George, *Descriptive Catalogue of a choice Assemblage of original pictures by some of the most esteemed Masters etc.* (Edinburgh 1807)

Walpole, Horace, *Anecdotes of Painting in England*, 4 vols. (London 1765–1771)

Whitley, W. T., *Artists & their Friends in England, 1700–1799*, 2 vols. (London 1928)

Whitley, W. T., *Art in England, 1821–37* (Cambridge 1930)

Wilkie, William, *Fables* (London 1768)

Wood, Robert, *An Essay on the Original Genius & Writings of Homer etc.* (privately printed 1767, & London 1769)

II.3

AIKMAN, William; (Anderson, James), 'Biographical Sketches of Eminent Scottish Artists; William Aikman', *The Bee* (6 Nov. 1793); Holloway, James, *William Aikman*, NGS (1988)

ALLAN, David; Ramsay, Allan, *The Gentle Shepherd*, illustrated by David Allan (Glasgow 1788); Ramsay, Allan, *The Gentle Shepherd*, The Newhall Edition, including memoir of David Allan & other notes on Scottish painting, 2 vols. (Edinburgh 1808); Errington, Lindsay, *David Allan's Seven Sacraments*, NGS (1982); Gordon, T. Crowther, *David Allan of Alloa, the Scottish Hogarth* (Alva 1951); Skinner, Basil, *The Indefatigable Mr Allan*, SAC (Edinburgh 1973)

BROWN, John; anon., 'Biographical Sketches of Eminent Scottish Artists; John Brown', *The Bee*, (8 May 1793); Brown, John, *Letters on the Italian Opera*, intro. by Burnett, James, Lord Monboddo, 2nd ed. (Edinburgh 1792); Gray, John M., 'John Brown, the Draughtsman', *Magazine of Art* (1889); Skinner, Basil, 'John Brown and the Antiquarians', *Country Life*, 150 (Aug. 1971)

BURNET, John; Burnet, John, *Practical Essays on various Branches of the Fine Arts etc.* (London 1848); Burnet, John, 'Autobiography of John Burnet', *Art Journal*, (1850); Burnet, John, 'Recollections of my Contemporaries', *Art Journal* (1860)

CARSE, Alexander; Errington, Lindsay, *Alexander Carse*, NGS (1987)

CLERK, John, of Eldin; Clerk, John, of Eldin, *Etchings, chiefly of views of Scotland*, Bannatyne Club (Edinburgh 1825); Bertram, Geoffrey, *John Clerk of Eldin* (Edinburgh 1978)

DEUCHAR, David; Deuchar, David, *Collection of Etchings after the most Eminent Masters of the Dutch & Flemish Schools etc.* (Edinburgh 1803)

DRUMMOND, James; see III.3

FAED, Tom, James, & John; MacKerrow, Mary, *The Faeds* (Edinburgh 1985)

GEDDES, Andrew; Geddes, Adela, *Memoir of the late Andrew Geddes ARA* (London 1844); Laing, David, *Etchings by Sir David Wilkie & Andrew Geddes* (Edinburgh 1875)

GEIKIE, Walter; Geikie, Walter, *Sketches from Nature* (Edinburgh 1833); Geikie, Walter, *Etchings Illustrative of Scottish Character & Scenery executed after his own Designs etc.* with biographical introduction by Sir Thomas Dick Lauder (Edinburgh n.d. c. 1841 and various editions thereafter); Macmillan, Duncan, *Walter Geikie*, TRG (1984); Morris, Roy, 'The Etchings of Walter Geikie', *Print Collector's Quarterly*, XXII (1935)

HAMILTON, Gavin; (Anderson, James) 'Biographical Sketches of Eminent Scottish Artists; Gavin Hamilton', *The Bee* (10 July 1793); Irwin, David, 'Gavin Hamilton; Archaeologist, Painter & Dealer', *Art Bulletin*, XLIV (1962); Waterhouse, Sir Ellis, 'The British Contribution to the Neo-classical Style of Painting', *Proceedings of the British Academy*, XL (1954)

HARVEY, Sir George; Smith Art Gallery Stirling, *Sir George Harvey* (1986)

HILL, David Octavius; Macmillan, Duncan, 'Born like Minerva, D. O. Hill and the Origins of Photography', in *British Photography in the Nineteenth Century, the Fine Art Tradition*, ed. Mike Weaver (New York 1989); Michaelson, Katherine, *A Centenary Exhibition of the Work of David Octavius Hill & Robert Adamson*, SAC (1970); Stevenson, Sara, *David Octavius Hill & Robert Adamson*, SNPG (1981)

LAUDER, Robert Scott; see III.2., Errington, Lindsay, *Master Class*

LIZARS, William; Elizabeth Strong, *W. H. Lizars, Engraver*, Scottish Antiquarian Booksellers (Edinburgh, Mar. 1989)

MEDINA, Sir John de; Marshall, Rosalind K., *John de Medina*, NGS (1988)

MORE, Jacob; Holloway, James, *Jacob More*, NGS (1987)

NASMYTH, Alexander; Nasmyth, James, *James Nasmyth, Engineer: an Autobiography*, ed. Samuel Smiles (London 1883); Crawford Art Centre, St Andrews University, *Alexander Nasmyth* (1979); Cooksey, Janet, *Alexander Nasmyth*, unpublished PhD thesis, St Andrews University (1984)

NORIE, James; (Werschmidt, Daniel A.), *James Norie, Painter* (Edinburgh 1890)

NORIE, Robert; Holloway, James, 'Robert Norie in London & Perthshire', *Connoisseur* (Jan. 1978)

RAEBURN, Sir Henry; Duncan Andrew, *A Tribute of Regard to the Memory of Sir Henry Raeburn RA* (Edinburgh 1824); Morrison, John, 'Reminiscences of Sir Walter Scott, the Ettrick Shepherd, Sir Henry Raeburn etc.', *Tait's Edinburgh Magazine*, X (1843), & XI (1844); Armstrong, Sir Walter, & Caw, Sir James L., *Sir Henry Raeburn* (London & New York 1901); Arts Council of Great Britain, *Raeburn Bicentenary Exhibition* (Edinburgh 1956); Dibdin, E. R., *Raeburn* (London 1925); Greig, James, *Sir Henry Raeburn RA* (London 1911); Irwin, Francina, 'Early Raeburn reconsidered', *Burlington Magazine*, CXV (1973); Stevenson, Robert Louis, 'Some Portraits by Raeburn', in *Virginibus Puerisque* (London 1881)

RAMSAY, Allan; Ramsay, Allan, 'On Ridicule' (1753), in *The Investigator* (London 1762); Ramsay, Allan, *A Dialogue on Taste* (1755), also in *The Investigator* (London 1762); Brown, Ian G., 'Allan Ramsay's Rise & Reputation', *Walpole Society*, L (1984); Brown, Ian G., *Poet & Painter, Allan Ramsay, Father & Son*, NLS (1984); Brown, Ian G., 'The Pamphlets of Allan Ramsay the Younger', *The Book Collector*, 37 (Spring 1988); Caw, Sir James, 'Allan Ramsay, Portrait-Painter', *Walpole Society*, XXV (1936–37); Fleming, John, 'Robert Adam & Allan Ramsay in Italy', *Connoisseur* (Mar. 1956); National Gallery of Scotland, *Allan Ramsay, His Masters & Rival*, NGS (1963); Smart, Alastair, *The Life and Art of Allan Ramsay* (London 1952)

READ, Catherine; Manners, Victoria, 'Catherine Read', 3 parts, *Connoisseur*, LXXXVIII & LXXXXIX (Dec. 1931; Jan. & Mar. 1932); Steuart, A. F., 'Miss Katherine Read, Court Paintress', *Scottish Historical Review*, 2 (1904)

ROBERTS, David; Roberts, David, *Landscape Illustration of the Bible etc.*, 2 vols. (London 1836); Roberts, David, *The Holy Land, Syria, Idumea, Arabia, Egypt etc.*, 20 monthly parts (London 1842–49); Ballantine, James, *The Life of David Roberts etc.* (Edinburgh 1866); Bendiner, Kenneth, 'David Roberts in the Near East: social & religious themes', *Art History*, 6 (Mar. 1983); Guiterman, Helen, *David Roberts RA* (London, 1978); Guiterman, Helen & Llewellyn, Briony, Barbican Art Gallery, *David Roberts* (London 1986); Hardie, Martin, 'David Roberts', *Old Water Colour Society*, XXV (1947); Stevens, Mary Anne, ed. *The Orientalists: Delacroix to Matisse, European Painters in North Africa*, RA (1984)

ROBERTSON, Andrew; *Letters and Papers of Andrew Robertson AM*, ed. Emily Robertson (London 1895)

RUNCIMAN, Alexander; (Ross, Walter), *A Description of the Paintings in the Hall of Ossian at Pennycuik* (Edinburgh 1773); Buchan, Henry Stuart Erskine, Earl of, 'Biographical Sketch of Alexander Runciman', *The Scots Magazine* (Aug. 1802); Gray, John M., *Notes on the Art Treasures at Penicuik House* (Edinburgh 1889); Macmillan, Duncan, 'Alexander Runciman in Rome', *Burlington Magazine*, CXII (1970); Macmillan, Duncan, *Alexander Runciman & the influences that shaped his style*, unpublished PhD, EU (1974); Macmillan, Duncan, 'Truly National Designs; Runciman at Penicuik', *Art History*, I (1978); Rowan, Alastair & Hodkinson, Ian, 'Penicuik House, Midlothian', *Country Life*, CXLIV (1968)

RUNCIMAN, John; Merchant, W. Moelwyn, 'John Runciman's Lear in the Storm', *Journal of Warburg & Courtauld Institutes*, XVII (1954), reprinted in *Shakespeare & the Artist* (Oxford 1959)

SHARPE, Charles Kirkpatrick; *Etchings with a Memoir* (Edinburgh 1869)

SIMSON, William; Nicholson, Robin, *William Simson RSA 1800–1847*, The Fine Art Society (London 1989)

SKIRVING, Archibald; Skinner, Basil, 'Archibald Skirving', *Transactions of East Lothian Antiquarian Society*, XII (1970)

SMIBERT, John; Chapell, Miles, 'A Note on Smibert's Italian Sojourn', *Art Bulletin*, CXIV (Mar. 1982); Foote, Henry W., *John Smibert* (Cambridge Mass. 1950); Smibert, John, *The Notebook* (Boston 1969)

STEUART, Charles; Irwin, David, 'Charles Steuart, Landscape Painter', *Apollo*, XCX (1975)

STRANGE, Sir Robert; Dennistoun, James, *Memoirs of Sir Robert Strange and Andrew Lumsden*, 2 vols. (1855)

TASSIE, James; Holloway, James, *James Tassie*, NGS (1986)

WILKIE, Sir David; Cunningham, Allan, *Life of Sir David Wilkie*, 3 vols. (London 1843); Raimbach, Abraham, ed. M. T. S. Raimbach, *Memoirs and Recollections of the late Abraham Raimbach* (London 1843); Wilkie, Sir David, *The Wilkie Gallery*, in 4 parts (London n.d.); Ashmolean Museum, *Catalogue of Drawings and Sketches by Sir David Wilkie*, compiled by David Blaney Brown (Oxford & London 1985); Errington, Lindsay, *Sir David Wilkie: Drawings into Paintings*, NGS (1975); Errington, Lindsay, *A Tribute to Wilkie*, NGS (1985); Laing, David, *Etchings by Sir David Wilkie & Andrew Geddes* (Edinburgh 1875); North Carolina Museum of Art, *Sir David Wilkie of Scotland* (1987); Pointon, Marcia, 'From *Blindman's Buff* to *Le Colin Maillard*'; Wilkie and his French Audience', *The Oxford Art Journal*, 7 (1984)

WILLIAMS, Hugh William; *Travels to Greece & the Ionian Islands*, 2 vols. (Edinburgh 1820); Williams, Hugh William, *Select Views in Greece* (London 1829)

Part III: Chapters XI–XV, The Victorian Era

III.1

Boase, T. S. R., *English Art 1800–1870* (Oxford 1959)
Farr, Denis, *English Art 1870–1940* (Oxford 1978)

Glasgow Art Gallery & Museum, *Scottish Painting 1880–1930* (1973)
Hardie, William, *Scottish Painting 1837–1939* (London 1976)
Maas, Jeremy, *Victorian Painters* (London 1969)
Redgrave, Richard & Samuel, *A Century of Painters of the English School* (London 1866, reprinted 1947)
Redgrave, Samuel, *A Dictionary of Artists of the English School* (2nd ed. London 1878, reprinted 1977)
Smout, T. C., *A Century of the Scottish People 1830–1950* (London 1986)

III.2

Arts Council of Great Britain, *Landscape in Britain 1850–1950* (1983)
Billcliffe, Roger, *The Glasgow Boys* (London 1985)
Boardman, Philip, *The Worlds of Patrick Geddes etc.* (London 1978)
Brown, Gerard Baldwin, *The Glasgow School of Painters* (Glasgow 1908)
Brown, Gerard Baldwin, 'Some Recent Efforts in Mural Decoration', *Scottish Art Review* (1889)
Buchanan, William et al., *The Glasgow Boys*, 2 parts, SAC (Glasgow 1968 & 1971)
Buchanan, William, *Mr Henry & Mr Hornel visit Japan*, SAC (Edinburgh 1979)
Carter, Charles, 'Art Patronage in Scotland', *Scottish Art Review*, n.s. 6 (1957)
Clausen, George, 'Bastien-Lepage and Modern Realism', *Scottish Art Review*, I (Oct. 1888)
Constable, John, 'Letterpress to English Landscape', *John Constable's Discourses*, ed. R. B. Beckett, *Suffolk Records Society*, vol. XIV (1970)
Constable, W. G., *Richard Wilson* (London 1953)
Crane, Walter, & others, *Art and Life and the Building and Decoration of Cities*, Lectures to the Arts and Crafts Exhibiting Society, 1896 (London 1897)
Crane, Walter, *Bases of Design* (London 1898)
Crane, Walter, *The Claims of Decorative Art* (London 1892)
Crane, Walter, 'The Prospects of Art under Socialism', *Scottish Art Review* (September 1888)
Donnelly, Michael, *Glasgow Stained Glass*, GAGM (1981)
Errington, Lindsay, *Master Class; Robert Scott Lauder & his Pupils*, NGS (1983)
Fine Art Society, The, *Guthrie & the Scottish Realists* (Glasgow & London 1981)
Fine Art Society, The, *The Rustic Image: Rural Themes in British Painting 1880–1912* (London 1979)
Gallie, Elspeth, 'Archibald McLellan', *Scottish Art Review*, n.s. 5 (1954)
Geddes, Patrick, ed. and colleagues, *The Evergreen; a Northern Seasonal*, 4 numbers, 'Spring' & 'Autumn' (Edinburgh 1895), 'Summer' (1896), 'Winter' (1896–97)
Geddes, Patrick, *Every man his own Art Critic* (Edinburgh & Glasgow 1888)
Geddes, Patrick, 'Life and its Science', *The Evergreen*, 'Spring' (1895)
Geddes, Patrick, 'The Megalithic Builders', *The Evergreen*, 'Winter' (1896/7)
Geddes, Patrick, 'Political Economy & Art', *Scottish Art Review* (June 1889)
Geddes, Patrick, 'The Sociology of Autumn', *The Evergreen*, 'Autumn' (1895)
Germ, The, 1–4 (1849–50) reprint ed. by W. M. Rossetti (London 1901)
Good Words, ed. Norman McLeod, I & II (Edinburgh 1860–61) III seq. (London 1862–)
Gordon, Esmé, *The Royal Scottish Academy etc. 1826–1976* (Edinburgh 1976)
Goudie, Robert, *David Laing* (Edinburgh 1913)
Honeyman, T. J., 'Van Gogh, a link with Glasgow', *Scottish Art Review*, 2 (1948)
Jones, Owen, *The Grammar of Ornament* (London 1856)
Jones, Owen, 'The Writings of Owen Jones I–III', *The Architect* (Apr., May, June 1874)
Laing Art Gallery, Newcastle upon Tyne, *Pre-Raphaelites: Painters & Patrons in the North East* (1989)
McConkey, Kenneth, 'The Bouguereau of the naturalists: Bastien-Lepage & British art', *Art History*, I, 3, (1978)
McConkey, Kenneth, 'From Grez to Glasgow: French Naturalist Influence in Scottish Painting', *Scottish Art Review*, n.s. 15 (1982)
McConkey, Kenneth, et al., *Peasantries*, Newcastle upon Tyne Polytechnic Gallery (1981)

Mairet, Philip, *Pioneer of Sociology; the Life and letters of Patrick Geddes* (London 1957)
Martin, David, *The Glasgow School of Painting* (London 1897)
Meller, H. E. 'Patrick Geddes: An Analysis of his Theory of Civics, 1880–1904', *Victorian Studies*, XVI (1973)
Miles, Hamish, 'Early Exhibitions in Glasgow', *Scottish Art Review*, n.s. 8 (1962)
North, Christopher (Pseud. John Wilson), *Noctes Ambrosianae*, collected ed. (Edinburgh 1868)
Paterson, James, 'A Note on Nationality in Art', *Scottish Art Review*, I (Sept. 1888)
Paterson, Lindsay, 'Geometry & the Scottish Imagination', *Cencrastus*, 17 (1984)
Royal Academy of Arts, *The Hague School: Dutch Masters of the Nineteenth Century* (London 1983)
Royal Academy of Arts, *Post-Impressionism* (London 1979)
Stevenson, R. A. M., *Velasquez* (London 1896)
Weisberg, Gabriel P., *The Realist Tradition* (Cleveland, Ohio 1981)

III.3

BLACKBURN, Jemima; Blackburn, Jemima, *Birds from Nature* (1866); Fairley, Robert, *Jemima; Paintings by Jemima Blackburn* (Edinburgh 1989)

BOUGH, Sam; Gilpin, Sidney, *Sam Bough* (1905); Moss, Rachel, *Sam Bough RSA*, Bourne Fine Art (Edinburgh 1988)

CHALMERS, George Paul; Pinnington, Edward, *George Paul Chalmers RSA & the Art of his Time* (Glasgow 1896)

CRAWHALL, Joseph; Bury, Adrian, *Joseph Crawhill: The Man & The Artist* (London 1958)

DRUMMOND, James; Cumming, Elizabeth, *James Drummond RSA; Victorian Antiquary & Artist of Old Edinburgh*, Canongate Tolbooth Museum (Edinburgh 1977); Drummond, James RSA, *Old Edinburgh* (Edinburgh & London 1879); Drummond, James RSA, *Sculptured Monuments in Iona & the West Highlands*, supplementary volume of *Archaeologica Scotia* (Edinburgh 1881)

DYCE, William; Dyce, William, & Wilson, Charles H., *Letter to Lord Meadowbank & the Committee of the Hon. Board for the Encouragement of Arts & Manufactures, on the best means of ameliorating the arts and manufactures in point of Taste* (Edinburgh 1837); Aberdeen Art Gallery, *Centenary Exhibition of the Work of William Dyce* (1964); Pointon, Marcia, 'Dyce's Pegwell Bay', *Art History*, I (1978); Pointon, Marcia, *William Dyce* (Oxford 1979)

FARQUHARSON, Sir Joseph; Aberdeen Art Gallery, *Joseph Farquharson of Finzean* (1985)

GUTHRIE, Sir James; Caw, Sir James, *Sir James Guthrie: A Biography* (London 1932)

HENRY, George; Buchanan, George, 'A Galloway Landscape', *Scottish Art Review*, n.s., 7 (1960); See also III.2., Buchanan, William

HERALD, James Watterston; Fine Art Society, The, *James Watterston Herald* (Edinburgh 1981)

HERDMAN, Robert; Errington, Lindsay, *Robert Herdman*, NGS (1988)

HORNEL, Edward Atkinson; Fine Art Society, *Edward Atkinson Hornel 1864–1933* (Glasgow 1982); See also III.2., Buchanan, William

LAVERY, Sir John; Lavery, John, *The Life of a Painter* (London n.d.); McConkey, Kenneth, *Sir John Lavery RA*, The Fine Art Society & the Ulster Museum (1984); Sparrow, Walter Shaw, *John Lavery, His Life & Work* (London 1911)

McCULLOCH, Horatio; Fraser, Alexander, *Scottish Landscape, The Works of Horatio McCulloch* (Edinburgh 1872); Smith, Sheena, *Horatio McCulloch, 1805–1867*, GAGM (1988)

McTAGGART, William; Caw, Sir James, *William McTaggart RSA* (Glasgow 1917); Errington, Lindsay, *William McTaggart*, NGS (1989); Dott, P. McOmish, *Notes Technical & Explanatory on the Art of William McTaggart* (Edinburgh 1901)

MANN, Alexander; Fine Art Society, The, *Alexander Mann* (London 1983)

MELVILLE, Arthur; Dowells Ltd, *Arthur Melville* (Edinburgh 1922); Dundee Art Galleries and Museums, *Arthur Melville* (1977); Fedden, Romilly, 'Arthur Melville', *Old Watercolour Society*, I (1923–4); Mackay, Agnes Ethel, *Arthur Melville, Scottish Impressionist 1855–1904* (Leigh-on-Sea 1951); McCurdy, Edward, 'Arthur Melville', *Scottish Art & Letters*, 5 (Glasgow 1950); Robertson, W. Graham, *Time Was* (London 1931); Wood, T. Martin, 'Arthur Melville', *The Studio*, XXXVII, (1906)

ORCHARDSON, Sir William Quiller; Gray, Hilda Orchardson, *Sir William Quiller Orchardson RA* (London 1930); Hardie, William, *Sir William Quiller Orchardson*, SAC (Edinburgh 1972)

PATERSON, James; Belgrave Gallery & The Fine Art Society, *The Paterson Family: One Hundred Years of Scottish Painting* (London & Edinburgh 1977); Lillie Art Gallery, *James Paterson, Moniaive and following family traditions* (Milngavie 1983)

PATON, Sir Joseph Noel; Aytoun, William, *Lays of the Scottish Cavaliers*, illus. Sir Joseph Noel Paton (Edinburgh 1865); Auld, Alastair, *Fact & Fancy: Sir Joseph Noel Paton*, SAC (1967); Noel Paton, Margaret H., *Tales of a Grand-Daughter* (privately printed, Edinburgh 1970)

PETTIE, John; Hardie, Martin, *John Pettie* (London 1908)

PHILLIP, John; Aberdeen Art Gallery, *John Phillip* (1967)

ROCHE, Alexander; Macfall, Haldane, 'Alexander Roche RSA', *The Artist* (1906)

SCOTT, David; Bunyan, John, *The Pilgrims Progress*, illus. David Scott (London & Edinburgh n.d.); Coleridge, Samuel Taylor, *The Ancient Mariner*, illus. David Scott (Edinburgh 1837); Scott, David, *Monograms of Man* (Edinburgh 1831); Gray, John M., *David Scott RSA & his Works* (Edinburgh 1884); Nichol, J. P., *The Architecture of the Heavens* with illustrations by David Scott (London 1850); Campbell, Mungo, *David Scott*, NGS (1990); Scott, William Bell, *Memoir of David Scott RSA* (Edinburgh 1850)

SCOTT, William Bell; Scott, William Bell, ed. W. Minto, *Autobiographical Notes of the Life of William Bell Scott*, 2 vols. (London 1892); Scott, William Bell, *Illustrations to the Kingis Quair of King James I of Scotland painted on the staircase of Penkill Castle* (Edinburgh 1887)

THOMSON, Rev. John, of Duddingston; Baird, William, *John Thomson of Duddingston, Pastor & Painter* (Edinburgh 1895); Napier, Robert W., *John Thomson of Duddingston, Landscape Painter* (Edinburgh & London 1919); Telfer, William, *John Thomson of Duddingston* (Falkirk 1950)

TRAQUAIR, Phoebe; Cumming, Elizabeth Skeoch, *Phoebe Traquair*, unpublished PhD thesis, EU (1987)

WALTON, E. A.; Forrest, Martin, *E. A. Walton*, Bourne Fine Art (Edinburgh 1981)

WINGATE, Sir James Lawton; Caw, Sir James L., 'J. Lawton Wingate' *Art Journal* (1896); Fine Art Society, The, *Sir James Lawton Wingate* (Edinburgh 1990)

Part IV: Chapters XVI–XXI, The Modern Age

IV.1

Barbican Art Gallery, *The Last Romantics* (London 1989)

Fergusson, J. D., *Modern Scottish Painting* (Glasgow 1943)

Firth, Jack, RSW, *Scottish Watercolour Painting* (Edinburgh, 1979)

Gage, Edward, *The Eye in the Wind: Scottish Painting Since 1945* (London, 1977)

Hall, Douglas, *Twentieth Century Scottish Painting*, ACGB (London 1963)

Hall, Douglas, & Brown, Andrew, *Twentieth Century Scottish Painting*, 369 Gallery (n.d.)

Hardie, William, *Scottish Painting 1837–1939* (London 1976)

Oliver, Cordelia, *Painters in Parallel*, SAC (1978)

Royal Academy of Arts, *British Art in the Twentieth Century* (London 1987)

Scottish National Gallery of Modern Art, *Concise Catalogue* (1977)

Hartley, Keith, *Scottish Art since 1900*, SNGMA (1989)

IV.2

Barbican Art Gallery, *A Paradise Lost* (London 1988)

Benton, Thomas Hart, 'Mechanics of Form Organisation in Painting', *The Arts* (Nov. and ff. 1926)

Bergson, Henri, *Creative Evolution* (*Evolution Créatrice*, first pub. 1907), English ed., ed. & trans. Arthur Mitchell (London 1910)

Bergson, Henri, *Time and Free Will* (*Essai sur les données immediate de la conscience*, first pub. 1889) English ed., ed. & trans. F. L. Pogson (London 1910)

Billcliffe, Roger, *The Scottish Colourists* (London 1989)

Bold, Alan, *Letters of Hugh MacDiarmid* (London, Hamilton 1984)

Bourne Fine Art, *Scottish Impressionism: McTaggart to Eardley* (Edinburgh 1988)

Bourne Fine Art, *The Edinburgh Group* (Edinburgh n.d.)

Brown, Andrew, et al., *Art in Scotland*, 369 Gallery (Edinburgh 1988)

Calvacoressi, Richard, *Three Scottish Colourists*, Guildford House Gallery (1980)

Clyde Group, The, *Broadsheet*, 1 (Dec. 1946)

Contemporary Scots Art, reprinted from the *Scots Observer* (n.p. 1932)

Currie, Ken, Allan, Elise & Moffat, Alexander, 'The New Scottish Painting', *Edinburgh Review*, 72 (1986)

Cursiter, Stanley, *Scottish Painters*, British Council Exhibition (Toledo & Ottawa 1950)

Cyril Gerber Fine Art, *Paintings of the Forties, Members of the New Scottish Group & Millie Frood* (Glasgow 1989)

Davie, George Elder, *The Crisis of the Democratic Intellect* (Edinburgh 1986)

Dickson, T. Elder, 'The East Coast Painters', *Scottish Art & Letters*, 2 (1945)

Edinburgh College of Art, *The Edinburgh School* (1971)

Farr, Denis, *New Painting in Glasgow 1940–46*, SAC (1968)

Fergusson, J. D., & MacDiarmid, Hugh, 'The Freedom of the Writer & the Freedom of the Artist', *Scottish Art & Letters*, 5 (1950)

Fine Art Society, The, *Frederick Cayley Robinson ARA* (London 1977)

Fine Art Society, The, *Glasgow 1900* (Glasgow 1979)

Fleming, Ian & Whyte, Ann, *Great Scottish Etchers*, Aberdeen Art Gallery (1981)

Gibbon, Lewis Grassic, *A Scots Hairst* (London 1967)

Hamerton, P. G., *Etchers & Etching* (London 1876)

Hardie, William, *The Hills of Dream Revisited*, Dundee Art Galleries and Museums (1973)

Hardie, William, & Honeyman, T. J., *Three Scottish Colourists*, SAC (Edinburgh 1970)

Honeyman, T. J., 'Art in Scotland', *The Studio*, CXXV (1943)

Honeyman, T. J., *Three Scottish Colourists: Peploe, Cadell & Hunter* (Edinburgh 1950)

Institute of Contemporary Arts, *The Independent Group* (London 1990)

Irwin, David, 'A Revived Glasgow School', *Scottish Art Review*, n.s., 9 (1964)

Kemplay, John, *The Edinburgh Group*, CEAC (1983)

Knight, Dame Laura, *Oil Paint & Grease Paint* (London 1936)

Lanntair, an, Stornaway, *As an Fhearan, From the Land: a century of images of the Scottish Highlands* (Edinburgh 1986)

Lethaby, W. R., *Architecture, Mysticism & Myth* (London 1892)

MacDiarmid, Hugh, *Aesthetics in Scotland*, ed. Alan Bold (Edinburgh 1984)

MacDiarmid, Hugh, *The Complete Poems*, 2 vols. (London 1976)

MacDiarmid, Hugh, *Francis George Scott; Essay on his 75th Birthday* (Edinburgh 1955)

MacDiarmid, Hugh, 'Guide through the Maze' (review of Thomas Robertson, *Human Ecology*, pub. by William McLellan) *Scottish Art and Letters*, 4 (1949)

Macmillan, Duncan, et al., *Scottish Art Now*, SAC (Edinburgh 1982)

Macmillan, Duncan, 'Tradition & Identity', in *The Scottish Show*, Glyn Vivian Art Gallery (Swansea 1988)

Million: New Left Wing Writing, ed. John Singer, pub. by William McLellan, 1st coll. (n.d. Glasgow), 2nd coll. (1944), 3rd coll. (1945)

Moffat, Alexander, *The New Image, Glasgow*, Third Eye Centre (Glasgow 1985)

National Association, *Transactions of the National Association for the Advancement of Art etc.* (London 1890)

New Scottish Group, The, (essays by J. D. Fergusson, James Bridie et al.) pub. William McLellan (Glasgow 1947)

Patrizio, Andrew, *Industrial Themes in Scottish Art*, unpublished PhD, EU (n.d.)

Powell, Anthony, *A Dance to the Music of Time* (London 1967)

Peacock Printmakers: Recent Work, TRG & Peacock Printmakers (Edinburgh & Aberdeen 1986)

Rhythm, ed. John Middleton Murry, art ed. J. D. Fergusson (London 1911–13)

Robertson, Pamela, *From McTaggart to Eardley: Scottish Watercolours & Drawings 1870–1950*, Hunterian Art Gallery (1986)

Savage, Peter, *Lorimer & the Edinburgh Arts & Crafts Designers* (Edinburgh 1980)

Scottish Gallery, The, *Contemporary Art from Scotland* (Kendal & other venues 1981–82)

Scottish Gallery, The, *Scottish Art 1900–1990* (London 1990)

Scottish National Gallery of Modern Art, *The Vigorous Imagination; New Scottish Art* (1987)

Sert, J. L., 'Quand les Cathédrales étaient Blanches', *Derrière le Miroir* (Paris 1950)

Smith, Edward Lucie, et al., *The New British Painting* (Cincinnati & Oxford 1988)

Society of Independent Scottish Artists, *Modern Scottish Painting*, Edinburgh Festival (Edinburgh 1947)

Studio, The, CXVI, special number on Scottish art, with essays by Stanley Cursiter, Ian Finlay & H. Harvey Wood (1936)

Sturrock, Alec, 'Art Exhibition at Community House', *Scottish Art and Letters*, 5 (1950)

Stuijvenberg, Karel van, Collection of, *Cobra; Forty Years after* (Amsterdam 1988)

Taylor, E. A., 'The Edinburgh Group', *The Studio*, LXXIX (1920)

Tonge, John, 'Scottish Painting', *Horizon* (May 1942)

Whitehead, Alfred North, *Process and Reality; an Essay in Cosmology* (Cambridge 1929)

Wood, H. Harvey, 'Contemporary Scottish Art', *Scottish Art Review*, n.s., 3 (1950)

IV.3

BAIN, Donald; Montgomerie, William, *Donald Bain*, pub. by William McLellan (Glasgow 1950); Melville, Robert, 'Donald Bain', *Million*, 3 (1945)

BARNES-GRAHAM, Wilhelmina; Hall, Douglas, *W. Barnes-Graham: Retrospective 1940–1989*, CEAC (1989)

BELLANY, John; Scottish National Gallery of Modern Art, *John Bellany* (1986)

BLACKADDER, Elizabeth; Bumpas, Judith, *Elizabeth Blackadder* (Oxford 1988); Fruitmarket Gallery, *Elizabeth Blackadder; Retrospective*, SAC (Edinburgh 1981)

BONE, Sir Muirhead; Bone, Muirhead, *Glasgow, Fifty Drawings*, Notes by A. H. Charteris (Glasgow 1911); Bone, Muirhead, *The Western Front*, pub. in monthly parts (London 1917); Bone, Muirhead, *War Drawings by Muirhead Bone from the collection presented by H.M. Government to the British Museum* (London 1917); Bone, Muirhead, 'Talks with Great Scots', *Scotland* (Spring 1937); Dodgson, Campbell, *Muirhead Bone: Etchings & Drypoints 1899–1907* (London 1909); Dodgson, Campbell, 'The Later Drypoints of Muirhead Bone (1908–1916)', *Print Collectors Quarterly* (Feb. 1922); Trowles, Peter, *Muirhead Bone*, Crawford Art Centre (St Andrews 1986)

BURNS, Robert; Forrest, Martin, *Robert Burns, artist & designer*, Bourne Fine Art (Edinburgh 1982)

CADELL, Francis Campbell Boileau; Billcliffe, Roger, *F. C. B. Cadell, a Centenary Exhibition*, The Fine Art Society (Glasgow 1983); Hewlett, Tom, *Cadell: the Life & Work of a Scottish Colourist* (London & Edinburgh 1988)

CALLENDER, Robert; Callender, Robert, & Ogilvie, Elizabeth, *Watermarks*, SAC, Fruit Market Gallery (Edinburgh 1980)

CAMERON, Sir David Young; Arts Council of Great Britain, Scottish Committee, *Sir David Young Cameron, 1865–1945; Centenary Exhibition* (1965); Hind, Arthur M., *The Etchings of D. Y. Cameron* (London 1924); Rinder, Frank, *D. Y. Cameron, an illustrated Catalogue of his etchings and drypoints 1887–1932* (Glasgow 1932); *Modern Masters of Etching, no. 7, D. Y. Cameron*, intro. by Malcolm Salaman (London 1925)

CAMPBELL, Steven; Fruitmarket Gallery & Riverside Studios, *Steven Campbell* (London & Edinburgh 1984); Marlborough Fine Art, *Steven Campbell* (London 1990)

COLQUHOUN, Robert; Brown, Andrew, *Robert Colquhoun*, CEAC (1981)

COWIE, James; Arts Council of Great Britain, Scottish Committee, *James Cowie: Memorial Exhibition* (Edinburgh 1957); Calvacoressi, Richard, *James Cowie*, SNGMA (1979); Cyril Gerber Fine Art, *James Cowie: Paintings & Drawings* (Glasgow 1988); Oliver, Cordelia, *James Cowie* (Edinburgh 1980); Oliver, Cordelia, *James Cowie: the artist at work*, SAC (Glasgow & elsewhere 1981)

CROSBIE, William; Scottish Gallery, The, *William Crosbie* (Edinburgh 1980); Crosbie, William, 'Oriental & Occidental Art', *Scottish Art & Letters*, 3 (1947)

CROZIER, William; Scottish Gallery, The, *William Crozier* (Edinburgh 1989)

CURRIE, Ken; Third Eye Centre, *Ken Currie* (Glasgow 1988)

CURSITER, Stanley; Eddington, A., 'The Paintings & Lithographs of Stanley Cursiter', *The Studio*, LXXXII (July 1921); Pier Art Gallery, Orkney, *Stanley Cursiter; Centenary Exhibition* (Stromness 1987)

DAVIDSON, George Dutch; Dundee Graphic Art Assocation, (David Foggie, John Duncan & others) *George Dutch Davidson, a Memorial volume* (Dundee 1902); Hardie, William, 'The Hills of Dream Revisited: George Dutch Davidson', *Scottish Art Review*, n.s., 13 (1973)

DAVIE, Alan; Bowness, Alan, *Alan Davie* (London 1967); Davie, Alan, *Major Works of the Fifties*, Gimpel Fils (London 1987); Davie, Alan, 'Interview with Keith Patrick', *The Green Book*, III, 3 (Bristol 1989); Horowitz, Michael, *Alan Davie* (London 1963); Royal Scottish Academy, *Alan Davie: Paintings* (1972)

DINGWALL, Kenneth; Scottish Arts Council, *Kenneth Dingwall* (Edinburgh 1977)

DONALDSON, David; Billcliffe, Roger, *David Donaldson RSA*, GAGM (1983)

DUNCAN, John; Armour, Margaret, 'Mural decoration in Scotland, Part 1', *Studio*, X (1897); Geddes, Patrick, & Duncan, John, *Interpretation of the Pictures at University Hall* (Edinburgh 1928); Kemplay, John, *John Duncan*, CEAC (1987)

EARDLEY, Joan; Buchanan, William, *Joan Eardley* (Edinburgh 1976); Oliver, Cordelia, *Joan Eardley* (Edinburgh 1988); Pearson, Fiona, *Joan Eardley 1921–63*, NGS (1988); Westwater, R. H., 'Joan Eardley', *Scottish Art Review*, n.s., 6 (1957)

FERGUSSON, John Duncan; Fergusson, J. D., 'Art & Atavism; the Dryad', *Scottish Art & Letters*, 1 (1944). (Fergusson as art editor also designed the cover of *Scottish Art & Letters*.); Fergusson, J. D., 'Chapter from an Autobiography', *Saltire Review*, VI, No 21 (1960); Arts Council of Great Britain, Scottish Committee, *J. D. Fergusson 1874–1961; Memorial Exhibition of Paintings & Sculpture* (Edinburgh 1961); Billcliffe, Roger, *J. D. Fergusson 1874–1961, a Centenary Exhibition*, The Fine Art Society (Glasgow 1974); McIsaac, Nigel, 'J. D. Fergusson', *Scottish Art Review*, n.s., 7 (1959); Morris, Margaret, *The Art of J. D. Fergusson; A biased biography* (Glasgow 1974); Morris, Margaret, *Café Drawings in Edwardian Paris from the sketch-books of J. D. Fergusson*, arranged by Jean Geddes (Glasgow 1974); Murry, John Middleton, *Between Two Worlds* (London 1935); Sykes, Diana, *J. D. Fergusson 1905–1915*, Crawford Art Centre (St Andrews 1982); Watt, Alexander, 'J. D. Fergusson', *The Artist* (May 1937); Cumming, Elizabeth et al., *Colour, Rhythm and Dance*, SAC (Edinburgh 1985)

FINLAY, Ian Hamilton; Finlay, Ian Hamilton, et al., *Heroic Emblems* (Calais, Vermont, 1977); Finlay, Ian Hamilton, *Poursuites Revolutionaires* (Paris 1987); Finlay, Ian Hamilton, *Nature Over Again After Poussin*, Collins Exhibition Hall (Glasgow 1980); Finlay, Ian Hamilton, *Inter Artes et Naturam*, Musee d'Art Moderne de la Ville de Paris (Paris 1987); Abrioux, Yves, & Bann, Stephen, *Ian Hamilton Finlay; a Visual Primer* (Edinburgh 1985); Bann, Stephen, *Ian Hamilton Finlay; an illustrated essay*, SNGMA (1972); Bann, Stephen, *Ian Hamilton Finlay*, ACGB, Serpentine Gallery (London 1977); Edeline, Francis, *Ian Hamilton Finlay*, (Liege 1977)

FLEMING, Ian; *Ian Fleming*, Peacock Printmakers (Aberdeen 1982)

GEAR, William; Karl & Faber Gallery, *William Gear* (Munich 1988)

GILLIES, Sir William; Smart, Alastair, 'William Gillies', *Scottish Art Review*, n.s., 5 (1955); Scottish Arts Council, *William Gillies: Retrospective*, RSA (1970); Dickson, T. Elder, *W. G. Gillies* (Edinburgh 1974)

GUTHRIE, James (printmaker); Guthrie, James, 'The Different Art of Hand-Printing', *Modern Scot*, I, (1930)

HANNAH, George; Hannah, George, 'The Painting of George Hannah', *Million*, 1st coll. (Glasgow 1943)

HARDIE, Gwen; Fruitmarket Gallery, *Gwen Hardie* (Edinburgh 1987); Scottish National Gallery of Modern Art, *Gwen Hardie* (Edinburgh 1990)

HENDERSON, Keith; Whitworth, Geoffrey, 'Keith Henderson', *The Studio*, 90 (1925)

HOUSTON, John; Macmillan, Duncan, *John Houston Works on Paper 1960–1987*, TRG (Edinburgh 1987)

HUNTER, Leslie; Honeyman, T. J., *Introducing Leslie Hunter* (London 1937)

JAMIESON, Alexander; Manson, J. B., 'Alexander Jamieson', *The Studio*, Vol. LI (1911)

JOHNSTONE, Dorothy; Aberdeen Art Gallery, *Dorothy Johnstone* (1983)

JOHNSTONE, William; Johnstone, William, *Child Art to Man Art* (London 1941); Johnstone, William, 'The Education of the Artist', *The Studio*, CXXV (Jan. 1943); Johnstone, William, *Creative Art in Britain* (first pub. as *Creative Art in England* 1936) 2nd ed. (London 1950); Johnstone, William, *Points in Time; an autobiography* (London 1980); Christies & Co., *Catalogue of the Sale of the Studio of Dr William Johnstone OBE* (Glasgow 1990); Cunningham, A. T., 'William Johnstone', *Studio*, CXXV (Jan. 1943); Ehrensweig, Anton, *William Johnstone*, Stone Gallery (Newcastle upon Tyne 1961); Hall, Douglas, *William Johnstone* (Edinburgh 1980); Hayward Gallery, London, *William Johnstone; retrospective* (London & Edinburgh 1980); Macmillan, Duncan, 'William Johnstone; an appreciation', *Art Monthly* (July 1981); Saurat, Denis, 'Scottish Intellectualism, William Johnstone', *Studio* (Aug. 1943); Scottish Arts Council, *William Johnstone: Retrospective Exhibition* (Edinburgh 1970)

KING, Jessie, M.; Oliver, Cordelia, *Jessie M. King*, SAC (Edinburgh 1971); White, Colin, *The Enchanted World of Jessie M. King* (Edinburgh 1989)

KNOX, Jack; Oliver, Cordelia, *Jack Knox*, Third Eye Centre, (Glasgow 1983)

KIRKWOOD, John; Hare, Bill, 'Pie in the Sky', *Alba*, I (Summer 1986)

LAWRENCE, Eileen; Fischer Fine Art, *Eileen Lawrence: recent work* (London 1980); Fischer Fine Art, *Eileen Lawrence: recent work* (London 1985)

LOW, Bet; Oliver, Cordelia, *Bet Low*, Third Eye Centre (Glasgow 1985)

LUMSDEN, Ernest S.; Lumsden, E. S., *The Art of Etching* (1925); Salaman, Malcolm C., 'The Etchings of E. S. Lumsden', *Print Collector's Quarterly*, XXIII (1921)

McBEY, James; Hardie, Martin, *James McBey: Catalogue Raisonée 1902–24* (London 1925); Hardie, Martin, & Carter, Charles, *James McBey: Etchings & Drypoints from 1924* (Aberdeen 1964); McBey, James, *The Early Life of James McBey: An Autobiography 1883–1911*, ed. Nicholas Barker, (Oxford 1977); Salaman, Malcolm C., *The Etchings of James McBey* (London 1929)

McCANCE, William; McCance, William, 'The Idea in Art', *The Modern Scot*, I, no. 2 (1930); Cyril Gerber Fine Art, *William McCance* (Glasgow 1989); Dundee Art Galleries and Museums, *William McCance* (1975); MacDiarmid, Hugh, 'The Art of William McCance', *Saltire Review*, VI, no 22 (1960); MacDiarmid, Hugh, 'William & Agnes McCance', *Scottish Educational Journal*, 20 Nov. 1925, reprinted MacDiarmid, *Contemporary Scottish Studies* (Edinburgh 1976); Reading Museum and Art Galleries, *Work by William McCance* (1960)

McEWEN, Rory; Hall, Douglas, *Rory McEwen: the Botanical Paintings* Royal Botanic Garden (Edinburgh 1988)

MACKIE, Charles Hodge; Bourne Fine Art, *Charles Hodge Mackie* (Edinburgh n.d.)

MACKINTOSH, Charles Rennie; Billcliffe, Roger, *Architectural Sketches – Flower Drawings by Charles Rennie Mackintosh* (London 1977); Billcliffe, Roger, *Mackintosh Watercolours* (London 1978); Young, Andrew McLaren, *Charles Rennie Mackintosh*, SAC (Edinburgh 1968); Howarth, Thomas, *Charles Rennie Mackintosh & the Modern Movement* 2nd ed. (London 1977); Reekie, Pamela, *The Mackintosh House*, Hunterian Art Gallery (Glasgow n.d.)

MACKINTOSH, Margaret Macdonald; Reekie, Pamela, *Margaret Macdonald Mackintosh*, Hunterian Art Gallery (Glasgow 1983)

MACLEAN, Will; Third Eye Centre, *Will Maclean; The Ring-Net* (Glasgow 1978); Claus Runkel Fine Art Ltd., *Will Maclean: Sculptures & Constructions 1974–1987, Catalogue Raisonnée* (London 1987); Macmillan, Duncan, *Will Maclean*, Runkel-Hew-Williams (London 1990)

MACNAB, Iain; Garrett, Albert, *Wood Engravings & Drawings of Iain Macnab of Barachastlain* (Tunbridge Wells 1973); Grimsditch, Herbert, 'Ian MacNab', *The Artist* (Apr. 1937)

MACTAGGART, Sir William; Wood, H. Harvey, *William MacTaggart* (Edinburgh 1974); Scottish National Gallery of Modern Art, *Sir William MacTaggart* (1968)

MAXWELL, John; Westwater, R. H., 'John Maxwell', *Scottish Art Review*, n.s., 4 (1956); McLure, David, *John Maxwell* (Edinburgh 1976)

MOFFAT, Alexander; Third Eye Centre, *Seven Poets: an exhibition of Paintings & Drawings by Alexander Moffat* (Glasgow 1981); Scottish National Portrait Gallery, *A View of the Portrait; Portraits by Alexander Moffat, 1968–73* (1973)

MORRISON, James; McLean, H., 'James Morrison', *Scottish Art Review*, n.s., 1 (1959)

OGILVIE, Elizabeth; Ogilvie, Elizabeth, text by Duncan Macmillan, *Sea Sanctuary*, TRG (1989); Callender, Robert, & Ogilvie, Elizabeth, *Watermarks*, SAC, Fruit Market Gallery (Edinburgh 1980)

ONWIN, Glen; Onwin, Glen, *The Revenges of Nature*, Fruit Market Gallery (Edinburgh 1988); Onwin, Glen, *The Recovery of Dissolved Substances*, Arnolfini Gallery (Bristol 1978)

PAOLOZZI, Sir Eduardo; Arts Council of Great Britain, *Eduardo Paolozzi* (Newcastle 1976); Kirkpatrick, Diane, *Eduardo Paolozzi* (London 1970); Macmillan, Duncan, *Eduardo Paolozzi*, TRG (1979); Macmillan, Duncan, & Patrizio, Andrew, *Eduardo Paolozzi; Nullius in Verba*, TRG (Edinburgh 1989); Miles, Rosemary, *The Complete Prints of Eduardo Paolozzi*, V&A (1977); Paolozzi, Eduardo, *Lost Magic Kingdoms*, Museum of Mankind (London 1985); Schneede, Uwe, *Eduardo Paolozzi* (London 1971); Scottish Sculpture Trust (Robin Spencer) *Eduardo Paolozzi; Recurring Themes* (Edinburgh 1984); Sculpturenmuseum, Marl, *Eduardo Paolozzi* (Kopfe 1986); Spencer, Robin, *Paolozzi Portraits*, NPG (1988); Tate Gallery, *Eduardo Paolozzi* (London 1971)

PARKER, Agnes Miller; MacDiarmid, Hugh, 'William & Agnes McCance', *Scottish Educational Journal*, 20 Nov. 1925, reprinted MacDiarmid, *Contemporary Scottish Studies* (Edinburgh 1976)

PATRICK, James McIntosh; Billcliffe, Roger, *James McIntosh Patrick*, The Fine Art Society for Dundee District Council (1987)

PEPLOE, Samuel J.; Fergusson, J. D., 'Memoir of S. J. Peploe', written in 1945 and published *Scottish Art Review*, n.s., 8 (Jan. 1962); Peploe, Guy, *S. J. Peploe*, NGS (1988); Cursiter, Stanley, *Peploe: an intimate memoir of an artist and his work* (London 1947)

PHILIPSON, Sir Robin; Billcliffe, Roger, *Robin Philipson*, Edinburgh College of Art (1989); Lindsay, Maurice, *Robin Philipson* (Edinburgh 1976); Dickson, T. Elder, 'Robin Philipson', *Scottish Art Review*, n.s., 8 (1961)

PRINGLE, John Quinton; Brown, David, *John Quinton Pringle*, SAC (1981); Johnston, Elizabeth, 'John Quinton Pringle', *Scottish Art Review*, n.s., 9 (1963)

PRYDE, James; Hudson, Derek, *James Pryde 1866–1941* (London 1949)

REDPATH, Anne; Bourne, Patrick, *Anne Redpath* (London & Edinburgh 1989); Bruce, George, *Anne Redpath* (Edinburgh 1974)

ROBERTS, Derek; Laing Art Gallery, Newcastle upon Tyne, *Four Seasons: Paintings by Derek Roberts* (1988)

ROBERTSON, Eric; Piccadilly Gallery (John Kemplay) *Eric Robertson* (London 1987)

SHANKS, Duncan; Macmillan, Duncan, *Duncan Shanks; Falling Water*, TRG (1988)

SIVELL, Robert; Arts Council of Great Britain, Scottish Committee, *Robert Sivell* (1960)

SOUTAR, John Bulloch; Bourne Fine Art (Elcy Cruickshank Broadhead née Soutar) *John Bulloch Soutar* (Edinburgh 1986)

STRACHAN, Douglas; Strachan, Douglas, *Stained Glass Windows of Douglas Strachan*, privately printed (Aberlemno 1972)

STRANG, William; Binyon, Laurence, 'The Etchings of William Strang', *Print Collector's Quarterly*, VIII (1921); Newbolt, Sir Frank, *The Etchings of William Strang* (London n.d.); Sheffield City Art Gallery, *William Strang RA* (1981); Strang, David, 'The Etchings of William Strang', *Print Collector's Quarterly*, XXIV (1937); Strang, David, *Catalogue Raisonneé of the Printed Work of William Strang* (1962)

SUTHERLAND, David Macbeth; Aberdeen Art Gallery, *D. M. Sutherland 1883–1973* (1974)

WALKER, Frances; Talbot Rice Gallery, *Frances Walker: the Tiree works* (1990)

WHITEFORD, Kate; Third Eye Centre, *Kate Whiteford: Rites of Passage* (Glasgow 1984)

WILSON, William; McIsaac, Nigel, 'William Wilson', *Scottish Art Review*, n.s., 7 (1959)

INDEX